LIGHT AND LENS

The new edition of this pioneering book allows students to acquire an essential foundation for digital photography. Fully updated, it clearly and concisely covers the fundamental concepts of imagemaking, how to use digital technology to create compelling images, and how to output and preserve images in the digital world. Exploring history, methods, and theory, this text offers classroom-tested assignments and exercises from leading photographic educators, approaches for analyzing, discussing, and writing about photographs, and tools to critically explore and make images with increased visual literacy.

New to this edition:

- New larger page format
- Revised and renewed to reflect technological advances
- Expanded coverage of smartphone/mobile photography
- Extended coverage of the careers section
- More than 100 new images

Robert Hirsch is a photographer, writer, and curator and the director of Light Research *Exploring Color Photography: From Film to Pixels*. His books include *Seizing the Light: A Social & Aesthetic History of Photography*, *Light and Lens: Photography in the Digital Age*, *Photographic Possibilities: The Expressive Use of Concepts, Ideas, Materials, and Processes*, *Exploring Color Photography: From Film to Pixels*, and *Transformational Imagemaking: Handmade Photography from 1960 to Now*. Hirsch is a former Associate Editor for *Digital Camera* (UK) and *Photovision Magazine*, and a contributor to *Afterimage*, *Exposure*, *Buffalo Spree*, *Fotophile*, *FYI*, *History of Photography*, *Ilford Photo Instructor Newsletter*, *The Photo Review*, and *World Book Encyclopedia* as well as former Director of CEPA Gallery and founder of Southern Light Gallery.

Greg Erf is an accomplished imagemaker who has exhibited and published his photography throughout the United States. As a writer and Professor of Art at Eastern New Mexico University, his focus is the convergence of analog and digital imagemaking. Erf teaches two- and three-dimensional computer graphics and animation, plus photography. His two- and three-dimensional computer-generated work has been internationally exhibited in 360° full dome planetarium venues. His pieces are in various collections in the state of New Mexico, including the Museum of Fine Arts, Santa Fe. He is on the Board of the Capitol Art Foundation that manages New Mexico's extensive historic and contemporary art collection. For further details see www.gregerf.com.

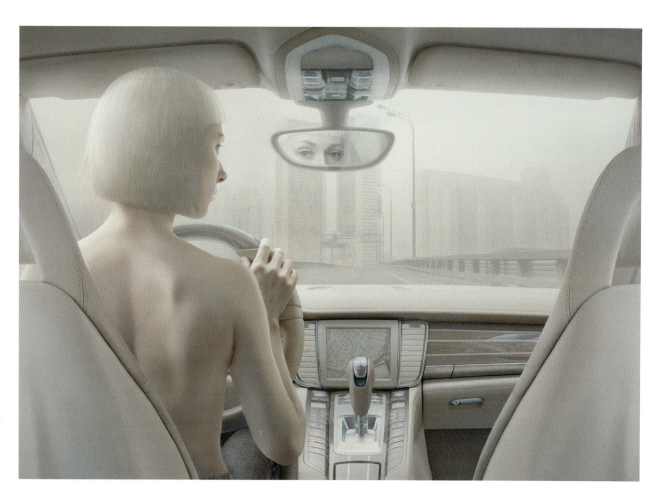

Katerina Belkina tells us: "My face and body are the main instruments I use to incarnate the images I want. Standing in front of the camera as a model, I follow the age-old theatrical practice of playing roles. It gives impetus to the development of my own manner of narration in which shooting is akin to a theatrical performance. A passion for classical art and interest in everything new—technology, discoveries, experiments— led me to the type of mixed media. From painting, I take colors and create air as an element of space. From photography, reality and character. My style originates from the artistic tradition of collage. That is how my characters and spaces come together. At the next stage, I choose a brush of a graphics program. This is a subtle and accurate tool to create a light, weightless atmosphere similar to that of a dream. Undoubtedly, this view is based on my feminist principles. Yet, the matter is not in confrontation, but in balance and harmony, where a woman is not an object, but foremost—energy."

Credit: © Katerina Belkina. *The Road*, 2011. 37 x 51 inches. Inkjet print.

LIGHT AND LENS

Photography in the Digital Age

THIRD EDITION

Robert Hirsch
with Greg Erf

Routledge
Taylor & Francis Group

NEW YORK AND LONDON

Third edition published 2018
by Routledge
711 Third Avenue, New York, NY 10017

and by Routledge
2 Park Square, Milton Park, Abingdon, Oxon OX14 4RN

Routledge is an imprint of the Taylor & Francis Group, an informa business

First edition published by Elsevier 2008
Second edition published by Elsevier 2012

Library of Congress Cataloging in Publication Data
A catalog record for this title has been requested

ISBN: 978-1-138-21302-9 (hbk)
ISBN: 978-1-138-94439-8 (pbk)
ISBN: 978-1-315-67195-6 (ebk)

Typeset in Bembo
by Florence Production Ltd, Stoodleigh, Devon, UK

Printed and bound in India by Replika Press Pvt. Ltd.

*To my wife, Adele Henderson, my mother, Muriel Hirsch,
and my companion, Marty Keeshond, for their love and support.
In addition, to all the artists, writers, and teachers, past and present,
who have influenced and inspired my own endeavors.*

"If I am not for myself, then who will be for me?
And when I am for myself, what am I? And if not now, when?"

Hillel the Elder

"Here the ways of man part: If you wish to strive for peace of soul
and pleasure, then believe; if you wish to be a devotee of truth,
then inquire."

Friedrich Nietzsche

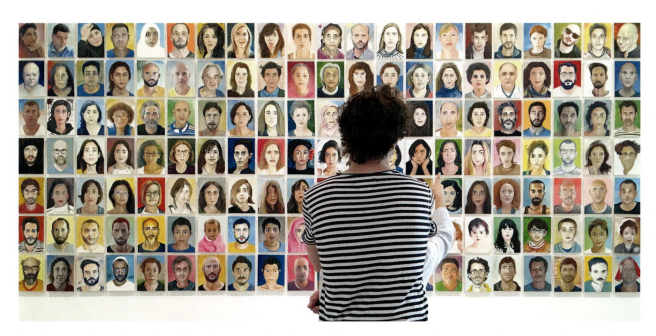

Digital imagemaking and social media has shattered analog photographic practice by empowering anyone with a camera in their smartphone to become a maker and publisher of images.

Credit: © Robert Hirsch. *Faces*, 2017. Dimensions vary. Digital file.

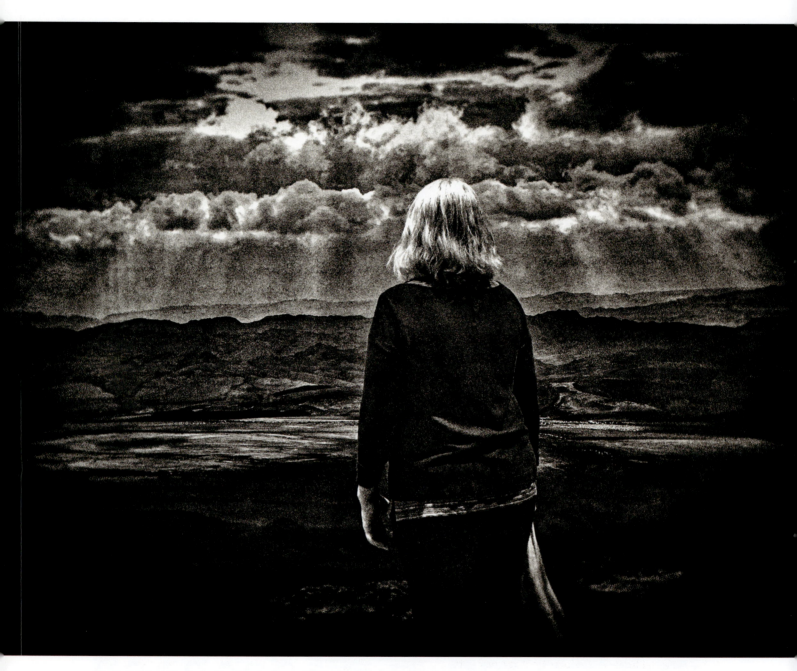

Credit: © Robert Hirsch. *Looking into the Future*, 2017. 30 x 40 inches. Inkjet print.

Contents

Preface .. *xix*

Artist Contributors .. *xxvii*

Chapter 1—Why We Make Pictures ... 1

A Concise History of Visual Ideas ... *1*

Not Just Pictures but Photographs ... *2*

The Grammar of Photography .. *3*

The Evolution of Photographic Imaging ... *3*

Full Circle: Some Things Remain the Same *4*

Determining Meaning .. *4*

Before Photoshop .. *4*

 Combination Printing 5

 The Advent of Straight Photography 6

 The Pictorialists 6

 The Photo-Secessionists 7

 The Arrival of Straight Photography 7

Modernistic Approaches ... *7*

 Documentary/Photojournalistic Approach 7

 Straight Photography and Previsualization 8

 Group f/64 and the Zone System 9

 Postvisualization 9

 Social Landscape and the Snapshot Aesthetic 9

 The Alternative Scene 10

 The Rise of Color Photography 10

 Postmodernism 10

Electronic Imaging: New Ways of Thinking *12*

The Digital Imaging Transformation .. *12*

New Media .. *15*

Questions Regarding Photo-Based Imagemaking *16*

References .. *28*

Chapter 2—Design: Visual Foundations ... **31**

Learning to See: Communicating with Design ... 31

Beginner's Mind .. 31

The Design Process .. 32

The Nature of Photography: Subtractive Composition 32

Departure Point .. 33

Attention Span and Staying Power ... 33

Photography's Privilege ... 34

The Language of Vision .. 34

Photography's Native Characteristics ... 35

Design Principles .. 37

 Unity and Variety 37

 Emphasis 38

 Scale and Proportion 39

 The Golden Mean: The Rule of Thirds 40

 Balance 41

Visual Elements ... 45

 Line 45

 Shape 46

 Space 47

 Texture 48

 Pattern 48

 Symbolism 49

 General Symbol Categories 51

 Shapes and Their General Symbolic Associations 54

 Color Symbolism 54

 Common Symbols and Some Potential Associations 54

References .. 57

Chapter 3—Image Capture: Cameras, Lenses, and Scanners **59**

The Role of a Camera .. 59

What Is a Camera? ... 60

How a Camera Imaging System Works .. 62

Digital Cameras .. 63

 Digital Observations 63

 Image Sensors: CCD and CMOS 64

 Color Filter Array: Bayer Filter Mosaic 65

 Pixels 65

 Image Resolution 65

 PPI: Pixels per Square Inch and Digital Camera Resolution 66

 DPI: Dots per Square Inch and Printer Resolution 66

 The Differences between PPI and DPI 67

 Visual Acuity and 300 DPI 67

CONTENTS

Types of Digital Cameras .. *68*

 Compact Digital Cameras 68

 Digital Single-Lens Reflex Cameras 69

 Single-Lens Translucent Cameras 70

 Mirrorless Cameras 70

 Smartphone Cameras 71

 Other Camera Types 71

Choosing a Camera ... *75*

Camera File Formats ... *75*

 Image Compression Algorithms: Lossless and Lossy 76

 Major Image File Formats 76

 JPEG 76

 HEIC 77

 TIFF 77

 RAW and Post-Processing 77

 DNG 78

 Opening Files 78

The Lens System and Exposure .. *78*

 Aperture 78

 Aperture/f-Stop Control/Shutter Control/ Exposure Modes 79

 Depth of Field 80

 Lens Focal Length 82

 Focusing the Image 84

 Autofocus Modes 85

 Types of Lenses 86

 Zoom Lens 86

 Normal Lens 86

 Wide-Angle Lens 87

 Telephoto Lens 87

 Special-Use Lenses 88

 Shutters: Rolling and Global 89

 Shutter Speed Control 90

 Shutter Lag 90

 Shutter Modes 90

 Determining Exposure 90

Digital Camera Features .. *92*

 Resolution and Print Size 92

 Monitor 93

 Monitor Playback Mode and Histogram 93

 Metadata/EXIF 94

 Optical and Digital Zoom 95

 Digital ISO/Sensitivity 95

 Digital Aberrations: Noise, Banding, Blooming, and Spots 95

 White Balance 96

CONTENTS

Metering Modes 96

Aspect Modes 98

Color Modes 98

Image Enhancement and Scene Modes 98

Special Effect Modes 98

Video Mode 98

Sharpening Mode 99

Guide or Help Mode 100

Noise Reduction 100

Image Stabilization 101

Flash 101

Memory Buffer 103

Removable Camera Memory Storage 103

Firmware 103

Software: You Press the Button and the Camera Does the Rest 103

Battery 104

Battery Choices 104

Battery Care in Cold Conditions 105

Camera, Lens, Monitor, and Sensor Care ... *107*

Protection against the Elements 107

Scanners ... *109*

Flatbed and Film Scanners 109

Drum Scanners 109

Scanning Guidelines 110

Scanning Steps 110

Frame Grabber ... *112*

Effects on Photojournalists and Event Photographers 112

Storing Digital Images .. *113*

Digital Asset Management (DAM) 113

Storage Media for Final Image Files 114

Compact (CD), Digital Versatile (DVD) Discs 115

Mechanical Storage 115

Internal Hard Disk Drives 115

External Hard Disk Drives 115

Solid-State Storage: Hard Drives, USB Drives, Jump Drives, and Flash Memory Media 115

Image Transfer 116

Cloud Storage 116

Living Images: Authorship, Access, and the World's Largest Picture Book *117*

Chapter 4—Exposure and Filters ... **121**

Exposure Basics .. *121*

Camera Light Meters Are 18 Percent Gray Contrast ... 121

Reflective and Incident Light 121

How a Light Meter Works 123

How a Histogram Works 124

Using a Gray Card 124

Camera Metering Programs 125

Using a Camera Monitor 125

Electronic Viewfinder (EVF) 126

How a Meter Gets Deceived 126

Exposure Bracketing 127

Exposure Compensation 127

Manual Override 127

Handheld Meters 128

Brightness Range 128

Exposing to the Right 129

High Dynamic Range (HDR) Imaging 129

Basic Light Reading Methods 130

Average Daylight 130

Brilliant Sunlight 130

Diffused Light 132

Dim Light 133

Contrast Control/Tone Compensation 133

Light Metering Techniques 134

Electronic Flash and Basic Fill Flash 134

Red Eye 137

Unusual Lighting Conditions 139

Subject in Shadow 140

Subject in Bright Light 140

Zoom Exposure 141

Averaging Incident and Reflect Exposures 141

Scene Mode Exposures 141

Reciprocity Law 141

Long Exposures and Digital Noise 142

Filtering the Light .. *143*

Our Sun: A Continuous White Light Spectrum 143

Color Temperature and the Kelvin Scale 143

The Color of Light 144

White Balance 144

Camera Color Modes 145

Color Saturation Control 145

Hue Adjustment/RGB Color Mixing 145

Why a Color May Not Reproduce Correctly 146

Lens Filters 146

How Filters Work 146

Filter Factor 146

Neutral Density Filters 147

Controlling Reflections: Polarized and Unpolarized Light 147

What a Polarizing Filter Can Do 148

Using a Polarizer 148

Linear and Circular Polarizers 149

Ultraviolet, Skylight, and Haze Filters 149

Special Effects Filters 150

Homemade Color and Diffusion Filters 150

Digital Filters and Plugins 151

Fluorescent and Other Gas-Filled Lights 152

High-Intensity Discharge Lamps/Mercury and Sodium Vapor Sources 153

Chapter 5—Interpreting Light .. 155

Natural Light .. *155*

The Thingness of Light 155

Good Light 156

Light and the Camera 157

The Time of Day / Types of Light *158*

The Cycle of Light and Its Basic Characteristics 158

Before Sunrise 160

Morning 160

The Golden Hour 160

Midday 160

Afternoon 161

Sunset 161

Twilight/Evening 163

Night 163

Moonlight 164

The Seasons 165

The Weather and Atmospheric Conditions 166

Fog and Mist 166

Rain 166

Snow 167

Snow Effects 167

Dust 168

Heat and Fire 168

Beach and Desert 169

Artificial Light .. *169*

Add a Light 169

The Size of the Main or Key Light 172

The Placement of the Light 172

Contrast/Brightness Range 173

Basic Lighting Methods .. 174

 Front Light 175

 Side Light 175

 High Side Light 175

 Low Side Light 175

 Top Light 175

 Back Light 175

 Under Light 175

Lighting Accessories ... 176

 Barn Doors 176

 Diffuser 176

 Gels 177

 Reflector Card 177

 Seamless Paper Backdrops 181

 Snoot 181

 Studio Strobes 181

References ... 181

Chapter 6—Observation: Eyes Wide Open ... 185

How We See ... 185

 Literacy 185

 Learning to Look 185

 The Difference between Artistic and Scientific Methods 185

 Visual Literacy and Decision Making 188

Why We Make and Respond to Specific Images .. 189

 Victor Lowenfeld's Research 189

 Visual-Realists as Imagemakers 190

 Visual-Realist Photographic Working Methods 190

 Haptic-Expressionist Imagemakers 190

 Haptic–Expressionist Photographic Working Methods 191

The Effects of Digital Imaging ... 193

 Photography's Effect on the Arts 193

 Pushing Your Boundaries 194

Aesthetic Keys for Color and Composition ... 195

 The Color Key 195

 The Composition Key 195

 Recognizing the Keys 195

Figure-Ground Relationships ... 197

 The Importance of Figure-Ground Relationships 197

Chapter 7—Time, Space, Imagination, and the Camera 201

In Search of Time .. 201

The Perception of Time ... 202

Controlling Camera Time ... 204

 Exploring Shutter Speeds: The Decisive Moment 204

 Extending the Action/Deconstructing *The Decisive Moment* *204*

 Stopping the Action 205

 Smartphone Cameras: Controlling Shutter Speeds 208

 Stopping Action with Electronic Flash 209

 Blur and Out-of-Focus Images 209

 Motion Blur Filters 210

 Lensbaby: Bokeh/Selective Focus 210

 The Pan Shot 211

 Equipment Movement 212

 Free-Form Camera Movement 213

 Flash and Slow Shutter Speed 214

 Extended Time Exposures 215

 Drawing with Light 216

 Projection 217

 Multiple Images 218

 Sandwiching/Overlapping Transparencies 219

 Rephotography 220

 Post Documentary Approach 221

 Post-Camera Visualization 222

 Sequences 223

 Using a Grid 224

 Many Make One 224

 Contact Sheet Sequence 224

 Joiners 227

 Slices of Time 227

 Photomontage and Compound Images 228

 Photographic Collage 229

 Three-Dimensional Images: Physical and Virtual 229

 Image-Based Installations 231

 Public Art 232

 Social Media 235

 Recomposing Reality 236

Timeline Animation ... 237

 Getting Started: Making Your Timeline Animation 238

References .. 241

Chapter 8—Digital Studio: The Virtual and the Material Worlds **243**

The Megapixel Myth ... 243

 Pixel Size Matters 243

Displaying the Image File: Screen or Print ... *244*

 Pixels per Inch (PPI) and Dots per Inch (DPI) 244

 Sizing a Digital File 248

Resampling or Interpolation 248

Preserving Original Capture .. *250*

Working with RAW File Formats 250

True Resolution in the Physical World .. *252*

Default Image Preview Confusion 252

Digital Post-Capture Software Programs 253

The Image Window 253

The Bottom Line: Best Setting to Get the Desired Results 253

Making Photographic-Quality Prints ... *253*

Inkjet Printers: Converting DPI to Dots 253

Droplet Size: Picoliters 255

Paper: Uncoated and Coated 256

Inks: Dye and Pigment Based 257

Print Permanence 258

Printing Systems and Output Concerns 258

Image Correction and the Computer Workstation ... *261*

The Color Monitor 262

How Monitors Display Color 263

Bit Color 263

Comparing 8-Bit and 16-Bit Modes 264

Color Management (ICC Profiles) 265

Controlling Color Space: Profiles and Lights 265

WYSIWYG: What You See Is What You Get 265

Lighting in the Work Space 266

Digital Colors: CMYK and RGB 267

Digital Memory 267

Software and Imaging Applications .. *267*

Raster/Bitmapped Software 269

Vector Graphics Software 269

Basic Digital Imaging Categories and Tools .. *269*

Top Main Menu Options 269

Cut/Copy and Paste Functions 270

Scale and Distort Functions 270

Digital Filter Function 271

Toolbar Icons for Additional Photo Editing 271

Common Toolbar Icons from Photoshop .. *272*

Additional Toolbar Tools 275

Additional Photoshop Tools 276

The Computer as a Multimedia Stage: Moving Images *276*

The Internet and the World Wide Web ... *278*

Information Sharing: Search Engines and Weblogs 279

Digital Galleries 279

The Digital Future .. *279*

References .. *281*

Chapter 9—Presentation and Preservation .. 283

Digital Retouching and Repair .. 283

Archival Presentation .. 283

 Presentation Materials 283

 Mat Board Selection 284

 Window Mat 284

 Dry and Wet Mounting 287

 The Dry-Mounting Process 289

 Cold Mounting 291

 Floating a Print 291

 Frames 291

 Unusual Frames and Presentations 291

 Portfolios 292

 Books: Print on Demand 292

 Images on a Screen: Web Sharing 293

 Website Design/HTML 295

Factors Affecting Print Preservation .. 296

 Factors Affecting Print Stability 296

 Color Print Life Span 298

 Print Display Environment 299

 Storage Environment 300

Digital Archives .. 300

 Long-Term Storage and Migrating Digital Archives 300

 Transferring Film-Based Images to a Digital Format 301

 Digital Assessment Management (DAM): Post-Production Software 301

Digital Print Stability .. 302

 Dye-Based Inks 302

 Pigmented Inks 302

 Printing Media 302

 Protecting Pigment Prints 303

Camera Copy Work .. 303

 Lens Selection: Macro Lens/Mode 303

 Copy Lighting 304

 Exposure 305

Presenting Your Work .. 305

 Shipping 305

 Copyright of Your Own Work 306

 Where to Send Work 306

Chapter 10—Seeing with a Camera ... 309

The Framing Effect: Viewpoint .. 309

 Seeing Dynamically 309

 Working Methods 310

 Effectively Using Angles of View 310

Selective Focus .. 314
Contrast .. 317
 Complementary Colors 317
 Warm and Cool Colors 317
 Creating Color Contrast 317
Dominant Color ... 318
 Be Straightforward 318
 Sustaining Compelling Composition 319
Harmonic Color .. 320
 Effective Harmony 320
Isolated Color ... 322
 Chance Favors the Prepared Mind 323
Monochrome Images ... 324
 The Personal Nature of Monochrome 324
 Color Contamination 324
 Aerial Perspective 324
Perspective .. 327
 Essential Methods of Perspective Control 327
 Converging Lines 328
Subdued Color ... 329
 Operational Procedures 330
Highlights and Shadows .. 330
Attraction and Repulsion ... 331
 Surmounting Preconceptions 331
Counterpoints and Opposites .. 332

Chapter 11—Solutions: Thinking and Writing about Images ... **335**
Thinking Structure: A Process for Discovery and Problem Solving 336
A Thinking Model ... 338
 Stage 1: Thinking Time 338
 Stage 2: Search for Form 342
 Stage 3: Definition and Approach 344
 Stage 4: Bringing It Together 345
 Stage 5: Operations Review 346
 Stage 6: Evaluation 346
The Photograph as a Matrix ... 347
Size Matters .. 348
Communicating Culural Knowledge ... 348
The Image Experience: Photographing Meaning is Changeable 350
Writing about Images ... 352
 Writing an Artist's Statement 353
Essentials of Image Discussion ... 356
John Cage's Rules .. 357
References .. 359

Chapter 12—Imagemaker on Assignment ... 361

Making Portraits: Who Am I and Who Are You? .. 361
 Self-Portrait Research 361
 Self-Portraits 362
 Portrait of Another Person 362
 Environmental Portrait 363
Fauxtography: Photography's Subjective Nature .. 363
 Truthiness and Wikiality 364
Picturing Social Identity .. 366
 Depicting Social Customs 367
 Who Can Represent Us? 367
Interior Experience: The Significance of Daily Life .. 369
 Philosophical Belief: Optimism, Pessimism, and Existentialism 369
 Psychological Drama 371
 Social Issues 373
Fabrication for the Camera: Directorial Mode .. 374
 The Social Landscape 375
Still Life .. 377
 Still-Life Deliberations 379
The Human Form .. 380
The Screen: Another Picture Reality ... 383
 Alternative Approaches 383
Text and Images .. 384
Artists' Books and Albums .. 390
Self-Assignment: Creation and Evaluation ... 392
 Evaluation Guide—Before Making Images 392
 Guide to Evaluation—After Photographing 393

Addendum 1 Safety: Protecting Yourself and Your Digital Imaging Equipment 397

Ergonomic Workstations .. 397
Monitor Emissions: ELF/VLF .. 397
Eyestrain .. 397
Proper Posture/Lower Back Problems ... 397
Carpal Tunnel Syndrome .. 397
Taking Breaks .. 398
Neutral Body Positioning .. 398
Change Your Working Position .. 399

Addendum 2 Careers ... 401

The Working Photographer .. 401
Getting Started ... 403
References .. 404

Index .. 407

Preface

"Those who attain to any excellence commonly spend life in some single pursuit, for excellence is not often gained upon easier terms." Samuel Johnson (1709–1784)

Since *Light and Lens: Photography in the Digital Age* was first published in 2008 advances in digital image workflow, display, and distribution have largely displaced older forms of analog photographic practice. One result is the ease in which a person can now make technically competent pictures. Reflecting this change, this revised, expanded, and reformatted third edition concentrates on the visual skills beginning imagemakers need to quickly start creating engaging photographs by simplifying the ever-changing technical software sections.

The ascendancy of the photographic pixel as the accepted image building block has necessitated a rethinking about how beginning photography courses are structured and taught at the college level. Photography's original analog role was to provide a fixed, recognizable, physical representation of a subject in the material world. Digital imaging dispenses with this anchor of mirroring the material world by making images that are easily changeable and likely to exist only on a screen as opposed to being physically printed.

Thus photographic imagemaking has moved from being a firm, tangible witness of outer reality to being a flexible, immaterial fiction. In dispensing with the nineteenth-century notion of photographic truth, we have added the freedom to explore picturemaking's subjective nature by means of altering a camera's capture or creating an entirely new digital reality. Furthermore, every image ever made can now become digital, thus reinforcing the fact that all photo-based images are human constructions.

Light and Lens meets these challenges by clearly and concisely stressing the fundamental "forever" aesthetic and technical building blocks necessary to create thought-provoking, digitally based photographs. The methodology is practical, explaining how theoretical principles relate directly to introductory imagemaking by presenting the most straightforward means of realizing one's ideas with digital photography. Those interested in analog and handmade processes can read my other books, *Photographic Possibilities: The Expressive Use of Concepts, Ideas, Equipment, Materials, and Processes, Fourth Edition* and *Transformational Imagemaking: Handmade Photography Since 1960*, which specifically deal with that approach.

The goal is to provide a starting point for making intriguing images without getting bogged down in technical details. By highlighting composition, design, and light as the strategic elements of photographic seeing, *Light and Lens* pursues the conceptual stance that camera vision remains the primary skill of a photo-based imagemaker. Concentrating on the camera as the initial

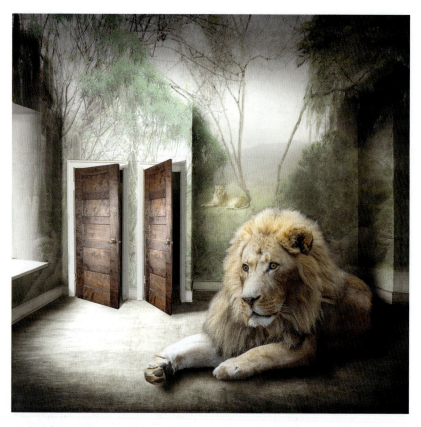

Carol Erb explains: "Like many people, I grew up with a fascination for animals. Storybooks, cartoons, puppet shows; our culture fosters the whimsical fantasy that animals are our friends. The truth is much darker. Animals are commodities that we use for food, clothing, labor, and entertainment. The *Old Testament* gave man a pretext for using animals to suit his needs. Modern civilization developed in ways to shield us from the cruelty and neglect with which we treat our fellow creatures. Today, attitudes are changing, due in large part to the long campaign of animal welfare groups that have worked to expose and question our exploitation of animals. In each of my images, an animal has been removed from its natural environment and placed in a human space where it does not belong. The longing to be elsewhere is clear from the animal's expression and confinement. Faded murals allude to a history of domestication and the way we can often fool ourselves into thinking of animals as extensions of our own needs and emotions. These animals are not at home here. Nonetheless, there is a disturbing beauty in their isolation."

Credit: © Carol Erb. *The Veldt*, from the series *Dominion: Portraits of Animals in Captivity*, 2016. 22 x 22 inches. Inkjet print.

and principal imagemaking tool, the book highlights how to observe and use cameras to realize one's visual ideas. Until these skills are mastered, one remains unprepared to make the most of post-capture software techniques. Therefore, *Light and Lens* thoughtfully presents methods for using the essential decisions that comprise every camera image: aperture, focal length, focus, ISO, and shutter speed.

Digital single-lens reflex cameras (DSLRs) are emphasized because of their manual control and versatility. However, the DSLR acts as a representative for all fully adjustable cameras. Additional attention has been given to how resourceful photographers can utilize widely popular smartphone cameras, as well as scanners, to effectively capture images.

Inkjet printing is highlighted as the primary means of physically outputting images while other methods, such as lithophanes and photogravure, are mentioned that can be contemplated for future investigation.

Light and Lens is an adventurous idea book, featuring numerous classroom-tested assignments, often provided by diverse photography professors, which have been gathered from a variety of photographic educators. These proven exercises, placed throughout the book,

Oropallo deconstructs and enhances images to investigate the seduction and power that is evoked by gesture and pose. Oropallo layers images of contemporary women in provocative costumes, borrowed from the Internet, with opulent eighteenth-century portrait paintings of men. These traditional portraits were often contrived to convey not merely a likeness of the sitter, but also a sense of his importance and authority. Attributes such as nobility and dignity were portrayed through stance, gesture, and attire, and portraits often involved elaborate costumes and props. Through this re-employment of the vast symbolism of classic portraiture, Oropallo's hybrid image suggests issues of gender, costume, fantasy, potency, power, and hierarchy.

Credit: © Deborah Oropallo. *George,* from the series *Guise,* 2006. 60 x 40 inches. Inkjet print. Courtesy of Gallery 16 Editions and Stephen Wirtz Gallery, San Francisco, CA.

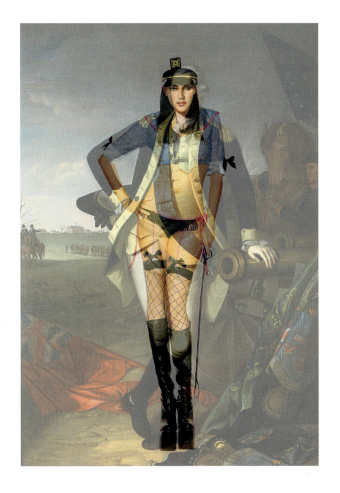

encourage readers to act independently to critically explore and make images from the perspective of *the photographer's eye*, one whose foundation is centered on solid ideas and aesthetics rather than technological ability.

Concepts and ideas are the dominant and driving guideposts; methods are learned and implemented to achieve one's vision. Technical information is presented to foster an understanding of the basic principles affecting how digital images can be formed and revised. By concentrating on the thought process behind the creation of successful photographic images, the information in *Light and Lens* will not soon go out of date. Since digital imaging software programs are constantly changing, *Light and Lens* takes the tactic of succinctly outlining key imaging methods while being neither a camera manual nor a software handbook. Companion ancillary materials, available from Focal Press and other

sources, including the Internet, serve to keep students' technical needs current.

Terms are discussed and defined upon their first appearance in the book, supplying the framework for needed background information. There are few references to the analog darkroom, as these have little relevance to most beginning students, who have known only a digital environment. When appropriate, additional sources of information and supplies are provided at the end of a topic.

That said, the spectacular technological transformations that continue at a rapid pace mean that whatever digital imaging skills one learns as a college freshman will need updating before graduation. To successfully deal with this cycle of change, imagemakers must become self-reliant by developing and deploying an independent set of long-term learning skills, including how to utilize the full array of online information and tutorials, blogs,

list-serves, podcasts, and imaging software Help sections to stay abreast of the changing technology as well as the works of makers past and present.

Discussions about contemporary issues affecting digital imagemaking, from appropriation and copyright to blogs and "mash-ups," are integrated throughout the book. Artistic and cultural references, from polymath Leonardo da Vinci to comedian Stephen Colbert, are intermingled as well, for meaning is derived from a cultural framework. Different goals and roles of photography are contrasted to reveal how various approaches can shape both the *what* and the *how* of an image and a multitude of interpretations.

Light and Lens brings together a compilation of my combined experiences as a curator, educator, imagemaker, and writer, with additions from numerous other photographic educators, who are credited throughout the text. Chapter 1 begins with a historical analysis of why and how pictures have been made and concludes with an extended series of questions and answers that are consistently asked at this stage of photographic education. Then, the text moves into a discussion about design as the visual foundation of imaging (Chapter 2). A chapter dealing with fundamental image-capture strategies utilizing cameras and scanners follows (Chapter 3). Next, technical matters of exposure and filters are covered (Chapter 4). This is followed with Chapters 5–7 that explain the qualities of light, observation, and methods of expressing time and space.

Chapter 8 takes on the fundamentals of the digital file as captured by the camera, displayed on a monitor, and outputted as a print. It is vastly simplified, as many technical issues can now be managed automatically with imagemaking software. Additionally, free, online software tutorials offer technical direction in this continually changing area.

Chapter 9 provides coverage of how to present and preserve your work. How to *see* with intent and dynamically use your camera is covered in Chapter 10, encouraging one to apply the materials covered in the text. The next unit, Chapter 11, conveys lively methods and exercises to help one become a critical visual problem solver and evaluator, and to succinctly talk and

write about the ideas that form your work. Finally, a series of exercises are presented in Chapter 12 to help expand your ideas and vision. The book concludes with addenda on health and safety concerns plus career options. Each chapter is divided into discrete units that facilitate finding topics of interest. This arrangement also encourages readers to browse and discover their preferred structuring of the material. Personal responsibility for using the digital world for self-education is promoted by numerous references made to artists and art movements that readers can begin exploring on their own.

Light and Lens's curated contemporary art program consists of inspiring examples by more than 250 international artists plus well structured, illustrative visual aids, whose common denominator is that each became digital at some point during the creation and distribution process. These images are presented to provide an overview of the diversity of contemporary practice. Unless noted, all of these thought-provoking images were supplied courtesy of each artist. This publication is a direct result of their support. No images may be reproduced without their written permission. The new, expanded format allows images to be reproduced at a larger scale.

Affordable digital technology and the Internet have drastically altered our sense of what it means to make, view, and interpret photo-based images. After reviewing thousands of digital images for this publication, certain trends emerged. The results of this research are a collection of images that reflect the ingenious thinking of today's digital imagemakers. The Internet, with its social media and cloud-based computerization, is the consummate postmodern tool that encourages the relational cross-fertilization and networking of countless image and text, art and media, and high and low culture combinations. Today, one can curate content from billions of searchable pictures, edit them to narrate one's own story, and rapidly get the result into circulation, bypassing the traditional gatekeepers. Many imagemakers are moving away from single still images and embracing the fluidity and cinematic character of interconnected moments, which blur the boundaries

between moving and still images and expand traditional concepts of photographic time and space, even when the final result is one image. This is also reflected in the continuing practice of pre- and post-capture fabrication that questions the veracity of the photographic image. Although identity issues remain a major concern, more imagemakers are looking outward and tackling broader topics dealing with animal rights, consumerism, climate change, natural disasters, tyranny, security, and the wars in the Mideast. There also is a wide interest in the intersection of art and science, as evidenced in images derived from microscopes, satellites, surveillance cams, and telescopes as well as the referencing of scientific processes. From a technical viewpoint, there is a continued rise in makers using a scanner as a camera. Furthermore, the plethora of ever improving smartphone apps allow for greater manual camera control plus rapid, on-site editing and sharing of photographs. Additionally, such apps have revived the panorama format and simplified High Dynamic Range (HDR) imaging, both of which formerly either required a special camera or elaborate post-capture work.

New digital printers are allowing photographers to straightforwardly increase the physical size of their prints as well as surface texture, which can be anything from metal to vinyl or a variety of textured paper surfaces. This gives the prints a sense of scale and aggressive wall presence that commands attention once reserved for painting. The book's new, expanded format allows images to be reproduced at a larger scale. However, reproductions in books flatten out size differences, making all the images appear similar in size. For this reason, it is important to pay attention to the image's size to get a sense of what it would look like if you saw the actual picture. This is another incentive to visit galleries and museums to experience original pieces. Also, imagemakers are now more likely to shift between digital and analog process, generating hybrid methods to achieve their desired results. This superhybridity, an amalgamation of sources and contexts, allows one to sample and mash up any culture, anytime, anyplace to an extent that it is transformed into the essence of the next idea.

Last of all, photographers are no longer only imagemakers but can now swiftly and affordably publish and distribute their own work. The way that photographic images circulate has shifted from the physical to the virtual, with the vast majority of images viewed solely on a screen. Digital presentation diminishes the need and importance of producing photographs as prints and photomechanical reproductions, creating a more democratic viewing field as well as the potential for malevolent misuse of the process and its products. Since electronic images can be constantly revised, they possess no finality. The more active and fluid nature of digital imagemaking invites viewers to respond to one picture with another, thereby changing photography's societal role from that of objective witness to one of subjective sociability. This defies the pessimistic attitude that there is nothing new for artists to say.

In addition to the work of widely recognized international artists, I have included exceptional images by emerging, underrecognized, and student artists, whose coherent bodies of work are often too nonconformist for mainline venues. All the outstanding visual examples provide models for points of departure. These photographic works remind us that images are not all equal and some pictures do communicate more broadly and significantly than others. As visual paradigms, they provide important guidelines to appreciate and understand visual culture but are in no way intended to be prescriptive. Readers are encouraged to first learn the rules and standards and then set them aside whenever they interfere with what they want to communicate.

Furthermore, I included the voices of individual photographers into the image captions. I distilled their statements about their significant aesthetic and technical choices, based largely on questions I posed to them, to provide readers with valuable insight and motivation about the creation process.

This ongoing photographic evolution from analog to digital has been unsettling for some. Ultimately, it is important to utilize the advantages that digital imagemaking provides while retaining the freedom to follow whatever path is necessary for one's creation

process. With its capability for limitless shooting, immediate feedback, in-camera programming, and post-capture image modifications, along with high-quality desktop printing, online publishing, and cloud archiving and computing, digital imaging allows us to realize Henry Fox Talbot's dream of every person as a maker and publisher of images.

Professor Greg Erf of Eastern New Mexico University, whom I have known since 1988, has been the principal contributor and the illustrator of all three *Light and Lens* editions. Over the past quarter century, we have developed a strong professional relationship based on an Internet workflow that includes hundreds of hours of Skype conversations and over 22,000 emails during which we volleyed text and illustrations back and forth until we were satisfied. *Light and Lens* represents the result of our commitment in helping to educate emerging photographers in the constantly changing digital age.

In addition to *Light and Lens*, Greg and I worked together to develop and teach one of the first online History of Photography courses (www.enmu.edu/photohistory) plus write columns for *Photovision* magazine and collaborate on *Exploring Color Photography: From Film to Pixels* and on various other projects. I continue to enjoy working and learning with Greg Erf because of his varied expertise in photography and digital imaging. Greg has been teaching photography for over 20 years and is recognized as one of New Mexico's leading photographers. Linda Durham, Santa Fe, New Mexico (www.thewonderinstitute.org), represents his work. Erf is also Vice President of the Capitol Art Foundation, a five million dollar collection housed at the State Capitol in Santa Fe, New Mexico. The mission of the Capitol Art Foundation is to collect, preserve, exhibit, interpret, and promote appreciation of the works of art that reflect the rich and diverse history, cultures, and art forms of the people of New Mexico (www.nmcapitolart.org).

Greg also bridges the gap between silver photography and digital photography. His personal work (www. gregerf.com) utilizes a vintage film-format 11 × 14-inch view camera, and his teaching involves digital pho-tography and computer animation. This combination roots Greg historically in the language of imagemaking as he and I endeavor to sort out and define the evolving language of digital photography.

Special thanks to the Routledge book team, including Judith Newlin, editor; Kristina Siosyte, production editor; Mary Dalton, copy editor; Florence Production Ltd, interior design; Gareth Toye, cover design; Greg Erf, illustrator; and William Burch, editorial assistant.

I appreciate the work of Abbey Hepner, the technical editor, who expertly reviewed and made suggestions on improving the working manuscript.

I especially want to extend my gratitude to the following individuals whose contributions have raised the level of this entire undertaking:

Professor Michael Bosworth of Villa Maria College, Buffalo, NY, whom I have known and worked with off and on since 1991, has kindly lent his expertise in revising and expanding the section on artificial light with numerous examples.

Professor Edward Bateman of the University of Utah, Salt Lake City, UT, who provided much appreciated critical aesthetic and technical feedback on a number of topics.

I also want to thank Patricia Butski and Patrick Foran, who assisted with the art program, caption writing, correspondence, database management, and manuscript preparation.

Ongoing kudos to all the previous photographic educators who have allowed me to incorporate their assignments and observations into the text.

Finally, feedback from teachers and students is welcome. This book is only as good as its contributors and readers who have helped shaped changes—straightening, widening, and even careening—to new destinations, providing pragmatic utility to those who follow.

Be persistent and let curiosity guide your imagination.

Robert Hirsch
Buffalo, NY, USA
www.lightresearch.net

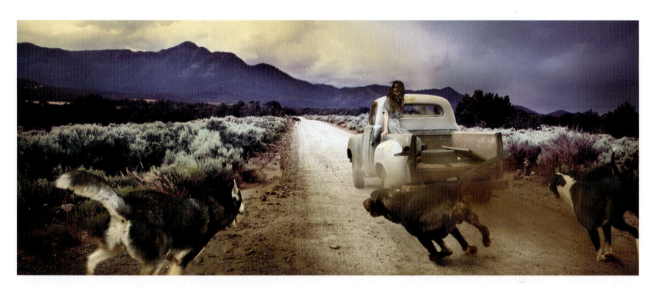

Influenced by traditional Mexican ex-voto painting celebrating unexplained miracles, Tom Chambers creates enigmatic visions that cannot be captured with the camera or witnessed with the naked eye. Chambers digitally combines separate photographs to produce scenes that are at once familiar and oddly surreal, delving into the mystery produced by the interaction and communication between animals and humans. Chambers elaborates: "Having grown up on a Pennsylvania farm, I am inspired by Andrew Wyeth's rural landscapes, characterized by subtle, but powerful emotion. I hope to strike a similar emotional connection in the viewer by illustrating a disturbed world that has been thrown out of balance as a result of climate changes created by man's blind disregard in fulfilling immediate, self-serving needs. These photomontages are composed of animals, children and adults, all of which are potential victims and at risk."

Credit: © Tom Chambers. *Dirt Road Dogs,* 2008. 30 x 12 inches. Inkjet print.

Artist Contributors

Berenice Abbot • Kim Abeles • Bill Adams • Theresa Airey • • Thomas Allen • Barry Andersen • Jeremiah Ariaz • • Bill Armstrong • Shannon Ayres • Tami Bahat • • Nathan Baker • Susan Barnett • Edward Bateman • • Craig Becker • Olaf Otto Becker • Katerina Belkina • • Paul Berger • Stephen Berkman • Laura Blacklow • • Colin Blakely • Michael Bosworth • Nadine Boughton • • Richard Boutwell • Susan Bowen • Deborah Brackenbury • • Richard Bram • Matthew Brandt • Nick Brandt • • Kristi Breisach • Priscilla Briggs • Dan Burkholder • • Chris Burnett • Edward Burtynsky • Tricia Butski • • Kathleen Campbell • John Paul Caponigro • Ellen Carey • • Tom Carpenter • Christine Carr • Tom Chambers • • Bruce Charlesworth •Alejandro Chaskielberg • • William Christenberry • Ulric Collette • Robert Collignon • • Kelli Connell • Gregory Crewdson • Kirk Crippens • • Leonardo da Vinci • Binh Danh • Meredith Davenport • • Debra A. Davis • Jen Davis • Tim Davis • • William (Bill) Davis • Stefano De Luigi • Thomas Demand • • François Deschamps • Marcus DeSieno • John Dickson • • Frank Donato • Beth Dow • Doug Dubois • Klaus Enrique • • Mitch Epstein • Carol Erb • Greg Erf • Susan E. Evans •

Katya Evdokimova • Christian Faur • Richard Finkelstein • • Robbert Flick • Kelly Flynn • Neil Folberg • • Joan Fontcuberta • Pere Formiguera • Patrick Foran • • Collette Fournier • Sergeant Ivan Frederick • Amy Friend • • Barry Frydlender • Adam Fuss • Stephen Galloway • • Klaus Gerdes • Hans Gindlesberger • Jonathan Gitelson • • Karen Glaser • Rafael Goldchain • Daniel Gordon • • Richard Gray • Jill Greenberg • Ryan Groney • • Andreas Gursky • Marcella Hackbardt • Toni Hafkenscheid • • Gregory Halpern • Jessica Todd Harper • Adam Harrison • • Laura Hartford • Evan Hawkins • Abbey Hepner • • Adele Henderson • Biff Henrich • Rachel Herman • • Dan Herrera • Elizabeth Hickok • Jessica Hines • • Oded Hirsch • Robert Hirsch • Nir Hod • Jenny Holzer • • Kirsten Hoving • Allison Hunter • Robert Lowell Huston • • Ellen Jantzen • Simen Johan • Keith Johnson • • Christopher Jordan • Nicholas Kahn • Thomas Kellner • • Kay Kenny • Robert Glenn Ketchum • Atta Kim • Kevin Kline • Oliver Klink • Karen Knorr • Martin Kruck • • Karalee Kuchar • Joseph Labate • Chris LaMarca • • Jessie Lampack • Nate Larson • Evan Lee • Liz Lee • • Sebastian Lemm • William Lesch • Douglas Levere •

Jim Kazanjian explains: "My images are digitally manipulated composites built from photographs I find online (sometimes more than 50) to produce a single homogenized image. I do not use a camera at any stage in the process. This series is inspired by the horror literature of H.P. Lovecraft and Algernon Blackwood, who transformed the commonplace into something foreboding and sinister. My work occupies a space where the mundane intersects the strange and the familiar becomes alien in the pursuit of rendering the sublime."

Credit: © Jim Kazanjian. *Untitled* (coach), 2016. 18 x 18 inches. Inkjet print.

David Levinthal • Michael Light • Adriane Little • Joshua Lutz • Loretta Lux • Patrick J. Lyons • Rita Maas • Martha Madigan • Adam Magyar • Mark Maio • John Mann • MANUAL (Ed Hill and Suzanne Bloom) • Stephen Marc • Fredrik Marsh • Didier Massard • Molly McCall • Dan McCormack • Thomas McGovern • Amanda Means • Diane Meyer • Robin Michals • Roland Miller • Jeffrey Milstein • Marilyn Minter • Beth Moon • Andrew Moore • Abelardo Morell • Steven P. Mosch • Morry Moskovitz • Brian Moss • Vik Muniz • Richard Murai • Eadweard Muybridge • Patrick Nagatani • Bea Nettles • Pipo Nguyen-duy • Lori Nix • Mike Nizza • Sue O'Donnell • John Opera • Suzanne Opton • Ted Orland • Deborah Orloff • Deborah Oropallo • Bill Owens • Burhan Ozbilici • Trevor Paglen • Robert ParkeHarrison • Shana ParkeHarrison • Martin Parr • Jeannie Pearce • John Pfahl • Klaus Pichler • Melissa Ann Pinney • Colleen Plumb • Robert Polidori • Kathleen Pompe • Carolyn Porco (Cassini Project) • Emma Powell • Douglas Prince • Sabrina Raaf • Mahmoud Raslan • Morten Rockford Ravn • Joyce Roetter • Sasha Rudensky • Alan Sailer • Morgan Sandacz • David Sanford • Damon Sauer • Joseph Scheer • Betsy Schneider • Sarah Schroeder • Larry Schwarm • Fred Scruton • Richard Selesnick • Andres Serrano • Paul Shambroom • Marni Shindelman • Matt Siber • Thomas Siegmund • Kerry Skarbakka • Jill Skupin Burkholder • Mark Slankard • Mark Snyder • Ursula Sokolowska • Dan Solomon • Jerry Spagnoli • Nancy Spencer • Devorah Sperber • Jan Staller • Doug Starn • Mike Starn • Stephen Strom • Stan Strembicki • Luke Strosnider • Sheila Talbitzer • Maggie Taylor • Michael Taylor • Calla Thompson • David Evan Todd • Terry Towery • Laurie Tümer • Brian Ulrich • Penelope Umbrico • Paolo Ventura • Corinne Vionnet • Franz von Stuck • Cara Lee Wade • Chris Walker • Kara Walker • Jeff Wall • Garie Waltzer • René West • Al Wildey • Kristen S. Wilkins • Lloyd Wolf • Work Projects Administration Art Project • Beth Yarnell Edwards • Dan Younger • Jody Zellen • Tricia Zigmund

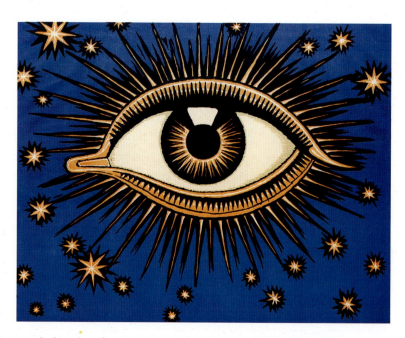

After dreaming about a huge eye looking down from the sky, Karl August Lingner, a wealthy businessman and lead sponsor of Dresden's 1911 International Hygiene Exhibition, commissioned a poster by Munich artist Franz von Stuck to promote the fair's theme of good health through hygiene. The all-seeing eye was an apt symbol for an exhibition that emphasized accessible visual representations of the human body during a time when people marveled at images showing previously unseen aspects made possible by microscopes and X-rays.

Credit: Franz von Stuck. *Internationale Hygiene,* Dresden, 1911 (detail). Exhibition poster.

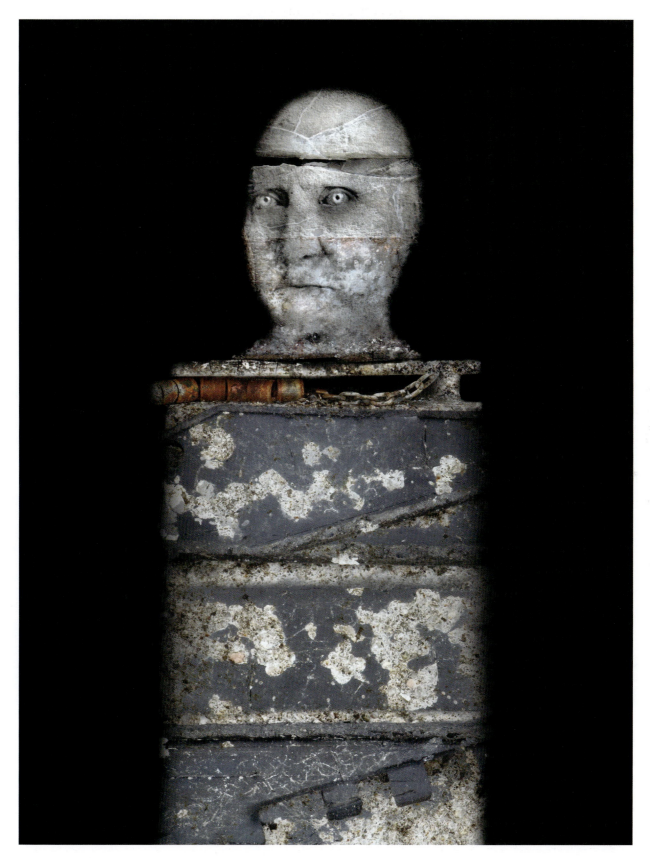

Craig Becker elaborates: "The genesis of this project was my father's declining health during the last three years of his life. The series comes together around notions of the unknown, loss, and transformation. The title is inspired by the scratchboard technique, the removal of portions of a black top layer revealing a contrasting layer below. Digitally, I use the same technique but with a soft brush revealing the figure emerging from the background. It was challenging to use technology to create fresh imagery without losing the humanity. The solution was to infuse the image with a strong emotional element translated through the eyes."

Credit: © Craig Becker. *Scratch 31*, from the series *Scratch*, 2017. 22 x 17 inches. Inkjet print.

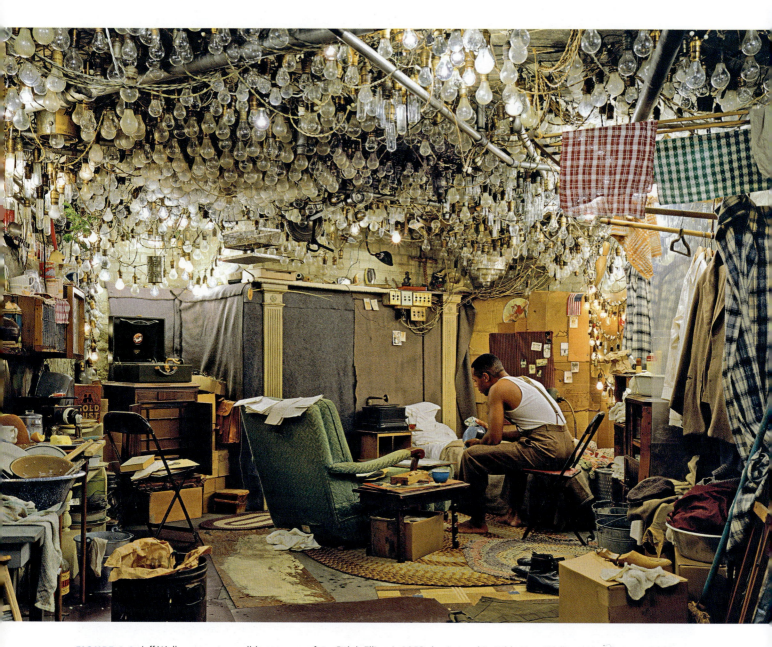

FIGURE 1.0 Jeff Wall represents a well-known scene from Ralph Ellison's 1952 classic novel *Invisible Man*. Wall's version shows us the New York City cellar room—"warm and full of light"—in which Ellison's black narrator lives, including the ceiling that is covered with 1,369 illegally connected light bulbs. Energy and light, stolen from the electric company, illuminate not only the character's basement dwelling, but also the truth of his existence. There is a parallel between this hidden, subterranean place of light in the novel and Wall's own photographic practice. Ellison's character declares: "Without light I am not only invisible, but formless as well." Wall's use of a light source behind his pictures is a way of bringing his own "invisible" subjects to the fore, giving form to the overlooked in society.

Credit: © Jeff Wall. *After "Invisible Man" by Ralph Ellison, the Prologue, 1999–2000.* 68½ x 98½ inches. Duratran in a lightbox.

Why We Make Pictures

A CONCISE HISTORY OF VISUAL IDEAS

The human desire to make pictures is deeply rooted. More than 30,000 years ago, Cro-Magnon people used colored oxide and charcoal to make paintings of large wild animals, tracings of human hands, and abstract patterns on cave and rock walls. Today, people create images with a multitude of mediums, including photography.

What propels this picturemaking impulse? Some make pictures for commercial reasons. Others create informational systems or employ scientific imaging tools to visualize the unseen. Artists use images expressionistically, to conceptualize and articulate who they are and how they view the world. However, the fundamental motive for making the vast majority of pictures is a desire to preserve: to document, and therefore commemorate, specific people, events, and possessions of importance.

Regardless of purpose, the making of images persists because words alone cannot always provide a satisfactory way to describe and express our relationship to the world. Pictures are an essential component of how humans observe, communicate, celebrate, comment, and, most of all, remember. What and how we remember shapes our worldview, and pictures can provide a stimulus to jog one's memory. In his poem "Forgetfulness" (1999), American poet Billy Collins sums up the fragile process of memory and indirectly the importance of images as keepers of the flame:

> The name of the author is the first to go followed obediently by the title, the plot, the heartbreaking conclusion, the entire novel which suddenly becomes one you have never read, never even heard of . . .

Making pictures matters because it is an inherent part of our human nature to want to shape the ordinary into the special in order to better define our relationship to the world. Pictures can provide a concrete yet individualistic structure of data for building our worldview. Additionally, our personal participation in organizing the world visually—the doing, the activity of imagemaking itself—can ease life's loneliness and uncertainty by helping us to feel capable of expression, validating us as individuals, and assisting us in finding a sense of purposeful well-being. All these aspects remind us that every photograph is a subjective construction based on personal choices, such as what to photograph, how to depict the subject, and what to include and exclude.

Discriminate

FIGURE 1.1 "This series questions what defines an image as a photograph, and in fact, asks 'What is a camera?' In my work there is no distinction between a 'pure' photograph and a digitally created image, as the medium of photography has been built upon the practice of change, especially in relation to technological advancement. In this series, the only instrument used for creation was a flatbed scanner (as camera), and another traditional artist tool—the eye—within the photographic editing environment."

Credit: © Liz Lee. *Observational Drawings: Eye*, 2004. 22½ x 30 inches. Inkjet print.

NOT JUST PICTURES BUT PHOTOGRAPHS

More than any other image medium, photography serves a multitude of purposes. Although we are conditioned to see the function of a photograph as providing a commentary or text about a subject, that need not be the case. A photograph's existence may have nothing to do with making a concrete statement, answering a specific question, or even being *about something*. Rather, it can be something unique in and of itself. A photograph may be enigmatic, or it may allow a viewer access to something remarkable that could not be perceived or understood in any other way. The *why* of a photograph can be analogous to what Isadora Duncan, the mother of modern dance, said: "If I could explain to you what I meant, there would be no reason to dance."

Think of a photograph as a dialog involving the photographer, the subject, and the viewer. During an oral conversation, participants not only exchange words but must also formulate meaning based on the context and tone of the spoken words, to whom they are addressed, the body language of the participants, and the environment in which the conversation takes place. In the visual analogy, participants necessarily consider the pictorial elements of a subject or image, making possible a distillation and refinement of meaning. This creative interaction can lead to definition. Definition allows us to acknowledge, take responsibility, act to solve a problem, respond to the aesthetics, or reach a conclusion about what an imagemaker deemed significant.

In the first decades of the twentieth century, Albert Einstein's concepts of relativity and quantum mechanics —ideas that showed that the classic Newtonian concept of physics with its absolutes could not be considered unconditionally true—began to influence how people, especially artists, depicted and interpreted their world. People began to see that a fluid interaction between the observer and the observed offers different frames of reference to generate meaning. This can occur through symbolic manipulation (mathematical, verbal, and visual) and a reliance on analogy, insight, and myths to draw attention to the significant elements in an otherwise chaotic and overwhelming flow of sensory input. Such a process involves the artist, the subject, and the viewer in an ongoing, reciprocal dialog of creation and interpretation. As the artist/photographer Man Ray once said, "Perhaps the final goal desired by the artist is a confusion of merging of all the arts, as things merge in real life."

THE GRAMMAR OF PHOTOGRAPHY

The fundamental grammar of photography is based on how a camera utilizes light and form to record an image that is then interpreted through societal visual codes that have evolved over centuries of Western imagemaking. Learning how to operate a camera, gaining an awareness of how light can reveal or suppress a subject's attributes, and then giving it visual presentation are the first steps one must master to transform an abstract idea into a photographic reality. This text introduces basic camera methods and visual construction blocks, gives examples of how and why other photographers have applied them, provides basic working procedures, and encourages readers to experiment and make modifications to the process to achieve their own results. Once a basic understanding of picturemaking is obtained, control over the process can begin.

To obtain maximum benefit from this book, each reader should begin thinking about how photography can be used to construct a meaningful expression. When process is put in service of concept to create meaningful and engaging content, the heart and the mind can combine to articulate an idea from the imagination and then find the most suitable technical means of bringing it into existence (see Chapter 11).

THE EVOLUTION OF PHOTOGRAPHIC IMAGING

Since 1839, when Louis-Jacques-Mandé Daguerre made public the first practical photographic process (the daguerreotype), people have been discovering new photographic materials and methods to present how they see the world. Through photographic evolution, the daguerreotype gave way to the wet plate, which in turn was supplanted by dry plates, and then, for more than 100 years, flexible roll film, all of which were processed in a darkroom. Now, the electronic digital studio has replaced the chemical processes of the wet

FIGURE 1.2 "Taking cues from a magician's manual, a scientist's notebook, and a novelist's manuscript," Stephen Berkman offers his audience an altered view of the world. Fashioning scenes specifically to be photographed, Berkman uses a large-format view camera to capture the wealth of detail that one can linger over in his warm-toned albumen photographs made from wet-collodion, glass-plate negatives. His watchfully assembled worlds, based in the nineteenth century, often feature an absurd twist. "Ironically, viewers are pulled into his photographs due to their familiar, if old-fashioned, appearance, only to be surprised to discover their idiosyncratic elements and the unanswered questions that arise as we try to decipher them."

Credit: © Stephen Berkman, Zohar Studios. *Conjoined Twins, Bliss, New York*, undated. 11 x 14 inches. Albumen print.

darkroom, a developmental leap that opens up photography to the possibilities of multimedia through moving images and sounds. Additionally, as mainline photographic practice has shifted to digital imaging, images that were never actually photographed in the real world can exhibit perfect photographic credibility, challenging photography's traditional role as the recorder of outer reality.[1] As digitally constructed images become the norm—as in filmmaking that combines live

action and digital animation—such images may no longer be clearly distinguishable from the pre-digital concepts of illusions of motion generated by hand-drawn methods. Ironically, this digital yet highly manual construction of images, long out of favor in a photographic mainstream that stressed the purity of the process, is now at the forefront of digital practice. Regardless of one's personal destination or that of photography itself, individuals can begin their journey by grasping the importance and value of still images as fundamental building blocks, for the still image allows us to meditate on a subject in our own time. It is this very limitation of not being dynamic but static in time and space that gives still images their power.

FULL CIRCLE: SOME THINGS REMAIN THE SAME

Although photographic technology has dramatically changed since 1839, the imagemaking process essentially remains the same. Making sharp photographs that capture, highlight, and shadow detail demands the best light-sensitive materials available. For example, High Dynamic Range (HDR) technology (see Chapter 4) involves combining multiple image files of varying exposures to create a single image with an extraordinary dynamic range of light and value. This twenty-first-century digital process recalls the nineteenth-century heliochromy color subtractive process in which three negatives were made behind three separate filters and then assembled to create the final image. Both methods endeavor to overcome their material limitations and extend the image's visual range.

Light and Lens explores concepts and issues that continue to challenge photography. Even with current digital technology, photographers continue struggling to extend the range of our materials, create panoramas, adjust color, and photograph in low-light and bright-light situations. The problems continue, but instead of using analog methods, we now employ digital means to find the solutions.

DETERMINING MEANING

People are meaning-makers who seek significance in their lives and learn from others, past and present, how to achieve it. Digital instruments, like the omnipresent smartphone camera, let anyone transform and circulate images, constantly reminding us that there are no neutral depictions and that photographic meaning is slippery. All depictions have a particular bias, with photography having three distinct kinds. The first bias comes from the people who create and manufacture the commonly utilized photographic systems, which include the cameras, lenses, consumable supplies, software, and ancillary equipment that the vast majority of photographers rely on to produce a photographic image. These companies set up the physical boundaries and the general framework within which most photographers operate. The second bias comes from the preconceptions of the photographer who uses these systems to create specific images. Every photograph reveals its "photographer's eye"—an intermingling of subject, photographer's intent, and process. The third predisposition is the life references that viewers bring in determining what a photograph means to them. In the end, who we are, what we believe, where we live, when we live, and why we look at certain things as opposed to others define what we can see and how we comprehend it.

BEFORE PHOTOSHOP

Long before Photoshop, methods that could alter a photographic image before and after the shutter clicked were practiced to achieve artistic and commercial goals. Early photographic practitioners regularly modified their working methods to accommodate their aesthetic and technical requirements. Miniature painters painted directly on daguerreotypes and calotypes (paper prints) to meet the demand for color reproductions, setting the precedent of hand-applied color. In the 1840s, Henry Fox Talbot sometimes chose to wax his paper calotype negatives (the first negative/positive process) after development to make them more transparent. This

FIGURE 1.3 Credit: © Amanda Means. *Flower #61*, positive, 1997. 30 x 30 inches. Inkjet print. Courtesy of Gallery 339, Philadelphia, PA.

FIGURE 1.4 To visualize the organic, luminous images that evoke the power that drives our world, Amanda Means places flowers inside her 8 x 10-inch view camera and projects them outward onto photographic paper attached to a wall. "The resulting prints are tonally negative, which gives the flowers a mysterious inner glow, because the light is coming through the petals, from within the flower. I scan my original prints and then invert them in Photoshop, which vastly increases the possibilities for controlled manipulation within."

Credit: © Amanda Means. *Flower #61*, inversion, 2006. 30 x 40 inches. Inkjet print. Courtesy of Gallery 339, Philadelphia, PA.

increased their visual detail, gave them heightened contrast, and made them easier and faster to print.

In 1848, Gustave Le Gray introduced a waxed-paper process in which the wax was incorporated into the fibers before the paper was sensitized. This process chemically and physically altered the speed and tonal range of the negatives and produced a different result from Talbot's waxed negatives. Other calotype photographers, such as Charles Nègre and the partnership of David Octavius Hill and Robert Adamson, used a pencil on their negatives to alter tonal relationships, increase separation between figure and background, accent highlights, add details or objects not included in the original exposure, and remove unwanted items. Such post-processing work is known as *retouching*. During the 1860s, Julia Margaret Cameron ignored—if not flouted—the standard camera rules for focus and exposure time to make portraits that revealed her subject's inner spiritual qualities.

COMBINATION PRINTING

Combination printing from multiple negatives became fairly common in the mid-to-late 1800s. The collodion, or wet-plate, process, which became the major commercial photographic method of the 1850s, had a low sensitivity to light, resulting in long exposure times that made the taking of group portraits difficult. Also, the wet plate's limited sensitivity to blue and ultraviolet light did not allow the making of naturalistic, full tonal-range landscapes in a single negative. If the subject or landscape were exposed correctly, then the sky would be grossly overexposed and would appear no better than a mottled white when printed. Combination printing was developed to overcome such inherent technical problems. Separate exposures were made for the subject and the sky and, through the use of masking, printed on a single piece of paper.

The artistic possibilities of this technique received a great deal of notice when Oscar Gustav Rejlander combined more than 30 negatives to create his allegorical *tableau vivant*—a "living picture" or staged image of a group of people arranged to represent a scene or incident—*Two Ways of Life* in 1857. The popularity of the photographs and writings of Henry Peach

Robinson, especially his book *Pictorial Effect in Photography* (1869), continued to promote combination printing as the method of choice for art-minded photographers.

THE ADVENT OF STRAIGHT PHOTOGRAPHY

Major objections to these working methods were raised in Peter Henry Emerson's *Naturalistic Photography for Students of the Art* (1889), which adamantly attacked the concept of combination printing. Emerson called for simplified working procedures and "selective naturalistic focusing." This visual approach was supposed to allow the imaginative photographer to more closely replicate human vision, in which some things are seen clearly and sharply, whereas others are less focused. Emerson, who thought the photographer's obligation was to discover the camera's own codex, saw the medium as a blending of art and science. He stated that good images could be made through careful use of framing, lighting, and selective focusing. In emphasizing the photographing of subjects in their natural surroundings without any of the artificial manipulations of the combination printers, Emerson came under

heavy attack for his ideas. Although he soon recanted with *The Death of Naturalistic Photography* (1890), the seeds of what would evolve into "straight" photography had been sown.

THE PICTORIALISTS

The 1890s were the heyday of many hand-printmaking methods, such as gum printing, which demonstrated how innovative photographers could control their medium in the same manner that artists working in other mediums, especially painting, could. This type of printing was favored by the Pictorialists and championed through the work and writing of Alfred Maskell and Robert Demachy in *Photo-Aquatint or the Gum-Bichromate Process* (1897). The Pictorialists, such as Gertrude Käsebier and Alice Boughton, stressed the atmospheric and formal effects of the image over that of the subject matter. Composition and tonal values were of paramount concern. Soft-focus lenses were used to emphasize surface pattern rather than detail. Pictorialists did not want to be bound by the tyranny of exactitude. These expressive printmakers were determined to demonstrate that photography was not merely a mechanical process but could be controlled

FIGURE 1.5 Beth Dow's series *Fieldwork* was influenced by the work of P. H. Emerson and other nineteenth-century, rural photographic pioneers. "Since I am removed from their subjects in time and space, I am left to imply my own mythos around the labors their early photographs depict. There are no people in my photographs, only traces and suggestions of their influence. An eerie sense of melancholy lingers, and *Fieldwork* challenges our notions of beauty while questioning the value we place on ecology." The work also blurs distinctions of time in their imagery and technique. "I begin with twentieth-century, medium-format roll film, and then use current digital technology to create contact negatives for the nineteenth-century platinum process, which allows me to fully represent the tonal subtleties of both subject and medium."

Credit: © Beth Dow. *Bags*, from the series *Fieldwork*, 2007. 16 x 16 inches. Platinum/palladium print.

by the hand of the maker and therefore was a legitimate visual art form. The Pictorialist attitudes and procedures dominated much commercial portrait and illustrative work throughout the first part of the twentieth century, with an emphasis on constructing beauty as opposed to finding it in nature.

THE PHOTO-SECESSIONISTS

In the United States, the Pictorialists were followed by the Photo-Secessionists, under the leadership of Alfred Stieglitz. In their quest to have photography recognized as an art form, they experimented with a wide variety of inventive printmaking methods.

THE ARRIVAL OF STRAIGHT PHOTOGRAPHY

Influenced by avant-garde artists such as Pablo Picasso, whom Stieglitz showed for the first time in the United States at his New York "291" gallery, Stieglitz began to promote a straight photographic aesthetic in the final issues of his publication, *Camera Work*, as exemplified in Paul Strand's photographs made around 1916. Strand had successfully incorporated the concepts of painterly abstraction directly into the idea of straight, sharp-focus, unmanipulated photography. He believed that photography's raison d'être was its "absolute unqualified objectivity" and that this could be found by investigating photography's own inherent characteristics. The emphasis of the art of photography switched from post-exposure methods to creating the image in the camera at the moment of exposure and maintaining a much narrower range of simplified printmaking techniques.

MODERNISTIC APPROACHES

DOCUMENTARY/PHOTOJOURNALISTIC APPROACH

The modern documentary photographic practice developed during the 1890s and 1900s in the pioneering work

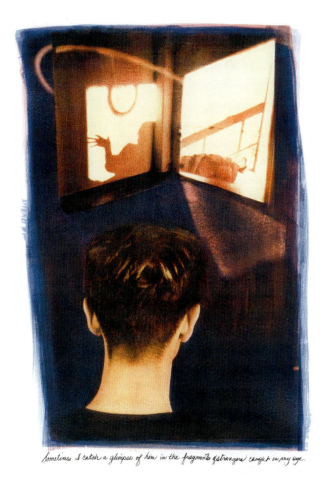

Sometimes I catch a glimpse of him in the fragments of strangers caught in my eye.

FIGURE 1.6 The text reads: "Sometimes I catch a glimpse of him in the fragments of strangers caught in my eye." Kenny recalls: "When I was a small girl, I imagined that my perfect other, my doppelganger perfect friend, lived in my house. I could speak and play with him, but never see him. As I grew older, he became the perfect father, brother, or boyfriend. As I entered puberty, I began to fear that I would never meet him, and, if I did, how he would change my life. This is a story about that transitional period in childhood when gender moves from a reflection of self to the other. Working with Photoshop allowed for greater enhancement and utilization of images that would otherwise not work for the final gum bichromate process."

Credit: © Kay Kenny. *Dreamland Speaks When Shadows Walk, #7*, 2004. 22 x 15 inches. Gum bichromate print.

of Jacob A. Riis in the slums of New York City and Lewis W. Hine's depictions of immigrants arriving at Ellis Island and children being forced to work in inhuman conditions instead of attending school. Documentary photographs provide evidence, often in a narrative form, of real people, events, and places for the purpose of communicating information or delivering

a message. This style was exemplified during the Great Depression when the Farm Security Administration (FSA) hired photographers such as Walker Evans, Dorothea Lange, and Arthur Rothstein to survey conditions in rural areas of the United States. Their photographs were intended to portray and communicate the dignity and suffering of poverty-stricken farm families to the American public. At the same time, the appearance of illustrated news magazines in the United States and Europe, such as *Life* and *Picture Post*, created a demand for documentary/photojournalistic photographs. Such photojournalists as Margaret Bourke-

White and Robert Capa vividly recorded important people and dramatic events of the period, including the World War II traumas of D-Day and the liberation of concentration camps. W. Eugene Smith's photo-essays that were published in *Life* magazine, such as *Country Doctor*, *The Spanish Village*, and *Nurse Midwife*, expanded visual documentary narrative and helped redefine who are worthy subjects of dramatic, heroic portrayals.

STRAIGHT PHOTOGRAPHY AND PREVISUALIZATION

Starting in the 1920s, Edward Weston's artistic work represents the concept of straight photography through the use of what has been referred to as *previsualization* or *visualization*. By this concept, Weston meant that he knew what the final print would look like before releasing the camera's shutter. The idea of visualizing the end result ahead of time would bring serious printmaking full circle, back to the straightforward approach of the 1850s, when work was directly contact-printed (no enlarging) onto glossy albumen paper. Weston simplified the photographer's working approach by generally using natural light and a view camera with its lens set at a small aperture. He produced a large-format negative that was contact-printed with a bare light bulb. Photographic detail and extended tonal range were celebrated in a precise black-and-white translation of the original subject on glossy, commercially prepared paper. By eliminating all that he considered unnecessary, Weston strove to get beyond the subject and its form and uncover the essence or life force of the "thing in itself." This philosophy rejected major post-exposure work as unholy and done only by those

FIGURE 1.7 This image taken in Ankara, Turkey, at a photography exhibition moments after an off-duty police officer shot and killed Russian ambassador Andrey G. Karlov was awarded the 2017 Photo of the Year by World Press Photo. The assassin is seen screaming at onlookers in Arabic: "God is Great. Those who pledged allegiance to Muhammad for jihad. God is great!" Then, in Turkish: "Don't forget Aleppo![2] Speaking with the *Los Angeles Times*, Ozbilici explained why and how he was able to keep on taking pictures, even as the killer paced in front of him, condemning Russia for their role in Syria. "I was, of course, fearful and knew of the danger if the gunman turned toward me. But I advanced a little and photographed the man as he hectored his desperate, captive audience . . . I was thinking: 'I'm here. Even if I get hit and injured, or killed, I'm a journalist. I have to do my work. I could run away without making any photos . . . but I wouldn't have a proper answer if people later ask me: 'Why didn't you take pictures?'"[3]

Credit: © Burhan Ozbilici. *Assassination of Russia's Ambassador to Turkey*, 2016. Dimensions variable. Digital file.

who were not skilled enough to get it right in the camera. By the 1950s, photographers such as Aaron Siskind expanded these ideas by incorporating the concepts used by Abstract Expressionists, with whom he often exhibited, giving rise to nonrepresentational photography.

GROUP F/64 AND THE ZONE SYSTEM

In 1932, a band of California-based photographers, including Weston, Ansel Adams, and Imogen Cunningham, founded Group f/64. Their primary goal was to create photographs of precise realism without any signs of pictorial handwork. The name of the group reflects the point that the members favored a small lens aperture that enabled them to achieve images with maximum detail, sharpness, and depth of field. They concentrated on natural forms and found objects that were representative of the naturalistic West Coast style.

The ideas from Group f/64 were refined and expanded by Ansel Adams in his Zone System method for black-and-white photography. The Zone System is a scientifically based technique for controlling exposure, development, and printing to give an incisive translation of detail, scale, texture, and tone in the final photograph. Adams's codification of sensitometry and its accompanying vision set the standard for pristine wilderness landscape photography. The Zone System, as taught by Minor White and others, was so popular and successful that it dominated serious photographic practice throughout the 1960s and 1970s.

FIGURE 1.8 Daniel Gordon works at the intersection of photography, collage, sculpture, and performance, creating hybrid images that challenge the traditional relationship between photography and documentation. Creating 3-D sculptures from appropriated Internet prints, Gordon explores photography's ability to manipulate and misrepresent reality. His lighted paper forms are photographed, outputted onto transparency film, and then drum scanned. Drawing a comparison to Dr. Frankenstein, the artist combines and reshapes his source material into grotesque portraits, obviously stitched together from incongruous components, which present as both familiar and repulsive.

Credit: © Daniel Gordon. *Red Eyed Woman*, 2010. 40 x 30 inches. Chromogenic color print.

POSTVISUALIZATION

The images and writings of William Mortensen—as in his 1934 essay "Fallacies of Pure Photography"—rejected the doctrine of the straight print and the singular aperture as being mechanistic, offering a counterpoint to the philosophy of Group f/64. A master craftsman, Mortensen taught imagemakers that they have the right to manipulate their negatives and/or prints to achieve their visual goals. Our current digital culture has adopted his fundamental premise that the initial exposure is only a starting point for image creation.

SOCIAL LANDSCAPE AND THE SNAPSHOT AESTHETIC

The idea that serious photography must involve previsualization was challenged in the 1950s by Robert Frank and William Klein, who intuitively used the small 35mm Leica camera in available-light situations to disregard journalistic standards of construction and

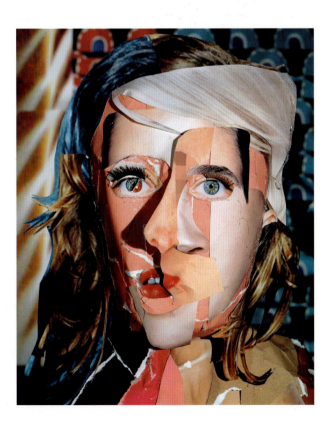

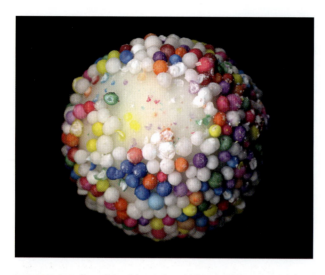

FIGURE 1.9 Betsy Schneider updates Winogrand by wanting to "see what things look like scanned. By using a scanner as a camera, I am able to render a degree of detail only previously available with a view camera. Sugar is a basic pleasure. I make pictures of candy with the hope of creating images which function both viscerally and conceptually, evoking nostalgia and desire and at the same time provoking repulsion at the consumption, greed, and indulgence of contemporary society. The images are printed relatively large on glossy paper to reinforce the superficial appeal of candy—colorful and promising instant gratification."

Credit: © Betsy Schneider. *Gum Ball,* from the series *All for Your Delight,* 2006. 40 x 30 inches. Inkjet print.

practices of the family snapshot, such as informal composition, extremes in lighting, and direct flash, which dispensed with directorial control and previsualization techniques into their photographs.[4]

THE ALTERNATIVE SCENE

The mid-1960s was a time of experimentation in many aspects of Western society: questioning how and why things were done, trying new procedures, and eliciting fresh outcomes. A rising interest in countercultural ideas sent many photographers back into photographic history to rediscover alternative techniques and encouraged new directions in imagemaking. A revival of historical methods surfaced with the national recognition Jerry Uelsmann received for his use of combination printing, and this spread to nonsilver approaches like cyanotypes and gum printing. The concept of postvisualization, in which the photographer could continue to interact with the image at any stage of the process, was reintroduced into the repertoire of acceptable practices. Photographers such as Robert Heinecken, Ray K. Metzker, Bea Nettles, and John Wood rejected the notion of a single, fixed perspective and actively sought alternative viewpoints.

THE RISE OF COLOR PHOTOGRAPHY

In the 1970s, alternative innovations challenged the dominance of the straight, black-and-white print as the fine art standard. This paved the way for such photographers as William Christenberry, William Eggleston, and Stephen Shore, whose color images of ordinary scenes ushered in the acceptance of artistic color photography, which is now taken for granted.

POSTMODERNISM

Beginning in the late 1970s, postmodernist beliefs that questioned the notion of a single author and the authenticity of any work gave rise to a new genre based on "appropriation"—the borrowing, reuse, and recontextualization of existing work—by artists such

content matter. Their use of blur, grain, movement, and off-kilter compositions gave photographers a new structure for discovering new subject matter and creating innovative, formal ways of making photographs through the picturemaking process. This approach to photographing the social landscape in the 1960s was summed up by street photographer Garry Winogrand's remark: "I photograph to find out what something will look like photographed." The social landscape is a personalized response to life that incorporates the informal artistic qualities of the snapshot to comment on "people and people things."

Diane Arbus used what was commonly known as the *snapshot aesthetic* to challenge the definition of what it means to be human and confront us with the "secret" that nobody is "normal." The snapshot aesthetic refers to the practice of professional photographers intentionally adopting the casual, immediate, and spontaneous

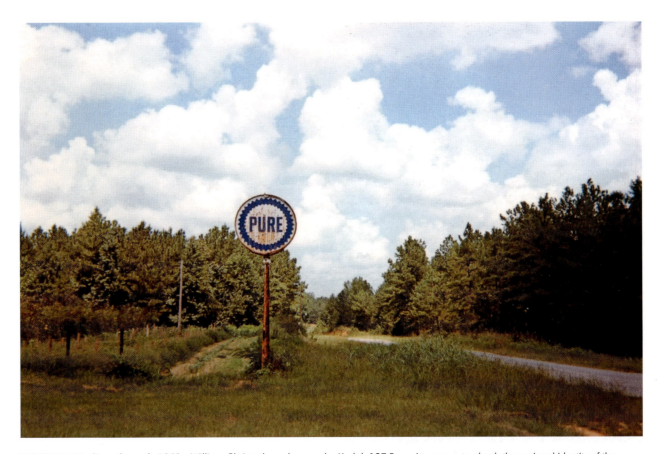

FIGURE 1.10 Since the early 1960s, William Christenberry has used a Kodak 127 Brownie camera to plumb the regional identity of the American South, focusing primarily on Hale County, Alabama, where he came of age. Christenberry's ritual documentation of "home" evokes pensive memories and scrutinizes scenes that unwaveringly record the physical changes brought about by nature and time without evoking nostalgia, establishing a connection between the past and the present. Each fleeting and simple structure can be considered a sculpture, an anxious agent for aging, decay, fragility, insecurity, and shifting purpose as well as a signifier for the closing of a way of life.

Credit: © William Christenberry. *Pure Oil Sign in Landscape, near Marion, Alabama*, 1977. 3¼ x 4¹³⁄₁₆ inches. Chromogenic color print. Courtesy of Pace/MacGill Gallery, New York, NY.

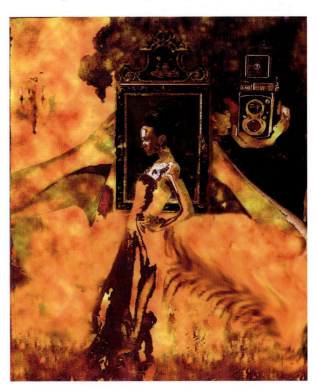

FIGURE 1.11 Cara Lee Wade addresses the role that the media plays in the women's beauty crisis by making a photogram of a page taken from a fashion or wedding magazine and then applying the alternative mordançage process in which an acid bath allows her to selectively remove areas of the image. Then the image is allowed to oxidize and produce a corrosive effect to which she adds oil paint. Next, the original magazine and mordançage images are scanned, combined, and manipulated in Photoshop. The result is "a manufactured grotesque based upon the idea that women put their bodies, and thusly their psyches, through torturous measures trying to live up to the elusive thing that is beauty."

Credit: © Cara Lee Wade. *The Lie That Leads to Truth*, 2004. 36 x 24 inches. Mixed media.

as Richard Prince and Sherrie Levine. During this era, Cindy Sherman made a series of photographs based on movie advertisements of the 1950s that featured and thus questioned female stereotypes. For her *Untitled Film Stills* (1977–1980), Sherman was the model, makeup artist, and set designer as well as the photographer. Her work exemplifies a movement by women and minorities to picture their own identity rather than having it imposed upon them. Another example of this is the work of Carrie Mae Weems, which explores issues about who we are and how we got to be that way from the perspective of African-American culture and experience. By the 1990s, postmodernism had also challenged the notion of separate, specific boundaries for different media and encouraged the cross-pollination of mediums, giving rise to new and widespread use of installations that incorporated photographs, three-dimensional and found objects, projected images, and sound.

ELECTRONIC IMAGING: NEW WAYS OF THINKING

Digital imaging started to surface in the scientific community during the mid-1950s, when Russell A. Kirsch made one of the first digital images. Along with other scientists working at the National Bureau of Standards, Kirsch created an early digital scanner. By the 1960s, the National Aeronautics and Space Administration (NASA) was using digitized images produced from its *Surveyor* landing craft in 1966 and 1968 to formulate never-before-seen composite photographs of the moon's surface. These were of great interest to both artists and the public, foretelling how artists now incorporate Google Earth and surveillance images into their work. Yet it was not until the late 1980s, with the advent of home computer graphics workstations, that digital image manipulation became a viable means for creating photographs. Digital image manipulation has removed the burden of absolute truth from photography. In doing so, it has revolutionized how images are created and generated a conceptual shift from a medium that records reality to one that

can transform it. In the late 1960s, Sonia Landy Sheridan incubated the notion of a Generative Systems Department at the School of the Art Institute of Chicago. Conceived to provide artists and scientists with the opportunity to investigate new means of image production that included electrostatic photocopy machines, video, and computer-generated images, the department offered its first course in 1970. What followed erupted into an explosive new set of technical possibilities that has enabled a vast extension of new and diverse visions to be produced.

THE DIGITAL IMAGING TRANSFORMATION

Digital imaging technology's transformational jump in photographic imagemaking has made it easier and quicker to create images and transmit them around the world. But more significant is how the digital upheaval has changed our conceptual notions regarding photographic truth. During the nineteenth century, people believed the stationary camera was an automatic and reliable witness. The photographer's job was to make "every person" views, with the camera acting as a stand-in by witnessing a scene and depicting what the viewer would have observed if present. This sense of "being there" gave people confidence that photographs were accurate representations of truth.

Digital imaging has demolished this unwritten arrangement between photographers and audiences by giving imagemakers the ability to seamlessly alter the picture of "reality." In the twenty-first century, seeing is no longer believing. The public's confidence in the accuracy of photographs has been eroding, as news providers modify photographs without informing their readers. It began in 1982 when *National Geographic* editors "moved" the Egyptian Great Pyramids at Giza closer together to accommodate the vertical composition of their cover. Unethical photojournalists have lost their jobs because they were caught "Photoshopping" images before transmitting them to their editors for publication. Revelations of unacknowledged use of such undetectable changes along with Madison

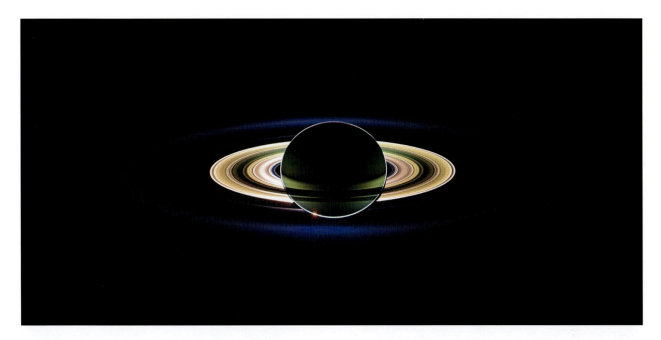

FIGURE 1.12 Carolyn Porco, Cassini Imaging Team leader, says: "There has yet been no greater visual survey of a planetary system in the outer solar system than Cassini's imaging of the bodies in the Saturn environment. The enchanting beauty and visual clarity of our images have earned the attention and admiration of people all over the world, and our scientific discoveries, some of them quite startling, have revolutionized our understanding of everything Saturnian." Cassini scanned across the planet and its rings, capturing three sets of red, green, and blue images to cover this entire scene showing the planet and the main rings. The exposures that were used to make this mosaic were adjusted to resemble natural color. Such space images made by unmanned remote-controlled cameras have had a noticeable influence on photographic practice. For more information see http://ciclops.org.

Credit: © Cassini. *Saturn, Approaching Northern Summer*, 2016. Variable dimensions. Digital file. Courtesy of Cassini Imaging Team and NASA/JPL/SSI.

FIGURE 1.13 Connell relates: "This work represents an autobiographical questioning of sexuality and gender roles that shape the identity of the self in intimate relationships. These images were created from scanning and manipulating two or more negatives in Photoshop to create a believable situation, which is not that different from accepting any photograph as an object of truth. These images reconstruct private relationships I have experienced, witnessed in public, or watched on television. The events portrayed look authentic, yet have never occurred. By digitally creating a photograph that is a composite of multiple negatives of the same model in one setting, the self is exposed as not a solidified being in reality, but as a representation of social and interior investigations that happen within the mind."

Credit: © Kelli Connell. *Kitchen Tension*, 2002. 30 x 30 inches. Chromogenic color print.

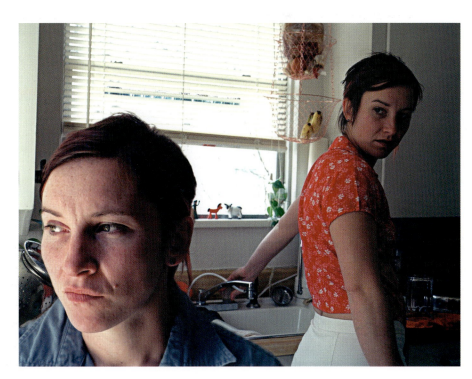

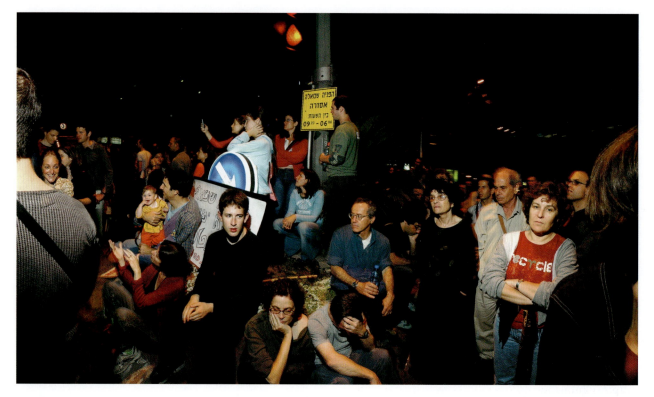

FIGURE 1.14 Barry Frydlender's images, which address the complexities of life in Israel, are indicative of how digital imaging has altered the definition of photographic truth by mimicking and therefore undermining traditional photojournalistic methods. Although they appear to be a seamless representation of an event, they actually are the antithesis of "cyclopean" photography. This image—the result of numerous images that Frydlender assembled into a single, time-compressed cinemascopic frame—delivers a synthesis of the event based on many different vantage points and moments in time. As the artist notes, "It's not one instant, it's many instants put together, and there's a hidden history in every image."

Credit: © Barry Frydlender. *Last Peace Demonstration*, 2004. 50 x 78 inches. Chromogenic color print. Courtesy of Andrea Meislin Gallery, New York, NY.

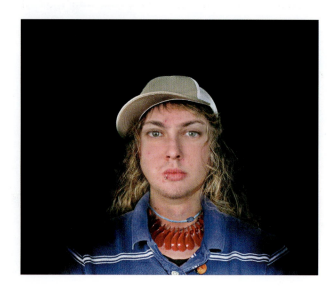

FIGURE 1.15 Robert Huston photographed 20 people in his photography class under identical conditions and then merged their pictures to create one universal class face. "I worked to achieve an image that was not sided towards one person more than another. Clothing, buttons, necklaces, hair, eyes, nose, and every other facial distinction that one views every day were given the utmost concern and detail to produce an image that shared the collective characteristics of 20 people." (See the "Human User Fusion" exercise in Chapter 12.)

Credit: © Robert Huston. *Universal Class Face*, 2006. 10 x 7½ inches. Inkjet print.

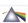

Avenue's and Hollywood's masterful deployment of highly processed digital imaging have made audiences more skeptical about the accuracy of all photographs, but subconscious conditioning, especially in how we see our bodies, affects our thinking patterns.

Now, digital imaging tools are so readily available and easy to operate that both amateurs and professionals use them daily. Computing power is at the core of the work of Nancy Burson, who used digital morphing technology in the 1980s to create images of people who never existed, such as a composite person made up of Caucasian, Negroid, and Asian features. Her pictures have no original physical being and exist only as digital data, showing us how unreliable images can be. They were the progenitors, setting the stage for the direction of much of today's digital work, such as *National Geographic*'s video clip showing the most "typical" human face (a 28-year-old Han Chinese man) based on a composite of almost 200,000 photographs (http://ngm.nationalgeographic.com/2011/03/age-of-man/face-interactive).

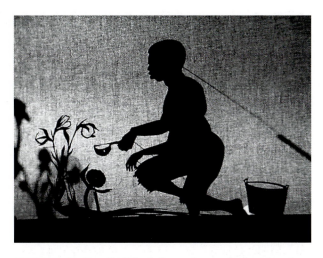

FIGURE 1.16 Kara E. Walker's film project employs a series of montages using animated cut-paper marionettes to draw a picture of the nascent antebellum South that is at times darkly menacing and at others disturbingly comical. The vignettes, which render all people black, conjure up an absurdist sideshow about the African-American experience that shifts between the metaphorical and the believable while maintaining an engaging realism of expression and gesture. The soundtrack features popular end-of-the-nineteenth-century music and the artist's own narration.

Credit: © Kara E. Walker. *8 Possible Beginnings or: The Creation of African-America, Parts 1–8, A Moving Picture* (video still), 2005. Courtesy of Sikkema Jenkins & Co., New York, NY.

NEW MEDIA

Another important element of the digital revolution is the end of the messy and smelly wet chemical darkroom as the primary place for making photographic images. The computer manipulation of digital data makes it possible for photographers to forge ever more new links among people, places, and events while seated in a clean, well-lighted room. Photographers no longer just capture a slice of time, but can alter it to enlarge our ideas about what makes up reality. Digital imaging encourages people to take chances and make many, including video capture, since the cost per exposure is not a factor. These changes make photography less rigid and objective and more flexible and subjective. This conversion offers us new possibilities for imaging and for understanding the world in new and different ways. It has opened up an entirely new category of work known as *new media*, which refers to interdisciplinary works that utilize new electronic media. New media can include video, online art, and interactive components with motion, sound, and touch, all of which can allow a work to change or be changed before one's eyes. In turn, this computer technology has produced new devices as well as social networks that utilize photographic images, such as podcasts and video blogs (a.k.a. vlogs), which rely on the Internet for posting and receiving digital files containing sound and moving images. These transfigurations demonstrate that the most important thing about a photographic image is not *how* it is made, but *what* it has to communicate.

EXERCISE 1.1 WHAT IS A PHOTOGRAPH?

Write your definition of what constitutes a photograph. Next, select a photograph, which can be one of yours or found online and rephotograph or scan it and make ten copies of it. Then produce ten variations of this image by adding both digital and physical properties, such as Photoshop, hand coloring, drawing, folding, collage, reassembling, scratching, rephotographing, and/or adding text. Focus on adding elements that will expand your first definition of what constitutes a photograph. After reviewing your results, revise your definition of what a photograph is and describe the main elements you used that changed your preconception of what a photograph can be or ought to be.

QUESTIONS REGARDING PHOTO-BASED IMAGEMAKING

Over the years, I have been collecting and responding to conceptual questions posed by people about photographic practice. The following series of questions and answers are designed to present a larger overview of fundamental concepts, images, and issues that can inform creative work. By thinking through these questions, readers can move beyond current styles or trends to expand and deepen visual potential and latent interests. The responses provided do not preclude other answers, but rather they offer an initial pathway to form the basis of a discussion, to provoke and in turn to help readers formulate thoughtful personal solutions. Additionally, I encourage people thinking about a life in the visual arts to actively seek out and establish their own foundation of inspirational sources from art, literature, philosophy, and science that can act as guideposts in their creative activities, motivation, and growth.

1. How does one become a photo-based imagemaker?

Since past photographs inform future photographs, looking at photographs and other visual material should be a primary activity. Observe what drives your visual curiosity. Examine the classics. They have been preserved because their artistic, conceptual, and technical content serves as a model that has proved useful over time. Explore contemporary work that is grappling with new and different ways of expressing ideas. Read, study, and practice different methods of photography, not merely for the sake of technique, but to ultimately discover the means to articulate your ideas. Do not make technical learning your priority. Form an idea first. The German artist Joseph Beuys said it best: "Once you've got an idea, the rest is simple." Step back from the familiar to see what you are missing and better understand it. One peril facing photo-based imagemakers is a lack of commitment to a thoughtful concept that translates into indifference in their work. Talking, thinking, and writing about photography are vital components of understanding the process, but these activities do not make one a photographer. Ultimately, to be a purposeful photographer, one must act and fully engage in the contemplative process of making photographs (usually lots of them).

2. What traits do effective photographers often possess?

As photographers often work under the pressure of a deadline, accomplished practitioners manage their time effectively while being adaptable, maintaining their concentration and discipline, staying in the moment with a combination of desire to succeed and a fear of failure, taking responsibility for what needs to be done, socially engaging people to get them to cooperate, and being persistent. Being determined—and not giving up—is probably the most important trait. However, the biggest hindrances are often egotism and the inability to expand the subject matter beyond oneself.

3. Why is photography important?

In disaster after disaster, survivors report their most irreplaceable objects are their snapshots. This reveals the crux of why people photograph: to save and commemorate a subject of personal importance. Such images may act as a memory nudge or an attempt to stop the ravages of time. Regardless of motive, this act of commemoration and remembrance is the essence of much photography.

What does this mean in terms of developing an artistic practice? Today, there are more options than ever to pursue. Whether the images are found in the natural world, in a book, or online, part of an imagemaker's job is to be actively engaged in the condition of "looking for something." How this act of looking is organized—its particular routines, astonishments, uncertainties, and quixotic complexities—is what makes a photographer unique.

4. Why is it important to find an audience for your work?

Part of a photographer's job is to interact and stimulate thinking within the community of artists and the world at large. This involves getting others to pay attention to your concerns. Without an audience to open a dialog, the images remain incomplete and the artist remains unsatisfied.

5. What can images do that language cannot do?

An accomplished photographer can communicate visual experiences that remain adamantly defiant to words. The writer Albert Camus stated, "If we understood the enigmas of life there would be no need for art." We know that words have the power to name the unnamable, but words also hold within them the disclosure of a consciousness beyond language. Photographs may also convey the sensation and emotional weight of the subject without being bound by its physical content. By controlling time and space, photo-based images allow viewers to examine that which attracts us for often indescribable reasons. They may remind us how the quickly glimpsed, the half-remembered, and the partially understood images of our

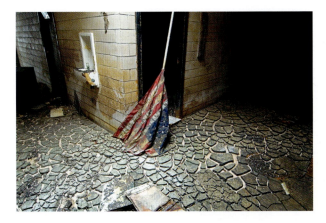

FIGURE 1.17 Having photographed in New Orleans for nearly 25 years, Stan Strembicki sought out objects, rather than citizens in distress, to represent the effects of lives lost, of culture washed away, and of the people displaced by 2005's Hurricane Katrina. "This water-damaged high school was symbolic to me of lost knowledge, traditions, and history. The ruined American flag was emblematic of the federal response to this disaster, while the mud is representative of ironic forces, which were never far off."

Credit: © Stan Strembicki. *Ruined Flag, Lawless High School, Lower 9th Ward*, from the series *Post Katrina New Orleans*, 2005. 17 x 24 inches. Inkjet print. Courtesy of Philip Slein Gallery, St. Louis, MO.

culture can tap into our memory and emotions to become part of a personal psychic landscape that makes up an integral component of identity and social order.

6. What makes an engaging photograph?

A significant ingredient of an attention-grabbing photograph is often *empathy* because it provides viewers with an initial entryway for cognitive and emotional understanding of the subject. Yet the value of a photograph is not limited to its depiction of people, places, things, and feelings akin to those in our life. An engaging image contains within it the capacity to sensitize and stimulate our latent exploratory senses. Such a photograph asserts ideas, fantasies, and perceptions that we recognize as our own, but which we could not have given concrete form without having first seen that image.

7. How is the meaning of a photograph determined?

Meaning is not intrinsic. Meaning is established through a fluid cogitative and emotional relationship among the

FIGURE 1.18 "As a photo-based artist, I see myself as the link between two realities—the one outside of the camera and the one that begins once the photograph has been taken. Rather than documenting or capturing the moment, I want to show what is not immediately visible. Inspiration comes from my fascination with the informational processes of the mind and in popular theories of physics. String Theory describes the existence of up to 26 dimensions and parallel universes that might be outside of our perception. I use a combination of analog photography and digital editing [to remove spatial references], for they enable me to create images that have the sensibility of drawings or paintings while retaining photography's reference to the outer world."

Credit: © Sebastian Lemm. *Subtraction #1*, 2006. 60 x 48 inches. Chromogenic color print.

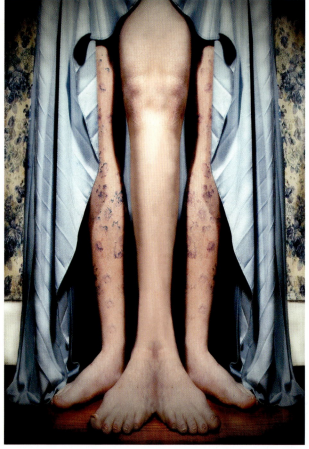

FIGURE 1.19 Sheila Talbitzer uses herself as the subject to produce tangible evidence of the human condition that is unseen or indescribable. "For me, words fail the complexity of the human emotional landscape. This failure is why my images exist. They communicate complicated feeling using symbolism that is both personal and universal and free from the burden of concrete meaning. What makes me human is also what makes viewers human. I cultivate that connection with heavily manipulated images that still appear photographically true while obviously defeating that truth."

Credit: © Sheila Talbitzer. *Untitled #5*, from the series *Curio*, 2006. 45 x 30 inches. Inkjet print.

maker, the photograph, and the viewer. The structure of a photograph can communicate *before* it is understood. A good image teaches one how to read it by provoking responses from the viewer's inventory of life experiences, as meaning is not always found in things, but sometimes between them. An exceptional photograph creates viewer focus that produces attention, which can lead to definition. As one meditates on what is possible, multiple meanings may begin to present themselves. The result is that meaning, like the weather, is local; viewers interpret images based on their own understanding of the world, which in turn is based on their background, historic context, and sense of time.

8. How can photographers know and define beauty and truth in the twenty-first century?

Beauty is the satisfaction of knowing the imprimatur of this moment. Although beauty and truth are based in time and may exist only for an instant, photographers can capture a trace of this interaction for viewers to contemplate. Such photographs can authenticate an experience, allowing us to reflect upon it and to gain deeper meaning.

During the past three decades, previously neglected issues such as gender, identity, race, and sexuality—and more recently, globalization—have been predominant themes. In terms of the practice of digital imaging, the artistic ramifications have been the overriding concern. But whether an imagemaker uses analog silver-based methods to record reality or pixels to transform it, the two greatest issues that have concerned imagemakers for thousands of years—beauty and personal truth—have receded into the background, especially in university settings, where academic theories and irony have been the major forms of artistic expression.

Beauty is not a myth, in the sense of being simply a cultural construct or the creation of manipulative advertisers, but an innate part of human nature. Our passionate pursuit of beauty has been observed for centuries and should not be ignored simply because it isn't trendy or cannot be scientifically measured. The record of ideas can be represented in terms of visual pleasure. In pre-Christian times, Plato recognized the three wishes of every person as "to be healthy, to be rich by honest means, and to be beautiful." More recently, American philosopher George Santayana postulated

FIGURE 1.20 Is photography serving truth? Is science monopolizing our knowledge? Can the unexpected still exist? Joan Fontcuberta and Pere Formiguera attempt to provide some answers. Fontcuberta explains: "Based on the myth of the *found* archive and the postmodern strategy of the *death of the author*, we created the fictional narrative of an obscure German naturalist, Professor Peter Ameisenhaufen, and his assistant Hans von Kubert. They devoted their lives to research the exceptions in Darwin's Theory of Evolution and collected all kind of monsters, hybrids and mutations in their many expeditions around the world. Advancing the effects of the digital age, the story of this fantastic bestiary, *documented* with a sophisticated scientific display, confronts us—with a healthy irony—with issues of credibility based in technology, with the fictional status of the photographic images, and with the authority of institutional contexts (the scholar presentation, the museum, science). Here photography of *nature* is not but a pretext to deal with the *nature* of photography."

Credit: © Joan Fontcuberta and Pere Formiguera. *Cercopithecus Icarocornu*, from the series *Fauna*, 1985. 19 ½ × 15 ¾ inches. Gelatin silver print toned with tea.

that there must be "in our very nature a very radical and widespread tendency to observe beauty, and to value it."

Although elusive, certain visual patterns that can be observed define a *personal truth*—a conclusion beyond doubt that guides one's actions. As individuals, when we recognize such a certainty, it may grab hold and bring us to a complete stop—a full mental and physical halt from what we were doing—while simultaneously producing a sense of clarity and conviction that eliminates the need for future questioning and reinforces the genuine voluble role that art plays in our lives.

9. What advantages does digital imaging offer over silver-based imagemaking?

Practically speaking, one no longer needs a physical darkroom with running water and enlarging equipment that exposes you to the dangers of handling chemicals. Conceptually, as in silver-based photography, digital imaging allows reality to be made up (edited) by whatever people deem to be important and whatever they choose to subvert. Typically, analog silver-based photographers begin with "everything" and often rely on subtractive composition to accomplish these goals. On the other hand, digital imaging gives artists the option to start with a blank slate and build up to a final image. This allows imagemakers to convey the sensation and emotional weight of a subject without being bound by its physical conventions, giving picturemakers a new context and venues to express the content of their subject.

10. What are the disadvantages of digital imaging?

Manufacturers promote the fantasy that all it takes to be an artist is a few clicks of a mouse or the application of a preprogrammed filter. However, the vast majority of digital images continue to rework past strategies and do not articulate any new ideas. The challenge remains open: expanding the native syntax for digital imaging. Presently, this appears to encourage the commingling and hybridization of mediums, though future practice remains unknown.

On the practical side, having a tangible negative allows one to revisit the original vision without worrying about changing technology. One still could take a paper negative that Henry Fox Talbot made to produce the first photographic book, *The Pencil of Nature* (1844–1846), and make a print from it today. In 172 years, will there be a convenient way for people to work with images saved only as digital files? Or will they be technically obsolete and share the fate of those computer floppy disks that most people no longer have the means to access?

One need not be a Luddite to enjoy making analog prints. One reason to work in a variety of analog processes is that digital imaging tends to physically remove the maker from the photographic process. This is not a romantic notion or a nostalgic longing for the ways of the past. Often what is lost is the pure joy of being alone in a darkroom with an orange glowing light— the exhilaration of being corporeally creative as your body and mind work together to produce a tangible image. The act of making an analog photograph is a haptic experience that does not occur while one is seated in a task chair. The smell of chemicals and the ambient sound of running water as an image emerges in the developing tray from a white nothingness—such sensory experiences are missing when making digital images. A silver-based photograph never looks better than when it is seen still glistening wet as it emerges from the washing process. And regardless of how long one has been making prints in the darkroom, there is still that magical thrill that your photograph "has come out" and can now have its own life.

11. How can I find something intriguing to photograph?

Photography is exceptional at capturing the surface of things, but not as effective at getting beneath it. However, do not automatically assume that the physical subject of an image always reveals its content. Meaning is not always linked to the subject matter being represented. Photographs that affect people may have nothing to do with the apparent subject matter and everything to do with the subsequent treatment of that subject. This realization creates limitless potential for subject matter.

Light and shadow are vital components of every photograph. This was recognized early in the medium's

history by Talbot's image *The Open Door,* 1844, which demonstrated his belief that subject matter was "subordinate to the exploration of space and light." The quality of light striking a subject can reveal or conceal its characteristics, which will make or break a photograph. Light may be natural or artificial, but without the appropriate kind of light, even the most fascinating subjects become inconsequential. Ultimately, light is a principal subject of every photograph that imagemakers must strive to control and depict. As Talbot stated, "A painter's eye will often be arrested where ordinary people see nothing remarkable. A casual gleam of sunshine, or a shadow thrown across his path, a time-withered oak, or a moss-covered stone may awaken a train of thoughts and feeling, and picturesque

imaginings." This is the realization that the subject in front of the lens is not always the only subject of the photograph.

12. Hasn't it been done before?

Accepting the notion it has all been done before is to believe that there is a correct first way of depicting a subject, an assumption that embraces the banality of clichés. The problem with platitudes is not that they are erroneous, but that they are unimaginative, oversimplified, and superficial articulations of complex concepts. Clichés are detrimental because they encourage imagemakers to believe that they have done a sufficient job when in fact they have merely gazed at its surface. The act of taking a photograph of Niagara Falls

FIGURE 1.21 Patrick Ryoichi Nagatani's project centers on the fictional account of an enigmatic Japanese archeologist and his 15-year excavation of the world's monuments. Presented as a series of field photographs, Nagatani's alternative past highlights the cultural importance of the automobile, challenging us to examine the ways in which photography creates, re-creates, or supports a particular history.

Credit: © Patrick Ryoichi Nagatani. *Model A Woody, National Radio Astronomy Observatory (VLA), Plains of St. Augustin, New Mexico, U.S.A.,* 1997/1999. 17¾ x 22⅞ inches. Dye destruction print.

FIGURE 1.22 "I began to create large-scale posters as an extension of artists' books. I have used the work of Chris Ware, the Russian Constructivists, and old cinema posters as sources of inspiration, and have often accompanied my posters with short films."

Credit: © Jonathan Gitelson. *What Does It All Mean?* 2004. 63 x 44 inches. Inkjet print.

or a pepper is no guarantee that one has communicated anything essential about that subject. Good photographers provide visual clues and information about their subject for viewers to contemplate. They have learned how to distill and communicate what is essential to them about their subject. By deeply exploring a theme and challenging truisms, photographers can reconstruct their sight of distorted, neglected, or other contextual issues that surround a subject and its meaning and gain a fresh awareness and understanding.

13. What if I'm not in the mood to make photographs?

Responding to life with joy and sorrow is part of being human. At times when pain and suffering are inescapable, it is important to remember that this is part of the process by which we acquire knowledge. This does not mean that one must be in discomfort to make art, but stress can be channeled into a creative force if it produces a sense of inquisitiveness and an incentive for change. Thinking through making pictures can allow us to place our distress in context. The images we make can help us understand its source, catalog its scope, adapt ourselves to its presence, and devise ways to control it. There are things in life, once called wisdom, which we have to discover for ourselves by making our own private journeys. Stress can be directed to open up possibilities for intelligent and imaginative inquiries and solutions that otherwise might have been ignored, overlooked, or refuted.

14. What happens when I have difficulty photographing a subject?

When you get stuck and cannot find a solution to your problem, try changing your mental approach. Instead of forcing an issue, go lie down in a quiet and comfortable dark room, close or even cover your eyes, and allow your unconscious mind a chance to surface. Some people may prefer to take a bath or go for a walk. The important thing is to find something that will change the pattern of your brainwaves. Anecdotal accounts indicate that the following can be an excellent problem-solving method: turn off the cognitive noise and allow your internal "hidden observer" to scan the circumstances, and then return to your normal state with a possible solution. Record new ideas and bear in mind the advice of French Renaissance writer Michel de Montaigne: "Observe, observe, perpetually."

15. Why is it important to understand and be proficient in your medium?

Understanding the structure of the photographic medium allows one the freedom to investigate new directions. Upon first viewing, an image may appear to

be exciting and magical; however, the photograph needs to be objectively evaluated. To do this, one must have the expertise of craft to understand that photograph's potential. Mastery of craft allows one the control to be flexible, to sharpen the point of concentration, and to discard extraneous material. This evaluation process requires you to reexamine and rethink your initial impulse and jettison inarticulate and unadorned fragments, and allows you to enrich and refine your direction by incorporating new and/or overlooked points of view. An artist who invests the extra time to incubate fresh ideas, learn new technical skills, try different materials, and experiment with additional approaches can achieve a fuller aesthetic form and a richer critical depth. This procedure is often attained by reaching into different parts of ourselves than those we display in our daily demeanor, in our community, or in our imperfections.

16. Why is it important to make your own photographs?

The physical action of making a photograph forces you into the moment and makes you look and think more than once, increasing your capacity for appreciation and understanding. This not only allows you to see things in new ways, but can also be physically and psychologically exhilarating. It reminds us that while life may be absurd, it is not mediocre, even if our daily conception of it is. Making one's own images allows a photographer to forge connections between the structure of the universe and the organization of one's imagination and the nature of the medium. Consider what artist/educator Pat Bacon says: "Make work . . . make it often . . . make it with what's available!"

17. How much visual information do I need to provide a viewer to sustain meaning?

There are two basic stylistic approaches for transmitting photographic information. One is an open or indirect approach in which a great deal of visual data is presented. It allows viewers to select and respond to those portions that relate to their experiences. The other method is the guided or expressionistic form. Here a photographer

presents selected portions of a subject with the idea of directing a viewer toward a more specific response. Photographers need to decide which technique is more suitable for a particular subject, their specific project goals, and their own way of seeing. Approaches shift depending on the project situation, but generally it is helpful to keep a constant approach throughout one body of work. Consciously selecting a single stylistic method for a series also provides a basic template for displaying your thoughts and producing work that possesses a tighter organization and focus of concentration.

18. How much of my output is likely to be "good"?

The American poet and writer Randall Jarrell wrote an apt metaphor that can be applied to other forms of artistic endeavor: "A good poet is someone who manages, in a lifetime of standing out in thunderstorms, to be struck by lightning five or six times; a dozen or two dozen times and he is great." Ansel Adams said he was satisfied if he made one "good" image a month. Much of any artistic practice is working through the process. Superior artists take risks but also recognize that not everything they do is for public circulation. Situations that provide constructive and challenging criticism can be beneficial in helping to resolve a project. Over time, skillful artists can learn to edit and critique their own work, presenting only their most thought-out solutions for public consideration. Keep in mind what Henri Cartier-Bresson said: "It's seldom you make a great picture. You have to milk the cow quite a lot and get plenty of milk to make a little cheese. Hmmmm?"

19. How do photographers explore subjects like time and space?

The process of making pictures involves keeping an open mind. Always be prepared to rethink your initial approach to a subject. Consciously ask yourself questions to help determine whether single- or serial-image constructions, narrative or non-narrative formats, and in-camera juxtapositions or post-camera manipulations would best serve your intent. For example, does

FIGURE 1.23 This image acknowledges the horror of the people who jumped from the Twin Towers on 9/11. However, it is but a single entry in a series about which Kerry Skarbakka notes, "Falling is a metaphor for life in general. Mentally, physically, and emotionally, from day to day, we fall. Even walking is falling: You take a step, fall, and catch yourself." He goes on to say that "philosopher Martin Heidegger described human existence as a process of perpetual falling, and it is the responsibility of each individual to 'catch ourselves' from our own uncertainty. This unsettling prognosis of life informs my present body of work. Using myself as model and with the aid of climbing gear and other rigging, I photograph the body as it dangles from dangerous precipices or tumbles down flights of stairs. The captured gesture of the body is designed for plausibility of action, which grounds the image in reality. However, it is the ambiguity of the body's position in space that allows and requires viewers to resolve the full meaning of the photograph."

Credit: © Kerry Skarbakka. *Office*, from the series *Life Goes On*, 2005. 60 x 72 inches. Chromogenic color print. Courtesy of Fifty One Fine Art Photography, Antwerp, Belgium, and Burt Michaels and Associates, Chicago, IL.

changing the sense of scale—the size one normally expects something to be—affect viewer reaction? If so, does the unusual scale evoke humor, mystery, or horror? Other questions may include: Would changing to black and white or color affect the image's emotional outcome? Does placing a photograph into a pair or series modify the meaning of the images? What happens if text is added to an image? Does meaning shift with a title as opposed to leaving a photograph untitled? What is the most effective form of presentation, and what is the appropriate venue?

20. Why study the history of photography?

History is how we define ourselves based on what we make of the past, which determines our future relationships. Being grounded in the story of photography allows an imagemaker to see what has already been done. Photographs are built upon other photographs. Look at the work of other imagemakers who have covered similar ground and ask: What did they do that allows you to connect to their work? What would you do similarly? What would you do differently? The study of photographic history also offers an opportunity to

advance the skills needed to critically examine photographs and the context of their social history: description, interpretation, and evaluation. Going forward from a foundation of knowledge, the imagemaker is in a position to carry out the Irish writer Oscar Wilde's aphorism, "The duty we owe to history is to rewrite it"—or in the photographic sense, to re-image it.

21. What are the limitations in studying the images of others?

The French novelist Marcel Proust stated, "There is no better way of coming to be aware of what one feels than by trying to recreate in oneself what a master has felt." While viewing the work of others can help us understand what we feel, it is our own thoughts that we need to develop, even as someone else's picture assists us through this process. This also involves gaining an understanding of the visual and media culture that makes up our social environment. Regardless of how much another's image opens our eyes, sensitizes us to our surroundings, or enhances our comprehension of social issues, ultimately the work cannot make us aware enough of the significance of our predilections—because the imagemaker *was not you*. Looking at work can place

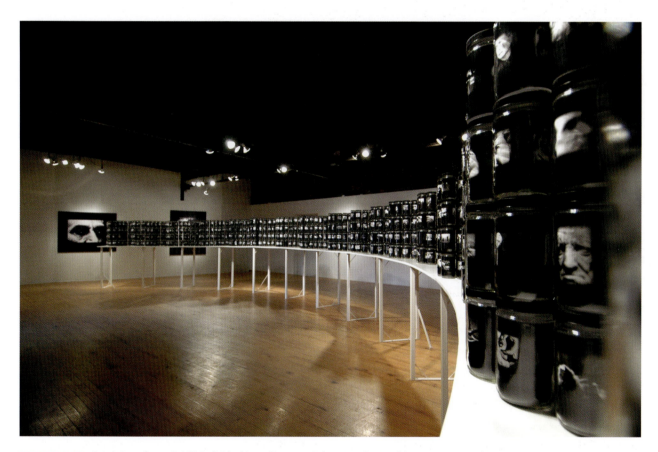

FIGURE 1.24 Consisting of over 1,000 individual jarred images, Robert Hirsch's *World in a Jar: War and Trauma* is not a conventional documentary yet pays homage to the tradition and expands the genre into a postmodern form. It does this by reworking historical images and original material to examine visual cultural memories involving loss, popular culture, religion, tragedy, and wickedness over the past 400 years. The artist states, "It is a Socratic process that allows me to engage in a philosophical dialog with other times, places, and makers, following the principle there is no correct first version of how an image should look. I am not redefining an image as much as I am inquiring into metaphysical contradictions and opposing social forces that swirl around each image. I am asking each picture a question while examining the origin of the image and the way its meaning has changed over time."

Credit: Robert Hirsch. *World in a Jar: War and Trauma* (installation detail), 2004. 4 x 2 x 50 feet. Mixed media. Courtesy of the Burchfield Penney Art Center, Buffalo, NY.

one at the threshold of awareness, but it does not constitute cognizance of it. Looking may open deep dwelling places that we would not have known how to enter on our own, but it can be dangerous if it is seen as material that we can passively grab and call our own. Many of us become photographers because we have not found pictures that satisfy us. In the end, to be a photographer, you must cast aside even the finest pictures and rely on your internal navigational devices to inform your images. Regardless of what pictures already exist, innovative artists think, imagine, and express notions differently from previously recognized views of a similar subject.

22. Can too much knowledge interfere with making photographs?

The answer is both yes and no. Beware of those who do not think independently, but rather rely upon received aesthetic, theoretic, or technical principles as sole guides to eminence. You do not have to know all the answers before you begin. Asking questions for which you have no immediate answers can be the gateway to a dynamic new body of work. Do not get overwhelmed by what you do not yet know. Acknowledge that there is always more to know and learning is a lifelong process. Use your picturemaking as a discovery process, but do not allow the quest for data to become either the central concern or a deterrent to making pictures. While prior knowledge of a subject can offer points of entry for visual explorations, ascertain what you need to begin your project and then allow the path of knowledge to steer you to new destinations.

23. Is it necessary to explain my photographs?

Yes, it is vital to provide viewers a toehold to an understanding of your work through an artist's statement. This process benefits both artist and audience, as it also allows a photographer to learn if the viewer agrees with the stated intentions of the work. However, while useful, an artist's intention offers only a single perspective for approaching work. By remaining open to different interpretations, imagemakers may discover meanings in the work that was not in their conscious mind.

Yet enigma remains an essential quality of art making. British painter Francis Bacon, whose work was strongly influenced by photography, believed that the power of a work lay in its ability to be alluring *and* elusive. He thought that once an image could be sufficiently approximated in words, it became an illustration. If an idea could be made clear in a text, then why go to the trouble of painting it? Bacon felt that a successful image remains, by definition, indefinable. He took the existential position that since he himself had nothing to say, his pictures meant nothing and said nothing. To him, painting was the pattern of one's nervous system projected on the canvas. In the end, consider what English painter Walter Sickert thought: "Never believe what an artist says, only what he does."

24. What is the role of critics and critique?

"Unless you are one critic in a hundred thousand," wrote literary critic and poet Randall Jarrell, "the future will quote you only as an example of the normal error of the past." Artist/filmmaker Jean Cocteau quipped that one should "Listen carefully to first criticisms made of your work. Note just what it is about your work that critics don't like—then cultivate it. That's the only part of your work that's individual and worth keeping." The real importance of criticism is for the sake of the work that it criticizes. Good critics do not set up rigid agendas and templates or try to impose their own prescriptive notions, but allow the work and the experience of it to set the general expectations to which the criticism conforms. The one sure thing we know about the future is that it is not what we think it will be. Therefore, an accomplished artist remains open to forthcoming possibilities.

25. What is the role of theory in relation to contemporary photography?

It is a matter of perspective and priority. Do you want to be concerned with the object of study or with constructing a cohesive conceptual system? At its best, postmodernism's schema of inclusion creates a

permissive attitude toward a wide range of interpretive possibilities. At its worst, it encourages a nihilistic solipsism where all expression resides in a nebulous haze of indeterminate value. As a student, one does not expect to learn and unlearn photography all at once, but regardless of one's personal inclinations, one should become informed about past and present artistic theory, from English Victorian era artist and writer John Ruskin to French philosopher Jacques Derrida. That said, making pictures just to facilitate an ideology is not making pictures at all.

26. What do good teachers teach?

Good teachers instill a sense of personal responsibility, generosity, and discipline. They encourage students to be curiously critical, to find the means to accomplish their goals by working autonomously, and to be respectful of others with the goal of building a practice.

27. How do photographers earn a living?

Living as an artist depends on what you want to do and how much money you require. Less than 1 percent of artists can live on what they earn from their artwork. Do not expect to get a full-time teaching job in higher education, even if you are willing to work for years as an adjunct faculty member at numerous institutions. However, there are career opportunities in arts and cultural organizations, primary and secondary education, and the commercial sector. Take advantage of being a student to do an internship that will give you firsthand experience within an area you would like to work. Successful internships can lead to entry-level jobs. The visual arts community is still a relatively small field. Hard work and networking skills can benefit you and the organization that you serve in terms of letters of reference and bridges to your future that are at present unimaginable (see Addendum 2, Careers).

28. Which equipment is the best?

It does not matter what camera you use, but how you use it. Travel photographer Peter Adams said, "Photography is not about cameras, gadgets and gismos. Photography is about photographers. A camera didn't make a great picture any more than a typewriter wrote a great novel." What is important is having a camera with you and knowing how to use it.

29. Can creative efforts in other fields inspire your work?

Absolutely. Einstein was fascinated by Wolfgang Amadeus Mozart, and he sensed affinities with the Austrian composer, in both their creative processes and personal histories. As a boy, Einstein was a poor student who found that playing the violin provided an outlet for his emotions. At 13, he discovered Mozart's sonatas and felt an almost mystical connection. In addition to his passion for Mozart's work, Einstein also identified with the maestro's ability to continue to compose magnificent music, even in very difficult and impoverished conditions. In 1905, the year Einstein discovered relativity, he worked in the Swiss patent office and lived in a cramped apartment while dealing with a difficult marriage and money troubles. Yet that spring he wrote four papers that would change the world.

Einstein's ideas on space and time came in part from aesthetic discontent. It seemed to him that asymmetries in physics concealed essential beauties of nature—existing theories lacked the "architecture" and "inner unity" he found in the music of Mozart and J.S. Bach. In his struggles with the complex mathematics that led to the general theory of relativity of 1915, Einstein often turned to Mozart's music for inspiration. Scientists have described general relativity as the most elegant theory ever formulated, and Einstein himself emphasized the beauty of the theory, which essentially represents his personalized view of how the universe ought to be. Amazingly, the universe turned out to be more or less as Einstein imagined, including such spectacular and unexpected phenomena as black holes. Could any artist ask for more?

30. Now it is your turn. Add a question and answer to this list—above all: *Be curious* and be prepared to test out every possibility if you want to discover something new.

FIGURE 1.25 "Due to the current tensions in the Middle East and my cultural background, I was moved to make a limited edition book probing the relationship of personal history to political issues. I work on books rather organically; that is, I get an idea and make a loose mock-up based on the information and pictures I gather. I constantly change pages as I create the book. Using a computer is particularly advantageous for this methodology, as I can virtually collage, move, alter the size or re-do both text and images with relative speed. I have used family photos, historical images, web pictures, and objects placed on a scanner to create the digitized imagery, which I have altered in size, color, cropping, and detail, either at the point of scanning or while using Photoshop before printing." Text in left panel reads: "Sometimes I am embarrassed for anyone to know that I am Jewish." Text in right panel reads: "Some of the most influential modern figures were born Jewish: Albert Einstein, Bernard Malamud, Karl Marx, Arthur Miller, Sigmund Freud, Emma Goldman, Benjamin Disraeli, Martin Buber, Frank Gehry, Franz Kafka, Claude Levi-Strauss, Alfred Stieglitz, Noam Chomsky, Allen Ginsberg, Jonas Salk, Norman Mailer, Isaak Stern, Sarah Bernhardt, Jacques Derrida, Gertrude Stein, Robert Frank, Diane Arbus, Ludwig Wittgenstein, Rothschild Family."

Credit: © Laura Blacklow. *Confessions of a Jew, Double Page* (from artist's book by the same title), 2003/04. 6½ x 5½ inches. Inkjet prints.

REFERENCES

Adams, Ansel. *The Ansel Adams Photography Series.* Three volumes. Tenth Edition. New York: Little, Brown, 1995.

Adams, Robert. *Why People Photograph: Selected Essays and Reviews.* New York: Aperture, 2005.

Beckley, Bill (ed.), with David Shapiro. *Uncontrollable Beauty: Toward a New Aesthetics.* New York: Allworth Press, 2001.

Hirsch, Robert. *Seizing the Light: A Social and Aesthetic History of Photography.* Third Edition. New York & London: Taylor & Francis, 2017.

Newhall, Beaumont. *The History of Photography from 1839 to the Present.* Fifth Edition. New York: Museum of Modern Art, 1982.

Stiles, Kristine, and Peter Selz (eds.). *Theories and Documents of Contemporary Art: A Sourcebook of Artists' Writings.* Second Edition. Berkeley and Los Angeles: University of California Press, 2012.

Szarkowski, John. *Looking at Photographs: 100 Pictures from the Collection of The Museum of Modern Art.* New York: The Museum of Modern Art, 1973.

FIGURE 1.26 Lens test chart used for evaluating lens distortion and color balancing of digital and film cameras.

Credit: © DGK Color Tools.

NOTES

1. Originally, photography provided an automatic mechanical method for transferring what was seen in nature into a two-dimensional form of Renaissance perspective. This indexical characteristic gave people the illusion that photographs were stand-ins for reality. Photography proved so able at reality substitution that people came to see this capability as photography's sole purpose. The photographer was supposed to act as a neutral observer, an operator of an automatic machine merely aiding the camera in its work of accurately recording the subject.

2. Kark Vic, "Haunting Image of the Assassination of Russia's Ambassador to Turkey," December 19, 2016. http://time.com/4606972/russian-ambassador-karlov-turkey-assassination-photo-burhan-ozbilici/?xid=newsletter-photos-weekly.

3. "A photographer's eyewitness account of Russian ambassador's assassination," December 19, 2016. www.latimes.com/world/la-fg-turkey-assassination-photographer-20161219-story.html

4. See Robert Hirsch and David Harrod, *Point and Shoot*, Buffalo, CEPA Gallery, 1992 (www.lightresearch.net).

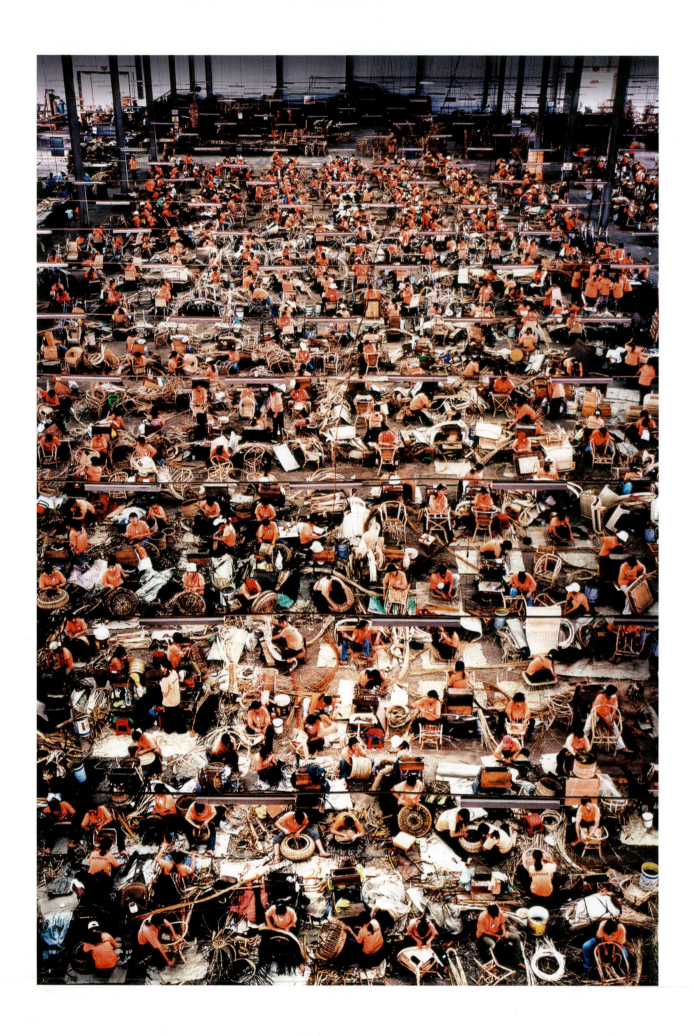

Design: Visual Foundations

LEARNING TO SEE: COMMUNICATING WITH DESIGN

When it comes to photographic imagemaking, people have plenty of questions about cameras yet seldom ask how best to accomplish their visual goals. What determines the success of an image is not the camera, but the knowledge of the person operating the camera. The principal job of a photographer is observing, which defines all photographic processes. Effective photographs are made by learning to see. Effectual photographers become skilled at following their eyes and seeing things others overlook. Imagemaking is 10 percent what we encounter and 90 percent how we respond. Engaging images are powerful shaping tools that do not just communicate facts but create facts by generating their own history—past, present, and future—that can stand alone as a statement. An engrossing photograph creates a memory in a viewer.

The foundation of enthralling photography is composition. Fascinating photographers distill, organize, and synchronize their visual material by managing the visual disorder within the confines of the photographic space. The arrangement of objects within a pictorial space determines the degree to which a photograph connects with other people. Visual order revolves around understanding composition, which, as Edward Weston said, "is the strongest way of seeing" a subject.

BEGINNER'S MIND

Beginner's mind is a Zen Buddhist concept that refers to maintaining an attitude of openness, eagerness, and lack of preconceptions when studying a subject, even at an advanced level. The term was also the title of Zen Master Shunryu Suzuki's book, *Zen Mind, Beginner's Mind* (1970), which reflects his saying: "In the beginner's mind there are many possibilities, in the expert's mind there are few." Make the most of the innocence and

FIGURE 2.0 Andreas Gursky's big, bold, colorful images, often made from a high viewpoint, are extraordinarily precise and rich in detail. This gives his works a highly textured feel while revealing an internal geometry of the subject. His choice of subject matter favors late capitalist society and systems that include enormous industrial plants, apartment buildings, hotels, office buildings, and warehouses, which minimize the importance of the individual. Gursky makes no pretense about objectivity. He digitally manipulates his images—combining discrete views of the same subject, deleting extraneous details, and enhancing colors—to create a kind of "assisted realism," making him a leading representative of our contemporary Zeitgeist.

Credit: © Andreas Gursky. *Nha Trang, Vietnam*, 2004. 116 x 81½ inches. Courtesy of Matthew Marks Gallery, New York, NY, VG Bild-Kunst, Bonn, Germany, and Artists Rights Society (ARS).

simplicity of the first inquiry when your mind is open to all possibilities, including both acceptance and doubt. Such open mindedness allows you the chance to see things as they are and intuitively realize the core nature of what you are observing, thereby providing an excellent point of departure. Take advantage of digital imaging's instantaneousness to capture your first responses to a subject, but don't hesitate to recapture or rework after studying the results.

THE DESIGN PROCESS

Design involves all the visual elements that make up a composition. The design process is the act of organizing all these parts into a coherent whole for a specific purpose. A fascinating photographic image is an extension of the photographer that creates a response in a viewer. A beguiling photograph engages and sustains a viewer's attention and elicits a response. When these criteria are met, the design can be considered effective. Having a firm understanding of the nature of the photographic process can allow one to consistently make effective photographs. Design is like a muscle: it swells, strengthens, and becomes more flexible with exercise.

THE NATURE OF PHOTOGRAPHY: SUBTRACTIVE COMPOSITION

Making camera photographs involves the practice of subtractive thinking. Since anything and everything touched by light can be photographed, the camera is an arbitrary and indiscriminate instrument. Ignorance of this fundamental quality leads many beginners to overcrowd their pictorial space with too much information, thus producing a visual chaos that often obscures the idea and motivation behind the pictures. The critical power of a photographer lies in the choice of what to leave out of a picture. Photographer Ray K. Metzker said, "The camera is nothing but a vacuum cleaner picking up everything within range. There has

to be a higher degree of selectivity." In the act of making good photographs, a discriminating eye is all. The camera makes no objections or judgments about what it records, leaving the photographer to create a reality through selection, a crucial act that makes all photographs simultaneously true and false.

Use subtractive composition by going directly for what you want to include in the picture and eliminating all that is not necessary, even if it means discarding elements that interest you. Concentrate on communicating one thing well while bearing in mind the idiom: "Keep your eye on the prize." Stay focused. Do not get distracted by other petty bits of information in the scene. Compositions suffer when you dilute your message with unneeded visual distractions. Eliminate visual clutter. Concentrate on communicating one thought by having a point of departure. Instead of trying to make a picture that embraces three ideas in a single frame, make three images, with each communicating a different concept. This subtractive method of putting the picture together can help you learn basic photographic vocabulary, which leads to producing images you desire. A skillful photographer is like a magician who knows how to make the unwanted objects on stage disappear, leaving only what is necessary to create striking images.

The need for selectivity applies to ideas as well as composition. Do not assume that something of importance to you will be attention-grabbing to anyone else. Some ideas are definitely better than others. As Ansel Adams said, "There is nothing worse than a sharp image of a fuzzy concept." Simplify, simplify, simplify. Imagine yourself as a sculptor of images who chips away at a monolithic block of reality until only what is absolutely necessary remains and then relies on each viewer to fill in the missing pieces to complete the meaning. When you compose, fill your frame by getting close to what is most important to you, leaving out unnecessary clutter. Compositions are weakened when important subject matter is too small for viewers to see. Think about what photojournalist Robert Capa said: "If your pictures aren't good enough, you aren't close enough."

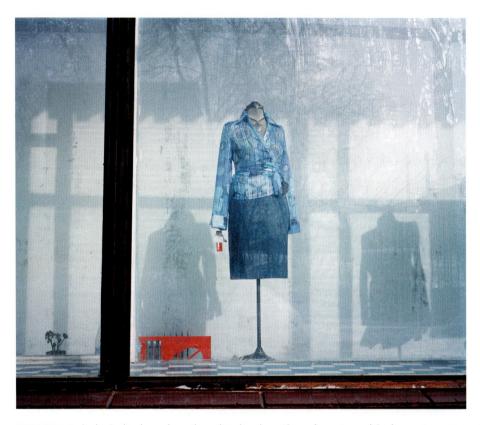

FIGURE 2.1 Sasha Rudensky explores the political and social transformations of the former Soviet Union by focusing on the intimate details of daily life, the interiors and exteriors that form the essence of a culture. Working "in the simplest method possible," Rudensky utilizes subtractive composition to eliminate extraneous components. "The personal, yet simultaneously restrained photographs transcend the specificity of locations where they were shot. Instead, they concentrate on the common experience of disintegration. A feeling of nostalgia and weariness permeates the images, which points to the reservation with which former Soviet citizens look towards their unclear future."

Credit: © Sasha Rudensky. *Mannequin, Moscow, Russia,* 2005. 30 x 36 inches. Chromogenic color print.

DEPARTURE POINT

Think about what you want to do before you do it. When you pick up a camera to do something deliberate and specific, the possibility of capturing the significant and the useful is greater than if you stand on the corner waiting for a photographable moment. Avoid being the photographer Irish playwright George Bernard Shaw described as a codfish who lays a million eggs in the hope that one might hatch. Prepare your mind in advance and start in a specific direction while remaining flexible and open to the unexpected. As the Indian spiritual teacher Sri Nisargadatta Maharaj pointed out, "Intelligence is the door to freedom and alert attention is the mother of intelligence."

ATTENTION SPAN AND STAYING POWER

Before the Internet, smartphones, giant flat-screen televisions, file sharing, and texting, educated people devoted time to reading books—often long and complicated works like Adam Smith's 900-page tome *The Wealth of Nations,* which revolutionized economic thought and theory when it was published in 1776. Today such contemplative reading is rare. In our media-saturated world, imagemakers compete in a no-time mentality of multitasking and channel surfing. This climate makes it critical that imagemakers not only grab viewers' attention but hold on to it as long as possible by producing work that continues to say something over

time. Photographic staying power has almost nothing to do with the technical means of producing a photograph, for the integrity is found in how we visually express our thoughts and feelings about a subject. When the expression of something of significance is communicated, an image can be said to possess meaning.

PHOTOGRAPHY'S PRIVILEGE

Photography is omnipresent in our society, so when you go out with a camera, people will often give you a unique privilege, some leeway, as they too have directly experienced the photographic process. Learn to use this shared understanding to your advantage, not as an excuse for irresponsible or unethical behavior, but to make the images you want to make without exploiting the subject. With the appropriate approach, dress, and manners, you can get people to act in your picture, to get out of your picture, to hold equipment, or to just leave you alone. Their response depends on the attitude that you project to others and your interpersonal skills in getting people to cooperate.

THE LANGUAGE OF VISION

Photographic imagemaking can transform any subject, making it part of our experience that can be fixed and studied later at our convenience. In ancient Greece, Socrates spoke of the eternally beautiful geometric forms. Over time these forms have codified into an

FIGURE 2.2 Curator Brian Wallace informs us: "Dan Solomon appropriates and blurs images from historical source materials to explore the nature of photography and memory. Bystanders extracted from the background of Abraham Zapruder's 8mm home movie of the assassination of President Kennedy on November 22, 1963, serve as silent and innocent witnesses to the violent events that unfolded before them that day." Solomon adds: "Removing everything from the frame but the spectators shifts the focus away from the action of the assassination to the act of observation. No longer constrained by the temporal scene, the viewer is freed from considering the historical event and made available to contemplate epistemological questions relating to the nature of knowledge and truth."

Credit: © Dan Solomon. *Witness #7*, 2013. 48 x 60 inches. Inkjet print. Courtesy Howard Greenberg Gallery, New York, NY.

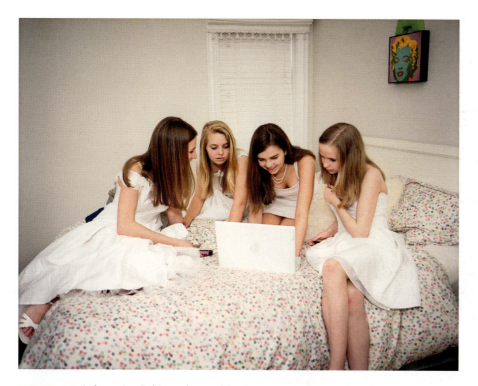

FIGURE 2.3 In her series *Girl Ascending*, Melissa Ann Pinney utilizes a 6 x 7-cm camera to chronicle the experience of girls aged 9 through 15 as a way to study the formation of self over time. Pinney focuses on a touchstone moment: their emergence from protected youth to public maturity. She states, "I am interested in the passage of time, the cycle of seasons, girls' friendships, and their ties to the elders who guide them. The images that most intrigue me are epiphanies, in which the ordinary reveals an underlying significance. Here the soft light, white dresses, white girls, and white room made the image appear flat—no hard edges. I worked to separate and clarify the whites by removing color casts in Photoshop."

Credit: © Melissa Ann Pinney. *Marilyn*, from the series *Girl Ascending*, 2009. 36 x 43½ inches. Inkjet print. Courtesy of the J. Paul Getty Museum, Los Angeles, CA.

analytical system that has tremendously influenced imagemaking. This language of vision utilizes light, color, contrast, line, shape, pattern, texture, similarity, and movement. Through these formal visual elements, one can make images that convey and enlarge our ideas of what is worth looking at, what we have the right to observe and make pictures of, and how we interpret pictures. Influential photographers know that an understanding of the visual process and its tools allows them to express ideas and stories that resonate in their time. Those with vision push out the boundaries of photographic language, invent new means for the rest of us to use, and create images that affect how we know the world.

Principles of design—such as balance, emphasis, scale, and variety—control the flow and representation of the overall structure of any composition, while visual elements—such as line, shape, color, and texture—organize and embody the detail and content within the structure. Together, these principles and elements provide the set of basic tools that need to be mastered to communicate photographically.

PHOTOGRAPHY'S NATIVE CHARACTERISTICS

Theoretically, a "line is a line" regardless of the medium, but a line painted on canvas is different from a photographically made line. Why? Any photographically represented visual element inherently has more real-

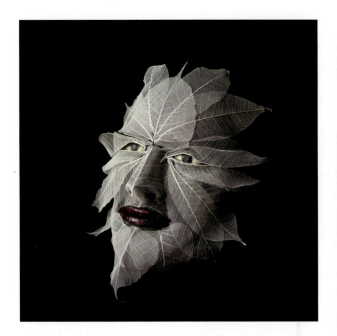

FIGURE 2.4 Paying homage to the bizarre paintings of sixteenth-century artist Giuseppe Arcimboldo, who recombined objects to create a new subject, Klaus Enrique explores the nature of portraiture by constructing human-like forms from flowers, leaves, and vegetables. His synergistic combinations, which are at once abstract and figurative, display the unexpected and/or the contradictory to represent life's unending puzzles and riddles.

Credit: © Klaus Enrique. *Head of a Woman #3*, 2017. Chromogenic color print.

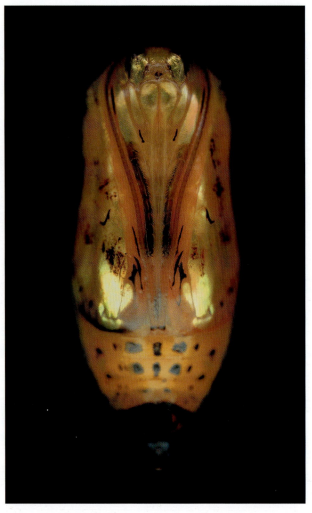

FIGURE 2.5 The images in Adam Fuss's series of butterfly chrysalides depict actual metamorphoses. These detailed body casings, presented vertically on velvety black backgrounds, are magnified hundreds of times and appear more extraterrestrial than butterfly-like. Their delicacy and fragility are distinctly captured in the solemn and darkly luminous, human-sized blowups that call to mind a sarcophagus while showing us a moment just before a new kind of life begins. Fuss's unspoken subject has been called the evolution of the human soul, a watcher who experiences our singular lives, from whom meaning emanates, and from whom we perceive our true self.

Credit: © Adam Fuss. *Untitled*, 2003. 72 x 44 inches. Inkjet print. Courtesy of Cheim & Read, New York, NY.

world content because of its foothold in concrete reality. Imagine the world before photography. In her book *Photography and Society* (1974), photographer Giselle Freund observed, "Before the first press pictures, the ordinary man would visualize only those events that took place near him, on his street or in his village. Photography opened a window. As the reader's outlook expanded, the world began to shrink." Even if a subject is unfamiliar, the visual language of photography and its connection to reality are immediately recognizable. Therefore, a line created by a street curb in a photograph creates a much different meaning from a line painted on canvas because of all its real-world associations. One is not better or worse than the other, but they are different. To succeed photographically, imagemakers must come to terms with and understand this intrinsic difference. One should keep inquiring into photog-

raphy's native characteristics and how its direct, realistic connection between the subject being pictured and the resulting image can be applied to achieve a desired outcome. Try dipping into the history of photography

to compare and contrast how important imagemakers such as modernist photographer Paul Strand and constructivist artist Aleksandr Rodchenko had highly divergent ideas about how to organize their visual space.

DESIGN PRINCIPLES

UNITY AND VARIETY

Unity and variety are compositional twins. Unity, also known as harmony, is a state achieved by forming a complete, consistent, and pleasing whole that is planned and controlled by an imagemaker. Variety refers to a diversity of elements within a similar class of subjects contained in an image. For example, if your composition is based on circular elements, you could introduce variation through the use of different colors and/or sizes of circles or by including half- and quarter-circles. A composition devoid of a unifying principle will generate a chaotic or haphazard response to what has been photographically represented, similar in effect to a group of people all talking at once. However, a completely unified composition without variety is often monotonous and pictorially uninteresting. Unity controls variety, yet variety provides a diverse pull within that unity to keep things visually intriguing. Effective compositions usually have an equilibrium between these two qualities—a variety of elements held together by a unifying device.

The repetition of pattern, shape, or size and the harmony of color and texture are visual ways of creating unity. The more complex a composition, the greater the need for a unifying device. A more subtle method of realizing unity is through continuation, such as when a line or the edge of an object leads a viewer's attention from one area of a composition to another. Consider a

FIGURE 2.6 "The photographs in *NextNature* are inextricably linked to the plants and forests from which they came. I present these materials life-size, emphasizing the primary physical reality in a format that references the magnitude of the forest floor. The works are composed on a large lightbox and then photographed straight down using a high-resolution scanning back in the place of film, enabling me to show an astonishing visual clarity at large scale. This allows me to make images that are less metaphorical in their representation and more direct, which in turn supports a sense of 'matter-of-fact-ness' in the work."

Credit: © Stephen Galloway. *Scatter*, from the series *NextNature*, 2004. 40 x 76¼ inches. Chromogenic color print.

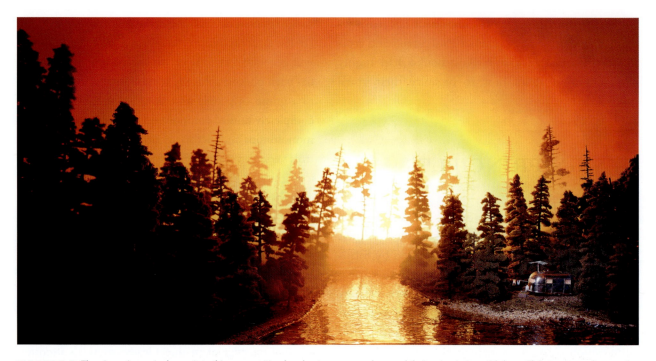

FIGURE 2.7 The viewer's eye is drawn into this composition by glowing warm colors and their association with beautiful sunsets, only to discover that what is being depicted is the awesome destructive power of a fire. Lori Nix observes, "I play on the nostalgia of the romantic landscape tradition, suggesting that the natural environment is rife with hidden dangers. At first glimpse, the mundane image appears little more than the quotidian photograph. Upon further examination, something seems amiss. These are not real landscapes but miniature re-creations of real-life situations. Here a sweet little trailer is in the path of an oncoming wildfire, its inhabitants too preoccupied watching their TV to notice."

Credit: © Lori Nix. *California Fire*, 2002. 40 x 70 inches. Chromogenic color print. Courtesy of Miller Block Gallery, Boston, MA.

checkerboard pattern or grid that is completely unified and therefore static. When you vary the color, size, or texture of the pattern, it immediately becomes dynamic. In photography, contrast is a major method of controlling variety—light against dark, large against small, smooth against rough, hard against soft. Dramatic lighting, known as *chiaroscuro*, which was developed during the Renaissance, emphasizes these contrasting gradations of light and dark values in two-dimensional imagery, whereas soft lighting minimizes these differences. Photographers can use these strong lighting contrasts to generate the illusion of three-dimensionality in their work.

EMPHASIS

Most photographs need a focal point or points to provide a visual entryway that will attract the eye and act as a visual climax. These elements stress a key point or points within the composition. In an image without emphasis, your eye tends to wander and is never satiated. Focal point devices to keep in mind are color, contrast, depth of field, isolation, light, placement, perspective, and size; one is often played against another. For example, a limited depth of field may be used to isolate the primary subject. Secondary points of interest, known as accents, can direct the eye to parts of a composition that have less visual value than the primary focal point, but are still important for understanding the work. Sometimes an imagemaker will purposely create an ambiguous composition without a single focal point by deploying a multiplicity of points, which draws attention to the entire surface of the work instead of its individual elements. This can generate a visual circulation that keeps the viewer inside the composition by not providing a convenient exit.

SCALE AND PROPORTION

Scale and proportion, both of which refer to size, are interrelated. Scale indicates relative size or extent in comparison to a constant standard of the size something "ought to be." When objects are pictured as relatively larger or smaller than what is considered normal, a viewer is made to see the form in a new way. Such juxtapositions encourage audiences to take

a fresh look at the subject. A classic example is the *diminutive* effect, which is visible when a human figure is arranged in conjunction with a massive natural or human-made site such as the Grand Canyon or a Gothic cathedral. Dadaists, who made anti-art rejecting prevailing values, and Surrealists, who relied on their subconscious, dreams, and being spontaneous to inform their work, often employed scale as a way to make

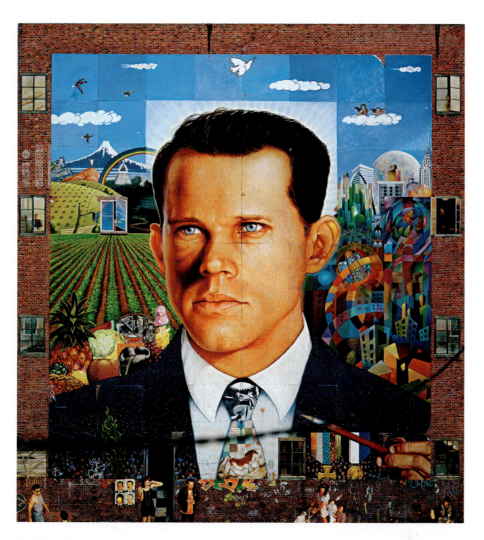

FIGURE 2.8 By building scale models and casting himself as all the characters, Bill Adams fabricated an elaborate parody of a grandiose political poster, featuring a clash of political and artistic themes and styles. "Rather than cover up or reject the influence of digital imaging, I suggest digital manipulation that was not done. Instead of a fake photograph of a real scene, it's a real photograph of a fake scene [made with an 8 x 10-inch view camera], in which authenticity, illusion, and apparent digital manipulation create a maze of puzzles and paradoxes. There are often clues to the illusions, such as reflections of the backs of cardboard characters and extra figures lying around the set. But there being dubious documents of illusions is fully in keeping with the other contradictions and deceptions in the piece."

Credit: © Bill Adams. *Billboard 2006*, 2006. 29 x 32 inches. Chromogenic color print.

the familiar strange and the strange familiar. An easy way to begin experimenting with scale is by varying the focal length of your lens.

Proportion involves the relationship in size or shape between one thing and another or between the parts of a whole within a composition. Proportion is linked to ratio; the proportions of a subject are considered correct or normal if the ratio of one component to another is acceptable. Shapes are proportional based on their ratio to the area they occupy within the composition. For example, when you are making a portrait, if the circle formed by the head is 3 inches in diameter on a 6-inch background, it will appear more disproportional than if placed on a 12-inch background. Correct proportion is generally based on what society considers normal, real, or ideal and can change over time.

THE GOLDEN MEAN: THE RULE OF THIRDS

The ancient Greeks developed a set of ideal proportions called the *Golden Mean*, which they converted into ratios that could be applied to draw the "perfect" body or build the superlative architectural structure. The Golden Mean, a.k.a. the Rule of Thirds, is the proportion arising from the division of a straight line into two parts so that the ratio of the whole line to the larger part is exactly the same as the ratio of the larger part to the smaller part. Mathematically, it is a ratio of 1 to $1/2(\sqrt{5} + 1)$, a proportion that is considered to be particularly pleasing to the eye and can be found in natural growth patterns in nature. Its modular repetition has facilitated its use throughout the history of design. While the Golden Mean can be a good starting point, because something is disproportional to a subjective ideal does not automatically make it flawed. On the contrary, uniqueness is often attention-getting. Therefore, deliberately altering a composition's proportions can be a good method for creating impact. Changing the position of the camera and altering the distance of the subject from the lens are the easiest ways to manipulate proportion. Digital imaging software allows for extensive post-camera modifications to be made in the areas of proportion and scale. All these factors control how the meaning is constructed. Garry Winogrand observed, "Photography is about finding out what can happen in the frame. When you put four edges around some facts, you change those facts." (See Exercise 2.1.)

EXERCISE 2.1 THE GOLDEN MEAN: A BASIC APPROACH TO GOOD COMPOSITION

To heighten awareness of the image frame and its edges, you are going to take on a challenge developed by Graham Revell of Cavendish College, London, and Betsy Schneider of Arizona State University. Set aside your usual subject matter and concentrate on detritus. Originally a Latin word that means "worn away," *detritus* is any matter produced by erosion, such as gravel, sand, silt, or rubble. It also refers to debris or waste of any kind, including rubbish, litter, trash, or garbage; flotsam and jetsam; remains, remnants, fragments, or scraps; dregs, leavings, or sweepings; and dross or scum, as well as organic matter produced by the decomposition of organisms. For this exercise, you are to interpret, either literally or metaphorically, the word detritus and make photographs following the steps below.

1. Build an image using the principle of the Golden Mean, a rectangle whose dimensions are 1 unit x 1.62 units. If your camera permits, set its framing aspect ratio to 1 x 1.5. The aspect ratio is the relationship of the frame's width to its height. The traditional 35mm aspect ratio is about 2 units high x 3 units wide.

2. Use the grid pattern in your camera's viewfinder to divide your frame into thirds, which will aid in locating the "sweet spots" in which to place your center of interest. Do not divide the frame into four equal quarters, as this tends to produce static compositions. Steer clear of placing your principal point of interest in the center of the frame.

3. Intentionally lead your viewer's eye through the frame by supplying a visual path that steers to your center of interest. Use a shape such as a diamond, oval, or pyramid to make your path. Link the path to the top, bottom, and sides of your composition, and provide an entrance to and an exit from the picture space. Traditionally, the entrance is at the bottom of the picture. The exit is usually in a less visually important area. A door, window, or patch of sky can give a viewer's eye a place to stop and rest, providing a subtle exit. If your path begins to lead out of the frame, adjust it, using other design elements to bring the viewer's eye back to your path.

4. Simplify. Eliminate details that complicate your composition. Delete anything that does not express your message clearly and concisely. Keep combining, deleting, and modifying until you are satisfied with the visual balance and flow.

5. Pay attention to the figure/ground relationships, the correlation between the subject and the background, by bringing the positive and negative space into balance (see Chapter 6).

Keep in mind that Western societies read from left to right, which tends to make the left side of the frame more prominent than the right. We also read from top to bottom, making the top of the frame more noticeable than the bottom. The corners of a rectangle act as visual anchors, which is why book page numbers are traditionally found in the lower left and right corners. The center of the frame does not necessarily have the importance that many take for granted, especially in a printed format where the center may cross the gutter.

6. Do the opposite. Now that you have tried this exercise, reverse all the instructions and compare and contrast the results. Apply your findings to your next picture-making opportunity.

Educator Joseph Labate of the University of Arizona takes this exercise a step further by having his students intentionally make "bad" and "good" photographs that are technically the same, and then has the class analyze the differences.

BALANCE

Balance is the visual weight or equilibrium of the objects within a composition. Balance is instinctive and determined by imagining a center axis running through the picture plane with the expectation that there will be some equal distribution of visual weight on either side. Think of the axis as a fulcrum on a seesaw, where it is necessary to maintain equilibrium or crash into the ground. Perfectly balanced pictures tend to be monotonous, so it generally is desirable to have a certain degree of imbalance to generate visual tension and movement within a composition. Keep your horizon line straight unless you wish to put the viewer off kilter. Some key categories of balance to consider:

- *Symmetrical balance:* If you were to draw a line through the center of this type of composition, both sides would be an equal mirror image. Symmetrical balance tends to be calm, stable, and dignified (see Figures 2.10 and 2.11).

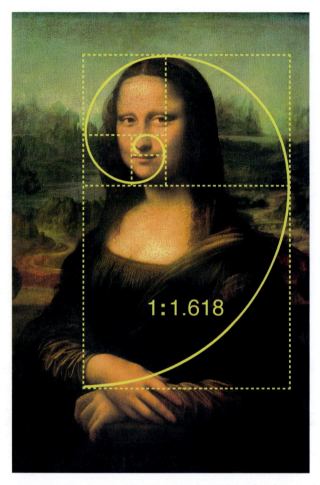

1:1.618

FIGURE 2.9 The ancient Greeks observed that the Golden Mean (a.k.a. Golden Ratio), sometimes known as Phi, offered an aesthetically balanced and harmonious proportion of sides of a rectangle. This was applied by Renaissance artists such as Leonardo da Vinci in the classic publication *Divine Proportion* (1509). It can be seen in diverse situations such as the structure of the inner ear, the spiral of a hurricane, the construction of the Parthenon, and the beauty of the *Mona Lisa* (circa 1503–1506). Some software programs offer visual overlays based on the Golden Mean that can be utilized as compositional guides.

- *Asymmetrical balance:* A composition that has equal visual weights, but whose forms are disposed unevenly. For instance, a smaller shape positioned near the composition's outer edge may balance a large shape near the center of a composition. Asymmetrical balance is active, dynamic, and exciting (see Figures 2.12 and 2.13).

- *Radial balance:* This occurs when a number of elements point outward from a central hub, like the spokes of a bicycle wheel. It is readily seen in nature, such as in snowflakes and the outward growth pattern of flowers. Radial balance can be explosive, imply directional movement, and indicate infinity. It often can be revealed photographically through the use of close-ups.

- *Balance through color and value:* The visual weight of color can become the focal point in a picture. Warm colors (red, magenta, yellow) tend to advance and/or have more visual weight than cool colors (blue, green, cyan). Warm colors are complementary, the opposite of cool colors. When juxtaposed, complementary colors make each seem brighter and more vivid. The majority of a verdant landscape is composed of cool colors; warm colors appear mainly as accents (birds and flowers). In such landscapes, a small amount of red can be equal to a large area of blue or green. Much of the landscape in the American West is an exception; there are few trees and the predominant colors are the warm earth tones. During fair-weather daylight hours, the amount of a cool color can be regulated by varying the proportion of sky included in the frame. The time of day and weather conditions also affect the amount of cool and warm colors, as the color of the light changes.

- *Balance through contrasts in value:* The contrast between dark and light also provides a resting point for the eye. A small, dark subject can have visual weight equal to a larger, light one. Since a black subject against a white background generates a stronger contrast than gray against white, a smaller amount of black can provide a visual balance equal to a larger amount of gray.

- *Balance with texture:* Any visual texture possessing a varied dark and light pattern has more visual attraction and weight than a smooth, untextured one; thus, a small, textured area can balance a large area of smooth surfaces.

- *Alternating rhythm:* This sense of rhythm consists of successive patterns in which the same elements

FIGURE 2.10 Symmetrical balance—Yin Yang.

FIGURE 2.11 Symmetrical balance—Ball.

FIGURE 2.12 Asymmetrical balance—Fulcrum.

FIGURE 2.13 Asymmetrical balance—Mountain and plant.

reappear in a regular order. A common example of this alternating theme can be seen in the columns of a classic Greek temple. Photographically, alternating light against dark areas or using complementary colors, such as red and green, is a way to create this effect.

- *Progressive rhythm:* This is produced through the repetition of a shape that changes in a regular manner, generating a sequential pattern. It is frequently accomplished with a progressive variation of the shape's size, through its color, value, and/or texture. (See Exercise 2.2.)

EXERCISE 2.2 BALANCE

Familiarize yourself with these categories of balance and then conduct personal tests by making different horizontal and vertical compositions of a static scene and reviewing them on your camera monitor to see which one delivers the results you are after. Next, make two engaging photographs that go beyond illustrations, which demonstrate your understanding of symmetrical and asymmetrical balance.

FIGURE 2.14 Adam Magyar's *Squares* are a series of nonexistent urban places created by sequencing hundreds of photographs of people inhabiting the same section of sidewalk. He creates three-dimensional models and scripts to aid in achieving the correct perspective, positioning, and lighting during image capture. In these composites, images taken at different times are combined into a single timeline that depicts the movement of the urban landscape without adding any particular action to them. "It is the swirl of people creating the flow of energy in the *Squares*, rather than the interaction between them."

Credit: © Adam Magyar. *Squares #517*, from the series *Squares*, 2007. 47½ x 68¾ inches. Inkjet print.

FIGURE 2.15 By day, Morry Moskovitz works as a gastroenterologist, but at night he captures scenes of what he calls "art graveyards." Moskovitz uses a supplemental flash to amplify the vivid and colorful landscape of graffiti found in these train yards. He further re-envisions these settings by digitally adding the foreground figure, which he separately photographs, to create a more dynamic and surreal interplay involving depth perception.

Credit: © Morry Moskovitz. *Sean*, 2010. 24 x 36 inches. Inkjet print.

VISUAL ELEMENTS

Once you comprehend the basic principles of design and overall structure, you are ready to make use of the visual elements within this construct.

LINE

The line is a two-dimensional human abstraction invented for the simplification of visual statements to symbolize ideas. Lines, per se, do not exist in nature, which is three-dimensional and thus composed of mass. In nature, line is portrayed photographically through the use of contour, which implies a line that separates one area of space from another. The best-known example would be the earth's horizon, as in Hiroshi Sugimoto's seascapes. A line, whether real or implied, carves out areas of space on either side of it. Any open line, except one that is straight, describes a shape; a closed line creates a shape.

The direction of a person's gaze or gesture can suggest a line. Positioning a sequence of visual points for the eye to automatically or subconsciously connect also can imply a line. Psychic lines occur when we forge a mental connection between two points; when an object looks or points in a particular direction, our eyes usually will follow and draw an invisible line. Digital software allows imagemakers to alter the character of lines—rough and smooth, thick and thin—to reinforce emotional and/or expressive qualities in the final composition.

Lines can be majestic, flowing, or undulating. They can convey abstract or symbolic concepts and can show contour, emphasis, form, pattern, texture, and directional movement. The direction of lines also can reinforce the mood of a picture. Horizontal lines can express calmness, dignity, and magnificence, implying repose and stability. Vertical lines indicate an up-and-down flow that suggests a smooth and continuous motion. Diagonal lines, being neither horizontal nor vertical, are placed at angles within a composition. They

FIGURE 2.16 "Placement of the image frame is the most important factor in the creation of an image; every image involves elimination [subtractive composition] to one degree or another. Most of my images are hyperconscious of the border. The border defines the images; I use it to control the visual flow in an image. I'm drawn to images that suggest the spaces that exist beyond them. In this image, the mountains at the horizon were digitally eliminated by replacing them with sky, which allows the recession of space to continue indefinitely. Cracks in the earth were digitally eliminated to form the path that delivers a sense that what is left unseen is greater than what is seen."

Credit: © John Paul Caponigro. *Path, I*, 1999. Variable dimensions. Inkjet print.

are dynamic and indicate action, energy, and movement. Commonly, such lines are created by objects or shapes that fit into a pattern. Learn to look for these patterns and incorporate them into your composition. Leading or convergent lines move the viewer's eye toward the key component of a composition and are effective in generating a visual sense of distance, drama, or tension.

FIGURE 2.17 Inspired by the works of Frederick Sommer and Henry Holmes Smith, Fredrik Marsh created a series of cliché-verre prints. This process, pioneered in 1839, produces a cameraless photographic image, at once a painting and a photograph. Using frosted Mylar as his support material, Marsh creates images with mediums that include evaporated charcoal, salt, sugar, and ink. Picture elements, surfaces, and textures work formally as a coherent visual statement. The resulting image, captured on a scanner and manipulated in Photoshop, is mysteriously evocative—a completely different type of abstract than a conventional photograph. For Marsh, this is the appeal of this process, "to create a truly unique thing, the excitement of not knowing the final outcome."

Credit: © Fredrik Marsh. *Homage to Frederick Sommer*, 2000/2007. 24 x 20 inches. Mixed media.

SHAPE

A closed line creates a shape, which is an area having a specific character defined by an outline, contrast, color, value, or texture that is different from the surrounding area. Shape usually refers to flat, two-dimensional elements, whereas mass or volume indicates three-dimensional objects. Frequently the chief structural element of a composition, a shape often can enable a viewer to immediately recognize a face, a structure, or an object in a picture.

The shapes of such objects as rocks and seashells can in themselves be intriguing. A combination of different shapes can provide pictorial variety. For example, an outdoor scene can be made more attention-grabbing by contrasting the sharp, jagged shape of a fence with the soft, smooth curves of clouds and hills. Shape can be used to create a frame around a subject. For instance, when a photographer composes a picture of a person in a doorway, the doorway serves as a natural frame that directs the viewer's eye to the person. Interplay between shapes can form repetitive patterns that help unify a composition. The shapes of shadows or silhouettes can create fascinating effects. Shapes also play a role in producing visual texture, as they help create the illusion of physical, three-dimensional surface qualities.

There are four basic types of shapes:

1. Geometric shapes include the circle, rectangle, square, and triangle.
2. Natural shapes imitate things in the natural world.
3. Abstract shapes have been altered to reduce them to their fundamental essence. Natural sources for abstract shapes are often recognizable, even when they have been simplified and transformed by omitting nonessential elements. Artificial sources can be intriguing and mysterious, as viewers must think to discover meaning where there is no obvious narrative.
4. Nonobjective shapes do not correspond to anything in the natural world. Usually, we cannot put specific names on these pure forms. These original shapes primarily delight the eyes and the emotions, but not the intellect, for they do not convey traditional storytelling narratives. They represent the intuitive and the subjective, not the empirical and the rational, parts of our being and often appeal to our innate urge to construct connections with other objects and experiences.

FIGURE 2.18 Roland Miller's series *Abandoned in Place* blends documentary, abstraction, and hybrid imagery to capture the physical remains of a vanishing era of space exploration and the Cold War. To make this image, Miller "laid on my back looking up, utilizing two legs of my tripod and my face as the three brace points. I pointed the camera straight up at a lightly overcast and raining sky. I made three exposures to ensure that my awkward position would not induce any blur in the image. When I made the proof sheet, I recognized the visual impact that a diptych of two frames would have. The temporal nature of life is evident in views of these decaying sites that once captured the attention of the entire world."

Credit: © Roland Miller. *Apollo Saturn V F1 Engine Cluster* (Diptych), 1996. 14 x 35 inches. Inkjet print.

SPACE

The area between and surrounding the objects in an image, known as negative space, can be used to draw attention to the main subject, to isolate details, and to establish meaning. However, large amounts of space may detract from a picture's compositional focus. As a starting guideline, limit the amount of blank space to no more than a third of the photograph. As you gain experience, experiment with this ratio, even to the point where the blank space is the most predominant element of the composition. The appropriate placement of a subject within a picture space can help to convey scale. For instance, placing a small subject next to a large subject can help a viewer gauge their relative sizes.

There are four kinds of photographic space:

1. Actual space is the two-dimensional area enclosed by the borders of the camera's viewfinder and the surface on which the image later appears. Three-dimensional spaces are inside and around or within an object.

2. Pictorial space is the illusionary sense of depth that we see in two-dimensional work such as photography. It can vary from appearing perfectly flat to receding into infinity. You can create more depth by lowering the viewpoint, which will make the lines appear more extreme.

3. Virtual space exists within the confines of a computer screen. It may or may not exist in any concrete form. It may be compressed, stretched, and/or manipulated differently from how the camera initially recorded the scene(s).

4. Positive and negative space refers to how the contrast of the color and brightness of subjects can be used to organize and define compositional space. Positive and negative space is also known as *figure-ground*, the relationship between the subject and the background (see Chapter 6). You may want to ask yourself, how much space is around my subject? Where is my subject within the compositional frame, and as you look through the viewfinder, which is more important, the subject or the background? (See Exercise 2.3.)

TEXTURE

Two-dimensional texture generates the visual appearance, consistency, or feel of a surface or a substance. In photographic practice, texture and pattern are intertwined. Texture refers to the tactile quality of the surface in the image, whereas pattern gives only a visual sense of texture, letting us sense the differences in the surface with our eyes, even though it does not exist to the physical touch. As a rule, smooth textures tend to produce cool sensations, and rough textures make for warm sensations. For our purposes, we need to be conversant with both tactile texture and visual texture.

Tactile texture refers to surface qualities that are physical and can actually be felt. Such textures possess three-dimensional characteristics and can be rough, smooth, hard, soft, wet, or dry. Examples of this can be found in the making of collages (see Chapter 7).

Visual texture, which is strictly two dimensional, is produced by variations in light and dark. Our eyes and brain generate this illusion, the suggestion of a tactile quality. The phenomenon is produced by spatial variations of stimuli, such as the relationship of color placement and tonal value within the composition. Additionally, depth of field can play a role in determining the sense of an image's visual texture (see Chapter 3).

The subtle use of background texture can produce a visual play between the subject and its surroundings, thus keeping the viewer's eye moving around within the composition. A careful application of background texture also can be useful in creating a visual separation between the subject and its environment, thus allowing the subject to stand out from its setting.

PATTERN

Pattern is the unifying quality of an object. The interplay between shape, color, and space, it forms a recognizable, repetitive, and/or identifiable unit. Pattern can unify the composition, establish a balance among diverse elements, or create a sense of rhythm and/or movement. Patterns appear to be visually weightier than solid, lighter colors.

The chief difference between texture and pattern is one of degree. The key is whether a surface most awakens our sense of touch or design. While almost every texture makes a pattern, many patterns produce only a visual texture. Tactile texture, however, does not always contain a distinct pattern. A single weathered board has texture, but only an entire row of weathered boards is likely to create a pattern. Pattern is found in the repetition of design. In a pattern, no single feature dominates. Its distinctive look is made possible by the repetitive quality and generally serves well as a background.

Surprises regularly occur when working with pattern. When compositional components are placed in

EXERCISE 2.3 4 x 4

Imagemaker and educator Debra Davis has her University of Toledo classes learn about spatial concepts by confining their physical and visual space. The idea is to create a visual narrative, in a sequence of at least six images, while remaining in a 4 x 4-foot space. This space can be literally or mentally defined. Your visual space may move from the floor, up the wall, and onto the ceiling or enter a cave or niche in the mountains.

There is a great deal of information to be found in 4 feet of space. The image sequencing makes one aware of how your photographs relate to one another and to the group of images as a whole. Look closely and engage with your chosen subject. Try a variety of angles, viewpoints, and physical positions: lie on the ground, stand on something, choose a variety of focal lengths, or get in close—explore! (See Chapter 10.)

FIGURE 2.19 Attracted by the distinctive topography and light of Death Valley, Stephen Strom's pointillist and textural compositions not only reveal the patterns and effects of geological forces over millennia, but also take in the vast, colorful sweep of land and sky as well as the land's myriad details— volcanic cinder cones and sand dunes, dry lakes and salt pans, colorful badlands and canyons, and pine-studded mountains. Strom informs us: "I have spent my professional life as an astronomer, searching out patterns encoded in the light from distant stars in the hope of understanding how our sun and solar system came to be. For over 1500 nights, I found myself perched on remote mountaintops using powerful telescopes and measuring instruments to record and deconstruct light from forming stars. Following a night of intense concentration, dawn brought precious moments of quiet and solitude that found me fully open to contemplating the desert below." The results can be seen in his book *Death Valley: Painted Light* (2016).

Credit: © Stephen Strom. *Hillsides, looking east from Ubehebe Crater, Death Valley National Park*, 2014. 5 x 16 inches. Inkjet print. Courtesy Center for Creative Photography, Tucson, AZ.

repetition with other elements over a large area, their new forms may showcase the unexpected. These unanticipated results often are caused by the interplay of negative/background space (the space around the design or weaving through it), which can create shapes that are intriguing in and of themselves. Within the pattern, these new shapes may be so apparent that they begin to dominate the space or spaces and become the prevailing visual factor. (See Exercise 2.4.)

SYMBOLISM

A symbol is anything that stands for something else. Usually a symbol is a simplified image that, because of certain associations in a viewer's mind, represents something that is not readily seen: a more complex idea, event, emotion, state of mind, relationship, or system. Lines that form letters, words, or musical notes are symbols. Since a photograph of a person is not that person, but a representation of the person, it also is a symbol. Symbolism holds a vast power for imagemakers

FIGURE 2.20 What began as an art installation turned into a serious biodiversity project. Compelled by the moths he was collecting and the sheer number of different species, Joseph Scheer decided to document each species where he lives. This has expanded to specimens from the whole world in an effort to link art and environmental activism, facilitate new visual access to nature, and reveal the surprising beauty of moths with all their preposterous hair and scales. Scheer's high-resolution scans also offer new ways of reading the natural world by incorporating an effect of hyperreal vision that allows us to see structures of pattern and texture that the naked eye cannot discern.

Credit: © Joseph Scheer. *Grammia virgo*, 2002. 34 x 46 inches. Inkjet print. Courtesy the collection of William and Rachel Tippet.

FIGURES 2.21–2.22 Kim Abeles's work mixes sculpture, illustration, and photography to address a variety of sociocultural issues. This installation piece, a wallpaper-effect created with embedded video and movie stills in combination with hand-drawn and digital photo prints of Niagara Falls, was exhibited at *Touched: Artists and Social Engagement* in Pasadena. The unexpected movement and sound introduced by the video elements create a visceral sense of depth in an intentionally two-dimensional landscape. Its combination of high- and low-tech processes re-creates an experience of this sublime landscape as both an iconic tourist destination and natural wonder, addressing notions of collective memory.

Credit: © Kim Abeles. *Thunder of Waters*, 2007. 10 x 20 feet. Inkjet prints, video, and mixed media. Installation view at the Armory Center for the Arts, Pasadena, CA.

Credit: © Kim Abeles. *Thunder of Waters*, detail, 2007. Inkjet prints, video, and mixed media.

because it allows the communication of enormously complicated, often abstract ideas with just a few lines or shapes. Symbols provide us a streamlined means for sorting information and drawing inferences that can help us to communicate more effectively. Photography is a sign language, and symbols are its shorthand. Learn to recognize and use the signs to communicate your ideas.

The following categories of symbols are offered to get you thinking about what they can represent. Symbols are not absolute terms. They are fluid and have multiple readings based on such factors as cultural background; economic status; geographic location; gender; psychological state; and political, religious, and sexual preference. Symbols are highly complex, and each image requires its own reading. The process of reading and decoding images is diverse and variable. Based on personal experiences, different people will give a variety of readings; moreover, your own interpretation may expand or change over time. The following symbols and some of their possible meanings are provided only as a portal of departure.

GENERAL SYMBOL CATEGORIES

The following are some common American and European general symbols:

- Commercial symbols visually dispense information and/or advertise a service or product to be sold. Examples include the spiraling red, white, and blue pole signifying a barbershop; three balls symbolizing the pawnbroker; international road signs; and logos for corporations, such as Apple, Coca-Cola, McDonald's, Nike, and Shell Oil, which have also become cultural icons.

- Cosmic symbols include yin (feminine, dark, cold, mystery, wetness) and yang (masculine, light, heat, dryness) and the zodiac (forces that some believe govern the universe). Historically, the four "humors" within the body—blood = sanguine, meaning amorous, happy, or generous; phlegm = phlegmatic, meaning calm, dull, or pale; choler (yellow bile) = choleric, meaning energetic or aggressive; and melancholy (black bile) = melancholic, meaning pensive, sad, or depressive—were once widely used as a symbolic shorthand to describe a person's temperament. These ruling passions were thought to give off vapors that ascended to the brain, where they influenced an individual's physical, mental, and moral characteristics. The perfect temperament was thought to be one in which none of the four humors dominated.

- Cultural symbols are shorthand representations of mythological, religious, or cultural concepts that have changed over time and geographic location and are used by various groups of people to

EXERCISE 2.4 **THE KITCHEN AND VISUAL DESIGN**

At the beginning of the twentieth century, the Clarence H. White School of Photography fostered the careers of many photographers. One of the school's assignments was to create a still life made from objects found in a kitchen. John Valentino of Southeastern Louisiana University updated this project: "Use photographic means to create a series of still-life images from items found in a common kitchen that underscore your understanding of at least three design fundamentals, such as line, shape, and texture. Do your best to communicate your choices and design sense to the viewer. Do not forget the interior of the refrigerator and the kitchen drawers."

symbolize, or "stand for," something significant in their culture. For instance, St. Nicholas, who can be traced back to third-century Turkey, has had numerous incarnations from a tall, serious European to the current fat and jolly Santa Claus, which has become highly commercialized and nonsectarian.

- Magical symbols can be traced back to cave paintings of animals that may have been used to help ensure a successful hunt. Tribal masks were employed for getting the desired results in battle, love, and the search for food. Masks let the wearers both disguise themselves and represent things of importance, allowing people the freedom to act out situations according to the desires of their inner fantasies. The Christmas tree can be traced back to the ancient use of evergreen trees that were thought to keep away witches, ghosts, evil spirits, and illness and to guarantee the return of the sun. Also a Roman agricultural and fertility symbol, it has been transformed into a glowing emblem of capitalist plenty.

- Patriotic and political symbols in the United States include the bald eagle (made the national bird in 1782, it symbolizes strength, courage, freedom, and immortality); the American flag (red, white, and blue "stars and stripes"); the Statue of Liberty (a gift of international friendship from the people of France to the United States that opened in 1886, it is one of the most universal symbols of political freedom and democracy); Uncle Sam (a personification of the United States with a white goatee and star-spangled suit, he is an invention of nineteenth-century artists and political cartoonists); and the donkey and elephant (for Democratic and Republican political parties, respectively). At a glance, such symbols provide a wealth of information and express certain political and social points of view.

- Personal symbols are created by artists to meet their individual requirements. Some photographers whose works contain personal symbols include Man Ray, László Moholy-Nagy, Maggie Taylor, and Jerry Uelsmann.

- Psychological symbols offer a system for investigating the conscious and unconscious processes of the human mind. Sigmund Freud's *The Interpretation of Dreams* and Carl Jung's *Man and His Symbols* are two watershed works dealing with these ideas. Filmmakers, such as Ingmar Bergman, Joel and Ethan Coen (a.k.a. Coen Brothers), Francis Ford Coppola, Stanley Kubrick, Martin Scorsese, and Quentin Tarantino, have emphasized the psychological side of human nature in their works.

- Religious symbols, such as the Buddha, the Cross, and the Star of David, stand for such ideals as faith, generosity, forgiveness, hope, love, virtue, and the quest for enlightenment.

- Status symbols indicate the status or station in life of the owner or bearer: cars, clothes, electronic devices, military insignia, and wedding rings are a few examples. Lately, product placement, which embeds brand name products and their identifiable logos within television and film scenes, has become a prevalent means of "branding" status symbols in popular culture.

- Traditional symbols have been woven into our visual arts for thousands of years. While a symbol may remain the same, each group that uses it alters the context and meaning. The swastika is a good example of how this works. Used as an ornament by the American Indians since prehistoric times, it also appeared as a symbol throughout the ancient world, in China, Crete, Egypt, India, and Persia. In the twentieth century, the swastika's meaning was hijacked and perverted, from one of well-being to that of death, when Germany's National Socialist Workers' Party (the Nazis) adopted it as the official emblem of the Third Reich.

FIGURE 2.24 This image was created in response to Joyce Roetter's bout with Lyme's disease, which affected her brain. Here, the artist combined a scan of her brain with reflective particles of paint to try to understand the process. "I felt as if I was symbolically energizing my brain—creating an aesthetic healing process."

Credit: © Joyce Roetter. *Self-Portrait, SPECT Scan, #10*, 2005. 16 x 20 inches. Mixed media. Courtesy of the Santa Fe Community College Foundation Collection, New Mexico.

FIGURE 2.23 "Inspired by the proliferation of very tall signs in the American Mid-West, *Floating Logos* draws attention to this often overlooked form of advertising. Elimination of the support structure in the photographs allows the signs to float above the earth. In some cases the ground is left out of the image to emphasize the disconnect between the corporate symbols and terra firma. Making the signs appear to float not only draws attention to this type of signage but also gives them, and the companies that put them there, an otherworldly quality."

Credit: © Matt Siber. *Burger King*, from the series *Floating Logos*, 2004. 40 x 32 inches. Inkjet print.

FIGURE 2.25 Challenged by an assignment given by her professor—Bill Davis at Western Michigan University—to use color in a grid design to structure a social or political message that also could emphasize the relationships between color as form and pattern, Kristi Breisach undertook an exploration of objects and ideas that are symbolic of American culture. Taking photographs in a makeshift garage studio using a variety of lights and backdrops, she "produced variances in background and object color, causing the overall flag image to look worn and aged, thus emphasizing my observation that many of the icons have stood the test of time and are likely to remain 'American' in the future. Also, the same variances emphasize the patchwork aspect of the overall flag, suggesting that, standing alone, these objects might not seem emblematic or American, but when pieced together produce a contradictory representation of American culture."

Credit: © Kristi Breisach. *All Things American*, 2006. 19¼ x 32½ inches. Inkjet print.

FIGURE 2.26 *"This project juxtaposes re-interpreted elements from historical images to scrutinize the tragic and comedic events that made up the twentieth-century zeitgeist. Using Photoshop, we adjusted individual images to fit the tapering, gore patterns used to fabricate the original globe, and then printed and collaged them with archival paste onto the surface of the globe."*

Credit: © Adele Henderson and Robert Hirsch. *Globes of Our Time*, 2006. 16-inch diameter. Mixed media.

SHAPES AND THEIR GENERAL SYMBOLIC ASSOCIATIONS

Shapes can also have symbolic meaning. Some possible Western interpretations follow:

- The circle is associated with wholeness, perfection, heaven, intellect, the sun, unity, eternity, the celestial realm, and, of course, our earth.
- The equilateral triangle can represent three forces in equilibrium, such as communication between heaven and earth, the number three, the Trinity, aspiration, upward movement, a return to origins, sight, light, and fire.
- The square may represent firmness, stability, or the number four.
- The rectangle often denotes the rational and secure. It is used to ground concrete objects.

- The spiral can illustrate a continuous directional winding or flow, the evolution of the universe, orbit, growth, deepening, cosmic motion, the relationship between unity and multiplicity, spirit, water, and continuing ascent or descent.
- The maze delineates a complex puzzle, the endless search, confusing information, or a state of bewilderment.

COLOR SYMBOLISM

Along with shapes, color has widespread symbolic associations that have come down over time. In Western cultures:

- Blue signifies sky, thinking, the day, the sea, height, depth, heaven, innocence, truth, psychic ability, and spirituality.
- Green represents the earth, environmentalism, fertility, sensation, vegetation, water, nature, sympathy, adaptability, growth, and thinking.
- Orange shows fire, pride, ambition, and, ironically, safety.
- Red portrays sunrise, birth, blood, fire, emotion, wounds, death, passion, anger, excitement, heat, physical stimulation, and strengthening.
- Violet marks memory, nostalgia, and advanced spirituality.
- Yellow indicates the sun, light, intuition, illumination, luminosity, air, intellect, royalty, and desire.

COMMON SYMBOLS AND SOME POTENTIAL ASSOCIATIONS

Think about these symbols and how their connotations can be applied in your work (see Exercise 2.5):

- Air symbolizes activity, masculinity, creativity, breath, light, freedom, liberty, and movement.
- Ascent indicates height, transcendence, inward journeying, and increasing intensity.

FIGURE 2.27 Edward Bateman tells us: "This work came from an invitation to contribute an image to a portfolio consisting of works by two artists from each of the fifty United States. Utah was settled by Mormon immigrants in 1847, where they established networks of communities united by their religious belief. On May 10, 1869, this insular and agrarian society was threatened by the arrival of the outside world when the transcontinental railroad linked east and west, meeting here in Utah. This took place at Promontory Point, a location near the future location of Robert Smithson's *Spiral Jetty* (1970). My dinosaur, which is wholly constructed using the computer technologies of my day, represents the powerful technology of the locomotive. In my image, it is threatening the industrious harmony of the beehive, the state symbol of Utah. The arrival of this steam-powered technology would forever alter the culture of Utah by bringing diversity and communication with a wider world, much as how the Internet would alter our world by connecting us all in its digital web. For me art is a process of thinking of symbols and their various meanings and finding ways to mesh these linkages into a plausible (although perhaps unlikely) image."

Credit: © Edward Bateman. *CDV Utah 1869*, 2011. 12 x 9 inches. Inkjet print.

- Centering depicts thought, unity, timelessness, spacelessness, paradise, the Creator, infinity, and neutralizing opposites.
- The Cross portrays the tree of life, axis of the world, ladder, struggle, martyrdom, and orientation in space.
- Darkness connotes the time before existence, chaos, and the shadow world.
- Descent shows unconsciousness, potentialities of being, and animal nature.
- Duality suggests opposites, complements, and pairing.
- Earth suggests femininity, receptiveness, solidity, and mother.
- Eye connotes understanding, intelligence, the sacred fire, creativeness, and the power of vision.
- Fire represents the ability to transform, love, life, health, control, spiritual energy, regeneration, the sun, God, and passion.
- Food represents abundance and thankfulness to nature for providing what is needed to sustain life.
- Lake represents mystery, depth, and unconsciousness.
- Light stands for the spirit, morality, all, creative force, the direction east, and spiritual thought.
- Moon symbolizes the feminine and fruitfulness.
- Mountains demonstrate height, mass, loftiness, the center of the world, ambition, and goals.
- Sun indicates the hero, knowledge, the divine, fire, the creative and life force, brightness, splendor, awakening, healing, and wholeness.
- Unity signifies spirit, oneness, wholeness, centering, transcendence, harmony, revelation, supreme power, completeness in itself, light, and the divinity.
- Water denotes feminine qualities, life, and the flow of the cycles of life.

EXERCISE 2.5 PERSONAL SYMBOL INTERPRETATION

After reading about symbols and some of their possible meanings, add your own symbols to the lists provided. Consider how Western culture defines these symbols, based on how we read from left to right and top to bottom, and how other cultures might interpret them differently. Discuss some of the symbols with members of various generations to see how meaning can shift over time.

Next, choose some of your favorite pictures (made by you or someone else) and make a list of the symbols you discover in these images. Write a description that decodes their meaning for others to ponder. Then visit an open source image website, such as www.flickr.com or www.tumblr.com, and look for "tags" (keywords or categories that imagemakers use to label the content of their images) that identify areas of symbolism that interest you and examine how others have visually expressed these ideas. To finish, purposely use what you have discovered about your personal use of symbols as your point of departure to make three new images that possess staying power and post them to an open source image website designed for young artists, such as http://www.saatchionline.com.

Some believe that the meaning of a work is determined strictly by the intentions of the author (known as intentionalism). You should keep in mind, however, that viewers are under no obligation to accept a maker's stated meaning. Although the opinion of a maker can and should help provide clues for understanding the work, an imagemaker's interpretation should not be the only factor in determining the meaning or setting the standard for other interpretations. Think of what Marcel Duchamp, a cofounder of the Dada group, said: "It is the spectator who makes the picture."

REFERENCES

Archive for Research in Archetypal Symbolism. *The Book of Symbols: Reflections on Archetypal Images*. Cologne: Taschen, 2010.

Biedermann, Hans. *Dictionary of Symbolism: Cultural Icons and the Meanings Behind Them*. New York: Meridian, 1994.

Cirlot, J. E. *A Dictionary of Symbols*. Second Edition. New York: Philosophical Library, 1971.

Dondis, Donis A. *A Primer of Visual Literacy*. Cambridge, MA, and London: The MIT Press, 1973.

Fontana, David. *The New Secret Language of Symbols: An Illustrated Key to Unlocking Their Deep and Hidden Meanings*. London: Duncan Baird Publishers, 2010.

Hornung, C. P. *Handbook of Design and Devices*. Second Edition, reprint. New York: Dover, 1946.

Jung, C. G. *Man and His Symbols*. Garden City, NY: Doubleday, 1964.

Jung, C. G. *The Red Book*. Edited by Sonu Shamdasani. New York: W. W. Norton, 2009.

Tresidder, Jack. *1,001 Symbols: An Illustrated Guide to Imagery and Its Meaning*. San Francisco: Chronicle Books, 2004.

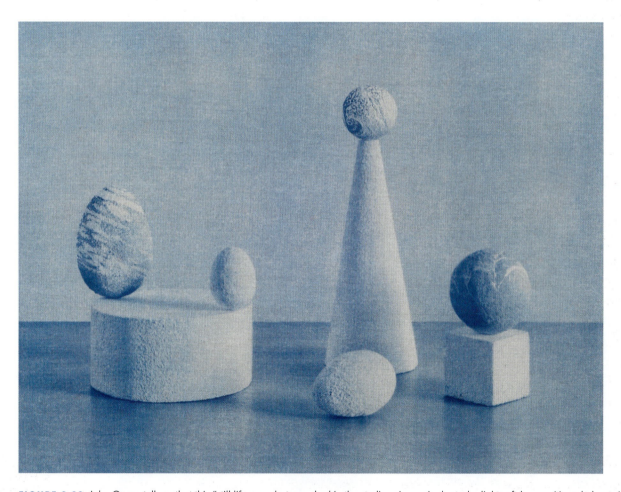

FIGURE 2.28 John Opera tells us that this "still life was photographed in the studio using a single strobe light soft-box positioned about six feet above the forms. After initial editing in Adobe Camera Raw, the still-life image was further processed in Photoshop and combined with open-source images from NASA's website using the program's 3D modeling space. My intent was to use the macro images from NASA in a way that dramatically altered their perceived scale in the image. After the digital file was fully edited, it was inverted and a custom luminosity curve was used to create a digital negative that was then printed on linen using the cyanotype process. The subject matter functions as a set of broad signifiers for the generic human experience, while also remaining mysteriously personal in its conceptual associations."

Credit: © John Opera. *Forms I*, 2013. 21 x 27 inches. Cyanotype on stretched linen.

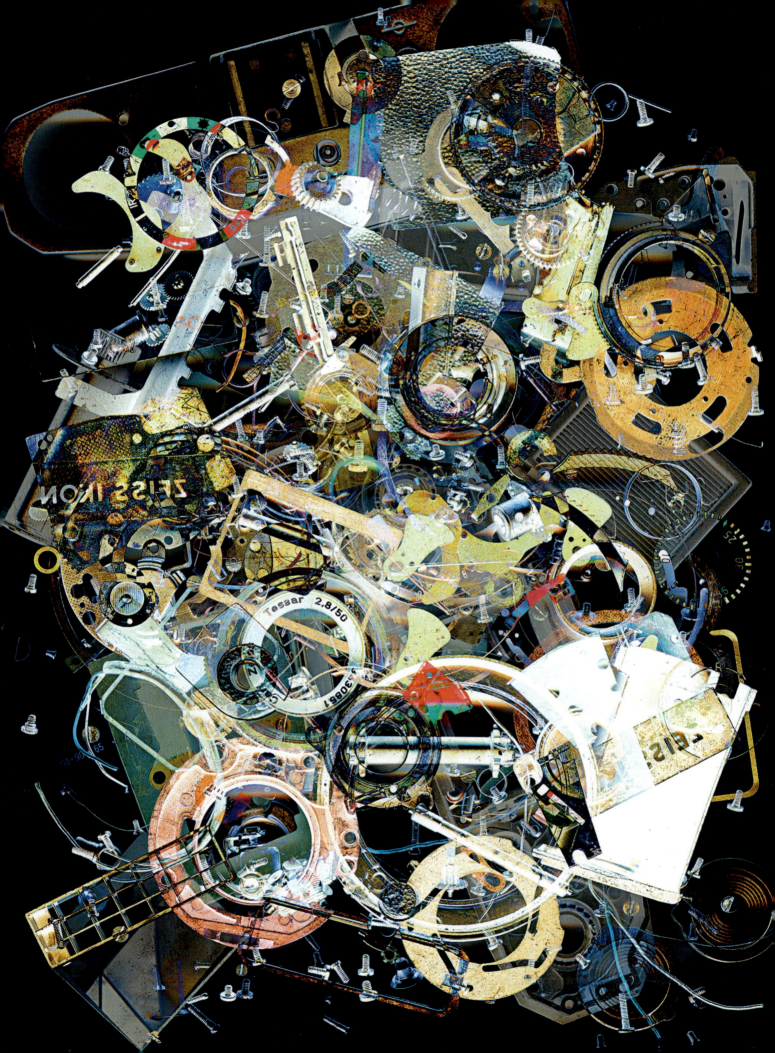

Image Capture: Cameras, Lenses, and Scanners

THE ROLE OF A CAMERA

The camera is the key component of photographic vision. The role of the camera has been to make an "acceptable" and recognizable depiction of the visible world based on established visual conventions. The early camera, called the *camera obscura*, was an optical drawing device designed to imitate the visual models of perspective and scale that were formulated during the Renaissance.

Cameras and lenses leave their fingerprints all over the basic characteristics of the final photographic image, including field of view, contrast, sharpness, tonal range, and noise. Because the camera plays such a vital role in the formation of the final picture, photographers should select a camera that supports their specific visual goals. No single camera can be expected to produce acceptable results in every situation. The standard of what is acceptable depends on a variety of factors, including the purpose for which the picture is being made, the subject being photographed, the intended audience, and the desires of the photographer. For this reason, photographers should learn about the differences among cameras—both their strengths and limitations—in order to make intelligent choices for achieving the anticipated outcome. When possible, experiment with different types of cameras. Street photographer Garry Winogrand observed: "A photograph can only look like how the camera saw what was photographed. Or, how the camera saw the piece of time and space is responsible for how the photograph looks. Therefore, a photograph can look any way. Or, there's no way a photograph has to look (beyond being an illusion of a literal description)."[1]

The camera's design is a basic part of the photographer's visual language. Although a camera may shape the construction of an image, it is the private individual response to a situation that gives an image its power. It is up to each photographer to understand and apply a camera's capabilities, to learn its characteristics, and to know when to use different cameras to achieve the desired results.

FIGURE 3.0 In splaying across the scanner glass all the disassembled components produced during a performance piece, Lee takes the seventeenth-century Dutch still-life genre into the digital age. Photographer Adam Harrison observes, "This brings Lee's photographic practice full circle, using the form that he has found after eight years of confliction to represent the initial action that marked the beginning of his investigations in this area."

Credit: © Evan Lee. *Every Part from a Contaflex Camera, Disassembled by the Artist During Winter, 1998.* 2006. 50 x 38 inches. Inkjet print. Courtesy of Monte Clark Gallery, Vancouver/Toronto.

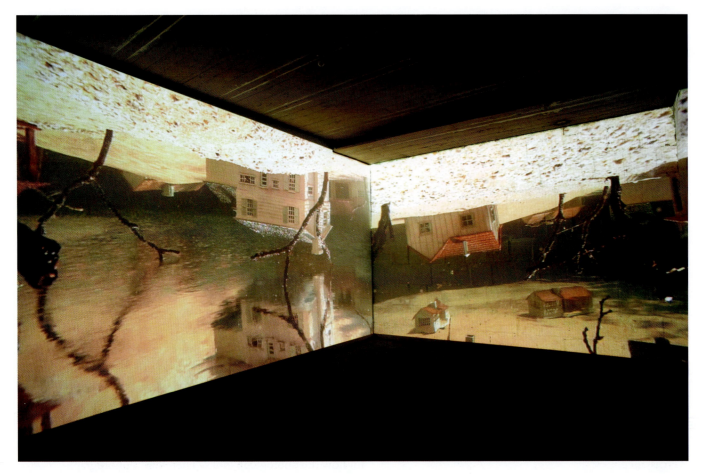

FIGURE 3.1 Michael Bosworth's images highlight the continuity among disasters by illustrating a condition, not the state of the individual. The installation involves a series of hand-built slide projectors, two video projections, and a wall of camera obscuras. Inside each projector are a 500-watt halogen lamp and a glass tank filled with water. Suspended in the water is a sheet of film. As the heat from the halogen bulb brings the water in the tank to a boil, the projected image is destroyed. Standing between the video projections and the camera obscuras, viewers watch the imagery from the perspective of themselves being upside down and underwater, as if caught in the flood. All optics cast an image that is upside down, so from within the cameras the scenes are flipped again: the video imagery appears right-side up and the viewers watching from outside are upside down.

Credit: © Michael Bosworth. *Floodtown* video installation view, from the series *Not Me and Probably Not You*. 2010. Variable dimensions. Digital file.

WHAT IS A CAMERA?

This chapter describes the key camera components and covers the four essentials that make up every camera image: aperture, focal length, focus, and shutter speed. The digital single-lens reflex (DSLR) camera is the nucleus of discussion, but its fundamental principles can be applied to any camera, including point-and-shoot digital and smartphone cameras. Smartphone cameras are nearly omnipresent, outselling traditional cameras at the rate of 10 to 1, giving individuals the ability and power to record both still and moving images and transmit out into the world whatever is happening in their presence. At least two-thirds of Americans own a smartphone, and an estimated 90 percent use it as their primary camera. News organizations encourage "citizen journalists" to send them their smartphone images and videos, which they then circulate. Many bypass the

customary media sources and post their material live on social media. In the course of historic events, such as the latest disaster, police shooting, or terrorist attack, amateur-generated images can have national and/or worldwide impact.

A traditional camera, from a room-size camera obscura to the latest handheld digital, is essentially a light-tight box. A hole (aperture) is made at one end to admit light, and light-sensitive material is placed inside the box opposite the hole. The camera's purpose is to enable the light to form an image on the light-sensitive material, in this case a light-sensitive sensor. This can be accomplished in a variety of ways, but most new digital cameras have the same basic components:

- A lens that focuses light rays to form a sharp image on the light-sensitive sensor.
- An optical viewing system and/or monitor for image composition and review.
- An electronic shutter mechanism that prevents light from reaching the image sensor until the shutter is released. The shutter opens for a measured amount of time, allowing light to strike the sensor. When the desired amount of time has elapsed, the shutter closes, preventing any additional light from reaching the sensor.
- A light-sensitive sensor that electronically records the image created by the light onto a memory card. The inside of a camera must be completely dark so that rays of light reach the sensor only through the aperture.
- A control data-panel display that shows the camera's functions, including aperture, shutter speed, battery life, flash, focus, sensitivity, white balance, and metering modes. Professional models display this information on the composition monitor.
- A Mode dial that allows control over camera settings, including aperture, shutter speed, and flash. The camera may also have programs designed for specific situations such as close-ups, landscapes, night, and portraits.

FIGURE 3.2 Recognizing that more images are being made with smartphone cameras than any other means, Sony Ericsson commissioned Martin Parr to photograph while traveling with its equipment. The images from the resulting project, *Road Trip*, were posted to a website, along with tips by Parr on how to make better smartphone photos. Additionally, the public was invited to upload their smartphone images to the site.

Credit: © Martin Parr. *Singapore*, from the series *Road Trip*, 2005. Digital file. Screen shot from www.sonyericsson.com/k750/. Courtesy of Sony Ericsson Mobile Communications.

- Menus typically include management controls for Set Up, Color, Exposure, Custom, Shooting, and Playback. They allow you to personalize the camera's color space, file type, resolution, and white balance, among others.
- A Sensitivity setting (ISO equivalency) that controls the light sensitivity of the sensor by electronically amplifying the signal.
- A memory card and memory card slot.
- An image advance mechanism to automatically go to the next free space on the memory card.
- A built-in light-metering system that measures the intensity of the light and then automatically sets the exposure. Cameras generally have numerous exposure modes, including automatic and manual settings.
- A small built-in electronic flash, which can be controlled automatically or manually, depending on the camera.
- A battery to power all the camera functions.
- A tripod socket.
- A microphone.
- Video recording ability.

HOW A CAMERA IMAGING SYSTEM WORKS

Photography begins and ends with light. There are five principal steps in making a photographic image: (1) capturing light rays, usually with a lens; (2) focusing the image; (3) making an exposure (also known as *image capture* or *capture*), which records the image on the sensor array, carries out initial processing (depending on the type of file selected), and stores it on a memory card; (4) post-capture processing the digital image; and (5) making a print or displaying the image on a screen.

A typical imaging system requires integrating many elements into a confined space (see Figure 3.3):

1. *Lens:* Light passing through the lens forms an image, which is inverted and laterally reversed.

2. *Mirror with reflex action or translucent mirror:* The mirror stays in the down position for focusing and framing of a scene. When the shutter button is depressed, the mirror instantly retracts upward, allowing the digital image sensor to capture the image. A few cameras use a translucent mirror, rather than one with a reflex action, to minimize vibration and simplify construction (see the section "Digital Single-Lens Reflex Cameras" later in the chapter).

3. *Digital sensor array:* The image sensor converts light into digital information known as pixels, which are measured in the millions (one million pixels equals one megapixel).

4. *Pentaprism:* A five-sided reflecting prism is used to twice internally reflect a beam of light by 90°. The pentaprism, together with the mirror, creates an exact reflection of what is seen in the

DIGITAL SINGLE LENS REFLEX (DSLR) CAMERA

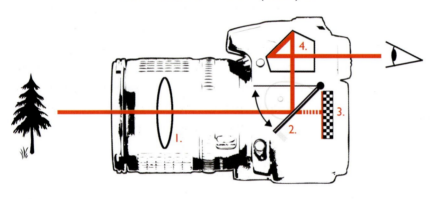

FIGURE 3.3
How a DSLR camera utilizes light.

MIRRORLESS CAMERA

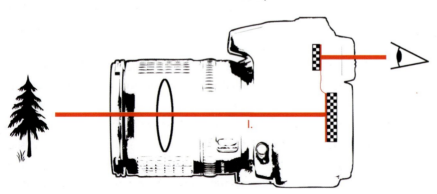

FIGURE 3.4
How a mirrorless camera utilizes light.

viewfinder; it also corrects (turns around) the lateral orientation of the image.

5. Mirrorless cameras have no mirror or pentaprism, which allows light to go directly to the sensor.

FIGURE 3.5
Smartphone camera—Back and front views combined. Newer models may not have a home button.

1. Single or Dual lens. 2. Sensor, located behind lens and built into the camera. 3. Home button, not to be confused with shutter button, which will appear on screen with camera software.

DIGITAL CAMERAS

In 1975, Kodak engineer Steve Sasson built the first prototype digital camera using off-the-shelf parts and custom-built circuitry. The size of a large toaster, it weighed 8 pounds, required 16 NiCad batteries to produce about 0.01 megapixel (10,000 pixels), and took 23 seconds to capture its first black-and-white image onto a cassette tape. Analog electronic cameras, which

were basically a video camera that recorded single frames onto a floppy disk, debuted in the 1980s. The early commercial digital cameras were very expensive and produced images that were not as good as those made by cheap film cameras. The first DSLR, the Kodak DCS (Digital Camera System), was introduced in 1991, cost about $20,000, and produced a one megapixel image that was stored on a separate unit. Today, advances in electronic technology have made digital cameras that equal or surpass the quality of film cameras. Their ease of use; ability to make satisfactory images in a wide variety of situations; new features; and the elimination of certain film-camera design elements, such as a prominent shutter speed dial, f-stop clicks, depth-of-field guide on the lens barrel, and in some cases even the traditional optical viewfinder and mirror, permit a streamlined way of working that was not previously possible. Most digital cameras share common components, which are discussed in this chapter. However, it is essential to read your specific camera manual to learn the precise camera architecture and how the manufacturer has set up the controls and features. There is a danger in letting a camera make all its preprogrammed decisions for you: the resulting images tend to share a "cookie-cutter" sameness due to the absence of variable, individual decision making. Take the time to experiment and customize the programs to exposure for your aesthetic and technical requirements.

DIGITAL OBSERVATIONS

What is the best way to make images your own? Once you become familiar with your camera's basic functions, you can start customizing these features to reflect your personal aesthetics and capture requirements. Digital technology can be enabling, as it offers new tools for the creation and dissemination of information and images. Its availability and influence have grown at an explosive rate, especially in less mature markets outside of North America and Western Europe, giving more people access to new thoughts and observations via the Internet. For example, in the past, professional photo-journalists and their networks of commercial distribution

FIGURE 3.6 The Abu Ghraib prison (20 miles/32 kilometers west of Baghdad) was known as a place where Saddam Hussein's government tortured and executed dissidents. It achieved additional infamy after smartphone camera photographs portraying abuse of Iraqi detainees by U.S. military guards circulated on the Internet. Here, a hooded prisoner had wires attached to his hands and genitalia and was reportedly told that he would be electrocuted if he fell off the box he was standing on. When this image, which was made by a member of the American military, became public, U.S. officials stated that the wires were not actually electrified. This was later denied by the person claiming to be in the photograph, who stated in an interview that the wires were electrified and had been used to give shocks.

Credit: Sergeant Ivan Frederick. *Prisoner Being Tortured, Abu Ghraib Prison* (a.k.a. *The Hooded Man*), 2004. Digital file. Screen capture from the Internet.

the Internet, were deemed so powerful that the U.S. government tried to suppress them (see Figure 3.6). Changes in who is making and circulating pictures is evolving with the widespread use of social networking sites, Web logs (blogs), video blogs (vlogs), and alternative news and open-content reference websites. The character of imagemaking and its distribution has seriously diminished the influence of traditional photographic approaches and creating new, fresh, and diverse ways of seeing, understanding, and knowing our world.

IMAGE SENSORS: CCD AND CMOS

Like a traditional film camera, a digital camera generates images by focusing a scene through a lens. When a photographer makes an exposure with a digital camera, the focused image is captured with a sensor, a postage stamp–size electronic wafer that converts light into electrical current. However, sensors vary noticeably in size. For instance, a medium-format camera sensor will be dramatically larger than a smartphone camera sensor, allowing it to deliver more accurate and detailed images. The sensor is positioned where the film would be in a conventional camera and generally utilizes either a charge-coupled device (CCD) or complementary metal-oxide semiconductor (CMOS) technology, which are the most common types of light-sensitive chips used for image gathering. The sensor chip is composed of many light-sensitive photocells. When light strikes these cells, the properties of the light, such as brightness and color, are converted into electrical signals and broken down into pixels. These pixels are the tiny points of color that actually make up the image you see. Since the camera can represent brightness and color only mathematically, this information is recorded as binary data, or bits—a series of ones (1s) and zeros (0s). Each pixel is assigned the proper data and then organized into a grid so that the information gathered by the sensor is interpolated into a digital version of the image. CCD sensors are devoted to light capture only and rely on the onboard camera computer to complete the imaging processing into bits. CMOS sensors include light sensors with digitization circuits so that the chip directly outputs

provided the photographs the public would see of any given conflict. Now, digital imaging allows soldiers themselves to document and tell their uncensored stories of war. The grainy, amateur snapshots made of prisoners being abused by the guards in Abu Ghraib prison in Iraq, distributed by email and eventually on

digital bits to the camera computer, requiring less camera circuitry. When the sensor and camera computer have captured and processed all the bits, the image is recorded onto a memory card in the camera.

An image sensor has millions of tiny light-sensitive cells called *silicon photodiodes* (SPDs), also known as *photosites*, arranged in a grid. Each SPD accumulates an electrical charge according to the amount of light that strikes it. When an exposure is made, the lens focuses light on the sensor, and each cell, which has either a red, green, or blue (collectively known as RGB) filter in front of it, measures the intensity of the light that falls on it. Every position on the grid is recorded as a solid-toned picture element, or pixel, with its color, brightness, and position given as a binary series of 1s and 0s. Each pixel corresponds to an SPD on the sensor (see following section on pixels).

COLOR FILTER ARRAY: BAYER FILTER MOSAIC

The most common color filter array (CFA) pattern is the Bayer filter mosaic. Used in most single-chip digital cameras, the Bayer pattern arranges one of the three RGB color filters on each photosite in a square grid of photosensors, resulting in only one color of light passing through to each SPD. The human eye is more sensitive to green light, so green is used in half of the filters on the grid and red and blue each account for one quarter. Since each exposed pixel initially contains only a single primary color, it therefore lacks the other two. Employing a process known as *interpolation,* a mathematical method of creating missing data, the camera guesses the color information absent in each pixel by examining nearby pixels and then generates an accurate reproduction of the subject's colors through a re-created RGB combination. Pixels, unlike silver particles in photographic negatives, are not "fixed" by processing. Once an image is digitized (recorded), imaging software can be used to select and alter the color, brightness, and position of any pixel.

Other less common sensor technology includes a non-Bayer "stacked" system of photodiodes, such that each pixel site records red, green, and blue data. There is also the backside illuminated sensor, which moves wiring to the back of the silicon chip to increase the light hitting the SPDs. New technologies, such as seen in the Lytro cameras, record light data in three dimensions and produce images that allow the focus to be changed after capture. It works by placing a microlens array in front of the sensor, which scatters the incoming light, based on the angle from which it approached. This information can then be used to calculate where the light would have ended up, had the camera been focused differently.

PIXELS

A pixel, short for picture element, is essentially an electronic point with a given color and brightness value (data) that is the smallest component of a digital image. A typical digital image is composed of an array containing millions of these tiny pixels—one million pixels are known as a *megapixel*—and is perceived by your eye in continuous tones, just as it would with a film-based photograph. Generally, the more pixels the image contains, the sharper the image and the higher its resolution (amount of detail). However, this depends on the quality and density of the photosites, which makes it possible for a smartphone camera to outperform a DSLR. Also, one must take into account that the illusion of continuous tone also depends on the number of values captured in the image. Low bit-depth and overprocessed images will encounter color shifts and loss of detail or resolution.

IMAGE RESOLUTION

Image resolution describes the amount of detail any particular image can display. The measurement of image resolution varies dramatically and is specific to each medium, such as digital cameras, inkjet/laserjet printing, TV/video, film, or computer monitors. In any digital medium, higher numbers usually translate into higher resolving power, or ability to reveal image detail. For cameras, resolution is measured as pixels per square inch

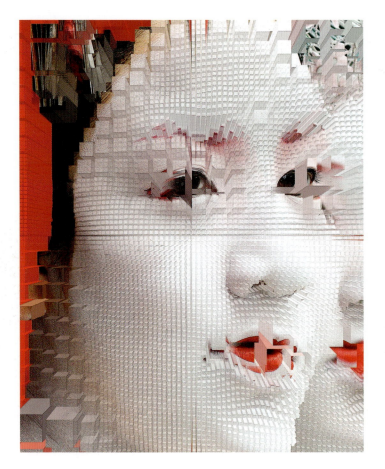

FIGURE 3.7 Digital imaging offers Douglas Prince numerous options to pursue his lifetime concern of photographically revealing insights into the character of things beyond their surface appearances. For his *Extrusion Maps* series, Prince takes a reductive approach. "I use the Photoshop's extrude filter to reduce images to a composition of basic pixel building blocks. The image is rebuilt into an illusion of a relief of fragmented planes, creating a new spatial and tactile experience."

Credit: © Douglas Prince. *Extrusion Map 89*, 2010. 9⅝ x 12 inches. Inkjet print.

maximum number of pixels (maximum pixel count) such a camera is capable of capturing. The pixel count is the number of pixels displayed in the image file, which directly refers to image resolution. Digital cameras have capture settings that can be set to less than the maximum PPI. For example, most digital cameras have image size or pixel count settings usually described as Large, Medium, and Small. The *Large* setting represents the maximum allowable image resolution for that particular camera and will always produce a larger image file than the Small setting. Hence, a 10-megabyte image file may be created with the Small setting. The Large setting always contains the maximum pixel information, greater than either the Small or Medium settings.

A 25-megapixel camera using the Large setting might have a PPI setting of 6000 (width) × 4000 (height), which will have sufficient resolution for 20 × 24-inch photographic-quality prints that is adequate for most professionals. A Small setting might be adequate only for use on the Web. A computer with image processing software can resize the PPI from large, medium, and small image files for printing, emailing, or posting to a website. It is always best to capture Large and reduce the PPI for the Web or other uses rather than to capture Small and increase PPI to print, which results in a quality that is less than optimal.

(PPI), whereas inkjet/laserjet printing technology uses dots per square inch (DPI). Television/video uses the number of scan lines to determine image resolution. Motion picture film and analog photography utilize a standard in which lower numbers indicate higher resolving power, and computer monitors use dot pitch. Regardless of the medium, accepted resolution standards are dependent on the ability of the human eye to resolve or see detail and the quality of the equipment and materials being used.

PPI: PIXELS PER SQUARE INCH AND DIGITAL CAMERA RESOLUTION

Digital cameras can capture images in various resolutions. Low-resolution images are appropriate for display on a website, but not for making photographic-quality images. A 16-megapixel digital camera refers to the

DPI: DOTS PER SQUARE INCH AND PRINTER RESOLUTION

Dots per square inch, or DPI, refers to printer resolution. In general, the more dots the printer can physically produce per linear inch, the better and sharper the image. Both DPI and PPI are key controlling factors in

producing high-quality photographic prints, but ultimately it is the printer resolution, or DPI, setting that has the greatest effect on the final image resolution. Looking at a photograph on paper is an analog experience because our eyes convert value and detail into recognizable shapes. Hence, it is the number and size of the dots physically applied to the paper that give a viewer the final visual experience.

THE DIFFERENCES BETWEEN PPI AND DPI

Although PPI and DPI control image quality in similar ways, they are very different, and it is critical that these distinctions be clearly understood. Be aware that PPI refers to pixel density or pixel dimensions and is usually measured in pixel height and width. For imagemaking purposes, think of PPI as digital information that relates only to the resolution of your camera's capture mode and DPI as it correlates to the resolution of your printer's output. The mantra to remember is: For PPI, think of your camera; for DPI, think of your printer. (See Box 3.1 and Chapter 8 for more information about PPI and DPI.)

BOX 3.1 PPI AND DPI MANTRA

PPI = Input/camera

DPI = Output/printer

VISUAL ACUITY AND 300 DPI

Visual acuity is the capability of the human eye to resolve detail, but this power of human vision to recognize fine detail has limits. When it comes to digital imaging, the point where dots, lines, and spaces are seen by the human eye as continuous tone is approximately 300 dots per inch (DPI). This is why photographic printers, known for high-quality output, have resolutions of 300 DPI and higher. There are many variables,

FIGURE 3.8
Dots to continuous line.

such as individual differences in visual acuity, lighting conditions, and viewing distance, but generally about 300 DPI is considered acceptable for replicating continuous tone. An 8 × 10-inch digital print at 300 DPI and viewed at 12 inches (30 centimeters) easily allows the dots to be seen as a continuous tone to the average eye. As prints are made larger, the standard viewing distance increases, which theoretically means the DPI could be reduced and the average eye would still see it as a continuous tone (see Figure 3.8).

Printers create images in a variety of ways. Depending on how a printer lays down its dots on a page, a print made at 200 DPI on one printer can look finer than a print made at 400 DPI on another. Regardless of what printer you use, 300 DPI has become the common standard that photographers and publishers use as a base line for making image files for general reproduction. Those with a more demanding critical eye, such as professionals intending to greatly enlarge their digital files and still maintain continuous tone quality at close viewing distances, will require higher DPI output, such as 600 to 8,000 DPI.

As previously discussed, printing at 300 DPI is the standard for photographic quality, so be careful not to let inkjet printers rated at 1,440/2,880/4,800 DPI impress you. Inkjet printers rely on technology that applies many tiny droplets of color for each dot. Manufacturers are literally counting each and every one of those minuscule droplets, which can be misleading. Visually, a dot is a dot regardless of whether one dot is composed of a cluster of eight minuscule color droplets and another is not. Some manufacturers count the eight minuscule droplets as separate dots to inflate their DPI figures. Inkjet technology is changing rapidly; droplets are getting so small that their blending on the page obscures the individual droplets altogether. This improvement in inkjet printer technology does offer better color control, but has only a minimal impact on actual image resolution.

TYPES OF DIGITAL CAMERAS

Digital cameras are the most direct method of capturing images for digital manipulation or printing. Combining the mechanics of cameras and the technology of scanners, digitally captured images may be stored on a camera's solid state memory or within a removable memory card and later transferred to a computer, or the camera may be directly connected to a computer and the image transferred as the picture is taken. Exposure times in digital cameras can vary from a fraction of a second to several minutes. Digital cameras come in two styles: the all-in-one digital camera and the professional-level scanning back. Scanning backs connect to traditional, larger-format cameras. The camera makes the exposure, and the scanning back converts the image into digital data. (These are used to make high-end professional images and will not be covered here.) The sensor captures images as electronic data, which can be down-loaded into a computer. In the computer, a digital imaging software program allows changes to be made to the image, which can be saved and then printed or trans-mitted via email as a digital file or posted on a website and/or social media. Often, digital images are never printed and remain strictly as electronic information that is shared only on a screen.

COMPACT DIGITAL CAMERAS

Since the advent of affordable digital photography, compact digital cameras have been the choice of casual photographers. Now, smartphone cameras and their abundant applications (apps) have replaced compact cameras in terms of images taken and uploaded to the Internet at an accelerating rate. Both types can be considered as *point-and-shoot* cameras because they can function automatically and they require users to simply compose the scene and press the shutter release. Basic inexpensive point-and-shoot cameras have a fixed focus, which relies on a small aperture and a wide-angle lens to ensure that everything within a certain range of distance from the lens (about 6 feet to infinity) is in acceptable focus. Other point-and-shoot cameras may have a limited focusing range indicated on the camera body. With these, the user guesses the distance to the subject and adjusts the focus accordingly. On some cameras, the focusing range is indicated by graphic symbols: head and shoulders (portrait), two people standing upright (group), one tree (nature), and mountains (landscape). Such lightweight point-and-shoot cameras have a viewing system that is separate from the lens. Generally, the viewfinder is a small window above or to one side of the lens. More expensive compact cameras have a rangefinder; an angled mirror behind the lens reflects a second image of the subject into the viewfinder. To focus, a person looks through the viewfinder and adjusts the focusing mechanism until the two images come together as a single image. The focused image in the viewfinder differs slightly from the image on the sensor or film. This difference is called parallax error. To help correct for parallax error, the viewfinder has lines that frame the subject area seen by the lens.

Compact digital cameras may have a monitor instead of a viewfinder, or both. Many make use of an electronic viewfinder (EVF). An EVF relies on a miniature monitor inside the back of the camera.

The photographer looks at the monitor through a small window and sees the scene from the same viewpoint as the lens. Thus, parallax error is avoided.

Compact digital cameras usually have many features and creative controls, including variable focal-length zoom lenses, automatic focus, and software programs to cover situations such as close-ups and nighttime exposures. Some permit wireless fidelity (Wi-Fi) picture transmission that sends pictures directly from a camera to a computer without wires. Higher-quality digital cameras have greater resolution (the amount of image detail the camera is capable of recording), which results in sharper images.

DIGITAL SINGLE-LENS REFLEX CAMERAS

Digital single-lens reflex (DSLR) cameras are the most common type of camera used by professional and serious photographers because of their larger sensor, interchangeable lenses and their direct viewfinder image. A mirror mechanism between the lens and the sensor reflects the image onto a viewing screen. When the shutter release button is pressed, the mirror rises out of the way so that the light makes an exposure on the sensor. Thus, the photographer sees the image almost exactly as it is recorded on the sensor, and parallax error is avoided.

In general, single-lens reflex cameras are heavier and more expensive than other digital models. More versatile than compacts, most DSLRs offer both manual and automatic controls and the ability to utilize a variety of interchangeable lenses. Their standard optics can be replaced with such lenses as wide angle, telephoto, macro, and zoom—all of which render different size and depth relationships of objects in a scene. Professional and proconsumer DSLRs offer numerous creative controls and feature larger and more accurate imaging sensors that provide for greater picture resolution, less noise, more color accuracy, and better performance at higher ISO settings.

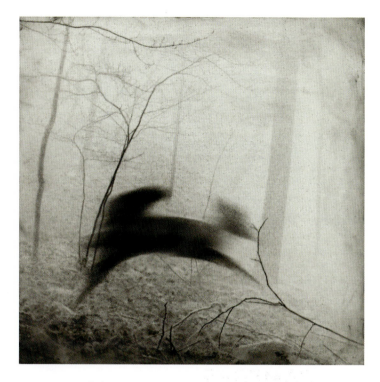

FIGURE 3.9 Jill Skupin Burkholder relates: "Scientists speak of parallel universes that exist in other dimensions but those who observe Nature see a closer, more accessible secret world. A motion-sensitive trail camera set up in the Catskill Mountains near my home records visions from these secret worlds and instantly transmits these captured moments to an iPhone. These 'photo texts' from the animals are triggered by chance, creating random, intimate compositions uniting the world of the seen with the unseen. We become joined for an instant through the mystical window of technology. Choice of a low resolution, but technically appropriate camera, contributed to the 'smudge and dots' look to the imagery. When appropriate, the original image file was enhanced by inverting the image to make the woodland setting appear light and fanciful. This approach transformed the predictably literal natural setting into an unexpected visual gift, a hidden world not commonly observed. Each surveillance-style snapshot is hand-worked and interpreted to evoke the form of an apparition. With these shared moments, viewers connect with the Earth, promoting awareness and a greater sense of responsibility to the environment."

Credit: © Jill Skupin Burkholder. *Running Deer, Catskills*, 2014. 24 x 24 x 2 inches. Inkjet print with beeswax and charcoal.

There are also special-use DSLRs capable of taking photographs in the ultraviolet and infrared light spectrums or 3-D, which have been designed for use in the science, medical, law enforcement, and fine art fields. Also, infrared camera conversion is offered by www.lifepixel.com.

FIGURE 3.10 Nikon DSLR.

Credit: Courtesy of Nikon Inc. USA.

FIGURE 3.11 Nikon Mirrorless Interchangeable Lens Camera (MILC).

Credit: Courtesy of Nikon Inc. USA.

SINGLE-LENS TRANSLUCENT CAMERAS

A single-lens translucent (SLT) camera is similar to a DSLR camera, but in place of a solid mirror with a reflex action that retracts during exposure, the SLT uses a fixed, translucent, beam-splitting mirror to deliver light to both the light sensor and the optical viewfinder for focusing and framing. This allows the SLT to make exposures without the vibration associated with mirror movement. Another advantage is continuous image calibration and autofocus, which is desirable when making photographs of moving subjects or recording HD video. The SLT mirror can be retracted when cleaning the sensor.

MIRRORLESS CAMERAS

Unlike their DSLR cousins, mirrorless cameras with interchangeable lenses (MILC) do not have a mirror or an optical viewfinder. Compared with a comparable DSLR, mirrorless models are less expensive, lighter, smaller, thinner, and quieter due to the lack of a flipping mirror while still offering through-the-lens previews. Composing is done via an electronic viewfinder (EVF), which in lower end models can be difficult to see in certain situations. Mirrorless lenses are smaller than

FIGURE 3.12 Hasselblad medium-format DSLR with digital back.

Credit: Courtesy of Hasselblad USA.

FIGURE 3.13 "I use my camera's built-in panorama mode to shoot and then stitch the images together to represent my interest in the appearance and meaning of our persistent attempts to dominate nature—the human impulse to impose geometric structure upon perceived chaos—and in nature's equally relentless attempts to absorb our imprint into its own larger order. In this particular image, I wanted the rising sun to appear exactly in the center, shining directly into the lens, so I started with the sun directly at my back, which allowed me to include my shadow as a point of self-reference, and work my way back around to the beginning. I utilize this bookend approach as a way of creating a sense of slightly distorted symmetry."

Credit: © Steven P. Mosch. *Tabby Ruins #3, Spring Island, SC*, 2002. 1½ x 16 inches. Inkjet print.

DSLR lenses, but the lens selection is more limited and expensive. Nevertheless, most MILC cameras can use DSLR lenses by adding an adapter. They are excellent for video, and their LCD screen offers a uniform interface compared to most DSLRs, plus offering advantages such as overlaying information within the scene and the ability to reflect live exposure changes. However, they do require constant battery power, which can prove too limiting in many situations. Mirrorless cameras are marketed as Interchangeable Lens Cameras (ILCs) or Compact System Cameras (CSCs).

SMARTPHONE CAMERAS

The three major components that control exposure in a smartphone camera are ISO, shutter speed, and aperture. In automatic mode, the sophisticated algorithms built in to the camera's software produce excellent results in a variety of lighting situations. Some smartphone cameras and additional apps allow you to adjust these three components, but only to a limited degree. ISO is given priority and remains constant, so when you change shutter speed or aperture settings, it is likely the ISO that is actually being altered. Shutter speed and aperture are given a lower priority and usually change the least. Smartphone algorithms make accurate exposure a priority since a correct exposure will always deliver a better capture regardless of the smartphone's shutter speed or aperture. Smartphone cameras have front and rear use cameras, and auxiliary lenses can be added. As technology advances, smartphones will have manual controls and features similar to DSLRs.

OTHER CAMERA TYPES

Medium-format cameras are often preferred by professional photographers because their larger sensor or digital back can capture bigger files (more pixels) and thereby provide more precise and detailed images than their smaller counterparts—though at more expense, bulk, and weight. Medium-format cameras can also be shot in a variety of aspect ratios—that is, the ratio of its longest dimension to its shortest dimension—which differs depending on the camera or frame insert used. The most

common aspect ratios are 6 × 4.5 cm (also known as 645, or rectangular) and 6 × 6 cm (also known as 2¼, or square). Other frequently used aspect ratios are 6 × 7 cm, 6 × 9 cm, and 6 × 17 cm (panoramic). Panoramic refers to any high-aspect-ratio (1.85 or greater) or wide-screen image or film format, which is especially suitable for scenic, horizontal landscapes. Some cameras have a switch that allows you to switch between different aspect ratios, such as 3:2, which is the same aspect ratio as a 35mm camera; 4:3, which has the same aspect ratio as a computer monitor or TV; or 16:9, which is suitable for landscapes or playing back images on a wide-screen TV. Other types of cameras include:

- *Smartphone cameras* continue to be the fastest-selling type of digital camera. These point-and-shoot devices, which also have been incorporated into portable personal digital assistants (PDAs) and tablet computers, allow one to take, adjust, and transmit still or video images with a few keystrokes.
- *Digital camera backs*, designed for commercial applications, are available for 645, 2¼, and 4 × 5 film cameras, and their sensors offer unparalleled digital image capture. The digital back simply replaces the conventional film back.
- *Disposable film cameras* offer an inexpensive way to experiment with different imagemaking devices, including waterproof, underwater, and panorama models.
- *Drones* equipped with cameras can capture still images and video by a remote operation, enabling first-person point of views that would normally not be possible for photographers to achieve.
- *Homemade film cameras* can be specifically constructed to meet your own unique way of seeing.
- *Instant cameras* use self-developing film, capable of delivering an image in under a minute, and have largely been replaced by inexpensive digital cameras.

- *Kit cameras,* such as Big Shot with its companion website (www.bigshotcamera.org), provide the components and instruct one how to build a digital camera.
- *Light field,* or *plenoptic, cameras,* such as the Lytro, capture all the light rays of a scene in four dimensions, which allows one to endlessly refocus an image *after* it has been captured.
- *Multimedia cameras* merge media boundaries with features such as digital still cameras and video recorders and players, plus MP3 players, all in a single device.
- *Panoramic cameras* are specifically designed to create images with exceptionally wide fields of view by means of a high aspect ratio, in which the length of the image is much greater than its height. The lens of a true panoramic camera rotates to scan a scene, which is captured on a wide sensor or on film. The broad sweep of the rotating lens records the scene with minimum distortion and is useful for photographing expansive landscapes and large groups of people. True panoramic images capture a field of view comparable to, or greater than, that of the human eye—about 160° by 75°. This gives it an aspect ratio of 2:1 or greater, indicating the image is at least twice as wide as it is high. Panoramic images can have aspect ratios of up to 10:1 and cover 360°. There are software programs that will "stitch" images made with wide-angle lenses into panoramas. In addition, there are digital cameras that offer different aspect ratios, including panoramic.
- *Photomicrographs* can be made by means of a special apparatus that permits a camera to be attached to a microscope.
- *Pinhole cameras* do not have a lens and can be made out of an oatmeal box or a coffee can and can expose film or photographic paper. The light producing the image passes through a tiny aperture, which can be made with a small sewing needle. The shutter usually consists of a hand-operated flap of heavy, black tape to cover and

uncover the pinhole. Pinhole cameras need much longer exposure times than conventional cameras because of the small aperture; typical exposure times can range from a few seconds to more than an hour. Pinhole cameras with CCDs are sometimes used as spy cameras for surveillance work because of their small size. A pinhole drilled into a camera-body plate cap that screws into the camera's lens mount in place of a lens can convert a digital camera into a pinhole camera (see Figure 3.15). Precision-made pinhole body caps are commercially available from sources such as the Pinhole Resource (www.pinholeresource.com) and fit many cameras, including view cameras. To prevent dust from getting on the sensor, you hold the camera facedown and quickly change to the body cap.

- *Remote* or *trail cameras*, commonly used in sports and wildlife photography, are placed in areas where a photographer cannot gain convenient access and can be programmed to record by hand and sound triggers.
- *Spy* or *hidden cameras*, commonly found in banks and stores, are used to make still or video recordings of people without their consent or knowledge. They have also been used in "reality" television shows to capture unsuspecting people in unusual or embarrassing situations. Pinhole cameras with CCDs are sometimes used as spy cameras for surveillance work because of their small size.
- *Stereo* or *3-D cameras* have twin lenses, 2½ inches apart, which allow imagemakers to generate the illusion of depth. Some cameras offer an interchangeable 3-D lens.
- *Telescopes* equipped with a clock drive and a camera-body attachment mount can be used to make images of the sky at night. Intriguing results also can be obtained by simply pressing the camera lens up to the telescope's eyepiece, making an exposure, and then reviewing and adjusting as you work.

- *Time-lapse cameras* make a series of exposures over a specific amount of time, on either one frame or consecutive frames.
- *Toy film cameras*, such as the Holga and Lomos, challenge the accepted standards of image quality and encourage playfulness and simplicity.
- *Underwater cameras* have a watertight seal or special housing that allows them to be used when swimming, snorkeling, or scuba diving (see Figure 3.14).
- *View cameras*, such as the 4 × 5 inch, 5 × 7 inch, and 8 × 10 inch, have many additional adjustments that give serious photographers more creative control in setting up their compositions. Such cameras provide a lot of perspective control but do require a tripod. Most large-format cameras use digital backs or sheets of film to capture images of the highest resolution.
- *Wearable digital cameras*, such as the GoPro, have an extremely wide-angle lens (up to 170°) and can capture video or still images. They can be mounted on a helmet, handlebars, or other surfaces, and some are waterproof.
- *Web cameras*, or *webcams*, are real-time cameras whose images can be accessed using the World Wide Web or instant messaging or with a computer video-calling application, such as Skype. Generally, a digital camera delivers images to a web server either continuously (streaming) or at regular intervals. Today, webcams provide views into homes and buildings as well as views of bridges, cities, and the countryside; they also are used to monitor traffic and weather and by police for public safety and surveillance purposes.

When the opportunity presents itself, challenge yourself by working with a camera format different from the one you normally use and compare the resulting images. Become aware of how the camera itself affects what you look at and how you see, and then interpret the results.

FIGURE 3.14 For more than two decades, Karen Glaser has documented the hidden worlds beneath the surface "inside" Florida's springs, swamps, and waterways. Operating in hot, buggy conditions, Glaser relies on a Nikon underwater camera to work in water with various levels of floating sediment that reflect, refract, and bend the natural light to create layers of visual complexity. The resulting visceral images invoke a primordial landscape that is simultaneously appealing and unnerving.

Credit: © Karen Glaser. *Leon's Dome*, from the series *Florida Springs and Swamps*, 2009. 25 x 37 inches. Inkjet print.

FIGURE 3.15 Nancy Spencer made this 1-second exposure by replacing the lens on her DSLR with a pinhole body cap. "To use a pinhole body cap on my digital camera, I set the camera to the Manual exposure mode and find the correct exposure by trial and error. For me, the white horse is an archetype representing power, transience, and freedom. The black horse that appears in the shadow of the neck of the white horse was a gift from the pinhole gods. I didn't see it until I printed the image."

Credit: © Nancy Spencer. *White Horse, Black Horse*, 2006. 10 x 15 inches. Inkjet print.

FIGURE 3.16 Richard Gray examines the intersection of photography, human identity, and scientific imaging. Working to understand the role of new technologies in redefining the contemporary idea of self, his work explores the cultural evolution of scientific images and their influence on our understanding of what it means to be photographed. Gray made this photograph in total darkness with a thermal imaging camera. The areas with the highest temperature appear the darkest in the recorded image.

Credit: © Richard Gray. *98.6 TH*, 2010. 20 x 20 inches. Inkjet print.

FIGURE 3.17 To make her birding images, Jeannie Pearce places her digital camera next to the telescope eyepiece without an adapter "to encourage some lens feedback and odd reflections. Mode is set to Aperture Priority, and exposure is determined through the lenses of both the camera and telescope. The resulting capture is presented in a circle with a variety of colored vignetted edges. Why birds? I have a fascination with their ability to adapt using their amazing navigation skills, and they are omnipresent in myths, fairytales, and symbolism. Besides, they are just cool to watch and allow me to take the time to relax."

Credit: © Jeannie Pearce. *Female Blackbird*, 2006. 16 x 16 inches. Inkjet print.

CHOOSING A CAMERA

Before choosing a camera, ask yourself: (1) How and where will I use this camera? (2) What types of pictures do I plan to take? (3) Consider the camera's ergonomics: Are the controls comfortably and logically located? Does the camera "feel" right in my hands? Is it too heavy or too light? (An awkward camera fit will limit your handling skills and interest in using it.) (4) What will I do with the pictures? (5) What optional accessories do I need? (6) How much can I afford to spend? These factors allow you to determine the resolution, size, ease of use, degree of creative control desired over the camera, and cost. Unless there are special circumstances or requirements, everyone should consider a digital camera because of its affordability; ease of use; the convenience of organizing, controlling, and storing images electronically; and the portability of your pictures as digital data.

CAMERA FILE FORMATS

Any digital file uses a binary code to electronically record data, whether it is an image or text, which allows it to be stored, processed, and manipulated in a computer. Although all images are written in binary code, there are a variety of file formats for capturing and storing images. Each format has a unique method of translating

the resolution, sharpness, value, and color of a digital image, and each has its uses, advantages, and limitations. For this reason, it is important to select the file format that is best for your particular needs before making any images, as changes made later to the original format can result in loss of image quality (see the section "Major Image File Formats" later in this chapter).

Most digital cameras provide several file format options, such as JPEG, TIFF, and RAW, plus a range of quality settings in a variety of resolutions, such as low, medium, and high, which can be set to meet the needs of a particular situation. You must know the differences between various file formats and quality settings, as well as the final print size, to obtain the desired results.

IMAGE COMPRESSION ALGORITHMS: LOSSLESS AND LOSSY

Selecting the right file format for the image quality you need requires that you understand image compression. Compression algorithms, a set of mathematical program instructions, are designed to reduce the original file size to create extra storage space or to speed up file transfer over a network. Digital cameras can compress images to save file space on the memory card.

There are numerous file compression types, but they all fit into two basic categories: lossless and lossy. Lossless compression uses an algorithm that allows a compressed file to recover all the original data when the file is uncompressed. Lossy compression, by contrast, permanently reduces a file's size by eliminating redundant data or data not visible to the average person's untrained eye, and this data cannot be recovered. The loss of image quality in lossy compression is proportional to the amount of compression. Compression is accomplished by dividing the picture into tiny pixel blocks, which are then halved over and over until the desired amount of compression is achieved. Most lossy file types give you options for setting the amount of compression. Different file types are best for different applications (see Box 3.3).

MAJOR IMAGE FILE FORMATS

Quality cameras can save images in three basic file formats—JPEG (compressed), TIFF (uncompressed), and RAW (unprocessed)—which are explained in the following sections.

JPEG

JPEG, which stands for Joint Photographic Experts Group, is the default file format used on most digital cameras because it allows for the maximum number of pictures per megabyte of camera memory. JPEG is a compression format that uses *Basic*, *Normal*, and *Fine* settings on the camera to manage both the amount of compression and the resulting image quality. Do not confuse JPEG settings, which control image quality through compression, with the image size settings *Large*, *Medium*, and *Small*, which control document size.

JPEG is commonly used because the image processing is done during capture according to the photographer's camera presets. However, once this is done, the image cannot be restored to its original state because information has been permanently changed and/or eliminated. The JPEG image file format uses a lossy compression scheme and is commonly used for low-resolution, continuous-tone images on the Web. JPEG compression also allows the creator to decide the trade-off between file size and image quality: higher quality means larger file size, and smaller file size means lower image quality. JPEG files should not be opened and resaved multiple times because images will slowly deteriorate (due to the lossy compression scheme) and become soft and pixelated. Compression is like crushing an eggshell and gluing it back together. During the rebuilding process, tiny pieces are lost, the glue smears, and the shape is not quite smooth. The more you crush, the more noticeable the defects. Abrupt color and highlight gradations, loss of sharpness, jagged lines, and swirling patterns are a few such problems, known as *artifacts*. For this reason, it is best to work from a copy of your original JPEG file when making any changes to the image.

BOX 3.3 OTHER MAJOR DIGITAL FILE TYPES

- BMP is the standard Windows image format. It is lossless and designed for pictures or graphics.
- EPS is short for Encapsulated PostScript. EPS files were designed for saving high-resolution documents, illustrations, and photographs for electronic prepress for page layout software in the printing industry.
- GIF stands for Graphics Interchange Format and is a lossy format primarily used for the Web. It is excellent for flat color graphics but not ideal for photographs.
- PICT is encoded in Macintosh's native graphics language. PICT files are lossless, can be opened on the Windows platform, and can be saved in most software applications.
- PNG, or Portable Network Graphics, format was designed to supplant the older GIF format. A lossless file format with good compression, it has two major uses: the Internet and image editing. It is a substitute format for many of the common uses of the TIFF format.
- Program-specific file types, such as Photoshop (.psd) or Illustrator (.ai), are native file formats that contain the maximum amount of information about an image for use in its own native program. Sometimes these native files are much larger than similar common file formats because the program-specific features are saved only in native file formats. When you are saving an image to a common file format, which is sometimes called a non-native file format, the image's layers may have to be combined, and certain formatting information may be eliminated.

HEIC

In 2017 Apple replaced the use of JPEG files on their smartphones and computers with a new lossy image format known by the acronym HEIF. This stands for High Efficiency Image Format and allows for greater compression, utilizing half the storage size of a JPEG, of images and short image sequences. Besides supporting 16-bit color, this format sustains focus stacking and depth-of-field effects that are now common on camera phones. The risk of using any new file format is in anticipating its longevity, so it may be useful in the short term to convert your images into a second format for archiving. Apps are available to convert HEIC files to JPEGs.

TIFF

An acronym for Tagged Image File Format, TIFF saves a file without compression and is the current standard in the graphics and printing fields and in cases in which an image needs to be examined digitally in detail. The TIFF format is used to exchange files between applications and computer platforms and for high-quality printing. Lossless compression options are available for TIFF files, but generally are not used because many high-quality output devices will accept only uncompressed TIFF files. Even compressed, TIFF files are much larger than inherently compressed GIF or JPEG files. TIFF is known as an interchange format, easily opened on any platform, and is considered one of the most universally accepted high-resolution file formats.

RAW AND POST-PROCESSING

RAW files are a type of minimally processed data from the camera's image sensor as opposed to a standard storage format. Raw files can be considered a pure "digital negative" because they contain unmanipulated binary files with information pertaining only to individual pixels from the image sensor. When a raw image file is saved (shutter released), only the sensor data is saved; there is no post-processing for color balance, color palette compression, size, white balancing, or sharpening that is required

with other file formats. The data is not formatted for a specific application, and the main advantage of these files is that they are uncompressed and smaller than TIFF files. All image processing is done later using computer imaging software; this allows for maximum control over the interpretation of the image in terms of color balance and saturation, detail rendering (noise reduction and sharpening), and tonal rendition. Professional photographers prefer the raw file format because its pure, unprocessed pixel data gives them the most flexibility and control when converting to other file formats (see the section "Working with RAW File Formats" in Chapter 8).

DNG

When the RAW format was introduced, it came not from a central source, but rather from various DSLR makers who produced their own competing proprietary systems and software. Since their specifications are not publicly available, not every RAW file can be universally read by all software applications. Introduced in 2004, the Digital Negative (DNG) format is Adobe's proprietary attempt to solve this vexing problem of incompatibility with an open (generic) format that it hoped would be universally adopted by the camera manufacturers (see the section on "Working with Raw File Formats" in Chapter 8). The manufacturers' response has been mixed at best, with most still preferring to maintain their own proprietary RAW file formats.

OPENING FILES

Regardless of the type of file you are working with, each computer file has what is called the *file header*, which is the portion of the file that tells the computer what the file is, what program created it, the date it was created, and so on. Although the files themselves can easily go back and forth between various computer systems, the file headers do not always work properly. When you double-click on a file, the computer reads the header and attempts to guess what to do with the file. Sometimes it guesses wrong. If you have trouble opening a file, open it within the application.

Once an image file is downloaded to your computer and opened, digital imaging software can be used to change size, colors, contrast, and other image characteristics. Software can also be used to drastically alter and/or combine images or to create a new image that did not previously exist in reality.

THE LENS SYSTEM AND EXPOSURE

The heart of the digital camera is its lens, which is made of optical-quality glass shaped to bend light rays to form an image. The camera lens system collects light rays coming from a subject in front of the camera and projects them as images onto a sensor at the back of the camera. In this way, the lens gathers enough light to make an exposure in only a fraction of a second. Without a lens, an exposure could be several minutes long, and it would not form a sharp image. The lens also determines the field of view and influences the depth of field in the scene.

A similar effect, known as a *mirage*, can occur naturally. For instance, people standing on the shore of Lake Erie in Cleveland have been known to see the distant sweep of the Canadian shore some 50 miles away. This is the result of an atmospheric inversion, which can happen when a layer of cold air blanketing the lake is topped by layers of increasingly warm air. At such times, the light filtering through these layers from across the lake may bend, forming a lens that creates the illusion of distant objects. The air has to be extremely calm for the mirage to appear; if the wind blows, it distorts or dissolves the image.

APERTURE

A key component of the lens system is the aperture, which is an opening created by an adjustable diaphragm, usually an overlapping circle of metal leaves. The aperture determines the amount of light entering the lens, and on most cameras it can be controlled automatically and/or manually. When it is widened (opened or stopped up), it permits more light to pass through the lens.

When it is closed (stopped down), it reduces the amount of light passing through the lens. The various sizes of an aperture are called *f-stops*. On most adjustable cameras, the f-stop range for a normal lens varies from about 1.4 or 1.8 to 22. Longer, telephoto lenses usually start with an f-stop around f/4. DSLRs generally have the ability to set the aperture opening at any point in the aperture range of the lens, such as f/8½ or f/13. The selected aperture generally appears inside the viewfinder and/or in the data-panel readout display. The smaller the f-stop number, the larger the size of the lens aperture. Like shutter speeds, each f-stop lets in either twice as much light as the preceding setting or half as much light as the next higher setting. For example, if you open up the setting from f/11 to f/8, the aperture will admit twice as much light into the camera. If you stop down the setting from f/11 to f/16, the aperture will let half as much light into the camera (see Figure 3.18).

APERTURE/F-STOP CONTROL/ SHUTTER CONTROL/EXPOSURE MODES

A camera's built-in light meter automatically determines exposure by selecting a combination of f-stop and shutter speed based on similar situations in the camera's internal database. F-stops, which determine depth of field, also control exposure by letting in greater or lesser amounts of light. The smaller f-stop numbers, such as f/2.8, let in more light, thus requiring a faster shutter speed (for less light) to obtain a proper exposure. On the other end of the scale, the larger f-stop numbers, such as f/22, let in much less light than f/2.8, thereby requiring a considerably longer exposure and thus slower shutter speed. DSLR lenses have f-stops that range, on average, from f/1.2 to f/22. Shutter speeds control exposure by varying the duration of time the shutter is open. Typically, DSLR cameras have shutter speeds that range from 1/4,000 second to 30 seconds. Faster shutter speeds are used to ensure the image is sharp when either the photographer or the subject is moving.

The Aperture Priority mode allows one to choose the aperture or f-stop while the camera controls the

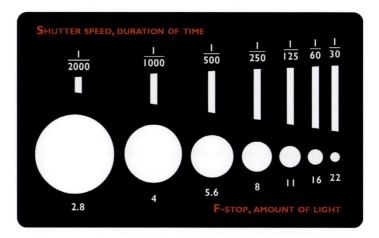

FIGURE 3.18 The relationship between shutter speed, f-stops, and exposure. This illustration shows seven different combinations of f-stop and shutter speed that all equal the same exposure for an outdoor photograph made during a cloudless mid-to-late afternoon day. In any given situation, there are many combinations that can provide an accurate exposure. An exposure of f/2.8 at 1/2,000 second is technically the same as f/22 at 1/30 second, although the resulting images would not appear the same due to the differences in depth of field and shutter speed.

FIGURE 3.19 "This work looks at how humans live with animals, how they define us, and how we define them in relation to us. I explore simulation, consumption, destruction, and reconstruction of the natural world while seeking to understand how the human connection to the rest of nature is often developed through assimilation and appropriation. Under existing fluorescent lights, I squatted to be at the pigs' eye level and opened my lens to the widest aperture so their eyes would be sharp and everything else would fall out of focus."

Credit: © Colleen Plumb. *Meat Packer*, 2003. 30 x 30 inches. Inkjet print.

shutter speed. The Shutter Priority mode allows one to choose the shutter speed while the camera controls the aperture. The Program mode automatically sets both the aperture and shutter speed within user-set parameters, and the Manual mode allows one to set both the aperture and shutter speed. Aperture and shutter settings are controlled through an exposure display in the viewfinder and/or in the data-panel readout display. In the Automatic mode, the camera determines both the aperture and the shutter speed.

DEPTH OF FIELD

Changes in the size of the aperture affect the overall sharpness of the picture. As the aperture becomes physically smaller, the area of sharpness in front of and behind the point of focus becomes greater. This area of acceptable sharpness is called *depth of field* (see Figure 3.20). It extends from the nearest part of the subject area in focus to the farthest part in focus. A small aperture, such as f/11 or f/16, gives more depth of field than a

large aperture of f/2. For example, a landscape photograph made with a small aperture, f/16, will have great depth of field, bringing subjects both in the foreground and in the background in focus. As you open up the aperture, the area in focus becomes shallower. At f/2 or f/4, the subject will be in focus, but objects in the foreground and background may be soft, not in sharp focus. For instance, a close-up photograph of a person's face may have a shallow depth of field (with the background behind the person visible but out of focus).

Digital cameras that are not full frame have smaller image sensors and smaller lenses than 35mm film cameras. The smaller sensors and lenses tend to create a much smaller *circle of confusion*, which is the circle of light formed by the lens in which the light rays are unfocused. The smaller the digital sensor, the smaller the circle of confusion, and therefore the smaller the area with unfocused light rays. This can make it almost impossible to obtain a shallow depth of field (the range of distance between the nearest and farthest points from the camera

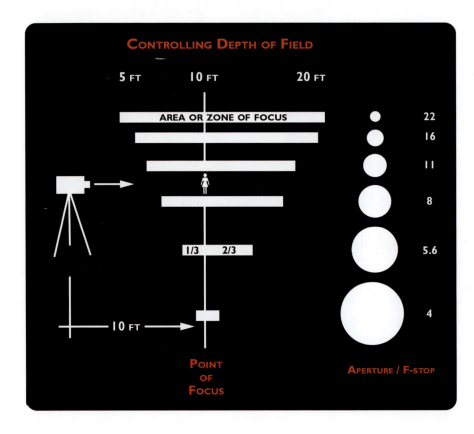

FIGURE 3.20 Depth of field and the zone of focus. Focusing on a subject creates a "point of focus," which is always in focus regardless of the f-stop or aperture used. The point of focus begins a zone of focus, which is the inherent depth of field that radiates from that point, falling both in front of and behind the subject. This figure shows that the zone of focus is not evenly distributed from the point of focus (10 feet) but is distributed one-third toward the camera and two-thirds behind the point of focus (the subject). Moving the camera closer to the subject causes the zone of focus to shrink at all f-stops.

BOX 3.4 HINTS TO CONTROL DEPTH OF FIELD

To make images with limited depth of field, get very close to your subject (2–4 feet) and use the large f-stops, such as f/2, f/2.8, f/4, or f/5.6. This will put the background out of focus, thus emphasizing the main subject.

To make images with extended depth of field, move back from the main subject (8–15 feet) and use the small f-stops, such as f/8, f/11, f/16, or f/22. All subjects within this zone of focus will visually relate to one another because of their equal prominence.

Remember: To maintain proper exposure when adjusting the f-stop in Manual (M) mode, be sure to change the shutter speed. Use Aperture Priority (AP) mode when experimenting with apertures.

Hold the camera absolutely still when using f/16 or f/22, as the shutter speed may drop below 1/30 second and any camera movement will affect overall sharpness.

Use post-capture software to alter the depth of field.

FIGURE 3.21 Levinthal tells us: "My goal is to re-visit iconic works from both history paintings and photographs that have been etched into our popular and historical culture. I rely on focus, lighting, and the composition of the figures in the diorama or scene that I have constructed as opposed to any post-camera methods other than slight color corrections. I try to get viewers involved by using their visual memory. I tell people that there is less in my photographs than meets the eye. For instance, in the John F. Kennedy assassination based on the Abraham Zapruder 8mm film, Jackie Kennedy's hat and the flag on the front of the car give you the information you need to identify the scene. You knew where you were. You don't need anything else."

Credit: © David Levinthal. *Dallas 1963*, 2013. 61½ x 79¼ inches. Inkjet print.

FIGURE 3.22 In his series *Folded in Place*, John Mann deconstructs maps and then reconstructs the fragments to redefine places he has not yet experienced. "The resulting constructions use elements of sculpture, drawing, and mapping to further abstract the mapped landscapes. But these constructions were made only for the camera, using a single vantage point that mimics the aerial or distanced view. Natural light was combined with low-tech artificial lights (clip lamps and table lamps) to isolate and emphasize specific areas."

Credit: © John Mann. *Untitled (To France)*, from the series *Folded in Place*, 2009. 24 x 30 inches. Chromogenic color print.

that is rendered acceptably sharp). For instance, many digital cameras make it extremely difficult to create the soft-focus background that is *de rigueur* in portraiture and nature photographs. To attempt shallow depth of field, use your lens's longest focal length and largest f-stop possible. The smaller image sensors and lenses of inexpensive and proconsumer digital cameras will dramatically increase the depth of field, which can make a digital f/4 the equivalent of f/22 on a 35mm film camera. This can be controlled with post-capture software applications and filters, such as Lens Blur or Tilt-Shift (see the section "Digital Filters and Plugins" in Chapter 4).

F/22 or smaller gives the greatest depth of field, often referred to as *extended depth of field*. All subjects within

this zone of focus will be sharp, with equal prominence, and thus will visually live within the same contextual space. F/2.8 or larger gives the shortest depth of field, referred to as *limited depth of field*. A short or limited depth of field helps isolate a subject from the background or foreground, giving it more visual emphasis. (See Box 3.4).

LENS FOCAL LENGTH

What Focal Length Establishes

Lenses are described by their focal length, which is the distance in millimeters (mm) between the lens and the plane of the image it forms on the sensor or film when it is sharply focused at infinity (the farthest

possible visual distance). The lens's focal length determines the magnification, that is, the size of the image that the lens forms, and thus the angle of view—how much of a scene a lens sees. This controls what a camera may capture, though the extent that is actually recorded depends upon the size of the sensor or film. The greater the focal length of a lens, the greater its magnification and the smaller its angle of view.

The Focal Length Rule

Increasing the focal length of a lens—using a "longer" lens—causes an increase in magnification and a decrease in angle of view. This results in the object becoming larger in size relative to the overall image. Focal length also affects perspective. As the focal length and magnification of a lens increase, the image depth becomes more compressed, resulting in less distinction and visual separation between the foreground, middle ground, and background.

35mm Film Camera Equivalencies

Frequently one sees 35mm film camera lens equivalencies given to digital camera lens focal lengths (see the following section "Calculating Lens Equivalency for Digital Sensors"). The roots of this trace back to 1925, when Ernst Leitz GmbH introduced the Leica (Leitz camera), the first popular handheld camera to use 35mm roll film. These German cameras utilized existing 35mm motion picture film to produce a 24 × 36mm recording area between the film's sprocket holes. Historically, this 24 × 36mm image area has been used to determine the angle of view or look associated with any normal, wide-angle, or telephoto lens used with the traditional 35mm film camera (see the section "Types of Lenses" later in the chapter).

Angle of View

In most digital cameras, the image sensor is smaller than the 24 × 36mm recording area of a 35mm negative. This makes the relative focal length of the camera lenses numerically longer (more telephoto) than their film camera equivalents, which changes the expected angle of view or look historically associated with each lens. For example, in 35mm photography, a 50mm lens, with an angle of view of about 47°, is considered to be the "normal" lens. However, if your digital camera has an image sensor that is smaller than the customary 24 × 36mm recording area, on the DSLR the 50mm lens effectively becomes more telephoto, creating a smaller angle of view (see the next section). Camera manufacturers do produce full-frame DSLRs whose image sensors are equivalent to the 35mm film size, making their angle of view the same as that of 35mm film cameras. However, these cameras are expensive.

Calculating Lens Equivalency for Digital Sensors

Unless the image sensor in your digital camera is a full-frame 24 × 36mm, the image area covered by your lens will differ from that of a lens of the same focal length on a 35mm film camera. The smaller sensor size of most digital cameras gives them a narrower angle of view with the same focal-length lens, making the lens more telephoto by essentially cropping (reducing) the area covered. When the sensor is not full frame, the focal length of a film camera lens is effectively increased by a specific factor (X) that is determined by the size of the sensor. This factor, known as the *crop factor* (a.k.a. the field-of-view factor, picture angle factor, and focal-length multiplier), has been developed to provide a lens focal-length equivalency between the historical 35mm film format and any size digital sensor. By multiplying the crop factor by the 35mm film-camera lens size, you can determine the equivalent focal length of the lens when used on a particular digital camera. For instance, a 50mm film camera lens combined with an image sensor having a crop factor of 1.6 becomes the equivalent of an 80mm lens (50 × 1.6 = 80) on a digital camera. As there is no standard sensor size, the angle of view at any given focal length may vary from camera to camera. The same 50mm lens combined with an image sensor that has a crop angle factor of 1.5 becomes the equivalent of a 75mm lens (50 × 1.5 = 75) on that camera. Specific camera/lens equivalencies can be found online at sites such as www.pointsinfocus.com/tools/

TABLE 3.1 Angle of View Equivalency Table

Angle of View	35mm Film SLR	DSLR (1.6X)
(114°–94°) Super-Wide Angle	14mm–20mm	8.7mm–12.5mm
(84°–63°) Wide Angle	24mm–35mm	15mm–21.8mm
(47°) Normal	50mm	31mm
(28°–8°) Telephoto	85mm–300mm	53.1mm–187.5mm
(6°–3°) Super Telephoto	400mm–1000mm	250mm–625mm

depth-of-field-and-equivalent-lens-calculator/#fmt= 13&ap=8&fl=50&dst=10&u=us.

Based on 35mm film-SLR lens standards, Table 3.1 shows the focal length of lens needed to maintain the same angle of view with a DSLR having a crop factor of 1.6X. Check the manual for your camera's exact sensor size, which will allow you to determine the proper crop factor. The same crop factor will apply to any older film camera lenses that can be used with your DSLR. For example, suppose you want to determine the digital equivalency of a 24mm wide-angle film lens that is compatible with a DSLR having a crop factor of 1.6. To do so, you multiply 1.6 by 24mm and discover that the lens now becomes the equivalent of a 38mm lens on this digital camera, giving it a narrower angle of view and thus a more telephoto effect. Check your camera's manual for exact details.

To calculate the focal length of the lens you would need on your DSLR to create the same angle of view as the 24mm film lens did on a 35mm camera, you divide 24mm by 1.6, which shows that a 15mm lens is required. Table 3.2 shows some typical angles of view used in 35mm photography and the focal lengths of the lenses needed to achieve those views with either a 35mm SLR or a DSLR (assuming a 1.6X crop factor).

When a lens from an SLR film camera is used on a DSLR camera, what is seen in the viewfinder is directly captured by the digital sensor. Since what you see is what you get, there is no need to mentally crop the picture. However, you will notice that the angle of view or the look is different from that achieved with a 35mm camera. Also note that an SLR lens may not support a DSLR's automatic functions.

TABLE 3.2 Focal-Length Conversion Table

35mm Film SLR		DSLR (1.6X)
14mm–20mm	=	22mm–32mm
24mm–35mm	=	38mm–56mm
50mm, Standard	=	80mm, Standard
85mm–300mm	=	136mm–480mm
400mm–1000mm	=	640mm–1600mm

FOCUSING THE IMAGE

In addition to concentrating the incoming rays of light, the camera lens serves to focus them on the image plane (sensor or film). As light rays pass through the aperture into the camera, the lens bends them so that they form a sharp image. The sharpness of the image depends on the distances between the object and the lens and between the lens and the sensor. DSLRs have a focusing control that changes the lens to sensor distance, either automatically and/or manually, thereby allowing a sharp image of the subject to be formed at various distances. Inexpensive cameras may have a fixed focus or zone control that sets the focus for predetermined close-up, portrait, or landscape distances. With a manual focus camera, you select the part of the scene you want to be sharpest and adjust the lens barrel to obtain that result.

DSLR cameras use ground-glass viewing screens to show how your picture will appear. Light coming through the lens strikes a translucent piece of ground glass, which creates a surface for the photographer, looking through the viewfinder or monitor on the back of the camera, to see and focus an image. The lens barrel can be automatically and/or manually controlled until

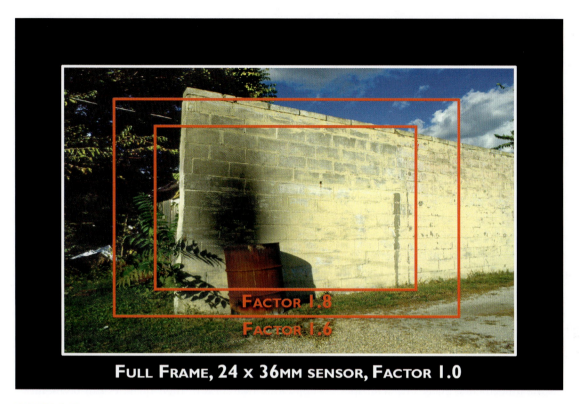

FIGURE 3.23 Image factors sensor equivalency: Full-frame image sensors compared with smaller image sensors. The white rectangle shows what a full-frame DSLR or 35mm film camera will capture. The inner red frames show what a DSLR having a smaller digital sensor and corresponding image factors of 1.6X and 1.8X will record. This factor (which can be found in your camera manual) is sometimes called the crop factor, though no cropping is involved. The angle of view visible in the camera viewfinder may not precisely show what the camera actually records.

the image appears at the desired level of sharpness. Ground-glass focusing can be aided by a microprism, a small circle in the center portion of the viewfinder that appears dotted until the image is focused. Sometimes a split-image focusing aid is used instead, whereby the image appears to be slightly out of register until it is focused. Mirrorless cameras, which do not have a mirror reflex optical viewfinder, rely on the digital image sensor to provide an image to an electronic viewfinder (EVF) of what the lens sees. Rangefinder cameras, which rely on split-image focusing, operate by superimposing two images of the same scene.

AUTOFOCUS MODES

The majority of DSLRs have two focusing modes: Manual and Autofocus (AF). Most DSLRs have either an active (infrared) or a passive autofocus system. Active autofocus sends out a beam of red light that the camera uses to measure and set the distance of the subject. Passive autofocus, which automatically focuses on objects at a certain distance from the lens, uses light that is naturally reflected by the subject to read the contrast of a scene and set the focus. Some cameras have an eye-activated autofocus system. Move your eye to the viewfinder and the camera focuses on whatever it is pointing at, based on your AF zone selections (see below), which can be turned off to prevent it from focusing every time something is near the viewfinder.

DSLRs usually have a variety of autofocusing zones. In single-area focus, the camera focuses on a subject in the selected area only; in area focus, the camera uses information from multiple focus areas to determine the focus; and in closest-subject focus, the camera automatically selects the focus area that has the subject closest to the camera. Pressing the shutter release button

halfway down will lock autofocus at a specific distance. Autofocus options often include Single-servo and Continuous-servo focus settings. Single-servo locks the focus at the time of exposure. Continuous-servo allows the camera to focus constantly while the shutter release button is pressed halfway, which is useful when photographing moving subjects. The downside of continuous focus is that it drains the battery faster and can be noisy. DSLRs offer an AF Assist Lamp, which flashes a small amount of light as a focusing aid, allowing the autofocus to function in low-light situations. Some cameras have specialty modes, such as face detection (FD), which gives precedence to the faces in an image, ensuring that they come out looking crisp and well lighted. The camera can pick out faces in a scene and is not thrown off by eyeglasses.

TYPES OF LENSES

The lens defines the fundamental image characteristics of magnification, angle of view, and perspective; hence, lenses are designed for a variety of purposes. A change in focal length allows you to come closer to the subject or to move away from it, and therefore also has an indirect effect on an image's perspective. DSLR cameras typically use interchangeable lenses. Inexpensive cameras, such as in smartphones, often have fixed focal-length lenses, but the vast majority of all digital cameras come with either an interchangeable or fixed zoom lens that allows the focal length to be varied. Many cameras will accept aftermarket auxiliary lenses (products made to replace original manufacturers' equipment).

ZOOM LENS

In pre-digital times, most cameras came with a fixed-focus lens, which required a photographer to change location in order to adjust the distance between the camera and subject. Today, most digital cameras have a zoom lens that covers the physical distance by combining a range of focal lengths within a single lens, providing coverage from wide angle to telephoto. When shooting film, photographers were aware of the camera's angle of view and thus the corresponding focal length of the lens they were using. With the varying sensor sizes of digital cameras, little attention is paid to focal length, due to the lack of a standard formula for focal length to angle of view. Instead, we simply adjust the focal length as we compose the scene.

In the past, conscientious photographers wrote down exposure information to learn what combinations of film, lens, aperture, and shutter speed worked best for them in specific situations. Today, digital cameras show this information in the data display. Now, exposure information is recorded automatically—lens focal length, aperture, shutter speed, and other camera functions—for later reference (see the section "Metadata/EXIF" later in the chapter). Yet this abundance of data is rarely analyzed because the automatic features on digital cameras can consistently deliver good results in most situations. Nevertheless, the optical characteristics of lenses remain the same as in the past, and having a conscious awareness of their qualities can be useful in making stronger compositions and creating a more personal vision.

NORMAL LENS

In traditional 35mm film photography, lenses with a focal length of 50mm are referred to as "normal" because they work without reduction or magnification to generate two-dimensional images in a manner camera manufacturers considered similar to how humans see a scene with our naked eyes, which encompasses an angle of view of about 47°. The straightforward optical qualities and minimal amount of distortion of a normal lens allow the formation of what was considered a natural photographic representation of the size relationships of the subjects that make up a composition.

A DSLR with a full-frame sensor continues this tradition of using a 50mm lens as its normal focal length. However, since most DSLRs use a smaller-size sensor, a shorter focal-length lens—somewhere in the range of 31 to 38 millimeters—is needed to produce the same angle of view as a 50mm lens on a film camera. The reason is that the smaller sensor multiplies the focal

length of a lens by a crop factor of 1.5X or 1.6X, though this may vary based on the sensor size.

Some digital camera lenses are designed to reduce the size of the image-forming circle as compared with traditional 35mm lenses. The result is a decrease in the telephoto effect, which allows for wider angles of view; also, there is a reduction in a lens's size and weight. For instance, a 12mm digital lens of this design, when used on a camera with a crop factor of 1.5X, would have an angle of view of 99°. Check your manufacturer's website for details.

WIDE-ANGLE LENS

Wide-angle lenses (short focal length) capture a broader view of a scene than a standard lens does by making subjects appear smaller than they would with a normal lens, except in the immediate foreground, where the subject is enlarged and exaggerated. A wide-angle focal length is handy for large scenes and in locations where it is not possible to move back far enough to photograph the entire scene. Wide-angle lenses encourage a photographer to step into the scene to fill the frame. Getting closer to your subject gives the composition a sense of involvement, by placing the viewer inside the action rather than at a distance from it.

Wide-angle lenses capture more subject detail by providing greater depth of field (the area of acceptable sharpness) at any given f-stop than does a normal or telephoto lens. For instance, if you set your zoom lens to its widest focal length, focus on a subject 6 feet away, and stop down to f/11, it should render everything from about 3 feet to infinity in acceptable sharpness. This can be a very effective device in making dramatic near/far compositional relationships. For example, a landscape composition would have both the predominant features in the foreground and a wide expanse in the background sharply in focus. A moderately wide-angle focal length is an excellent starting place for environmental portraiture, compositions of people and their surroundings, because it has broader coverage than a normal focal length and produces minimum distortion, thus allowing both the people and the immediate area to be in critical focus. A wide-angle focal length allows one to photograph in confined interior spaces and to take in multistory buildings. However, one must pay attention to the distortion of straight lines that can occur from "barrel distortion" with wide-angle lenses, which can be corrected (if desired) by careful composition or later with imaging software. An extremely wide-angle focal length offers tremendous depth of field, thus permitting one to get very close to a subject and produce exaggerated size relationships, unusual perspectives (due to distortion), and an intimate viewing experience that can be intentionally used to generate visual interest.

Because most pocket digital cameras have image sensors smaller than the 35mm standard (which enhances the telephoto capabilities of the lens at the expense of reducing wide-angle coverage), an auxiliary wide-angle lens attachment is usually required to achieve wide-angle capabilities.

TELEPHOTO LENS

Telephoto lenses (long focal length) have a narrower angle of view than a normal lens and make subjects appear larger. They also have less depth of field at any given aperture than normal or wide-angle lenses, rendering the subject sharply while the foreground and background are out of focus, thereby making the subject stand out. However, the limited depth of field means that accurate focus is critical. Unlike wide-angle lenses that stretch visual space, telephoto lenses compress space, making subjects appear closer together than they really are. This can be useful in creating visual interest through unusual perspective. On the downside, telephoto lenses magnify lens movement, so they require faster shutter speeds (see Box 3.5) or blurring will result. Telephoto lenses, which tend to be heavy and bulky, are not as fast as other lenses—having a higher starting aperture—and often require a tripod or other support.

A telephoto is useful when it is not possible to get physically close to a subject, allowing photographers to take detailed pictures of distant subjects. A short telephoto focal length is excellent for portraiture.

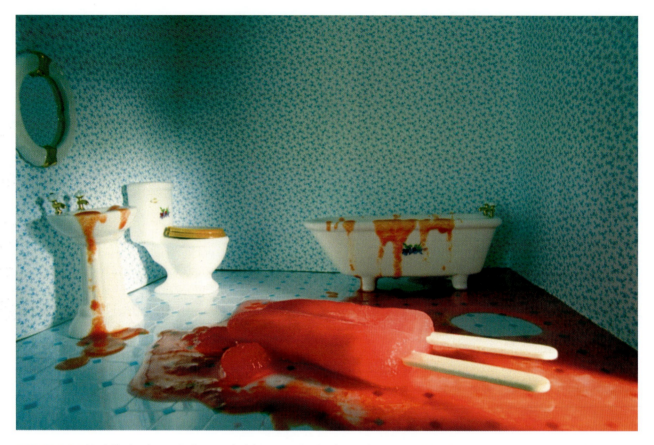

FIGURE 3.24 Mark Slankard says: "I photographed the miniaturized interiors of my sister's old dollhouses with an ultra-wide-angle lens to suggest that they may be intimately occupied by the viewer. The scenes are intended to evoke deep unconscious fears and desires, and explore tensions between childhood innocence and aggression. Gigantisized artifacts, elements, and unseen destructive entities act out against the unassuming environments. These transgressions reference adult anxieties that emerge early in life—desires for power and control; fears of natural disasters; domestic violence; understanding of our own potential for destruction; and the unknowable terrors that threaten to invade the tranquility of our insulated spaces of domesticity."

Credit: © Mark Slankard. *Bathroom with Twin Pop*, from the series *Minor Invasions*, 2005. 12 x 18 inches. Chromogenic color print (Duratran).

It permits a photographer to stand back from the subject and delivers a highly naturalistic rendition of the human face, avoiding the distortion typical of shorter focal lengths, which exaggerate whatever is closest to the lens, usually the nose and chin. Wide-angle focal lengths also tend to stretch the shape of the human head, giving it an unnatural appearance. A longer focal length is good for tight compositions of small objects because you don't have to be right on top of the subject to fill the frame. The extra working space also leaves room for the placement of artificial lighting or the use of flash. A longer focal length is commonly used to capture close-range sports action. Wildlife photographers regularly use extremely long focal-length lenses to make close-up views of distant animals.

SPECIAL-USE LENSES

A macro lens, which is used in extreme close-up photography, focuses on subjects from a close distance, often allowing small subjects to be photographed 1:1 (capturing a subject so that it can be reproduced life size). Most digital cameras have a Macro mode, which facilitates close-up work (see Chapter 9). An auxiliary macro lens attachment may be needed with some cameras and/or with certain subjects.

FIGURE 3.25 Murai explains he works with an infrared converted DSLR because it "offers an overall luminescence especially with skin tone and fabric, the longer exposure time offers an ethereal feeling of the nun in motion. The 220º circular fisheye communicates an enveloping feel and distorted near-far perspective with extreme depth of field that provides detail from a few inches to infinity and challenges traditional compositional tenets while encouraging spontaneity. The sphere or circle is a symbol that transcends time and is ubiquitous to all ancient religions and cultures. Its harmonious shape has no beginning or end and can symbolize unity, protection, eternity, and harmony. The Tibetan mandala, the megalithic stone circles in Great Britain and the Native American medicine wheels and sweat lodges are synonymous with sacred or consecrated space. The Buddhist practice of circumambulation, the repeated clockwise procession around a sacred shrine, bestows blessings and good fortune and affirms the meditative and healing power of the circle."

Credit: © Richard Murai. *Altar, Interior, The Bayon, Angkor Thom, Cambodia,* 2016. 20 x 20 inches. Inkjet print.

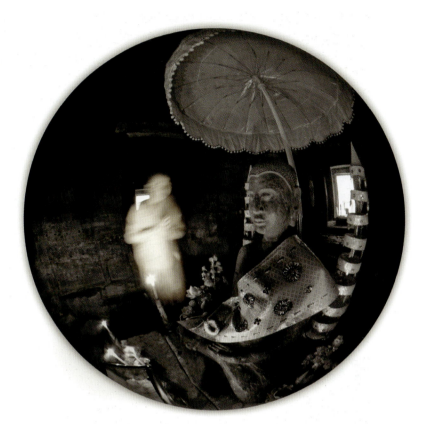

A *fisheye lens* has a super-wide angle of view—up to 180°. It produces tremendous depth of field and extremely exaggerates the differences in size between subjects that are close to the camera and those that are farther away.

A *perspective control lens* shifts up, down, or side-ways to correct for perspective distortion of parallel lines, such as on buildings, which diverge toward each other when the camera is tilted. Such a lens works properly only with a DSLR. An alternative is the website http://tiltshiftmaker.com, which allows you to upload your photographs and apply perspective control and depth-of-field effects. Many imaging programs, such as Photoshop, have robust perspective controls too.

Ultimately, there can be no such thing as a "normal" lens since there isn't just one normality; it all depends on how one sees the world. Some prefer wide-open expanses, whereas others like a tighter, narrower view. Vision is not fixed and can change depending on the subject or the maker's state of mind. When possible, you should experiment by using different focal lengths or physically changing the camera-to-subject distance to see how it affects your composition and the results you desire.

SHUTTERS: ROLLING AND GLOBAL

Along with aperture, the shutter is the other key component of the imaging system, for its speed controls the amount of time that the light-forming image strikes the sensor. Typically, DSLRs allow exposures as long as 30 seconds to as fast as 1/8,000 second in small increments of time, such as 1/60, 1/80, 1/100, or 1/125 second. They usually have a B (bulb) setting, which allows the shutter to remain open as long as the shutter release button is held down. DSLRs may use a combined mechanical and CCD electronic shutter that turns the sensor off and on to control exposure time. Many CMOS sensor cameras use a mechanical or

electronic "rolling shutter" that rapidly scans the entire scene; thus not the entire image is recorded at the same instant. On the other hand, CCD-based cameras often use a "global shutter" that electronically controls the exposure of all the pixels simultaneously, allowing the entire frame to be captured at the same instant. As there are no moving mechanical parts, they are silent. Also, they are capable of producing very fast shutter speeds, allowing them to record fast-moving subjects without distortion.

SHUTTER SPEED CONTROL

Specific shutter speeds can be controlled through the Shutter Priority mode: you choose the shutter speed via the command dial, and then the camera automatically selects the aperture. It can also be set directly in Manual mode. The selected shutter speed generally appears in the data-panel readout display.

As the shutter speed increases, the amount of light reaching the sensor decreases. For example, a shutter speed of 1/125 second lets in twice the amount of light as a shutter speed of 1/250 second and half the amount of a shutter speed of 1/60 second. Slow shutter speeds will allow moving objects to blur, while high shutter speeds can be used to freeze motion.

To avoid blurry images caused by camera shake, follow the *shutter speed rule*: use a shutter speed equal to or greater than the focal length of the lens. For example, when photographing with a 125mm focal length, use a shutter speed of 1/125 second or higher. When possible, stabilize yourself, hold your breath, use a tripod/monopod, and gently depress the shutter.

BOX 3.5 SHUTTER SPEED RULE

Using a shutter speed equal to or greater than the focal length of the lens will help to ensure sharp, shake-free exposures.

SHUTTER LAG

Shutter lag is the time difference between when the shutter is pressed and when the camera actually captures the image, a gap of time that often makes you miss the moment you wished to record. The lag is due to the camera having to calculate the exposure, set the white balance, focus the lens, charge the sensor, and transmit the capture data to the circuitry of the camera for processing and storage. It is more pronounced with smaller inexpensive cameras, whereas high-quality DSLRs have little or no shutter lag. You can avoid this situation by holding the shutter halfway down, giving the camera time to calculate, and depressing the shutter the rest of the way when you are ready to make the capture.

SHUTTER MODES

The shutter may be programmed for different shooting modes. *Single frame* takes one photograph each time the shutter release button is pressed. *Continuous* records photographs at faster rates, such as three frames per second (fps), while the shutter release button is held down. *Self-timer* automatically fires the shutter at a set number of seconds after the shutter release button is pressed, which is good for self-portraits or to reduce camera shake. When in this mode, the camera usually is placed on a tripod or a flat, level surface. Some cameras also have an optional delayed remote-control feature, which controls all the shutter functions with a handheld remote control. Some allow multiple exposures in one image, with the ability to automatically compensate for the multiple exposures. The selected shooting modes appear in the data-panel readout display.

DETERMINING EXPOSURE

Proper exposure chiefly depends on (1) the lighting, (2) the subject, and (3) the desired depth of field. Each of these factors may require an adjustment in aperture size or shutter speed. You need to choose a combination of settings that will meet all your requirements (see Chapter 4).

FIGURE 3.26 The walking sequence was made using the camera's continuous shutter mode during the late afternoon on the winter solstice. "The principal function of the woman in a grid of multiple frames is to draw us into the landscape. We see her through the monoptical eye, the conventions of a moving (digital) camera that follows behind. Layered with the set of walking images is the representation of a kind of parallel, 'perfect' world, in this case the numeric world of the daily Sudoku puzzle, starting at 100 percent opacity in the upper left to 20 percent in the last walking image."

Credit: © MANUAL (Suzanne Bloom and Ed Hill). *Solstice 12.21.05/ Daûy Sudoku 12.2105*, 2006. 34½ x 35¾ inches. Inkjet print. Courtesy of Moody Gallery, Houston, TX.

The amount of light in a scene affects both shutter speed and aperture size. On a cloudy or overcast day, you would reduce the shutter speed and increase the f-stop. On a bright, sunny day, you would use a fast shutter speed and a small aperture.

The type of subject to be photographed may require an adjustment in the shutter speed, and depth of field may determine the aperture size. If the subject is moving, you must increase the shutter speed to stop the action unless you want it to blur. If you want greater depth of field in your photograph, you need to select a small aperture.

If you adjust either the shutter speed or the aperture size, you must also adjust the other setting to maintain the proper exposure. Think of it as a balancing scale. A fast shutter speed stops the action, but also reduces the light reaching the sensor. To make up for this reduction in light, you should increase the f-stop. Similarly, a small aperture increases depth of field but reduces the amount of incoming light. Therefore, you should change to a slower shutter speed.

Suppose you want to photograph your dog on a sunny day. A suitable exposure might be a shutter speed of 1/125 and an aperture of f/11. If your dog is moving and you wish to freeze the dog's movement, you might increase the shutter speed to 1/250. This speed is twice as fast as 1/125, so half as much light will reach the digital sensor. You should make the aperture twice as large by setting it at f/8.

You may want the photo to include a bone on the ground in front of your dog and also the bushes in the background. To make sure these extra subjects are in acceptable focus, you can increase depth of field by reducing the aperture size. At a setting of f/16, the sensor will receive half as much light as it did at f/11. You should also change the shutter to the next slowest speed, doubling the length of the exposure time. At a slow shutter speed, however, movement by your dog or the camera may cause blurring. A better option in this situation might be to retain the faster shutter speed and increase your ISO setting. For details, see Chapter 4.

DIGITAL CAMERA FEATURES

RESOLUTION AND PRINT SIZE

A key factor to consider when selecting a digital camera, after optical quality, is resolution, which is measured in millions of pixels, known as *megapixels*. Resolution is the sensor's ability to sharply record the smallest details in your composition.

The resolution of digital cameras is determined by the number of pixels produced by the sensor's light-sensitive cells that convert light into electrons (based on the quality of the lens). On the camera's sensor, a sensel (photodiode) records the red, blue, or green brightness of the light that hits it. Each sensel is then interpolated with its eight neighbors through a demosaicing algorithm to create one pixel in the image file. This process reconstructs a full-color image from the incomplete color samples output from an image sensor overlaid with a color filter array (CFA).

The greater the number of pixels produced, the higher the resolution. For instance, a resolution of approximately 6000 × 4000 indicates that the digital camera produces images at a maximum of 6000 horizontal pixels by 4000 vertical pixels, or 24 megapixels, compared with about 20 million pixels calculated for 35mm color transparency film (24 × 36mm).

Digital camera manufacturers have adopted the 35mm full-frame film proportions to facilitate comparing their digital sensor size to this common film size. Furthermore, camera manufacturers have set no common standard as to the number of megapixels required, nor are there any standards that set the actual size of the individual pixels contained within their chosen sensor size to make the best high-quality images.

That said, image quality is also affected by the following: (1) the size of the digital sensor measured in millimeters, (2) the actual size of the digital pixels measured in microns—1.5 is average, larger is better—and (3) the lens's optical quality.

Additionally, subject matter and personal taste play a big role in deciding what size to make a print. For instance, a picture of clouds in the sky can go quite large if it does not rely on fine detail for its image quality. On the other hand, a head and shoulders portrait cannot go quite as large, where a slight softening of the subject's feature is often welcome. Alternatively, a corporate photograph of its employees standing in front of a building would likely follow the guidelines in Table 3.3, as detail is critical since everyone is going to want to see their face. So how large can a file go and look good? Professor Edward Bateman tells his students:

Set up the image size to the dimensions you want and then turn on the rulers. Zoom in until the inches in the ruler are about actual size and get your eyes very close to the screen (6 inches). Does it look good? Then you will probably be happy with your print. Kind of crazy, but there is no math required and it seems to work for just about everyone.[2]

Squeezing more pixels into a smaller-sized sensor has an adverse effect by increasing noise. Manufacturers

TABLE 3.3 Camera Format

Camera Format in MP Resolution*	Sensor Size (mm²)**	Optimal Print Size at 300 PPI***
10 Smartphone Small & variable resolution	6 × 4 (25)	7 x 11 inches
20 Four Thirds, compact Medium & variable resolution	17 × 13 (225)	8 × 12 inches
25–36 Full frame, DSLR Large—6000 w × 4000 h	36 × 24 (864)	11 x 15 inches
100 Medium format Best—8272 w × 6200 h	44 × 33 (1433)	Large as desired
500 High-end Medium format Ultimate—11600 w × 8700 h	53 × 40 (2120)	Large as desired

*No industry standards. **Rounded up to the nearest millimeter. ***Standard commercial photographic quality.

engage in a constant balancing act between cost, sensor size, and number of pixels. Fewer pixels in a larger sensor size will always create less noise or unwanted artifacts. This advantage is always offset by an increase in cost.

Ultimately, most of today's cameras have enough resolution so one can crop and/or make high-quality enlargements for most needs, permitting you to select a camera on its personal fit and other features.

Table 3.3 provides the camera format, resolution, and sensor size.

MONITOR

Most digital cameras have a monitor in the back of the camera that shows the image on which the lens is focused. Some monitors can be moved in a variety of positions, thus increasing the framing options by letting you compose while holding the camera above your head or below your waist. When not in use, the monitor can be kept clean and protected with a detachable, transparent monitor cover. Some digital cameras have both a monitor and an optical viewfinder. Others have only a monitor or an electronic viewfinder (see Chapter 4).

Compact and super-zoom cameras and some DSLRs have a "live" monitor that is active whenever the camera is turned on. This allows you to compose an image without using an optical viewfinder, which has been eliminated on many cameras. It also lets you see previously recorded images in the camera's memory card, so you can review your work as you make it. Older DSLR monitors are not live view and allow one to see only previously made exposures. However, an after-market live screen can be added to the eyepiece of older DSLRs. Most newer models offer the live-view option.

Composition guidelines can be displayed in the monitor and/or in the viewfinder. These thin horizontal and vertical lines make it easier to compose and/or to hold the camera level. Monitors can quickly drain batteries; therefore, many DSLRs have a battery-saving option control that allows you to turn off the monitor or to program the length of time the monitor stays on.

Video screens, whether in cameras, smartphones, laptops, tablets, or electronic billboards, have become de facto windows of the digital age, and many people prefer using the screen to compose their images. Instead of peering through the keyhole of a viewfinder, you are able to use the monitor and hold the camera at arm's length, which invites more interaction with the subject while promoting more opportunities for creative compositions. On the downside, some monitors—such as liquid crystal displays (LCDs)—can be difficult to see in bright light or at certain angles; they use a great deal of battery power and are not an accurate guide of color, tonal values, or focus. Organic light-emitting diode (OLED) screens are brighter, but more expensive. In the end, choosing between an optical viewfinder or a screen comes down to a matter of personal preference, what products are available in your price range, and the type of picturemaking situation you find yourself in (see the section "Using a Camera Monitor" in Chapter 4).

MONITOR PLAYBACK MODE AND HISTOGRAM

The monitor can display an image both while it is being recorded and afterward when the playback button is pressed. The Playback mode offers other options, such as viewing all the images on the memory card as well as all the shooting data, from exposure information to image size, plus the histogram of each image. A histogram is a graph that shows the distribution of the tones in the image, known as *brightness range* (see Chapter 4, Figure 4.4), by sorting the image pixels into 256 levels of brightness from black (value 0) to white (value 255) with 254 gray levels in between. The horizontal axis bar, which is one pixel wide, corresponds to pixel brightness, with shadows to the left, midtones in the center, and highlights to the right. The vertical axis bar shows the number of pixels for each level of brightness in the image. The monitor allows for single-image playback and multi-image thumbnails, typically in groups of four or nine images. There are controls that allow you to zoom in and enlarge an image. Selected images can be deleted and/or protected from erasure. See Chapter 4 for details about how to use the camera monitor to help determine proper exposure.

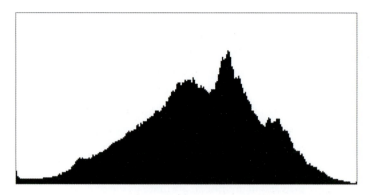

FIGURE 3.27 Luke Strosnider relates: "Observing how digital photographers evaluate the quality of their images by looking at the histogram to see the distributions of highlights, shadows, and mid-tones brought to mind Ansel Adams's Zone System. Then my thoughts turned to the language of histograms—the 'peaks,' 'spikes,' and 'valleys' that compose these small charts. In them I saw landscapes, and I began to connect them to Adams's love of natural form and photographic technology. I acquired a book of Adams's favorite images, scanned the images, and evaluated the histograms, looking for a variety that alluded to a simple, graphic landscape form. Using screen capture, I 'grabbed' the histograms and then reopened them in Photoshop, where I resized them to a suitable print quality. Lastly, I paired the histogram with the title of its original Adams image and added '(2006)' to the ends of the titles to denote that this was a contemporary re-envisioning of Adams's work. Digital technologies have not only changed the way photographs are made and how photographers work, but they've given us new tools with which to reinterpret the history and aesthetics of the medium. The works of the past are not finished; new interpretations are waiting to be made. Digital technologies continue to influence the way photographers work today; so too can they change the works of past imagemakers."

Credit: © Luke Strosnider. *Dune, White Sands National Monument, New Mexico, circa 1942,* from the series *Ansel Adams/New Landscapes,* 2006. 11 x 17 inches. Inkjet print.

Various camera menus also can be displayed. These include the Setup menu for basic camera programming, including formatting of memory cards and setting the date and time; the Shooting menu, which controls such functions as noise reduction and image optimization; the Custom Setting menu, which controls the fine details of the camera's operation, from grid display to whether the camera makes a noise when the shutter is depressed; and the Playback menu, which offers options for managing the images stored on the memory card and for playing back pictures in various formats, such as automated slide shows. The monitor can be programmed to turn off automatically to save battery power.

METADATA/EXIF

Metadata (a.k.a. shooting data) describes the data recorded by the camera that gives details about the shooting conditions for each exposure. It is attached in a file that uses an industry standard awkwardly known as the EXIF (Exchangeable Image File). Typically, metadata records such shooting information as the time stamp, aperture and shutter speed, lens focal length, sensitivity, white balance, and whether the flash was

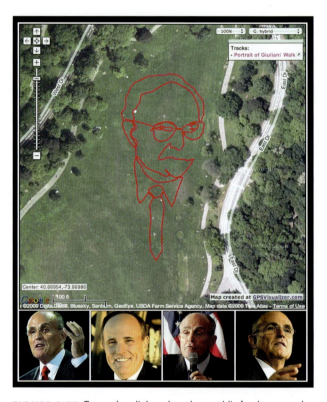

FIGURE 3.28 To spark a dialog about how public funds are used to support the arts and make visible the often-unseen influence of politicians on the practice of art, collaborators Nate Larson and Marni Shindelman created this portrait of former New York City Mayor Rudy Giuliani. They used GPS mapping devices to make large-scale drawings that reference the history of the selected site. In this case, Brooklyn's Prospect Park was chosen due to its proximity to the Brooklyn Museum, the venue of the 1999 *Sensation* exhibition that Mayor Giuliani tried to defund because of the controversy over Chris Ofili's *The Holy Virgin Mary.* As Larson and Shindelman walk the drawing, a GPS tracking device relays their real-world coordinates to a Web interface, and the drawing is built segment by segment from their movements and conveyed to the Web in real time.

Credit: © Nate Larson and Marni Shindelman. *A Portrait of Rudy Giuliani,* 2009. Variable dimensions. Digital file.

used, as well as the camera model and serial number. Most cameras allow you to add keywords, copyright, GPS coordinates, and other information useful when later searching for files. Metadata can usually be accessed via the Playback mode in the monitor after each exposure and later during image processing.

OPTICAL AND DIGITAL ZOOM

Digital cameras are equipped with optical zoom, digital zoom, or both. Optical zoom physically magnifies the subject by moving the lens elements to the desired magnification. Regardless of whether the zoom is set at wide-angle or telephoto settings, the resolution of the image remains the same.

Digital zoom electronically crops and enlarges an image by increasing the number of pixels until the desired magnification occurs. This is done using interpolation, which is a set of mathematical algorithms applied automatically when the original pixel dimensions are changed for resizing. For instance, a 10,000-pixel image can be increased to 20,000 pixels by generating additional pixels using the average of the value of the two pixels on either side of the one to be created. Unfortunately, this results in the loss of surrounding pixels and decreased resolution, and degrades the overall image quality because the program "guesses" or makes up information that was not in the original image capture.

DIGITAL ISO/SENSITIVITY

Digital cameras use the International Standards Organization (ISO) designation to describe sensitivity to light and the resulting effect on an image. Typical ISO numbers are 50, 100, 200, 400, 800, 1600, 3200, 6400 and so on. The higher the ISO number, the more sensitive the CCD is to light, allowing pictures to be made in low-light conditions without a tripod or flash. However, increasing the ISO amplifies digital noise (see the next section).

To compensate for varying light levels, digital cameras adjust the electrical gain of the signal from the sensor. Increasing the gain amplifies the power of the signal *after* it has been captured on the image sensor. The ISO can be changed from frame to frame. For example, one frame can be exposed outside at ISO 100 while the next frame may be exposed indoors at ISO 800. ISO can be selected manually, or the camera can automatically vary the sensitivity to ensure proper exposure and flash levels.

DIGITAL ABERRATIONS: NOISE, BANDING, BLOOMING, AND SPOTS

Increasing the ISO has side effects. The higher the ISO setting, the greater the likelihood that pictures will contain "noise" in the form of randomly spaced, brightly colored pixels. Digital noise occurs most often in brightly lit or dark scenes where some pixels function incorrectly, resulting in "dead" or "hot" pixels. Dead pixels lack all color, whereas hot pixels are bright white. Using a high ISO or working in dim light may degrade the image quality with noise. Noise is a factor with all digital cameras, but it is reduced with higher-quality cameras. Many digital camera manufacturers suggest turning off "image sharpening" features, as they will exacerbate the noise problem (see the later section "Sharpening Mode"). Imaging software programs usually have a Noise filter that can help reduce noise by discarding pixels that are too different from adjacent pixels. On the flip side, such aberrations can be become a resource for innovative artistic effects.

Banding—unpredicted bands that appear in areas with no detail—is also more likely to occur at a higher ISO. Overexposure may cause blown-out highlights that lack all detail and have spread into adjacent image areas, a defect known as *blooming*. Bracketing and exposure compensation are recommended to keep blooming in check. Most DSLRs can be custom programmed to automatically carry out these tasks.

DSLR cameras are designed for use with interchangeable lenses, and foreign matter can enter the camera when lenses are changed. Once inside the camera, such detritus can adhere to the sensor or its low-pass filter, which is designed to help prevent moiré

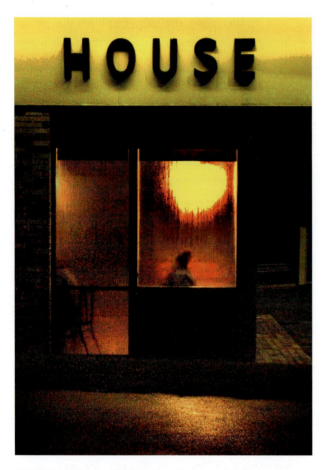

FIGURE 3.29 Joe Mills shares that his process is "akin to an archeological dig, an archeology of the moment where thought is lifted, and succumbs to the almost meditative task of uncovering what is unknown to you. Dictation, preconception, preference, all fall by the wayside, deferring to chance and accident as the driving force, the artist simply the first observer of what is uncovered. What is found, its coherence is stunning, for what should be chaos is anything but. One is left only to marvel at the 'edge of horror and beauty' encountered, as it continually maintains its mission, revealing the deeper truths lying just below that dusty surface." In terms of attitude, Mills does "whatever is necessary, without hesitation, to bring 'It' to its fullness as an image."

Credit: © Joe Mills. *House*, 2016. 13 x 19 inches. Inkjet print.

(an interference pattern of irregular, wavy lines). Dirt can adhere directly to the sensor and may appear as spots in images taken under certain conditions. Some cameras have a built-in cleaning system that helps reduce this problem. Such spots can be eliminated with imaging software. To reduce the chance of this occurring, turn off the camera and point it down when changing lenses, try not to change lenses in dusty conditions, and use a clean body cap when there is no lens attached to the camera body. Sensor cleaning kits, usually containing methanol, are available. Check your camera manual for specific cleaning instructions.

WHITE BALANCE

Digital cameras can automatically or manually adjust the color balance of each frame electronically, according to the color temperature of the light coming through the lens. Known as white balancing, this procedure adjusts the camera's light filtering system to accurately record RGB colors so that white in a scene appears white, without any color cast. One image can be white balanced for daylight, whereas the next one can be white balanced for incandescent (indoor) light. Better cameras have a larger variety of settings for different lighting sources, which can include any of the following: Auto, Daylight, Incandescent, Fluorescent, and Cloudy white balance controls (see Table 3.4). High-end digital cameras also offer white balance bracketing for mixed lighting sources. Learning how to adjust and control the white balance can mean the difference between capturing a spectacular sunset or having the camera automatically "correct" it down to gray sky.

METERING MODES

DSLRs have outstanding metering capabilities and options. Most offer metering options of *Matrix*, which uses the sensor to set exposure based on a variety of information from all areas of the frame and is effective where the composition is dominated by bright and dark areas; *Center weighted*, where the camera meters the entire frame but assigns the greatest weight to the center area, which is excellent for portraits; and *Spot*, where the camera meters a small circle (about 1 percent of the frame), which is helpful when the background is much brighter or darker than the subject. In particular modes, such as Aperture or Shutter Priority, the metering mode determines how the camera sets the exposure. In certain programs, such as Closest Subject, the camera selects the metering mode.

TABLE 3.4 Common Digital White Balance Controls

Control	Description
Auto	White balance is automatically measured and adjusted.
Custom	White balance is manually measured and adjusted in the same lighting as the subject (a gray card is recommended as a target). This control is useful under mixed-light conditions.
Daylight	Preset for daylight. Subsets let you make the image either more red (warm) or blue (cool).
Incandescent	Preset for incandescent (tungsten) light.
Fluorescent	Preset for fluorescent light. May have subsets for FL1 (white), FL2 (neutral), or FL3 (daylight) fluorescent lights. Check the camera's owner manual for the correct setting designations.
Cloudy	Preset for cloudy or overcast skies.
Shade	Preset for shade.
Flash	Preset for flash photography.
Bracket	Makes three different white balance exposures (selected value, reddish, and bluish).

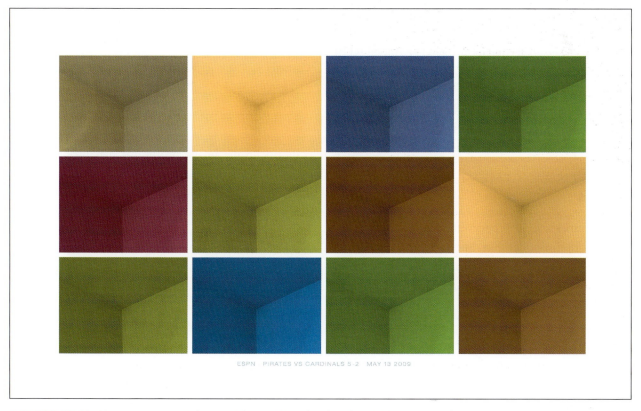

ESPN PIRATES VS CARDINALS 5-2 MAY 13 2009

FIGURE 3.30 Rita Maas ruminates on Italian artist Giorgio Morandi's claim that "Nothing is more abstract than reality." Maas's series *Reality TV* explores the relationship between our compulsion to consume data and the effect it has on us. Each composite photograph represents a television program. After disabling the camera's auto white balance, Maas photographs light and colors reflected from the TV onto a white wall while the program is being viewed. The assembled images of saturated color vibrate against each other, creating their own visual sensation. They form a strip of colored data resembling pixelated information, transforming the data from which it was created. Maas elaborates: "I feel our understanding of the world we live in has not grown proportionally with the amount of content we absorb about it. This series is meant to highlight issues of observation and comprehension. How much do we really observe? How much do we comprehend of what we see and absorb everyday? To what extent do we create our own reality?"

Credit: © Rita Maas. *ESPN, Pirates vs. Cardinals 5-2, May 13 2009*, from the series *Reality TV*, 2009. 24 x 38 inches. Inkjet print.

ASPECT MODES

Some digital cameras allow you to select from different shooting aspect ratios, such as 16:9, 3:2, or 4:3, which alter the width and height of the image frame. For instance, the 16:9 mode allows you to make dramatic panoramic images.

COLOR MODES

Digital cameras have image-processing algorithms designed to achieve accurate color, but there are variables within these programs and within the scene that may produce distinct color variations. To help correct for these, professional cameras offer a range of application modes. For instance, one mode might be optimized to set the hue and chroma values for skin tones in portraits. A second mode could be Adobe RGB gamut based, which gives a wider range of color for output on color printers. A third mode could be optimized for outdoor landscape or nature work. Lastly, there can be a black-and-white mode.

IMAGE ENHANCEMENT AND SCENE MODES

Digital cameras have programming modes that automatically optimize contrast, hue (color), outlines, and saturation based on the scene being recorded. Standard exposure modes include *Normal*, suggested for most situations; *Vivid*, which enhances the contrast, saturation, and sharpness to produce more vibrant reds, greens, and blues; *Sharp*, which sharpens outlines by making edges look more distinct; *Soft*, which softens outlines to ensure smooth, natural-looking flesh tones; *Direct Print*, which optimizes images for printing "as is" directly from the picture file; *Portrait*, which lowers contrast and softens background details while providing natural-looking skin color and texture; *Landscape*, which enhances saturation and sharpness to produce more vibrant greens and blues; and *Custom*, which allows you to customize color, contrast, saturation, and sharpness. Additionally, some cameras provide

TABLE 3.5 Major Image Enhancement Modes

Enhancement Mode	Use
Normal	Suggested starting point for most situations
Vivid	Enhances the contrast, saturation, and sharpness to produce more vibrant reds, greens, and blues
Sharp	Sharpens outlines by making edges look more distinct
Soft	Softens outlines to ensure smooth, natural-looking flesh tones
Direct Print	Optimizes images for printing "as is" directly from the picture file
Portrait	Lowers contrast and softens background details while providing natural-looking skin color and texture
Landscape	Enhances saturation and sharpness to produce more vibrant greens and blues
Custom	Customizes color, contrast, saturation, and sharpness
Monochrome	For black-and-white images

a monochrome image profile for making black-and-white images, which often can be tweaked to adjust sharpness, contrast, filter effects, and toning (see Table 3.5). Check your camera for a list of its Scene Mode menus, which might feature an array of settings, including Baby, Food, Night, and Sports Modes.

SPECIAL EFFECT MODES

Many cameras have Special Effect Modes, such as 3D Still Shot Mode, which takes one exposure and then switches focus and takes a second exposure of the same scene to calculate the distance of the objects in the frame. The two are then combined into a single image that gives the illusion of 3-D, but is not a genuine 3-D image.

VIDEO MODE

Cameras equipped with Video Mode can record moving images. Cameras with this feature often have a microphone for recording audio when using the motion

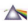

FIGURE 3.31 Orland tells us: "This was a photograph that could ONLY have been taken in the digital era—the tonal range and excessively dim lighting would have been impossible to record hand-held with a camera using traditional materials. The color balance resulting from a random mix of sodium vapor streetlight, car headlight, and incandescent porch and window lights would have been equally impossible to manipulate in a chemical-based darkroom. My camera was handheld using its *Hand-held Night Scene* mode setting. When the shutter was tripped, the camera made ten separate 1/10th second exposures in rapid succession, then aligned and superimposed them using in-camera software, retaining the sharpest and/or best exposed portions from the various individual frames, and compositing the result as a single jpeg image file. The overarching technical issue was that as the noise increased and the subject's contrast (and hence detail) lessened, I eventually reached a threshold crossover point where noise and detail become equal and indistinguishable from each other. The philosophical question I found myself confronting was: 'When does Nothing become Something?'"

Credit: © Ted Orland. *Dancing Girl*, from the series *Seabright at Midnight*, 2013. 10 x 13½ inches. Inkjet print. Courtesy Ansel Adams Gallery, Yosemite, CA.

and still image recording features, and a speaker to listen to the audio recorded on your motion and still image recording segments as you play them back on the monitor screen. The standard is 1080p (1,920 × 1,080) high-definition (HD) that can record cinematic-quality movies with sound. High-end cameras offer 4K resolution video (4,096 × 2,160) and are used for commercial productions.

SHARPENING MODE

Sharpening, which increases the contrast of pixels around the edges of objects to amplify the image's apparent definition or sharpness, is most noticeable around the borders of light and dark areas. Digital photographs appear somewhat soft in focus because the image formed by the sensor is mosaic in nature, like classic tile pictures

found in ancient Mediterranean cultures. Most digital cameras interpolate this mosaic into a smooth picture, but sharp edges get slightly blurred during the process. Some cameras automatically sharpen the image as part of their software. Others allow you to control the degree of sharpening; usually you'll want to fine-tune this process in your imaging software program as part of your processing. Many imagemakers prefer not to have the camera do any sharpening, but instead opt for the precision of sharpening selectively with their imaging software. Oversharpening can excessively accentuate pixels, calling attention to them and thereby making an image appear exceedingly "digital."

DSLRs typically offer an array of sharpening modes, including *Auto*, in which the camera automatically makes adjustments by sharpening according to the subject, with results varying from image to image; *Normal*, where all images are sharpened by the same amount; *Low*, where images are sharpened by less than the standard amount; *Medium Low*, where images are sharpened by slightly less than the standard amount; *High*, where images are sharpened by more than the standard amount; *Medium High*, where images are sharpened by slightly more than the standard amount; and *None*, where images are not sharpened at all.

GUIDE OR HELP MODE

Guide or Help Mode offers in-camera guidance for things one might want to do, such as soften backgrounds in a portrait or freeze motion. The guide, shown on the camera's LCD display, shows step by step how to achieve a desired effect by using settings like Shutter Priority or Aperture Priority, often with a sample demonstration photograph.

NOISE REDUCTION

Noise, in the form of randomly spaced, brightly colored pixels, may appear in an image capture when using an ISO of 400 or higher or in exposures of 1 second or longer. Quality cameras offer different levels of noise reduction levels: *Normal*, *High*, *Low*, and *Off*. Typically, noise reduction comes at the expense of sharpness. Cameras with noise reduction capabilities are excellent when photographing in available or low-light situations. It is advisable to test your camera before using the noise reduction settings in critical situations, so you will know what to expect. Noise reduction software is also available for post-capture work.

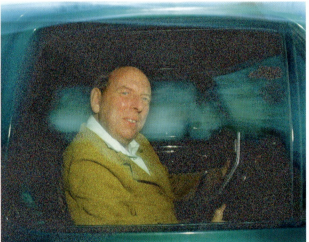

ISO 1600 WITH NOISE REDUCTION WITH SOME LOSS OF SHARPNESS

ISO 1600, NOISE IS MOST APPARENT IN THE SHADOWS

FIGURE 3.32 Images were shot on an overcast day with a man seated inside a darkly lit pickup truck. ISO was set to 1600 for greater depth of field during flash exposure. Higher ISO settings allowed for more detail in surrounding ambient light areas not affected by flash.

IMAGE STABILIZATION

Sometimes dim lighting conditions prevent one from following the shutter speed rule (Box 3.5). To make sharp images in such instances, many digital cameras offer an optical image stabilization option (a.k.a. anti-shake), which helps eliminate blurry photographs caused by camera movement. There are a number of different methods in use, but the most effective is in-body stabilization (IBIS), as opposed to other methods like individual lens-based stabilization, as this system works with any compatible lens.

Image-stabilized cameras and lenses use tiny gyros that process camera movement and send a signal via a servomotor to move lens elements, a prism, or the sensor plane in the opposite direction that the camera moves. Basically, when you move one way, the camera moves the other way. This helps steady the image projected onto the sensor, which compensates for high-frequency vibration, such as camera shake that becomes noticeable during long exposures or when using long focal lengths. It also performs tilt, pitch, yam, and roll correction.

Typically, good optical image stabilization can allow you to take handheld shots at almost two shutter speeds slower than recommended. This capability is very useful when you are photographing moving subjects in low-light conditions or when panning and/or using long focal lengths (see Chapter 6). Stabilization gives huge improvements in sharpness between 1/2 second and 1/15 second with normal lenses and good results with telephoto lenses up to 1/500 second.

FLASH

Most DSLRs have a small, built-in electronic flash that can be used effectively when subjects are 3 to 15 feet from the camera, focal lengths are no wider than 28mm, and there is inadequate natural light. These little onboard units are good for fill flash—a.k.a. flash-fill, fill-in flash, and balanced-fill flash—which can add a controlled amount of artificial daylight-balanced electric flash light to properly expose backlit subjects, bring out a subject that is in the shadows, or add a catch light to a subject's eyes. Most DSLRs perform this function automatically, and some allow manual override for custom results (for details, see "Electronic Flash and Basic Fill Flash" in Chapter 4). DSLRs often are equipped with a "hot shoe," which will automatically synchronize very wide-angle lenses and larger optional flash units that cover greater distance.

Most DSLRs have a choice of flash sync modes, which allow the flash to synchronize with the shutter so that the flash goes off while the shutter is fully open. These modes include *Front-curtain sync*, used in most general, dim-lighting situations or when the subject is backlit; *Red-eye reduction*, which fires a small light about 1 second before the flash, causing the pupils in the subject's eyes to contract and thereby reducing the red effect sometimes caused by flash; *Slow-sync*, which is used with long shutter speeds to record both the subject and the background in low-light conditions or at night, usually with a tripod; *Slow-sync with red-eye reduction*, which combines both features; *Rear-curtain sync*, where the flash fires just before the shutter closes, producing a stream of light following a moving subject, usually with a tripod; *Slow rear-curtain sync*, which records both subject and background; and *Off*, where the flash will not fire so exposure can be made with available light only. In certain shooting modes, such as *Automatic*, the flash will pop up and fire automatically when the program senses there is not enough light. Be aware it can produce unflattering effects like red eye, harsh shadows, and loss of detail. Flash can also be bounced off a neutral surface or with a white card attached to a swivel flash head that is tilted about 90° to diffuse the light, make it less harsh, and reduce red eye. A frosted diffuser can also be placed over the flash head to produce a soft look with minimal shadows. Units with Automatic or TTL functions can usually handle bounce flash metering, but it is advisable to test to see whether any compensation is needed.

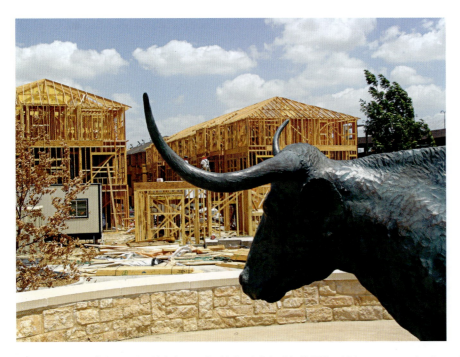

FIGURE 3.33 Bill Owens is widely known for his book *Suburbia* (1972), which presents an ironic tension between the idealism of his subjects who view their suburban homes as the realization of the American Dream and the detached superficiality of this lifestyle. This humorous image is part of a new documentary project showing the *New Suburbia* with a focus on the daily life of people in north Texas. It was made using his camera's built-in flash to bring out the detail in the statue of the longhorn cow in the foreground.

Credit: © Bill Owens. *Model Home, Plano, TX*, from the series *The New Suburbia*, 2006. Dimensions vary. Digital file. Courtesy of James Cohan Gallery, New York, NY.

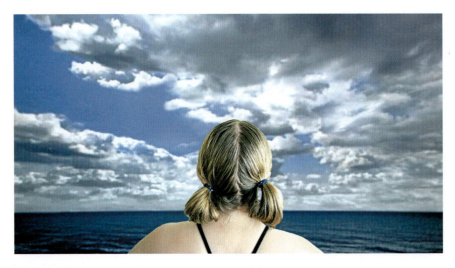

FIGURE 3.34 Martin Kruck tells us: "This series of digitally enhanced images is based on notions of familiarity, presence, artifice, and location provoked by manufactured tourist imagery, especially nineteenth-century painted backdrops of exotic locations, and its significance on our perceptions of personal experiences. The location within the images has been constructed to simultaneously resemble nowhere and everywhere; this apparent recognition frames the encounter, attempting to construct nostalgia for a place never visited. The figure is artificially placed in the Xcape to reinforce the significance or insignificance of the vista by reenacting the posture of gazing meaningfully toward it. Here, the model was photographed on nine separate occasions and locations utilizing natural lighting in conjunction with slow and rear flash."

Credit: © Martin Kruck. *Xcape #6*, 2005. 70 x 118 inches. Inkjet print.

MEMORY BUFFER

Higher-end digital cameras have a memory buffer for the temporary storage of images, allowing shooting to continue while the images are saved to the memory card. The camera will hold a number of these files in the buffer, depending on the quality (size) of the file. When the buffer is full, the shutter is disabled until enough data has been transferred to the memory card to make space for another image. This recording time can be as short as a few seconds or as long as many minutes, and depends on the type of camera buffer, the speed of the memory card, and the size of the image being captured.

REMOVABLE CAMERA MEMORY STORAGE

Digital cameras have a limited amount of internal storage capacity and use removable memory cards to store images. When the removable memory card becomes full, the data can be transferred to a computer or to a printer for output either directly from the camera or via a card reader. After the images have been transferred, the card can be formatted, which deletes any data it may contain, and reused. Formatting should be done in the camera. You should not remove the card or battery or unplug the AC adapter during formatting; otherwise, the card may be permanently damaged. Be certain all your images have been properly downloaded and backed up before reformatting the card for future use.

There are numerous reusable types and sizes of removable memory. Your choice will be based on your imaging requirements, the latest technology, and your particular equipment. Three factors influence the usable speed that the data can be written: how fast the camera can process the image and write it as data; how fast the card itself can write the data; and the speed of the data transfer between the card and camera. The minimum speed card your camera requires can usually be found in the camera manual or on the manufacturer's website. When you are making still images in a compressed format like a JPEG, the minimum speed card should be fine. A faster card is recommended when using formats that capture lots of data, like RAW, especially if they are making exposures in quick succession, or using video at 1080p and 30fps (frames per second).

FIRMWARE

A DSLR's operations are controlled by a computer program, known as *firmware*, which is sometimes upgraded with improvements and new features, which can be accessed by contacting the camera manufacturer's website.

SOFTWARE: YOU PRESS THE BUTTON AND THE CAMERA DOES THE REST

In-camera software programs make use of a digital camera's built-in computing power to allow you to edit images without downloading them to a computer. In the spirit of the old Kodak motto "You press the button, we do the rest," camera manufacturers now provide in-camera options such as red-eye correction and cropping; a skylight effect or warm filter; a way to combine multiple images into a single panorama; a sepia or cyanotype blueprint tone; a filter to convert an image into what the manufacturer calls a "cartoon or pop art masterpiece à la Andy Warhol"; a "slimming function" that makes people appear thinner; "Revive Shot," in which you can photograph old pictures and have the camera remove any distortion and adjust faded colors; a feature that corrects "plunging lines" in wide-angle shots of buildings that would normally make the subject appear to be tilting backward; a "pre-shot" function that allows you to place your subjects in front of any background; and lastly, "Instant Advice" from the camera, which tells you how to improve your picture. And the list is constantly expanding. Quality cameras save these changes as a separate file, so the original capture remains untouched.

FIGURE 3.35 Foran narrates: "The landscape of media images is increasingly generated by and consumed through mobile technology. The universality of smartphone cameras creates a nearly ubiquitous blanket of coverage that can be tapped by news outlets to feed their continual dissemination of 'breaking news.' This series was made using a smartphone's in-camera panorama software, which was handheld and rotated on an axis to pan across a live television news program in a darkened room. I kept a steady speed to let the camera's algorithm struggle to 'interpret' it. Moving the camera across a moving image disrupts the camera's attempt to keep things static, and the shifting, asynchronous nature of the broadcast images are revealed. This process relies on nothing but the 'eye' of the camera's algorithm as it struggles to piece together the discontinuous content, contradicting the illusion of 'objective coverage' and exposes the constructed, intentional fictions of news media."

Credit: © Patrick Foran. *Live Coverage 6559*, 2017. Variable dimensions. Digital file.

BATTERY

All DSLR operations require electric power in the form of a rechargeable battery supplied by the camera manufacturer or by disposable batteries inserted into a special holder. Some cameras also can be operated with an AC adapter. Having an adapter can be useful when using the camera for extended playback operations, such as viewing images on a television, but is not practical for most picturemaking situations. Battery life depends on the number of frames shot and how you operate the camera (see Boxes 3.6 and 3.7). Using the monitor, the flash, repeated autofocus operations, and slow shutter speeds, as well as keeping the shutter release button pressed down, and taking RAW photographs, all reduce battery power. Cold temperatures will also greatly diminish battery life (see the later section "Battery Care in Cold Conditions"). It is advisable to have fully charged or fresh batteries at all times. Many photographers buy a second rechargeable battery so one can be charging while the other is in use or so two batteries will be available in the field.

BATTERY CHOICES

Battery life depends extensively on age, brand, camera, type, and usage conditions. Digital cameras are dependent on battery power, but not all batteries perform well in digital cameras. Nickel-metal hydride (Ni-MH)

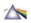

BOX 3.6 BATTERY CARE GUIDELINES

- Use only a supplier-specified AC adapter with your camera, as a different adapter or one with a different voltage could damage your camera and battery.
- Do not touch the battery terminals with metallic objects.
- Replace the battery with only the same or equivalent type.
- Do not recharge a battery for longer than the specified period of time.
- Do not continue charging a battery if it does not recharge within the specified charging time, as this could cause it to become hot, explode, or ignite.
- Remove the battery from the camera when it is stored for long periods of time.
- Keep batteries out of the reach of children and animals.

- Store the battery in a dry, cool place and attach the battery cap.
- Do not place a battery on or near fires, stoves, or other high-temperature settings.
- Do not place the battery in direct sunlight, or use or store the battery inside automobiles during hot weather, as this can cause a loss of performance and shortened life expectancy or cause the battery to generate heat, explode, or ignite.
- Discontinue use of a battery if, while using, charging, or storing the battery, it emits an unusual smell, feels hot, changes color, changes shape, or appears abnormal in any manner.
- Dispose of used batteries according to the manufacturer's instructions.
- Utilize battery-recycling programs.

and lithium ion (Li-ion) rechargeable batteries deliver the best results in a variety of conditions. Ni-MH and Li-ion batteries are designed for high-demand devices, like digital cameras, and do not exhibit the memory effects seen with other rechargeable technologies. Memory effect means that a battery remembers how full it was when it was last recharged and does not go past that point the next time it is charged. This problem can be reduced by completely draining the battery before recharging to ensure the longest charge. Regardless of type, one of the best strategies to prolong battery life is to use them. Otherwise, they will lose their capacity to hold a charge. Among nonrechargeable batteries, look for batteries that are intended for use in cameras, which, unlike flashlights or radios, require short bursts of high energy. Lithium batteries perform extremely well in cameras, as do photo-flash grade alkaline batteries.

BATTERY CARE IN COLD CONDITIONS

Batteries do not perform well in cold weather. At temperatures of 20 °F (−6.7 °C) or lower, there is a danger that all battery-powered equipment will become sluggish. Outdoors in winter, your batteries will last less than half the time they ordinarily do in more temperate conditions. Check the batteries for all your camera gear before going out into cold conditions, and carry spares. Shutters are affected first, with shutter speeds slowing and producing exposure errors. For instance, if a battery-powered shutter is off by 1/1,000 second, and if you are attempting to stop the action of a skier speeding downhill at 1/1,000 second, then the exposure would be off by one f-stop. This would not present a serious problem unless you are shooting above 1/125 second. In cold conditions, make use of the middle and slow ranges of shutter speeds whenever possible to avoid this difficulty.

BOX 3.7 GENERAL BATTERY TIPS

- Turn off your camera when not in use.
- Limit the use of your monitor, which rapidly drains batteries.
- Do not mix new batteries with used ones. Replace all batteries simultaneously.
- Do not mix rechargeable and nonrechargeable batteries.
- Do not mix alkaline, nickel-metal hydride (Ni-MH), or nickel-cadmium (Ni-Cd) batteries.
- Do not mix different grades or brands of batteries.

- Do not recharge any battery that is not marked "rechargeable."
- Do not attempt to rejuvenate a battery by heating it.
- In cold weather, keep your camera and spare battery inside your jacket.
- Occasionally clean the battery contacts and compartment components with a clean pencil eraser.

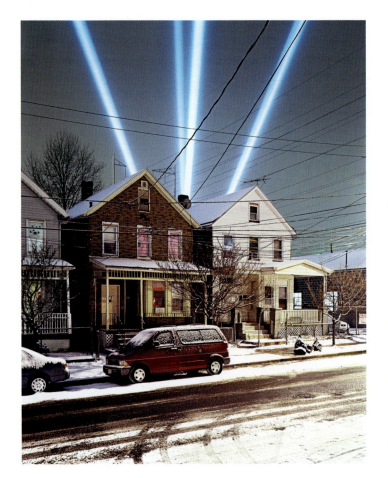

FIGURE 3.36 On a cold wintry night, Tim Davis's technical challenge was making a 45-second exposure using his 4 x 5-inch view camera, which does not rely on battery power to function. "In this series I am photographing grand and gorgeous failures of light to sync up to its supposed functions: Braille billboards, odd elaborate shadows behind figurative sculptures, spring pear blossoms arc-lit into oblivion, neon koans to no one. I am interested in light that obscures as it illumines, overstates and overblows, and in some cases, that fails to appear at all. You can sift through any photographer's amassed images and find moments when the light shifts from something that describes to something that is described; moments when the photographer has seen— or better, understood—the light."

Credit: © Tim Davis. *Searchlights*, from the series *Illuminations*, 2005. 55 x 44 inches. Inkjet print. Courtesy of Greenberg Van Doren Gallery, New York, NY.

When working in cold weather, carry a spare battery in an inside pocket, where your body heat can keep it warm. When it is time to swap, put the "drained" cell in that pocket to warm it up. If necessary, you can put that battery back in the camera, as it often will be good for a few more shots after it has warmed. Among disposable batteries, lithium batteries have the best cold-weather performance, with an operating range of −40 °C to +65 °C. If the batteries appear to have expired, do not dispose of them until they have been warmed up and tested again. Avoid mixing battery types, brands, and different mAh numbers (current capacity); otherwise, they will drain faster.

CAMERA, LENS, MONITOR, AND SENSOR CARE

First and foremost, read your camera's manual and visit the manufacturer's website to get answers to questions that specifically relate to your camera.

Keep the outside of your camera clean by wiping it with an unsoiled, dry cloth. Do not use abrasive or harsh cleaners or organic solvents on the camera or any of its parts.

Keep your lens clean. Get a lens cleaning kit that includes a blower brush (a.k.a. *bulb brush*)—an ear syringe will work too—to blow away grit; a lens cleaning cloth to wipe the lens and a small resealable plastic bag to keep it in; and lens cleaning solution to use sparingly on the cloth when necessary. Most lenses have special surface coatings that can be damaged by careless handling. Check your lens after each use, and clean it only if it is dirty. Begin by blowing off any loose dirt with the blower; then brush gently to remove any that won't blow away. If any dirt or fingerprints remain, use a photographic lens tissue or a clean, soft, dry cloth made of microfiber (which is washable). A clean piece of a cotton T-shirt or a soft handkerchief also can be used. Paper towels, napkins, and facial tissue should never be used to clean any lens. Never wipe a dry lens. Moisten the cleaning material with a photo-graphic lens cleaner. Wipe gently, placing the fluid on the lens cleaning paper, not directly onto the lens. Use a lens cleaner intended only for cameras. Do not use alcohol or eyeglass solutions, as they could damage your lens. Protect your lens by leaving a UV filter in place at all times and using a lens cover when it is not in use.

Your camera monitor screen should be cared for in the same manner as a lens.

Keep the image sensor clear. Always point a DSLR down when changing lenses. Avoid changing lenses in dusty or wet conditions. Do not leave the camera body open. If necessary, use a body cap to cover the open lens mount. Some cameras have a feature that shakes the dust off their sensor, preventing specks in your images that require imaging software to correct; others require a careful manual cleaning with a special kit.

Protect equipment plugged into an electrical outlet from power surges, called *spikes*, which occur when the electrical power to your equipment is restored after an interruption. These surges can damage the sensitive circuitry in your camera, computer, and peripherals. Surge suppression devices are designed to protect your equipment from such a spike.

PROTECTION AGAINST THE ELEMENTS

Simplify your camera operations as much as possible (see Boxes 3.8 and 3.9). Remove any unneeded accessories that cannot be operated with gloves, or add accessories that permit easier operation. Preset as many camera adjustments as possible before going outside. Avoid using power accessories or the monitor screen to conserve power. Do not take a camera that has condensation on it out into the cold until the condensation has evaporated, because it may freeze. The camera will cease operating, and the inner components will be ruined. Once outside, avoid touching unpainted metal surfaces with ungloved hands, face, or lips because your skin will stick to the metal. Wear thin gloves so that your skin does not come in contact with the cold metal and you can operate the camera with ease. Metal parts can be taped to prevent this from happening. Do not

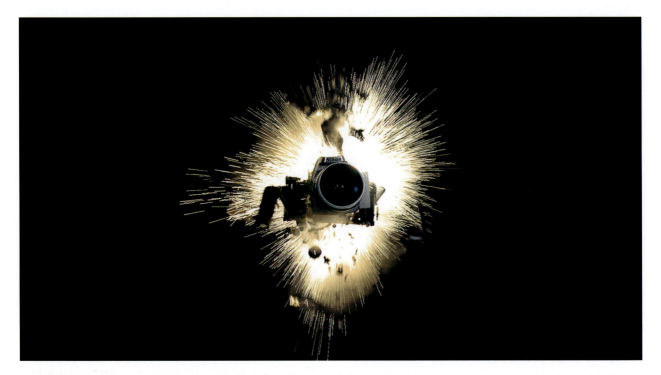

FIGURE 3.37 "After years of devoting myself to the study and practice of photography, while at a critical juncture of my artistic career, I came to realize that it didn't mean the same thing any more. Photography had changed, as well as my relationship with it. I decided it was time to start over with the camera as my phoenix." Working with a licensed explosives expert, David Evan Todd blew up all his film cameras with electrically detonated explosives within a custom studio constructed for safety. Todd recorded the action using a high-definition, slow-motion, specialty video camera and a continuously cycling hard drive to directly capture the approximately 20,000 still images, which resulted from the 1,025fps recording speed. "Visually, it recalls the creation/destruction moment of the Big Bang, when time and light, the essential photographic ingredients, began. Technically, the process is evidence of the merging of the still and moving image found in digital culture today. Metaphorically, I opened the black magic box, allowing the image to explode from within, as opposed to the traditional process of collecting the outside world in. My goal is to understand what is photography today. Is it still photography?"

Credit: © David Evan Todd. *Nikon SLR* from the series *Still Photography*, 2009. 9 x 16 inches. Inkjet print.

BOX 3.8 TOP 10 CAMERA MAINTENANCE SUGGESTIONS

1. Regularly clean the outside of the camera with a clean, dry cloth.

2. Do not subject your camera to knocks, vibration, magnetic fields, moisture, smoke, water, steam, sand, and/or chemicals, including suntan lotion.

3. Handle all moving parts of the camera with care and do not touch the inside of the camera.

4. Keep the sensor clear.

5. Turn off the camera before removing or disconnecting the power source or a cable, or removing the battery or memory card.

6. Keep your camera dry and free from condensation.

7. Avoid storing or using your camera in dirty, dusty, or humid places.

8. Avoid extreme temperatures, such as in direct sunlight for prolonged times or in a car when it is hot.

9. When not in use, store your camera according to the manufacturer's recommendations.

10. If your camera falls into the water or gets seriously wet, wipe it off and contact a camera repair technician as soon as possible.

BOX 3.9 DIGITAL CAMERA GROUND RULES

- Format the memory card in-camera only.
- Capture the highest-quality files possible.
- Download directly from the camera to computer; verify files.
- Back up files on a second hard drive or in the cloud.

breathe on the lens outside to clean it because your breath might freeze on it.

When bringing a camera in from the cold, let it warm up before using it, so condensation does not damage its working gear. Condensation can be avoided by placing the camera in an airtight plastic bag and squeezing out the air. This prevents the camera from being exposed to the warmer temperature. Condensation forms on the outside of the bag instead of on the lens and camera body. After the equipment has reached room temperature, remove it from the bag.

Dust, salt, and sand can easily damage camera equipment, so protect it before going out. When you return, inspect your lens, and if you see any dust and salt particles, clean it with lens tissue liberally moistened with lens cleaner. Unmoistened tissue drags abrasive dust or salt grains along the highly polished lens surface, and may cause scratches or abrasions. To dislodge sand, blow the outside of the camera body and lens, but not the inside, with a blower brush or compressed air from a small, portable canister.

SCANNERS

Scanners are input devices that digitize information directly from printed or photographic materials in a method similar to photocopiers. Aside from a digital camera, scanners are the most common means of getting images into a computer. The most common scanners use a line of CCD cells to record one row of the image at a time, which the scanner then assembles into a grid that digitally reconstructs your original image. Light is reflected off or through an image or object and interpreted by light sensors. Color scanners use RGB filters to read an image in single or multiple passes. After the scan is complete, software is typically used to make color and contrast corrections and to crop and adjust image size. Scanners also have optical character recognition (OCR) programs that allow text to be scanned and converted into digital data, which gives one the ability to combine text and pictures with imaging software. Although manufacturers use their own "drivers" (software that converts data to be printed to the form specific to a printer), there are some basic scanning features and procedures (see the later section "Scanning Steps").

FLATBED AND FILM SCANNERS

Flatbed scanners, capable of digitizing images in a variety of resolutions, are the most common way to digitize a document and can be thought of as large, flat cameras. These devices allow the user to preview an image and make minor corrections before scanning. Although designed to digitize prints, some flatbed scanners can do a good job of handling color transparencies (slides) or negatives, especially when coupled with quality software. Also, intriguing results can be obtained by scanning three-dimensional objects (see Exercise 3.1).

Film scanners are specifically designed to capture the minute details of small negatives and transparencies by transmitting light through an image. They are more expensive than flatbed scanners.

DRUM SCANNERS

Drum scanners are generally the most accurate way to digitize flat media. An image is read on a glass drum while being spun at several thousand revolutions per minute. Scans of both prints and transparencies made on these more expensive devices are more precise and translate images with greater detail than with traditional flatbed scanners. Some high-end flatbed scanners are

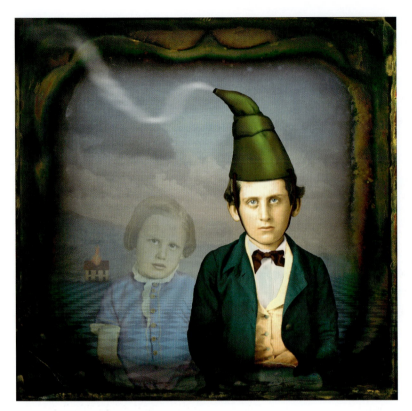

FIGURE 3.38 Maggie Taylor's surreal images possess a sense of "imagining yourself inside of them in a dream." Taylor created this digital composite using nineteenth-century daguerreotypes paired seamlessly with scanned images and landscapes photographed using a point-and-shoot digital camera. "I do not start with a clear idea of what I am going to make. It is a discovery process and a form of play." Working with small batches of three to five images for weeks or months, "I try out different visual elements in the manner of someone making an old-fashioned collage who moves pieces of paper around until they see something that strikes some emotional chord."

Credit: © Maggie Taylor. *Strange Days IV*, 2008. 15 x 15 inches. Inkjet print. Courtesy of Laurence Miller Gallery, New York, NY.

capable of scanning prints, 8 × 10-inch transparencies, or film at a quality that can rival drum scans.

SCANNING GUIDELINES

Although there are numerous types of scanners, some basic principles are applicable in most scanning situations. Scaling and resolution must be set at the time the image is scanned. The input settings draw reference from the original image, producing the best-quality scans. A common mistake is to allow the scanner's photo-imaging software to automatically set the final size (scaling) and resolution, which may force interpolation to occur and degrade the final image. Select the appropriate resolution based on the intended use (see Table 3.6).

The best resolution for continuous-tone prints is dependent on the maximum DPI of the printer being used. Good scanning software will allow a user to input a scaling factor into a dialog box and then will automatically do the file-size math. If your software does

TABLE 3.6 Scanning Resolutions for Printing

Usage	Scan Resolution
Internet	72 DPI
Newspaper	150 DPI
Glossy Magazine	300 DPI
Photo-Quality Print	300 DPI
Large Fine Art Print	4,000 DPI and higher

not do this, use the simple formula in Table 3.6 to calculate input resolution based on printer resolution and the scaling of the image.

SCANNING STEPS

Follow these steps to scan an image (see also Exercise 3.1):

1. Open the scanning software. Often, this can be done through imaging software, under File > Import > Name of the scanning software.

Many scanners use an independent software application to drive the scanner. In this case, open the independent application and proceed to the next step.

2. Set the scanner for Positive or Negative. Many scanners are dual use, with the ability to scan photographic positives (reflective) and negatives or slides (transparent). Make sure the scanner is properly physically configured for reflective or transparent materials and set to the proper medium before scanning.

3. Select Gray scale or Color. Even though scanning in gray scale is possible, scanning in color often provides superior results because the scan is occurring in three channels (red, green, and blue) instead of one. If a black-and-white image is desired, simply change the saturation levels to remove all color with the saturation adjustment tool and print in RGB to maintain quality.

4. Set the Color or Bit Depth. If your scanner permits it, set the appropriate bit depth. Color or bit depth is the amount of information the scanner generates from what is being scanned; a higher bit depth means more colors will be utilized, resulting in a higher-quality scan. Gray scale images are 8-bit images, with 256 levels of gray. Color images scanned with a 24-bit scanner will have nearly 17 million colors; 36-bit scanners will produce more than 68 billion colors. The trade-off is you get huge file sizes. Unless you are doing high-end professional work, there is not much need to be concerned about bit depth. Most new scanners have at least 24-bit color depth, whereas older models have 8-bit depth, which is fine for most purposes (see "Bit Color" in Chapter 8).

5. Place the image/negative or object on the scanning bed. For flat artwork, be sure to place the image squarely on the scanning bed, as this will reduce the amount of post-scanning scaling and rotating.

6. Preview the scan of the entire scanning bed. This will allow you to see the entire scanning area and the image to be scanned. Use the Marquee tool to select the target area as closely as possible.

7. Make tonal adjustments. Most good scanning software will create a preview of the image based on the area you selected with the Marquee tool. All scanning software has settings to control the brightness, contrast, and color balance of images. Change these settings to get the previewed image color balanced as closely as possible before scanning. Contrast is a critical adjustment. An image that has excessive contrast contains less information about tonal values. Slightly flat-contrast images contain more information in the highlight and shadows and generally provide better results in post-scan processing. After scanning, use your photo-editing software to make final color and contrast adjustments to an image.

8. Set the file size. Before scanning, decide what size your final print is going to be. Scanners display and define size in two ways: image size and resolution. Most scanning software will display the size of the area being scanned, multiplied by a scaling factor. Increasing the scale of the image increases the dimensions of the final scanned image. Increasing the resolution of the scan increases the potential quality of the image. Both operations increase the file size. As a general rule, the larger the file size, the more options you have in working with the finished scanned image. Know the limitations of your scanner and select the appropriate file size. There is no need to scan at a greater resolution than necessary, as larger files are slower to work with and take up more storage space. However, do use a resolution that can accommodate the largest print or use you anticipate.

9. Scan the image.

10. Save the file immediately, once your image is scanned. If you regularly work in Photoshop, save the file as a PSD. Keep these original scans protected and work only with copies of these scans.

EXERCISE 3.1 SCAN-O-GRAM: SCALE AND SPATIAL EFFECTS

Utilize a scanner to create an image made from found objects. Practice scaling the composition by following the steps listed in the section "Scanning Steps" to make the found objects larger than life.

Start by collecting a variety of two-dimensional and three-dimensional objects, including text, which will fit comfortably on your scanner to create a 4 x 5-inch composition. Experiment with opaque, translucent, and transparent objects.

Next, create a background using a piece of any colored material cut to 4 x 5 inches or a photograph approximately that size. First, arrange the found objects facedown in the middle of the scanning bed, and then place the background material on top of the objects. Close the scanner top, preview the scanning bed, and select a scanning area that includes the 4 x 5-inch cut material that has been used for the background.

Once you are satisfied with the composition, set the scale at 200 percent to produce a final image that will be enlarged and printed to 8 x 10 inches. Now, determine the printer resolution, calculate the input resolution needed, and set it before final scan. Finally, make a series of prints increasing both the scale and the input resolution (refer to Table 3.6), and compare the differences in the various prints. Look specifically for how scale changes the spatial relationship between the viewer and objects because they are now much larger than life.

Artist/educator Laurie Tümer assigns her students a variation of this exercise, asking them to use the scanned object to create patterns and textures. Students make a second file of their original scan and create a pattern, multiplying it by copying, pasting, and using the transformation tools to reduce and rotate. In a third file, they import the pattern and then texturize it by continuing to reduce its size, copying and pasting until the object is transformed in scale and/or perspective. In addition, they practice adding and adjusting color, inverting colors to add interest to the texture, and punching holes through layers to reveal and conceal information.

FRAME GRABBER

A frame grabber is another form of input that enables one to capture an individual analog video signal and digitize it as a still image. The resulting image file can be manipulated just like one made by a still digital camera. It is not the same as a screenshot, as the program must compensate for differences in the rate that data flows between the two components. Frame grabbers can be either stand-alone devices that plug into a computer port or a program function built into a video capture board or display adapter. Software can also be used with digital camcorders to grab an already digitized image.

EFFECTS ON PHOTOJOURNALISTS AND EVENT PHOTOGRAPHERS

Improvements in frame grabbing technology and high-definition (HD) video camcorders have led newspapers to utilize this equipment and publish HD video stills on a regular basis. News photographers use HD camcorders as they would a still camera that has the added capability to shoot 30fps. This allows them to record an entire sequence of an unfolding event and then later thoughtfully distill the climatic moment(s) that would otherwise be extremely difficult to obtain. Many digital cameras have continuous shooting to capture fleeting action and/or 1080p HD video capable of recording short cinematic-quality movies.

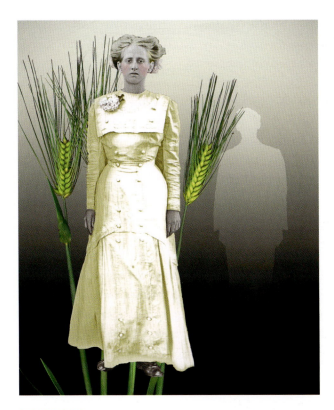

FIGURE 3.39 Combining vintage glass-plate negatives dating from the turn of the nineteenth and twentieth centuries with natural forms and objects from her garden (bugs, flora, and shells), Kathleen Campbell employs a scanner to create new worlds of digital collage that encompass nature and history. She uses these digital collages to highlight the small-scale and changeable nature of life. Each image is a visual fiction, implying the true relationship of humans to nature and time, into which are cast all pieces of lost worlds.

Credit: © Kathleen Campbell. *Relics from the Garden: Disappearing Airplane*, 2011. 24 x 20 inches. Inkjet print.

Some still photojournalists have objected to such methods, but Richard Koci Hernandez, deputy director of photography and multimedia for the *San Jose Mercury News*, says: "It's just about the moment. When you see a picture that moves you, I don't care how they got it. Ultimately the lasting image is more important than how they got it." These developments make it likely that a future Pulitzer Prize in print journalism will result from a frame grab, while also offering print-based media the means to include more video presentations on their websites. Other visual professionals, such as event and wedding photographers, will likely adopt these methods, including super-high definition (7580 × 4320), cinema-oriented video cameras that record in 8K 30p or 30 33MP images per second.

STORING DIGITAL IMAGES

After an image has been captured by the sensor and converted into pixels, the data is transferred to the camera's storage device. This can be a removable disk, such as a flash card, or a built-in device that stores the information in electronic memory. In the storage device, the image is saved as a single, self-contained computer file, much as conventional photographs are saved on individual frames of film. Because images composed of a megapixel or more require a large file of data, digital cameras contain software that compresses, or shrinks, the size of the image file for easier storage. RAW files offer sophisticated post-capture processing control but are not compressed and therefore take up more storage space. Cards of 32 gigabytes or larger are recommended so one does not readily run out of storage space. Check your camera manual for details. Also, using a number of smaller cards instead of one large card can minimize problems due to breakage, corruption, or loss.

At the same time, other camera software is generally used to automatically adjust the captured image, except RAW, to produce a naturalistic representation of the subject and should be adjusted to meet your particular needs. For example, the edges of the pixels are digitally smoothed (sharpened) to make the image look more like a traditional photograph. Additionally, the overall brightness level of the scene and color temperature is adjusted to deliver a normal contrast range and color balance.

DIGITAL ASSET MANAGEMENT (DAM)

Digital Asset Management (DAM) is a process for organizing, storing, and retrieving digital media. Once final image adjustments are made, then name each file so you can locate it in the future. Organizing images in

groups of folders by subject/topic name and date also makes image retrieval easier. Consider using a cataloging program, such as Lightroom, to make a file library for locating work for later retrieval (for details see the section "Digital Asset Management (DAM): Post-Production Software" in Chapter 9).

STORAGE MEDIA FOR FINAL IMAGE FILES

Besides hard drives, there are many expandable and portable devices for storage and transportation of information. From the 1970s to the early 1990s, the 5¼-inch floppy disk and later the smaller 3½-inch floppy disk were the standards for storing files. Each disk held 400 to 800 kilobytes (KB) and 1.4 megabytes (1,433KB) of information, respectively. At that time, a typical word processing file might require 8KB, but today an image file can easily exceed 100MB

(100,000KB), requiring gigabytes of storage space. Storage devices are continually being developed, enlarged, and improved.

Regardless of which storage medium you initially deposit your image in, it is highly recommended that you back up important files on a storage device other than the computer you are working on. It is risky to have all your images on a single storage medium, as it will eventually fail, possibly be lost, or even get stolen. Your computer's mechanical hard drive spins at 7,200 rotations a minute. A delicate reading arm hovers a fraction of an inch above the surface of the drive's spinning platters, moving across them at 60 miles an hour; one thud, and your files can be damaged or lost. Your mechanical hard drive's likelihood of mechanical failure is 100 percent; it's only a matter of when. For these reasons, it is highly advisable to archive images in separate stand-alone devices, including large flash drives, on CDs or DVDs, or off premises, such as on a website or other Internet storage facility (a.k.a. the cloud). New high-end computers have solid-state (flash) drives (SSD) for storage that have no moving mechanical components. Therefore SSDs can operate silently, be more resistant to physical shock, and are less likely to fail. Other computers make use of both technologies to improve performance.

The following sections describe some storage options that have made a major impact on the digital medium.

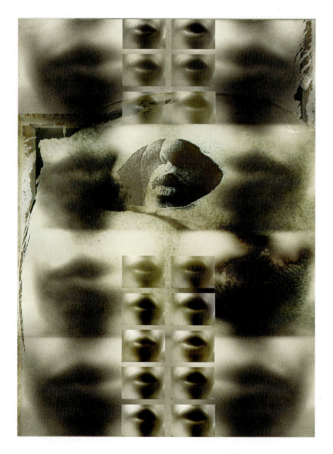

FIGURE 3.40 "The images in this series are 'collectives' from various sources. Parts of this image are still-video captures from footage of a person repeating the line, 'If I kiss you on the mouth, will you turn the other cheek?' These captures are montaged with an old photograph from human scientific and psychological experiments. Also included in the 'collective' is an extreme crop of two people kissing, taken from a magazine. These images of repetitive oral activities are laid over and sandwiched between direct flatbed scans of latex rubber stretched on a gilded frame. The drive in making these images comes from being able to manipulate and redefine a given image. I rely on the referent in the original to echo in the 'collective.' I want viewers to see the components and then to fuse them into a whole. The act of experimentation becomes the process and the product."

Credit: © Debra A. Davis. *Repetition Increases Outcome,* from the series *Incidental Specimens,* 2005. 13 x 10 inches. Inkjet print.

COMPACT AND DIGITAL VERSATILE DISCS

Inexpensive metallic discs, coated with a clear resin, use laser technology to optically record data and are standards for reliably distributing large quantities of information, text, images, sound, and video. Compact discs (CDs) hold approximately 700MB of information, and digital versatile discs (DVDs) can hold from 4.7GB up to 9GB, depending on the type. CDs and DVDs can be written on once (CD-R, DVD-R) or can be rewritable (CD-RW, DVD-RW). There are competing formats for DVDs, so do the research to select the format most suitable for your needs. Also, there are differences in quality, with some manufacturers claiming to make archival CDs with a 300-year life span and DVDs that are good for up to 100 years. New computers no longer contain a built-in optical drive for reading and writing data from optical disks through laser beaming technology, but they can be inexpensively purchased as a stand-alone plug and play device.

MECHANICAL STORAGE

Hard disk drives, the most common and least expensive mechanical storage device, are metal disks coated with iron oxide that spin and rely on a synchronizing head to read and write digital information. The head floats just above the surface and magnetically charges the oxide particles to store the digital data. The downside is that over time, the moving parts wear out and fail, causing the drive to break (crash), which means they are not suitable for long-term storage. However, they are excellent for backup and short-term storage.

INTERNAL HARD DISK DRIVES

An internal hard drive is the place where a computer's operating system (OS), programs, and files are stored. When the computer is turned off, all saved data remains on the hard drive. Hard disk drives come in a variety of sizes, measured in gigabytes and terabytes.

EXTERNAL HARD DISK DRIVES

Small, portable, and mechanical, external hard disk drives add often-needed storage directly to the computer through various external ports. They are an ideal solution for transferring large digital files and for backing up valuable data. Current drives are hot swappable, which means they can be connected or disconnected without turning off the power, but should be "ejected" before disconnection to avoid data corruption.

SOLID-STATE STORAGE: HARD DRIVES, USB DRIVES, JUMP DRIVES, AND FLASH MEMORY MEDIA

Solid-state storage is neither magnetic, like hard disk drives, nor optical, like CDs or DVDs, but is electrically erasable RAM-like memory that is available for both internal and external applications. Access time is faster than with a disk because the data can be randomly accessed and the process does not rely on a read/write head searching for data on a rotating disk. In addition, this type of storage uses less power and is shock resistant, but has a higher cost per megabyte of storage than mechanical storage. Its lack of moving parts makes it more rugged and reliable than mechanical storage devices.

The most common solid-state storage devices are the flash memory cards, used to record images in digital cameras, and USB flash drives, or jump drives. Flash memory is nonvolatile, meaning it will retain data even when an electronic device is turned off, and comes in a wide variety of names, physical shapes, and storage capabilities. Flash memory cards generally require special adapters, known as *card readers*, which plug into standard computer ports. Some cards have a built-in adapter that permits them to be directly plugged into a computer. USB flash drives require only a USB port and are small enough to fit on a key ring, making them handy for moving picture files for temporary storage.

IMAGE TRANSFER

If your camera stores its images primarily on a removable memory card, the card can be taken out of the camera and inserted into a card reader or computer, which can then be used to access and manipulate the digital images. Digital cameras that store digital photos electronically usually have a connector cable that plugs into a computer for downloading. Cameras that use removable memory cards also can be accessed in this fashion. Others have special docking stations that download the data. Some can send the data to a computer with wireless technology (Wi-Fi) built into the camera. Additionally, there are Wi-Fi memory cards that can beam images directly to your computer or website when a Wi-Fi signal is available.

CLOUD STORAGE

Cloud storage is a type of Internet hosting service that allows users to upload digital data, which can be accessed over the Internet from any networked digital device. The providers are responsible for keeping the data available and accessible and the physical environment protected and operating. Cloud storage can offer greater accessibility and reliability; rapid deployment; and strong protection for data backup, archival, and disaster recovery purposes. It can lower storage costs and save time, as one does not have to purchase, manage, and maintain hardware. However, cloud storage does have the potential for security and compliance concerns that one does not have with the aforementioned storage systems.

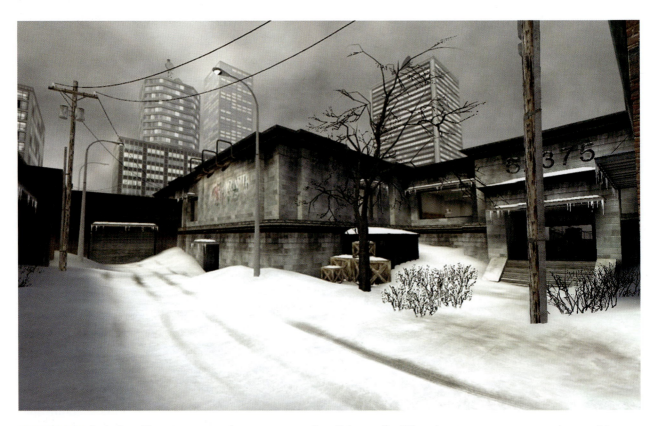

FIGURE 3.41 Beginning with a screen capture from a war game, Greg Halpern utilized Photoshop to remove weapons and traces of the game. The altered landscape invokes a memory of or anticipation of violence, holding an ominous psychological charge.

Credit: © Greg Halpern. *Untitled,* from the series *Landscapes without Violence,* 2009. 5 x 7 inches. Inkjet print.

LIVING IMAGES: AUTHORSHIP, ACCESS, AND THE WORLD'S LARGEST PICTURE BOOK

Thanks to television's universal saturation, we live in a post-literature culture in which the screen has replaced the printed page as our go-to source of knowledge. This can be unceasingly experienced on the Internet, the world's Communication Boulevard, where most people do not make hardcopies of the material they are viewing.

This phenomenon offers digital imagemakers the ability to "go live," encouraging people to freely interact with images in ways not previously possible. Uploading an image to an open website, such as Tumblr, Instagram, or Flickr, which permits free redistribution of posted material, allows others to see, comment, download, revise, and repost an image, so it is never permanently fixed. Unlike conventional media, these websites do not provide systematic programming, but instead rely on their users for content. A photograph no longer has to be a static picture on a wall, though that is fine too. Now, images can be part of a dynamic collaborative process that harnesses collective intelligence, much in the same way that the open-source online encyclopedia Wikipedia (www.en.wikipedia.org) allows people to write and edit articles (see also www.opensource.org).

This global conversation reflects the belief that a multitude of bloggers can provide an alternative experience that is richer than even that of the brightest individual experts, thus altering classic notions of authorship. The phenomenon of group action that results in creating a collective new work can also be seen in a "mash-up," a website or web application that seamlessly combines content from more than one source into an integrated experience. The mash-up has roots in pop music, where DJs take a vocal track from one song and combine it with an instrumental track from another song to create a new composition. A pioneering example of a mash-up can be heard in Danger Mouse's (Brian Burton) *The Grey Album* (2004), which combines

an *a cappella* version of rapper Jay-Z's *The Black Album* (2003) with samples from the Beatles album *The Beatles* (1968) (a.k.a. *The White Album*).

This living process of ongoing human presence increases the possibilities for making new works based on multiple authorship, getting non-mainline work before the public, and changes how images are circulated, experienced, and understood. The challenge with so much unfiltered information is being able to evaluate the accuracy of the information being delivered and to select what one wants to take in. In *The Long Tail: Why the Future of Business Is Selling Less of More* (2006), *Wired* editor Chris Anderson explains how this affects society at large, as he declares the death of "common culture" and makes the case that we are witnessing the decline of the commercial "blockbuster," which mass numbers of people see, read, or hear—a shift he feels is for the best. Anderson posits that the "emerging digital entertainment economy is going to be radically different from today's mass market" and "if the twentieth-century entertainment industry was about hits, the twenty-first will be equally about niches." The result of "shattering the mainstream into a zillion different cultural shards" is a vastly expanded universe of opportunities for makers and marketers to cast a wide net that is reshaping our understanding about what people actually desire to experience.

A real-world example of this phenomenon is how Netflix (founded in 1997) brought about the demise of brick-and-mortar video rental stores. Even in their heyday, physical locations were limited in the number of titles they could stock. By contrast, Netflix's original business model had customers ordering films online and receiving them by mail, doing 70 percent of its business from a back catalog of more than 100,000 titles. Many of its titles were art-house films, documentaries, and other low-budget, little-known productions that might never have had a theatrical release and previously would not have been available to the general public. This is indicative of a larger shift in the nature of cinema distribution: films now go to people rather than people going to films. And this is why Netflix and other media companies are now streaming movies, TV shows, and

videos as digital data directly to subscribers' computers, tablets, and televisions. In 2016 alone, Netflix released over 125 original series and films, directed at multiple demographics, to some 86 million worldwide customers in over 190 countries, making this a Golden Age of Choice.

Other commercial media websites permit subscribers to view multiple unfiltered video streams of news sources from around the globe plus access to their online video library. Additionally, sites such as YouTube allow people to post and view videos ranging from late-breaking news (a.k.a. citizen journalism) through a variety of categories, from art and animation to music videos and video games. Henry Fox Talbot, who invented the negative/positive photographic process and dreamed of "every man [being] his own printer and publisher," would approve of this updated scenario that includes moving pictures and sound and

gives permission to everyone to become his or her own content provider.

This zenith of vastly expanded viewing selection opportunities is most evident in the distribution of images on the Web, allowing strangers with common visual interests to share their work. This trend broadens our notion of the public commons to include virtual space, and it has the advantage of bypassing traditional gatekeepers, such as museum curators and gallery owners, who often have a vested interest in promoting their stable of artists, which tends to keep alternative views from the public eye. Ultimately, as images become digital, the act of imagemaking and the viewing of images are converted into a larger community activity that essentially fashions a collective picture library that functions as one gargantuan single image—the world's picture book—and gives it wide access through digital means.

FIGURE 3.42 Ulric Collette photographically explores the genetic differences and similarities between multiple members of the same family. To make this combination portrait, Collette split images of the face of the sister and the brother and then merged them together in Photoshop to create a unique individual that exists only in the virtual world. A video of the project can be seen at http://genetic.ulric collette.com.

Credit: © Ulric Collette. *Genetic Portrait, Sister/Brother: Karine, 29, and Dany, 25,* 2009. 18 x 18 inches. Inkjet print.

NOTES

1. Garry Winogrand, "Understanding Still Photography," from the portfolio *Garry Winogrand* (New York: Double Elephant Press, 1974).

2. Email with Edward Bateman and the author, May 8, 2017.

FIGURE 3.43 Images can be captured from innumerable sources. Here, Amy Friend made photographs from Super-8 film that she projected onto dusty mirrors. Friend illuminates: "The resulting imagery focuses our attention on certain elements while occluding others, which questions the truth in photography and the fictions inherent in our perception. As viewers, we draw inferences from subtle visual cues—a gesture, an object, an expanse of negative space—I play with these elements leaving room for the viewer to project, to imagine, to forget. When experiencing these remnants, which have been extracted from their moment in history, our understanding is informed more by our own stories than by those of the depicted. Throughout my work, I reference the history and science of photography, often by playing with light and the technical elements that make imagery possible, in this case using light and mirrors."

Credit: © Amy Friend. *Stargazers*, 2015. 30 x 40 inches. Inkjet print on velvet.

FIGURE 4.0 Robert Polidori created mementos of the devastation that Hurricane Katrina brought to New Orleans, documenting the paradoxically beautiful wreckage. He entered the ruins to make photographs that serve as psychological witnesses, mapping the lives of the absent and deceased through the remains of their homes. "As photographic records, these exoskeletons are offered as a kind of visual Last Rites to chosen life trajectories that are no more and can no longer be."

Credit: © Robert Polidori. *2732 Orleans Avenue, New Orleans, LA*, from the series *After the Flood*, 2005. 50 x 66 inches. Chromogenic color print. Courtesy of Edwynn Houk Gallery, New York, NY.

Exposure and Filters

EXPOSURE BASICS

Proper exposure technique—satisfactory highlight and shadow detail of the subject or scene—is the technical prerequisite to the process of transforming ideas into photographs. Although digital imaging software offers numerous correction tools, it is preferable to make original exposures as accurately as possible, to ensure the highest possible image quality with the minimum amount of time and effort. The following exposure guidelines can deliver standard exposures under a wide variety of conditions with a minimum of fuss.

CAMERA LIGHT METERS ARE 18 PERCENT GRAY CONTRAST

Built-in camera exposure meters are what most of us initially employ to make our exposure calculations. All DSLRs have a sophisticated through-the-lens (TTL) metering system that makes getting a good automatic exposure a sure thing in most situations. However, there are particular times when you will want to change the exposure mode from Automatic and make specific exposure decisions. The more you know about the camera's metering system, the greater the likelihood you can use it to achieve your desired exposure. All meters are partially blind, as they see only a middle 18 percent gray reflectance. This means the meter's reading tells a photographer how to set the camera for only an average

exposure that assumes an 18 percent reflectance. The meter measures only the intensity of the light; it does not judge the quality of the light or the sensation and mood that the light produces upon the subject. Therefore, the best exposure is not necessarily the same as that which the meter indicates. The meter is a guide that only reads the signs. It is up to the photographer to see, respond to, and interpret the light and decide what exposure will deliver the color, detail, and atmosphere needed to express and convey the situation to the audience. Learning to recognize and control the quality of light illuminating a subject is the aesthetic essential for making superior photographic images. But first you must become skilled with the basic technical metering guidelines, summarized in Table 4.1.

REFLECTIVE AND INCIDENT LIGHT

There are two fundamental ways of measuring the amount of light in a scene. *Reflective light*, which is metered as it bounces off the subject, is the kind of light all in-camera meters are designed to read. Metering is done by pointing the meter directly at the primary subject. A reflected reading from low midtones and high shadows delivers good general results in most situations.

Incident light is measured as it falls on the subject. The meter is not pointed at the subject but toward the camera or main light source. Incident meters are not influenced by the multiple reflectance values of a subject

TABLE 4.1 Basic Metering Guidelines

1.	Make sure the sensitivity selector (digital ISO) is at the selected setting.
2.	Perform a battery check before going out to make pictures.
3.	When taking a reflected light reading, point the meter at the most visually important neutral-toned item in the scene.
4.	Get close to the main subject so that it fills the metering area. Avoid extremes of dark or light when selecting areas on which to base your general exposure.
5.	When it is not possible to meter directly from the subject, place an 18 percent gray card in the same type of light and meter from it.
6.	In situations of extreme contrast and/or a wide tonal range, consider averaging the key highlight and shadow areas or take a reading from an 18 percent gray card under the same quality of light.
7.	When in doubt, decide the key area where you want to retain detail and texture, and expose for it by zooming in, locking the exposure by depressing the shutter button halfway, reframing, and then making the photograph.

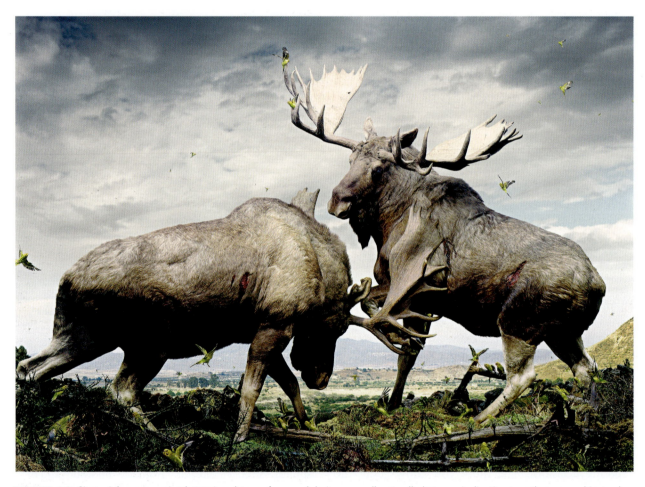

FIGURE 4.1 Simen Johan uses animals to mirror human fears and desires, as well as to allude to our inclination to anthropomorphize and domesticate the wild. Exposure is critical, as his final images are built from numerous separate exposures. This fantastical composition took six months to bring to fruition: the moose was photographed in four sections; wounds were created with different pieces of fur, various foods, and paint; birds were photographed in the studio; and the background is a mixture from Norway and Spain.

Credit: © Simen Johan. *Untitled #133*, from the series *Until the Kingdom Comes*, 2006. 71 x 92 inches. Chromogenic color print. Courtesy of Yossi Milo Gallery, New York, NY.

and therefore do not require as much expertise to achieve satisfactory results. Most in-camera meters cannot read incident light without a special attachment that fits over the front of the lens. This adapter permits incident reading with most TTL metering systems.

HOW A LIGHT METER WORKS

Your camera's light meter reads the light reflecting back from every part of the scene shown in the viewfinder to generate a mean exposure from all reflectances within the entire scene. The meter's coverage area (the amount of the scene it reads) changes whenever you alter the camera-to-subject distance or use a zoom lens. If you move closer to your subject or zoom in on a detail within the scene, the suggested exposure (aperture and shutter speed settings) will probably be different than if you meter the overall scene from a distance.

The light meter's sensor reads less light as a darker value. In an average photograph, the darkest surfaces or areas appear so because they reflect the least amount of light. The blackest surfaces or areas reflect back a minuscule 3 percent of the light. While the whitest areas of a scene reflect back the most light, no surface or area reflects back 100 percent of the light. Even the lightest surface or area absorbs approximately 4 percent of the light, thus reflecting back 96 percent and creating the lightest value, excluding mirrors or any high-tech surface or material.

These physical laws of reflectance help define photographic 18 percent middle gray, a standard value that occurs when 18 percent of the light is reflected from a surface or area. This creates a specific gray value that

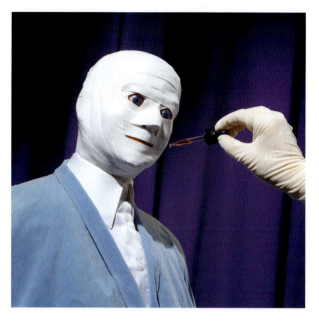

FIGURE 4.2 Bruce Charlesworth's interdisciplinary approach intersects film, installation performance, photography, and video. Charlesworth's photographs capture his complicated yet ambiguous scenes, expanding the boundaries of the stage by allowing performers to interact with a broader audience. He uses a combination of incident light metering and exposure bracketing to accurately record the light emitted by various theatrical lights that illuminate the scene.

Credit: © Bruce Charlesworth. *Drip*, from the series *Serum*, 2005. 32 x 32 inches. Chromogenic color print.

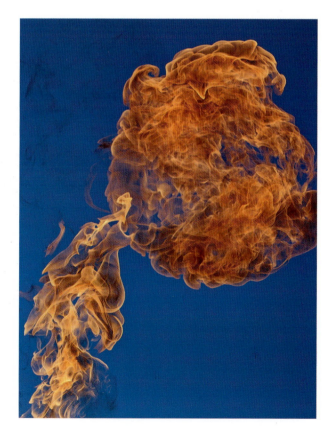

FIGURE 4.3 Michael Taylor's *Helios* series is based on the theme "fire light" and is part of the lifetime project *Lumen*, which explores light itself as an elemental metaphor and structure. Working in an outdoor environment Taylor employs a handheld medium-format camera that gives him freedom of movement to make split-second compositional decisions. He presets both his exposure and focus and relies on the camera's "burst" exposure mode, which allows him to later edit his fast-moving subject matter.

Credit: © Michael Taylor. *Helios* 331, 2014. 36 x 48 inches. Chromogenic color print.

represents the absolute middle between all the blacks and whites in a scene. Look at Figure 4.4 and observe that 18 percent reflectance represents the median that is exactly 3.5 f-stops from the blackest value and 3.5 f-stops from the whitest value in any scene. Such an exposure would be the exact middle between the black and white surfaces or areas governed by the theoretical laws of reflectance in any scene.

An in-camera light meter sees the world as if looking through frosted glass. By blurring all the details and eliminating the specifics, the meter is able to accurately measure a scene's overall average brightness. The result of this averaging method is that a photographer taking a photograph of an average subject illuminated by daylight will get a proper exposure 90 percent of the time. However, to make scenes that do not average out to 18 percent middle gray appear normal in your image, you need to alter the exposure to lighten or darken the picture.

HOW A HISTOGRAM WORKS

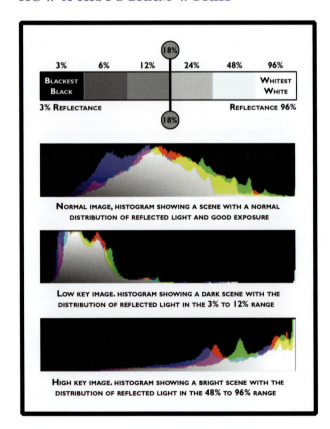

NORMAL IMAGE, HISTOGRAM SHOWING A SCENE WITH A NORMAL DISTRIBUTION OF REFLECTED LIGHT AND GOOD EXPOSURE

LOW KEY IMAGE. HISTOGRAM SHOWING A DARK SCENE WITH THE DISTRIBUTION OF REFLECTED LIGHT IN THE 3% TO 12% RANGE

HIGH KEY IMAGE. HISTOGRAM SHOWING A BRIGHT SCENE WITH THE DISTRIBUTION OF REFLECTED LIGHT IN THE 48% TO 96% RANGE

A histogram is a simple graph that visually displays the distribution of reflected light in any scene, showing where the reflectance (brightness) levels are located. The right side of the histogram represents the brightest (96 percent reflectance) areas of the scene, and the left side represents the darkest (3 percent reflectance). The histogram can be found in the menu settings of your digital camera and is viewed on the camera's liquid crystal display (LCD). Histogram viewing options may include superimposing the histogram over the picture, or it may be shown by itself. Display options also include a single black-and-white graph of reflectance; single graphs of the colors red, green, and blue (RGB); or everything shown simultaneously, as seen in Figure 4.4.

USING A GRAY CARD

Both reflective and incident meters can be easily fooled if there is an unusual distribution in the tones of a subject. For this reason, it can be desirable to ignore the subject completely and take your meter reading from an 18 percent gray card. The gray card provides a neutral surface of unvarying tone that is influenced only by changes in illumination. In this respect, a gray card reading is like an incident reading, except it measures reflective light. The gray card is designed to reflect all visible wavelengths of light equally, in neutral color, and to reflect about 18 percent of the light striking it. To obtain accurate results, be certain the card is clean and not bent. Position it in

FIGURE 4.4 There is no such thing as a bad histogram. The distribution of the reflectances will be either clustered to the right, representing a high-key photograph, or gathered to the left, representing a low-key photograph. A histogram grouped in the middle signifies a lot of reflectance (brightness) around the mean of 18 percent gray. A scene with an equal distribution of reflectances from 3 to 96 percent will show a more full-bodied histogram. Overexposure and underexposure also will affect the histogram and ultimately the brightness or darkness of that digital image file. Once you become proficient at "reading" a histogram, you will be able to evaluate the quality of the exposure based on middle gray. When shown with or superimposed over the image, the histogram is much more meaningful.

light similar to the principal subject. Point your reflective meter to fill as much of the gray card as possible, and avoid casting any shadows in the area being metered. It is a popular misconception that the gray card represents the average reflectance of an ideal subject; actually, the average reflectance of a normal subject is about 9 percent.

Additionally, digital calibration targets can be purchased that allow one to do custom white balancing, accurate metering, and exposure monitoring through the camera's histogram function.

CAMERA METERING PROGRAMS

Matrix Metering/In-Camera Metering Methods

Most DSLRs have computer-assisted matrix metering. With this feature, the meter is programmed to recognize common lighting situations and adjust the exposure accordingly. Typically, the camera's meter divides the scene being metered into a series of weighted sectors and compares the scene to the light patterns from numerous photographs in its memory. The meter may automatically shift between sensitivity patterns, depending on whether the camera is held horizontally or vertically. Effective in the majority of general situations, matrix metering also can be useful where the frame is dominated by bright or dark colors. This type of metering allows one to choose among different programs to automatically deliver highly accurate results, depending on the light. Options typically include center weighted, spot, highlight or shadow biased, and segment averaging. Metering modes often are displayed in the control panel and are easy to change.

The *center-weighted* method meters the entire frame but assigns the greatest sensitivity to light to the center quarter of the frame. It is an excellent choice for portraits and when using filters with an exposure factor greater than 1X (see "Filter Factor" section later in this chapter).

The *spot* method measures light from a small zone in the center of the viewfinder. As it may be reading only 1 percent of the frame, care must be taken to read crucial areas of detail in the picture to obtain the desired results. When it is not practical for the photographer to get up close to measure the light on a subject, as with a distant landscape or a sporting event, the spot meter has the advantage of being able to measure the light from any number of key areas of the scene from a distance. It is most helpful in ensuring proper exposure when the background is much brighter or darker than the principal subject.

The best way to achieve a general, overall accurate exposure is by metering from a middle gray area of a scene and not from the dark or light areas. Ideally, this is accomplished by metering from an 18 percent gray card that is placed directly in front of the key subject in the same type of light. If this is not possible, look for a key area within the scene that comes closest to representing an 18 percent gray, meter from that value, and use the monitor to review and make appropriate adjustments.

USING A CAMERA MONITOR

Generally, digital cameras have a monitor on the back, commonly a liquid crystal display (LCD). Monitors come in a variety of sizes, dynamic ranges (the maximum contrast ratio of dark and light areas that can be accurately displayed without distortion), and resolutions. As noted in Chapter 3, monitors that can be moved into a variety of positions offer you an increase in framing options, making it easier to compose while holding the camera above your head or below your waist.

These monitors have played a major role in popularizing digital cameras, primarily because they permit you to instantly view and share images with those around you. They also have other characteristics that are innately different from conventional optical viewfinders. Unlike most optical viewfinders, which crop off 5 to 10 percent of a scene, thus not showing exactly what the camera will record, a digital camera monitor can display 100 percent of the image that the camera will capture, permitting accurate, full-frame composition. Additionally, a camera monitor can effectively

show focus and exposure, and it offers a convenient way to compare changes in exposure and/or color settings as you bracket. The monitor allows the camera to be held away from your eye, making it viable to simultaneously compose while following live action. An adjustable monitor facilitates overhead and low-angle frame composition. The monitor also displays the camera's various menus, simplifying the navigation process of selecting modes and options.

On the downside, camera monitors drain battery power, can be difficult to see in bright light and when glare and/or reflections are present (optional shades are available), and cannot deliver as high a level of fine detail as an optical viewfinder. All these factors may undercut the effectiveness of what you can actually see on a monitor, making precise exposure calculations difficult to determine. Also, the dynamic range of a camera monitor will not accurately show the levels of highlight or shadow detail contained in the actual image file. Because of these traits, when critical focus is required, use the optical viewfinder (if it is available).

ELECTRONIC VIEWFINDER (EVF)

Some digital cameras have both a monitor and an optical viewfinder, while others have only a monitor or *electronic viewfinder* (EVF). An EVF is essentially a miniature second monitor inside the back of the camera that replaces the traditional optical viewfinder (see the section on monitors in Chapter 3). The photographer looks at the monitor through a small window and sees the scene from the same viewpoint as the lens. Thus, parallax error is avoided.

The desire to make cameras smaller and keep manufacturing costs down has resulted in an increase in the use of EVFs. Using an EVF on a camera is equivalent to looking at the world through a video monitor. Compared with an optical viewfinder, an EVF view is less sharp, colors are less accurate, and the resolution is generally too low for accurate manual focusing. The main advantage of an EVF is that it is

internal and shaded, thus providing the ability to see picture files under very bright conditions when it is not possible to clearly see them on the camera's monitor.

EVF super-zoom cameras boast powerful but fixed (noninterchangeable) zoom lenses and use only an EVF, making them less bulky and heavy than a DSLR. The EVF shows the image directly from the image sensor on a tiny eyepiece LCD, thus avoiding parallax error. It also makes for very quiet, vibration-free shooting. The only shutter noise is an electronic sound effect, which can be adjusted or turned off. While the EVFs are highly accurate in terms of showing nearly 100 percent of what the camera sees, what you actually view is a video image that can be jumpy. Therefore, an EVF does not provide the clarity of a DSLR viewfinder and can make tracking a moving subject difficult (see the section on monitors in Chapter 3).

HOW A METER GETS DECEIVED

Scenes containing large areas of light, such as fog, sand, snow, or white walls, deliver a meter reading that causes underexposure because the meter is deceived by the overall brightness of the scene. To correct the meter error, you need an additional exposure of between one and two f-stops. Review the image on your monitor and make the necessary adjustments.

Scenes with a great deal of dark shadow produce overexposures. This happens because the meter is designed to reproduce an 18 percent gray under all conditions. If the predominant tones are darker or lighter than 18 percent gray, the exposure will not be accurate and must be corrected by the photographer. A reduction of one to two f-stops is often needed for dark subjects. Again, review the image on your monitor and make the necessary adjustments. An incident reading performs well in these situations because it is unaffected by any tonal differences within the subject. Bracketing of exposure (see the following section) is a good solution in both of these situations.

FIGURE 4.5 Christine Carr explores the intersection of worship, architecture, and structure. "I search for nondescript facades that serve as blank canvases to hold the light. With long exposures and a transitional time of day, I encourage the available light from natural and artificial sources to emphasize the form of the buildings. I bracket my 6 x 7-cm film exposures to compensate for reciprocity failure. Plus, having a variety of exposure times is important if there are moving objects in the scene, as it is almost impossible to predict how they will be recorded. When necessary, I crop images to heighten boldness and remove context, in order to portray these common structures as contemporary monuments. I am intrigued that most of the ideal locations host stores, cars, and entertainment, which many would argue are our modern-day devotions. After having the film processed, I scan the film, and output on Epson Exhibition Fiber paper."

Credit: © Christine Carr. 221.05.72, 2008. 18 x 23 inches. Inkjet print.

EXPOSURE BRACKETING

Exposure bracketing begins by first making what you believe is the correct exposure. Then you make a second exposure 1/2 f-stop under that "correct" exposure. And finally, you make a third exposure 1/2 f-stop over the original exposure. In tricky lighting situations, such as fog or snow, it is a good idea to bracket two 1/2 f-stops in each direction (overexposure and underexposure) for a total of five exposures of the scene. Many cameras have an Auto Bracketing mode that will make a series of three exposures— normal, under, and over (usually ±0.5 or ±1 f-stop)—in rapid succession. Do not be afraid to expose a few more frames and review your results on the monitor. Bracketing can help a photographer gain an understanding of the relationship between light and exposure. Analyze and learn from the results so you can apply it the next time a similar situation is encountered.

EXPOSURE COMPENSATION

Numerous cameras offer an exposure compensation dial that will automatically provide you with the desired amount of correction. For instance, if you photograph a dark figure against a dominant light background, the exposure suggested by an averaged meter metering will produce an unexposed image. By setting an exposure compensation of +1.5, for example, the result will be more natural.

MANUAL OVERRIDE

Cameras that have fully automatic exposure systems without a manual override reduce a photographer's options. The machine decides how the picture should look, how much depth of field it should have, and whether to stop the action or to blur it. If you have only

an automatic camera, try experimenting with it by adjusting the shutter speeds, altering the ISO setting, or using Scene modes, such as Backlight to change your lens aperture or Sports to increase the shutter speed. Learn to control the machine rather than being its captive.

HANDHELD METERS

Once the in-camera meter is mastered, those wishing to learn more about measuring light can acquire a handheld meter. When purchasing a handheld meter, make certain it can read both reflected and incident light. Incident light readings are accomplished by fitting a light-diffusing attachment over the meter's cell. The meter can then be pointed at the light source rather than at the subject. Since it measures the light falling on the subject rather than the light reflected by the subject, the incident reading is useful in contrasty light or when a scene has a large variation in tonal values. Many handheld meters also can take spot meter readings or deliver readings when using an off-camera electronic flash.

BRIGHTNESS RANGE

The brightness range of a subject (the difference in the number of f-stops between the key highlight and

FIGURE 4.6 "The series begins with photographs of the familiar: my own home and neighborhood. I use digital collage to bring in elements exterior to the confines of the photograph and integrate them as seamlessly as possible. The work places the landscape in a larger context that contains not only political, spiritual, and cultural narratives, but also the air within the scene, the weather, and light. This situates each image within something larger than itself: the planets, stars, and solar systems hidden from sight yet still present behind every sky [star chart was embedded into the sky]. To make the original exposure, with a 4 x 5-inch view camera, I metered off the snow and overexposed by 1½ f-stops to compensate for the brightness of the scene."

Credit: © Colin Blakely. *Rain Turning to Freezing Rain Overnight*, from the series *Domestic Weather Patterns*, 2004. 24 x 28 inches. Inkjet print.

key shadow area of a scene) is one way to determine exposure. Today's digital cameras are capable of recording a brightness or dynamic range of about 64:1. In many cases, this forces you to either expose for the highlights and let the shadows go black, or vice versa. In 1965, Gordon Moore, a founder of the Intel Corporation, observed that the number of transistors on a chip doubles every 18 months. Since then, Moore's Law has pretty much held true, which means that future digital sensors will have a greater dynamic range. But what does one do to retain wanted detail now?

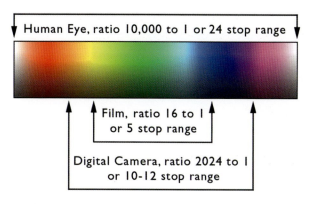

FIGURE 4.7 Dynamic Range Chart comparing lighting ratios between human eye, digital, and film.

EXPOSING TO THE RIGHT

Bearing in mind what Vladimir Nabokov, the Russian-American author of *Lolita* (1955), observed—"In art as in science there is no delight without detail"—the general rule for average scenes is to expose for the highlights. This entails finding that spot where the scene retains detail in the brightness areas without them "blowing out" and losing detail. Also, it is known as "Exposing to the Right," as you want to ensure that the highlights fall as close to the right side of the histogram as possible.

HIGH DYNAMIC RANGE (HDR) IMAGING

Dynamic range is the ratio between the maximum highlight (white) and darkest shadow (black) in a given scene. It is usually measured in luminance ratio or f-stops. For example, a ratio of 6 to 1 is the difference of three f-stops between the correct exposures for highlights and shadows on an overcast day. On a cloudless, sunny day the ratio might be 24 to 1 or a 12-f-stop difference (see Figure 4.7). The pupil of the human eye can open and close in varying light conditions, which allows us to have a dynamic range of about 10,000 to 1, or 24 f-stops. This is far greater than any camera can take in a single exposure. However, the eye cannot adjust instantaneously. For instance, if you are stargazing outside and then walk directly into a brightly lit

room, it takes your brain a few seconds to compile the new scene.

Photography's current Holy Grail is a digital sensor that can capture the full dynamic range of the human eye with a single exposure, thus rendering electronic flash and its lack of highlight and shadow detail a thing of the past. High Dynamic Range Imaging (a.k.a. HDR), attempts this feat by creating a single image through the combination of a series of bracketed exposures. By bringing extended value ranges together in one image, HDR makes a photograph that is closer to how humans actually see, a goal of photography since the introduction of the daguerreotype in 1839.

A high-end camera can record between 7 and 14 f-stops. To extend its range, HDR compiles three bracketed exposures: overexposure by one stop for shadow detail, a normal exposure, and underexposure by one stop for highlight detail. For clarity's sake, making HDR images requires a tripod, as all exposures must be of a still subject without camera movement; moving objects will introduce blur. Some digital cameras can perform this function automatically, but HDR images can be created with any camera having a Manual mode and the application of appropriate software (exposures should be made at the same shutter speed). Most imaging software programs have an HDR function, which some manufacturers call tone mapping.

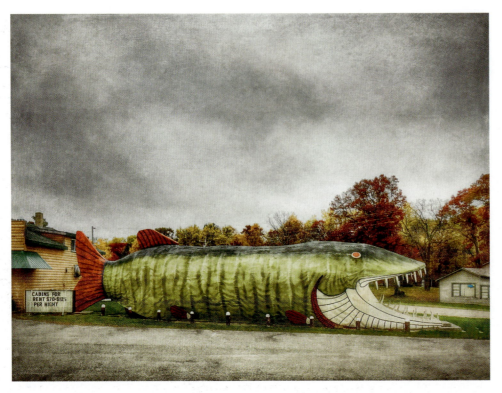

FIGURE 4.8 Dan Burkholder says: "I'm looking for visual intrigue and beauty. Everything after the initial discovery is intended to amplify those attributes. Whimsy is always welcome." With this in mind, Burkholder used a smartphone with the Vivid HDR app, which automatically combines bracketed exposures for better tonality from shadow to highlight. The app also provides a plethora of editing controls. "One of the things I love about mobile imaging is how you can shoot and edit and socially quickly share an image. I edited this image immediately after shooting, sitting along the road's shoulder in a rental car. This image was printed on thin, translucent inkjet vellum from Butler-Deardon paper. After the inkjet print is dry, I apply white painter's gesso to the reverse side of the vellum, behind the image area. This keeps highlights pure even when matting the print on a warm colored mat board; more importantly, the combination of vellum and gesso imparts a sweet luminosity to the print. Both sides of the print are varnished with an archival, non-yellowing acrylic varnish that protects the print and—more importantly—makes the vellum very translucent."

Credit: © Dan Burkholder. *Big Fish along Highway, Minnesota*, 2016. 6 x 8 inches. Inkjet on vellum over gesso. Courtesy Sun to Moon Gallery, Dallas, TX.

BASIC LIGHT READING METHODS

The brightness range method can be divided into four broad categories: average bright daylight with no extreme highlights or shadows; brilliant, contrasty, direct sunlight; diffused, even, or flat light; and dim light.

AVERAGE DAYLIGHT

In a scene of average bright daylight, the contrast is more distinct, the colors look more saturated and the highlights are brighter and the shadows darker, with good detail in both areas. Meter reading from different parts of the scene may reveal a range of about seven f-stops. Care must be given to where meter readings are taken. If the subject is in direct sunlight and the meter is in the shadow, overexposure of the subject will result.

BRILLIANT SUNLIGHT

Brilliant, direct sunlight generates maximum contrast and produces the deepest color saturation. The exposure range can be 12 f-stops or greater, which can stretch or surpass the sensor's ability to record the scene (correctable to some degree with imaging software). These conditions result in black shadows and bright

FIGURE 4.9 "Natural light in a 'clear-cut' is about as harsh as it gets; the magic hour of light lasts only 2 or 3 minutes during the summer months at either sunset or sunrise. The light has nothing to filter through, nothing to bounce off of—all the trees have been stripped away. What was once an amazing natural-lit forest has been turned into a graveyard of debris and downed wood. The trees tattooed on this man's legs were the only ones standing for hundreds of yards. It was a magical moment in the harshest of light, a moment of metaphor and striking paradox. I exposed for the highlight; shadows are often best left dark for me. This allows me to record the contrast and negative space I like in my images. When printing, I burned-in the sky around the body to add to the heaviness I felt within the surrounding environment, and dodged the tattoos on his legs to help them pop off of his calves."

Credit: © Christopher LaMarca. *Untitled*, from the series *Forest Defenders*, 2005. 11 x 11 inches. Chromogenic color print.

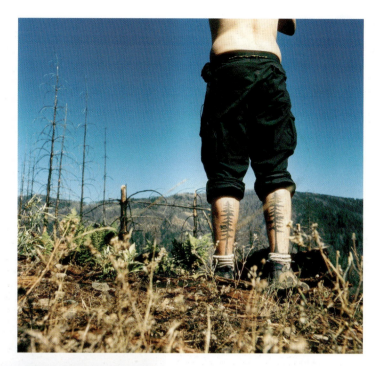

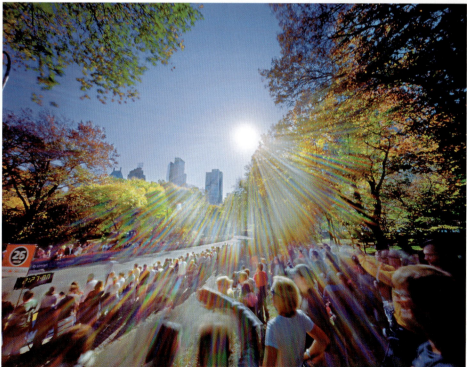

FIGURE 4.10 The technology used for Jerry Spagnoli's project of depicting large spaces bookends the history of photography by combining prephotography—an 8 x 10-inch pinhole camera—with results that are digitized and adjusted in Photoshop. Spagnoli established a consistent central motif, the sun, and allowed the landscapes to form themselves around it, realizing that he "was breaking a fundamental rule of good photography by shooting into the sun. The pinhole eliminates typical optical aberrations produced by a glass lens. The effects you do get, the rays in particular, actually occur inside the camera box, making it an active pictorial space as well."

Credit: © Jerry Spagnoli. *Marathon*, 2004. 30 x 40 inches. Chromogenic color print.

highlights. Color separation is at its greatest; white appears at its purest. Determining on which areas to base the meter reading is critical for obtaining the anticipated results. These effects can be compounded when photographing reflections off glass, polished metal, or water. Selective exposure techniques such as incident light or spot reading may be needed (see the section "Unusual Lighting Conditions" later in this chapter).

A hood or shade may be needed to prevent lens flare—the scattering and internal reflection and refraction of bright light—which commonly occurs when an optical system is pointed toward intense light sources.

DIFFUSED LIGHT

Cloudy and overcast days offer an even, diffused quality of light. Both highlights and shadows are minimal, which provide flattering conditions for portraits. Colors appear muted, quiet, and subdued. Whenever the scene is metered, the reading usually remains within a range of about three f-stops. The apparent brightness range and contrast can be increased through overexposure or with post-exposure software.

FIGURE 4.11 The accurate capturing of the diffused light enabled Keith Johnson to maintain the subtle color that generated the necessary visual ambiguity to make an astute, formal, and humorous examination of our interdependent cultural network. His framing pulls the eye into the frame, gently guiding viewers through a deep-space perspective to an intruding foreground object. The resulting juxtaposition turns the sublime into the absurd while presenting the interaction of two energies—yin and yang—that cause everything to happen and cannot exist without each other.

Credit: © Keith Johnson. *Do Not Open*, 2004. 30 x 30 inches. Inkjet print.

FIGURE 4.12 Kirk Crippens worked within the time constraints of a fast-paced, real estate bus tour showcasing repossessed homes in Stockton, CA, a town dubbed the epicenter of the foreclosure crisis. Here Crippen's 15-second exposure captures details from the artificial light that illuminates the refrigerator as well as the dimly lit garage.

Credit: © Kirk Crippens. *3-Car Garage,* from the series *Foreclosure, USA,* 2009. 24 x 36 inches. Pigment print. Courtesy of SFMOMA Artists Gallery, San Francisco, CA.

DIM LIGHT

Dim natural light taxes the ability of the sensor to record the necessary color and detail of the scene. Colors can be flat and monochromatic, and contrast often is low and problematic. When artificial light sources are included within the scene, contrast can be pushed to the other extreme. At either end of the scale, details are usually difficult to determine. Post-exposure corrections are often necessary. Low levels of light translate into long exposures; a tripod, a higher ISO setting (see the section "Long Exposures and Digital Noise" later in this chapter), or additional lighting may be needed to make the desired picture.

CONTRAST CONTROL/TONE COMPENSATION

DSLRs have an image adjustment control for altering the image contrast and brightness at the time of exposure. Altering the tone curve, a process sometimes known as tone compensation, can control the contrast of an image, the relationship between the distribution of light and dark tones. DSLRs offer a host of contrast management options. The *Automatic* or default option optimizes the contrast of each exposure by selecting a tone curve to match the situation. *Normal* uses the same curve setting for all images. *Low contrast* prevents highlights from being washed out in direct

sunlight. *Medium low contrast* produces slightly less contrast than Normal. *Medium high* produces slightly more contrast than Normal. *High contrast* can preserve detail in low-contrast situations, such as in a foggy landscape. Some cameras allow a *Custom* curve to be created to deliver a unique look or to handle uncommon lighting situations.

LIGHT METERING TECHNIQUES

Metering for the Subject

Metering for the subject is another way to determine proper exposure. When in doubt about where to take an exposure reading, decide what the principal subject is in the picture and take a reflected reading from it. For instance, when making a portrait, go up to the subject or zoom in and take the meter reading directly from the face. When photographing a landscape in diffused, even light, you can make an overall meter reading from the camera position. If the light is hard (not diffused) or directional, you can point the camera meter up, down, or sideways to emphasize the sky, the ground, the highlights, or the shadows.

Exposing for Tonal Variations

Exposing for tonal variations is another method that can be used in calculating the exposure. A scene having large amounts of either dark or light tones can give incorrect data if the exposure is based on a single reading. When you are photographing a general outdoor scene, taking two Manual light meter readings—one each from key highlight and shadow areas—and then averaging them together can deliver the desired exposure. For example, suppose you are photographing a landscape late in the day, when the sky is brighter than the ground, and detail needs to be retained in both areas. First, meter a critical highlight area, in this case the sky, in which detail is required. Let's say the reading is f/16 at 1/250 second. If the exposure was made at this setting, the sky would be rich and deep, but the ground detail would be lost and might appear simply as a vast black area. Second, take another meter reading from a key shadow area of the ground. Say it is f/5.6 at 1/250 second. This would

provide an excellent rendition of the ground, but the sky would be overexposed and would appear white, completely desaturated of color, and with no discernible detail. To obtain an average reading, meter the highlight (sky) and the shadow (ground) and halve the f-stop difference between the two readings. In this case, an average reading would be about f/8½ at 1/250 second. It is permissible to set the aperture in between the f-stops, though DSLRs display the actual f-stop number, such as f/8, f/9, f/10, and so on. The final result is a compromise of the two situations, with acceptable detail and color saturation in each area.

If the subject being photographed is either a great deal darker or lighter than the background, such as a dark-skinned person against a white background or a fair-skinned person against a black background, averaging will not provide good results. If there is more than a 5-f-stop range between the highlight and shadow areas, there can be an unacceptable loss of detail in both areas. In a case like this, let the background go and use post-exposure correction methods, or use additional lighting techniques, such as fill flash, to compensate for the difference.

ELECTRONIC FLASH AND BASIC FILL FLASH

Electronic flash operates by producing a veritable bolt of lightning between two electrodes inside a quartz-crystal tube that is typically filled with xenon gas. A quick discharge of high-voltage current from the system's capacitor excites the gas, and a brief, intense burst of light is emitted in the color temperature range of 5600 to 6000 K (see the section "Color Temperature and the Kelvin Scale" later in the chapter). Many cameras have built-in flash units that are convenient but have limited capabilities. The range of the built-in flash is determined by the ISO setting and lens aperture and will cover only certain focal lengths, such as 20–300 mm (see your camera manual for details). Flash can be extremely useful, as digital cameras may not perform well in low light without the benefit of electronic flash, producing significant noise at longer exposures.

Other cameras have dedicated external flash units designed to function with that particular camera. These units provide automatic exposure control and expanded versatility. Professional portable and studio strobes are synchronized with a camera by means of a sync cord or a "slave" unit. The shutter must be completely open at the time the flash fires. Many cameras will not sync at speeds faster than 1/500 second (check your camera manual). If the shutter speed is too high, only part of the frame will be exposed. Systems can have multiple flash heads and variable power control that can be set to use only a portion of the existing light. This allows you to control the intensity of the light, which is very useful for stopping action, bringing a subject forward in a composition, and creating atmospheric and fill flash effects. Filters can be placed over the flash head(s) to

alter the color of the light for purposes of correction or to create a mood.

DSLRs offer a basic automatic fill flash option, but there are times when you may wish to alter this to achieve the look you desire. Fill flash is used to brighten deep shadow areas, typically outside on sunny days, but the technique can be helpful any time the background is significantly brighter than the subject. To use fill flash, the aperture and shutter speed are adjusted, either automatically or manually, to correctly expose the background, and the flash is fired to lighten the foreground. Bear in mind that there are two potential light sources that determine flash exposure. One is the ambient light, and the other is the light emitted by the flash—and you must always consider both. Remember to use the proper sync shutter speed (see your camera

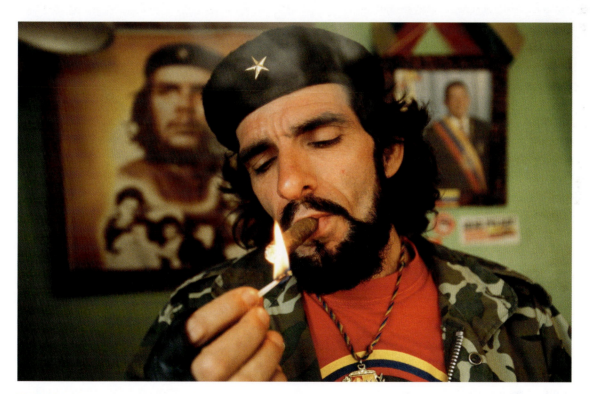

FIGURE 4.13 For a *National Geographic* story, "Venezuela According to Chavez" (April 2006), Meredith Davenport spent a day with Humberto "Che" Lopez, a fervent supporter of controversial Venezuelan president Hugo Chavez. Both men admire the Cuban Revolution, and Lopez acts as an unofficial people's advocate while assuming the persona of Latin American revolutionary Che Guevara. Davenport says, "I sought to portray his connection to Che Guevara and to Chavez, so when he stood in front of the two portraits and lit the cigar it was a perfect moment to capture. As the room was small and I wanted to record both him and the portraits in the background, I relied on a zoom lens set on a wide focal length. Then I used a half f-stop of fill flash to separate his face from the background and selected f/4 to provide enough depth of field to read the portraits, but not so much as to distract from his gesture of lighting the cigar."

Credit: © Meredith Davenport. *Untitled*, 2004. Variable dimensions. Digital file.

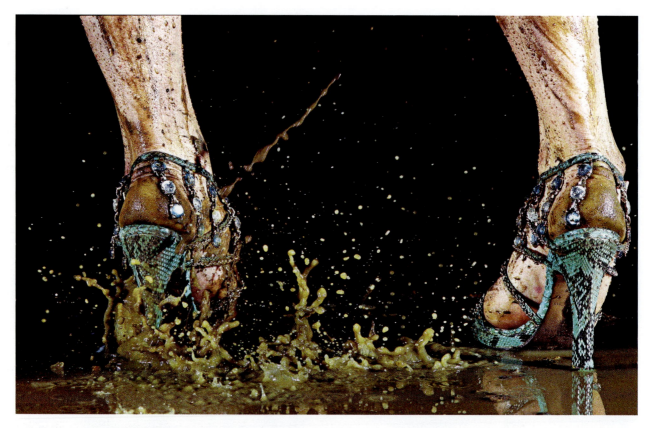

FIGURE 4.14 In images that appeared as a Creative Time billboard project in New York City, Marilyn Minter used stop-action flash to re-imagine lush photographs she had made for fashion magazines. In this exposure, she substituted mud for water, exposing an impossible fashion ideal to its messy, flawed, and highly human reality. The billboards are an outgrowth of Minter's interest in blurring the boundaries between fine art and commercial art. She states, "I want to make a fresh vision of something that commands our attention and is so visually lush that you'll give it multiple readings, adding your own history and traditions to the layered content." The images both attract and repel, yet ultimately seduce. Complicit with our own secrets, we succumb to the guilty pleasure of looking at a tainted object of desire, stirring anxieties about our own imperfect bodies and their urges.

Credit: © Marilyn Minter. *Shit Kicker*, 2006. 35 x 50 inches. Chromogenic color print. Courtesy of Baldwin Gallery, Aspen, CO, and Salon 94, New York, NY.

manual) and to check the operational lights on the back of your flash. If the green or equivalent ready light is glowing, then you are set to properly expose the scene. Be sure to review each exposure on the camera monitor and make adjustments as needed.

A basic fill flash technique involves first taking an available-light meter reading of the scene, setting your camera's shutter to the desired flash synchronization speed, and then determining the f-stop. Next, divide the guide number (GN) of your flash unit, which can be found in your camera manual, by the exposure f-stop number. The result is the distance (in number of feet) you need to be from your subject. Shoot at the available-light meter reading with the flash at this distance. For example, suppose the meter reads f/16 at a synchronization speed of 1/125. Your flash unit has a GN of 80. Divide 80 (GN) by 16 (f/16). The result is 5, the distance you need to be from the subject with an exposure of f/16 at 1/125.

A second fill flash method is to set the camera to make a proper ambient light exposure, using a correct synchronization speed. Note the correct f-stop that is required. Position or adjust the flash unit to produce light that is the equivalent of one or two f-stops less exposure, depending on the desired effect. If the flash produces an amount of light equal to the original

BOX 4.1 MIKE'S FLASH BASICS

Courtesy of Professor Michael Bosworth of Villa Maria College, Buffalo, NY.

- Guide number = (Flash to subject distance) × (f-stop)
- Formula for calculating flash guide numbers: GN/D = f (f-stop)
- The flash guide number provides a general indication of how powerful the flash is and, hence, how much of an area it can illuminate.
- Use a powerful (and more expensive) flash with a high guide number if you plan to use the flash to light subjects from a distance or if you do not want your aperture choices to be limited.
- Strobes plug into AC; flashes run on batteries.
- Exposure is affected by the power setting of the flash or strobe and its distance from the subject.
- The exposure at any ISO is controlled in the camera by the aperture alone and not the shutter speed.
- When using a camera with a focal plane shutter, one can expose at any shutter speed from the X-sync down (slower). Check camera manual for correct X-sync speed.
- Using a slower shutter speed with a flash will produce an image that is a combination of the flash and ambient light. Motion blur from the slow shutter speed can be combined with the motion-stopping flash exposure. When the camera is set to "front" or first curtain, the flash goes off just after the shutter opens; when it is set to "rear" or second, the flash goes off just before the shutter closes.
- If the camera has a leaf shutter, any shutter speed will work.
- Light modifiers, such as soft boxes or umbrellas, can diffuse the light, softening the shadows, and they will affect the exposure.
- When using multiple lights, the exposure is set according to the key (main) light.

exposure, the shadow areas will be as bright as the directly lighted areas. This equal balance of light will cause the loss of the modeling effect that normally defines the three-dimensional features of a subject, producing a flat, featureless-looking image.

A third technique is to determine the correct ambient light exposure at the proper flash synchronization speed and then vary the output of the flash by using a different power setting (half- or quarter-power) so the amount of flash light is correct for the subject-to-flash distance. If the flash does not have a power setting, putting a diffuser or neutral density filter in front of the flash head can reduce the output. You can also improvise by putting a clean, white translucent cloth in front of the flash head; each layer of cloth reduces the output by about one f-stop. Most external dedicated flash units can

also make automatic fill flash exposures. Fill flash can also be employed selectively to provide additional illumination or with filters to alter the color of specific areas in the scene. Additionally, it may be employed to stop action and/or to record both stop action and a continuation of subject movement.

RED EYE

When you are photographing any living being with a flash unit attached to the camera, red eye can result. If your subject looks directly at the camera, and the light is next to the lens axis, light passes directly into the pupils of your subject's eyes and is strongly reflected back to the camera. This is recorded as a pink or red spot in the center of the eye because the light illuminates the

EXERCISE 4.1 HAVE FLASH, WILL TRAVEL

Courtesy of Frederick Scruton, Professor of Art at Edinboro University of Pennsylvania.

Select three to six of the following categories. Shoot one or two in each for a total of six shots. Do a lot of bracketing of the flash power and exposure combinations.

1. Ceiling bounce (or other indirect, reflected flash). Use flash in manual mode and adjust power settings to achieve proper exposure. Use small reflector slightly overlapping the flash head for portrait subjects to place light in eyes of subject.

2. Handheld with flash with a slow shutter speed. As a starting point use 1/4 or 1/2 of a second and an aperture that underexposes the ambient light by about one f/stop and the flash by approximately one f/stop.

3. Tripod with shutter speed that combines blur in a moving subject with flash. As a starting place use a shutter speed aperture combination that allows for the blur and underexposes the continuous light source by approximately one f/stop. The selected aperture should underexpose the flash by about one f/stop.

4. Fill flash in direct sunlight. As a starting spot use a full normal exposure for the ambient light, combined with a flash power setting that will be one f/stop underexposed by the aperture that you have selected.

5. Fill flash in overcast sunlight. Try underexposing the ambient light by one f/stop or more, until the sky is properly exposed, and a flash exposure approximately as follows:

Underexposure of ambient	Underexposure of flash
1 f/stop	1 stop
2 f/stops	1/2 stop
3 f/stops	none (full flash exposure)

If you choose both "4" and "5" be sure they are distinctly different scenes in different kinds of sunlight (overcast and direct) of different subjects.

6. Over flash. A flash and shutter speed combination that artificially darkens the background while normally exposing the subject. Similar to above, typically in overcast sunlight, but perhaps no sky in the background, and toward more of an overtly artificial looking result. Outdoors only!

7. Out of a shadow. Normally expose or intentionally "blow-out" backgrounds. A flash and shutter speed combination where an outdoor subject in a full shadow is mostly flash filled while the background is normally or intentionally overexposed by about one f/stop. As a starting place use an aperture shutter speed combination that exposes the bright part of the background as you want it to appear and a flash power setting that will be one stop underexposed by the aperture that you are using. Soft, diffused flash usually works best.

8. Paint with flash. With the shutter set on B (if there is no other light source) do multiple flashes of areas in the frame (hidden behind black if the flash travels into the frame). Power the flash according to the aperture you have set on the camera and the distance you are from the subject.

9. Paint with a continuous light source, such as a flashlight.

Make sure to use either your camera's sync speed or any slower shutter speed when using flash; otherwise you will get only partially exposed frames. Cameras with relatively slow sync speeds may not allow you to do some of the sunlight shots. Slower ISO settings or neutral density filters may assist in overcoming this problem.

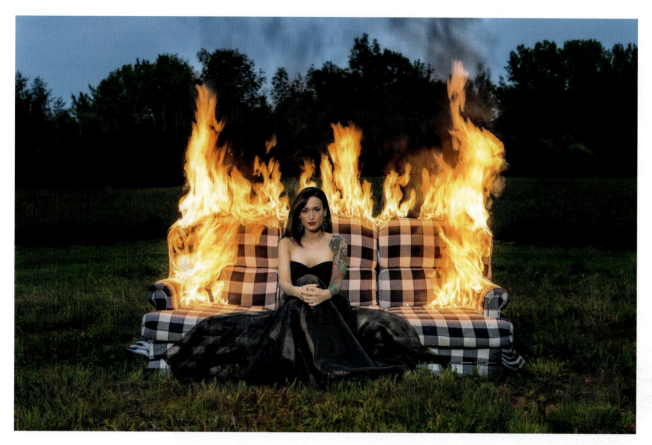

FIGURE 4.15 Ryan Groney explains: "I enjoy creating surrealist, fantasy-inspired photographs that are simultaneously familiar and other-worldly, able to capture the viewer because they are both expressive and moody, conveying something just beyond the edge of mundane human perception. Here, I made two separate images, one with the model in the chair using flash and a second of the chair on fire with no flash. My challenge was balancing the flash with the light given off by the fire to give a more realistic light, which required multiple test exposures. The resulting exposures were blended together in Photoshop."

Credit: © Ryan Groney. *Got a Light*, 15 x 24 inches. Inkjet print.

blood vessels in the retina of the eye. Try one of the following to eliminate this phenomenon: use the camera's red-eye reduction mode; have the subject look to one side of the camera; bounce the flash light; or move the flash unit some distance (6 inches or more) from the lens axis. The unit can be moved by elevating the flash on a commercially available extender post or by getting a long flash synchronization cord and holding the unit away from the camera with one hand. The red-eye reduction mode fires a small light about 1 second before the flash, causing the pupils in the subject's eyes to contract and thereby reducing the red effect sometimes caused by the flash. You will find that the camera needs to be held still when the lamp goes on,

and the 1-second delay makes this mode unsuitable with moving subjects or when a quick shutter response is needed. Digital imaging software, often built into cameras, can be employed for red-eye correction.

UNUSUAL LIGHTING CONDITIONS

Unusual lighting conditions can often result in exposure problems, including uneven light and color temperature, light hitting the subject from an odd angle, backlight, glare and reflections, areas with large highlights, or shadows, such as those inside doorways and windows, as well as light emitting from computer, smartphone, or television screens. The wide range of tones in such

FIGURE 4.16 Larry Schwarm tells us: "I photograph agricultural fires. Therefore, I have to be portable and able to move quickly. Part of the process of harvesting sugar cane is that the cane is first cut and laid in rows on the ground. It is then set on fire to burn the dry leaves off the stalks, which are then loaded and sent to a refinery. This photograph is of the cane burning in the fields late in the afternoon. Because of the nontraditional light sources and unusual shooting conditions, there are many more decisions to be made about exactly how to best present the final image in terms of color and density."

Credit: © Larry Schwarm. *Burning Sugar Cane, Bayou Tesch, Louisiana,* 2004. 29 x 29 inches. Chromogenic color print.

scenes can tax the sensor's ability to record them. A photographer must decide what is important to record and how to get it done.

SUBJECT IN SHADOW

When the subject is in shadow, the photographer must decide which is the most important area of the picture, which details need to be seen, and which colors are most intriguing. If the subject is in shadow, take a reflected meter reading from the most important shadow region. This provides the correct exposure information for that key area. Other areas, mainly the highlights, may experience a loss of color saturation and detail due to overexposure, which can be corrected with imaging software. At other times, there may be a key highlight striking the subject in shadow. The exposure can

be made based on the highlight reading, letting the remainder of the subject fall into obscurity. Additional light, by means of flash and/or reflective fill cards, such as a piece of white foam core, can be used to put more illumination on the subject.

SUBJECT IN BRIGHT LIGHT

Should your main point of interest be in a brightly lit area, take a reflected reading from the key highlight area or use an incident reading. Dealing with a contrasty subject in this fashion provides dramatic, rich, and saturated color along with good detail in the bright areas, though the shadows will lack detail and provide little visual information. Anything that is backlit becomes a silhouette with no detail under these circumstances.

FIGURE 4.17 "After the tragic events of September 11, 2001, our then President Bush II encouraged us to go shopping as an act of solidarity to maintain our country's economy. The act of shopping has become a temporary salve of instant gratification, a means of expressing repressed desire, and within the malls of America, an escape into the unreal. Using the Mall of America near Minneapolis as the setting, I created an installation to question and reveal the nature of our desires as they are reflected and directed in the mall and in the character of the fetishized commodity. The figures are silhouetted by well-lit spaces to erase their identity while the name brands of stores are emphasized. I achieved this by setting my camera to Shutter mode and metering for the highlights."

Credit: © Priscilla Briggs. *MAC*, 2006. 32 x 40 inches. Inkjet print.

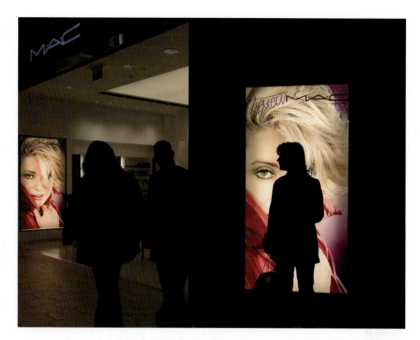

ZOOM EXPOSURE

Inexpensive digital cameras often overexpose highlights, resulting in a lack of detail. In contrasty situations, determine the areas that you want to retain detail and texture, and expose for them by zooming in, locking the exposure by depressing the shutter button halfway, reframing, and then making the photograph. This method can be very useful in a variety of tricky lighting conditions.

AVERAGING INCIDENT AND REFLECT EXPOSURES

If it is not acceptable to lose the details in the shadows, there are other alternatives. They include averaging the reflective reading, bracketing, using additional lighting techniques such as fill flash, or combining both an incident and a reflective reading. To accomplish this last method, first take an incident reading by pointing the meter toward the camera. Then, take a reflected reading with the meter aimed at the key subject area. Now, expose for the average of the two readings. When in doubt, the best insurance is to bracket and use imaging software to make additional corrections.

SCENE MODE EXPOSURES

Most cameras have Scene mode selections designed to match the subject and the recording situation, whereby the camera sets the exposure and hue to deliver a satisfactory image in a variety of situations. Selections include Landscape, Portrait, Sports, Night, Food, Party, Candle Light, Fireworks, Aerial, Beach, and Snow. These selections can provide useful starting points until you understand how to deal with these lighting situations.

RECIPROCITY LAW

The reciprocity law is the theoretical relationship between the length of exposure and the intensity of light. It states that an increase in one is balanced by a decrease in the other. For example, doubling the light intensity should be balanced by exactly halving the exposure time. In practical terms, this means that if you meter a scene and calculate the exposure to be f/8 at 1/250 second, you could obtain the same exposure by doubling your f-stop opening (light intensity) and cutting your shutter speed (exposure time) in half. Thus, shooting at f/5.6 at 1/500 second should produce

the same results as shooting at f/8 at 1/250. You also could cut your f-stop in half and double your shutter speed, shooting f/11 at 1/125 second to achieve the same results. Table 4.2 shows some of the theoretical exposures equivalent to an exposure of f/8 at 1/250 second.

LONG EXPOSURES AND DIGITAL NOISE

When you are making long exposures, such as before sunrise, after sunset, at night, and in dimly lit interiors, highlight areas have a tendency to burn out (lose detail)

TABLE 4.2 Theoretical Exposure Equivalents

f-stop	Time in Seconds
f/16	1/60
f/11	1/125
f/8*	1/250*
f/5.6	1/500
f/4	1/1,00

*Based on a starting exposure of f/8 at 1/250 second

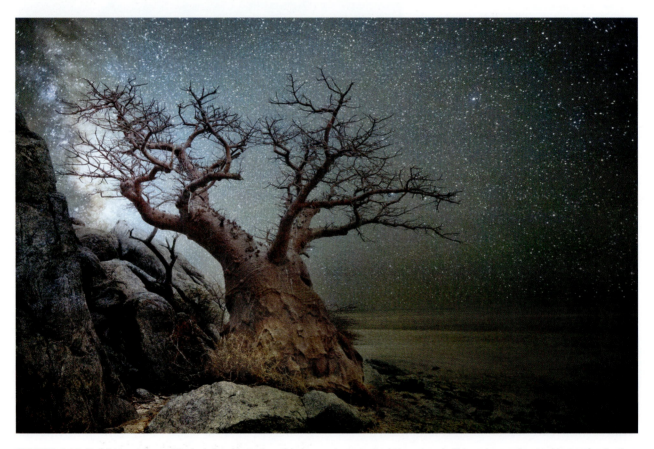

FIGURE 4.18 Beth Moon tells us: "Our relationship to the wild plays an important role in my work. This series was inspired by two fascinating, scientific studies that connect tree growth with celestial movement and astral cycles. Most of these photographs were created during moonless nights, shot with a wide angle lens at an ISO of 3200 x 6400. The Milky Way, a ribbon of stars that stretches from horizon to horizon, burns brightly in some of the images. Exposures up to 30 seconds allowed enough light to enter the lens without noticeable star movement. Each location required experimenting and different lighting techniques. Sometimes a short burst of diffused light from a flashlight was sufficient, or bounced light from multiple flashlights was used for a softer more natural glow."

Credit: © Beth Moon. *Lyra* from the series *Diamond Nights*, 2013. 32 x 48 inches. Inkjet print. Courtesy Corden Potts Gallery, San Francisco, CA.

and digital noise increases. It is common to see high levels of digital noise that show up as specks or mottling, especially in the shadows. Digital noise can be described as "flecks" of visual static that appear as light snow in the image. Known as *artifacts*, these flecks do not produce global color shifts, but can cause color tinges around their edges (see Chapter 3, "Digital Aberrations: Noise, Banding, Blooming, and Spots").

Stopping Action

This f-stop and shutter speed information can be useful when you need to stop action, as you can swap a decrease in aperture for an increase in shutter speed. Suppose you calculate the exposure to be f/8 at 1/125 second, but you know that you need 1/500 second (an increase of two full f-stops) to freeze the motion (see Chapter 6). Using the reciprocity law, you can then determine that you would need to open your lens aperture an additional two full f-stops to compensate, thus giving you an exposure of f/4 at 1/500 second. Also, flash can be utilized to freeze motion.

FILTERING THE LIGHT

OUR SUN: A CONTINUOUS WHITE LIGHT SPECTRUM

Our sun radiates "white" light, which is a continuous spectrum of all the visible wavelengths produced by the elements burning on the sun's surface. As these wavelengths are separated out by absorption and reflection, we see them as color. The shortest wavelengths appear as violet, the longest as red, and all other colors fall somewhere in between. In total, the human eye can detect only a tiny portion of the electromagnetic spectrum, the slice known as the *visual spectrum*. Just beyond the blue-violet end of the visual spectrum lie the ultraviolet (UV) wavelengths, which are too short to be seen by the human eye. In the other direction, just past the visible red portion of the electromagnetic spectrum, are the infrared (IR) wavelengths, which are too long for humans to see.

COLOR TEMPERATURE AND THE KELVIN SCALE

The balance of the amount of color contained in a continuous-spectrum light source that has all the visible wavelengths (red, orange, yellow, green, blue, and violet) in various amounts is measured as color temperature. Color temperature is expressed on the Kelvin scale, which starts at absolute zero or −273.15° Celsius (usually rounded off to −273° C). Absolute zero is the temperature at which all molecular motion theoretically stops. The degree symbol is not used when expressing the color temperature of a light source in Kelvin (K). The Kelvin temperature of a particular color is determined by adding 273 to the number of

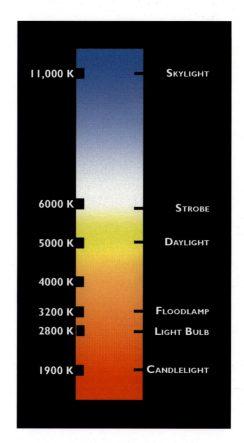

FIGURE 4.19 The Kelvin scale is used by photographers to measure the coolness or warmth of light. Always bear in mind, the cooler (bluer) the light, the higher the Kelvin temperature. This particular illustration shows the approximate Kelvin temperatures of common photographic light sources. Table 4.3 provides more specific details.

TABLE 4.3 Common Light Sources and Their Approximate Color Temperatures

Daylight Sources*	Color Temperature (K)
Skylight during summer	9500 to 30,000
Summer shade, average	7100
Summer sun and blue skylight	6500
Overcast sky	6000
Direct sunlight, midsummer	5800
Noon sun with clear sky (summer)	5000 to 7000
Noon sun with clear sky (winter)	5500 to 6000
Photographic daylight	5500
Noon sunlight (depends on time of year)	4900 to 5800
Average noon sunlight (northern hemisphere)	5400
Sunlight at 30° latitude	4500
Sunlight in the early morning and late afternoon	4300
Sunlight one hour after sunrise	3500
Sunrise and sunset	2000 to 3000

*All daylight color temperatures vary according to the time of day, season of the year, and latitude and altitude of the location. Sunlight refers only to the direct light of the sun, while daylight is a combination of direct and indirect outdoor light. The values given are approximate because many factors affect color temperature outdoors: the sun angle and the conditions of the sky—clouds, haze, dust particles—raise or lower the color temperature.

Artificial Sources†	Color Temperature (K)
Electronic flash	5500 to 6500
Warm white fluorescent tubes	4000
500-watt 3400 K photolamp (photofloods)	3400
500-watt 3200 K tungsten lamp (photolamps)	3200
200-watt household lamp	2980
100-watt household lamp	2900
75-watt household lamp	2820
40-watt household lamp	2650
Gaslight	2000 to 2200
Candlelight (British Standard)	1930

†The age and the amount of use of the bulb, lamp, or tube affect the color temperature indoors: lamp age (and blackening), voltage, type of reflectors, and diffusers all affect tungsten bulbs, and each can influence the actual color temperature of the light.

degrees Celsius to which a black metal radiator must be heated before turning that color. A black body is used as a standard gauge since it does not reflect any light falling on it and emits radiation only when heat is applied to it. Just as the ISO scale expresses the sensitivity of an image sensor, the Kelvin scale describes the color temperature of light (see Table 4.3).

THE COLOR OF LIGHT

Although we think of daylight as being "white," its color varies according to the time of day, the time of year, and atmospheric conditions. Nor is artificial light usually white. Our brain remembers how things are supposed to look and often will recast a scene for us, fooling our eyes into believing that light is white, even when it is not.

WHITE BALANCE

Digital cameras have built-in white balance control, which compensates for variations in the color of common types of light so that white and gray objects appear to have a neutral color balance. The color of a light source is described in terms of its color temperature, measured in degrees Kelvin (K). If the color temperature of the light does not match the white balance setting, the final image will have a color cast to it. Think of the white balance control as a built-in set of electronic filters that allows you to alter the color temperature of each frame. Typically, the white balance can be set to one of a variety of fixed values or can be measured and set manually.

Learning how to adjust and control the white balance is the best initial method for achieving the desired color balance of the final image. DSLRs can automatically or manually adjust the color balance of each frame electronically according to the color temperature of the light coming through the lens. Begin with *Auto* white balance for general light sources of 3500 to 8000 K. If the desired results are not achieved, then try one of the following: *Incandescent*, for use with 3000 K incandescent lighting; *Fluorescent*, for use under 4200 K fluorescent

lighting; *Direct sunlight*, for use with subjects lit by 5200 K direct sunlight; *Flash*, for use with 5400 K built-in flash units; *Cloudy*, for use in daylight under 6000 K overcast conditions; *Shade*, for use with subjects in 8000 K shady conditions; and *Preset*, for use with a gray card or white object as a reference to create a custom white balance. Using Preset allows the white balance to be fine-tuned to compensate for variations in the color of the light source or to deliberately introduce a slight warm or cool cast into an image. Raising the white balance setting can slightly compensate for light sources with a red or yellow cast, making an image look more bluish. Lowering the white balance setting can slightly compensate for bluish light sources, making an image appear slightly more red or yellow. Many DSLRs offer White Balance Bracketing, in which the white balance is automatically varied in a series of exposures. When using RAW file capture, the white balance, along with other image controls, is adjusted using post-exposure software. However, it is still best to get the white balance as accurate as possible to reduce later workflow problems (see Exercise 4.2).

CAMERA COLOR MODES

Digital cameras have image-processing algorithms designed to achieve accurate color, but there are variables within these programs and within the scene that may produce distinct color variations. DSLRs offer a range of application modes. For instance, one mode might be optimized to set the hue and chroma values for skin tones in portraits that will be used "as is" (no or minimal post-exposure processing). A second mode could be Adobe RGB color space that can give a wider gamut of colors, which is the preferred choice when images will be extensively processed. A third mode could be optimized for making "as is" outdoor landscape or nature images.

COLOR SATURATION CONTROL

Digital cameras usually have a saturation control for adjusting the intensity of color in the image for printing and/or manipulation in the computer. The color saturation or vividness of an image can be set to Normal, recommended for most general situations; Moderate, useful when post-exposure image processing is planned; or Enhanced, for increased saturation, which can be useful in "as is" situations when no additional post-modifications are planned. Again, when using RAW capture, color saturation is controlled with post-exposure software.

HUE ADJUSTMENT/RGB COLOR MIXING

The RGB color model used in digital photography reproduces colors using differing amounts of red, green, and blue light. When two colors of light are mixed, a variety of colors can be produced. For instance, red light

EXERCISE 4.2 WHITE BALANCE SETTING

Purposely make photographs under lighting conditions that do not match the type of light for which the camera's white balance is set. Then, under the same mismatch of conditions, take corrective actions using white balance, flash, and/or filters to make corrections. Compare your results. Discuss the emotional effect that is created when the white balance and light do not match. Might there be a situation when you would intentionally create a mismatch? Why?

Observe any frequently occurring problem situations that a filter would help to solve. Base future purchases on your own shooting experiences, and get the equipment that lets you make the pictures you desire.

combined with a small amount of green light produces orange. Mixing equal amounts of red and green will produce yellow. Combining various amounts of red and blue light can generate a range of colors, from reddish purple through purple to navy. Combinations of all three colors produce a range from white through gray. Arranging this progression of hues in a circle results in what is known as a *color wheel*. Using this method, you can slightly adjust the hue or color of a captured image in varying increments. For example, raising the hue adjustment of red would increase the amount of yellow, resulting in a more orange image. Lowering the hue level would increase the amount of blue, giving a more purple image.

WHY A COLOR MAY NOT REPRODUCE CORRECTLY

Camera image sensors are designed to replicate what the designers believe is an agreeable rendering for most subjects in a variety of situations. Since the sensors are not sensitive to colors in precisely the same way as the human eye, there can be times when it is impossible to

FIGURE 4.20 This exposure was made in Bermuda at Palm Gardens using a digital camera with a #87 deep red filter on the lens. "This print illustrates how recording the infrared spectrum, which our human eyes cannot see, can turn a typical scene into a fairytale-like image capturing the magic of the place. This technique allows a photographer to record how she/he felt about a location and not just how it was seen."

Credit: © Theresa Airey. *The Wishing Well*, 2004. 12 x 16 inches. Inkjet print.

re-create a specific color. Sensor designers concentrate on trying to successfully reproduce flesh tones, neutrals (whites, grays, and blacks), and common "memory" colors, such as sky blue and grass green, under a variety of imagemaking situations. As a result, other colors, such as yellow and orange, often do not reproduce as well. Also, the ability to properly match the input to the output source—screen, print, or transparency—plays a major role in determining how accurately colors will reproduce (see Chapter 8).

LENS FILTERS

A photographic filter is a transparent device that can alter the quality and quantity of light. It can be placed in front of the camera lens or in the path of the light falling on the subject. Filters that go in front of the lens must be of optical quality; otherwise, they can degrade the image quality. Those used in front of a light source do not have to be of optical quality, though they must be able to withstand high heat without becoming distorted, faded, or subject to combustion.

HOW FILTERS WORK

Most filters are colored and work subtractively, absorbing the wavelengths of light of their complementary (opposite) color while transmitting wavelengths of their own color. The color of a filter is the color of the light it transmits. For example, a red filter absorbs green and blue light while transmitting red light. Although a filter transmits its own color, it also passes all or parts of the colors next to it in the spectrum while absorbing part or most of all other colors. While a red filter does not transmit yellow light, it does allow some light from yellow objects to pass. This occurs because yellow is made up of green and red. Thus, the red filter passes the red portion of the yellow while blocking the green.

FILTER FACTOR

Filters are normally uniform in color but may differ in density (color strength). The amount of light absorbed

depends on the density of the filter. Since filters block some of the light, they generally require an increase in exposure to make up for the light lost due to absorption. This compensation is known as the *filter factor* and is indicated as a number, followed by an X sign, which tells by how much the exposure must be multiplied. A filter factor of 2X means that one additional f-stop of exposure is needed; 2.5X shows 1⅓ additional f-stops are necessary; 3X means an extra 1⅔ f-stops are needed; 4X indicates two additional f-stops of exposure. To simplify matters, many manufacturers indicate how many f-stops are needed to increase the exposure. Table 4.4 shows the effect of filter factors on exposure.

Most TTL camera metering systems give an accurate reading with a filter in place; if not, adjust the ISO to compensate. Some TTL meters can be fooled and give faulty readings with certain filters. Bracket and review your exposures in your monitor when using a filter for the first time. Table 4.4 also shows the amount of additional exposure needed for many common filters when working with a handheld or non-TTL camera meter. Autofocus systems may not operate properly with heavy filtration, diffusion, or certain special effects filters. If the system balks, switch to manual focus.

TABLE 4.4 Filter Factor Adjustments

Filter Factor	Exposure Adjustment
1.2X	+1/3 stop
1.5X	+2/3 stop
2X	+1 stop
2.5X	+1 1/3 stops
3X	+1 2/3 stops
4X	+2 stops
5X	+2 1/3 stops
6X	+2 2/3 stops
8X	+3 stops

Note: Cameras with TTL meters should make the correct filter factor adjustment automatically. When using a handheld meter, you'll have to make the adjustment manually. The lens aperture may be set in between the standard f-stops to achieve accurate exposure adjustment.

NEUTRAL DENSITY FILTERS

Neutral density (ND) filters are applied to reduce the intensity of the light by absorbing the same amount of all the wavelengths. ND filters will not affect the color balance or tonal range of a scene. They have an overall gray appearance and come in different densities (ND2, ND4, and ND8) that will cut the light by 1, 2, or 4 f-stops. An ND2 transmits 50 percent of the light; ND4, 25 percent; and ND8, 12.5 percent. Kodak's Wratten ND filters, available in dyed gelatin squares, come in 13 different densities, ranging from 0.1 (needing 1/3 f-stop more exposure) to 4.0 (needing 13⅓ more f-stops of exposure).

An ND filter can be used anytime the light is too bright to use a large lens aperture opening and/or a slow shutter speed. Using ND filters for outdoor portraiture can be very effective because it permits you to use a large aperture to reduce the depth of field, thus putting the background out of focus and giving more emphasis to the subject. They are effective when using fill flash on a bright, sunny day to maintain correct sync speed. ND filters also can be employed to get a slower shutter speed and produce intentional blur action shots. For example, a slow shutter speed would let the movement of cascading water be captured as a soft blur. In another instance, when moving the zoom control of the lens during exposure, you will want to use a tripod and a shutter speed of 1/15 second or slower. ND filters also can be useful in making pan shots.

CONTROLLING REFLECTIONS: POLARIZED AND UNPOLARIZED LIGHT

Normally, while a light wave moves in one direction, the light energy itself vibrates in all directions perpendicular to the direction of travel of the light wave. Such light is said to be *unpolarized*. Polarizing filters are designed to transmit only the part of each light wave vibrating in a particular direction; the rest of the light wave is refracted away from its original direction. The portion of the light that is transmitted is called *polarized* light.

WHAT A POLARIZING FILTER CAN DO

A polarizing filter is made up of submicroscopic crystals that are lined up like a series of parallel slats. Light waves traveling parallel to the crystal slats pass through unobstructed, while those light waves vibrating at all other angles are blocked. Because all the polarized light is at the same angle, a polarizing filter is designed to rotate so it can transmit the polarized portion of the light.

Usually a gray-brown color, polarizers are used to eliminate reflections from smooth, nonmetallic, polished surfaces, such as glass, tile, tabletops, and water, which often improves the color saturation by screening out the polarized part of the glare. This can make a clear blue sky appear deeper and richer and have more contrast

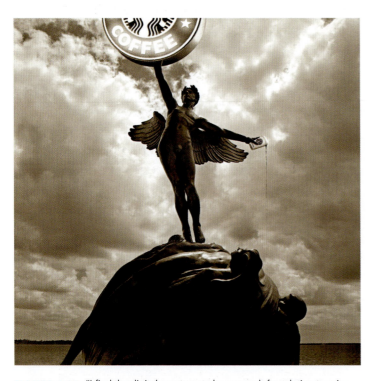

FIGURE 4.21 "I find the digital montage to be a superb foundation to raise questions around the ethics behind consumerism. Has consumerism reached a level of absurdity? Or is that label reserved for the moment when Starbucks begins to incorporate public park statues into their ad campaigns? Here I used a polarizer at the time of exposure to manipulate the reflections on the statue. This work allows me to visually explore the gap between *what if* and *what is*, for if I can use these ideas to create a farce, how much longer will it be until someone else seriously applies them."

Credit: © Frank Donato. *Starbucks*, 2006. 14 x 14 inches. Chromogenic color and inkjet prints.

without altering the overall color balance of the scene. The increase in saturation results from a decrease in surface glare. Since most semi-smooth objects, such as flowers, leaves, rocks, and water, have a surface sheen, they reflect light, thus masking some of the color beneath the sheen. By reducing these reflections, polarizers intensify the colors.

For cutting through haze, a polarizing filter can be more effective than a haze filter because it reduces more of the scattered blue light and decreases reflections from dust and/or water particles. The net effect is the scene appears to be more distinct and sharp while also increasing the visual sense of depth and adding to the vividness of the colors. When copying original art and reproductions from books or when photographing glossy surfaced objects, you can obtain maximum glare control by using polarizing filters in front of the light sources as well as in front of the camera lens. Evaluate each situation before using a polarizer, as there are situations in which the purposeful inclusion of reflections can strengthen a photographer's underlying concept.

USING A POLARIZER

When using a polarizing filter, focus first, turn the filter mount until the glare decreases and the colors look richer, and then make the exposure. The filter factor, which varies from about 2X to 3X depending on the type of polarizer used, will not be affected by how much the filter is rotated. The amount of the effect is determined by how much polarized light is present in the scene and the viewing angle of the scene. At an angle of about 35° from the surface, the maximum reduction in reflections can be achieved when the polarizer is rotated to the correct position.

A polarizer may also be combined with other filters for special effects. Some polarizers come with color, combining a gray and a single colored polarizing filter. Any color, from gray to the full color of the other filter, can be achieved by rotating the filter frame ring. There are also multicolored polarizers that combine a single gray polarizing filter and two colored polarizing filters. Rotating the filter frame ring alters the colors.

LINEAR AND CIRCULAR POLARIZERS

Two types of polarizers are used in photography: the traditional linear and the contemporary circular models. If your camera has a semi-silvered mirror, which includes all current autofocus DSLR cameras, the linear filter will produce underexposed and out-of-focus pictures. To avoid these undesirable side effects, use only a circular polarizer on a DSLR.

ULTRAVIOLET, SKYLIGHT, AND HAZE FILTERS

Traditionally, ultraviolet and skylight filters were commonly used with film cameras because they absorb ultraviolet (UV) radiation that could adversely affect film and have no filter factor. However, UV light does not adversely affect most contemporary color films and digital sensors because they have their own built-in filter. Even so, many photographers leave a UV filter on all their lenses to protect the lens surface from dirt, fingerprints, moisture, and scratches. UV filters are colorless, whereas skylight filters are pinkish. Both filters can effectively remove UV light, though skylight filters may produce slightly warmish images because of their pinkish cast.

Haze is due to dust particles in the air. These particles reflect the shorter wavelengths more than the longer ones. Thus, UV is affected the most, followed by blue, and then by green and red, which results in images that are not very sharp. Haze filters reduce this effect and are especially useful at high altitudes and over long distances, particularly water. They are not effective when dealing with fog, mist, smog, or smoke. Haze filters are yellowish in color to counter the excessive blue and are available in different grades. However, for color photography, polarizers are frequently used. Although in certain situations polarizers may not cut through haze as effectively as haze filters do, a polarizer can increase the contrast of the scene by eliminating reflection.

BOX 4.2 SPECIAL EFFECTS FILTERS

- **Center spot**: Diffuses the entire area except the center.
- **Changeable color**: Used in combination with a polarizing filter. Rotating the filter changes the color, from one primary, through the midtones, to a different primary color.
- **Color spot**: The center portion of filter is clear with the surrounding area colored.
- **Color vignette**: A clear center portion of filter shades off into colored edges.
- **Cross screen**: Exaggerates highlights into star shapes.
- **Diffraction**: Takes strong highlights and splits them into spectral color beams.
- **Diffusion**: Softens and mutes the image and color.
- **Double exposure**: Masks half the frame at a time.
- **Dual color**: Each half of the frame receives a different color cast.
- **Fog**: Delivers a soft glow in highlight areas while lowering contrast and sharpness.
- **Framing**: Masks the frame to form a black or colored shape.
- **Graduated**: Half the filter is colored and the other half is clear.
- **Prism/multi-image**: Repeats and overlaps the image within the frame.
- **Split field**: Allows differential focus within the frame.

FIGURE 4.22 Dan Burkholder captures and processes his images on-site, in the manner of plein air painters, using a smartphone paired with an assortment of inexpensive imaging apps. Burkholder observes, "For the first time we have both camera and darkroom in the palm of our hands." He then enhances the digital by utilizing an analog printing process that involves hand-coating thin, vellum paper prints with platinum/palladium sensitizer and 24K gold leaf to create the desired visual outcome.

Credit: © Dan Burkholder. *Tree in April Snow. Catskills*, 2011. 10 x 10 inches. Platinum/palladium print on vellum over gold leaf. Courtesy of John Cleary Gallery, Houston, TX.

SPECIAL EFFECTS FILTERS

Special effects filters produce unusual visual effects at the time of exposure (see Box 4.2). These same effects can be replicated, post-exposure, with imaging software, especially with after-market plugins (see the section "Digital Filters and Plugins" later in the chapter) and with smartphone applications, such as Hipstamatic. Such plugins simulate popular glass camera filters, specialized lenses, optical lab processes, film grain, and exacting color correction, as well as natural and infrared light and photographic effects—all in a controlled digital environment. Be sure to exercise thought and care before using any special effects filters, however, for they have been chronically overused by imagemakers who lack genuine picturemaking ideas. Most images made with such effects are clichéd and entirely predictable.

HOMEMADE COLORED AND DIFFUSION FILTERS

You can express your ingenuity by making your own filters for your particular purposes. Although homemade filters will likely not match the quality of commercially manufactured filters or software, they can produce unique results that would not otherwise be possible. A universal filter holder, attached in front of the lens, permits experimentation with a variety of materials, including gelatin squares of commercial filters. All you need to make a filter is transparent material. Colored cellophane and theatrical gels provide simple and affordable starting places. Marking clear acetate with color felt-tipped pens is an excellent way to produce pastel-like colors. Photographing a light-colored subject against a bright background can heighten the pastel effect. There are endless possibilities, including making split-field filters with numerous color combinations.

Photographing through transparent objects, such as stained glass or water, is another way to transfer color and pattern to a subject.

Homemade diffusion filters can be made from any transparent material, with each creating its own unique way of scattering the light and producing a different visual effect (see Exercise 4.3). Test some of the following methods to see which ones suit your needs:

- *Cellophane:* Crumple up a piece of cellophane, and then smooth it out and attach the cellophane to the front of your lens with a rubber band.
- *Color felt-tipped pens:* A variety of pastel effects can be achieved on clear acetate.
- *Matte spray:* On an unwanted clear filter or on a plain piece of Plexiglas or glass, apply a fine mist of spray matte material.
- *Nail polish:* Brush some clear nail polish on a piece of clear glass or an unwanted UV filter. Allow it to dry and it's ready to use. Painting different patterns and/or using a stipple effect will deliver a variety of possibilities. Nail polish remover can be used for cleanup.
- *Petroleum jelly:* Carefully apply the petroleum jelly to a clear piece of glass or a UV filter with your finger, a lint-free towel, or a brush. Remove any that overflows onto the sides or the back of the support so it won't get on your lens. The direction of application and the thickness of the jelly will determine the amount of diffusion. Use soap and warm water for cleanup.
- *Stockings:* Stretch a piece of fine-meshed nylon stocking over the front of the lens and attach it with a rubber band. Use a beige or gray color unless you want the color of the stocking to influence the color balance of the final image. White stockings scatter a greater amount of light and thus considerably reduce the overall contrast of the scene.

- *Transparent tape:* Apply a crisscross pattern of transparent tape on a UV filter. The amount of diffusion is governed by the width and thickness of the tape.

DIGITAL FILTERS AND PLUGINS

Some digital cameras have built-in filter effects that can be accessed from the Menu, but imaging software programs offer an abundance of digital filters that may be applied *after* image capture to mimic traditional photographic filters and/or to correct, distort, enhance, or manipulate all or any part of an image. The best way to see what each filter can do is to open up an image with your imaging software and go through the Filter menu. Some filters provide a pop-up dialog box that will allow you to see the default action, whereas others require the use of sliders to see the various effects. Most have a preview window that shows the filter's effect on the image.

The most commonly used filters for general photographic image processing are those for sharpening and noise reduction. For instance, *Gaussian Blur* is widely applied to reduce pixelization, image noise, and detail by softening a selected area or an entire image. It operates by smoothing the transitional areas between pixels through averaging the pixels next to the hard edges of defined lines and shaded areas in an image. *Lens Blur* can manage the widespread problem of too much depth of field by adding a controllable amount of blur to an image so that some areas in the scene remain

EXERCISE 4.3 FILTERING FOR EMOTIONAL IMPACT

Using one or more of the methods discussed in this chapter, or one of your own design, make a series of photographs that derive their emotional impact through the use of filters. Photograph a scene with and without the filter. Use your monitor to compare compensated versions with uncompensated ones. See what looks more engaging to you. Bracket and review your exposures to ensure acceptable results. Mix and match results with software filters. It is very difficult to become a good photographer without making lots of pictures, but do not expect most frames to be a keeper. Ansel Adams reportedly said he was happy to make 12 good photographs a year.

FIGURE 4.23 By replacing the natural color of this scene with an artificial one and adding digitally drawn components, Joseph Labate generates a tension through his juxtaposition of the camera's familiar description with the new language of digital imaging. On one hand, the image closely resembles a "straight" photograph, yet on the other, it appears to be an obvious contrivance that hints at another level of reality, suggestive of images made with photographic materials sensitive to the infrared part of the spectrum.

Credit: © Joseph Labate. *Landscape #1152*, 2006. 24 x 32 inches. Inkjet print.

sharply in focus, whereas others appear to be out of focus. *Tilt-Shift* provides advanced controls for simulating shallow depth of field (see the section "Perspective" in Chapter 10).

A third-party filter, known as a *plugin*, is designed to be integrated into another program and provide additional functionality that was not available in the original application. A plugin can take many forms: filters, image processing, file formats, text, automation, and more, with the most common being special effects. The special effect can be as simple as shifting a pixel to the right or as complex as altering the direction of light and shadow in an image.

Thousands of digital filters, plugins, and smartphone applications are available and can be viewed online. Many websites offer free downloadable demonstration trials. Once installed, these filters and plugins usually appear at the bottom of the Filter menu.

Applying a filter, plugin, or smartphone application to a mediocre picture and converting it into something that looks like a Georges Seurat pointillist painting will

not make it a better picture. Filters and plugins should be applied thoughtfully to avoid making overbearing, hackneyed pictures. Filters and plugins have the potential to become seductive side trips that waste time and steer you away from your vision. Bear in mind such sayings as "You cannot make a silk purse out of a sow's ear" and the more contemporary "Garbage in, garbage out," and be sure you begin with an appropriate and visually articulate image before experimenting. Think of filters and plugins as tools capable of reinforcing well-seen images, and not as lifesavers for trite pictures.

FLUORESCENT AND OTHER GAS-FILLED LIGHTS

A fluorescent light source consists of a gas discharge tube in which the discharge radiation causes a phosphor coating on the inside of the tube to fluoresce. Although such light may appear similar to light from other artificial sources, it is not. Fluorescent light possesses both a discontinuous and an unbalanced spectrum. The type of phosphor and gas used affects the color of the light, which has peak outputs in the green and blue regions of the spectrum, valleys or deficiencies in red, and gaps of other wavelengths. Light intensity varies as the gas moves in the tube. This makes it a discontinuous source, lacking the full range of wavelengths that are present in the visible spectrum. For this reason, it is generally unsuitable for naturalistic color photography. However, there are "full-spectrum" fluorescent lamps with a high color rendition index (CRI) that have color temperatures of about 5000 to 6000 K.

If you photograph with an improper white balance setting under fluorescent light, the resulting image will have a green cast. This generally is not attractive, especially if you are making pictures of people. If a green cast is not what you had in mind, corrective action is required. Start by using the fluorescent white balance setting. If you are not satisfied with the results, try experimenting with different white balance settings and features (see Exercise 4.4). Should problems continue, consider the following corrective actions:

EXERCISE 4.4 FILTERING FOR FLUORESCENT LIGHT

Photograph a subject under fluorescent light with no color correction. Next, under the same fluorescent conditions, try one or more of the suggested corrective actions. Compare the two. Which do you favor? Why? How does the quality of light affect the subject matter?

Photograph a subject under unnatural and natural lighting conditions. Evaluate how the unusual colors affect your emotional and intellectual response. Which elicits a stronger response? Why? How does the type of light affect the interpretation of subject matter?

1. Use a shutter speed of 1/60 second or slower to minimize the flickering effect of the fluorescent lamp.
2. Replace the standard fluorescent lights with tungsten lights or with full-spectrum fluorescent lamps.
3. Place corrective plastic filters over standard fluorescent tubes to bring the color temperature closer to daylight.
4. Use fill flash to help offset the green cast.
5. Correct using post-capture imaging software.

HIGH-INTENSITY DISCHARGE LAMPS/MERCURY AND SODIUM VAPOR SOURCES

High-intensity discharge lamps, such as mercury vapor rated at about 4100 K to 4500 K and sodium vapor at approximately 2100 K to 2500 K, fit into the category of gas-filled lights. These bright lamps are generally used in industrial and public spaces. They are extremely deficient in many of the wavelengths that make up white light, especially red, making them almost impossible to correct. Try experimenting with different white balance settings and features, but the situation may require extreme amounts of additional filtration in front of the lens.

FIGURE 4.24 Mark Maio engages his photographic eye, an aesthetic way of seeing, when making and arranging images. To accomplish this, Maio utilized the now defunct Kodachrome film with a Zeiss photo slit lamp, which is made for the examination and photography of the lens, cornea, and iris of the human eye. Here, Maio selected 20 images from more than 200 photographs of individual human eyes that he photographed at 25X magnification, which he lit at an extreme angle to capture the iris's texture. Maio has spent over 35 years in the field of ophthalmology, and here, he unites his fine art and scientific interests to update an obsolete analog process with current digital technology. The resulting deep and rich images reveal an inner space with subconscious associations, allowing viewers a glimpse into the seldom-seen landscapes of the human body.

Credit: © Mark Maio. 20/20, 1995–2011. 12 x 12 inches. Inkjet print.

FIGURE 5.0 Folberg explains: "In this series I take measure both of myself and the phenomena that I experience. My presence inserts, both literally and figuratively, an element of control. Whether it's man's need to dominate nature, a photographer's need to construct an image, or an artist's need to understand the nature of the world in which we live, the desire to feed that knowledge is seen throughout this series." Photographed during a solar eclipse, Folberg experienced the enormity of this natural phenomenon but was unable to see the full eclipse due to cloudy skies. The unseen eclipse became a visual metaphor for experiencing what cannot be seen directly. Folberg continues: "I was photographing myself by using the setting sun to project my shadow on the steam coming out of the fumaroles; I watched my shadow and the reflection of the sun in the lens to help determine correct placement and composition. The Schneider Super-Angulon f/3.5 40mm lens allows one to shoot straight into the sun without flare. The Leaf digital camera back has such an extensive dynamic range that I knew contrast would not be a problem and I could retain detail in the shadows and highlights while shooting directly into the setting sun."

Credit: © Neil Folberg. *Passing Shadow at Summer Solstice*, from the series *Taking Measure*, 2016. 44 x 60 inches. Inkjet print. Vision Neil Folberg Gallery, Jerusalem, Israel.

Interpreting Light

NATURAL LIGHT

Physics shows us that light is ambiguous and paradoxical, possessing the qualities of both particles and waves. Light's multidimensionality can reveal any subject's many diverse realities, which may be as fleeting as light itself. The ever-changing physical properties of light demonstrate that everything is in flux and nothing is as it appears, signifying the numerous ways any subject may be viewed and interpreted. Exceptional two-dimensional examples of this principle can be seen in Roberto Matta's surrealist paintings, such as *Les Humarbes* (1973), which created new visual dimensions by blending cosmic and organic life forms. A three-dimensional model can be seen in Brion Gysin's *Dreamachine* (1960), which utilizes light to produce a stroboscopic "flicker" effect that generates colors and visions.

THE THINGNESS OF LIGHT

Every photograph is about light. Each image provides a different set of conditions in which we can experience light. A plastic medium capable of being physically manipulated, light is the key ingredient shared by all photographs and the determinant in the look of every photograph you make. Light's primal authority defines the essence of a subject. The powerful glue that holds your image together, light makes known the emotional

and physical contents within your visual space and activates vision and meaning. If the light does not inhabit and reveal the perceived nature of the subject, the picture will not communicate the content you wish to transmit to a viewer. In short, light is the photographer's ever-present collaborator.

A form of visual grammar that can activate specific physical sensations and psychological sensibilities, light allows us to touch with our eyes. Its diverse characteristics, analogous to how we use words to explain our world, offer imagemakers a wealthy descriptive toolbox to call upon. One could say that imagemakers use light as adjectives to bring out the attributes that best describe or modify their subjects. Experienced imagemakers know how to expand their photographic vocabulary by using light's broad depictive attributes to communicate expressive, emotional, metaphoric, and symbolic meaning. This is learned through observation of light's natural cycle. Developing an awareness and knowledge of natural light is the first step toward the discerning use of its substitute: artificial light. The possibilities of natural light are infinite and self-renewing. To study photography is to study light by emphasizing your visual results rather than the means of containing them. The type of equipment you use is not important. What matters is learning how to make your gear an extension of your own vision. Begin to recognize what light artist and *Roden Crater* project creator James Turrell calls the "thingness" of light, the ever-changing characteristics

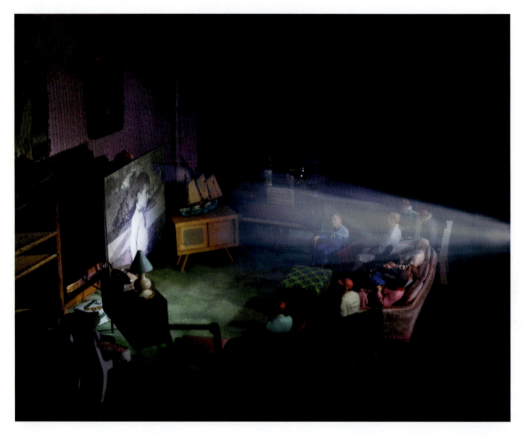

FIGURE 5.1 The Robert Mann Gallery expounds: "The lights begin to dim, ambient noises fade away, suddenly there is a burst of light overhead and you are transported... this is the premise of Richard Finkelstein's *Sitting in the Dark with Strangers*. Finkelstein uses miniature figurines and meticulously fabricated sets to compose his images that find inspiration in painting and film. In this image the quality of his use of stark lighting with linear breaks are reminiscent of works by Edward Hopper. Finkelstein not only comments on how movies impact our emotions, but how like a dream, a film allows a viewer to give up the appearance of reality to that which is unreal."

Credit: © Richard Finkelstein. *Home Movie*, from the series *Sitting in the Dark with Strangers*, 2015. 30 x 40 inches. Inkjet print. Robert Mann Gallery, New York, NY.

and psychological qualities that natural light possesses throughout the day, and learn to experience and incorporate them into your composition for a complete visual statement.

GOOD LIGHT

The definition of "good light" is solely dependent on a photographer's intent. There is no time of day or year when the sunlight is photographically better than another. However, it may be more suitable for a particular subject. At various times of day and in different seasons, light takes on a range of unique physical attributes, each with its own tactile and emotional qualities. Have you ever photographed a scene that you thought would make an engaging image, yet the results were disappointing? There is a strong probability that it was photographed at a time of day when the light did not reveal those fundamental aspects of the subject that were important and attracted you to the scene in the first place. Try making pictures of the scene again at a different time of day. Keep in mind that discovering the best natural light for any subject is often just a matter of timing and waiting for the light to be "right." If a scene grabs your attention and you don't have a camera with you, make a mental note of the time of day and the weather conditions so you can return later and capture what you initially found intriguing. Just as

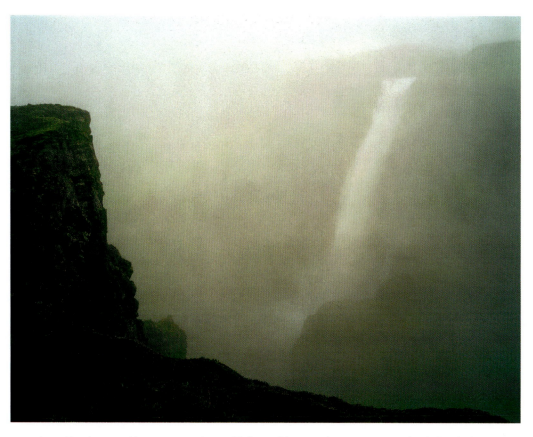

FIGURE 5.2 "I am drawn to primeval landscapes with extreme weather and light conditions to cultivate a certain melancholy, which I carry within, along with my enthusiasm for life. I photograph at night and in the rain because the light is very flat and the reduced amount of visual information under these conditions gives the composition more space. The reflective quality of the landscape is evoked through the reduction of light. You are perplexed and almost feel uneasy, and you have to take a stand on this mood confronting you. There is a stillness, a vacuum that leaves you only with yourself. The same thing happens later with a viewer that happens to me the moment I take the picture under these reduced light conditions: You pause for a moment. Time seems to be standing still."

Credit: © Olaf Otto Becker. *Haifossnebel, Iceland*, 2002. 45 x 54 inches. Inkjet print. Courtesy of Cohen Amador Gallery, New York, NY.

writing is about rewriting, photography can be about rephotographing a subject until you get what you want. Linking light's physical and ephemeral components, the objective with the subjective, can result in a transformative sensory experience.

LIGHT AND THE CAMERA

Your ability to act as a creative photographer depends on your knowledge of how to make your equipment work for you. A camera is a recording device that will not usually interpret a scene or an experience as you desire without your guidance. The camera can isolate a subject and reduce it to two dimensions. It can freeze a slice of time and set it into a frame. What it does not do is record the sequence of events that led up to the moment you pressed the shutter button. Nor does it register the private emotional response that sparked your urge to make a picture in the first place. Because the camera does not discriminate in what it sees, you have to learn to incorporate the essence of these off-screen happenings into your pictures if you expect to make photographs that stand on their own instead of snapshots that require explanation. You can, and must, make such distinctions to create successful images. Keep in mind that the camera, lens, software, and paper have but a single purpose: to capture and present light.

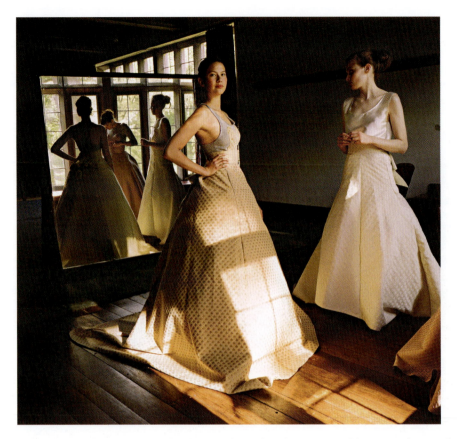

FIGURE 5.3 The grouping of the family members and friends in Jessica Todd Harper's photographs reflect the influence of domestic scenes by painters Mary Cassatt and John Singer Sargent as well as those by Johannes Vermeer, Hans Memling, and Pieter de Hooch. "I was impressed with how their painting could convey the beauty and fragility of the human experience. My pictures are about identity, familial relationships, and the unspoken things that make up the inner stories of our lives. Sometimes that involves waiting for a 'decisive moment' when the light is just right, and other times I use Photoshop in a process analogous to combining different sketches for a final painting to bring all the ingredients together."

Credit: © Jessica Todd Harper. *Chloe and Sybil and Becky*, 2005. 32 x 32 inches. Chromogenic color print. Courtesy of Cohen Amador Gallery, New York, NY.

THE TIME OF DAY/TYPES OF LIGHT

The classic photographic adage instructed people to "Take pictures after ten in the morning and before two in the afternoon." This rule had nothing to do with aesthetics. Its purpose was to encourage amateur photographers to take pictures when the light was the brightest because early roll film was not very sensitive to light. By breaking this rule, you can create some astonishing results.

THE CYCLE OF LIGHT AND ITS BASIC CHARACTERISTICS

Begin by observing the cycle of light and noting its characteristics, especially in terms of color and shadow. The following are some of the basic qualities of the predictable phases of light that will affect your images (see Exercise 5.1).

EXERCISE 5.1 TIME OF DAY/TYPE OF LIGHT

This exercise is based on *The Nature of Light and Shadow,* created by artist/educator Myra Greene.

Objectives
- To help you realize that the true subject matter of many photographs is light and how photographers modify it.
- To heighten your awareness of some of the different qualities of light as they appear during various times of day, seasons, and weather conditions.
- To demonstrate that the light's direction, the angle at which it strikes a subject, can make a dramatic difference and impact in the appearance and perception of a subject: you can emphasize or minimize certain subject details by thoughtfully using the direction of light.
- To help you to realize that light is one of the most essential elements that you must learn to see, use, and control in your photographs.

Procedure and Requirements
1. Set ISO to 100.
2. Use a tripod as needed.
3. Use only natural ambient light. Do not modify any existing lighting and/or use electronic flash or any other artificial light source.
4. Photograph during many different times of the day: morning, midday, and evening.

Observe the quality of light at various times and under various conditions—sunny, clear, hazy, or cloudy—of the day and see how it differs. Observe the direction of the light. Side lighting can emphasize texture. Front lighting usually will come from close to the camera's position and generally flattens the perspective of your subject. Back light will define the shape of your subject but typically will obscure some details. Diffused and bounced lighting is quite different from direct light; it can soften the contrast of your subject and minimize its texture. The important issue to think about is how light illuminates any subject and can transform even mundane subject matter into exceptional photographs. Keep a small notebook and record your observations about the lighting conditions each time you go out to make photographs.

The Subject: Your Environment
Explore the environment *outside* your immediate surroundings. Investigate these three different themes by making a minimum of 30 exposures for each topic, from which you will then edit down to three final prints:

- "Urban" ambience
- "Residential" habitat
- "Natural" surroundings

Remember that light is the main consideration for framing and vantage point but does not have to be the subject matter of the image. It is not enough to show just the variations in the quality of light at different times of the day. Make pictures having strong compositions, and relate your observations to your viewers. Think of creative ideas that

continued

will couple well with various forms of natural light. Consider how to effectively compose within your frame and to choose an interesting vantage point. Enlist depth of field and/or motion to establish the tone of the image. Experiment with exposure. The only correct exposure is one that delivers the desired effect in your final image.

Submit

1. Contact sheets of all final exposures.
2. Three completely finished prints, of the appropriate contrast and density, with full-frame images and *nothing cropped out.*
3. One print should represent the "urban" environment, another print should represent the "residential" surroundings, and the third should represent the "natural" atmosphere.
4. A comment/observation and self-evaluation sheet at least one full page in length. Discuss the nature of light and shadow as you observed and recorded it for this assignment, including your environment, any discoveries and new impressions, how the shoots went, your thoughts on the project and your process, and any other observations you think are pertinent. Evaluate your exposures, the quality of your image files, the contact sheets, and your three final photographs. Mention any problems you encountered technically, and last, but certainly not least, include a thoughtful analysis of your results.

BEFORE SUNRISE

In the earliest hours of the day, our world is essentially black and white. The light exhibits a cool, almost shadowless quality, and colors are muted. Up to the moment of sunrise, colors remain flat and opalescent. The intensity of the colors grows as the sun rises. Artificial lights can appear as accents and/or create contrast with their unnatural color casts.

MORNING

As soon as the sun comes up, the light changes dramatically. Since the sun is low and must penetrate many miles of atmosphere, the light that gets through is diffused and much warmer in color than it will be later in the day. The shadows can look blue, as they lack high, brilliant sunlight and because of the great amount of blue from the overhead sky. As the sun rises, the color of light becomes warmer (red-orange). By midmorning, the light begins to lose its warm color and starts to appear clear and white.

THE GOLDEN HOUR

This first hour of sunlight, as well as the last hour before sundown, is known as the golden, or magic, hour. Many photographers favor it because the diffused light reduces the contrast range, making it easier to capture without overexposing the highlights, while the warm hues are considered to be desirable enhancements to the colors in a scene. The most dramatic effects may last for only a few minutes, so be prepared.

MIDDAY

The higher the sun climbs in the sky, the greater the contrast between colors. At noon, the light is white and may be too crisp, harsh, or stark for many subjects. Colors stand out strongly, each in its own hue. Shadows are black and deep. Contrast is at its peak. Subjects may appear to look like cardboard cutouts. Often, fill flash is needed to balance the lighting across a subject and reduce the harsh shadows.

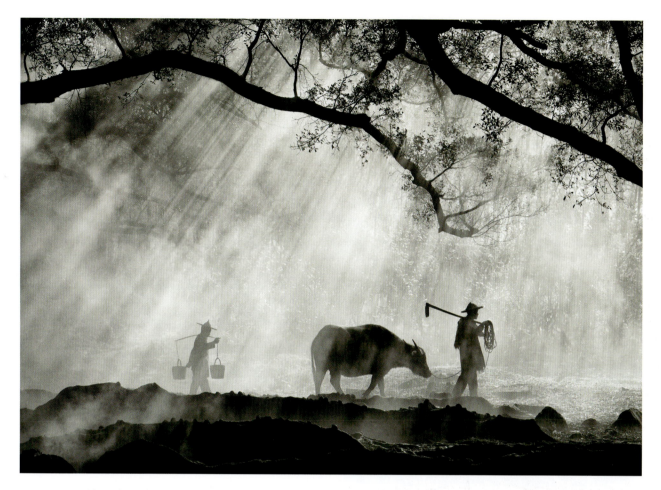

FIGURE 5.4 Oliver Klink informs us: "The transition from a pre-modern or traditional to a modern society is frequently described as modernization. *Ancient Farming* addresses the current threats to natural and cultural diversity, sites where modernity, tradition, and wild lands collide. It is an elegy for what is vanishing and a celebration of those cultures on the fringe of modern society resilient enough to maintain their vibrancy. It is cliché, but being at the right place with the right weather pattern was critical. After three attempts, I finally got the early morning God's rays to cooperate. Artistically, I wanted to incorporate elements that complement the ancient traditions of farming in China. The banyan tree was a great addition to the scene with its complex root system. Technically I expose for the highlights and process for the shadows. I use a special inkset and printing technique (Piezography), which enables me to pull granular details in the shadows and give volumes to the various shapes (tree roots, farmers, water buffalo). The translucency of the background was made possible by adjusting the tones thru luminosity masks."

Credit: © Oliver Klink. *Ancient Farming*, from the series *Consequences*, 2015. 16 x 24 inches. Inkjet print.

AFTERNOON

As the sun drops to the horizon, the light begins to warm up again. This is a gradual process and should be observed carefully. On clear evenings, objects can take on an unearthly glow, repeating the effect of the morning's golden hour. Look for an increase in red. The shadows lengthen and become bluer. Surfaces are strongly textured. An increasing amount of detail is revealed as the level of the sun lowers.

SUNSET

At sunset, the angle of light is at its most extreme and hard. Highlights are blazingly intense while shadows are dark and deep and well defined and contrast is at its peak. Detail vanishes, making it an ideal time for making silhouettes that emphasize form and shape. Atmospheric effects and luminous energy are intense, and the quality of light is very warm.

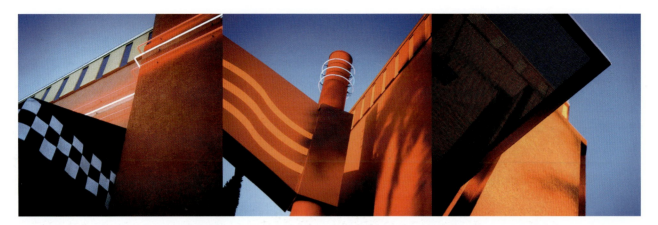

FIGURE 5.5 "This image was constructed from three separate negatives made in the 'Golden Hour' of late afternoon light. I scanned the negatives and 'gently' assembled them in Photoshop, matching colors and aligning some angles to create the natural flow between the images. I purposely chose not to knit the images together to make a seamless panorama, feeling that viewers at the turn of the twenty-first century have assimilated disparate imagery that coexists simultaneously. I also wanted the 'constructed environment' to be very clear, as a metaphor for our lives and how we, in the digital, postmodern age have come to embrace dissonance."

Credit: © Thomas McGovern. *The New City, #18*, 1999–2001. 10 x 30 inches. Inkjet print.

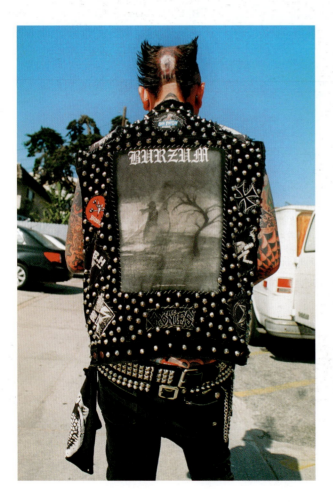

FIGURE 5.6 Influenced by the typologies of August Sander, Susan Barnett's environmental portraits capture "those who are willing to wear their heartfelt message on their back without fear of reprisal." Barnett's use of a wide-angle lens with a polarizer allows her to record vibrant blue skies that complement the bold slogans sported on her subjects' T-shirts while highlighting their relationship to the landscape. "On the streets, these personalities create their own iconography that survey the cultural, political, and social issues that have an impact on our everyday lives. The seeds of this project were planted in the 1960s when, as an activist in the antiwar movement, I made cardboard posters and T-shirts for protest rallies and marches."

Credit: © Susan A. Barnett. *Spike: The Cronies*, from the series *Not in Your Face*, 2010. 18 x 12 inches. Chromogenic color print.

TWILIGHT/EVENING

After sunset, there is still a lot of light in the sky. Notice the tremendous range of light intensity between the eastern and western skies. Often, the sunset colors are reflected from the clouds. Just as at dawn, the light is very soft, and contrast and shadow are at a minimum. After sunset and throughout twilight, notice the warm colors in the landscape. This phenomenon, known as *purple light*, arises from light from the blue end of the spectrum falling vertically from the overhead sky. Observe the glowing pink and violet colors as they gradually disappear and the earth becomes a pattern of blacks and grays.

NIGHT

The world after the sun has set is seen by artificial light and reflected light from the moon. The light is generally harsh, and contrast is extreme. Combinations of artificial light and long exposure can create a surreal atmosphere. Photographing under these conditions usually entails long exposures at a high ISO setting in combination with a sturdy tripod, a brace, or a very steady hand.

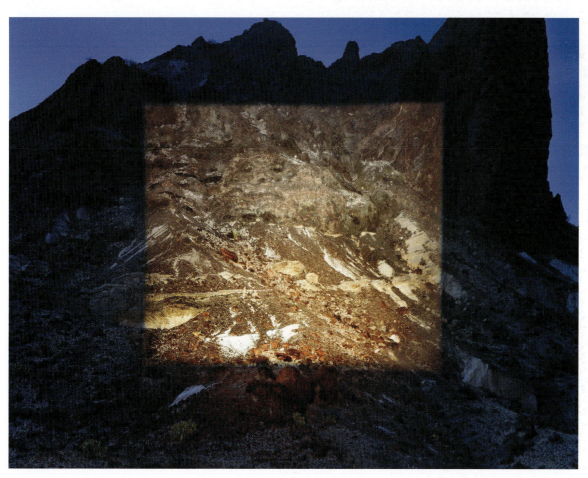

FIGURE 5.7 Abelardo Morell's landscapes focus on the interplay of distinctive zones of light and darkness by getting a "perfect mix of ambient and artificial light." Morell achieves this balance in a series of photographs made at twilight while illuminating the central portion of the image with a spotlight that is focused with barn doors attached to the light stand. These images "show how a continuous stretch of landscape can take on a new set of contrasting properties of space, description, and mood, all within the same moment in time."

Credit: © Abelardo Morell. *Square Light on Landscape, Big Bend National Park, Texas*, 2010. 48 x 60 inches. Inkjet print. Courtesy of Bonni Benrubi Gallery, New York, NY.

FIGURE 5.8 Bill Davis apprises us that "Quality of light affects quality of life. When the night looks like day, we have a problem. It's not natural. There is a dark side to light. Artificial light unplugs the circadian clock from its evolutionary wall. These images are the result of a humanities-centered collaborative sustainability grant I received to photograph sky glow, light trespass, and light pollution—as cause and effect. Planetary well-being is rapidly changing due to the presence of artificial light. I am photographing sites that meet the ratings of the Bortle Dark-Sky scale as dangerously or recklessly overlit tropospheric nighttime space. Light affirms life, but it has the potential to alter or end it. As a photographer, I was educated to see light as an ally. I still do, but only in the context of its appropriate and precautionary applications. In the wrong hands, light can lead to dark results. At night, one need look no further than the cities we inhabit for pedestrian evidence of unnaturally lit space. We should wake up to natural light as a sovereign right because we are not yet waking up to its artificial use as a risk factor threatening biodiversity, health, public policy, and sustainable longevity."

Credit: © Bill Davis. *Site 0340*, from the series *No Dark in Sight*, 2016. 16 x 24 inches. Inkjet print.

MOONLIGHT

Moonlight is reflected sunlight that changes the spectrum of sunlight. When it reflects off surfaces, the color range is further restricted. This limited color palette can be a powerful tool in shifting the mood and/or emotional response to a subject photographed in full-spectrum daylight. Landscapes make excellent subject matter for moonlight photography, provided you have a solid tripod to eliminate camera movement during long exposure (typically lasting minutes even during a full moon). Finding the proper balance between ISO and exposure duration can enhance or minimize the movement of nature as well as the inherent digital noise associated with high ISO and/or long exposures. When working in or near an urban area, the sky will likely be bright due to light pollution. Monitoring the amount of sky in your composition can control these issues. Accommodate for the other numerous light interference sources in the sky, including airplanes, planets, and stars, which will not only affect

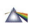

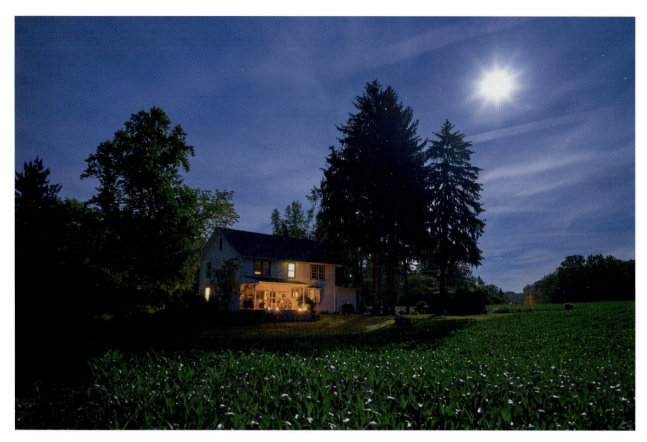

FIGURE 5.9 Biff Henrich's moonlight landscapes appear otherworldly as the digital artifacts of the long exposures deceive our sense of what is real. This elusiveness is at the center of Henrich's conceptual practice: all his work is untitled, there is no artists' statement, and he is not concerned about institutional explanatory notes about his work. What we do know is that he makes it possible to happen in the camera at the time of exposure, emphasizing how the camera is capable of seeing beyond the human eye. This reflects his philosophy that "At its essence, this work is how process reveals 'All.'"

Credit: © Biff Henrich. *Untitled*, 2016. 40 x 60 inches. Inkjet print.

your exposure, but may also produce unwanted bright streaks. Pay attention to passing clouds, as their movement and shape will affect the outcome. Subjects with high *albedo* (reflectance or optical brightness), such as rocks, trees, snow, and water, can make worthy subject matter. Practice, patience, exposure bracketing, and good note taking along with the embrace of chance are qualities that can be embraced to ensure intriguing outcomes. For a handy mobile exposure guide, see https://mkaz.com/light/moonlight/.

THE SEASONS

The position of the sun varies depending on the time of year and your geographic location in relation to the equator. This has a great impact on both the quality and quantity of the light. Learn to recognize these characteristics, and look for ways to go with and against the flow of the season to obtain the best possible photographs.

Winter means a diminished number of daylight hours. Bare trees, pale skies, fog, ice, rain, sleet, and snow all produce the type of light that creates muted and subtle colors. Spring brings an increase in the amount of daylight and the introduction of more colors. Extended summer light offers the world at its peak of

color, though its harshness at midday can present a host of contrast and exposure problems. Fall is a period of transition that provides tremendous opportunities to show the color changes that are occurring.

THE WEATHER AND ATMOSPHERIC CONDITIONS

Just as there is no such thing as bad light, there is no bad weather for making photographs. However, certain meteorological conditions produce lighting conditions that are better suited to particular subjects and for eliciting specific emotional and psychological effects. Fog can provide quiet, pearly, opalescent, muted tones. Storms can add dramatic intensity and an atmosphere of mystery. Rain mutes some colors and enriches others while creating glossy surfaces with brilliant reflections. Dust softens and diffuses color and line. Lightning can add dramatic effect and a sense of the sublime, as thunderbolts have been considered to be divine weapons and potent symbols of strength from Zeus to the Schutzstaffel (Nazi SS).

Bad weather conditions often provide an excellent opportunity to create pictures full of brooding theatrical ambiance and intrigue. With a few precautions to yourself and equipment, you need not be just a fair-weather photographer. Before going out into any unusual weather conditions, be certain your memory card has plenty of room, preset as many functions as possible to avoid exposing your camera to inclement conditions, and review Chapter 3's sections on camera, lens, and battery care. Also, this is the time to experiment with your camera's Scene modes.

FOG AND MIST

Fog and mist diffuse the light and tend to provide monochromatic compositions. The light can tend toward the cool (blue) side. If this is not acceptable, adjust your white balance control, or photograph in the early morning or late afternoon, when there is the chance to catch some warm-colored light. If the sun is going in and out of the clouds, wait for a moment when a shaft of light breaks through the clouds. This can create drama and break up the two-dimensional flatness that these cloudy scenes often produce.

Because the light is scattered, both colors and contrasts are made softer and subtler. If the scene appears too flat, adjust your contrast control. If you want to include a sense of depth in the mist, try not to fill your frame completely with it and/or include the horizon line. Attempt to offset it with a dark area. To capture mist, expose for the highlights. Bracket, review your exposures on your monitor, and make ongoing adjustments.

In fog, take a reading from the palm of your hand in light similar to that which is on your subject. Then, overexpose by 1/2 to one f-stop, depending on how intense the fog happens to be. Bracket and review your exposures.

Fog and haze can also be artificially produced by a fog machine or with an aerosol spray product, such as Atmosphere Aerosol, which claims to be nontoxic and does not require electricity to operate.

RAIN

Rain tends to mute and soften color and contrast while bringing reflections into play. Include a warm accent if contrast or depth is desired. The shutter speed is important in the rain. The faster the speed, the more distinct the raindrops will appear. At speeds below 1/60 second, the drops blur. Long exposures will seem to make them disappear. Experiment with different shutter speeds to see what you can achieve. Bracket, review, and make exposure adjustments as you go.

When working in wet conditions, keep your camera in a plastic bag with a hole for the lens. Use a UV filter or cellophane with a rubber band and a lens hood to keep the front of the lens dry. Place the camera inside your jacket when it is not being used. If you are going to be constantly wet, get a waterproof bag to hold your equipment. Inexpensive plastic bag cases, available at camping stores or online, allow you to photograph in wet conditions without worrying about ruining your camera. Carry a bandana to wipe off any excess moisture.

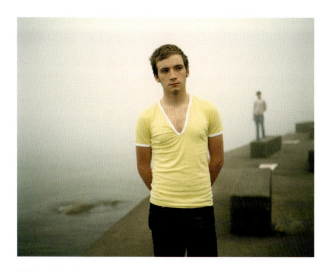

FIGURE 5.10 Rachel Herman's series *The Imp of Love* deals with the complicated feelings and relationships of former couples. Here, the watery backdrops and fog create an extended metaphor and further the muted, neutral palette. The choice of a large aperture opening, f/4, provides a limited depth of field that produces a distancing effect between the two individuals.

Credit: © Rachel Herman. *Neal and Chris*, from the series *The Imp of Love*, 2006. 40 x 50 inches. Inkjet print.

SNOW

Snow reflects any predominant color. Blue casts and shadows are the most common in daylight situations. Use your white balance controls to help neutralize this effect. This technique also works well at higher elevations, where the color temperature of the light is higher (bluer).

Brightly lit snow scenes can fool a meter because there is so much reflected light. The meter thinks there is more light than there actually is and closes the lens down too far, producing underexposed images. Some cameras have a special exposure mode that is designed to compensate for brightly lit situations such as are found in snow or at the beach. Another method to obtain good shadow detail is to meter off the palm of your hand. Fill the metering area with it, being careful not to get your shadow in it. Then, open up the lens one f-stop from the indicated reading. When in doubt, bracket and review to learn which exposure works best for you. To bring out the rich texture of snow, photograph when the sun is low on the horizon.

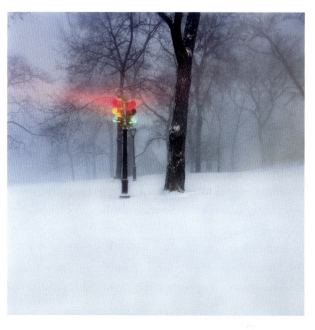

FIGURE 5.11 Staller recalls: "All night driving around Manhattan in a blizzard, I ended up in Central Park just before daybreak, well before pedestrians or plows would sully this perfect snowfall. Cresting a hill on Park Drive, I saw this traffic light marooned in a field of unmarked snow. I have always looked to the expressive and transformative qualities of photography in making my work. This photograph was made during an impressionistic period of my work when I was making atmospheric photographs of the effects of light and weather. In this incongruous pairing of a snowy wood scene and a traffic light, I made the exposure long enough to complete the full cycle of light changes, thereby creating this confounding signal." By means of scanning his old negative, Staller was able to apply present-day tools to past processes.

Credit: © Jan Staller. *Dawn*, 1984. 20 x 20 inches. Inkjet print. Courtesy of the San Francisco Museum of Modern Art, San Francisco, CA.

SNOW EFFECTS

Slow shutter speeds can make snowfall appear as streaks. Fast speeds arrest the action of the flakes. Flash also can be utilized. For falling snow, fire the flash from the center of the camera. The snow will reflect the light back, producing flare and/or spots. Using a synchronization cord and holding an auxiliary flash at arm's length off to one side of the camera can bring snowflakes to a standstill, providing an effect comparable to one produced inside a snow globe. Want to stop the action of some of the falling snow while letting the rest of it appear blurred? Place the camera on a tripod, use a lens

opening of f/8 or smaller plus a shutter speed of 1/8 second or longer, and fire the flash during the exposure. Bracket and review your exposures until you obtain enough experience to determine what will deliver the types of results you are after.

DUST

Picturing dust can be a painfully biting experience to photographers and their equipment. Use a UV filter, plastic bag, and lens hood to protect the camera and lens. Consult the same shutter speed guide for snow to help determine how the dust will appear. Dust in the sky can produce astonishing atmospheric effects. If turbulence is to be shown, expose for the highlights. This causes the shadows to go dark, and the clouds will stand out from the sky. A polarizing filter may prove very useful to darken the sky and increase color saturation. If detail is needed in the foreground, use the camera to meter one-third sky and two-thirds ground, and bracket one f-stop in either direction. Review and revise your exposures as you make them.

HEAT AND FIRE

Heat and fire are often accompanied by glare, haze, high contrast, and reflection. These factors can reduce clarity and color saturation, but if handled properly they can make colors appear to stand out. In extremely bright situations, adjust your contrast to a lower setting.

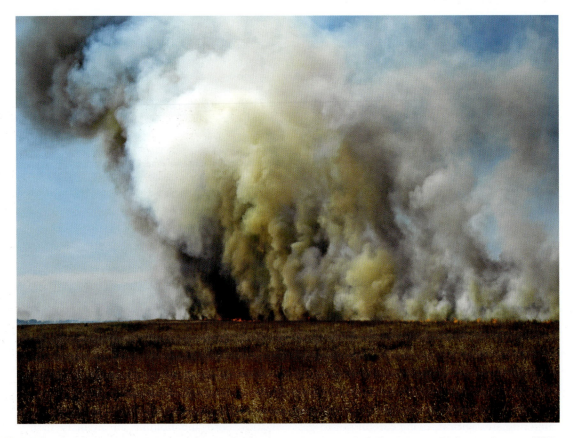

FIGURE 5.12 Larry Schwarm informs us: "This particular fire is intentional and controlled. The Conservation Reserve Program (CRP) pays farmers to plant cropland in native grasses to give cover for wildlife, rejuvenate the land, and control erosion. Every seven years the grass is burned to kill invasive weeds and trees. With so much growth, the fires are spectacular, producing large amounts of smoke with intense flames. Fire is so much a part of civilization. It heats our homes and cooks our food but can also destroy and kill. In every major religion, fire is symbolic, often both good and evil. Fire has been an ongoing theme in my work for nearly thirty years."

Credit: © Larry Schwarm. *Columns of Smoke for CRP Fire near Bedford, Kansas*, 2015. 30 x 40 inches. Inkjet print.

Do not point the camera directly into the sun, except for very brief periods of time. The lens can act as a magnifying glass and ruin internal parts. Store the camera in a cool place. Avoid carrying unnecessary equipment if you will be doing a good deal of walking in the heat. Do not forget a hat, sunscreen, and water.

BEACH AND DESERT

Beach and desert lighting is similar to light under snowy conditions in that it is bright and uniform. The sun and sand act as giant reflectors, so expect to use a small aperture and a fast shutter speed. Such lighting can be so intense that it will fool your meter and underexpose scenes, making a white beach appear too dark. If your camera has a Scene mode for such bright situations, now is the time to try it. If not, use an f-stop setting ½ to 1½ times greater than what your meter recommends. For example, if your meter reads f/16 at 1/500 second, try f/11½, f/11, and f/8½ at 1/500 second. If necessary, adjust your contrast to a lower setting. Bracket, review, and make adjustments.

The reverse problem can occur on water, which often is darker than a meter reading indicates. In this case, less exposure may be required. Also, try using a polarizing filter, which will deepen the blue of the water and sky by reducing reflections. Do not just make pictures only when the colors are at their deepest, as this effect can be overdone and make the water and sky appear artificially blue.

FIGURE 5.13 Inspired by his love of pop-up books, Thomas Allen comments on his ability to observe with the camera lens as he deconstructs and photographs old books: "I am mesmerized by the illusion of reality that vaults from a seemingly flat space whenever a page is turned. My subjects, weathered and long-discarded volumes, find new life as actors in the pictures that I direct and make. Their characters are developed by pulling and folding the various parts that have been carefully cut from a page or cover. Wire, tape, pins, and other hidden means are used to hold the pieces in place before the camera. Controlled lighting evokes drama and a shallow focus simulates the feeling of depth in pictures of books that mimic pop-ups."

Credit: © Thomas Allen. *Chemistry*, 2006. 24 x 20 inches. Chromogenic color print. Courtesy of Foley Gallery, New York, NY, and Thomas Barry Fine Arts, Minneapolis, MN.

A major problem with beach photographs is a distracting slanted horizon line. It is perfectly okay to tilt your camera for creative effect, but pay attention to the horizon line and keep it straight by holding the camera level. Use the line where sky and water or sand meet as your guide to what is level. If your camera has it, this is a time to turn on your viewfinder's Framing Grid option. Just before you press the shutter, glance at this horizon and make any adjustments necessary to level your camera. Generally, avoid placing the horizon in the middle of the frame, as this tends to make the composition static. Review your exposures and continue to make corrections as needed.

ARTIFICIAL LIGHT

ADD A LIGHT

Once you understand the cycle of natural light, you might want to consider additional possibilities of

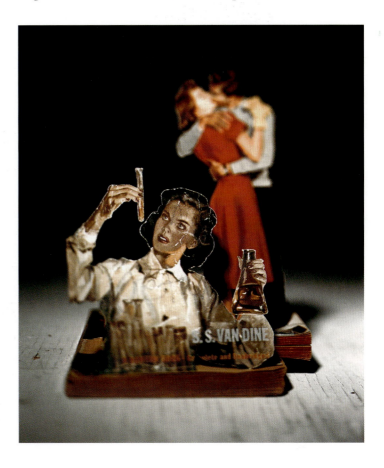

controlling the light in your images. The simplest way is to begin working with an artificial light in a bowl-shaped reflector on an adjustable stand having three folding legs and a center pole that can be raised or lowered. Edward Steichen, one of the most successful photographers of the twentieth century, learned to precisely control his camera, materials, and lighting by photographing a white cup and saucer more than a thousand times, which took his vision in new directions (see Exercise 5.2).

Continuous lighting and strobe are the two common types of artifical light utilized by photographers. Continuous lighting refers to incandescent light bulbs, tungsten lights, fluorescent lights, and LEDs (light-emitting diodes) that can be left on to provide a constant source of light. Strobe indicates a flashlight that illuminates a scene for a brief amount of time. Continuous lighting is essential for video, as it allows the maker to observe and adjust to changing lighting conditions. Contemporary cameras have excellent low light capabilities, which make continuous lighting more useful. Strobes are essential for stopping action. Modern studio strobes are equipped with a "modeling light," which acts as a continuous light bulb that is placed near the actual flash tube. This allows you to see exactly what your strobe lighting will look like. A modeling light allows you to set up your strobes precisely so that when you do flash them, you will get the same lighting as you were seeing.

The most common light is a photoflood, which has a tungsten filament and is similar to, but more powerful than, a household bulb. Photoflood bulbs are designed for use with indoor (tungsten) color settings and therefore produce a color temperature of 3200 K. The bulbs are physically hot to work under and have short life spans, and their light output becomes increasingly red with use.

A recommended alternative is a daylight compact fluorescent (CFL) spiral bulb that is specifically designed for digital imaging. Such CFLs have a color temperature of 5000 K, are comfortable to work under, have a long life, and are energy efficient. The output of a 25-watt CFL bulb is equivalent to 100 watts incandescent and that of a 55-watt CFL bulb to 250 watts incandescent. Triple reflector heads can hold three CFLs, which produce an excellent source of cool, even daylight. Placing a diffusion screen, of either transparent or translucent material, in front of the reflector, can further soften the light. (See the section "Color Temperature and the Kelvin Scale" in Chapter 4.)

Another alternative are LED lighting panels, which are either daylight balanced or can be adjusted from 3200 to 5500 K from a dial on the unit.

When employing artificial light, adjust your white balance accordingly and avoid mixed lighting. Keep in mind that whatever type you use, it will possess the same fundamental characteristics as daylight. The direction of the light and the degree of its diffusion will deter-

EXERCISE 5.2 EMULATING THE SUN

Apply what you have learned about natural light and utilize your single light source to replicate sunlight. Make a series of head-and-shoulders portraits of one individual against a plain white background as you move your single light source to imitate parts of the cycle of natural light; follow this by using back lighting and under lighting. Compare and contrast the results with those from *Time of Day/Type of Light*. Based on the similarities and differences within your own images, how might this affect your future lighting decisions? Incorporate your personal observations into the making of your future work. Once you feel comfortable working with one light, try adding a second and see what else you can accomplish.

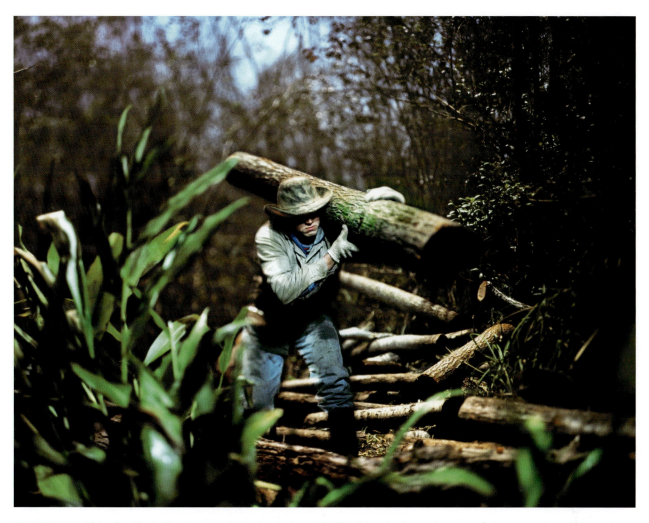

FIGURE 5.14 Alejandro Chaskielberg's series *The High Tide* depicts the life of the islanders in the Paraná Delta River, "where the river tides determine the activities and movements of its inhabitants." A long, 6-minute exposure allows him to capture the moonlit background while he uses LED flashlights to selectively illuminate his subjects. Chaskielberg breaks with documentary tradition by casting real people in imagined situations based on their own lives. In this project, everyday reality is transformed into a dreamlike world where customary perceptions of color, light, and space are challenged.

Credit: © Alejandro Chaskielberg. *The Paraguayans*, from the series *The High Tide*, 2007. 43 x 55 inches. Chromogenic color print.

mine whether its effect is hard or soft edged. Another factor is the size of the light source in relationship to the subject: the larger the source, the softer its quality of light. The closer you set a light to your subject, the broader the light will be, making it more diffused and softer in appearance. The farther back you place that light, the smaller it will be relative to your subject and the harder the shadows will appear. Thus, if you want a soft and shadowless look, use a broadly diffused light source close to the subject; if you want dark and sharply defined shadows, use a directional light that is relatively far from the subject. Also, the position of the light and its distance from the subject will determine the amount of texture and volume (the amount of viewable space within the frame) in your image. To determine which lighting style was used when making portraits, photo educator Lesley Silvia tells her students to look at the shadow cast by the nose.

FIGURE 5.15 Like a director of a fantastical film, Didier Massard uses miniatures lit with studio lights to create deceptive illusions that encourage viewers to suspend their notion of reality and embrace the sense of illusion and artifice. Devoid of human references, the dramatic, misty, and moody environments suggest the Romantic canvases of Caspar David Friedrich. Here, Massard also references Albrecht Dürer, whose archetypal woodcut "The Rhinoceros" (1515) is not a realistic transcription, as Dürer never saw the beast. Working in a manner similar to Massard, Dürer fabricated his image based on a mental schema constructed from sketches and verbal descriptions. Conceptually, Massard's fictional work points out how photography has again co-opted painting's role, this time by evolving from the presenter of actuality to a constructor of aura.

Credit: © Didier Massard. *Rhinoceros*, 2004. Chromogenic color print. 70½ x 89⅜ inches. Courtesy of Julie Saul Gallery, New York, NY.

THE SIZE OF THE MAIN OR KEY LIGHT

Again, the larger a light source, the softer its quality. Thus, the size of your main light, also known as the *key light*, determines and defines shadow and texture. This is very important in portraiture, as the hard shadows of a small light will emphasize skin texture. While this can be excellent for bringing out facial character, it may be at the expense of conventional standards of beauty. Most people do not appreciate a portrait that reveals every line, hair, scar, or skin pore. Therefore, large lights are generally used in conventional portraits because they produce soft shadows, reduce skin texture, and make facial irregularities less noticeable.

THE PLACEMENT OF THE LIGHT

The placement of your main light determines where the highlights and shadows will fall and how sharply they will be defined. Bear in mind that creating a three-dimensional illusion of space in a two-dimensional photograph requires highlight and shadow areas. While pronounced, highlights and shadows increase the illusion of spatial depth, if too pronounced, they become points of interest in themselves and compete with your principal subject.

CONTRAST/BRIGHTNESS RANGE

The other characteristic of light that concerns a conscientious photographer is the contrast or brightness range. This represents the difference between the brightest part of a scene and the darkest part. Extremely brightly lit scenes may have a brightness range of eight or nine f-stops, making it difficult for a sensor to accurately record detail in both the shadow and high-light areas. On the other hand, a dimly lit scene may have only a one-f-stop difference between the brightest and darkest parts of a scene, resulting in images that are low in contrast and appear flat and dull. In either case, monitor the contrast range by metering the key shadow and highlight areas, and increase or decrease your contrast control to match the situation and deliver the view you desire. Review Chapter 4 for metering suggestions.

EXERCISE 5.3 TRANSLUCENCE

Translucence

Courtesy of Frederick Scruton, Professor of Art at Edinboro University of Pennsylvania.

For any subject matter, construct a lighting scheme where light passing through a translucent or transparent material is an important aspect of the composition.

Examples include light passing through a model's hair or clothes and subjects with glass, plastic, fabric, or other translucent materials that can be made to "glow" or look internally lit. Non-translucent subject matter where the surrounding frame contains materials that can be lit to produce a translucent effect will also work.

These lighting schemes require one to balance the brightness of the translucent light with the amount of surrounding environmental or "fill" light, and usually you will need to have a way of altering the brightness of one or both light sources.

Working Measure

1. Looking carefully at your camera's exposure histograms, use the camera's Manual mode and try different exposures until the translucent areas are exposed near, but not all the way to, the white end of the histogram (where they would lose detail and texture, i.e., be "clipped"). Then, increase or reduce the amount of the environmental light that illuminates the other parts of the frame to get the desired translucent effect.

2. This type of lighting usually requires some environmental fill light—do not use silhouettes or deep shadows unless they really work for your situation.

3. Avoid underexposing the environmental light so it does not clip at the black end of your histogram.

4. Using a flash with manual power settings pointed toward the ceiling can often provide a soft and easy to control the amount of fill light for the environment.

5. For static subjects, long tripod-mounted exposures can allow for balancing the brightness of one source with the other by turning one of the sources off or on during the exposure.

FIGURE 5.16 Tricia Zigmund states: "Rather than attempting to document my physical experiences as they occur, I use my body as a prop to reconstruct fleeting facets of personal experience with the mimetic nature of the photographic medium itself. For this image, the camera was set to B, the shutter released, and while the ambient light was being exposed, I moved into the scene and fired the flash behind my back, then moved to the next position and did so again for each figure in the scene. I rely on experimental methods, such as light painting, multiple exposures, and unconventional light sources, to depict a dreamlike or alternate reality, which is the core of the world I create."

Credit: © Tricia Zigmund. *My Every Midnight*, 2007. 16 x 24 inches. Chromogenic color print.

BASIC LIGHTING METHODS

Artist and educator Michael Bosworth provides these thoughts and examples of basic lighting methods for contemplation, based on his experiences teaching studio lighting:

Lighting reveals texture and form. Relatively feature-less subjects may provide too subtle an illustration of the lighting techniques. Complex constructions and unfamiliar subjects can lead to abstraction. Students may have difficulty comprehending how the light source is functioning and how

best to go about making changes. A simple, recognizable object featuring form and texture provides an understandable canvas on which to work with the light.

One of the challenges in photography is seeing the world as color and tone with the impartiality of the light meter. Beginners may have trouble separating an object's meaning from its surface. One of the challenges of making portraits is to see the light without being distracted by meaning, empathy, and desire. A more banal subject offers fewer distractions while building the skills of photographic grammar. With experience, constructing a photographic image becomes a marriage of the treatment of a subject with its symbolism to create new meaning.

FRONT LIGHT

We are accustomed to seeing things illuminated by the sun from above the horizon line. This effect, known as *front lighting*, can be re-created by placing your light in front of your subject, slightly above the height of your camera lens and directly to the right of your camera. It is equivalent to shooting with the sun to your back. Experiment with the distance of the light from the subject, initially keeping it within a 3–6 foot range. Front light is flat and produces only thin shadows, which keep texture and volume to a minimum while retaining detail. Your built-in camera flash also produces this type of light.

SIDE LIGHT

Side light is created by placing a light level to your subject, directly to the side. This dramatic light literally divides your subject in half and emphasizes texture. Traditionally, it is used for male portraits because it amplifies facial features and textures associated with rugged masculinity, such as chin clefts, jaw lines, whiskers, and wrinkles. Strong side light is similar to light coming directly from a window or a sunset, which produces long shadows and a dark side/light side relationship on a subject. Metering can be tricky, so average a close-up meter reading of both the bright and dark sides, and then bracket, review, and correct as needed.

HIGH SIDE LIGHT

High side light is achieved by placing your light at about 45° to one side and 45° above the subject. It is considered the classic angle for portrait lighting because the light sculpts the face into a natural-looking three-dimensional form and is often used to generate an "executive" look.

LOW SIDE LIGHT

Low side light is realized by placing your light at about 45° to one side and level or below level with your subject. Low angle light is effective for adding a sense of drama and mystery that emphasizes texture. It can be unflattering for men with short hair, as it illuminates ears, or with balding heads, which may reflect the light.

TOP LIGHT

Top light is produced by setting your light almost directly above your subject. It generates deep shadows in the eye sockets and under the nose and chin. It is similar to making portraits outside at noon when the sun is directly overhead. Shifting the light so its placement is high but in front of your subject will smooth out the shadows and the skin texture yet retain the emphasis on your subject's facial form. It is commonly utilized in fashion magazines.

BACK LIGHT

Back light is made by pointing your light directly at the back of your subject. It produces a rim of light, a halo effect, dramatically outlining the subject and emphasizing form and shape. The most extreme form of back lighting is a silhouette, in which a subject is outlined without color, detail, or texture, creating a highly abstract and theatrical form. Carefully adjust the light so it does not shine directly into the camera's lens, unless you want lens flare. Also, check your viewfinder to be certain the light fixture itself is not in your viewfinder. Back light does a good job of separating the subject from the background but requires careful metering. If the meter sees mostly the bright light in the background, the exposure will be adjusted lower to compensate, resulting in underexposure. Bracket, review, and correct as necessary. An 18 percent gray card can be useful in determining exposure in such lighting situations.

UNDER LIGHT

Under light is created by placing your light directly below your subject. Since natural light seldom comes from below, this configuration makes unnatural-looking shadows. It has often been used in horror and monster movies to suggest a menacing presence.

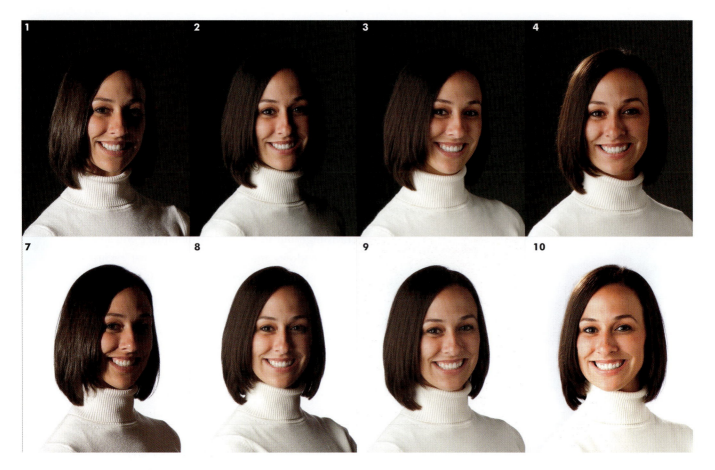

FIGURE 5.17 These portraits of photographer Ashley Austin were made by Michael Bosworth using Dynalite strobes, Pocket Wizard radio slaves, and a white paper background. One strobe head was set at a 3/4 angle to the side of the subject, and a second was used to fill the white paper background. The key light (main strobe on the subject) was flagged (blocked) with barn doors to prevent the light from reaching the backdrop. The same white background paper is in both sets of portraits. For the examples of soft lighting, a 30 x 40-inch softbox was used, and to bounce the light, a sheet of white foam core was held about 2 feet from the subject. All the images were made with a Nikon. The first 11 were exposed at f/16 at 1/200 at ISO 200. For the 12th image, the strobes on the background were replaced with a Lowel Omni Light and red gel. The ISO was kept at 200 and aperture at f/16; however, the shutter speed was set to 1/8 of a second. While the flash exposure was in the thousandths of a second, the slower shutter allowed the background light to continue to expose as the model swung her head.

LIGHTING ACCESSORIES

Here are some common lighting accessories that can be useful in gaining more control over specific aspects of your lighting setup.

BARN DOORS

Barn doors are a pair of black panels that mount on the front of a light source to block (a.k.a. flag) the light from reaching the background. They typically have two or four hinged flaps that move independently to control how narrow or wide an area the path of light covers. Homemade ones can be constructed out of black foam core board.

DIFFUSER

When you are using a bare bulb, the light reaching a subject is strongest in the center and then weakens, getting softer as it moves out toward the edges. A diffuser is a transparent disk that attaches to the front of your reflector for the purpose of softening the light and spreading it more evenly across your subject. The

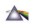

Credit: © Michael Bosworth. *Portrait Lighting*, 2011. Dimensions vary. Digital file.

1. Hard side light
2. Hard side light, background light
3. Soft side light
4. Soft side light, background light
5. Soft side light, bounce card
6. Soft side light, bounce card, background light
7. Soft side light, bounce card, hair light

8. Soft side light, bounce card, hair light, background light
9. Two soft side lights, equal ratio
10. Background light, no fill light
11. Soft light from above
12. Halogen light with gel on background, soft side strobe, slow shutter speed (1/8 second)

diffuser must be heat resistant when used with tungsten bulbs (see the description of a softbox in "Studio Strobes" later in the chapter).

GELS

Gels are gelatin filter sheets used over light sources to either change the color of the light balance or create unusual lighting effects, such as altering your background color. There are polarizing screens that can be used in front of your light source to reduce glare and reflection. Gels can be fastened to a reflector with tape or clothespins or placed in frames and mounted to the reflector or light stand.

REFLECTOR CARD

Reflector cards are used to reflect or bounce light into shadow areas to help illuminate details. They can be made from cardboard, fabric, foam core, metal, or wrapping paper and are usually white, gold, or silver. The color of the card will influence the color of the light being reflected.

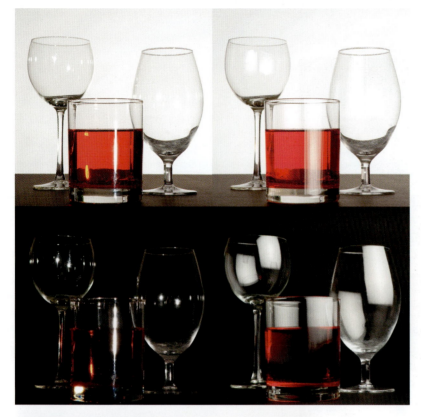

FIGURE 5.18 The glass subject of the top left was lit with a hard, point source light (a strobe with a small reflector), with a second strobe evenly lighting a white paper background. The subject at top right was lit with a softbox and a second strobe on a white paper background. The bottom left was lit with a hard light and no light on a black paper background. The bottom right was lit with a softbox and an unlit black paper background. The main differences can be seen in the translucence of the glass and the liquid. Note: On a black background, the reflection of the softbox is more easily seen revealing the form of the glass, while the white paper reveals the color of the water. Scratches, imperfections, or details in cut glass will more easily be seen with a hard light source against a black background.

Credit: © Michael Bosworth. *Lighting Glass*, 2011. Dimensions vary. Digital file.

FIGURE 5.19 These images were lit with a softbox and a bounce card, both positioned so the metal blade did not reflect them back into the scene. An evenly lit white card and an unlit black card were positioned out of frame so that from the camera's perspective they are reflected in the metal's shiny surface. Note: The trick to lighting any reflective object is not to light the object, but what can be seen reflected in the object. In the case of the top image, a neutral white panel is reflected in the surface of the knife, thus eliminating glare and reflections.

Credit: © Michael Bosworth. *Lighting Metal*, 2011. Dimensions vary. Digital file.

FIGURE 5.20 On the left, the water is lit with a softbox and set against an unlit black background. The reflections of the softbox in the surface of the water reveal its form. On the right, a white paper backdrop is evenly lit and no light is set in front of the water. The back light shining through the water enhances shape through refraction and colors of dye. Note: Experiment with combining ratios of front and back lighting to reveal form or color. Stronger white highlights will hide color but help define form, whereas a brighter back light will reveal color but obscure the highlights.

Credit: © Michael Bosworth. *Lighting Water*, 2011. Dimensions vary. Digital file.

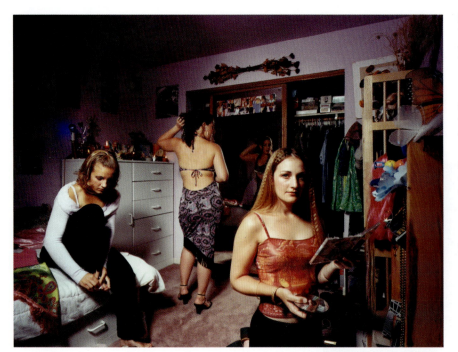

FIGURE 5.21 In her quest to investigate the relation between people and their places and things, Beth Yarnelle Edwards brings on location a lighting kit that includes lamps, bulbs, barn doors, black aluminum foil, stands, clamps, and clothespins. "In this tight situation, my technical challenge was to make sure the light did not show in the mirror. Artistically, I wanted to show how these three girls resembled different artists' women in paintings, which I did by directing their body language and positioning."

Credit: © Beth Yarnelle Edwards. *Niki, Age 24*, 2000. 30 x 38½ inches. Chromogenic color print. Courtesy of Robert Klein Gallery, Boston, MA.

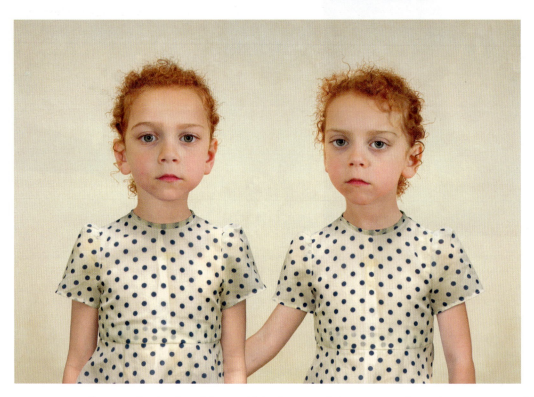

FIGURE 5.22 Circumspectly using the artfulness and light of master painting as sources, Loretta Lux creates mesmerizing images of enigmatic children who have been superimposed in front of her painted backgrounds and appear trapped in time between two worlds. This double paradoxical tension between the past and future, the painterly and the photographic, the ideal and the absurd, the real and the fake challenges our sentimental visions of childhood.

Credit: © Loretta Lux. *Sasha and Ruby*, 2005. 19 x 25 inches. Dye-destruction print. Courtesy of Yossi Milo Gallery, New York, NY.

SEAMLESS PAPER BACKDROPS

Seamless paper is a heavy paper that comes in long rolls, 3 feet and wider, in various colors to provide a solid-toned, nonreflective backdrop that can be extended down a wall or across a table or floor so you can make images without a visible break or horizon line. The roll is supported by two upright poles with a crossbar that runs through the hollow core of the roll. As the paper becomes dirty or wrinkled, fresh paper is unrolled, and the old paper is trimmed off.

All sorts of fabric and material can be tried to create different background effects and textures. You can make your own backdrop by painting on canvas, muslin, or other materials. White backdrops can be made to look gray by adjusting the back light. Black velvet works well when a black background is required.

SNOOT

A snoot is a tube (which can be made out of heavy paper) that is attached to the front of the light for the purpose of narrowing its beam in order to highlight specific areas.

STUDIO STROBES

Stand-alone electronic flash units are powered by special battery packs and synchronized with the camera by means of a flash synchronization cable, light trigger, or radio transmitter. The camera needs to be synchronized with only one flash unit, which in turn can fire the other units simultaneously. Studio strobes operate at about 5500 K and provide a "cool" alternative to "hot" tungsten bulbs for controlled illumination and are excellent for capturing movement and stopping action (see Chapter 4).

The two types of studio strobes are monolights and power packs paired with heads. Monolights are self-contained flash units. Unlike a power pack, which consists of a separate generator and a number of flash heads, the monolight has its own built-in power source and is larger than the power pack strobe heads. The main benefits of studio strobes are that they are AC powered, are continually recharged so there is no waiting between exposures, and can produce a more powerful light source.

Most strobes fire at between 1/1000 and 1/6000 second, depending on the power of the strobe. The lower the power setting, the faster the exposure. The main advantage over continuous lighting is in the amount of light a strobe puts out in that brief amount of time. A strong strobe in a smaller studio will stop action and still allow for smaller apertures and its accompanying additional depth of field. Because the strobe burns for only a very brief amount of time, shutter speed does *not* affect the exposure from that light source. Only the distance of the strobe to the subject and any light modifiers used will affect the exposure.

A strong strobe in a smaller studio will stop action and still allow for smaller apertures and their accompanying additional depth of field.

A softbox is a diffusion device that is fitted over a strobe to provide nearly shadowless illumination. It is commonly used in portraiture or when photographing high-glare subjects. Homemade ones can be constructed out of foam core. Other inexpensive light modifiers include umbrellas and reflectors.

REFERENCE

Eibelshaeuser, Eib. *The Art of Photographic Lighting*. Santa Barbara, CA: Rocky Nook, 2011.

EXERCISE 5.4 SHOW A LIGHT SOURCE

Courtesy of Frederick Scruton, Professor of Art at Edinboro University of Pennsylvania.

Create photographs where a light source is included in the frame. Plus, have some sort of additional fill/ environmental lighting for the rest of the frame.

For example, when making a portrait you could include a lamp, television set, computer monitor, or headlight as a prop, but make sure that it's properly exposed and that the subject is as well. The included source may or may not actually be partially lighting the subject—it can just look like it is "on."

Static Subjects with Tripod-Mounted Camera for Long Exposures

Most included sources will require only partial exposure compared to the surroundings. For instance, a lamp is turned off after 2 seconds of a 12-second exposure—to properly balance the included source with the lighting that fills out the remainder of the scene.

1. Looking carefully at your test exposure histograms, especially for highlight overexposure, use the camera's manual mode and try different exposures until the light source is exposed near, but not all the way, to the white end of the histogram (where it would lose detail and texture, i.e., be "clipped"). Typically the rest of your frame will be very underexposed.

2. Turn off the light source included in the picture and try different exposures until the remainder of the frame is well exposed. Start with that as your total exposure time, and turn off the light source after the elapsed time determined in the Step 1.

3. Vary the total exposure time (for the overall environmental lighting) and the turn-off time for the included light source as needed to achieve the desired effect.

For interiors, usually the included sources contribute very little light to the environment; they are used simply to look "on" and perhaps create nearby highlights. The light in the space is usually coming from a large (soft) source that typically does not attract attention to itself. Instead, it gives the impression that the included lights are lighting the space while the viewer is not aware of the additional "artificial" source. You can try bouncing fill light off the ceiling or wall, exposing for that light, and turning off the included sources before they wash out due to overexposure.

Using Flash to Light the Surrounding Environment

You may use electronic strobes or a flash to light the environment around your included source and use the shutter speed to properly expose the (continuous) light coming from it. As long as your shutter speed is at, or slower than, the sync speed of your camera, then shutter speed changes will affect only the included light source while the quantity of light from the strobe or flash that lights the remainder of the frame will remain constant. Once the environmental light exposure gives you what you want (flash power matches the lens f-stop or aperture setting), the exposure of the included (continuous) light source will increase or decrease independently according to the shutter speed.

Keep in mind that if the included light source is partially lighting something moving in your frame, or if there is other ambient light in the scene, then a slower shutter speed may cause issues with blur and/or color temperature mismatches.

Mixed color temperatures may be an issue. For example, unfiltered flash fill for incandescent interior lighting produces very bluish shadows. Use a CTO color correction gel over the flash to match it to the color temperature of the environment.

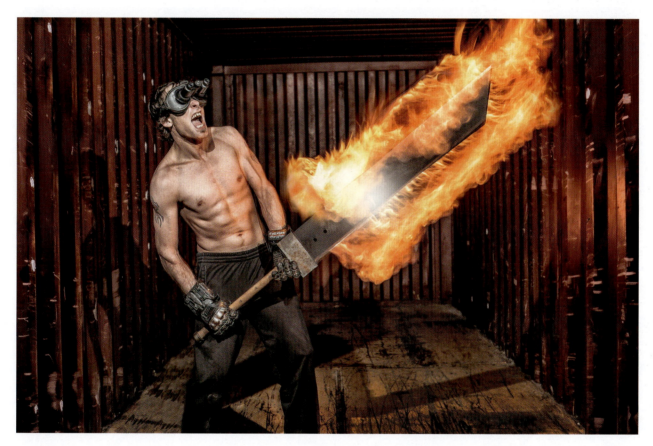

FIGURE 5.23 Wanting to create a "commanding visual experience" Ryan Groney employed two Nikon speedlights on stands for side lighting with three pocket wizards to sync flashes and camera wirelessly. Groney says: "I made an 8 second exposure to give my assistant time to go around the sword with the fire and then have the flashes fire at the end to freeze movement. Photoshop was used to eliminate my assistant and make adjustments to color, contrast, white balance, along with burning and dodging."

Credit: © Ryan Groney. *Flaming Buster Sword*, 2015. 23 x 15 inches. Inkjet print.

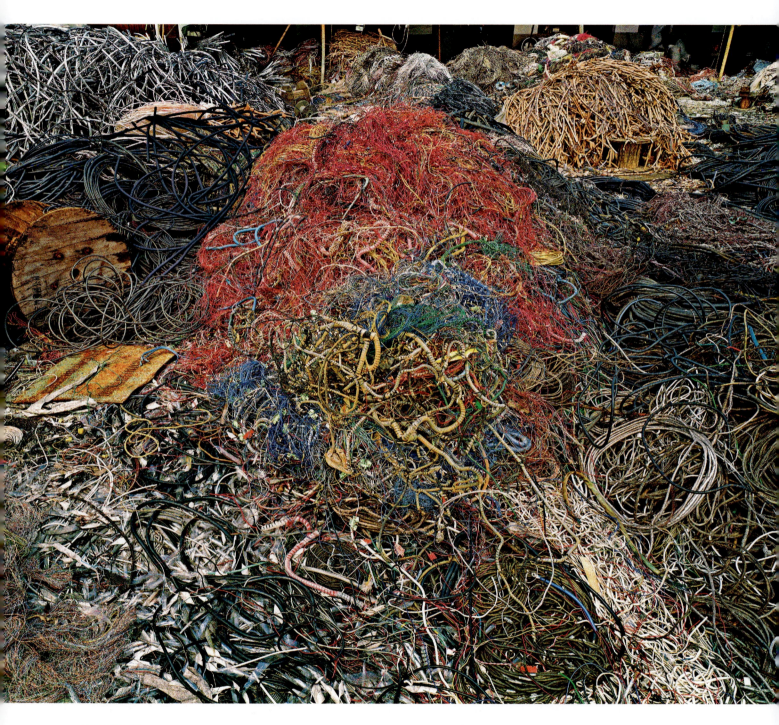

FIGURE 6.0 "For 25 years I have created images about the various man-made transformations our civilization has imposed upon nature. I started making photographs about China when construction began on the mammoth Three Gorges Dam project. In my view, China is the most recent participant to fall prey to the seduction of Western ideals—the promise of fulfillment and happiness. The troubling downside of this is something that I am only too aware of from my experience of life in a developed nation. The mass consumerism these ideals ignite and the resulting degradation of our environment intrinsic to the process of making things to keep us happy and fulfilled frightens me. I no longer see my world as delineated by countries, with borders, or language, but as 7.5 billion humans living off a single, finite planet."

Credit: © Edward Burtynsky. *China Recycling #7, Wire Yard, Wenxi, Zhejiang Province*, 2004. 39 x 49 inches. Chromogenic color print. Courtesy of Charles Cowles Gallery, New York, NY, and Robert Koch Gallery, San Francisco, CA.

Observation:
Eyes Wide Open

HOW WE SEE

Seeing is an act of perception that helps us to experience, learn, ascertain, and understand our world. It is an individual skill that is conditioned by our cultural values, education, personal experience, and physical anatomy. Western industrialized society depends on literacy to function. Being fully functional requires that we can decipher messages that have been put into a written code or language. When dealing with images, we need another skill set to interpret the coded information, and we need to learn this language to be visually literate.

LITERACY

Literacy is based on the quality and quantity of our stored information, yet at times we are reluctant to learn to read new images. Complacency leads us to favor the familiar and reject that which is different or new. Overcoming this fear and thinking for ourselves makes learning a more joyful and expanding process. Fresh data adds to our information storehouse, which can be called upon when dealing with new situations, thereby increasing our range of possibilities and outcomes.

Whatever type of communication is in use, a person must be able to understand the code. In the past, pictures showed something of recognized importance.

Traditional picturemaking used the act of seeing to identify and classify subject matter. This sort of typological illustration is all some expect of a picturemaker. Problems arise when something surprising or unusual appears and we have no data or method to deal with it. What we do not know or recognize tends to make us nervous and uncomfortable. This anxiety manifests itself in the form of rejection not only of the unfamiliar work but also of new ideas in general.

LEARNING TO LOOK

Looking at a picture is not like glancing out a window and viewing a known world. Initially, imaginative looking needs to be a conscious and directed act that requires thinking, sorting, analyzing, and decision making. *Stimulating looking* is an evolving system of thoughtful examination and scrutiny that can be taught and learned. *Creative looking* involves unleashing one's curiosity by getting in close to your subject and determining what lies below the realm of physical appearance. Such perceptual openness can allow one to discover worthy subjects just about anywhere.

THE DIFFERENCE BETWEEN ARTISTIC AND SCIENTIFIC METHODS

Western formal education does not place much value on learning visual language. For some people, the

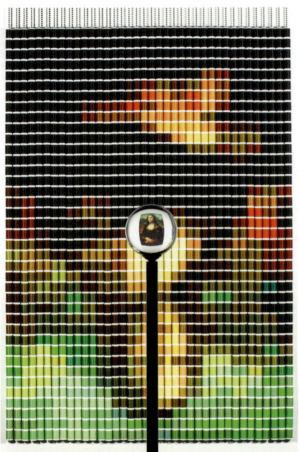

FIGURE 6.1 Devorah Sperber's images serve as dramatic mechanisms, illustrating that perception and reality are subjective concepts. This work, constructed from thousands of spools of thread, is rooted in the biological study of vision and the way we process sensory data as it moves from the eyes to the brain. One could say that Sperber de-resolutes well-known images, providing a shift in perspective that at first glance appears only as colorful yet random arrangements of thread spools. However, viewing her low-resolution re-creations through a clear plastic viewing sphere bends and condenses these "pixels," returning the image to the universally recognizable Mona Lisa, demonstrating how the eye and mind work together to make sense of apparently random data.

Credit: © Devorah Sperber. *After the Mona Lisa 8*, 2010. 68 x 47 inches. 1,482 spools of thread and mixed media.

FIGURE 6.2 Klaus Pichler reflects that "dust is a by product of civilization, the enemy of a sterile society, a constant presence hidden in corners, nooks and crannies. It is a microcosm made up of multiple components, a combination of different colors, textures, and structures, a construct reproducing itself. I spent nearly a year collecting dust bunnies in petri dishes from shops, factories, restaurants, and private flats in and around Vienna. The resulting 'dust archive' represents a kind of 'typology of dust.' The dust bunnies, each 1x1 inch in size, were photographed multiple times with different focal points and the final 100 images were digitally stacked to create a perfectly sharp image, a process that took me almost a year to complete."

Credit: © Klaus Pichler. *Dust #8: Tailor*, 2011. 40 x 40 inches. Inkjet print.

FIGURE 6.3 "This series of photographs uses humor, performance, and snapshot aesthetics to produce a series of self-portraits in mundane situations with various celebrities. In these photographs, the divide between fact and fiction becomes blurred and reconstructed, as the private life of the celebrity becomes public domain. The banality of the individual scenes refers to the recent rise in popularity of the Reality Television genre and its ironies, as it is packaged and presented as close to the viewer's livable experience, yet is completely scripted and controlled, or else rooted in absurdity. The images reflect our obsession with celebrity and the desire to make celebrity banal and see celebrities as ordinary people, which compelled me to use impersonators found on Craigslist rather than Photoshopping images of actual celebrities into the scene."

Credit: © Diane Meyer. *Me and Tom*, from the series *Quiet Moments Spent with Friends*, 2005. 20 x 24 inches. Chromogenic color print.

purpose of art is simply to be recognizable, pretty, and comfortable. Such people are not aware of a picture-maker's role within society as someone who can perceive, interpret, and offer a wider understanding of life. Yet these same people may appreciate the results of innovative and resourceful artistic explorations. People do not make fun of a scientist working in a laboratory, even if they do not understand what the scientist is doing, because society sanctions and rewards scientific inventions. Of course, art and science can intersect since both are investigative processes. Each involves hypotheses, ideas, and theories that are tested in places where hand and mind unite—the studio and the laboratory. Artists and scientists each study culture, history, materials, mythology, and people, in

an attempt to transform that data into something new and different. That said, the major difference between art and science is that art offers an intuitive approach to explain reality, whereas science uses an empirical model of exact, objective, and rational, repeatable methods and measurements. Art says there are many correct answers; science says there is only one right answer. The magnificence of our contemporary arts and letters and the contributions citizen-artists make to democracy give rise to a multiplicity of thought and an exploration of possibilities, which is why art thrives in open societies. It is the recognition of an artist's responsibility to have something to say, to resonate the culture (or lack thereof) we are embedded in, and directly or indirectly awaken our thinking.

VISUAL LITERACY AND DECISION MAKING

Our society does not stress visual literacy, and as a result, many people lack skills to navigate our media-saturated environment. With declining newspaper readership and a growing reliance on social media and video clips for information, it is critical to teach people how to interpret the signposts of our image-driven world; otherwise, they will not be properly equipped to go through a visual decision-making process. We then risk becoming "objects," easy marks for the gatekeepers of information to manipulate, and susceptible to "fake" news, the superficial suggestions of advertising, the dangers of government propaganda, the plain fluff of celebrity and "reality" TV, or the fad of the moment. This could lead us to react to situations in a simple binary mode that either accepts or rejects them, without critical analysis. Once we cease to question and analyze before reacting, we have been effectively removed from the decision-making process.

A picturemaker can be an active participant in this process we all face. Imagemaking offers opportunities to interact with, comment on, and/or challenge what is going on in society. An imagemaker's work can stimulate others to thought and action. The entire photographic venture can make life richer, more varied, and more meaningful. This process is a highly valuable asset, even if it cannot always be measured in tangible terms.

Seeing is a subjective and personal endeavor, and its results depend on a viewer's ability to decode the messages that are received in a symbolic form. A broad, flexible response allows viewers to understand that our culture determines the hierarchy of subject matter. Keeping an open mind enables us to uncover and negotiate the many levels and possibilities of new materials and to view the familiar anew. It boils down to what the Talmud says: "We don't see things as they are; we see things as we are."

Becoming visually literate is one small step we can take in accepting accountability for discovering and affirming our own values. Ultimately, such individual baby steps can have widespread effects. As people become visually educated, more aware of their surroundings, and able to see the world for themselves, they can participate more fully in making decisions that affect how their society operates (see Exercise 6.1).

EXERCISE 6.1 IMAGEMAKER AS FLÂNEUR

Take on the role of *flâneur*, one who leisurely yet alertly strolls through an urban environment. Take the time to investigate, examine, and observe the accidental, the fleeting, the strange, and the unknown. Circumnavigate urban settings as your whim dictates, giving yourself over to the "spectacle of the moment" while being vigilant for chance rhymes that may be lurking in every corner. Allow your poet's eye to generate the direction of your ideas and capture your findings for others to see. Remain open and respond to new, subtle impressions and situations while bearing in mind the essential design elements and how the light is affecting your choice of subject matter. In the spirit of critic and philosopher Walter Benjamin's view that the flâneur "goes botanizing on the asphalt," make lots of exposures that capture the physiology of urban life. Produce contact sheets of all your images and examine them for visual or conceptual threads that will allow you to stitch together a series of six different views of the chance rhymes in every corner of your wanderings.

For additional background information, see Rebecca Solnit's *Wanderlust: A History of Walking* (2000), which has a fine chapter about the origins of the flâneur.

FIGURE 6.4 Garie Waltzer's images of civic spaces—parks, piazzas, pools, and busy streets—evoke the spirit of a flâneur who witnesses and records a persistent rumble of change in the landscape. Using elevated vantage points and deep vistas, Waltzer "captures the resonant traces of mutable life, with its temporal rhythms and patterns of movement, as they intersect with the skeleton of place. Their structure, synchronicity, flow, and collective narrative reveal a layered history embedded in the visual landscape as detail and metaphor. Past and present reside simultaneously, narrating the transformative connections between a place and its inhabitants."

Credit: © Garie Waltzer. *Eiffel Tower, Paris,* 2005. 22 x 22 inches. Inkjet print.

WHY WE MAKE AND RESPOND TO SPECIFIC IMAGES

Why do we make pictures in a particular manner, and why do we react more strongly to certain images? Are you someone who favors an open, direct, and unadorned representation of reality, or are you an individual who prefers an expressive, individualized interpretation of reality? This section presents some direction on these subjects and encourages you to draw and apply your own conclusions.

VICTOR LOWENFELD'S RESEARCH

In 1939, Victor Lowenfeld began researching how people primarily know their world. Lowenfeld discovered that people can be divided into two basic groups: those who most often utilize their sense of sight

EXERCISE 6.2 **VISUAL OR HAPTIC**

Decide whether you possess the general qualities of either the visual or the haptic way of imagemaking. Choose a subject and photograph it in that manner. Next, flip that invisible switch inside your brain and think in the opposite mode. Make a picture of the same subject that reveals these different concerns. Compare the results. How are they different? How are they the same? What have you learned? How might this affect the way you make, view, and understand images in the future?

and those who use their sense of touch. Through ongoing research, Lowenfeld determined that people in the first group take an intellectual, literal, realistic, quantitative approach to knowing their world. He called this group "visual." People in the second group function in an intuitive, qualitative, expressionistic-subjective mode, which he described as "haptic." Lowenfeld went on to determine the major characteristics of each of these two creative types (see Exercise 6.2).

VISUAL-REALISTS AS IMAGEMAKERS

Lowenfeld found that "visuals" tend to produce wholly representational images, which is by far the most widely practiced and accepted form of imagemaking. Visuals are concerned about "correct" colors, measurements, and proportion. Visual-realists prefer to learn about their environment primarily through their eyes, relegating their other senses to a secondary role. Generally, visual photographers preserve the illusion of the world. The visual-realist style is an unmanipulated and objective mirror of the "actual" world. It is concrete, unobtrusive, and concerned with what is physically there. These photographers are observers/spectators who use a camera to supply a surrogate set of eyes on the ground for the rest of us who weren't able to actually witness an event. They go for hard facts rather than abstract form, presenting ocular proof in which the subject matter is supreme. Documentary work is their most apparent style. Visual-realists tend to preserve spatial continuity by photographing at eye level, using a normal focal length, and avoiding extreme angles. Their style is open, subtle, recessive, or even informal while leaning toward the familiar and the unobtrusive.

VISUAL-REALIST PHOTOGRAPHIC WORKING METHODS

The code of the visual-realists is that of linear reality. Their pictures reflect concrete themes and often tell a story. The image is usually created at the moment the shutter is released, using straightforward methods that do not alter the original context and present a wealth of detail. Digital manipulation and cropping are kept to a minimum. No unusual techniques are employed, except what is considered to be in keeping with the current standards of showing reality. Many visual-realists might not do their own image processing or printing because they see their primary role as witnessing the world. They use photography to match reality, enabling us to see places and things that we are not able to experience for ourselves. Often they use their work to bring deplorable conditions to public attention, indirectly acting as a catalyst for societal change.

HAPTIC-EXPRESSIONIST IMAGEMAKERS

Haptic, which means "laying hold of," comes from the Greek word *haptos*. Haptics are strongly affected by their bodily sensations and subjective experiences, making them highly kinesthetic (hands-on) types who are likely to physically interject themselves into their work. They associate and apply emotional and subjective values to the color and form of objects and are not particularly concerned with duplicating physical appearances. A prime example of a haptic artist is Abstract Expressionist painter Jackson Pollock, who is known for his "drip and splash" style that transformed picturemaking into dance. His manner of action painting allowed a direct expression or revelation of his unconscious feelings, moods, and thoughts onto canvas.

Haptic-expressionist photographers often alter, exaggerate, and stylize their subjects for emotional effect. They actively participate in the imagemaking process, inserting their presence, becoming part of the picture. Haptics explore and present their inner self, trying to liberate their internal vision rather than reproducing an image of the outer world. Because they are involved with a subjective and more personal vision, their approach often incorporates private symbols that deal with psychological and spiritual issues. This can make their work less obvious and more demanding of viewers, which can limit the audience appeal of their work.

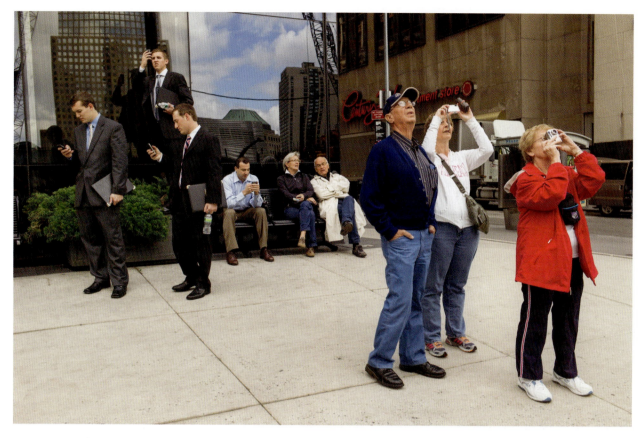

FIGURE 6.5 Richard Bram summarizes: "The challenge of street photography is being there with the camera ready, seeing the relationships within the rectangle, and clicking the shutter at just the right moment. No pre-planning is possible; one must be ready and fast. I set the camera for the light, pointed it at my subjects, threw a rectangle around them and pushed the shutter at precisely the right moment. This is straightforward, but incredibly difficult to do well. I often think of my street photographs as short stories. In looking at my photographs, I see a moment in a tale, sometimes serious, sometimes funny, often not funny at all. What is taking place before the lens has little to do with what each viewer reads into it. They decide for themselves what the story may be, imagining their own stories. My photographs may be taken directly from the flow of real life, but in that short moment when I click the shutter, they are transformed into fiction. I *always* have a camera with me—therein lies opportunity. The thing about street photography is that you are always looking, but you rarely know what you are looking for until it's in front of you. It's the challenge and delight of seeing something strange appear in real life, in real time, and throwing a rectangle around it."

Credit: © Richard Bram. *Century 21, Church and Dey Streets, New York City*, 2011. 12 x 18 inches. Inkjet print.

HAPTIC-EXPRESSIONIST PHOTOGRAPHIC WORKING METHODS

The haptics break with expectation, ritual, and tradition to represent other planes of reality. Their style is more self-conscious and conspicuous, placing importance on the unfamiliar. They emphasize form, stressing the essential nature of the subject rather than its physical nature. Haptic-expressionists deploy the camera flamboyantly, using it to comment on their subject. They make use of digital imaging software to heighten an image's response, having no qualms about altering a process and/or moving and rearranging a given reality to suit their needs. Often, they crop the picture space, preferring a closer, more controlled, and directed composition. Haptics relish creating their own mini-universes. They frequently practice postvisualization, considering the digital studio a creative opportunity to carry on their visual research, saturating their images with visual clues and information to direct and lead viewers around their composition.

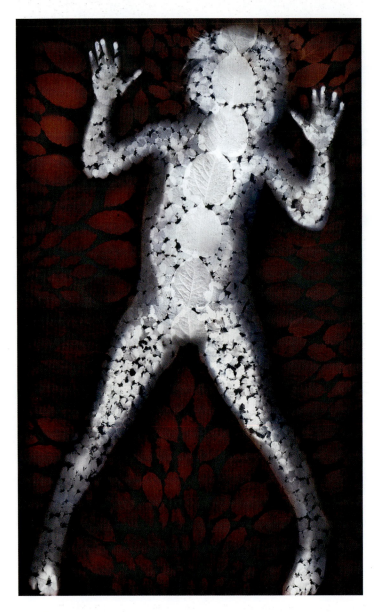

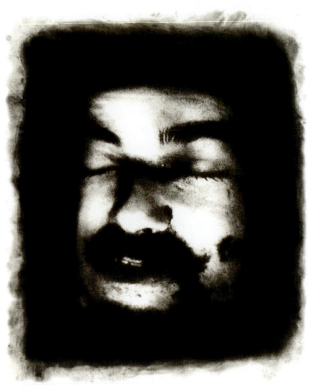

FIGURE 6.6 "My work connects and reflects the passage of time." Martha Madigan's daughter posed every summer from age 3 to 13 by lying on sheets of printing paper for 5 minutes in sunlight. The paper was put away and then re-exposed to the sunlight after a variety of plant forms were arranged on the paper, and then processed in gold chloride toner for permanence. The resultant images were scanned with a 4 x 5-inch digital back, and combined and manipulated in Photoshop to produce a seamless life-size image with a fantastical sense of reality that can be related to magical realism.

Credit: © Martha Madigan. *Graciela: Growth III*, 1993–2003. 40 x 24 inches. Inkjet print. Courtesy of Michael Rosenfeld Gallery, New York, NY, and Jeffrey Fuller Fine Art, Philadelphia, PA.

FIGURE 6.7 This image was made using a customized photographic process. This method takes appropriated imagery from an Internet archive, made of people after their murder, into the computer for processing. The imagery is then outputted to film to make silk-screen prints with water-soluble ink. Charcoal is then rubbed into the uninked surfaces of the paper, after which the water-soluble ink is dissolved to reveal paper to correspond with image highlights. "It was very important for me that the image be created by rubbing the image into existence (as in a Gravestone rubbing). I wanted to have contact with the surface of the image, to touch these victims' faces in order to make the image. The rubbing process for these images required me to vigorously work charcoal into the fiber of the paper, making my hands raw. These images marked me, they opened my skin, and made my hand incredibly sensitive to things it usually would not be sensitive to. It is my way of giving intimate physicality to the person imaged at their death through a process that uses an active and embracive human touch. Perhaps these ashen portraits become votive and aspirational in that way. They are meant to remind us of our common humanity, by way of our horrors. They ask us to remember, not in shame, but in earnest."

Credit: © Damon Sauer. *Death Rubbing: Unidentified Iraqi Civilian*, 2005. 28 x 22 inches. Charcoal rubbing on paper.

THE EFFECTS OF DIGITAL IMAGING

As of this writing, over 350 million photographs are being uploaded to Facebook every day, most captured with a smartphone or point-and-shoot camera. Although it is still too early to say with certainty, with over 90 percent of American households owning a digital camera or smartphone, this rapid explosion of digital photography could be indirectly creating a homogeneous look to today's photographic images. Autofocus, auto-exposure, auto-white balance, and auto-everything may unintentionally be pushing photographic imagemaking even more toward a mechanical visual-realist style and away from a haptic-expressionist style. The onslaught of programmed imaging apps gives only the illusion of handmade uniqueness. One thing is for sure: the rapid dissemination of photographic images through the Internet, online archives, and print media and the prolific consumer output that has arisen through affordable home digital technology are creating an evolution in the aesthetics of imagemaking.

PHOTOGRAPHY'S EFFECT ON THE ARTS

Photography continues to bring about groundbreaking changes in the arts. Initially, it relieved painters and writers of the role of having to laboriously describe people, objects, and happenings and allowed them the freedom to move from outer matching to inner matching. By turning art toward the inner processes of creative expression, photography helped lead to the development of modern, abstract, pop, conceptual, and postmodern art. Now, the explosive growth of digital imaging has given photographers the same options as other artists to control space/time realities (see Chapter 7).

The rapid changes in photo-based imagemaking make it extremely difficult to stay current. In this avalanche of transformation, it can be comforting to cling to what we know, but this attitude can block

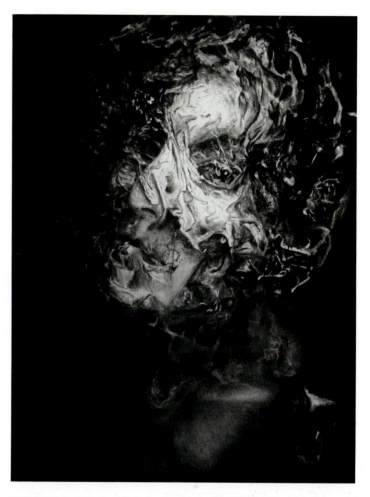

FIGURE 6.8 Tricia Butski's series, *Semblance*, examines issues related to memory, by exploring its limitations and aestheticizing the instability inherent in portraiture, and manipulates our sense of familiarity by alternating between analog and digital techniques. An unaltered source image is physically manipulated through an additive layering process, re-photographed, and then digitally transformed. The final image is then rendered through drawing in charcoal in larger than life scale. By challenging the boundaries between representation and abstraction and questioning the relationship between fluctuation and constancy, the work becomes entangled and disordered, mirroring the viewer's innate desire for clarity and his or her proclivity for pulling meaning out of partiality.

Credit: © Tricia Butski. *Visage*, from the series *Semblance*, 2016. 18 x 24 inches. Charcoal on paper.

one's creative path. Investigative research is necessary in any field to keep it alive, growing, and well. Photographers should engage their curiosity, ask questions, and experiment by synthesizing their varied modes of intelligence in the pursuit of new representational knowledge.

FIGURE 6.9 Paolo Ventura's *Automaton* series is presented as a linear sequence of photographs and texts, functioning as a complete narrative. Set in the Jewish ghettos of 1940s Venice, a watchmaker creates an automaton, a kind of robot resembling living and human forms, to keep him company. Diffused lighting and atmospheric fog float over narratives of fictional characters in historically inspired scenarios, the distinctive *mise en scènes* highlighting the cultural nostalgia in Ventura's meticulously created worlds.

Credit: © Paolo Ventura. *Automaton #15*, 2010. 50 x 40 inches. Chromogenic color print. Courtesy of Hasted Kraeutler Gallery, New York, NY.

When you are both a photographer and viewer of photographic images, it is important to know that there is no fixed way of perceiving a subject, only different ways that a subject can be experienced. Concentrate on photographing your experience of what is mentally and emotionally important, what is actively in your mind, and what you care about during the process of picturemaking. When looking at other photographs, especially ones that are unfamiliar or that you do not understand, attempt to envision the mental process that the photographer used to arrive at the final image. Regardless of approach, the visual photographers emphasize the "what" and the haptics the "how." Learn to recognize these two fundamental outlooks and appreciate their unique ways of seeing and knowing the world.

PUSHING YOUR BOUNDARIES

Digital photography offers a rapid sequence of rediscovery. New images can alter the way we look at past pictures and affect future directions. Feel open to use whatever methods are necessary to make your pictures work, whether it is previsualization (knowing how you want the picture to look before making an exposure), postvisualization, a preprocess idea, or an in-process discovery. When imagemaking you do not think with your eyes, so allow yourself freedom from the restraints of any single working method. Make digital imaging a study of how a camera and a sensor see, and think of each step of the process as a time for exploration, not as a situation to display your rote-memory abilities. Use the instant feedback to experiment and take chances, don't be afraid to walk on the edge, and never allow others to set your limits. Something unexpected is not something wrong. If you don't like the result, push the Delete button. Enjoy the process of making photographs. Don't turn it into a competition with yourself or others. There are major discoveries waiting to be made in digital imaging, so keep your definition of photography broad and wide. Listening to your genuine values and concerns places you on a course that allows your best capabilities to come forward and be seen. Do not get sidetracked by trendy art fashions, for they are not indicators of awareness, knowledge, or truth. They are simply a way of being "with it" for a moment. Keep in mind that talking about photography is not photography and words are not pictures. Keep your eyes on your destination, which is making pictures, and don't mistake the appearance of a thing for its essence. Make lots of images and then ruthlessly edit, edit, edit. In this instance, the "Trash" is your friend.

AESTHETIC KEYS FOR COLOR AND COMPOSITION

THE COLOR KEY

When you are formulating an image, it can be helpful to start with your own internal aesthetic inclinations, which offer a means to understand and gain access to how you are apt to visually order and decipher the world. Deciding what colors to include and their compositional arrangement is crucial in visualizing the outcome. We all have colors we tend to favor. Notice the colors with which you have chosen to surround yourself. Observe the colors of the clothes you regularly wear and of the objects in your living space because they are a good indication of your prevailing color key.

Your color key is a built-in automatic pilot. It will take over in situations when you do not have time to think. Everyone has one. It is not made, but has to be discovered. The choice of a color key mirrors a person's inner state of mind. It is a balancing act and is not a constant—it is not fixed. At one point, a person may be drawn to dark, moody hues, whereas bright, happy, and warm colors might be prominent later. When a picture is composed, the framing establishes the relationship of the colors to one another, which affects how they are perceived. The colors selected are the ones that a photographer currently identifies with in an innate way. Review the sections on color symbolism in Chapter 2 and the characteristics of light in Chapter 5 to get insights into what your key colors might represent (see Exercise 6.3).

THE COMPOSTION KEY

The composition key is the internal sense of construction and order that one applies when assembling the parts of a picture. Our authentic sense of design and style is a developmental process that cannot be forced. A rendition of how one naturally configures the world, it is incorporated into your work and is given back in your final image. Do you tend to place your principal subject in the center, to the right, or left of center? Is your visual emphasis placed on the top, bottom, or sides? Some universal compositional keys to begin looking for are the circle, figure eight, spiral, and triangle (see Chapter 2).

RECOGNIZING THE KEYS

Recognizing these keys is a way to make yourself more aware of your own inherent preferences, which then allows you to use these central inner guides to make better images. A good imagemaker can learn to make pictures in all kinds of conditions. The ability to see that there is more than one side to any situation helps make this happen. For example, you could complain it is raining and not go out and make pictures, or you could notice that it is raining and see it as an opportunity to make the diffused, shadowless picture that has been lurking in the back of your mind. Color and composition keys offer guides for understanding how we visually think. They are not hard-and-fast picture-making rules. They also show us that there are many ways to see things. When you start to pay attention to how others view the world, it is then possible to see more for yourself (see Exercise 6.4).

EXERCISE 6.3 ONE COLOR

Choose one color, and one color only, and make photographs of that color in a variety of lighting situations, including outside and inside, bright light and dim light, and under natural and artificial light. How is your interpretation affected by the quality of light and the context/environment? What happens when you fill the frame with that color? What if you pinpoint that color within the larger frame of the scene? How does varying the angles of view affect your color perception? Notice that there is much more to "blue" than blue—that there are multiple shades, hues, and values of a color—and observe how these differences can affect a viewer's response to the image.

FIGURE 6.10

Credit: Unknown photographer. *Boy from Warsaw Ghetto Uprising*, 1943. Variable dimensions. Gelatin silver print. From the Jürgen Stroop Report to Heinrich Himmler, May 1943.

FIGURE 6.11 By shifting one's point of observation, one can see things in a scene that one has never noticed before. In his series *Mother*, Nir Hod recreates 13 versions of the woman from the infamous image of *Boy from Warsaw Ghetto Uprising* (1943) in which she appears as if she has been shopping on New York's fashionable Fifth Avenue, pointing out how context determines meaning. Hod's work has to do with conflict and paradox and "that was the point of *Mother*. I came up with the title *Mother* as a way of giving back what was taken from her. They [the Nazis and their willing collaborators] took her life, and we don't even know who she was. She is like a figure in a biblical story, a modern Mother Mary. I used editing software to darken everything around her and realized there was a face reflected on the surface of her handbag. And if you look at her hair, you can see the ghostly image of a skull, like a sixteenth-century European painting. So I brought out those details more, but I didn't create them. They were always there, but I saw them for the first time in *Mother*."

Credit: © Nir Hod. *Mother*, 2012. 109⅟₁₆ x 78½ inches. Oil on canvas. Courtesy of Paul Kasmin Gallery, New York, NY.

FIGURE-GROUND RELATIONSHIPS

Figure-ground *is the relationship between the subject and the background. It also refers to the positive-negative space relationship within your picture. Figure refers to the meaningful content of your composition;* ground *describes the background of the picture.*

THE IMPORTANCE OF FIGURE-GROUND RELATIONSHIPS

The principle of figure-ground relationships is one of the most fundamental laws of perception and one that is used to help us design our photographs. Simply put, it refers to our ability to separate elements based upon contrast—dark and light, black and white, warm and cool. When the figure and the ground are similar, perception is confusing and difficult, and viewers might have trouble determining what is important for them to look at in a picture. This often occurs when an imagemaker attempts to provide too much or too little information in a composition. A viewer's eyes will tend to wander without coming to a point of attention. Such a composition lacks a visual climax, so viewers lose interest and leave the image. If you find yourself having to explain what you were trying to reveal, there is a strong possibility that your figure-ground relationship is weak (see Exercise 6.5).

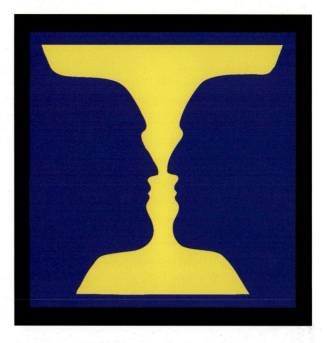

FIGURE 6.12 This image, a classic example of the figure-ground phenomenon, dates back to the eighteenth century. It demonstrates an ambiguous figure-ground illusion that can be perceived either as two blue faces looking at each other, in front of a yellow background, or as a yellow vase on a blue background. This illusion is important because it shows that perception is not solely determined by an image formed on the retina. The spontaneous reversal that you observe illustrates the dynamic nature of subtle perceptual processes, underscoring how your brain organizes its visual environment. What do you see first? Can you discern a different figure-ground relationship? What do you think most people see first? Why? What does this tell you about the role of contrast and contour?

EXERCISE 6.4 COLOR AND COMPOSITION KEYS

Learn to identify your personal color and composition keys. Do not expect to find them in every piece. They can be hidden. Doodles can often provide clues to your compositional key. Get together with another imagemaker and see whether you can identify each other's keys. Go to galleries and museums and look through books, magazines, and online collections to find a body of work by an imagemaker that you find personally meaningful. Ascertain the color and compositional devices in this imagemaker's work. Now, make an image in the same manner. Do not slavishly replicate the work, but take the essential ingredients and employ them to make your own image. Next, compare the two images. Last, compare both images to your other work. Write down the similarities and differences in color and composition that you notice. What can you now see that you did not notice before making these comparisons? Now, return to the same subject and make an image your way. Compare the results with what you previously have done. Has your thinking been altered in any way? Explain.

EXERCISE 6.5 FIGURE-GROUND STRATEGIES: LESS IS MORE

Observe a scene and determine exactly what interests you. Visualize how your content, the object/subject (figure) of primary interest, and the background (ground) are going to appear in your final photograph. Put together a composition that will allow a viewer to see the visual relationships that attracted you to the scene. Use a zoom lens at various focal lengths and vary the camera-to-subject distance. Try different angles to alter the areas of focus. Be very selective about what you include in your frame. Find ways to both isolate and connect the key visual elements of the composition. Try using a higher shutter speed and larger lens aperture to lessen the depth of field. Experiment with focus and see what happens when spatial visual clues are reduced. Do not attempt to show "everything."

Bear in mind the motto: *Less is more.* Often, showing less can tell the audience more about the subject because they do not have to sort through visual chaos. Intentionally limit the number of colors in your composition. A color photograph does not have to contain every color within our spectrum. Where everything seems to be of interest, nothing ends up being of particular interest. Maintain simplicity and make sure your audience gets your point. The key is to subtract the obvious and keep what is meaningful and significant.

Keeping these factors in mind, make two photographs of the same scene/subject. One should show a clearly definable figure-ground relationship. The other should portray an ineffective figure-ground relationship. Then compare and contrast the two. Identify the methods used to improve your figure-ground relationship. How can they be applied to further imagemaking situations? Now, apply what you have learned by making an image that shows a simple but intriguing figure-ground relationship and another that creates a successful complex figure-ground relationship.

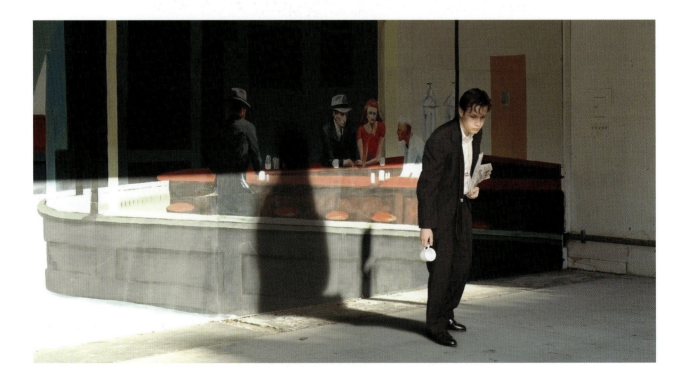

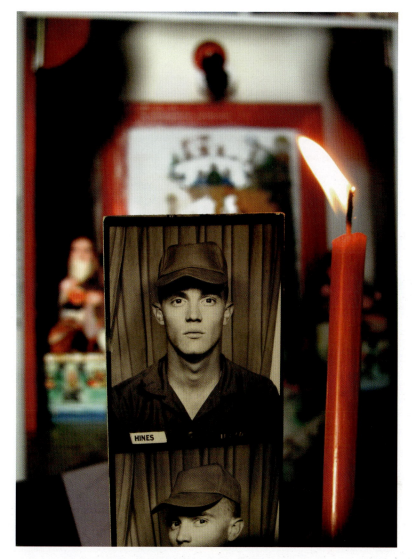

FIGURE 6.14 Twenty years after the post-traumatic stress disorder–related suicide of her brother Gary, Jessica Hines collected stories, interviews, and photographs from those he served with in the U.S. Army, along with the places where he had traveled during the Vietnam War. Combining physical artifacts into collages and dioramas, Hines pieces together a narrative interpretation about Gary's past and the psychological influence of the war. Her use of shallow depth of field brings the foreground into sharp focus while blurring the background, making her brother's photo-booth portraits move front and center.

Credit: © Jessica Hines. *My Brother's War: Chapter 7, Untitled 11. I Pray for Your Spirit*, 2009. 24 x 18 inches. Inkjet print.

FIGURE 6.13 Hans Gindlesberger explains that *"I'm in the Wrong Film* is a colloquialism spoken when one's surroundings have taken on a disconcerting, fictitious quality. In this series, the experience of individual dislocation is applied more broadly, in articulating the collective loss of identity that permeates the rural and post-industrial landscape of America. Each tableau manifests the psychology of a transient character and constructed environments suggestive of Middle America. The faltering construction of these describe both the desire and the absurdity in attempting to recover a sense of belonging in a time of dislocation." The figure was placed in front of an abandoned building in rural Ohio that had been painted over with a reproduction of Edward Hopper's *Nighthawks* (1942). The artist then digitally painted in the lighting effects to create a sense of continuity across the multiple layers of imagery, creating a scene that wavers between reality and illusion. The resulting image was face mounted to Plexiglas. The lack of a frame or border enhances the screen-like feel of the large format prints and the cinematic quality of the project.

Credit: © Hans Gindlesberger. *Untitled (Nighthawks)*, from the series *I'm in the Wrong Film*, 2008. 22 x 40 inches. Inkjet print.

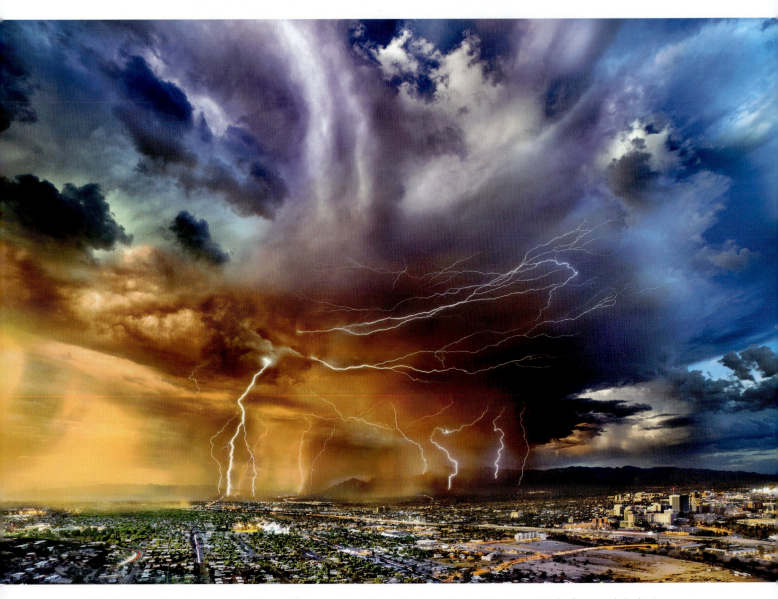

FIGURE 7.0 William Lesch explains: "The world does not fit neatly into the frame of a single instant, a sixtieth of a second. Reality is a constantly changing, living thing, a symphony of light and color. It is not something to be tamed into a decisive moment, but is a never-ending eternal present. I made approximately 500 exposures of this scene over a period of 4 hours, including multiple exposure HDR, which I later blended together to record the passage of time rather than one particular moment in time. As I weave these timescapes together I work intuitively, looking for the seams, chinks in the way we expect things to look. Sometimes I come away with a bit of the world as I believe it really exists: an endless, timeless river of past, present, and future."

Credit: © William Lesch. *Lightstorm over Tucson, 4 Hour Time-Lapse Montage*, 2013. 40 x 60 inches. Inkjet print.

Time, Space, Imagination, and the Camera

IN SEARCH OF TIME

In his *Confessions* (397–400) Saint Augustine summarized the complexity of defining time: "What then is time? If no one asks me, I know what it is. If I wish to explain it to him that asks, I do not know." Even physicists find the nature of time to be inexplicable. Time is baffling; it seems to flow past us, or we appear to move through it, making its passage feel subjective and incomprehensible. Yet a camera can purposely immobilize a subject in the flow of time for contemplation, giving photographs exceptional properties that other visual media do not possess.

When Albert Einstein proposed his Special Theory of Relativity in 1905, he proved that widely held concepts about time were not always true. For instance, Sir Isaac Newton's theory that time moves at a constant rate was proved erroneous after it could be demonstrated that time elapses at a slower rate for rapidly moving objects than it does for slowly moving ones. An example of this phenomenon would be an astronaut who goes on an extended space voyage. After returning, the astronaut would have aged only a few years, whereas his earthbound counterparts would have gotten dramatically older. The belief that two events separated in space could happen at precisely the same time—simultaneity—also has been demonstrated to be incorrect. Whether two events *appear* to happen at the same time is contingent on the vantage point of the viewer, and no single observer has the inherent privilege

to be such an authority. For Einstein, the concept that space is something that exists objectively and independently of things, including time, was a remnant of ancient, prescientific thinking. Einstein found that space and time bend, twist, and warp. According to the latest science, space is so malleable that the universe's size and momentum change over time. Sometimes expanding and other times contracting, it does not remain constant.

Einstein's endeavors made even more extraordinary revelations about time. Case in point, a clock will run faster at the top of a building than in the basement. In a nutshell, Einstein tells us there is no such thing as universal time and there is no master clock regulating how the universe works. Time is relative, slippery, and subject to gravity and motion. Time and space are not simply "there" as a neutral, static stage for existence to unfold upon. Time and space are physical things, malleable and mutable, no less so than matter, and subject to physical laws. In quantum theory, what is physically real is said to be undefined until it is observed (interacted with). This quality of being undefined also applies to the "reality" of the future and of past events. According to quantum theory, by observing an event, an observer literally determines the course time has chosen. These same forces of physics were at work in the arts and can be seen in Pablo Picasso's painting *Les Demoiselles d'Avignon* (1907), which altered Western notions of time and space to produce a rift dividing past and future that led to the blooming of modern art.

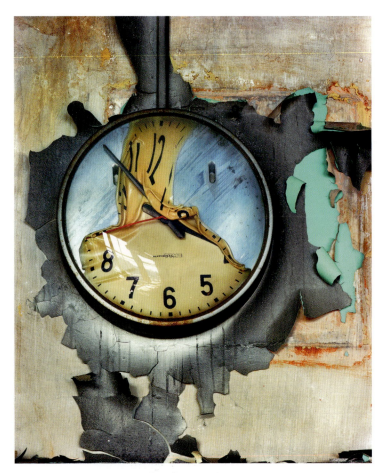

FIGURE 7.1 Andrew Moore's series *Detroit Disassembled* depicts Detroit's decline as an industrial dynamo by "affirming the carnivorous nature of our earth, as it seeps into and overruns the buildings that once epitomized humankind's supposed supremacy." Abandoned and neglected, the Daliesque clock suggests that time has taken a bizarre twist and been thrown into reverse and the ever-moving assembly line that once produced shiny automobiles now generates decaying ruins. This raises troubling issues about the future of a country in which such degradation continues unchecked while its wealth is drained on foreign wars. Moore photographed this scene with an 8 x 10-inch view camera, and the resulting negative was digitally color corrected and printed.

Credit: © Andrew Moore. *National Time, Former Cass Technical High School, Detroit*, from the series *Detroit Disassembled*, 2009. 40 x 30 inches. Inkjet print. Courtesy of Yancey Richardson Gallery, New York, NY.

THE PERCEPTION OF TIME

We perceive our world through our senses. We see colors, hear sounds, and feel textures, but how do we perceive time? Could there be a special faculty, separate from the five senses, for detecting time, or is it that we notice time through our perception of other things? And if so, how? What about the tension between organic time (nature) and mechanical time (culture) and the Western ideological associations attached to each?

How do such theories affect an imagemaker? If asked to imagine a photographic image, most of us would conjure up a slice of immobilized time that has been plucked from the flow of life with a frame around it. Everything in the picture is stationary, there is no movement, and it will never change, as the brief capture remains permanently available for ongoing examination. This Western convention of reality, based on Renaissance perspective, commands that photographs, like trial evidence, be clear, sharp, and to the point of the matter. In popular culture, a photographic image's value is determined by the abundance and readability of its details. In this scheme, the actions of a camera with its lens are supposed to emulate the human eye with its lens and retina. Yet critical thinkers and visual artists have realized that a photograph does not actually reproduce human vision. What it does is arrest a particular moment in time, shown from a specific vantage point—usually within a rectangle—where our head has held still, with one eye closed. And even then, the result is rendered with only the particular qualities of a specific image/color management system. Such a petrified Cyclopsian view actually reverses the original intent. Instead of a

camera showing us what our eyes would see, which is more like an egg-shaped field of view, we are now confronted with the notion that if our vision worked like a photographic process, we would indiscriminately see the world devoid of interpretation, without bias or prejudice.

This chapter concentrates on camera-based axioms dealing with the representation of space and time. Restricting your picturemaking options for conceptualizing time and space to a linear, Newtonian point of view is to constrain your mind and your camera responses. This is not to discourage imagemakers from working in this established mode, but to encourage exploration in uncharted zones where time can be visualized as up, down, in, out, and around space.

Photography's descriptive power has made it the principal visual medium from which most of us derive our impressions of and responses to the world. Digital cameras and image processing software give imagemakers unprecedented access for such undertakings. With sequential images, multiple "windows," and HD

video, along with a seamless incorporation of text and sound, digital technology plays a large role in the overall process of representation, defining dreams, and taking action. Websites like YouTube allow people to share their self-produced videos, while other sites offer simple tools for stringing together video clips and then adding soundtracks, titles, transitions, and unusual visual effects. Major newsgathering organizations ask viewers to act as citizen journalists and upload images and videos, usually captured with a smartphone, of local news stories for possible use. In the world of art, Christian Marclay's *The Clock* (2010) utilized digital tools to edit thousands of cinematic moments where clock time is either directly portrayed or a character interacts with it into a single 24-hour loop in which these moments sync with real time during a screening. Douglas Gordon's *24 Hour Psycho* (1993), a video installation of Alfred Hitchcock's movie *Psycho* (1960), slows down time by repeating frames so that a showing of the film lasts an entire day.

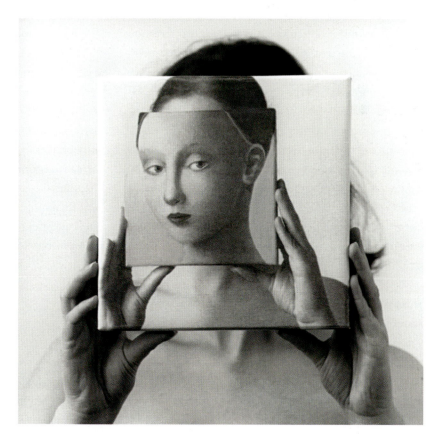

FIGURE 7.2 Inspired by the faces in early Renaissance paintings by Giotto and Piero della Francesca, Richard Bram used the contemporary painting of Silvia Willkens as masks and props to merge the identity of a model with the painted image. A digital component was entered in the middle of the process, when the original images were transferred to small canvases and then cropped and colored by Willkens. These became some of the props for the second photographic session. Bram's resulting photographs move forward and back through time and through the picture plane, between real and imagined personas, theme and variations in a visual fugue. All the original image-creation work was done in-camera.

Credit: © Richard Bram. *Isabel Trio 3rd*, 2000–2001. 40 x 40 inches. Inkjet print.

CONTROLLING CAMERA TIME

Although it has been mathematically demonstrated how the rate of time can fluctuate based on velocity, these equations cannot explain psychological time, which can seem to pass more slowly or more rapidly, depending on our mental attitude concerning an event. This chapter challenges imagemakers to take on the multifaceted enigmas of time that flummoxed even Einstein, such as the striking divergence between physical time and subjective time. The emphasis is on what can be done at the time of exposure with a camera, though it also is possible to either enhance or replicate these techniques with imaging software.

Relativity also informs us that time is not a series of moments—some not yet having occurred—but rather a block in which we exist at a specific position, much in the manner we exist at one point in space. The inconsistency between the frozen "block time" of physics and the flowing subjective time of the human mind implies a need to rethink how we represent time. Most of us find it difficult to surrender our impression of flowing time and its ever-moving present moment. Our sense of time is so basic to our daily experience that we cannot accept the possibility that it is an illusion or misperception, based on the limits of our senses. During cinema's infancy, the practice of "reversing," or running the film backwards, offered a uniquely photographic experience that altered a basic concept of how we were taught to perceive our world. Since the time of Aristotle (384–322 BC), logically minded people have demonstrated that personal experience and intuition are not a reliable guide to scientific understanding.

By diverging from customary imagemaking standards, we can start to include new ways of thinking about and depicting time using digitally based images. Once an image is digital, it can seep out of the confines of its frame and become capable of being woven together into a much larger tapestry. The net effect of this collective intelligence of images is our ability to see things we cannot see in a single image. Of course, this upsets the traditional apple cart, but that has always been one of the effects of new technology. It further democratizes the practice and generates new makers and new audiences for their work. See how you can take advantage of the following starting points to use your camera to investigate new ways of representing time and space (review camera concepts in Chapter 3). In addition to the camera-based methods, there are innumerable ways in which imaging software can be applied to manipulate a picture's time and space relationships.

EXPLORING SHUTTER SPEEDS: THE DECISIVE MOMENT

Most of us have been taught that taking a good picture involves stopping all the action so that we can clearly see the subject, which means using a shutter speed of 1/125 second or higher. This approach is best typified by photographer Henri Cartier-Bresson's *The Decisive Moment* (1952), in which he stated, "There is nothing in this world that does not have a decisive moment. To me, photography is the simultaneous recognition, in a fraction of a second, of the significance of an event as well as of a precise organization of forms that give that event its proper expression." The decisive moment can be thought of as the height of a formal visual performance, capturing the precise single instant in which the subject reveals its essence within the defined and formalized confines of the picture space. While Cartier-Bresson was a master of this picturemaking strategy, not all photographs have to be about distinctly isolated moments of time. Rather, it is also possible that photographs can be a collection of numerous moments.

EXTENDING THE ACTION/ DECONSTRUCTING *THE DECISIVE MOMENT*

One can begin experimenting with photographic notions of time by considering different methods of capturing motion that deconstruct *The Decisive Moment*.

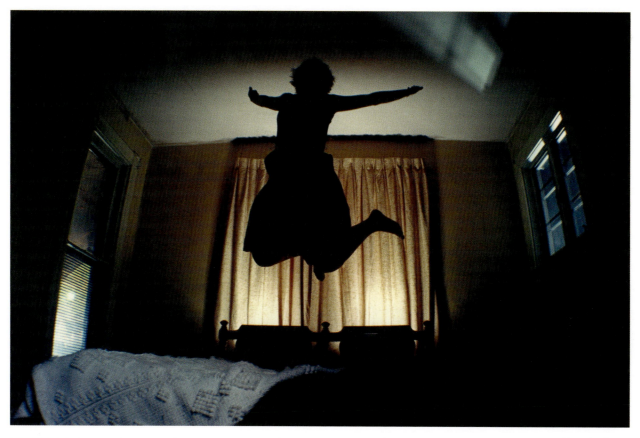

FIGURE 7.3 Tricia Zigmund employs experimental methods to depict a dreamlike or alternate reality, which is at the core of her imagery. In this instance her camera was set to B, shutter released, and the strobes were fired by an assistant while Zigmund jumped for the first portion of the exposure that utilized light painting. Then the strobe was aimed at the blanket and fired for another exposure, and then she went outside and fired a portable battery powered strobe into the windows from each side.

Credit: © Tricia Zigmund. *Collapse of the Swaying Steady*, 2006. 16 x 24 inches. Inkjet print. Courtesy Kolok Gallery, North Adams, MA.

By adjusting the shutter speed (shutter priority) to a slower speed, thereby lengthening the exposure, you can boost the amount of time recorded by the photograph. When the amount of time captured is increased, subjects are likely to be more actively involved in the structure of the composition. This extended play of light on the sensor can have astonishing results. As light is recorded over a longer period of time, a new interaction of color emerges as the hues whirl together and blend into new visual possibilities, offering a different way of seeing and experiencing for contemplation. Use the camera display to review each exposure and make corrections for exposure, shutter lag, and digital noise, as needed.

STOPPING THE ACTION

Another possibility is to stop the action of an event by using a fast shutter speed (shutter priority) or flash in conjunction with a higher sensitivity (ISO). Consider freezing motion when it offers viewers an opportunity to see something that unfurls too quickly for the eye to fully comprehend. High shutter speed also provides a method of halting an event at a critical point of the action for additional analysis and study, thereby providing the viewer with a new way of visualizing and thinking about a subject. This is what Eadweard Muybridge did in the 1870s when he used a series of cameras to photograph a trotting horse and prove that

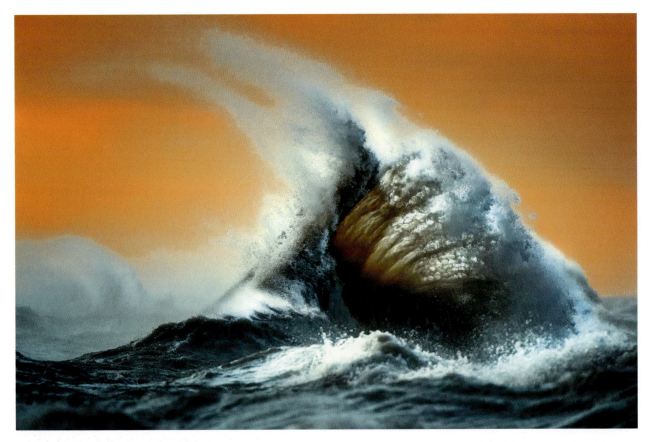

FIGURE 7.4 David Sandford said the foam and waves sometimes come together into "faces and images that pop up in my work, water and light that take on the form of a face or a skull." One image Stanford refers to as "Eerie Erie," referencing Lake Erie where this series was made, seems to capture a foam death's head atop a grasping figure, a perception that Sandford said existed only for an instant within a furious sequence of taking photographs, a form he saw only later when he was going through his captures in his studio.

Credit: © David Sanford. *Orange Dawn*, 2016. Dimensions vary. Inkjet print.

at one point it had all four feet off the ground, thereby altering how future artists would portray running horses. Muybridge went on to complete a larger study, *Animal Locomotion* (1887), and did the same for the human figure in motion (see the section "Timeline Animation" later in this chapter).

Anticipation and timing are critical for capturing the climax of an event. Whenever possible, study the action before making your exposures, familiarizing yourself with how the event unfolds so you can then press the shutter button with forethought. When shooting stop-action images, select the appropriate vantage point and lens focal length, and then preset both the exposure and focus, using the smallest possible aperture to attain maximum depth of field. A wide-angle focal length allows more room for error because it provides more depth of field at any given aperture than a normal or telephoto focal length.

Use the image optical stabilization or anti-shake camera system if it is available on your camera. Optical stabilization will reduce image blur caused by hand and body motion and is especially useful when using long (telephoto) focal lengths in any circumstances. With any camera-shake compensating system, it is important to bear in mind that it cannot stop the motion of a moving subject. On the other hand, motion blur filters can be utilized to mimic the effect of taking a picture of a moving object with a slower (longer) exposure time in specified densities and directions. It can blur an image in a specified direction representing your point of view

(from −360 to +360°), at a specified intensity representing any shutter speed below 1/30 second, and at a specified intensity from 1 to 999.

The telephoto focal length is useful for isolating action, as it will diminish the depth of field at any given aperture and therefore visually separate the subject from the background. Prefocusing, using autofocus lock, or using continuous autofocus all become options to consider to ensure your results are sharply focused.

The shutter speed needed to stop motion depends on the speed of the subject and its direction and distance from the camera (see Table 7.1). The nearer the subject or the longer the focal length of the lens, the higher the shutter speed needs to be to fully arrest the action.

TABLE 7.1 Shutter Speed Needed to Stop Action Parallel to the Camera

Shutter Speed	Action
1/125 second	Most everyday human activities, moving rivers and streams, trees in a light wind
1/250 second	Running animals and people, birds in flight, kids playing, balloons and kites, swimmers, and waves
1/500 second	Automobile at 30 miles per hour, bicyclists, motorcyclists, sport activities such as baseball, football, and tennis
1/1,000 second	Automobile at 70 miles per hour, jet airplanes taking off, high-speed trains, skiers, and speedboats

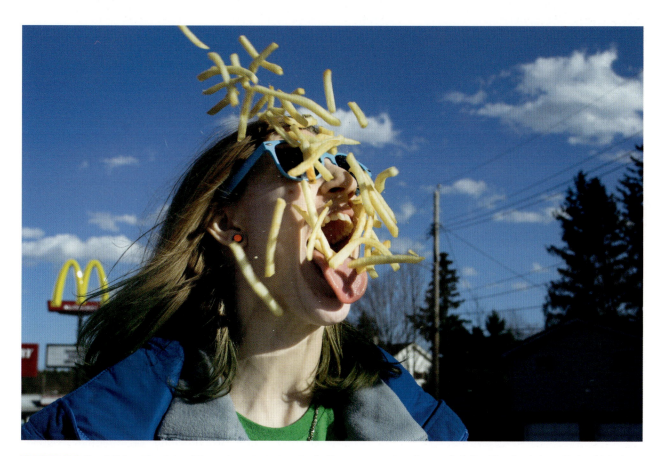

FIGURE 7.5 Sarah Schroeder states: "My goal was to capture the feeling one gets when they get their fix of fast food, that of being hit in the face with flavor. It's as though we don't care about the quality of the food; we just care that it tastes good and we can consume it quickly. Framing was critical, as I made sure the sign was in the background to give context. I photographed in the middle of the day when the sun was bright so I'd have enough light to shoot at shutter speeds fast enough to freeze some of the fries sharply in the air. To avoid my model from flinching, I had her wear sunglasses and close her eyes with her mouth open."

Credit: © Sarah Schroeder. *Fries With That*, 2016. 10 x 15 inches. Inkjet print.

EXERCISE 7.1 SHUTTER SPEED AND MOTION

Courtesy of Frederick Scruton, Professor of Art at Edinboro University of Pennsylvania.

This exercise explores how shutter speed affects the pictorial rendition of objects in motion.

Working with only available light (no flash), photograph subjects where motion occurs somewhere in the scene, such as amusement park rides, people in flux, and sporting events. Experiment with fast shutter speeds (up to 1/1000 of a second) where a quick moving object can be sharply frozen, down to about 1/60 or (when hand holding) where the same object may blur. The challenge is not just to freeze motion, but rather to also explore the visual impact of blurred motion.

Strategies

1. Experiment with a variety of lighting conditions and subjects.
2. Make many pictures by getting in close (3 to 5 feet) to the subject in motion.
3. Try various shutter speeds in each situation, making sure to adjust the aperture and immediately analyze the results and make corrections as you work.
4. Slower shutter speeds tend to blur motion, while faster shutter speeds tend to freeze motion.
5. By utilizing slower shutter speeds, down to 1 second or longer, even slowly moving objects may blur while the background remains sharp. Use a tripod when making exposures below about 1/60 of a second, as an overall blurry image rarely works as well.
6. You will not be able to use every shutter speed in each lighting situation. Instead, you will have to use faster speeds in brighter light and slower speeds in dimmer light.
7. Take your meter reading at the shutter speed you are using, then set your aperture, make a test exposure, and adjust accordingly.
8. Challenge yourself to achieve multiple solutions.

A subject moving across the frame requires a higher shutter speed than one approaching head-on or at the peak of its action. The basic guideline is that your shutter speed should be faster than the inverse of the focal length of your lens. For example, if you are using a focal length of 200 mm, then your shutter speed should be 1/200 second or faster.

SMARTPHONE CAMERAS: CONTROLLING SHUTTER SPEEDS

Most smartphone cameras have basic controls for exposure and focus, but not for white balance, ISO, and shutter speeds. Apps like ProCamera give priority to exposure and getting a clear picture based on value (lightness or darkness). The best way to get faster shutter speeds to stop the action is to work outdoors in bright sun. Your smartphone camera will select the fastest shutter speed available, based on the lighting condition. Bright sunlight will always give you 1/250 or faster, while early morning, late evening, overcast, or indoors may give you 1/25 of a second or slower. Use a tripod or support yourself against something solid when you expect slow shutter speeds. Camera or shutter speed apps are best used to inform you about your current shutter speed based on the lighting

conditions. However, shutter speeds will always be limited, as priority is given to ISO and exposure. When in bright light, your shutter speed app may allow you to choose between 1/250 and 1/500 of a second. In low light your shutter speed app will only increase the ISO or allow you to select a slower shutter speed.

STOPPING ACTION WITH ELECTRONIC FLASH

As seen in the pioneering stroboscopic work of Harold "Doc" Edgerton, the ability of electronic flash to stop movement depends on the duration of the flash. An average built-in flash unit usually gives the equivalent shutter speed of 1/250 to 1/500 second. High-end auxiliary flash units can be set at fractional power settings, which can supply much faster times, up to 1/10,000 second. Utilize image stabilization or anti-shake camera systems. Review your exposures and fine-tune as needed. This method can be effective in dimly lit situations where the electronic flash rather than high shutter speed can be used to stop action.

BLUR AND OUT-OF-FOCUS IMAGES

Blurred and out-of-focus images are as natural to photographic practice as those that are sharp and crisp. The blur's lack of precise focus frees an image from the restrictions of photographic correctness by offering another representation of reality, one that interjects a sensation of movement into a picture. This bends the traditional concept of photographic time, suggesting that an image can represent an awareness of the past, the present, and the future. The blur eliminates customarily recognizable photographic detail, revealing another aspect of a subject's physical and emotional essence. By suspending the fixed sense of photographic time and presenting the notion of changing time itself, the blur does away with the concept of a discrete parcel of framed time depicting the frozen past. Look at the work of Julia Margaret Cameron, Uta Barth, and Hiroshi Sugimoto for motivation.

Start by deciding what shutter speed is needed to stop the subject's movement in relation to the camera's position (see Table 7.1). A slower shutter speed produces more blur and consequently more contrast between the

FIGURE 7.6 Alan Sailer's work captures the exhilaration of childhood and adventure, immobilizing the moment of joyful destruction. His work, born from home experimentation, went viral in 2009 after being picked up by a social networking site. He links to information on how to build the unique flash, first developed by high-speed photography pioneer Harold Edgerton, warning "Please be careful. The main storage capacitor is pure death."

Credit: © Alan Sailer. *Last Crayon Standing*, 2008. Variable dimensions. Digital file.

moving and static areas of the composition. This can isolate a static subject from its surroundings. Consider which details are crucial and need to be retained. Determine whether it will be more effective to blur the background or the subject, as well as the direction of the movement. Linear blur is the most common and can be effective when following horizontal or vertical action. Intentionally moving the camera in a circular motion will cause globular blur, which needs to be carefully controlled; otherwise, it tends to become overwhelming. Disable image stabilization or anti-shake camera systems. Review each exposure on your monitor and make the necessary compensations.

One can also use a shutter speed that will freeze the subject, but focus either in front (front focus) or in back (back focus) of the principal subject. Another way is to defocus, utilizing a normal shutter speed while setting the lens's focus point on infinity. Both options, to varying degrees, will suppress detail and thus abstract and simplify the subject.

MOTION BLUR FILTERS

Additional modifications can be made with post-capture software. For instance, a radial blur filter can be applied to an image to simulate the effect of a zooming or rotating camera lens and produce a soft blur. Motion blur filters can mimic the vertical or horizontal blur of any picture or selected element within any picture file. Blur filters have given the photographer extensive blurring techniques that can be applied to any sharp image or used to enhance in-camera blurring techniques after the fact.

LENSBABY: BOKEH/SELECTIVE FOCUS

Special accessory equipment, such as a Lensbaby, can be very useful in these picturemaking situations. Used in conjunction with a DSLR camera, a Lensbaby allows you to bring one area of your image into sharp focus while the remainder is surrounded by graduated blur, similar to the selective focus controls of a view camera (see www.lensbabies.com). This effect is also known as *bokeh*, a Japanese term meaning blur that refers to the subjective aesthetic effects of out-of-focus points of light in an image. Bokeh effects can be achieved by using fast lenses at their widest aperture, such as f1.4. Tilt-Shift software is a post-capture option that allows you to make additional selective focus adjustments. Smartphone

FIGURE 7.7 Bill Armstrong's mandalas are made from collages that he then photographs with the camera's focusing ring set to infinity. "Extreme defocusing allows me to create rhapsodies of color that appear to change and pulsate as one looks into them as if they were alive." Loosely basing this series on traditional Buddhist paintings, Armstrong states, "Through abstraction, simplification, and blur, I create a context for the exploration of these broad spiritual themes. They are meant to be meditative pieces, glimpses into a space of pure color beyond our normal range of vision." As an aside, stare at the center of this image for at least 30 seconds and then immediately look at a white piece of paper. You should see a reversed afterimage in which the bright and dark areas are reversed and the colors appear complementary.

Credit: © Bill Armstrong. *Mandala*, from the series *Infinity*, 2010. 20 x 20 inches. Inkjet print.

cameras also have a Bokeh software based effect that will blur the background with some pictures that have a clear and distinctive main subject.

THE PAN SHOT

A camera may intentionally be moved to create a blur. One such method is the pan shot, which is an effective way to convey lateral movement by freezing the subject and blurring the background. Begin with a subject whose movement and speed are consistent. To accomplish the pan shot, use a slow ISO, holding the camera comfortably in the horizontal position. Prefocus on the spot that the subject will cross, and set the desired shutter speed. For instance, 1/15 second can be used to pan a vehicle moving at 30 miles per hour and 1/30 second for 60 miles per hour. Correlate the aperture with the speed, using the smallest possible aperture to get maximum depth of field. Frame the subject as soon as possible. Do not tighten up or hold the camera with a death grip; stay loose. Make the pan clean and smooth by following the subject with your entire body, not just with the camera. Gently release the shutter as the subject fills the frame and continue to follow through with the motion until you hear the shutter close. Generally, take care to not crowd the subject. Leave it some open space to keep proceeding in the direction of the movement, unless containment is the object. Review your exposure and fine-tune as needed.

For instance, if you are photographing a skateboarder, look through the viewfinder and watch as the skateboarder comes toward you. When the skateboarder gets close, aim the camera at the skateboarder's chest. Gently push the shutter release and keep the camera pointed at the skateboarder's chest while he or she moves past you. If you held the camera steady, the skateboarder would be blurry, but since you moved the camera at the same pace as the subject, the result will be a picture of a skateboarder who is sharp, while everything else will be a motion blur.

When you are panning or using a slow shutter speed, it is important to have a steady hand; leaving the shutter open for a long time allows the motion of the camera to affect the final picture. This is why sports photographers use a tripod or a monopod, which is like a walking stick that attaches to the bottom of a camera. A monopod allows you to steady the camera while you're shooting and is a worthwhile investment for anyone shooting sports pictures or other moving subjects.

Experiment with image stabilization turned off and on. Some lenses with image stabilization systems have a special mode that compensates only for vertical

FIGURE 7.8 For a series of portraits of people with physical scars representing transformative experiences, Biff Henrich lit his models with studio lights. Then, he used a 4 x 5-inch view camera with a scanning back to make exposures of up to 9 minutes to emphasize the digital artifacts, the subject's natural movement, and that of the moving background.

Credit: © Biff Henrich. No title, 2006. 67 x 48 inches. Inkjet print.

FIGURE 7.9 "The urban experience to me is largely about motion. I like to shoot fast and furiously with a simple low-tech tool—a Holga 120S plastic camera—and be immersed and swept up in, and along with, the tide of the moment. Either I am shooting people in motion or I myself am in movement around my subject. But then I'm very perfectionistic and exacting in the post-camera processing. The long overlapping images

(up/down) shake and does not try to adjust for the intentional movement created when panning horizontally with a moving subject.

Many random elements can enter into situations involving extended exposures, making such circumstances a deliberate combination of intent and chance. With practice and review, it is possible to get an idea of what the final outcome will look like. The unpredictability of these situations adds to their fascination. By learning to pan at just the right speed, you can capture the subject fairly sharply while the background is smoothly streaked, resulting in a convincing illusion of motion. Review each image on your monitor and make modifications accordingly. After you become skilled at this technique, try incorporating some variations, such as panning faster or slower than the object in motion. Using a slow shutter speed and intentionally moving the camera in nonparallel directions from the subject can create further motion effects.

EQUIPMENT MOVEMENT

Equipment-induced movement can be purposely utilized to impart an exaggerated sense of motion. However, this technique can easily be abused by unthinking imagemakers. When equipment is used not to *strengthen and support* an idea but *in place of* an idea, the end result is a gimmick, a superficial, attention-getting

trick that misrepresents the subject. Such deceptiveness indicates that a photographer does not know how to communicate the situation, and almost always results in dishonest, tired, worn-out pictures. With this in mind, use your monitor to review and make adjustments as you go. Ponder the following methods:

- Use a wide-angle focal length for its ability to produce dramatic feelings of motion when photographing movement at close range and at a low angle. The exaggerated sense of perspective created by wide-angle focal lengths can generate distortion and make background detail appear smaller than normal, thereby lessening its visual importance. Conversely, objects in the foreground seem larger and more prominent, making them more visually significant.

- Zooming during the actual exposure can create the illusion of motion, with blurred streaks of color extending out of the midpoint of the picture. It gives a stationary subject the feeling of momentum. To make this happen, put the camera on a tripod, set the lens to its longest focal length, and focus on the critical area of the subject. Start at 1/15 second, and then make a series of exposures using even longer times (1/8, 1/4, 1/2 second). Be sure to change the aperture to compensate for changes in speed. Zoom back to the shortest focal

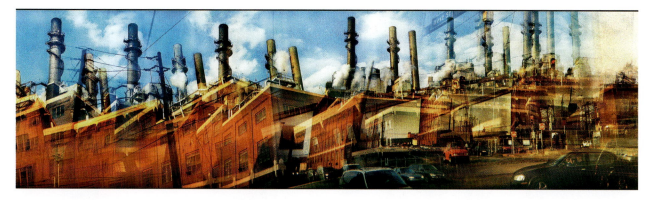

are created by only partially advancing the film between exposures. It delights me how these mostly unplanned juxtapositions capture my experience of a particular time and place and at the same time have an identity all their own."

Credit: © Susan Bowen. *Citizen's Thermal Energy Plant*, 2005. 29 x 4 inches. Chromogenic color print.

length as the shutter is gently released. Make a number of exposures and review your results. Pay attention to the exposure data, both in the display and the recorded metadata so that you know which combination produced each picture. Part of any learning experience is being able to use the acquired skill in future applications. It helps to practice the zooming technique without making any exposures, until the operation becomes second nature. Once you learn the basic method, you can combine it with other techniques. Experiment with turning image stabilization mode off and on. Some lenses have a special mode intended for use when a lens is mounted on a tripod.

- Pan zooming requires a photographer to pan with the subject while zooming and releasing the shutter. The camera needs to be on a tripod with a pan head. One hand is used to zoom while the other works the panning handle and shutter. A cable release is helpful, as is an assistant to fire the shutter at your instruction.
- Tilt zooming needs a tripod with a head that can both pan and tilt. Follow the same basic zoom procedure, but use longer exposure times (start at 1 second). Try tilting the camera during the zoom while the exposure is being made, and then try working the pan into this array of moves. The long

exposures give a photographer the opportunity to concentrate on a variety of camera moves.

- A multi-image prism that fits in front of the lens is a possibility, but its use requires discretion because its overuse has produced many hackneyed images.
- A scanning back or scanner can be utilized to record nonstationary subjects.

FREE-FORM CAMERA MOVEMENT

Free-form camera movement allows you to inject a haptic, subjective point of view in which the camera tells the story and yet is part of the account by following the emotional undercurrent of a scene.

With a stationary light source, use a variety of slow shutter speeds (starting at 1/8 second) while moving the camera in your hand. Begin by making simple geometric movements with the camera while visualizing the effect of the blending and overlapping of color and line. Using a wide-angle focal length will give you a larger area to work within. Ignore your camera's view-finding system and compose by feel and instinct. The key is to inject just the right amount of movement that adds a new dimension to the subject without overwhelming it. Too much movement results in color patterns and lines that tend to become chaotic. It is like moving down a river, and the picture needs to have that same kind of flow. Allow the camera to explore. Begin with a smooth,

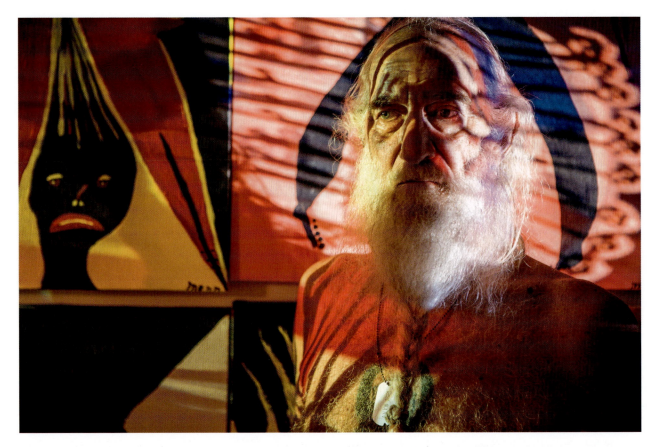

FIGURE 7.10 Fred Scruton documents contemporary vernacular artists and their undertakings. This body of work represents a neglected aspect of art and commerce in the public arena by identifying, recording, and celebrating these unsung practioners. Scruton proclaims: "Embracing the 'truth is stranger than fiction' tradition of street photography, this documentary project celebrates the expressive vitality of mostly self-taught artists working outside the mainstream of contemporary art. Shaped less by the influences of mass media and the academy, their built-environments and artworks reflect the artists' own lives, cultural histories, and inner-musings. Arising from the deep human instinct to communicate through art, their often ephemeral works reveal a rich, but passing, legacy of American culture." To record this concept, Scruton utilized two vintage 35mm slide projectors to project color slides of the Ronald Mann paintings onto him. Then, an off-camera strobe was fired onto the ceiling for fill light and to freeze motion as Mann tried to remain still during this extended exposure.

Credit © Fred Scruton. *Ronald Mann, Clio, MI*, 2011. 24 x 30 inches. Chromogenic color print.

fluid, and mobile camera movement. Then, try an irregular or jerky movement. Next, move in and out and around the subject. Now, allow the camera to drift from one point to another. Be spontaneous. Go with a feeling of unpredictability, but review each exposure and make adjustments accordingly.

Moving lights can put color and motion into a static environment. With the camera on a tripod and using small apertures, make exposures at 10, 20, 30, or more seconds. Try not to include bright, nonmoving lights because they will become extremely overexposed and appear as areas with no discernible detail and plenty of digital noise.

FLASH AND SLOW SHUTTER SPEED

Employ your camera's Slow Sync mode, which automatically combines flash with slow shutter speeds to capture both the subject and background. Combining flash with a slow shutter speed allows you to juxtapose areas of movement and stillness within a scene, thereby blending a sense of ambiguity and mystery with motion.

Start out when the ambient light level is low, such as in the early morning or evening or on a cloudy day. The effects can be varied depending on the ratio of flash to ambient light exposure and by the amount of movement of the subject and/or the camera (if it is handheld), or both.

Use your flash exposure compensation mode to increase or decrease the flash output. Usually, increasing the flash output makes the main subject come forward and appear brighter. Reducing the output helps to prevent unwanted highlights and/or reflections. Generally, positive compensation (+) is used when the principal subject is darker than the surroundings, whereas negative compensation (–) is used when the main subject is brighter than the background.

Using an optional auxiliary flash unit will increase your working options. A basic starting point is to cut the ISO sensitivity by one-half and use this new rating to take a normal exposure reading of the scene's ambient light. Set your flash with the same modified ISO rating. Determine the flash exposure based on the distance of the key object(s) in the composition. If the ratio of flash to ambient light is the same, the color palette and contrast will be soft. As the ratio of flash to ambient light is increased, the color palette tends to become more saturated and the contrast increases. Use a shutter speed

of 1/4 second or longer. The flash exposure freezes the subject, and the duration of exposure time determines the amount of movement that is recorded. Bracket your exposures, review them, and experiment with various types of movement until you gain a sense of how this interplay works.

EXTENDED TIME EXPOSURES

Many digital cameras have built-in shutter speeds of 30 seconds or longer. To make even longer exposures, attach your camera to a tripod and set your shutter control to the B (bulb) setting or, if available, to the T (time) setting. In the B setting, the shutter remains open as long as the shutter release button is held down. In the T setting, the shutter opens when the button is initially depressed and remains open until it is pressed a second time. Utilize the self-timer, a cable, or remote electronic release to avoid camera shake. Make use of a small lens aperture or a slow ISO setting to make the exposure longer. For even longer exposures, put neutral density filters in front of the lens. Avoid bright, static light sources, as they will cause gross overexposure with no detail. Pay attention to image noise and battery drain.

Clouds, lighting, wind, and passing lights can introduce a sense of motion and create a mood. Other

FIGURE 7.11 Chris Walker first used an 8 x 10-inch view camera to make a 2½-hour nighttime recording of the rapidly vanishing grain elevators that were indicative of rural America's pre-global economy. Five years later he made a 35-minute exposure of a similar night sky using a star tracker (a motorized clock drive), which allows a camera to record the stars as fixed objects rather than as star trails. The negatives were then scanned and montaged to create a representation of Walker's original viewing experience.

Credit: © Chris Walker. *Ash Grove, Missouri, 2:15 A.M.*, 2006. 6¾ x 9½ inches. Inkjet and platinum palladium prints.

TABLE 7.2 Star Trail Exposures*

Moon	Exposure Time
No Moon	1½ hours minimum
Quarter Moon	1 hour
Half Moon	30 to 60 minutes
Full Moon	10 to 20 minutes

*Based on starting exposures at f/2.8, ISO 50 with camera on a tripod.

atmospheric effects, such as moonlight and star trails, can be achieved with exposures of about 30 minutes and up (see Table 7.2). Wide-angle focal lengths are recommended for increased coverage, and the location should be away from the light pollution of ambient sources. Consider including a foreground reference, such as a building or a tree, for scale and sense of place. For maximum star trails, make long exposures on clear, moonless nights. If the moon is too bright, the star trails will not be visible, and the image can begin to resemble daylight, although the light from the moving moon may fill in the shadows that would otherwise be cast by the sun in a daylight photograph.

DRAWING WITH LIGHT

Drawing with light offers the opportunity to create an illuminated artifice that has no direct reference to the natural world of light. Doing so requires setting the camera on a tripod with a medium to small lens aperture. Start with a subject against a simple backdrop in a darkened room. Prefocus the camera, as the autofocus may have problems in the dark. Use a small pocket flashlight or an LED flashlight with a blind (a piece of opaque paper wrapped around the flashlight a few inches over its lens) to control the amount and direction of the light. Leave the lens open (use the B setting with a locking cable release). By wearing dark clothes, you can quickly walk around within the picture and draw with the light without being recorded by the

FIGURE 7.12 In his series *Luminescence*, Michael Taylor creates futuristic, unearthly portraits using long exposures of 2 to 5 minutes to capture light emanating directly from his subjects. To control lighting, obscuring even the figures themselves, Taylor blacks out the studio. His subjects, wrapped in Electro Luminescent wire, create intense movement, painting the image with trails of light. "My aim is to let light reveal itself."

Credit: © Michael Taylor. *Flight*, from the series *Luminescence*, 2010. 24 x 36 inches. Inkjet print.

FIGURE 7.13 Michael Bosworth explains the premise of his project: "The origin of photography is of an image without a preserved record. The shadow is cast by 'the thing itself' within the moment. As expressed by Plato in *The Allegory of the Cave*, we experience unique relationships to the thing and to its image. Viewers' relationship to a recorded image is like that of looking out the rear window of a car and seeing the landscape recede into the distance. Time has that effect on the recorded image; it is continually moving away from us into the past. By presenting a document with an event, the effect for the viewer might be more like looking out the side window of a car into the window of another car traveling in the same direction in the next lane. For a moment, they can exist in parallel. Technically, the magic lantern projectors are built with simple lenses and a strong light source between which is placed an acrylic box containing a large-format black-and-white sheet of film and a water pump spraying liquid. The projections, seen as yellow reflections, are a combination of the image on the film with the movement of the water. The subject was a series of small-scale sets built inside aquariums and filmed through the glass walls. Colored dyes and forced air were used to create the scenes."

Credit: © Michael Bosworth. *Upstate*, 2014–2016. 64 x 36 x 18 inches. Video projection inside an aquarium filled with water.

sensor. Visualize how the light is being recorded. As the final effect is difficult to anticipate, use your monitor to review each exposure and make adjustments accordingly. Vary your hand gestures with the light source to see what *effects* you can generate. Experiment with different color balance modes, such as tungsten, to see their effect. Colored gels can be applied to any light source to alter its color output. The gels can be varied to introduce a variety of hues into the scene. As you gain experience, you can use more powerful light sources, such as strobes and floods, to cover larger areas, including outdoor scenes. Review your exposures as you go and fine-tune as needed.

PROJECTION

A digital projector or a slide projector with a zoom lens also can be used to paint a scene with light (by placing a colored gel or gels over the lens) or to project an image, images, or moving images onto a scene to create a visual layering effect. Try using old images, making new images of the same subject, combining black-and-white

and color images, appropriating images or text from other sources, projecting more than one image, projecting different images onto different parts of the composition, or varying the size of the projection. Amend your color balance according to the desired effect.

MULTIPLE IMAGES

Some multiple exposures are made in-camera (not all digital models permit this), but many are created later with post-exposure imaging software because it offers more control. There are many avenues for in-camera exploration that can make image processing easier or provide additional post-exposure options. With the idea of combining two images, photograph a subject in a controlled situation with a black background. Light the setup, mount the camera on a tripod, and calculate the exposure based on the number of exposures planned. A good starting point is to divide the exposure by the number of planned exposures. For example, if the normal exposure is f/8 at 1/125 second, two exposures would be f/8 at 1/60 second each. A camera with automatic exposure control can do the same thing by multiplying the ISO by the number of exposures and then resetting the ISO to that new speed or using the exposure compensation dial (–) to reduce the exposure.

For stimulus, look at Duane Michals's multiple exposure images to see what very simple planning can achieve.

To experiment with other ideas for making multiple images, try some of the following:

- Vary the amount of exposure time. This can give both blurred and sharp images as well as images of different intensity within one picture.
- Repeated firing of a flash provides multiple exposures when the camera shutter is left open on the T setting. Move the subject or the camera to avoid getting an image buildup at one place on the image sensor.

Drawing with light involves leaving the shutter open while illuminating your subject with a small pocket penlight or an LED flashlight or headlamp, with one or more light sources fitted with a handmade opaque blinder. The blinder acts as an aperture to control the amount of light. Practice with one object in a darkened room, and then try working with a subject that moves. Start by setting your aperture at f/11 and your white balance for incandescent, or create your own preset using a white object as a reference. Consider experimenting with transparent color material over the penlight. Review your results and make adjustments (see Exercise 7.2).

EXERCISE 7.2 MULTIPLE EXPOSURE

- Photograph an urban night scene in which the first exposure is made at just after sunset, to capture the color in the sky, and a second exposure after the sky is completely dark, to record the building lights.
- Make a close-up of the subject and double expose it with a broader view that brings environmental information into play.
- Make two exposures of exactly the same composition, but make one exposure sharp and the second exposure slightly out of focus.
- Make one or more exposures of a scene varying exposure time and aperture, and use imaging software to build a new picture.
- Overlay any subjects that have something in common, or images and text. For example, double expose a subject with a close-up of some key text about the subject.

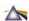

SANDWICHING/OVERLAPPING TRANSPARENCIES

A simple way to work with more than one image without using imaging software is to output images onto transparency material, which can be run through most printers. One can also use found images that were recorded on slide film, such as Kodachrome. These transparent images then can be overlapped and arranged in various combinations on a daylight-balanced lightbox. Also, by combining older images with contemporary pictures, one can combine, expand, and shrink time. Once selections are made, they are photographed, either full frame or cropped, using the camera's Close-up mode or with a macro lens. Transparent color tints can be added to modify the atmosphere. Tints can be made from any transparent medium or by photographing discrete portions of a subject, such as the sky or a wall. Bracketing provides a range of color choices, from supersaturated to high key. Review and fine-tune exposures as you work.

FIGURE 7.14 This image, one of hundreds made by overlapping transparencies on a lightbox and rephotographing them with a macro lens, was featured in the 9-foot *Unseen Terror Tower* fashioned from 1950s plastic *Girder and Panel* toy set pieces purchased on eBay. The tower's purpose is to evoke a dichotomous contrast between stability and fragility while offering an idiosyncratic micro and panoramic visual mini-history of 300 such invisible and innate cultural fears, using the atomic bomb as its focal point. This image was also featured in a collector's edition of *Atomic Playing Cards* and in an edition of *Atomic Calling Cards* with a nuclear fact printed on the back of each, which gallery visitors were encouraged to take as a project souvenir.

Credit: © Robert Hirsch. *Atomic Couple*, from the installation *Pluto's Cave—Unseen Terror: The Bomb and Other Bogeymen*, 2006. Variable dimensions. Digital file. Courtesy of CEPA Gallery, Buffalo, NY.

FIGURE 7.15

Credit: © Berenice Abbott. *Blossom Restaurant, Manhattan*, 1935. 8 x 10 inches. Gelatin silver print. Courtesy of the Museum of the City of New York.

REPHOTOGRAPHY

Rephotography is when a photographer returns to a previously photographed subject and attempts to make the exact picture again to show how time has altered the original scene. Precise records are maintained so the returning photographer can re-create the original scene. The original photograph and the new one are usually displayed side by side to allow a direct "then and now" comparison. A classic modern example is *Second View: The Rephotographic Survey Project* (1984), which, between 1977 and 1979, located and rephotographed over 100 sites of the U.S. government survey photographs of the late nineteenth century. A more recent example is Douglas Levere's project, *New York Changing* (2004), in which Levere rephotographed 114 images that Berenice Abbott originally made for her book *Changing*

New York (1939) to reveal the nature of urban transformation and to demonstrate that the only constant is change (see Figures 7.15 and 7.16). Scientific examples include work done by the U.S. Geological Survey that shows the effects of erosion and other geologic time-related phenomena.

Application of certain post-visualization methods can shatter the photographic cliché that time is a mirror and provide the freedom to personalize the depiction of time, enabling imagemakers to expand their *modi operandi* and explore new directions. These techniques can address the interaction between positive and negative space, the interface between different aspects of the same event, the relationships between static structure and movement, and the exchange between the viewer and the object being viewed. The results of using such methods make

FIGURE 7.16 Guided by Berenice Abbott's 1930s portrait of *Changing New York* (1939), Douglas Levere returned to the same locations at the same time of day and the same time of year, documenting the evolution of the metropolis. The paired images reveal much about the nature of urban transformation, suggesting that in New York, the only constant is change.

Credit: © Douglas Levere. *Everyware, CO., INC., Manhattan*, from the project *New York Changing*, 1998. 8 x 10 inches. Inkjet and gelatin silver prints.

clear that there is no such thing as objective vision, as too much subjectivity is involved in constructing and deciphering any image for it to have a single, fixed meaning.

In another form of rephotography, the photographer returns to the same subject over a period of time. Examples of this range from making a picture of oneself every day for a specific period of time to Alfred Stieglitz's photographs of Georgia O'Keeffe that span decades. The relationship of the photographer and the subject is pursued over a period of time. The results represent the wide range of visual possibilities that can be produced from this combination owing to changes in feeling, light, and mood.

The website www.historypin.com lets you upload photographs made outside and locate them on Google Maps and Google Street View, allowing you to visually compare the past with the present. It also permits you to upload your story about the image. Other artists use images from the Internet, such as Google Earth and Pinterest, as source material to build new works.

POST DOCUMENTARY APPROACH

Other artists employ what I call a "Post Documentary" approach, which operates in the space between art and documentary practice by utilizing existing photographs as a point of departure. From there, they actively inject their own interpretations, values, and creativity into the photographic process to expressively integrate the subjects' outer appearance with their subjective responses to it. The studio, instead of the street, becomes a creation site. As a photographer, one is no longer limited to

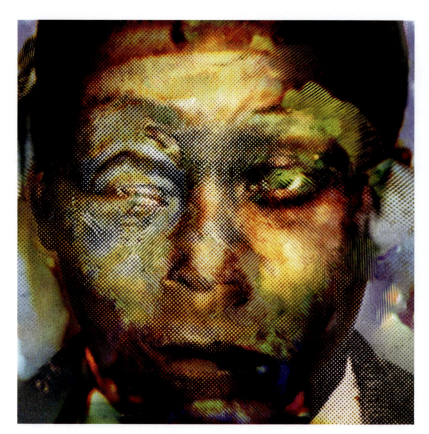

FIGURE 7.17 Utilizing the *Higgins Pocket Gallery, 1934*, produced by James W. Higgins, Buffalo police commissioner from 1934–1937, as source material, Hirsch rephotographed the tiny, poor-quality, black-and-white half-tone reproductions. In postproduction, his resulting image files were manipulated and synthetic colors were added. To make this image, five different mug shots were blended to make a new "suspect," which combined individuals of different ages, races, and sexes. In an age of increased surveillance, this fictional creation rebels against conventional time and space concepts to disrupt the original intent of being able to identify criminal suspects from a book of photographs.

Credit: © Robert Hirsch. *Mug Shot #39* from the series *Buffalo Rogues Gallery of 1934*, 2014. 20 x 30 inches. Inkjet print.

picturing only external realities. You are now free to create images that had once been considered to be beyond the realm of the photographic arts to capture.

Post Documentary practitioners consider art making as an adaptive, evolutionary process among and between artists, their work, and the world. They see it as a pragmatic model that acknowledges and reflects the premise that nothing is truly original and that our cultural heritage is founded on a practice of transformative art. It builds upon the photographic idea that we all start with something in front of our lenses and bring our own creative interpretations to it. The Post Documentary process, which has its origins in collage, pop art, and postmodernism, entails borrowing, sharing, re-borrowing, amending, cannibalizing, and morphing —the full range of ways new art learns from, builds on, and emerges out of the pre-existing archetypes. These makers think this is what defines the contemporary artist and drives cultural advances in the arts.

Post Documentary practice acknowledges and credits its source material's innate values while actively and constructively building upon the original documents to expand their meaning. On the other hand, appropriation artists, such as Richard Prince, typically make ironic comments on the original material to subvert the original intent and rarely credit the original source.

POST-CAMERA VISUALIZATION

There are a number of post-camera visualization options one may contemplate to assist the imagination in representing time and space. The digital studio offers an imagemaker a post-exposure opportunity to expand and induce movement and/or space and time into a subject. Many of these methods can be accomplished manually or with imaging software or using a combination of the two. Check with your imaging software for current technical steps.

SEQUENCES

A digital camera's capability to capture short bursts of sequential exposures in both single frame and continuous shooting modes plus 1080p HD video makes it an ideal tool to explore the realm of cinematic picturemaking. A vitality of movement can be conveyed through the use of still pictures linked together to form a cinematic sequence of events. This picture arrangement is designed not to function individually but to create a new order as a group. Here, each new frame implies a new episode, another step, a different perspective capable of transforming the representation and perception of photographic time. A good sequence is able to provide information that a single image is incapable of showing. Sequential imaging may be chronological or might skip around in time for the purpose of emphasizing the interaction among the objects within a composition in which the space between objects becomes part of the same structure that comprises the subjects. Serial arrangements encourage forms to take on new meaning as they visually reverse themselves, making for ambiguous figure-ground relationships. These temporal inter-relationships let sequences tell stories, present new information over an extended period of time, or supply different viewpoints. Comic books and graphic novels can be studied to see how they utilize sequential images for storytelling.

Sequences may take the form of visual allegory, in which situations are specifically constructed to be photographed. Duane Michals creates intriguing work in this genre by playing on the tension between the artifice of drama and photography's literalness. Extended sequences also may follow a close personal subject, such as Harry Callahan's images of his wife, Eleanor, or Emmet Gowin's extended family work in which viewers get to know Gowin's intimate world of close personal relations as exemplified in *The Photographer's Wife: Emmet Gowin's Photographs of Edith* (2006). Extended sequences also may pursue a concept, as in Larry Schwarm's "Seven Deadly Sins," which challenges his students at Emporia State University to interpret and illustrate philosophical ideas (see Exercise 7.3).

EXERCISE 7.3 SEVEN DEADLY SINS

Seven Seas, Seven Wonders of the Ancient World, Seven Days of the Week, Seven Dwarfs, Seven Sisters, Seven Falls, Seven Brides for Seven Brothers, House of Seven Gables, Seven Rays, Seven Virtues, Seven Years' War, Seven Chakras, Seventh Heaven, the number of holes in a Ritz cracker, and the Seven Deadly Sins!

In the sixth century, Pope Gregory the Great reduced the Greek list of the eight offenses to seven items, folding vainglory into pride and acedia into sadness and adding envy, and came up with this list of the sins: pride, envy, anger, sadness, avarice, gluttony, and lust. About ten centuries later, the Church replaced the vague sin of sadness with sloth. The list now reads gluttony, sloth, envy, avarice (excessive desire for wealth or gain—i.e., greed), temper, pride, and lust.

Make images that illustrate each of the seven deadly sins. These images are to be viewed as a group, so they need to have a similar style or some sort of thread that weaves the group together. You may interpret any way you want, but steer clear of clichés and formulaic representations that we have all seen too many times.

USING A GRID

A visual grid creates a uniform layout or pattern, like the lines on a map representing latitude and longitude, which divides an overall visual site into units and helps to determine a subject's location in time and space. Artists have utilized a grid made up of squares as a visual picturemaking aid since the Renaissance, but irregular shapes also may be used to evoke visual order. This network can act as a device to lead viewers through the details and visual relationships of your picture space. Gridded pictures invite audiences to spend more time looking because the sense of time is fluid and cannot be taken in all at once. Viewers must take numerous separate glimpses to build up a continuous experience, much as we see the actual world around us.

Photograph a subject so that the individual images collectively make a complete statement. Experiment with different shooting modes. If it is available, turn on the reference grid in your viewfinder to assist in aligning objects in your composition. The pictures do not have to be made from one particular vantage point but rather from a general point of view. Study how Cubist artists incorporated simultaneous multiple views of a subject into a single visual statement, and apply your observations to your own work. See if you can use this method to present your subject in a wider context. Notice if there is any change in the relationship of the subject and the background planes as they merge with one another. Does this create a new type of ambiguous, shallow space? If so, what effect does it have on how the subject is understood? Rely on your monitor for instant feedback. The actual image grid can be put together by manually cutting and pasting or through imaging software, which has greatly simplified the process of making picture grids. For inspiration, scrutinize Eadweard Muybridge's pioneering studies of human and animal locomotion involving grids.

MANY MAKE ONE

Many make one is the process of photographing a scene in numerous individual parts and then arranging these single sections of time together to form an image. The separate pictures of the original scene are made not from a specific vantage point but a general one that encompasses different points of view over an extended period of time.

Consider photographing from different angles and shifting the critical focus point to emphasize key aspects within each frame. Make prints at about 3 × 5 or 4 × 6 inches. Take all the prints and spread them out on a big piece of light gray or off-white mat board. The large size helps create impact from the sense of engagement that the ample space and the interaction among these multiple prints can produce. Start arranging prints into an entire image. It is fine to overlap pictures, discard others, and have open spaces and unusual angles. Don't crop the single pictures, as maintaining a standard size acts as a unifying device. When the arrangement is satisfactory, attach the prints to the board. They do not have to be flush.

This picturemaking method expands the sense of space and time that is often lost in an ordinary photograph. It breaks down the edges of a regular photograph and moves the frame beyond the conventional four perpendicular edges, which can bring the viewer right into the picture. These factors encourage viewers to spend more time investigating the overall image and its possible associations and connections. For inspiration, look at David Hockney's *Cameraworks* (1984) to see how an artist can weave hundreds of single images taken from different perspectives at different times to fabricate a new sense of time, space, and place.

CONTACT SHEET SEQUENCE

The contact sheet sequence is a modified technique of using many single contact-size images to make an extended visual statement. Pick a scene and imagine an invisible grid pattern in front of it. Photograph that scene using this invisible pattern as a guide. Use your imaging software to output a variety of contact sheets that you arrange in different sizes, spacing, rotation, columns, and rows to come up with an order that works with your aims. Eliminate any caption or metadata (text) below

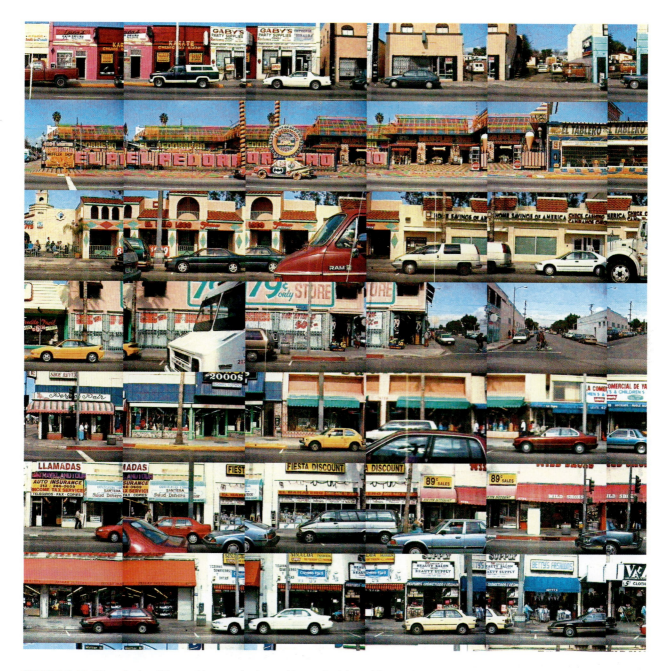

FIGURE 7.18 "Over the last 15 years I have evolved a working method that addresses the visual complexities and simultaneities of the Southern California metropolitan area. I videotape the city in long continuous sweeps from a moving vehicle, either by following predetermined trajectories or by systematically rendering parallel streets. From these tapes I select frames and construct large-scale digital photographic files. The resulting prints are a collection of visual textures and phenomena that capture the appearances of neighborhoods. This visual sampling, when woven together in consecutive frames and bands, plays on frequencies of occurrence to reveal conditions and to suggest possible contexts for interpretation. The sequences may be read from left to right and top to bottom, much like a Eurocentric text, or dealt with as isolated but related image clusters where the eye travels across the visual field, much like it does when approaching a painting. I try to find ways to invite viewers to scrutinize particulars—to look at details in different places at almost the same time and to establish relationships between them."

Credit: © Robbert Flick. *Along Whittier Boulevard* (detail), from *L.A. Document* series, 2006. 12 x 12 inches. Chromogenic color print. Courtesy of Rose Gallery, Santa Monica, CA.

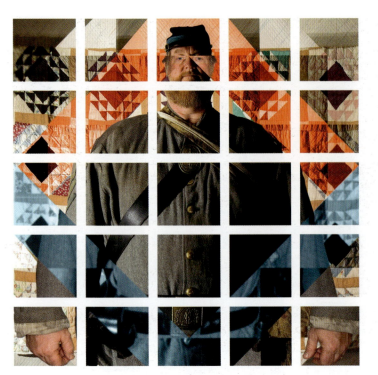

FIGURE 7.19 "These constructed portraits of Civil War re-enactors in Northern Virginia are inspired by Paul Cézanne's flattened portraits of the 1890s and David Hockney's composites of the 1980s. The formal qualities of the grid symbolize how our identities are composites. The push and pull of each plane symbolizes how our own time interacts with the past and also references the pixelation of modern imagery. Each image is composed of at least four images: a flat-light version of the subject; a contrast-light version of the subject; a flat-light version of the background; and a contrast-light version of the background. All four images are brought into one file and stacked atop each other using layers. I align the images using layers of low opacity. For the subject images, the background is removed using a mask and pen tool. A grid is created in Photoshop's Preferences menu, and each layer is masked to dynamically interact with the others."

Credit: © Shannon Ayres. *Reenactor 03*, 2006. 16 x 16 inches. Inkjet print.

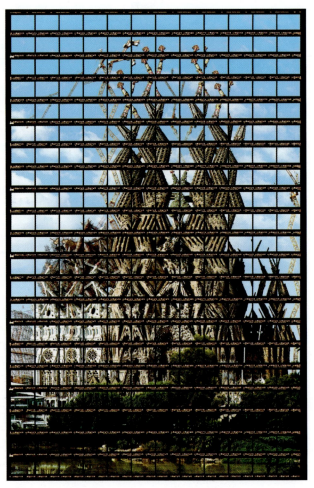

FIGURE 7.20 Thomas Kellner reconstructs the visual language of common architectural sights to present the shape of buildings and monuments in humorous and surprising ways. Influenced by photomontage and collage artists, such as George Grosz and Aleksandr Rodchenko, and the Cubistic works of Pablo Picasso and Robert Delaunay, Kellner's methodical style involves the precise, sequential photographing of individual fragments of his subjects. The resulting contact sheet, involving anywhere from 36 to 1,296 exposures, is printed in the same progression that the images were made to form the finished work.

Credit: © Thomas Kellner. *La Sagrada Familia, Barcelona*, 2003. 28 x 18 inches. Chromogenic color print. Courtesy of Cohen Amador Gallery, New York, NY.

FIGURE 7.21 Kathleen Pompe set out to re-create the sense of awe one feels while standing in front of a public aquarium's massive amount of blue water. "Additionally, I wanted to focus and refocus on several groups of jellyfish simultaneously through peripheral vision—left, then right—keeping the central image closest with the largest, sharpest jellyfish as the center of attention. To realize this, several aquarium shots were taken from various vantage points. The disparate segments were combined and arranged in Photoshop, taking care to keep the original, slightly dissimilar color density of each slice of time. The result reads not as one long image, but as discrete individual segments of time."

Credit: © Kathleen Pompe. *Jellyfish at Monterey*, 2006. 4½ x 18 inches. Inkjet print.

each image. If the contact sheet mode doesn't deliver the desired results, use your regular imaging software to create your own arrangement. If the white background isn't working for you, consider trying a custom background color.

JOINERS

Historically, joiners were used in nineteenth-century photographic practice to construct panoramas. More recently, David Hockney popularized the method and the term in the early 1980s. Joiners are created when two or more separate images of a scene are combined to make a whole. The subject can be divided into separate visual components and photographed individually, with the idea that each image should provide data about the subject that would not be possible if the subject were portrayed in a single frame. These additional exposures should alter how the subject is seen and therefore perceived. When making your images, pay attention to the following: your subject's relative position in time and space, changes in vantage point and angle, variations in subject-to-camera distance, and overlapping frames. Be sure to look up and down, and don't just pan/shoot in a straight line. Try photographing a moving subject showing the subject's movements as seen from the photographer's perspective, and then try moving the camera around the subject instead. Moving the camera in and around a subject tends to create a visual narrative as if a viewer is moving through the space. Make single prints, lay them out on a neutral-colored mat board, arrange, fit, and/or trim, and then attach into place or combine images using software to make a seamless rendition of time.

SLICES OF TIME

The slices-of-time method is when a single scene or event is photographed a number of separate times to display the visual changes that can occur over a period of time. Unlike in rephotography, the imagemaker often makes intentional alterations in light and placement of objects in each exposure. Consider photographing a scene with both stationary and moving objects so you can contrast the underlying patterns and rhythms of physical motion.

Prints can be butted together, overlapped, or cut into slices and pieced together. With practice, you may cut the pieces into a variety of sizes and shapes. Keep each cut picture separate. Select one of the pictures to be the anchor print. Arrange it on a neutral-colored mat board and begin to combine the slices from the other prints into the single base print. When the image is complete, attach the slices to the board. Check out the sliced-up

FIGURE 7.22 In one long panorama, *The Apollo Prophecies* threads the line between fantasy and history by depicting an imagined expedition of American astronauts who land on the moon. Portrayed by the artists, they discover a lost mission of Edwardian-era, steampunk-dressed space travelers who greet them as long-awaited gods. The inventively staged scroll of events that never happened playfully questions the concept of historical truth, as continuously joined images unfold into multiple episodes that mix H. G. Wells and Stanley Kubrick, intermingling artifacts from early twentieth-century exploration with space age gadgetry.

Credit: © Nicholas Kahn and Richard Selesnick. *Lunar Landing* (detail), from *The Apollo Prophecies*, 2004. 10 x 72 inches. Inkjet print. Courtesy of Yancey Richardson Gallery, New York, NY.

EXERCISE 7.4 PHOTOMONTAGE AND COMPOUND IMAGES

Both photomontage and compound images offer numerous opportunities to produce pictures of astonishing juxtaposition and paradox, utilizing both manual and digital techniques. Explore a theme, instead of a single subject, in which the overall collection of images provides an extended and deeper examination of a topic. Keep in mind two- and three-dimensional materials that can be incorporated into your picture space through scanning. Think about experimenting with three-dimensional surfaces and/or nontraditional support materials and combining physical and digital methods.

Polaroid images made by Lucas Samaras for inspiration. The process also can be done virtually, using imaging software.

PHOTOMONTAGE AND COMPOUND IMAGES

During the 1930s, Berlin Dadaist John Heartfield produced over 200 anti-Nazi and anti-conservative photomontages that were designed to be reproduced in newspapers and magazines, thus embodying the artist as an activist for social change. If an assembled image is rephotographed and outputted, it is considered photomontage. Compound images are made up of visual elements from various media sources and text, which are digitally intertwined, fused together, and outputted to into a final image (see Exercise 7.4).

FIGURE 7.23 "I photograph knowing I am preparing a subject for compositing, which means providing myself with numerous visual options. The montages provide a space for a greater degree of metaphorical interpretation of the Underground Railroad sites, with use of period artifacts and documents as well as contemporary references. My goal is to comment on this complex history and provide an alternative access through a recontextualization strategy that invites questions and discoveries. The faces of two women covered with braided hair flank the crawlspace hideaway portal and the donor walkway title stone at the home of Underground Railroad conductor Levi Coffin in Fountain City, IN. The entry, layered with the running man figure (taken from the tombstone of William Bush, a runaway who became Coffin's assistant), opens onto the 'stairway to freedom,' leading through the woods up to the Rankin House in Ripley, OH. The forest and stream on the sides of the montage are in Lancaster, IN, near the hideaway cave used by Lyman Hoyt, another conductor who helped to provide shelter and safe passage for freedom seekers."

Credit: © Stephen Marc. *Untitled*, from the *Passage on the Underground Railroad Project*, 2005. 18 x 52 inches. Inkjet print.

PHOTOGRAPHIC COLLAGE

Folk artists regularly combined different media, but it wasn't until the early twentieth century, when the Cubists integrated other materials, such as newspapers and sand, into their paintings, that the method was named *collage*—French for gluing—and came to be recognized as a legitimate art form. Later the Surrealists, including Max Ernst and Hannah Höch, made extensive use of collage because they viewed it as a way to liberate the unconscious mind and attain a state that is "more than" and, ultimately, "truer than" everyday reality: the "sur-real," or "more than real."

A photographic collage is made when cut or torn pieces from one or more photographs are pasted together, often with three-dimensional objects, to produce a final picture. It is not rephotographed, and no attempt is made to hide the fact that it is a highly textured assemblage. Now, this practice can be performed digitally or manually, or using some combination of both, with or without a sense of a three-dimensional surface. Electronic collages, often built up through multiple layers, can be useful to supplement a reconstruction wherever authentic visual material is not available to produce convincing-looking fake pictures. Consider making what the Surrealists called *inimage*, a collage method in which parts are cut away from an existing image to reveal another image. The Surrealists also invented *cubomania*, where an image is cut into squares and the squares are then reassembled "automatically" without regard for the new image, or at random.

THREE-DIMENSIONAL IMAGES: PHYSICAL AND VIRTUAL

Artists have purposefully introduced three-dimensional texture into media that were once considered exclusively two dimensional. Three-dimensional images are often made by emphasizing one attribute of a subject—color, pattern, shape, or texture—and having

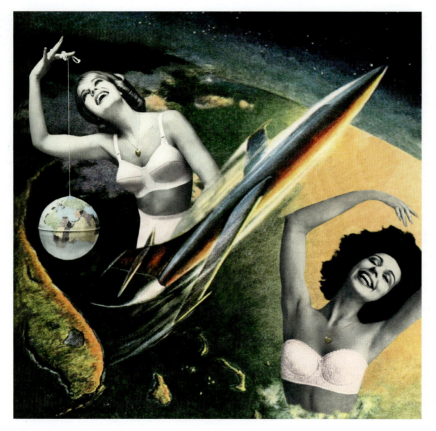

FIGURE 7.24 Nadine Boughton's emphasis is on gender polarities as depicted in popular magazines of the 1950s and early 1960s. Boughton exclaims: "My vision and concept was to have these worlds collide. My intention is to deconstruct these images, creating narratives of ambiguity with humor and a dark edge, and revealing some of the different relationships men and women have to power, beauty, and longing. The images play with the convergence of interior and exterior domains, abstract ideas, and the mystery of the female form. The women are from domestic settings, juxtaposed with the men from *Fortune* magazine that depicts power and big ideas, in this case space travel. This series is also a homage both to the handsome men in *Fortune* who look like all the fathers I watched in their big suits and briefcases, carpooling to a foreign land; and to the community of mothers who served egg salad sandwiches on the green lawns of suburbia."

Credit: © Nadine Boughton. *Cape Canaveral*, from the series *Fortune and the Feminine*, 2016. 15 x 15 inches. Inkjet print. Courtesy of the Trident Gallery, Gloucester, MA.

it physically come off the flat picture surface. This exaggeration in time and space calls attention to that aspect of the subject while de-emphasizing its other qualities.

Other artists employ physical processes, such as *lithophanes*, which are three-dimensional translucent porcelain casts that when backlit reveal detailed images.

Sequential images can also be used with special imaging software, such as Photo-synth, to create the illusion of three-dimensional space similar to the effect of viewing stereo images. These programs utilize a series of photographs of an object or place, analyze them for similarities, and display them in a reconstructed three-dimensional space. Such reconstructions allow you to visually fly or walk through a scene at any angle and zoom in or out of it. In *Landscapes Without Memory* (2005), Joan Fontcuberta, using a landscape-rendering software program, took the contours and tones of pictures by Paul Cézanne, J. M. W. Turner, Edward Weston, and others and transformed them into three-dimensional clouds, mountains, rivers, and valleys that serve as the basis for new fantastical landscapes devoid of human existence.

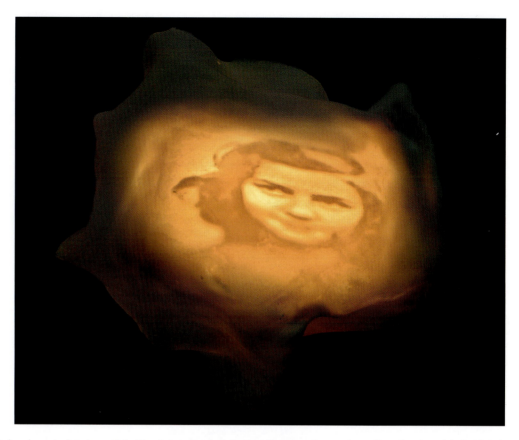

FIGURE 7.25 This backlit, hand manipulated porcelain lithophane was made by Tom Carpenter from a three-dimensional model of a digital image from Robert Hirsch's project *Ghosts: French Holocaust Children* (2016). Its physicality invites touch and thereby challenges the simulated virtual world by involving viewers with its concrete existence.

Credit: © Tom Carpenter. *Ghost*, 2017. 6 x 8 x 2 inches. Lithophane.

IMAGE-BASED INSTALLATIONS

Image-based installations comprise an entire arrangement of objects presented as a single piece rather than a group of discrete images/objects to be viewed as individual works. Installations provide viewers with the experience of being in and/or surrounded by the work, often for the purpose of creating a more intensely personal sensory realization that can feature still and moving images, computer screens, music, sound, performance, and the Internet. Instead of framed pictures on a "neutral" wall or individual objects displayed on pedestals, installations address an audience's complete sensory experience, leaving time and space as the only dimensional constants. Traditional image theory is disregarded, and viewers are "installed" into an artificial environment that optimizes their direct subjective perceptions. Some installations are site-specific, designed to exist only in the space for which they were created. The majority of installations are not salable and generally are exhibited and dismantled, leaving only photographic documentation as a record of their existence.

Precedents for installations can be found in the pop art era of the late 1950s and 1960s, such as Allan Kaprow's "sets" for happenings (temporarily transformed indoor spaces) or Red Groom's theatrical environments, such as *Ruckus Manhattan* (1975). Topical examples include Christo and Jeanne-Claude's *The Gates* (2005) in New York's Central Park and Alvaro

Cassinelli's *The Khronos Projector* (2005), "a video time-warping machine with a tangible deformable screen for untying space-time," which permits temporal control by allowing viewers to touch the projection screen to send parts of the image forward or backward in time (http://alvacassinelli.com/wp/2015/08/17/khronos-projector-2/).

PUBLIC ART

Art history has many examples of public rather than private art, ranging from the frescoes and sculpture of religious centers to the commemorative statuary found in our public squares. Traditionally, public art refers to works in any medium that have been planned and

FIGURE 7.26 *The Strange Loop You Are* is based on Doug and Mike Starn's *Big Bambú: 5,000 Arms to Hold You* that was installed on the roof of the Metropolitan Museum in New York. The undertaking represents an evolution from their earlier photographic work that was based on their cutting and attaching small pieces of images to make new connections. Now, instead of Scotch tape and staples that the Starns once employed in their photographic work, they use bamboo and nylon rope. Mike Starn explains: "The concept of *Big Bambú* has nothing to do with bamboo; it represents the invisible architecture of life and living things. Between structure and sculpture, *Big Bambú* grew and developed over time as a living organism, embodying the tension between order and chaos, and reflecting the constantly changing realities of nature, social constructs, and culture . . . It is at those intersections where all the activity happens and something gets made." The original Israel Museum version, within which people could physically interact consisted of 10,000 bamboo poles and 262,467 feet of climbing rope, which took 25 rock climbers 7 weeks and 350 hours, without using any architectural sketches to construct.

Credit: © Doug and Mike Starn. *The Strange Loop You Are*, 2015. 34 x 16 feet. Diameter, bamboo poles and climbing ropes. Courtesy Israel Museum, Jerusalem, Permanent installation.

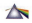

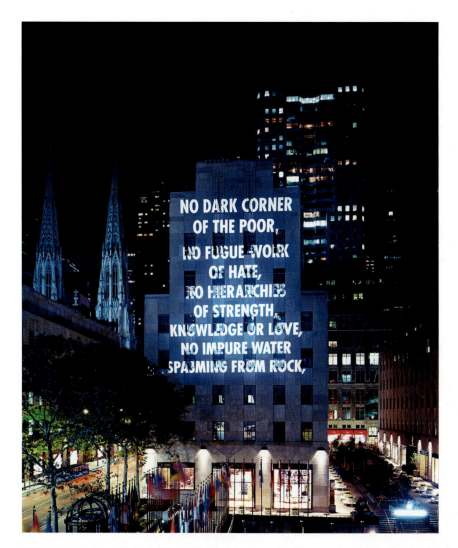

FIGURE 7.27 Jenny Holzer's light projections of poems detail hope, pain, and longing that fuse illumination and location and come from her belief that problems, especially those where the political and the personal are inseparable, must be attended to with openness and equanimity. The moving projections, akin to credits scrolling at the end of a film, allow Holzer to work demonstratively with the ephemeral. The cityscape and surrounding architecture are involved; spaces, people, and time are included in an affirming gesture. "I show what I can with words in light and motion in a chosen place, and when I envelop the time needed, the space around, the noise, smells, the people looking at one another and everything before them, I have given what I know." The lines from a Henri Cole poem "Necessary and Impossible" read: "no dark corner of the poor, no fugue-work of hate, no hierarchies of strength, knowledge or love, no impure water spasming from rock, . . ."

Credit: © Jenny Holzer. *For the City*, 2005. Projection on Rockefeller Center, New York. Presented by Creative Time, New York, NY. Photo by Attilio Maranzano. © 2003 by Henri Cole. Used/reprinted with permission of Farrar, Straus & Giroux. Courtesy of Artists Rights Society (ARS), New York, NY. Text: "Necessary and Impossible," from *Middle Earth* by Henri Cole.

executed with implications of community collaboration and involvement, for the specific intention of being sited or staged in the public domain, usually outside and accessible to all. Public art is not limited to physical objects; dance, poetry, and street theater have practitioners who concentrate on public art.

The dissolving of modernist notions of purity of form and the rise of government initiatives, such as the percent-for-art programs that require a certain percentage (usually 1 percent) of construction budgets for artists' projects in public spaces, have sparked interest in this area. A combination of changing attitudes by

artists willing to forgo the absolute control of the studio and new technologies has made it easier to bring artworks outside the traditional context of museums and galleries and into daily life. Work is shown in public spaces, such as transportation centers, city streets, and workplaces, breaking down barriers of accessibility to contemporary art. Part of the fun and power of public art is its ability to enter into everyday life and catch its audience by surprise, often momentarily disrupting the status quo.

Projects such as Robert Smithson's *Spiral Jetty* (1970), which reacts to and incorporates its environment, use the freedom of an outdoor site to create large works that would be unfeasible in a gallery. *Spiral Jetty* is a 1,500-foot-long; 6,500-ton; spiral-shaped configuration made up of basalt, earth, and salt that extends into Utah's Great Salt Lake, addressing the theme of entropy and time. The temporal nature of the work is demonstrated by the fact that the fluctuating water level of the lake often submerges it and will obliterate it over time.

Although technically not public art, many exhibition centers are taking a cue from this genre to commission artists to make work designed specifically to be exhibited in public spaces. For recent examples, visit www.creativetime.org, whose specialty is commissioning, producing, and presenting adventurous, temporary public artworks of all disciplines throughout New York City.

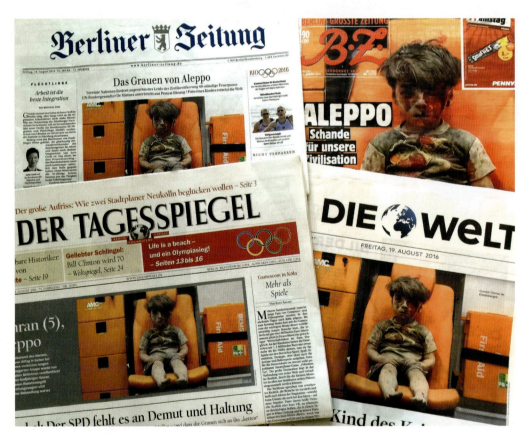

FIGURE 7.28 This child was reportedly rescued in the aftermath of an apparent Syrian government or Russian airstrike in a rebel-held neighborhood of Aleppo, Syria, which for years has been a battleground between government and opposition forces. Critic Michael Kimmelman observed that such images "are bearing witness, in real time, refusing to disappear without a trace. And in this era of connectedness, they are refusing to let us off the hook."[1]

Credit: Newspaper front pages of *The Boy in the Ambulance*, August 17, 2016. Video grab. Courtesy of Mahmoud Raslan and the Aleppo Media Center, http://time.com/4456905/aleppo-syria-boy-ambulance/?xid=newsletter-photos-weekly

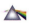

EXERCISE 7.5 IMAGING SOFTWARE SOLUTIONS

After you have exhausted the camera-based methods, try some of the countless ways to use imaging software to manipulate a picture's time and space relationships. The following are offered as starting suggestions.

Using your imaging software, create a multilayered image based on a single exposure to alter the perception of time within the picture. Many variations are conceivable. For example:

- Reduce the size of the picture and layer it a number of times to form a single image. Let parts of each picture overlap to form new images.
- Vary the size of the picture through a series of layers.
- Deconstruct an image into virtual pieces and reassemble into a new image.
- Generate a variety of different picture densities.
- Produce a full-frame layer and then start cropping pieces of the image and adding layers based on the different pieces.

Combination printing—compositing multiple scenes to form a new one—dates back to the early days of photography, perhaps most famously in O.G. Rejlander's *Two Ways of Life* (1857), which jettisons the traditional picture vision and embraces a far more complex image of reality. This technique is easily facilitated with imaging software.

Examine the work of Étienne-Jules Marey and then use your software to record several phases of a moving subject into a single photograph.

Changing the color balance can transform the picture's sense of time. Start with a scene that contains a basically monochromatic color scheme and simple linear composition. Mask one area of the picture with the normal color balance, and then alter the color balance and use that for the remainder of the image. Consider working with complementary colors. Also, look for situations where you can blend black and white with color.

Experiment and see what else you can come up with.

SOCIAL MEDIA

Traditional media—magazines, newspapers, radio, and television—are a one-way street where you can only read and/or listen. Today's social media are online communal spaces that provide interactive networking possibilities to anyone with Internet access. This capability to share images, music, text, and videos in real time allows one to become a participant who could affect the outcome. The most popular sites, such as Facebook, Flickr, Twitter, and YouTube, have become enormous virtual public squares that artists mine to critique how interconnectivity is affecting our culture. A recent example of this phenomenon is Paolo Cirio and Alessandro Ludovico's *Face to Facebook* (2011) project in which they grabbed one million Facebook profile pictures and grouped them by facial expression to construct a mock dating website (www.face-to-facebook.net). Artists are also utilizing social media to fund and promote projects. In turn, their work becomes source material for future online exploration. Additionally, an image can become supercharged when it goes viral on social media, propelling a story into the public eye in a way that was not previously possible.

FIGURE 7.29 Robin Michals explores the gap between daily domestic life and scientific knowledge. Sequential photographs of moldering bread are used to create representations of the planets and solar system. "The photographs take the form of an amateur science experiment, documenting bread as it transforms from food into rot. Each sequence of images is then divided into about 2,000 75-pixel squares. By cutting and pasting, these squares are then rearranged by color and tone to form a new image. The process echoes that of space imaging systems that take many photographs and assemble them in a grid to form one image. Although identical on the pixel level, the images simultaneously represent the everyday world that is grounded in direct observation of the visible and the world of science where complex instruments and calculations yield knowledge of the invisible while reminding us that these two worlds have never been so far apart."

Credit: © Robin Michals. *Jupiter*, from the series *Daily Bread*, 2004. 22 x 37 inches. Inkjet print.

RECOMPOSING REALITY

Being able to appreciate nontraditional approaches to photographic time and space entails a willingness to set aside previous notions about how a photograph is supposed to look. Whenever traveling into the unknown, we can hope to be rewarded with understanding, though this is not always the case. Ironically, the information that is brought with you may prove to be invalid in new circumstances or may generate more questions than answers. The reason is that time is something we cannot completely understand and is far from our control, as it is dualistic in nature and can both destroy and preserve. Be prepared to expand your previous concepts of how reality can be represented and see where it takes you.

Many of life's important aspects are hidden from us because of their familiarity and our own predeterminations and lack of knowledge. When a city dweller walks by a garden with plantings in it, the urbanite sees a garden with stuff growing in it. When a gardener walks by the same plot, he or she sees something completely different. The gardener can identify the types of plants, what condition they are in, whether they are being properly cared for, or whether they need attention. Both pedestrians view the same scene, but a broader

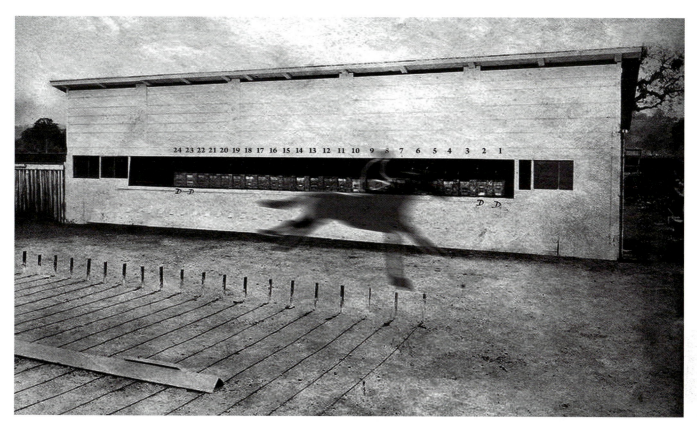

FIGURE 7.30 Eadweard Muybridge's timeline setup for photographing a running horse, circa 1880. The horse has been added to illustrate the motion path.

knowledge and understanding of what is there allows the gardener to read more visual clues. This provides the gardener with a more complete and richer account of the scene. By extending our picturemaking endeavors and knowledge, we can create new ways of looking at the world and enlarging our understanding of its complex interactions.

TIMELINE ANIMATION

Eadweard Muybridge created the first stop-motion timeline by horizontally lining cameras along the track where a horse would run (see Figure 7.30). As the horse raced by each camera, a tripwire triggered its shutter, capturing a series of stills of the animal in motion. This setup realized its goal, which was to scientifically prove that at some point a galloping horse has all four feet off the ground (see Figure 7.31).

Muybridge would go on to photograph and publish hundreds of plates with timelines of animals and humans in motion.

Muybridge's method of photographing selected moments of time over a given distance makes him a progenitor of motion pictures as well as all digital video and animation software programs. Drawing on Muybridge's work, Thomas Edison developed the first motion picture camera with fast shutter speeds and the ability to capture still images onto flexible roll film developed by George Eastman. Today, Photoshop's Timeline Animation allows you to give a sequence of still photographs the illusion of movement, in a manner similar to that expressed on the zoopraxiscope, a projection device invented by Muybridge. Additionally, GIFs (Graphic Interchange Format) can be employed to construct brief, simple, Web animations.

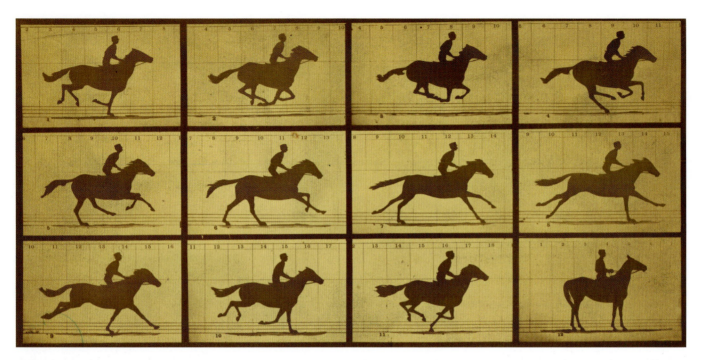

FIGURE 7.31 Eadweard Muybridge. *Galloping Horse, Motion Study—Sallie Gardner*, owned by Leland Stanford, running at a 1.40 gait over the Palo Alto track, June 19, 1878. 9⁹⁄₁₆ x 12 inches. Albumen silver print.

Credit: Courtesy Library of Congress Prints and Photographs Division, Washington, D.C., LC-DIG-ppmsca-2377.

GETTING STARTED: MAKING YOUR TIMELINE ANIMATION

First, you need to search for a current tutorial using keywords such as stop-motion animation and Photoshop with your current Photoshop version, which will likely deliver numerous choices. A simple one to start with is from Adobe's education exchange, a step-by-step guide to how to create a digital story with stop-motion animation at https://edex.adobe.com/resource/2600c-74/. This Adobe tutorial is recommended because of its simplicity and is part of Adobe's education exchange, which will assure its accessibility over the long term.

Stop-motion animation in Photoshop requires a basic familiarity with the program, and these tutorials will always start with this first step: Go to Window in the top menu bar and select the Muybridge-inspired timeline (see Figure 7.32: Selecting Timeline Animation). Once enabled this will turn on the timeline features, and you can begin the stop-motion animation tutorial of your choosing.

This section provides an introduction to creating a timeline animation. To begin, you will make 16 still photographs that clearly show how a subject changes in time and space. Do not think about making *movies*, but concentrate on making sequential *still images*. After choosing a subject, your next decision is whether to handhold your camera or use a tripod, as each will produce a different look.

Handholding a camera will produce a sporadic fluidity to the image sequence. Here, the emphasis is on how your main subject looks different with changes in angle, background, and lighting. For example, select a person and pay close attention to the framing of the first image and then repeat that compositional look throughout an image sequence of the same person in different locations. Although many DSLRs have a Continuous Mode capable of capturing up to 12 frames per second, this option is not recommended because the changes from frame to frame will be minimal, similar to watching 1 second of a conventional movie in slow

FIGURE 7.32 Selecting Timeline Animation.

FIGURE 7.33
Photoshop's Stop-Motion Interface.

motion, which results in no real changes. Instead, vary the length of time between exposures from at least a few minutes to an hour or more, which will allow you to fully explore the Timeline Animation features.

When using a tripod, the emphasis is on precision placement of your subject over time. For example, make an architectural study of 16 homes, from the nineteenth to the twenty-first century, by photographing their entryways as the dominant visual element. Each photograph should be precisely framed to create a meticulous transition from image to image that conveys a sense of flowing time.

Again, do not think about photographing a movie in the conventional sense of footage that is a continuous flow of time and place. Utilize either of the capture approaches and concentrate on making a sequence of related yet individual still images.

Preparing the Still-Image Files

Follow the guidelines your tutorial set up for you, some based on anywhere from 12 to 24 images. This section will cover making a 16 still-image movie, and most tutorials will show how to add sound. Each still image will appear for 1 second, thus producing a 12- to 24-second movie. Begin by making all your files the same size, resolution, and file type. Keep your file sizes small. Start with JPEG files having a resolution of 72 PPI and pixel dimensions around 576 × 720 pixels, which is the 8 × 10-inch document size format. Regardless of resolution or document size, keep your file size between 300 and 1,000 kilobytes. Smaller files are preferable to large files since you have no control over bandwidth or the speed of the computer your still movie will be seen on.

FIGURE 7.34 Is seeing believing? The core concept of the *ON-AIR Project* is that every single being in the universe will eventually disappear. Here, Kim digitally superimposed eight different images of Sacheongwangsang, who guards the entrance of a Korean Buddhist temple, so that they are subsumed within a new, composite image that represents a form of disappearance or an identity suggesting that it is possible for us to perceive the passage of time in radically different ways.

Credit: © Atta Kim. *Sacheongwangsang, 8 Buddhas*, from *ON-AIR Project*, 2003. 74 x 92 inches. Chromogenic color print.

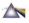

The timeline animation generates a movie from layers containing image stills. The short stop-action movie should have a distinct beginning and end. The first image in your sequence should be assigned a file name that includes 016, for example, filename016.jpg. The next file name should include 001: filename001.jpg—and so on, until you have counted down to 016 and assigned it to the final image in your sequence. For creative purposes, you can later move individual still-image files around, as long as you rename them in the proper sequential numbering order.

Timeline animation movie options are reminiscent of the old Walt Disney–style, hand-drawn, single cell animation method. Use your Photoshop skills to adjust the color and to add or subtract elements from your still images to expresses the passage of time.

NOTE

1. Michael Kimmelman, "They keep coming, both the bombs and the images from Aleppo . . ." (*New York Times*, December 14, 2016) http://www.nytimes.com/interactive/2016/12/14/world/middleeast/kimmelman-images-of-aleppo.html?emc=edit_ne_20161215&nl=evening-briefing&nlid=15316572&te=1

REFERENCES

For information concerning time and space, see the following:

Brookman, Philip, et al. *Helios: Eadweard Muybridge in a Time of Change*. Göttingen, Germany/Washington, DC: Steidl/Corcoran Gallery of Art, 2010.

Eisner, Will. *Comics and Sequential Art: Principles and Practices from the Legendary Cartoonist*. New York: W. W. Norton, 2008.

Gleick, James. *Faster: The Acceleration of Just About Everything*. New York: Pantheon, 1999.

Goldsworthy, Andy. *Time*. New York: Harry N. Abrams, 2000.

Hawking, Stephen. *A Briefer History of Time*. New York: Bantam, 2005.

Hawking, Stephen and Roger Penrose. *The Nature of Space and Time*, Revised Edition. Princeton: Princeton University Press, 2015.

Hockney, David, with Lawrence Weschler. *Cameraworks*. New York: Alfred A. Knopf, 1984.

Klett, Mark. *Third Views, Second Sights: A Rephotographic Survey of the American West*. Edited by W. L. Fox. Albuquerque: Museum of New Mexico Press, 2004.

Morris, Richard. *Time's Arrows: Scientific Attitudes Toward Time*. New York: Simon and Schuster, 1985.

Owen, Edgar L. *Understanding Time: What It Is and How It Works*. Paperback. CreateSpace Independent Publishing Platform, 2016.

Sheldon, James L. and Jock Reynolds. *Motion and Document, Sequence and Time: Eadweard Muybridge and Contemporary American Photography*. Andover, MA: Addison Gallery of American Art, Phillips Academy, 1991.

Digital Studio: The Virtual and the Material Worlds

THE MEGAPIXEL MYTH

The megapixel myth, started as a marketing tool by camera manufacturers, implies that the more megapixels a camera sensor (a.k.a. the chip) has, the greater the picture quality. This is no longer the case, as existing technology has reached a point of diminishing megapixel returns (see Chapter 3, "Visual Acuity and 300 DPI"). Now, even ordinary smartphone cameras can generate a good-quality 8 × 10-inch print or larger. Megapixels are no longer the determining factor in an image, unless you intend to make very large prints.

The key factors you can control that affect image quality are (1) holding the camera still; (2) using a moderate ISO in the 100–400 range and not using an extreme ISO, such as 3200; (3) proper exposure using the fastest shutter speed possible for the prevailing lighting conditions; (4) selecting the proper camera image functions, such as file format, image size, resolution settings, color balance, and sharpening; (5) scaling a picture file properly. Therefore, image quality depends on using one's photographic knowledge to make the appropriate decisions when setting camera controls, rather than the number of camera megapixels.

PIXEL SIZE MATTERS

Now that the majority of cameras have enough megapixels to produce excellent results in most situations, the three internal components that now effect image quality are sensor size, lens quality, camera software. Image sensor dimensions matter because it is their size that determines image quality. An average smartphone camera has a 4 × 6 mm chip. Technology can squeeze 40 megapixels within this space. However, it has a disadvantage when compared to a full frame 24 × 36 mm sensor whose overall surface area is dramatically bigger. As a result, a larger chip will accommodate larger individual pixels. This translates into improved detail, enhanced sharpness, smoother

FIGURE 8.0 Edward Bateman says: "My greatest challenge was finding a concept where I could depict something in our contemporary technological world that could be plausibly shifted into a Victorian time. It also needed to comment on my working method of combining actual historical documents with technologically constructed image elements. Three-dimensional printing draws upon the same tool set that I use, and is beginning to be used in a number of novel ways, including biological fabrication. In this work, every dog is linked to a piece of paper, as a way to suggest that these dogs are actually made of information (and to hint at the pun that these dogs are 'papered'—pure-bred in a truly immaculate conception). For me, working with symbols and their various meanings is the justification for constructing an image. I frequently present these works as historical facts (even though I will often include anachronistic references as a wink to the sharp-eyed viewer). This reminds me that history is constructed and may be just as valid (and malleable) as any other material for an artist to explore."

Credit: © Edward Bateman. Dog Printer, 2014. 13½ x 9 inches. Inkjet print.

color and tonal transitions, better low-light performance, and a greater dynamic range (the ratio between the maximum and minimum measurable light intensities—i.e., greatest recordable ratio between black and white).

Also, smaller sensor sizes require the lenses to be of much higher quality to be able to resolve the finest details in the captured scene. This is seldom the case with smartphone cameras, where the lens designs are not as sophisticated as those in a DSLR. Most camera phones have wide-angle lenses with a digital zoom feature, but this is not the same as having a true, optical zoom lens. When you zoom in using a camera phone, you are simply cropping your image, which is another way of saying that you are reducing the resolution of your image.

FIGURE 8.1 Sensor pixel array of a digital camera (pixel size is not representational).

DISPLAYING THE IMAGE FILE: SCREEN OR PRINT

The act of photographing is a human practice that merges scientific technology and pictorial conventions with personal values, along with a desire to tell and share a visual account or story. Digital imaging not only makes picturemaking and viewing instantaneous, but also makes picture distribution simpler and quicker by expanding the possibilities of how images can be outputted and circulated. A digital camera sensor creates images as an arrangement of pixels (see Chapter 3). The chips themselves do not have pixels; rather, they create pixels from the data collected from the sensors on the chip. The smallest electronic elements used to record light, the photosites are part of a larger camera sensor array (see Figure 8.1). The number of pixels that an

image sensor records is measured in megapixels, with 1 million pixels equaling one megapixel. For example, a camera with a chip array that creates 4,800 (h) × 6,000 (w) picture elements (pixels) would be rated at 28 megapixels (4,800 × 6,000 = 28,800,000 pixels). You can calculate the data size of an uncompressed image file by multiplying the megapixel size by three. For example, a 12-megapixel camera will create a 36-megabyte file (that would be compressed as a JPEG image).

PIXELS PER INCH (PPI) AND DOTS PER INCH (DPI)

The resolution of a digital file is designated in pixels per inch (PPI). After the image files are downloaded to a computer, the computer's internal video processor automatically converts the image files into display

BOX 8.1 PPI, DP, AND DPI FUNCTIONS

PPI (pixels per inch) = Input—Camera and scanner capture display pixel measurements

DP (dot pitch) = Computer display

DPI (dots per inch) = Output (printed material)

pixels that are shown in varying percentages of the original picture file. Only when you are at a screen resolution of 100 percent will you see one pixel of image data represented by one screen pixel. At 50 percent, four pixels are averaged together to create one screen pixel, the lesson being that to accurately see the details in your image, you must zoom in.

When you want to utilize this digital data to make a print, the computer's printer software then converts the digital image file into dots per inch (DPI), enabling the virtual image to be physically rendered onto paper by means of dots of ink (see Box 8.1). It is important to clearly understand the differences between PPI and DPI, which will be discussed in detail later in this chapter.

Viewing The Image File: Life to Print, *pictures exaggerated*

Life	Camera File	Display Resolution	Web	Print
Rods and Cones	Pixels Per Inch, PPI.	Dot Pitch, DP.	Pixels Per Inch, PPI.	Dots per inch, DPI.
Since 1839 photography has enabled people to capture what their eyes and brain can see, making image-making an integral part of our daily lives. Digitalization has vastly expanded the possibilities for making and deploying images worldwide.	Digital camera software allows variable settings, Large, Medium, and Small, for PPI. The higher the PPI setting (Large) the bigger the image appears on the display and the larger the file size.	Each triad of RGB elements represents more than one pixel from the camera file. Computer displays also support more than one display PPI setting. Higher PPI settings translate into display information appearing smaller on the screen.	Image management software accurately controls display image size by PPI only and never by inches. The proper solution for accurate sizing of digital files for the web or display is to use Pixels Per Inch, PPI.	Printing software converts PPI (pixels) into DPI (dots) for printing. Printing requires the physical application of ink on to a receiving surface such as paper. Printers produce thousands of dots of different colors, shapes, and sizes.

> Pixels Per Inch, PPI is a universal measurement of the number of pixel elements refering to the width and height of all digital information. Picture files, digital files, digital cameras or display resolution refers only to the number of pixels, **not** the size of each pixel. The actual size of each pixel is determined by the recording or display device. 640 (H) x 480 (W) is only the number of pixels used by each device and is not an exact measurement in inches.

FIGURE 8.2 Viewing the Image File: Life to Print, pictures exaggerated.

For example, using a camera's image size setting of Small (S) on a 20-megapixel (MP) digital camera will produce a file that is about five megapixels. This Small image setting would still be quite large when viewed on a display set at a standard resolution of 768 × 1024. It would completely fill the display, and you could not see the entire image without using the scrolling sidebars. This is ideal for displaying images on the Web and email when scaled down, but is insufficient for making quality photographic prints. An inexpensive 10 MP camera can easily make a high-quality 8 × 10-inch print at a resolution of 300 PPI. This is the commonly used file resolution for making digital prints that resemble a chemical photographic print.

DPI, a.k.a. *printer resolution*, can be found and set only through a computer's Print command. Depending on cost and intended use, printers are mechanically different and have various user options. Printers require software called *print drivers*, which must be installed on each computer to operate the printer and give full functionality to printer options, such as paper type and size, manual or tray feed, and, most importantly, DPI. These options appear on your computer screen after utilizing the Print command.

Printer resolution (DPI) does not affect the virtual image size (megapixels) of your image or its appearance on a computer screen. Those properties are determined solely by the imaging software in the Image Size dialog box using Pixel/Inch Resolution and Document Size. Settings in the Image Size dialog box help you optimize size and resolution for your print. The resolution of a digital file can be changed without affecting the total number of pixels in an image (when resampling is turned off), by assigning a PPI resolution to a size in inches. Remember that PPI resolution and size in inches are inversely proportional. As the dimensions in inches increase, the resolution goes down as pixel size increases. In other words, the larger a print becomes, the larger the pixels also become and fewer of them can fit into an inch. DPI settings found in printer drivers determine only the number of ink dots that will be physically applied to the paper. Properly managed image size proportions (PPI) combined with a high print resolution

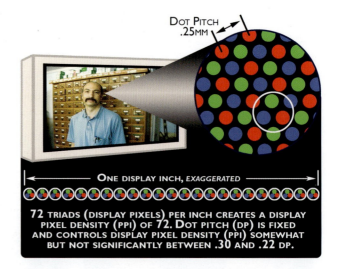

FIGURE 8.3 Red, green, and blue triads, and dot pitch.

can deliver digital prints equal to traditional silver prints.

Higher-resolution settings and large-megapixel cameras are specifically intended to generate higher PPI, which allows one to create larger photographic-quality prints that rival or even surpass traditional darkroom prints. Therefore, a 28 MP digital camera with 28,800,000 total pixels can generate a more detailed large-scale print than a 10 MP digital camera with a maximum of 10,000,000 total pixels.

A reasonable estimate of the proper image resolution to utilize can be obtained by first determining the final print size needed and then selecting a PPI setting that best fits how the image will be used. For instance, to make a photographic-quality print at 300 PPI (the most commonly used starting place), you simply multiply the width and height by 300 to determine the proper megapixel setting or camera needed. For instance, an 8 × 10-inch image at 300 PPI would require a camera sensor of 5.4 to 10 MP ($h = 8 \times 300 = 2,400$) + ($w = 10 \times 300 = 3,000$).

To maintain optimum print sharpness during sizing, you must not alter the original pixel count when determining final document size (see Box 8.2). With Resample Image unchecked, this will not happen. When left checked, Resample Image can degrade print sharpness dramatically because it will add or subtract

BOX 8.2 BEST PRACTICES FOR PRINT AND SCREEN IMAGE CAPTURE

Best Practices for Making Prints

1. Capture your image using RAW.
2. Open your RAW image file and make your preliminary RAW adjustments.
3. When operating with RAW, the camera will utilize its highest resolution.
4. Save your RAW image file as TIFF or PNG at 300 dots per inch (DPI*).
5. Make image adjustments to this TIFF or PNG using your image management software.
6. To preserve the image size, do not make any changes to the Scale setting.

Best Practices for Images Viewed on Computer or Mobile Device Screens

1. Utilize the camera's Automatic or Program settings.
2. Use the default image file selection, usually JPEG, which is more than adequate.
3. Ignore picture size: Small, Medium, or Large, all these setting will deliver a file size you need.
4. Select Auto whenever it appears as an option. It will not affect the file size required.
5. The default resolution for the Web is 72 pixels per inch, although many screens now have resolutions higher than 200 pixels per inch (PPI*). Typically, it is not necessary to make files with more than 72 pixels.
6. Mobile screens have a higher pixel density (some near 600 PPI), which allows larger picture files made for bigger displays to fit on the smaller mobile display, making the image appear sharper. However, the human eye can barely distinguish individual pixels when the PPI ratio of a smartphone display goes above 300, especially at a normal viewing distance of 12 inches.

*See Figure 8.2 for explanations of DPI and PPI.

FIGURE 8.4 DPI and PPI: coexisting spaces. In this figure, triads are placed over the pixel elements (grayed pixel squares) to show how dots and pixels coexist but are located in different spaces. The black-and-white pixel elements in the middle triads represent the overlap of the two spaces. The majority of the pixel elements (PPI) fall on one or more RGB display triads. This overlapping forces the video card to generalize the color and value of those pixels when they are displayed by a single triad, which is less than ideal for accurately reproducing the colors and values.

pixels by estimating new colors for every pixel based on changes to Pixel Dimensions. However, when you are sizing images for the Web or email, leaving Resample Image checked is generally necessary because it allows you to reduce or scale an image file. Most changes in Pixel Dimensions generally will not be noticed on a computer display because display densities are fixed and average only 72 pixels per inch.

SIZING A DIGITAL FILE

As previously discussed, file sizes in megabytes (MB), file resolution (PPI), and print resolution (DPI) are three distinctly different measurements that need to be understood to properly scale, scan, and prepare images for display or printing. Although closely related, none of these measurements is a true indicator of the actual image size when it is viewed on the screen or outputted to paper.

The size and quality of a final print are first determined by how many pixels were originally captured by the input device, such as a camera or scanner. Keeping the original pixel dimensions intact is absolutely crucial to maximize the quality of the final printed image. Digital cameras capture images based on the common settings of *Large*, *Medium*, and *Small*. Low-resolution settings, such as Small for the camera or 72 PPI for scanning, will produce a file usually around 2 MB or smaller, which is fine for images that will be viewed only on a computer display but is not suitable for photographic-quality printing.

RESAMPLING OR INTERPOLATION

Resampling, or interpolation, is a set of mathematical algorithms automatically applied when the original pixel dimensions are changed for resizing. When you check the Resample Image box in the Image Size settings area, any changes to Document Size will automatically increase or decrease pixel dimensions proportionally. With an increase or decrease in pixel dimensions, the image software has to resample, also known as *interpolate*, by recalculating new colors for each pixel in the image.

TABLE 8.1 Document Size at 300 DPI and Megapixels

Document Size in Inches	PPI (w × h)	Megapixels
8 × 10	2,400 × 3,000	7.2
11 × 14	3,300 × 4,200	13.8
16 × 20	4,800 × 6,000	28.8
20 × 24	6,000 × 7,500	45
30 × 40	9,000 × 12,000	108
60 × 80	18,000 × 24,000	432

This chart shows, for typical document sizes, the desired PPI and megapixels needed to create photographic-quality prints of a single-channel black-and-white image. An RGB color image will have three additional color channels and three times the information at the same PPI. The larger-format cameras listed are currently medium-format cameras with larger sensor sizes.

A computer will accomplish this by looking at adjacent pixels, estimating new colors for each pixel based on an average of the original adjacent pixels, and creating new pixels if scaling up or subtracting pixels if scaling down. There are many interpolating algorithms that perform slightly different mathematical computations, but the end result degrades the original image file. The reason is that the resampling process cannot make up "real" detail (that is, cannot add information that was not originally there), but can only add pixels of similar color and value, which can result in an image looking soft and out of focus. Also, doubling or halving the image's pixels per inch quadruples or quarters the actual uncompressed file size, respectively.

The six most common modes of resampling that appear when the Resample Image box is checked are *Automatic*, *Bicubic*, *Nearest Neighbor*, *Bilinear*, *Bicubic Smoother*, and *Bicubic Sharper*. Bicubic interpolation is recommended because it gives the smoothest results. Nearest Neighbor produces jagged results, but can be useful if you want to preserve a pixelated look. Bilinear splits the difference between Bicubic and Nearest Neighbor. Bicubic Smoother is used for better results when increasing image size or going beyond original pixel dimensions. Bicubic Sharper should give better results when reducing image size, although this method

FIGURE 8.5 The display shows resolution, not real inches. When you photograph or scan at a PPI higher than the fixed triad/pixel display density of 72 PPI, the image will appear huge when viewed on the display at the default 100 percent. The higher the PPI of the image file, the larger the image appears on the display. This image file has a PPI of 300. Notice there are 4 actual inches juxtaposed between inches 4 and 5 on the white display ruler: 1 display inch equals 4 actual inches at 100 percent at 300.

may produce an oversharpened image. If this occurs, use standard Bicubic or if you're still in doubt, use automatic.

It is worth reiterating that pixels per inch (PPI) and dots per inch (DPI) are two distinctly different measurements, which are often confused when scanning, scaling, or resizing a digital image as it is displayed on the screen for printing. Frequently, a digital camera image file will open up at a default resolution of 72 PPI. Figure 8.5 demonstrates what happens to an image that is photographed or scanned at a PPI higher than the display pixel density of 72 PPI and then viewed on the screen at 100 percent, or Actual Size. In such instances, the screen image will appear much larger than anticipated, requiring scrolling to view the entire image.

Properly Adjusting Image Size and Unchecking Resample Image

In all image management software, you will find a dialog box called Image Size that shows the relationship between Pixel Dimensions (the number of pixels that make up your image) and Document Size (print size). Before you adjust an image's width, height, or resolution, uncheck the Resample Image box and then proceed to make document size adjustments. When you

uncheck (leave it blank) Resample Image, the software will always keep the proper relationship between width, height, and resolution of the original Pixel Dimensions or total pixel count of a given image file (refer to Figures 8.6 and 8.7). By default, the Constrain Proportions option is always checked, thereby keeping your image in the proper ratio (not stretched or squished) when making other changes. Unchecking Constrain Proportions allows you to change the width and height of your image independently of each other. Beware, doing so can provide the desired look, but may visually distort the image.

To maintain optimum print sharpness during sizing, you must not alter the original pixel count when determining final document size. With Resample Image unchecked, this will not happen. When left checked, Resample Image can degrade print sharpness dramatically because it will randomly add or subtract pixels based on changes to Pixel Dimensions. However, when you are sizing images for the Web or email, it is not necessary to make files with more than 72 pixels (the Web's default resolution).

When scaling an image with the Resample box checked, such as Bicubic (default), pixilation will be minimized because the resampling algorithm adds pixels in a manner that minimizes artifacts and/or pixilation.

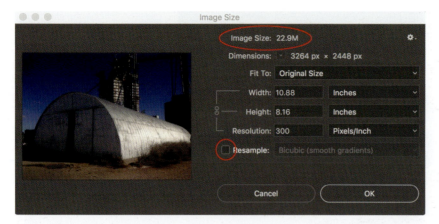

FIGURE 8.6

When scaling an image with the Resample box unchecked, the image will become pixilated because the additional pixels are randomly added.

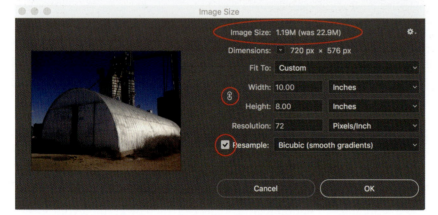

FIGURE 8.7

When changing resolution of this image with the Resample box checked, such as Bicubic (default), pixelation will be minimized but not eliminated. Notice the change in resolution from 300 PPI to 72 PPI, this automatically reduces image size, 22.9 MG to 1.19 MG and produces noticeable pixelation.

PRESERVING ORIGINAL CAPTURE

A helpful way to understand the relationship between picture size, pixels, and resolution is to think of pixel dimensions as representing the real size of original image capture, which contains all the data needed to make an image. Any first-generation image file capture, such as a JPEG, TIFF, or PNG, can be copied and saved into a separate folder devoted to this purpose. It is highly recommended that you retain the original, unprocessed, full-resolution file completely unaltered, alongside your copied version; that is, *you should not edit, manipulate, scale, or size original captured images.* Why? This preserves the original data, makes it easier to use the image for different purposes later, and avoids the potential mistake of overwriting an original image with a faulty version. It also ensures that you do not accidentally erase the EXIF data that the camera stored with the image, which is your record of the date and time the picture was taken and the camera settings used.

WORKING WITH RAW FILE FORMATS

Quality cameras allow one to capture a scene in a nondestructive, RAW image file format. This format contains only "raw," unprocessed pixel data (0s and 1s) straight from the camera's sensor. RAW can capture a wider tonal range and potentially deliver higher image quality than a JPEG while giving you the most control over the image's color saturation, contrast, sharpness, and white balance. You are making a decision between the computer in your camera making the appropriate choices designed by the manufacturer or using the computer desktop and taking control of these options

FIGURE 8.8

Screen shot of Adobe's RAW plugin for post-processing RAW image files.

yourself. The downsides are that RAW file sizes are much larger than JPEGs so fewer images can fit on a memory card and the imagemaker must spend more time performing these tasks instead of allowing the camera software to carry them out. Another issue is that each camera manufacturer has its own proprietary RAW file format and reader, so one program may not be able to read all RAW file formats. However, cameras with RAW capture come with their own software for making all post-capture decisions. Fortunately, this is becoming less of an issue, as more image manipulation software comes with a built-in universal RAW reader that works with most of the popular DSLR cameras.

Currently, using RAW with your smartphone camera is cumbersome. Although some smartphone cameras can save RAW (uncompressed files), they do not natively support RAW. Therefore, you will have to download a third-party camera app that supports RAW. These image files are large (15 × 25 MB each) and the image files are saved as uncompressed TIFF or PNG files to avoid a reader, which is also needed to view any RAW files on a smartphone. Then, another app is required to view RAW on your smartphone. It is more convenient to save images as uncompressed TIFF or PNG files and transfer these large uncompressed files to a computer if additional final manipulation is required.

Generally, most people allow their digital cameras to internally make instant, algorithmic decisions when processing the initial captured electronic data into another file format, usually a JPEG. All the typical image options, such as color balance, contrast, file format, image size, ISO, noise reduction, resolution, saturation, and sharpness, are automatically made by the camera's software. Manufacturers put a great deal of effort into their software to give excellent results. A digital camera internally processes this electronic data and converts it into a JPEG, TIFF, or DNG image file and then stores the converted file on the memory card.

While RAW files can give you the highest possible results from your camera, keep in mind that RAW file formats with their post-processing capabilities are not a substitute for poor camera work or indifferent composition. And it is certainly possible to get worse results using RAW through poor choices. Photographers who consistently make stimulating work comprehend the basic principles of exposure and focus, in addition to

BOX 8.3 SCREEN AND PRINT IMAGE ATTRIBUTES

Screen Image Attributes

1. Excellent for quick dissemination and viewing.
2. Easy to transport and if damaged, can be replaced with duplicate file.
3. Resolution of about 72 PPI on a computer screen, up to around 600 PPI on a smartphone. Screen images can rival those printed on paper.
4. Eliminates the cost of ink, paper, and presentation materials.
5. Display limited to computer, smartphones, and tablet screens and requires electricity.
6. Control over surface texture is homogeneous.
7. How image is actually seen depends on individual electronic screen and video card.

Print Attributes

1. Comprehensive control over image color balance, resolution, size, and surface features.
2. Provides a physical artifact for display.
3. Viewers tend to spend more time looking at a tangible physical picture than a virtual one on a screen.
4. Used extensively in commerce and art world.
5. Costs can be expensive, but can be passed on to the buyer.

composition and light, and utilize all four components in situations when you must override the automatic controls to get the desired results. Utilize your picture review and the histogram to immediately scrutinize your exposures and make corrections as you work.

TRUE RESOLUTION IN THE PHYSICAL WORLD

Join the crowd if you are confused about megapixels, resolution, DPI, PPI, image size, and file size, as not even the experts can agree about these topics. You will frequently find these terms used interchangeably and misused by manufacturers, which perpetuates this confusion. The crucial question at this stage is, Where does the "real" resolution of an image ultimately reside? There is no doubt that these digital matters are directly connected, but their interrelationship is strictly virtual, existing as unseen and untouchable digital data within one's camera, computer, or storage device. Due to

technological limitations, not even the best display can show the true resolving power of any digital file. At this point, the best one can do is to view this digital data as a numerical array that defines resolution as pixel dimensions in our image management software program. Therefore, a hands-on, practical position is that an image's definitive resolution resides in the material world of the print where DPI and printer capability give it physical presence. This is where the ink meets the paper and gives a real-world, tangible form to an electronic image.

DEFAULT IMAGE PREVIEW CONFUSION

All computers have a built-in image viewer for previewing images received through email or by other digital means. The Macintosh image viewer is called Preview; the Windows version is called Picture Viewer. Both disregard actual PPI and conveniently show images

using any four of these options: *fit to screen*, *without scroll bars*, *document size*, or *actual size*. Only document size and actual size follow normal PPI conventions.

DIGITAL POST-CAPTURE SOFTWARE PROGRAMS

Adobe's Lightroom and Bridge contain very efficient exposure, saturation, brightness, contrast, and color controls and brushes that you may be already familiar with and are simpler to use than Photoshop. They focus attention on image correction, encouraging you to make your work as technically proficient as possible. Lightroom's strength is its ability to categorize, sort, select, and group images in a folder hierarchy, customized to your specifications. This encourages good housekeeping and enables one to easily find images in the future (for details see the section "Digital Asset Management (DAM): Post-Production Software" in Chapter 9). All three programs are designed to work with RAW image files as well as other popular image formats and share the same basic underlying software programming. Other features include the capability to personalize presets that automatically apply effects at levels you determine. This is helpful when you need to apply the same effects to multiple images, a capability that is a benefit to commercial photographers.

THE IMAGE WINDOW

To help keep track of all the variables in a digital file, software programs display many key pieces of image information. Box 8.4 identifies the data that typically surrounds the working image and describes its meaning.

THE BOTTOM LINE: BEST SETTING TO GET THE DESIRED RESULTS

Digital photography is an evolutionary development in the history of photography. Automated camera features have eliminated the technical constraints once associated with the medium, simplifying the technical processes and thus allowing photographers to concentrate more deeply on image construction. Creating visually exciting photographs continues to be about understanding the basics: quality of light, composition, and subject matter. Putting these three fundamental elements together in a thoughtful and inspiring way is still the main objective for most photographers.

Screen Images

What are the basic technical guidelines you need to know? When making pictures that will be seen only on a computer screen, set the camera to Auto and make JPEG picture files, and you can expect to get satisfactory results 95 percent of the time. When making pictures for the Web, email, or simple documentation, you can use small PPI files, JPEG compression, and interpolation.

Prints

Meticulous photographers concerned with print output should consider using the RAW format and automated camera features when appropriate. The RAW format guarantees the widest tonal range available for that particular camera, delivering the best digital capture for post-processing. As previously discussed, the RAW format requires you to adjust your workflow to manage color balance, resolution, brightness, saturation, and exposure *after* capture. RAW also keeps your file formats intact without the risk of interpolation or overwriting.

MAKING PHOTOGRAPHIC-QUALITY PRINTS

INKJET PRINTERS: CONVERTING DPI TO DOTS

Photographic-quality inkjet printers are used to make continuous-tone photographic prints. The design of an inkjet print head allows it to spray minuscule amounts of ink onto receiving material at resolutions of 1440 × 720 DPI and higher. These printers along with their

BOX 8.4 DEFINITIONS OF INFORMATION DISPLAYED WITH A DIGITAL IMAGE FILE IN FIGURE 8.9

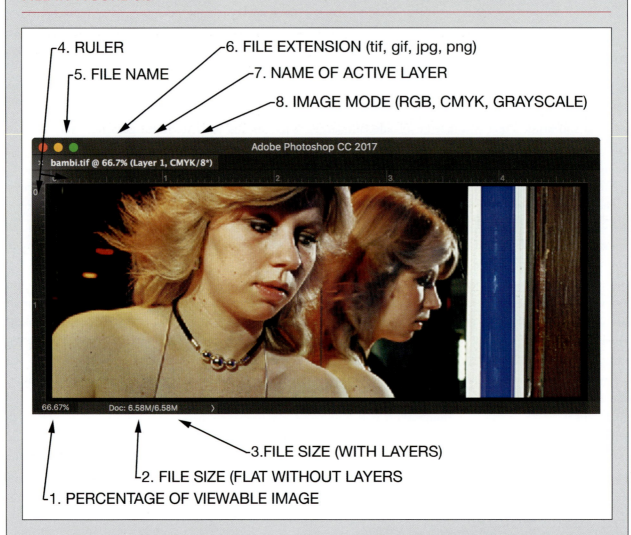

FIGURE 8.9 An image window and its elements.

1. **Percentage of Viewable Image**: Since a display can show only about 72 pixels per screen inch because of dot pitch (DP), the image program scales the image to show the difference between the image display and the document size (PPI). Figure 8.9 shows an image at 300 PPI. In this case, the software has scaled the image of the woman to fit the display and now shows only 66.7 percent of the actual pixels contained in the image. A display of 100 percent means that you see every pixel at a 1:1 scale, which would require the image to be much larger than the display. Hence, the display (video card) will scale (crop) the image to show what it can look like at 100 percent. The smaller your display screen, the more cropped or enlarged your image will appear at 100 percent.

2. **File Size**: This area shows the size of the file when it contains only one working layer or background.

3. **File Size (with layers)**: Layers are transparent surfaces that can be individually placed on top of the original image or background, increasing the size of a file. You can move, scale, draw, edit, and paste onto any layer without disturbing the other layers or the original image. Adding layers while working allows you to work separately on the various parts of your image, which helps to organize and manage the workflow. Individual layers can be deleted without affecting any of the others. Flattening an image converts all layers back into a single layer, thereby reducing the file size. Images sent to high-quality printers often have to be flattened before printing.

4. **Ruler**: Imaging software usually includes an option for displaying a ruler alongside an image. The particular units a ruler employs can usually be defined by the user in the program's Preferences.

5. **File Name**: Most imaging software displays the name of the file near the top of the image window.

6. **File Extension**: Extensions describe the file format to a computer's operating system. PCs and Web browsers require that the three-letter file extension be included in a file's name, such as .tif or .jpg; otherwise, it may not be properly opened or displayed.

7. **Name of Active Layer**: Files can have many layers with individual names; the active layer name is displayed in the image window.

8. **Image Mode**: Imaging programs allow you to work in a variety of color modes, including RGB, CMYK, Grayscale, Bitmapped, Duotone, or LAB. Some filters and operations can be performed only in RGB mode.

associated print drivers can deliver subtle detail with more accurate and saturated colors and print on a wider variety of materials than their less expensive office counterparts. These quality printers also can use more permanent (archival) inks and include more colored inks, greatly increasing the range of colors (color gamut) beyond traditional analog color photography.

DROPLET SIZE: PICOLITERS

Inkjet printers use different amounts and methods of applying inks to create photorealistic images. General-purpose quality inkjet printers use four inks: cyan, magenta, yellow, and black (CMYK), while higher-end photographic-quality inkjet printers often add colors such as red, green, blue, orange, and lighter versions of cyan, magenta, gray, and black, plus matte black. Creating photo-quality prints depends on how many droplets fit within an inch (DPI) of space and on the size and pattern of the ink droplets made by the printer head. When a photographic-quality inkjet printer makes an image from a 300 DPI file, it is not just depositing one droplet of ink for each pixel (PPI) or dot (DPI), but rather it places four or more droplets of ink to represent each pixel. Droplet size is the size of the smallest individual drop of ink that a printer can produce and is measured in picoliters (1/1,000,000,000,000 of a liter/one trillionth of a liter). Certain inkjet printers can vary the drop size, which may be as small as 1 picoliter for dye-based inks and 1.5 picoliters for pigment-based inks. As expected, the smaller the droplets, the greater the resolution of the print. Small droplets also allow you to generate smoother-looking prints with finer highlight detail and tonal gradations with less ink. Presently, 12-color inkjet printers use hundreds and hundreds of nozzles to apply varying

degrees of color and value accurately, predictably, and with smooth gradations.

If you are interested in making black-and-white images with a broad dynamic range and fine tonal separation, use a printer with at least three black ink cartridges. Presently, the gold standard for black-and-white printmaking is to use a printer with at least four black ink cartridges or to use a special third-party monochrome ink set, which provides four to seven black inks of various color tones and densities.

Inkjet printers must accurately control all those nozzles to properly set down droplets of ink in order to persuade our eyes that we are seeing a continuous tone. Better inkjet printers can deliver excellent photographic quality between the range of 150 and 360 DPI. Generally, a setting of 1200 DPI will provide outstanding quality. Although these printers are capable of resolutions up to 2880 DPI, it generally is not worth the extra ink, printing time, and storage space to produce image files that are beyond the visual acuity of the human eye.

PAPER: UNCOATED AND COATED

Uncoated (porous) printing papers are the most readily available papers and are best identified as the inexpensive xerographic, inkjet, or laser papers primarily used for printing text. Structurally, these papers are made of raw cellulose wood fibers that have been bleached and processed into the standard letter- and legal-size formats. These papers lack uniformity in absorbency, brightness, surface texture, and pH levels. They absorb more ink, which allows them to print and dry fast to the touch, but makes the colors appear duller and flatter than on coated paper. Uncoated papers are not archival, being more susceptible to fading caused by environmental factors and exposure to light than coated papers, and are not intended for long-term use.

Coated papers (micro-porous) have special coatings that either modify or completely cover the cellulose fiber, thus giving the paper superior print results and archival qualities. Designed to resist fading, these papers can have somewhat longer drying times. Coated papers

come in a variety of traditional photographic surfaces, including high gloss, semigloss, flat matte, and luster/satin, and also in many canvas-like textured surfaces. Glossy papers deliver clear, vibrant color and give a broader apparent tonal range to black-and-white images. Many serious printers use expensive fine art papers with a matte finish because they minimize reflections when framed and have archival qualities. Such acid-free papers are buffered with calcium carbonate to prevent environmental acidification and contain no optical brighteners that can break down and change color over time. Many papers are available with either smooth or textured tooth and in different weights and sizes. Paper thickness is generally measured in thousandths of an inch, or mils for short. A typical inkjet paper will measure anywhere from 10 to 25 mils depending on the structure, material, and coatings. Thick papers often require a printer with a straight path manual feed option, as they may not be able to bend in a circular manner.

Nonporous polymer or vinyl-based printing materials are used for printing banners and decals but are not considered archival.

Many manufacturers sell sample packages that allow one to try a variety of papers. For a comparison and ratings of different types of inkjet papers, see www.freestylephoto.biz/Inkjet/Paper-Ratings.

Before you utilize any new printing materials, it is a good idea to check the kind of coating or surface of the material and select the appropriate type of ink, making certain your printer can properly handle that particular combination. Look for compatibility information from the paper manufacturer. Begin with the printer manufacturer's paper and ink recommendations, generally its own brands, and then experiment with different materials. Many companies offer variety sampler packs that allow you to test-drive different papers so you can see how the various possibilities work with your imagery and equipment. Look for an ICC profile for each ink/paper combination, as it signals that it has been tested and should work at least acceptably well. Avoid papers with optical brighteners, for they will deteriorate as the paper reverts to its natural color, turning the prints yellow. Bear in mind that the differences in how each

FIGURE 8.10 After scanning photographs from history books and family albums purchased at flea markets, Kristen Wilkins altered them by substituting her own portrait for the original person's face, placing herself in a historic past. "Their purpose is to represent the inability of a picture to show a person's identity beyond what they looked like. As I want to fool the viewer into thinking they are seeing the 'original' photograph, I used matte paper adjusted to print as a warm-sepia color. The resulting images are framed in a very traditional style with a white window mat, just as historic photographs are presented in museums."

Credit: © Kristen S. Wilkins. *Us Girls*, from the series *Autoportraits*, 2003. 10 x 7 inches. Inkjet print.

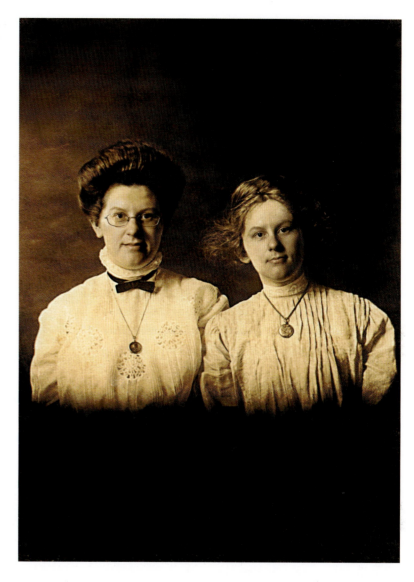

type of paper records the image will affect how you prepare your image file for printing. For instance, a heavy matte paper, such as Hahnemühle Bamboo Paper, will likely require different adjustments to capture the shadow details than a smooth paper, such as Epson's Premium Luster paper. In all cases each paper choice will require experimentation and the making of test prints before you can produce an appropriate solution.

INKS: DYE AND PIGMENT BASED

There are two basic groups of inks: water-soluble dye based and pigment based. Dye-based inks are capable of producing a broad and vibrant range of colors with a limited number of inks and often are used with porous (swellable) paper. They are less prone to *metamerism*, which occurs when a color changes hue under a different light. They also do not produce low-sheen patches on glossy paper. Inexpensive inkjet printers utilize dye inks, which should be used only when permanence is not a concern, such as for color proofing and short-term use. Photographic-quality inkjet printers can use pigment-based inks, whose pigments make the inks more archival and fade resistant. Such inks are used on both coated and uncoated papers, with the coated papers taking longer to dry.

PRINT PERMANENCE

There has not been enough independent empirical testing to accurately predict the permanence of ink-jet prints, a particular problem since the equipment and materials are constantly changing. To maximize longevity, use coated papers and the best-quality pigment-based inks available. When permanence is a major concern, evaluate the current array of inks and papers before buying a printer to make sure everything is compatible and able to produce the results you desire. Using papers and inks from different manufacturers is not suggested until experience is gained because manufacturers test, rate, and guarantee the permanence of only their own system's products. While combining inks and papers from different manufacturers may produce the look you seek, the results may not be archival (see Chapter 9 for factors affecting permanence).

PRINTING SYSTEMS AND OUTPUT CONCERNS

Desktop Inkjet Printers

Desktop inkjet printers are inexpensive and use water-soluble inks and plain paper to make color prints. Better-quality paper will yield higher-quality images. Some dye-based inkjet printers produce prints that are impermanent and can, without protection, fade within six months.

Iris Printer

The Iris printer, introduced in 1985, was the first high-end printer used in digital fine art reproduction. Iris prints are a type of inkjet print produced by spraying millions of fine dots of ink per second onto paper to produce consistent, continuous-tone, photorealistic output on paper, canvas, silk, linen, and other low-fiber textiles. Created on a spinning drum, these gallery-quality prints can be made on virtually any material that will accept ink. The Iris printer uses dye-based inks that produce highly accurate, vibrant prints with wide tonal values. Depending on the type of ink, paper, and coating, such prints could have a life span of as little as six months, but generally Iris prints are made to last decades. Once the standard for high-quality fine art reproductions, Iris prints (a.k.a. *giclée* prints) are now a niche process used to indicate a superior product, as they have been superseded by less expensive large-format printers. Nevertheless, Iris prints continue to be a standard measure for digital prints.

Giclée Printing

The termed giclée (pronounced *zhee-klay*) is French for "spray" or "spit." It was coined by a printer at Nash Editions to be associated with Iris printers and connotes the use of professional 8-color to 12-color inkjet printers to produce high-end output. However, it is nothing more than a chic term for inkjet printing since technically, even an inexpensive inkjet printer produces giclée prints. Although the name was designed to appeal to print connoisseurs and their expectations of an archival pedigree lasting for hundreds of years, the process is not regulated and therefore carries no guarantees.

Mural-Size Prints

The making and acceptance of high-quality photographic digital images is a reality for both the consumer and professional and is visible in the art world's embrace of big prints. Even though digital cameras can exceed the resolving power of 35mm film cameras, enlarging limitations remain constant. Digital photography is not a panacea for making large prints from small cameras. A blow-up from a 35mm-equivalent DSLR will show a loss of sharpness due to increased pixelization in direct proportion to the enlargement size. When one takes that factor into consideration, intriguing images can be made by purposely incorporating the higher levels of pixelization into the design of the final image. Large digital prints are routinely made with a floor model photo-quality inkjet printer capable of printing up to 64 inches in height and widths as long as the roll of paper will allow, which can exceed 100 feet.

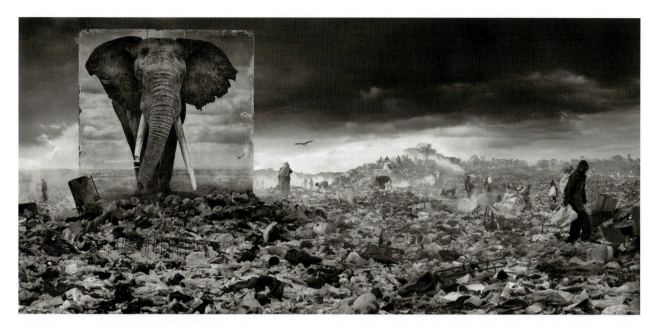

FIGURE 8.11 Nick Brandt asserts: "We are living through the antithesis of genesis right now. It took billions of years to reach a place of such wondrous diversity, and then in just a few shockingly short years, an infinitesimal pinprick of time, to annihilate that. 'Unreleased' portraits of animals that I had taken over prior years were printed life-size and glued to large panels. The panels were then placed within a world of explosive urban development—locations where animals such as these used to roam but, as a result of human impact, no longer do. The panels were built on the site of each location, such as this dumpsite, and were erected to withstand rain and wind. Then I waited for the local people to become used to their presence. Once people become oblivious to their presence and treated them like ghosts in the landscape, I would return to make the photographs for this project. The damnation of animal life, the debasement of human life, the destructive conjugality between the two: It is not just the animals who are the victims of environmental devastation, but also the humans now inhabiting these landscapes. If we continue to do nothing, future generations will be inheriting the sad remnants of a once-vibrant living planet. They will be inheriting dust."

Credit: © Nick Brandt. *Wasteland with Elephant*, from the series *Inherit the Dust*, 2015. 54 x 113 inches. Inkjet print. Courtesy of Edwynn Houk Gallery, New York, NY.

Unusual Printing Materials: Mixing Media

The combination of digital image files and high-quality printers plus an accompanying array of printing materials invites the exploration into the various methods of outputting pictures. Imagemakers have always experimented with the surface of the print, some by applying pigment to the surface, others by collaging images and materials to the print surface. All of these methods can be brought into play using digital imaging as well. In addition to traditional glossy paper, manufacturers have developed materials, such as artist canvas, that can be run through a digital printer and then be painted on with acrylic or oil paints like a conventional canvas. Materials such as poly silk cloth, a polyester-woven fabric with a ceramic-based coating, can convert an image into a flexible work that feels like silk. Lazertran allows images to be printed onto various types of waterslide decal material, which allows the transfer of an image onto many surfaces. You can even use several of these layered over each other because they are transparent. Other materials can be printed on and waterproofed, allowing them to be exposed to the elements or even washed. Images also can be printed on translucent and transparent films that can be used as backlit prints, as photographic negatives for other alternative processes, or in multilayered images. A liquid precoat called inkAID can be brushed or sprayed to create a matte, gloss, or semigloss coating on unlimited types of surfaces on which to print, including traditional fine art papers, metal, plastic, and wood veneer. Additionally, there is iron-on inkjet transfer material that allows images to be

FIGURE 8.12 Martin Kruck explains: "The *Habitorium* series makes a study of constructed spaces, those interior and exterior areas designed to satisfy both the emotional and bodily needs of its occupants. This work extends my focus on the aesthetics of the sublime and the strange feedback loop between it and the idea of self-domestication. The series combines photographic elements from human and animal environments to create post-naturalistic landscapes, where nature and artifice are largely indistinguishable. I am interested in how photography has made such an extremely detailed study of life, and the odd drive for us to use this optical view to replicate and augment it." The images are created through a photo-intaglio process, or photogravure. In the intaglio process an image is incised into a surface and the incised line or sunken area holds the ink. In the photogravure process a copper plate is coated with a light-sensitive gelatin tissue that had been exposed to a film positive, and then etched, resulting in a high-quality intaglio print that can reproduce the detail and continuous tones of a photograph.

Credit: © Martin Kruck. *Canopy*, from the series *Habitorium*, 2015. 14 x 21 inches. Photogravure print.

easily transferred onto cloth. If you are using an unusual paper and want to run it through your printer, check the printer manual to determine the maximum thickness the printer can accommodate. The most adventurous dig into traditional analog printing processes, including lithography, photogravure, and silk screening.

Preparing a Digital Print for Mixed Media

The advertising industry has fostered digital media innovation like store advertisements being produced by large-format printers. Imagemakers should be aware of the interests of the advertising industry when using these

new materials. Advertisers want materials that are sturdy enough to stand up to public display, but are not particularly concerned with image longevity. Fortunately, many of the same qualities that allow an image to survive outdoors will permit those same prints to last years or decades when they are properly displayed indoors (see Chapter 9). Imagemakers can protect such pictures from damaging ultraviolet rays or when preparing images for mixed media applications, such as acrylic or oil paint, by sealing the surface with a spray or liquid coating. These coatings are water or solvent based and can be used with water-sensitive inks. Since many of

FIGURE 8.13 "The images in the series often come from found snapshots of people posing with their pets or farm animals and generally are combined with images I have taken of taxidermy animals. The title *Wannabes* addresses our urge to create lives and stories for animals that often mimic or mirror our own desires, as well as presenting those desires in a variety of forms such as piglets decorating a pair of children's pajamas or a fish starring in a Hollywood production. Image manipulation is done in Photoshop, and the final images are printed onto a special waterslide decal paper, Lazertran, through the use of a Xerox copier. Finally, the image is baked-on in a conventional oven, giving a waterproof, archival, usable finish."

Credit: © Deborah Brackenbury. *Wannabes* (Brother and Sister), 2004. 10½-inch diameter. Mixed media.

these coatings can yellow or crack over time, researching and testing a particular combination before use is recommended.

Service Bureaus

The hardware and software necessary for many output operations are expensive and require special skills and materials; using service bureaus with knowledgeable technical support is a viable option for image-makers doing low-volume work. Most service bureaus specialize in high-quality scanning and printing using the latest technology and unlimited print options. The quality of the output always depends on the skill of the operators and the maintenance of equipment, but generally if the job is not done to the customer's satisfaction, service bureaus will do it again until it is right.

An affordable alternative is the Fuji Frontier Print system available at your local copy center, Wal-Mart, or Walgreens. This system provides a fast and inexpensive way to get small, high-quality images on glossy or matte paper. Be sure to check for the preferred file format and required resolution *before* submitting your image files. Using the automated system's default 5 × 7- or 8 × 10-inch printing options can be chal-

lenging when you want to crop or produce full-frame prints. However, you can experiment with cropping and retouching when formatting and overcome these problems.

IMAGE CORRECTION AND THE COMPUTER WORKSTATION

Just as a camera translates a three-dimensional scene into a two-dimensional representation, a computer seamlessly combines different media into a virtual representation, retaining the qualities of some and eliminating the traits of others. Any operation one can do with a camera, drafting set, or paintbrush can be simulated on a computer, which allows one to shift back and forth between different aspects of what constitutes reality.

Large, high-resolution image files require extra processing time and plenty of available hard drive space to operate efficiently. Typically, a 100 MB file should have at least five times that amount (500 MB) of free hard drive space to make use of the imaging software tools and filters.

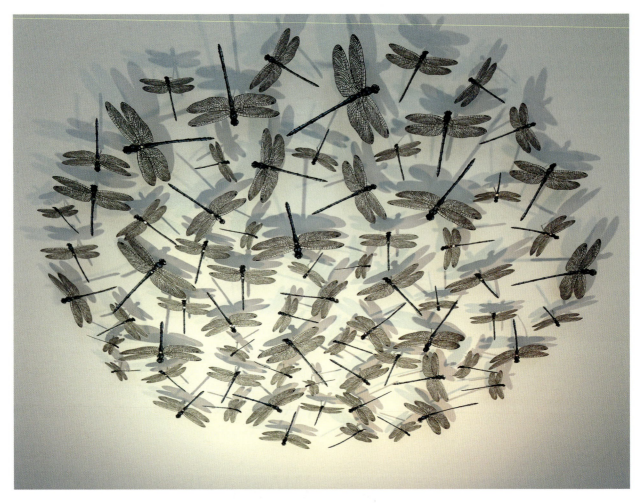

FIGURE 8.14 *"Dragonflies* was created digitally. The process included creating the likeness of a dragonfly using a photographic source image and redrawing it in Adobe Illustrator using a Wacom tablet, then digitally duplicating the drawing in a variety of sizes and printing them on vellum using an electrostatic printer. I spent hours cutting each dragonfly using an X-Acto blade and experimenting with paint and glitter until I found the right match. I constructed each dragonfly, then pinned them one by one to create the mandala installation."

Credit: © Sue O'Donnell. *Dragonflies*, 2015. 28 x 28 inches. Electrostatic prints and mixed media.

THE COLOR MONITOR

All monitors use an additive RGB (red, green, and blue) color system. A monitor mixes a color by illuminating tiny red, green, and blue dots called *triads*. By illuminating each of the dots to a different brightness, thereby mixing together various amounts of red, green, and blue light, the monitor can create almost any color. Additive colors get lighter when mixed; all three colors mixed in balanced amounts make white light. Since light is transmitted from the image, the colors tend to be more saturated and luminous than in a printed image that relies on reflected light in which portions of the rays are absorbed. Prints use a CMYK (cyan, magenta, yellow, and black) subtractive system to form an image on a sheet of paper, and any increase in pigment density will subtract the initial amount of light and produce a darker result.

There is an inherent visual difference between images seen on your monitor, other monitors, and output devices. Sophisticated monitors allow for color correction as well as contrast and brightness adjustments, but these adjustments affect only how the image appears on

FIGURE 8.15 Calla Thompson's stripped-down comic book characters employ humor to deal with the ways in which power is enacted through small actions and are the result of a collaboration between photography and multimedia. Thompson tells us, "In my work the computer is a tool; a means to an end, rather than an end in itself, a way to generate a final form that exists outside the computer."

Credit: © Calla Thompson. *Untitled*, 2005. 18 x 18 inches. Inkjet print.

HOW MONITORS DISPLAY COLOR

that particular monitor and not other monitors and/or paper output. Color management hardware and software, such as a monitor calibration spider and ICC profiles, are available to help control the color balance between monitors and output (see the section "Color Management" later in the chapter).

HOW MONITORS DISPLAY COLOR

Depending on the monitor size and the amount of video memory (VRAM), it is possible to see and manipulate millions of colors with image processing programs. All video monitors represent color by displaying minute RGB dots, which appear on the monitor as pure color. All other colors shown onscreen are a mixture of pixels used to approximate the color needed. In addition to full color, images can be produced as grayscale, which produces 256 shades of gray, or bitmap images, which are purely black and white.

BIT COLOR

Most digital photographers seek to capture the maximum amount of color, exposure, and resolution information, which is edited to preserve as much of the original data as possible. However, digital editing is a destructive process that results in a loss of original information. One way to minimize this loss of information is through the use of bit color.

Most RAW file formats and post-processing software allow one to choose between 8-bit and 16-bit color. The bits refer to the number of available tonal values that can be stored by each pixel. In the 8-bit mode, each pixel can replicate 256 values of red, green, and blue, which together can create over 16.7 million possible RGB values for each pixel. (See Box 8.5.)

The 16-bit mode generates individual pixels capable of revealing 65,536 values for each of the RGB channels, delivering an astronomical 281 trillion possible

BOX 8.5 BIT COLOR

2-bit	=	Black and white
4-bit	=	16 colors
8-bit	=	256 colors
16-bit	=	32,000 colors
24-bit	=	16.7 million colors (the limit of human acuity)
32-bit	=	Many millions of colors plus increased color depth
48-bit	=	Billions of colors further increase in color depth
64-bit	=	Trillions of colors plus increased color resolution and detail

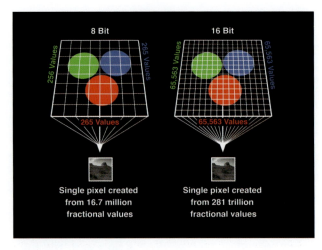

FIGURE 8.16 This illustration compares the differences between the number of values created by a single pixel used in either the 8-bit or 16-bit mode. The difference between 16.7 million and 281 trillion values created by a single pixel may seem dramatic, but the human eye may see only minor differences. The advantage of using 16-bit color mode over 8-bit is that it allows for more accurate color correction.

values to each pixel. It does this by fractionalizing the same information, rather than by capturing more initial information. However, be conscious that the human eye can't distinguish much beyond 10 million colors or values.

COMPARING 8-BIT AND 16-BIT MODES

Whether you use the 8-bit or 16-bit mode, the photographs will look alike until you begin making adjustments. Editing software applies a set of algorithms that alters the original image data. In the 8-bit mode, the observable destructive changes (loss of data) are minimal. The greater bit rate of the 16-bit mode makes for higher color accuracy and a less noticeable deficit of data, but it requires more storage space and a faster computer to work effectively. Be aware that an 8-bit image is sometimes referred to as a 24-bit image file because it consists of three 8-bit colors (RGB), $3 \times 8 = 24$-bit. Similarly, 16-bit image files are sometimes referred to as 48-bit because they consist of three 16-bit colors (RGB), $3 \times 16 = 48$-bit (See Figure 8.16).

It is advisable to utilize nondestructive editing practices to preserve as much initial data as possible. This can be done by selecting and duplicating all or part(s) of the original file and then editing the duplicate layer. This allows you to apply the editing algorithms to only selected layers, which can be individually altered without affecting the editing done on other layers. At the bottom of the Layers window in your image software program is a circle icon used to create a New Adjustment Layer, which automates making a new layer to work nondestructively with the image file. When editing is complete, you can merge or flatten the image file to make the file smaller.

Presently, it is still largely an 8-bit digital world, as most printers support only 8-bit image files. So regardless of whether you are working in 8-bit or 16-bit mode, the printer driver will likely convert the image file to 8-bit to enable the printer to function at its 8-bit settings. Also, most popular inkjet printers transfer images to paper using a pattern of dots of varying size, value, and color to simulate each pixel in the image file and, at best, can reproduce only 15 to 18 values, a far cry from the 16 million or 281 trillion values in the original file itself.

COLOR MANAGEMENT (ICC PROFILES)

In 1993, a group of eight software and digital output device manufacturers formed the International Color Consortium (ICC) to establish and maintain a set of international color standards. The group introduced a standard device profile format, known simply as ICC, to define how different color devices, regardless of manufacturer, produce color images. An ICC profile is a file that describes how a particular device (printer or monitor) reproduces color. These profiles map onto an image file the characteristics of different output devices with their limited color spaces, making the output of images from varying devices predictable and observable.

CONTROLLING COLOR SPACE: PROFILES AND LIGHTS

In a digital setting, every workstation has a unique "printable color space" sometimes known as *color gamut*. ICC profiles are small digital files that help the computer determine the actual viewable and printable color space of a device. These files are sometimes preloaded in an image or software program, but many need to be loaded based on the device and the media being printed on. Color space is determined by everything that goes into making the image, including the camera or scanner (input), the type of monitor (viewable color space), and the printer along with its specific combination of inks and paper (output). As each paper and ink combination has a different color bias, using an ICC profile for a particular paper/ink combination will help ensure that your print will match the color values of your image file. The ICC profiles "remap," or reassign, a new color value to a digital image when color values are detected outside the viewable or printable color space. Sometimes the shift is not severe or even detectable. The standard ICC profiles, called *generic profiles*, are designed as a "best guess" method of normalizing many variables over a wide array of possible environments, and can do a good job. Factory ICC profiles are best and can reduce time and effort when color correcting. However, they do not work in every situation. Custom ICC profiles also can be purchased and downloaded from most manufacturers' websites.

WYSIWYG: WHAT YOU SEE IS WHAT YOU GET

In a controlled working environment with well-maintained equipment, a good understanding of ICC color management can minimize the process of color correcting digital images. ICC profiles are little data tags that tell computers and printers how to translate the numbers of digital files into specific colors. They encode the "color gamut" of a device—or in other words, a mathematical description of all the colors that a display or printer can show.

Begin by setting the color Working Space of your computer to one of the standard ICC profiles. The two most popular choices for Working Spaces are sRGB and Adobe RGB. For the most accurate and consistent results, always match your ICC profile to that of the printer. For example, if you are printing your images at a "big-box" store that outputs onto traditional photographic paper, then sRGB is the best choice since it is the most common default and is also the one recommended for images on the Web. Professionals commonly use Adobe RGB because it contains a few more saturated colors, primarily in the greens and blues. However, this can cause problems. For instance, if you send a file that is tagged with Adobe RGB to a company that is expecting the file to be in sRGB, you are likely to get prints with less color saturation.

Using special hardware and software one can create a monitor profile that describes how your computer display depicts colors. This is the only way for your computer to understand how images appear on your screen. In a controlled working environment with the proper software and color calibration equipment, the color calibration of the monitor to the printer can be done very precisely, allowing you to have WYSIWYG—what you see is what you get (pronounced *wiz-ee-wig*). Be aware that your eye sees prints and displays differently, and in fact, they use opposite

FIGURE 8.17 Before you get started you may want to personalize Photoshop's Color Theme to suit your color palette; the default is a dark gray. Photoshop gives you four choices that range from black to white, with the option to build your own background color. Open Photoshop and go to Preferences and then to Interface, and you will be given your background choices.

descriptions of color (additive/RGB vs. subtractive/ CMYK). Also, the longer you look at a screen, the more "normal" your images will appear. Therefore, it is advisable to take breaks and not have your monitor brightness turned up high.

In a group lab, the monitor controls and room lighting are often inconsistent, which can add challenges to working proficiently. Also, the type of lighting in a classroom or lab may not be ideal for viewing prints. Pantone makes sheets of little stickers, called D50 Lighting Indicators, that let you visually see whether you are in a good environment for evaluating color. Another simple rule of thumb is that if your prints look consistently too dark, you probably are working on a display that is turned up too bright. A completely white screen image should be close to the whiteness of a page of white paper when placed next to your screen. Many people turn up their displays to maximum brightness, but this gives a false interpretation of your file by letting you see too deeply into the shadows and increases eye fatigue.

The color of your desktop or default software interface can affect how you adjust your image. The colors that surround a swatch of color can make it appear very different (see Figure 8.17: Personalize Photoshop's Color Theme). Professor Edward Bateman at the University of Utah advises his students against using the dark Adobe Default for Photoshop because it can give incorrect feedback. Bateman asks his students: "How many of you print on dark paper? How many mat your work on dark mat board?" Bateman then explains that the surrounding colors can affect how one reads an image. Next, he shows a file that has the same image with different surrounding colors to demonstrate just how different the tones and contrast can appear.

Ultimately, you should take control of how your prints look. While well-maintained digital printers are remarkably consistent, you should not think that the first print is "right." When your final goal is a print, then make a test print early in the adjustment process and use that to evaluate your image while you work. Just as in a chemical darkroom, where you often have to make several prints to achieve your visual goals, you should expect to make several adjustments and test prints to get your digital print to meet your expectations.

LIGHTING IN THE WORK SPACE

The light sources illuminating your work environment can affect decisions about adjusting the color and contrast of your prints. Halogen lights can throw off the accuracy of color meters used for monitor calibration. Incandescent bulbs produce a yellow light, whereas sunlight fluctuates in color. Regular fluorescent bulbs tend to be green, inconsistent in their output, and lacking in certain colors of the spectrum. The ideal digital studio has light gray walls illuminated by diffuse 5000 K light sources. Light bouncing off brightly colored walls and objects, including your clothes, can affect the color outcome. Use a monitor hood to prevent light from directly striking the computer screen. A hood can be easily made from gray mat board. Keep the area around your monitor dim, but evaluate your prints in bright light that is the equivalent of the light under which the print normally will be viewed. As a

final point, regardless of what any calibration program states, color response is subjective, and it is our eyes that ultimately determine whether a color print achieves its desired results.

DIGITAL COLORS: CMYK AND RGB

Many software applications allow for the manipulation of color according to its hue, saturation, or luminosity (HSL) or through a licensed color system, such as Truetone or Pantone. These last two systems allow for the most accurate and simple color manipulation on a computer. Process color, or CMYK, is the traditional printing method of lithographic printers. This set of subtractive primary color is the system used by most color printers. Many output devices cannot print all the colors a computer is capable of processing. Some software packages will alert you if a particular device cannot print a selected color. Computer users can make color separations for printing using the CMYK mode. When switching from RGB to CMYK, the computer dulls the screen colors to simulate a subtractive print. High-end multicolor printers rely on RGB to manage all their possible color options. Duotone effects, the application of a second accenting color, are also possible.

DIGITAL MEMORY

RAM

When a program opens, its contents are loaded into random access memory (RAM). The instructions a computer needs to perform its tasks are stored and processed in RAM chips, sometimes called *memory chips*, which come in a variety of formats, sizes, pin configurations, and types. The amount of RAM a computer has directly affects its performance and capabilities and is usually expandable. Most software applications include recommended minimum memory requirement settings. However, effectively running a program may easily require twice the minimum amount of RAM; therefore, it is prudent to research programs before you purchase them.

ROM

Permanently installed in the computer, read-only memory (ROM) contains the basic operating instructions a computer needs to start up and to draw objects on a screen. Unlike RAM expandable memory, ROM is fixed and not alterable.

Hard Disks: Mechanical and Solid State

The hard disk, usually installed inside the computer, is either the traditional mechanical drive or the newer solid-state drive and saves necessary data for running applications and storing files. Since image files are often larger than the available RAM, some software applications use the hard disk to temporarily store information. The program shuffles information from the hard disk (*scratch disk*) into RAM, where it is processed. This enables the program to complete complex operations and functions, such as *undo* and *preview*. The scratch disk may use more than five times as much space as the original image because it stores several different versions of the image. The computer's hard disk must have enough free space to accommodate these temporary files, which is why some say you can never have too much RAM.

SOFTWARE AND IMAGING APPLICATIONS

Although the computer is a powerful tool, it is essentially an empty vessel that is dependent on the instructions contained in software to carry out its applications. Images created on a computer do not have to be exclusively photo based. The programs' own internal tools, integrated with devices such as pressure-sensitive graphic tablets and pens, allow users to simulate other media as well as create unique digital images.

Various types of software may be utilized at different stages in the imagemaking process. A single application can provide adequate tools for an imaging project, but it is often necessary to combine the strengths and tools of other software to create the desired outcome.

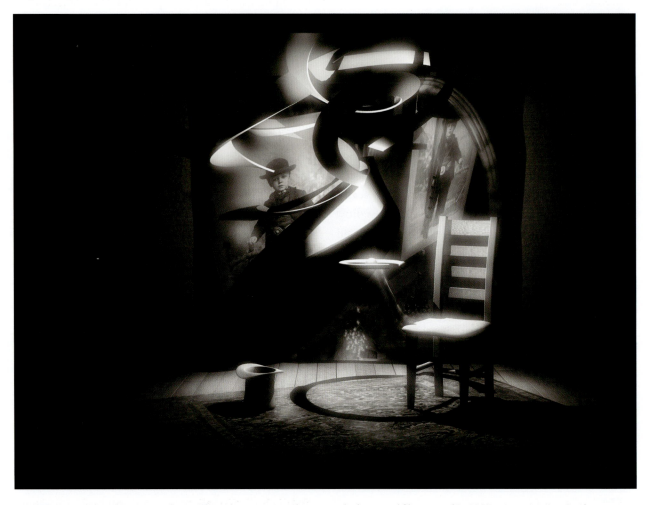

FIGURE 8.18 Edward Bateman relates: "This video purports to be a recently discovered film created in 1907 using a Lumière Brothers Cinématographe by an unknown auteur. In reality I created most of this image with 3D modeling software, utilizing a virtual camera and lights to simulate the early days of cinematic photography. Contemporary use of glowing screens and digital projectors traces a lineage back to the magic lanterns of the 1600s. Rather than depictions of the natural world, this technology was used to project a phantasmagoria of devils, animated skeletons, spirits, and the uncanny. Traveling magicians and showmen adopted this device to create wonders of unseeable worlds. The stage magic of the nineteenth-century inspired early filmmakers and is the source of our contemporary digital cinema. Today, many instances of digital art are presented in an immaculate, clearly digital language. However, it continues to follow in this centuries-old tradition, not through visions of the supernatural but in our contemporary equivalent—images seemingly derived from science fiction. Like black magic, the computer is a black box from which surreal possibilities emerge. The camera was the first machine of depiction, and for a time we believed it to tell only the truth. In the end, perhaps all the images we create share a strange mixture of magic, truth, and illusion." Video can be seen at https://vimeo.com/168904447.

Credit: © Edward Bateman. *Still image from Untitled Cinématographe, 1907*, 2016. Variable dimensions. Video/digital animation.

FIGURE 8.19 The top main menu categories provide access to hundreds of Photoshop options and shortcuts.

RASTER/BITMAPPED SOFTWARE

Most software programs that are designed to process photo-based pictures operate with raster (bitmapped) images. Raster images exist solely in 2-D space, made up of height and width only, and can be manipulated along the X (left/right) and Y (top/bottom) axes. The advantage of a bitmapped image is that it can be edited pixel by pixel. Photo-based or raster image programs, such as Photoshop, do not keep individual objects as separate files; they only keep track of the individual pixels that make up any object in 2-D space. New items should be applied to their own layer, at which time any alteration will affect that layer only and not the other layers or surrounding areas. Not all imaging programs operate in this manner. For instance, Nikon's Capture NX saves your image changes as instructions instead of layers, which allows the file sizes to remain small, thereby reducing working time and storage needs. Increasing the size of an image increases the number of pixels, spreading out the data; decreasing the size of an image eliminates pixels. Any change in an image's size reduces its integrity.

VECTOR GRAPHICS SOFTWARE

Vector graphics (object-oriented) software programs offer a wide range of options for manipulating lines and polygons in 3-D space. Such programs treat any drawn object as a 3-D model that exists in space made up of height, width, and depth and that can be viewed realistically from any angle when rotated or scaled. These 3-D models or objects will cast their own shadows and refract or reflect light from single or multiple light sources, just as any object would in the real world. Objects can be manipulated along the X (left/right),

Y (top/bottom), and Z (front/back) axes. They also can be colored, textured, stacked, reshaped, or moved without affecting the background or any other surrounding object.

The advantage of vector programs is that you can scale without interpolation in a manner similar to that of working with PostScript font files. The disadvantage is that a vector image is more difficult to edit pixel by pixel. Since vector software is designed for modeling, drafting, and illustration applications, it generally is not suited for working with photographic images, which are only 2-D objects. A photographer would use a vector program to create a lensless image, a photorealistic 3-D computer-generated image. For example, if a photographer wanted to add a dinosaur to a landscape picture, it could be created with a vector program and dropped into the scene.

BASIC DIGITAL IMAGING CATEGORIES AND TOOLS

TOP MAIN MENU OPTIONS

The major imaging software programs possess common categories and features located across the top of the screen in the main menu, which allows access to many of the editing functions. The most common basic categories are File, Edit, View, Insert, Layer, and Filter (see Figure 8.19). Within these categories (and sometimes unique features), there are hundreds of selections that, when used in combination with the toolbar, can create thousands of ways to manipulate an image.

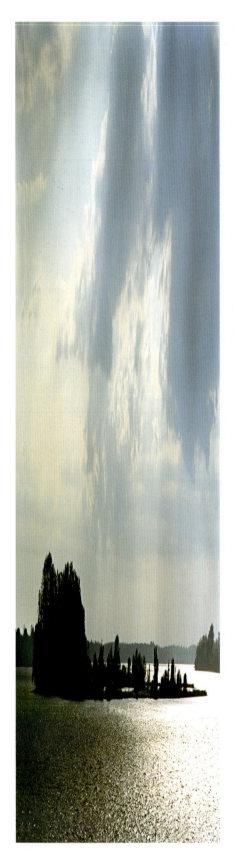

CUT/COPY AND PASTE FUNCTIONS

Located in the Edit category in the top main menu, *Cut*, *Copy*, and *Paste* are essential and powerful functions of the computer that allow one to replicate and move information. Cutting and pasting is possible between files made using different software as well as between documents made using the same software. Sometimes the data structure of the information is not compatible. However, most professional software applications have a set of procedures, usually located under File or Edit in the main menu, for converting and opening files produced by different applications.

SCALE AND DISTORT FUNCTIONS

In the Edit category in the top main menu, *Transform*, *Scale*, and *Distort* are the tools that can influence depth perception by altering an image's original context or creating an image that challenges prescribed visual assumptions and expectations. For example, an image or a portion of an image can be foreshortened to simulate perspective or stretched horizontally or vertically to fit into a specifically defined area.

Overall print sizing controls are generally located in the Image category in the top main menu under *Image Size* or *Canvas Size*. Both of these functions make an image larger or smaller when outputted. Changing image size affects the overall dimensions of the image, whereas altering the canvas size crops the image or allows for the creation of blank drawing space.

FIGURE 8.20 "This view camera image was taken of Strawberry Island in the Niagara River in Buffalo, NY. The resulting landscape was stretched into a shape where the vertical dimension was eight times normal. The scroll-like format squeezes the long, flat island into a compact shape, and the willow clumps are transformed into cypresses, seeming to recall Arnold Böcklin's painting *The Isle of the Dead* (1880)."

Credit: © John Pfahl. *Isle of the Dead*, 2006. 84 x 21 inches. Inkjet print. Courtesy of Janet Borden Gallery, New York, NY.

FIGURE 8.21 "I use the distortions of an oatmeal-box pinhole camera with 8 x 10-inch black-and-white film and the colorizations created in Photoshop to create a series of visceral images that probe the unconscious mind. These images step away from the literal reality, choosing instead to speak with a Jungian expressionism. Objects and places juxtaposed with the model trigger a response that I react to while colorizing each image. Through successive pulling of curves, black-and-white values are replaced with color that ultimately connects with the dreamlike state of the finished image."

Credit: © Dan McCormack. *Sara*, 2005. 12 x 11 inches. Inkjet print.

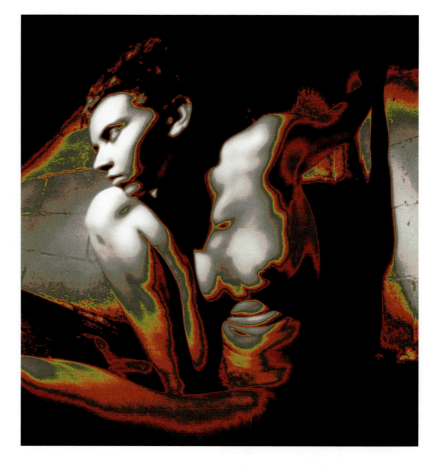

DIGITAL FILTER FUNCTION

An image also may be manipulated through a wide variety of filter effects located in the top main menu category called Filter. Typically, programs offer a wide range of common and artistic filter effects, such as blur, distort, mosaic, pixelate, sharpen, reticulation, chalk, and charcoal. In the nineteenth century, photographers adopted the aesthetic strategies of painting as picturemaking models. Today, third-party software manufacturers provide a similar service with special filter effects known as plugins (see Chapter 4), which offer additional digital tools to simulate drawing, painting, and photographic effects. As the digital aesthetic continues to evolve, imagemakers will be less reliant on older media and filters that simulate past and nostalgic working methods, allowing a new and authentic digital syntax to develop and mature.

TOOLBAR ICONS FOR ADDITIONAL PHOTO EDITING

Many of Photoshop's common editing tools have since migrated to other imaging programs. These tools can be found in a floating toolbar that defaults to the right or left side of your screen. Refer to the application's Help menu or the manufacturer's manual for complete and detailed descriptions of all tools. Depending on the program, many of the visible tools on the toolbar have hidden options that can be revealed by simply using Click-hold or Option-click on the visible icon. Also, each tool has editable options that are usually displayed in an Options bar underneath the main menu when a tool is in active use. The Options bar provides a convenient way to change numerous options related to the active tool's function, such as brush size, font size, type of gradient, transparency, and colors. Start exploring and see what tools work best for you.

COMMON TOOLBAR ICONS FROM PHOTOSHOP

Black Arrow

When an arrow appears in the lower right corner of a tool icon, there are more similar tools to be found by clicking and holding the mouse button on that arrow icon. The icon figures below show the Toolbar icon and the additional tools belonging in that group when holding down on the arrow symbol and selecting the other similar tools.

Important note: Toolbar remembers the last tool used and does not revert to default. Toolbar can become confusing at times because tools seem to change when using Arrow to switch to similar tools. All Tool Bar icons show the additional related tools in that group.

Move Tool

Use this tool to select and move objects. Keyboard arrow keys can be used to move pixel by pixel. Move tool is also used to change the hierarchy of the layers and to move a Layer around after it has been placed. Hold the [Shift] key to limit the movements to vertical/horizontal.

Marquee Tools

FIGURE 8.22
Photoshop Toolbar (left).

The Marquee tools are used for creating simple geometric selections in your images (rectangle, elliptical, and single row selections all are similar options). Since a computer cannot yet read your mind, use the Marquee tools to indicate the area you want to work within. Once an area is selected, any adjustments, tools, or filters will be applied only to that selected area.

Lasso Tool

The three Lasso tools are a free-form selection tool that, with practice and a steady hand, are excellent for selecting odd portions of an image that might otherwise be impossible to edit. Unlike the Marquee tool, the Lasso allows you to draw both irregular and straight-edged selections. The Lasso tools have three similar modes: Free-form Lasso allows you to draw complex, irregular selections in a manner similar to a drawing pen; Polygon Lasso allows you to draw simple, straight segments; and Magnetic Lasso automatically follows the edge of an image based on color differences or contrast.

Magic Wand

Use the Magic Wand to select a value or color range. This will select a block of color, or transparency, based on wherever you click. In the Options bar at the top, you can change the Tolerance to make your selections more or less precise.

Crop Tool

The Crop tools are used to draw a rectangle around a portion of an image and discard all image information outside that area. Before cropping, the rectangle can be adjusted for size and also can be tilted, rotated, and distorted by using control points on the edge of the selected object. Areas not selected appear darker, so it is easy to see exactly what will be cropped.

Eye Dropper

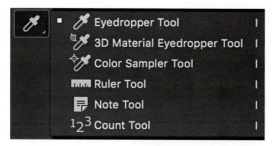

Both the Eyedropper and the Color Sampler tools can be used for gathering color data for adjustment and comparison purposes. The Eyedropper tool samples color of selected pixels to designate a new foreground or background color. The Eyedropper can be used in conjunction with the Info palette to read color values from your images as well as the X and Y coordinates of the cursor. Using the Color Sampler tool allows you to select up to four color samplers to display either RGB or CMYK color information in the sampled areas, which you can see in the top menu under the Window > Info box. These samplers are saved in the image file, so you can reference and compare color information repeatedly while working on an image. This color information will remain even after you open and close the file.

Healing Brush Tools

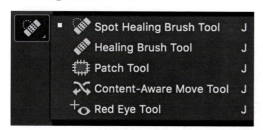

The five Healing Brush tools are used to sample an area of an image and copy that sample to another area. The tool is useful in removing imperfections because it matches the colors of the sampled pixels with the area around the target imperfection. In addition to matching the color of pixels, the Patch tool matches the lighting, texture, and shading of the sampled pixels to the target receiving area, which can be valuable when you are doing restoration work.

Brush and Pencil Tools

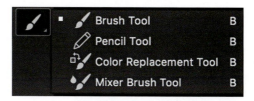

The Brush and Pencil tools allow you to paint with the selected color. The brush's size, shape, and edge sharpness can be changed in the Options palette. The blending mode, opacity, and flow of the brush also can be adjusted. Any Opacity setting lower than 100 percent will allow the underlying image to be seen. Flow determines how quickly the digital paint is applied. A lower setting produces lighter strokes. The Pencil tool allows you to draw a line in a specified pixel size. It creates sharper edges than does the Brush because it leaves out the antialiasing (softening of edges) that the Brush utilizes.

Clone

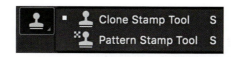

The Clone Stamp tool, like the Healing Brush, is used to sample pixels in one part of an image and clone (copy) them to another part of an image. As in the case of the Brush tool, the size, blending mode, opacity, and flow can be tailored to suit the task. The Clone, Healing, and Patch tools are excellent for removing dust spots and repairing damaged photographs.

History Brush

The History Brush tool provides a freehand way of selectively restoring color, detail, smoothness, saturation, or any other image attribute from an earlier point in a picture's history to a previous state of an image. You can use the History Brush from any step found in the History palette. Also, it is often used to convert a color image to black and white and then brush the original color back into a specific area.

Eraser

The Eraser tools delete or alter pixels. When you are working on the background layer or with the layer transparency locked, the pixels will be changed to the background color. In other situations, the pixels are erased and become transparent. The Background Eraser samples the color in the center of the brush (indicated by a brush shape with a crosshair) and deletes that color in the target area. The Magic Eraser tool changes or erases all similar pixels within a certain tolerance (tonal range).

Gradient Tools

The Paint Bucket tool fills an area with the foreground color. Like other tools with a tolerance setting, the Paint Bucket will replace all of the adjacent pixels that fall within the specified range. The Gradient tool works with the foreground and background colors to create a gradient between the two colors. It also allows you to

apply graduated color fills or effects that blend from one color or effect to another.

Blur Tools

The Blur tool makes things blurry. Click and drag to make things blurry. The more you click and drag, the blurrier things get.

Dodge and Burn Tools

The Dodge tool is used to lighten a portion of an image, such as an object in shadow. The Burn tool is used to darken areas of an image, such as in edge burning, where the corners are slightly darkened to help keep the viewer's eye from wandering out of the composition. The size of the tool, the range (highlights, midtones, or shadows), and exposure can be defined and controlled.

Pen Tools

Pen is for tracing in which you would use the Path Selection Tool to select the path. Paths can be used in a few ways, mostly to create clipping paths or selections. You use the tool by clicking to add a point. If you click and drag, it will change the shape of your path, allowing you to bend and shape the path for accurate selections and such.

Text

The Text tool is used to create horizontal or vertical type anywhere in an image or make a Type mask in the shape of any type. Any font that is properly installed and available to your operating system can be created. You can format the text in numerous ways, including font, size, style, color, alignment, horizontal or vertical orientation, justification, kerning, indenting, leading, and line spacing. Additionally, you can stretch and warp the shape of the text in a variety of ways.

Path Selection Tools

You use this tool when working with paths or shapes created with the pen tool. It is related to the Pen tool.

Rectangle Shape Tools

These tools create a Shape Layer in the form of the shape selected. They fill the rectangle with whatever color you have selected.

Hand Tool

The Hand tool is for moving or rotating the entire image within a window. So if you're zoomed in and your image area is larger than the window, you can use the Hand tool to navigate around your image; just click and drag.

ADDITIONAL TOOLBAR TOOLS

 Zoom

It allows you to zoom into your image for detailed work. Hold the [Alt] key to zoom out. Holding the [Shift] key will zoom all of the windows you have open at the same time. Double-click on the Zoom tool in the palette to go back to 100 percent view.

Color Picker

Toolbar Color Picker and selecting foreground background colors.

Quick Mask

Quick Mask is a temporary mode that is used to precisely define and edit selections, which can then be saved and used again. With Quick Mask, you can make selections using the Brush tools and then let color and opacity settings differentiate which items are fully selected and which are partially (semi-transparently) selected. It also allows you to preview your selection.

Screen Modes

In Full Screen Mode, panels are hidden. They can be accessed on the sides of the screen or revealed by pressing the Tab in the lower corner while in Full Screen Mode. You can return to Standard Screen Mode by pressing F or Esc. The three screen modes allow you to size what options you want to see outside the image area.

ADDITIONAL PHOTOSHOP TOOLS

Layers

Layers increase the creative control and flexibility of image building by allowing you to work separately on the various image components, such as a background color, shapes, selections from other images, and text. By clicking on the Create New Layer button, you can add new additional layers or levels (see Figure 8.23). Thus, a final composite image can be made up of numerous layers that are stacked in an order hierarchy. This order can easily be changed by dragging a layer from within the Layer window to another level or position. Moving a layer to the top makes it the most accessible layer, and the other layers fall below it in descending order. The opacity levels are set for each layer independently when a layer is active and selected. The control of opacity comes through the Opacity window located in the top

FIGURE 8.23 Layers with drop down Blending menu options showing how you can create an unlimited number of layers and name them separately.

right corner of the Layer menu. You can work on each layer as if it were an independent image without interference from any graphical elements that are on other layers. Located at the top left corner is a drop-down menu containing the Blending menu options. These options change the way the layers interact with each other. Experiment with the different modes. Each time you paste something into a Photoshop image, another layer containing the new content is automatically created.

Changing Mouse Pointer

When tools are selected, the mouse pointer matches the tool icon. Many of the drawing and painting tools are circles, which represent the selected width. Each cursor has a hot spot where the effect begins—for example, the selection begins at the tail of the lasso's loop for the Lasso tool.

Option/Shift/Command Keys

Knowing when to the use the Option, Shift, or Command keys in conjunction with the currently active tool is necessary to use many of the tools to expand their functions. For example, using the Option (Mac) or Alt (PC) key with the Zoom tool changes the mouse pointer to a plus or minus sign, allowing you to zoom in or zoom out of the image on screen. Also, using the Shift key with the Magic Wand allows you to add to your previous selection, enabling you to group selections as you click along with the Shift key held down.

THE COMPUTER AS A MULTIMEDIA STAGE: MOVING IMAGES

Moving images, including video, represent time and space differently from still images. With video, a viewer tends to get involved within an open flow of events, whereas a still image is a distillation that invites a tighter viewing and interpretation. The process of assembling and editing video images on a computer is known as

FIGURE 8.24 Ellen Jantzen explains: "Having recently moved, I have been exploring the realm of one's environmental surroundings, how it is absorbed into one's psyche and how this changes through relocations. A new environment can bring both delight and a fear of the unknown. How does one grow into feeling at home? I'm striving to visually capture the essence of my new environment while at the same time learning to understand. Add to that a landscape (the American West) that is fraught with cliché, and I find myself aspiring to bring my new home into focus, to make it my own. This image was made from two separate photographs. I captured the left side of the image and then moved the camera slightly to capture the right side. In Photoshop I blended the images, then created my montage using cut and past, blur and blending modes."

Credit: © Ellen Jantzen. *Pueblo Ascending*, from the series *Coming into Focus*, 2016. 24 x 52 inches. Chromogenic color print.

BOX 8.6 VALUABLE COMPUTER DATA HABITS

- **Save Often**: Problems with the power supply, misread data, and/or mechanical failure can make your digital data inaccessible. Frequently saving data, every 15 to 30 minutes, is the only way to avoid problems and frustration. When working on important projects, make copies on a reliable removable medium, such as a portable flash drive, for safekeeping.

- **Delete Old Files**: A hard drive filled with old files can become a liability by preventing you from having an adequate scratch disk. Free up space by transferring nonactive files to a backup storage medium, such as a hard drive or off-site Web storage (a.k.a. the cloud).

- **Back Up**: Set your computer to make regular backups on an external storage device, including the cloud. Files can be corrupted by a computer virus (a malicious program designed to infect computers and destroy or interrupt data) or even through everyday use.

FIGURE 8.25 Original image capture of Figure 8.26.

Credit: © Barry Andersen. *Sheep and Standing Stone, Avebury, England*, 1995. 10 x 12½ inches. Inkjet print.

FIGURE 8.26 "I am interested in the interface of humans and the land, and the beauty that often takes place in peculiar ways at this intersection. The original image had a bare, overcast, bright sky, and the right side of the picture dropped to a cluttered, deep space. These things left the image unsatisfactory to me for years until I began using digital tools. I replaced the sky with a sky shot earlier in England. The picture changed dramatically. I then copied the left hillside, changed its shape, and added textural and color variations to improve the right side of the picture. I then replaced the color of the brown grass near the sheep with a greener color and removed the bird droppings from the stone. This picture is one of my most heavily manipulated pictures but utilizes pictorial methods generally taken for granted by painters. It was a major breakthrough for me of freedom from the lens-formed image."

Credit: © Barry Andersen. *Sheep and Standing Stone, Avebury, England,* 2000. 10 x 12½ inches. Inkjet print.

nonlinear video. Software packages edit video by creating fragments called *clips*. A video clip can be combined with sound, previewed, and altered in much the same way as a single image.

Cell animation programs, many of which are vector drawing programs, manipulate discrete objects and create the illusion of movement by showing sequential frames with incremental motion. The cell elements can be independently controlled, allowing the background to remain stationary while objects in the foreground display motion.

QuickTime is a multimedia platform developed by Apple for handling digital images, video, and sound. QuickTime movies incorporate a series of compression PICTS and allow moving images and sound to be created, stored, and viewed. QuickTime movies compensate for the speed of your computer, keeping the sound properly synchronized with the picture. Apple's newer AVFoundation allows moving images and sound to be created, stored, and properly synchronized for viewing. Adobe Premier is designed for timeline-based video editing with direct access to Photoshop.

Three-dimensional modeling programs are vector drawing programs that have the capability to render an object and simulate the effects of light. The completed object can be viewed from any angle and direction. Such modeling programs are often coupled with an animation component that allows a piece to be presented as a movie.

THE INTERNET AND THE WORLD WIDE WEB

The Internet is a global, publicly accessible system of interconnected computer networks that transmit data by means of packet switching using the standard Internet Protocol (IP). The combination of millions of small business, academic, domestic, and government networks, it carries information and services, such as electronic mail (email), online chat, and the interlinked Web

pages and other documents of the World Wide Web (WWW). By means of a modem, a computer user can send and receive digital data via the Internet to and from any other connected user. Online data services allow one user to download an image file and electronically mail it to other users. The downside to the Internet continues to be the time it takes to transmit data, service interruptions, and compatibility issues, especially with image files.

The Internet and the World Wide Web are not one and the same: the Internet is a collection of interconnected computer networks, linked by copper wires, fiber-optic cables, and wireless connections, whereas the Web is a collection of interconnected documents, linked together through hyperlinks and URLs (Web addresses), which is accessible through the Internet. In addition to the multifaceted physical connections that make up its infrastructure, the Internet is essentially defined by its interconnections and routing policies that are the result of commercial contracts and technical specifications (protocols) that describe how to exchange data over the network.

INFORMATION SHARING: SEARCH ENGINES AND WEBLOGS

The Web offers a unique environment for sharing information, images, videos, and other data. By means of keyword-driven Internet search engines, such as Google, people throughout the world can access vast and diverse amounts of online information. The World Wide Web has enabled a sudden and extreme decentralization of information and data, making traditional encyclopedias and libraries seem quaint and arcane. Numerous individuals, groups, and companies use social media, such as Facebook, Instagram, or Weblogs (blogs), which are basically easily updatable online diaries, to share images and thoughts.

DIGITAL GALLERIES

Digital galleries and artist websites have become major presentation venues for displaying images. Where once mainline brick-and-mortar art centers and big media once controlled what the public saw, now digital galleries, such as Lenscratch and L'oeil de la Photographie (The Eye of Photography), allow artists to bypass these traditional gatekeepers and get their work seen.

It is vital to bear in mind that viewing images in a gallery setting is quite different from looking at images on a computer monitor or in a book. A 4 × 5-foot image carries a distinctly different message from one that is 8 × 10 inches. The computer screen changes these circumstances by making all images roughly the same size and having them viewed by transmitted light instead of reflected light. The aura of a gallery setting is replaced by the appearance of the desktop. Work made specifically for important galleries and museums, such as the Guggenheim Museum, which has been commissioning and collecting online art for its permanent collection, has embraced the Web. Not having your work on online has become the equivalent of being invisible. Therefore, it is a must for imagemakers and galleries to represent their work online. As serious imagemakers expand their use of the Internet, the presentation, selection, and quality of images and the audiences responses continue to develop and expand.

THE DIGITAL FUTURE

The rationale for working with any photographic process should be embedded within the context of the imagery being created. Since the nineteenth century, camera-based imagery has followed three mainline processes: silver, digital, and hybrid. The silver process is rooted in the hands-on chemical darkroom dating back to the origins of photography and offers the benefit that one's knowledge and equipment can last for many years. The digital system encourages fast and accurate image construction through the convenience of a dry darkroom, but demands a constant investment in learning and technology due to its ever-changing knowledge base and its attendant equipment. The hybrid approach combines desired aspects from both models to deliver results that may not have been possible within the realm of one method. It can be

FIGURE 8.27 Michael Light created a conceptual meditation on the nature of the atomic bomb by digitally "cleaning up" historic imagery into a textless artists' book that was published in six worldwide trade editions. "The challenge was to fashion a narrative that could modulate a viewer's emotions of an apocalypse in order to reveal something that was not previously seen or understood without generating 'war porn' from such intrinsically terrifying images. Digital tools made the entire process, involving both the book and then an exhibition, easier." The project title, *100 Suns*, refers to J. Robert Oppenheimer's response to the world's first nuclear explosion when he quoted the Bhagavad Gita, "If the radiance of a thousand suns were to burst forth at once in the sky, that would be like the splendor of the Mighty One . . . I am become Death, the destroyer of worlds."

Credit: © Michael Light. *045 Stokes, 19 Kilotons, Nevada*, 1957, from *100 Suns*, 2003. 20 x 16 inches. Inkjet print. Courtesy of Hosfelt Gallery, San Francisco, CA, and New York, NY.

FIGURE 8.28 Working where nineteenth- and twenty-first-century technologies and theories of color vision intersect, Ellen Carey first makes a cameraless image (a photogram). Next, she copies this image onto 4 x 5-inch color transparency film, which is scanned, manipulated in Photoshop, and then printed. At the intersection of all the geometric lines of this large-scale work, the cones and rods of the human eye try to process the dissimilar color wavelengths of light. This results in an afterimage, an optical illusion that occurs after looking away from a direct gaze at an image, which blinks back at the viewer.

Credit: © Ellen Carey. *Blinks*, 2006. 44 x 55 inches. Inkjet print. Courtesy of JHB Gallery, New York, NY, and Paesaggio Fine Art, Hartford, CT.

the best of both worlds, allowing one both physical and electronic interaction with the imagemaking process.

In the end, what matters is the artistic and technical abilities of individual imagemakers, their handling of subject matter, and their viewers' reaction to the work. Recent artistic, economic, and environmental concerns; changing audience expectations; and a new generation of imagemakers who have grown up with digital technology have led to a rapid decline in silver-based photography. That said, as digital tools improve, utilizing them to intersect within the boundaries of analog photography has become easier and more acceptable. Almost every photographer now uses electronic-based correction devices to create new post-capture realities in the studio and experiment with hybrid methods that combine analog and digital methods to invent fresh visions. As the quality and variety of digital images progress, ingenious makers will find new applications in art, business, entertainment, and science, creating new pathways for digital images to circulate and be a ubiquitous part of daily life.

FIGURE 8.29 *Eastman Kodak Office Building at Night, Rochester, N.Y.* "Tallest Building in Rochester," circa 1930s. 3½ x 5½ inches. Color lithograph postcard. Published by Manson News Agency, Rochester, NY.

Credit: Courtesy of Robert Hirsch Collection.

REFERENCES

Adobe Photoshop Help: www.photoshop.com/products/photoshop/help

Evening, Martin. *Adobe Photoshop CC for Photographers: A Professional Image Editor's Guide to the Creative Use of Photoshop for the Macintosh and PC.* New York and Oxford: Focal Press, 2016.

Evening, Martin. *The Adobe Photoshop Lightroom CC Book: The Complete Guide for Photographers.* Berkeley, CA: Adobe Press, 2015.

BOX 8.7 MANUFACTURERS' WEBSITES

Check manufacturers' websites for product details, tutorials, and customer support. Some of the major ones include the following:

Adobe	www.adobe.com	Hewlett-Packard	www.hp.com
Apple	www.apple.com	Kodak	www.kodak.com
Canon	www.canon.com	Moab	www.moabpaper.com
Canson	www.canson-infinity.com	Nikon	www.nikon.com
Epson	www.epson.com	Olympus	www.olympus.com
Fuji	www.fujifilm.com	Sony	www.sony.com/electronics/
Hahnemühle	www.hahnemühle.com		cameras

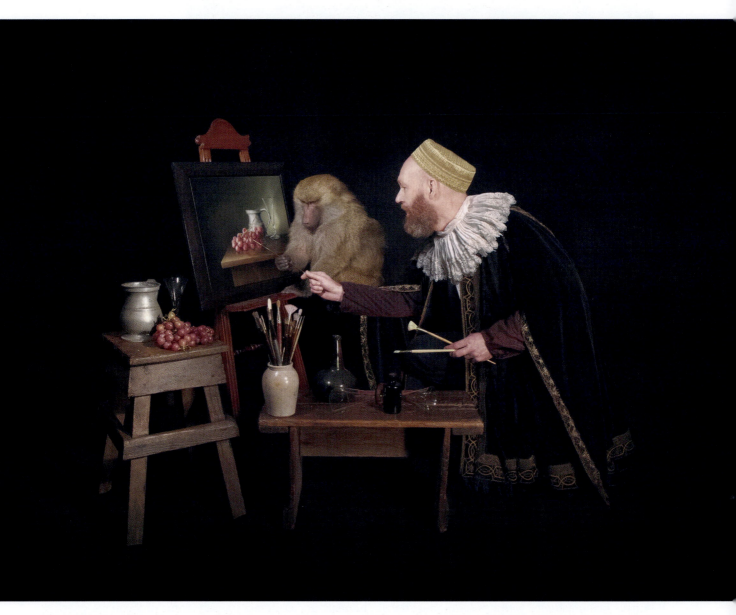

FIGURE 9.0 Tami Bahat tells us: "*Dramatis Personae* is an homage to the old masters: their brilliant use of light and the raw emotion of the characters portrayed. Caravaggio, Rembrandt, Vermeer . . . I grew up captivated by their stunning works, found hanging from museum walls and in art books at home. It's vital for me to show the essence of humanity in a way that moves far beyond trends and honors the souls of the 'ordinary' who are indeed extraordinary. This world of *Dramatis Personae* feels native to me, with all its idiosyncrasies and darkness. It's important for me to create a sense of mood and to sculpt the light for each particular scene. I often start with a single light source and fill as needed. Each photograph is paired with an antique frame that carries its own story. Often delicate because of age, they are an important component to each piece, bridging the gap between past and present."

Credit: © Tami Bahat. *The Painter*, 2017. Variable dimensions. Inkjet print.

Presentation and Preservation

DIGITAL RETOUCHING AND REPAIR

After you've made a meaningful digital image, you might want to physically present it and properly store it for future use. First, you should make sure that any visual defects, including dust marks, have been corrected before making final prints, which means using a few of the retouching and repair tools. Those same tools in your digital imaging software can also help you restore faded images as well as color negatives and transparencies (slides). Additionally, such software offers potent tools for retouching and repairing traditional photographic images. A moderately to severely damaged image can be scanned, electronically repaired, and then reprinted (see Figure 9.1). One of the most important advantages of repairing an image digitally is that, after the image is scanned, the original image is not touched and cannot be accidentally damaged further during the repair or retouching process. Some of the most useful software tools for image retouching and/or repair are described in Chapter 8.

ARCHIVAL PRESENTATION

Although manufacturers readily use the term *archival*, there is no accepted criterion of what archival actually means. What we do know is that every image has a natural life span and the length of that life span depends on the particular materials and process used and the conditions under which the image is cared for. The purpose of archival presentation is to protect the image from physical harm and to guard against elements that accelerate the aging process (see the "Factors Affecting Print Preservation" section later in this chapter). This ensures an image can last as long as physically feasible. A competent presentation can enhance the visual appeal of a work, protect it, and send the message that this work is something worth looking at and protecting. Sources for materials and supplies are provided in Box 9.8: Sources of Presentation and Preservation Supplies.

PRESENTATION MATERIALS

Mat board is the long-standing choice for providing a stiff backing and basic protection for photographic prints. Making thoughtful choices is essential, as the color, quality, and texture of mat board will affect how viewers receive your images.

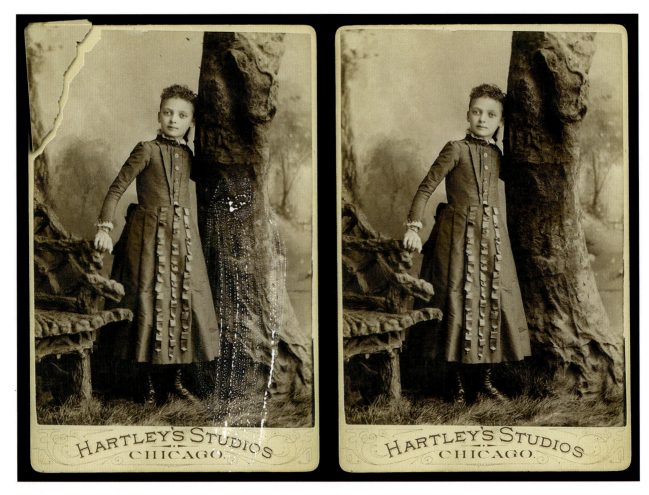

FIGURE 9.1 In preparation to repair this damaged cabinet card photograph made by Hartley's Studios, Chicago, Illinois, circa 1890s, Greg Erf scanned both pieces of the torn image separately and brought the scans together into a single file. Erf then utilized the Healing Brush, Patch tool, and Cloning Stamp to copy areas immediately next to missing visual information, which he used to cover the tear and the white streaks. He adjusted the contrast using Levels and the color using Color Balance, Hue, and Saturation. Finally, he sharpened the image.

MAT BOARD SELECTION

To select the proper type of mat board, you should become informed about how various products affect paper support materials. Check with manufacturers for their latest products and technical specifications. Consider the factors in Box 9.1.

WINDOW MAT

The window mat, considered the standard enclosure for photographic prints, is made up of two boards, larger in all dimensions than the print. The top board, known as the *overcoat*, has a window cut with beveled edges to keep it from casting a shadow onto the print. This overmat is attached, with a linen tape hinge, along one side of the backing board. The print is positioned and attached to the backing board so it can be seen through the window (see Figure 9.3). The mat gives the maximum protection to the print while it is being shown and also when it is stored. It provides a raised border to contain the work, and when the work is framed, it keeps the glass from directly touching the print surface. If the window mat is damaged or soiled

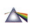

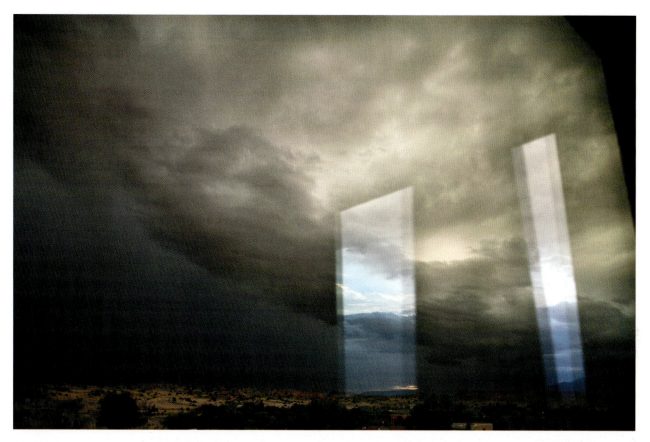

FIGURE 9.2 In Laurie Tümer's *Clouds* series is a meditation on the sky's ephemeral and ever-changing form that she photographs from inside her live-in studio in New Mexico that sits high with vast views. Her clouds are seen through a window mostly from a reclining position due to disability, thus why only a bit of the horizon is seen. A variable lens (28 x 200mm) allows her to bring clouds closer when needed. Human activity and the natural world meet in those images where she includes reflections on the glass. The effect is often surprising, with images that suggest monuments in the landscape or that are mistaken for surrealistic double exposures. She presents her prints in deep window mats (8-ply) that extend beyond the print to suggest that these were taken through a window. Tümer originally chose to print her clouds as miniatures, as she considered Alfred Stieglitz's small revolutionary (contact) prints of clouds that resonated larger than their scale, and she identified with him, as he also took these at a time when the excitement of what he saw was an antidote to hard times. She is interested in exploring the impact of scale and viewing these in book form, on a computer screen and wall.

Credit: © Laurie Tümer. *Cloud #8584*, from the series *Clouds*, 2015. 18 x 12 inches. Inkjet print. Courtesy of photo-eye Gallery, Santa Fe, NM.

for any reason, it can always be replaced without damaging the print. An acid-free tissue paper can be sandwiched over the print surface for additional protection.

A mat can be cut by hand with a straight edge and mat cutter, such as a Dexter-Russell, which requires practice before using. An easier but more expensive option is a tabletop device, such as a Logan mat cutter. If you have only an occasional need for a mat, have a local frame or art supply shop make one for you.

When selecting mat board, keep in mind the type of light under which the print will be viewed. Daylight tends to have a blue cast, incandescent light is orange, and fluorescent light is generally greenish.

Be sure to select a color that complements your image's color scheme or gray scale and does not overpower or distract from it. When in doubt, keep it simple and stick with an off-white or light gray colored board. To make a window mat, follow the steps in Box 9.2.

BOX 9.1 MAT BOARD CRITERIA

1. Composition board is the most widely available and has the least longevity. Usually, composition board is made up of three layers: a thin top paper sheet, typically colored; a middle core layer, made of chemically processed wood pulp; and a bottom paper backing. The core layer is the product's weakness because it contains a collection of acids and chemical compounds that break down and produce additional acid. These acids are transported in microscopic amounts of airborne water vapor onto the surface of your work. Here, they begin attacking the image, often within a year or two, causing discoloration and fading. UV radiation from the sun and/or fluorescent lights can accelerate this chemical reaction.

 The same thing can happen when a work is backed with corrugated cardboard or Kraft paper. The acids in these materials invade the work from behind, and by the time it becomes apparent, there is irreversible damage.

2. Conservation-grade board consists of thin layers, all of the same color, known as plies. One type of board is made from purified wood pulp and is simply known as conservation board. The other type is made from 100 percent cotton fiber and is called rag board. Plain conservation board can be used for most archival operations, since it costs less, has equal longevity, and is easier to cut when making window mats. Most board is available in two, four, six, or eight plies. Four-ply board is good for most standard photographic presentations.

3. Acid-free board is recognized as the board of choice. Paper products having a pH of 7 or higher are considered to be acid-free. The pH scale measures the most acidic (pH 1) to the most alkaline (pH 14), pH 7 being neutral.

 The "acid-free" label is an important criterion, but there are a number of factors to consider when making a selection. The reason is that the term acid-free can be very misleading and at face value should not be considered the gold standard of a board's permanence. In fact, some manufacturers use only a piece of acid-free paper to cover the wood pulp of composition board and then label their product "archival." Others have added regular wood pulp that has been heavily treated with alkaline calcium carbonate and refer to it as "archival." This is in spite of the fact that, over time, the impurities in the board deteriorate and form acids and peroxides, thus producing or returning to a highly acidic board. When selecting an acid-free board, investigate whether all the materials in the board are 100 percent acid-free, as this will offer your work the most protection.

4. The use of buffered versus nonbuffered board is presently being debated in the conservation community. Since our physical surroundings are slightly acidic, and because paper tends to become more acidic with age, manufacturers of premium mat board have been adding calcium carbonate to offset this tendency. Current research indicates that certain papers may be affected by the presence of this alkali buffer and that, for longest life, they should be mounted only on nonbuffered, acid-free board. This recommendation also applies to all color chromogenic prints processed in RA-4 chemistry, such as Lambda prints.

DRY AND WET MOUNTING

Traditionally, dry mounting was the most common way to present a finished print for display. It is a fast and neat method to obtain print flatness, which reduces surface reflections and gives the work more apparent depth (see also the later section "Cold Mounting"). Prints can also be wet mounted with glues, paste (Gudy paste is archival), and liquid and spray adhesives, which can be useful when time is of the essence or when working with certain nontraditional materials.

There are a number of problems resulting from dry mounting:

1. Dry mounting can ruin a finished print through accident or failure of equipment or material.
2. After the print has been dry mounted, changes in heat and humidity, especially if the prints are shipped, can cause the print to wrinkle or come unstuck from the board. This happens because the print and the board do not expand and contract at the same rate. Since they are attached and the board is stronger, the print suffers the consequences.
3. The adhesives in most dry-mount tissue are not archival and can have adverse effects on the print, causing it to deteriorate. However, there is "archival-grade" dry-mount tissue made of buffered paper.
4. Since dry mounting usually does not include an overmat, if the print is dropped facedown, it is offered no protection and the print surface can be damaged.
5. Any damage to the board creates a problem. Conventional dry mounting is not reversible or water soluble, making it almost impossible to detach the print undamaged from the dry mount. Therefore, replacement of a damaged board is extremely difficult. Some low-heat dry-mounting tissues claim to be temperature reversible.
6. Many papers, especially glossy inkjet paper, react negatively to heat. High temperatures can produce blisters, color shifts, mottling, loss of glossy finish, and/or smearing.

FIGURE 9.3 The construction of a typical hinged window mat. The use of photo corners facilitates removing the photograph from the mat without harming it.

FIGURE 9.4 The dimensions of a window-type overmat for a 16 x 20-inch print on a 20 x 24-inch board. More space is usually left on the bottom of the mat than at the top to keep the print from appearing to visually sink on the board. The side borders are generally of equal dimensions.

7. Other methods of dry mounting with spray mounts and glues are not recommended because the chemical makeup of these materials can have an adverse effect on all prints over time.
8. Curators and collectors no longer dry mount work that is received unmounted. Also, it is not advisable to dry mount unless you made the print yourself or a duplicate is available. If, after considering these problems, you still want to dry mount, use only a matte surface paper and follow the guidelines in the next section.

BOX 9.2 MAT CUTTING STEPS

1. Clean your hands, working surface, and all materials.

2. Work under light similar to that under which the print will be seen.

3. Protect the cutting surface with an unwanted piece of board that can be disposed of after it gets too many cut marks. If you plan to cut mats on a regular basis, consider getting a self-healing cutting surface with a grid pattern and nonslip bottom.

4. Using a good, cork-backed steel ruler, measure the picture exactly. Decide on precise cropping. If the picture is not going to be cropped, measure about 1/16 to 1/8 inch into the picture area on all sides if you do not want the border to be seen.

5. Decide on the overall mat size. Leave enough space. Do not crowd the print on the board. Give it some neutral room so the viewer can take it in without feeling cramped. Box 9.3 offers a general guide for the minimum size board with various standard picture sizes.

 Many photographers try to standardize their sizes. Standardization avoids the hodgepodge effect that can be created if there are 20 pictures to display and each one is a slightly different size. It also allows you to swap prints and reuse the mat. When you have decided the proper size, cut two boards, one for the backing board and the other for the overmat. Some people cut the backing board slightly smaller (1/8 inch) than the front. This way there is no danger of its sticking out from under the overmat.

6. When you are figuring the window opening, it is helpful to make a diagram (see Figure 9.3) with all the information on it. To calculate the side border measurement, subtract the horizontal image measurement from the horizontal mat dimension and divide by two. This gives even side borders. To obtain the top and bottom borders, subtract the vertical picture measurement from the vertical mat dimension and divide by two. Then, to prevent the print from visually sinking, subtract about 15 to 20 percent of the top dimension and add it to the bottom figure.

7. Using a hard lead pencil (3H or harder, to avoid smearing), carefully transfer the measurements to the back of the mat board. Use a T-square to make sure the lines are straight. Check all the figures once the lines have been laid out in pencil.

8. Put a new blade in the mat cutter.

9. Align the markings with the mat cutter so that it cuts just inside the line. Check that the angle of the blade is cutting at 45° in the "out" direction for all the cuts, to avoid having one cut with the bevel going in and another with it going out. Practice on some scrap board before working on the real thing. When ready, line up the top left corner and make a smooth, nonstop, straight cut. Make all the cuts in the same direction. Cut one side of the board, and then turn it around and cut the opposite side until all four cuts are made. Start the cut slightly ahead of where your measurement lines intersect and proceed to cut a little beyond where they end. With some practice, you will be able to make the window come right out with no ragged edges. If you continue to make overcuts, simply stop short of

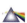

the corners. Then, go back with a single-edge razor blade and finish the cut. Be sure to angle the blade to agree with the angle of the cut. Sand any rough spots with very fine sandpaper. Erase the guidelines with an art gum eraser so that the pencil marks do not get on the print.

10. Hinge the overmat to the backing board with a piece of gummed linen tape (see Figure 9.3). The mat will now open and close like a book, with the tape acting as a hinge.

11. Place the print on the backing board and adjust it until it appears properly in the window. Hold it in place with print-positioning clips or a clean smooth weight with felt on the bottom.

12. Use photo corners to hold the print to the backing board. They will be hidden by the overmat and make it easy to slip the print in and out of the mat for any reason (see Figure 9.3).

BOX 9.3
MINIMUM IMAGE AND MAT BOARD SIZES*

Image Size	Mat Board Size
5 x 7	8 x 10
8 x 10	11 x 14
11 x 14	16 x 20
16 x 20	20 x 24

*All dimensions are in inches.

FIGURE 9.5 Basic materials for dry mounting a photograph.

THE DRY-MOUNTING PROCESS

Dry-mounting tissue is coated with adhesive that becomes sticky when it is heated. This molten adhesive penetrates into the print and mounting board to form a bond. It is best to use a tacking iron and a dry-mount press to successfully carry out the operation. A home iron is not recommended because it can create unnecessary complications.

Follow the guidelines below when dry mounting. The necessary materials are shown in Figure 9.5.

When mounting an inkjet or laser print, be certain that the dry-mounting tissue has been designed for use with that particular paper; otherwise, the print may blister and/or melt. Usually a specially formulated archival-grade, temperature-reversible adhesive tissue is recommended. It provides a safe bond that will not attack delicate items, such as inkjet prints, silk, tissue, and rice papers. Check before proceeding.

Use four-ply mounting board so that the print does not bend. As previously mentioned, keep the color selection simple. Use off-white or a light gray-colored board. The board should not call attention to itself or compete with the picture. To obtain maximum print life, use a nonbuffered, acid-free board. Regular board contains impurities that in time can interact and damage the print.

BOX 9.4 DRY-MOUNTING GUIDELINES

1. Make sure all materials and working surfaces are clean and level. Wipe all materials with a smooth, clean, dry cloth. Any dirt will create a raised mark between the print and the board.

2. Turn on the tacking iron and dry-mount press. Allow them to reach operating temperature. Check the dry-mount tissue package for the exact recommended temperature, which varies from product to product, and set the press to that temperature. Using a higher temperature will damage the print.

3. Pre-dry the board in the press. This is done by placing a clean piece of paper on top of the board (Kraft paper is all right but should be replaced after each mounting operation). Place this sandwich in the press for about 15 to 30 seconds, depending on the thickness of the board and the relative humidity. About halfway through this procedure, momentarily open the press to allow water vapor to escape, and then close it for the remaining time. This should remove any excess moisture.

4. Place the print facedown with a sheet of mounting tissue at least the same size as the print on top of it. Take the preheated tacking iron and touch it against a clean piece of paper that has been placed over the tissue in the center of the print. This one spot should be just sufficient to keep the print and the tissue together. Do not tack at the corners.

5. Trim the print and tissue together to the desired size. Use a rotary trimmer, a sharp paper cutter, an X-Acto knife, or a mat knife and a clean, cork-backed steel ruler. If you flush mount the print, the corners and edges are susceptible to damage, and it cannot be overmatted unless you crop into the image area.

6. Position the print on the board. The standard print position has equal distance on both sides and about 15 to 20 percent more space on the bottom than at the top. Without more space at the bottom, the print appears to visually sink or look bottom heavy when displayed on a wall. Carefully make the measurements using a good, clean metal ruler, and mark the board in pencil to get a perfect alignment.

7. Align the print and tissue faceup on the board according to the pencil marks. Raise one corner of the print and, with the iron, tack that corner of the tissue to the board. Next, tack the opposite corner. Now, do the remaining two. Make sure the tissue is flat; otherwise, it will wrinkle the print.

8. Put this sandwich of print, tissue, and board, with a cover sheet of clean paper on top, into the press. Make sure it is at the proper operating temperature for the materials. Close and lock the press and heat for the recommended time, usually about 30 to 45 seconds. Check the product for exact times.

9. Remove the sandwich and place it on a level surface under a weight to cool. Seal makes a special metal cooling weight for this purpose.

To maintain the integrity of large-scale prints, you may choose to dry mount onto rigid material, such as aluminum. This procedure can be done commercially using a special laminate.

COLD MOUNTING

Cold-mounting (pressure-sensitive) materials allow for quick and easy mounting of prints without heat or electricity. Premium cold-mounting material can be positioned and repositioned for accurate alignment before it is adhered, but may require its own special applicator that might not work with certain receiving materials, such as foam core. Mounting sprays also can be used but must be applied with care because you get only one chance to exactly position the print on the receiving board. Cold and spray mounting are the least desirable methods in terms of their archival qualities. Little is known about how these adhesives might change over time, and they are difficult or impossible to reverse should future circumstances warrant removal. Therefore, they are suggested only when time is of the essence and long-term preservation is not a concern.

FLOATING A PRINT

Some prints do not look good matted or mounted. The board and/or borders interfere with the workings of the picture space. In such instances, "float" the picture following the guidelines here.

1. Decide on the final picture size.
2. Working on a clean, level surface, trim the print to these dimensions.
3. Cut a nonbuffered, acid-free backing board or acid-free Fome-Cor to the same size as the print. Acid-free Fome-Cor (a.k.a. foam core) will not chemically interact with the picture and is cheaper than archival board.
4. Cut Plexiglas to size.
5. Sandwich together the Plexiglas, print, and board using a frameless device, such as Swiss Corner Clips, and it is ready to hang.

6. Clean the surface only with Plexiglas cleaner, as regular glass cleaner can damage the Plexiglas.

FRAMES

Often, a print needs a formal frame to indicate its completeness and set up a ceremonial picture-viewing space. The purpose of a frame is to provide a recognizable, conceptual structure that accents the image and focuses attention inside the picture space. Custom frames can be ordered online. Inexpensive neutral frames made of metal or wood are available at big-box discount stores. Used frames of all sorts, shapes, and sizes can be found in secondhand shops. Avoid overstating the frame, unless it is done for a specific purpose. Generally, any frame that draws and holds the viewer's eye, becoming its own point of focus, is a distraction from the image it is presenting. Ask yourself, Where are your viewers spending their time? Are they looking at the frame or looking at your picture in the frame?

UNUSUAL FRAMES AND PRESENTATIONS

Unlike traditional photography, digital imaging does not have a strict set of formal post-processing traditions. This lack of expectations allows makers and audiences to be more open to special-use frames, such as digital picture frames that allow you to upload a series of images and then play them back over and over on the frame's monitor. There are also times when makers purposely create images that are designed to be displayed in unusual containers or frames, such as a magnetic frame or even a talking frame, which contains a mini recording device that allows you to record a brief sound message. Shadow boxes, shallow, rectangular frames fronted with a clear Plexiglas cover that provides a recessed and protected view, are another option. Astonishing examples can be seen in the works of American artist Joseph Cornell, who employed them as gateways into his private dreamlike poetic world.

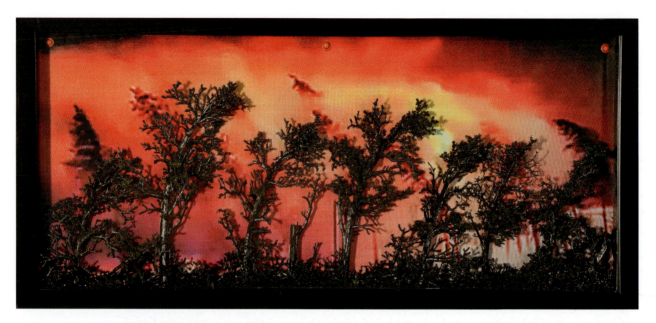

FIGURE 9.6 Bob Collignon tells us he relied on his "skills as a model and diorama builder to present a cynical sense of historical humor with the overwhelming feeling we're all heading towards the abyss . . . may be laughing all the way! The original source material were screen shots of U.S. military nuclear test film footage. The image file was then heavily processed for vibrant color and digital granularity. The diorama trees were built and bent as a counterpoint to the background appropriated image. The trees were painted with black sparkle paint to mimic both black charring from the nuclear blast, and the sparkle insinuates the 'sparkling air' that witnesses describe after experiencing a nuclear explosion. The resulting image was outputted on metallic printing paper and mounted in a three-dimensional shadow box with model trees."

Credit: © Bob Collignon. *RedSWAY*, from the series *Dance With The Devil*, 2015/2016. 10 x 21 x 2 inches. Inkjet print and mixed media.

PORTFOLIOS

Most digital images remain forever in their virtual state, yet there are situations, such as when visiting a curator or going on a job interview, when one needs to show actual prints. While getting a digital print to look good is important, the size of the print does not particularly matter because once you arrive at a good 8 × 10-inch print, making an equally good 11 × 14- or 16 × 20-inch version is not difficult. Contemplate building an 11 × 14-inch print portfolio of 20 images, something with turning pages and held in a good-quality case, which shows off the strength of your vision. Consider one that opens on three sides with clear heavyweight sheet protectors containing your images and a three-ring-binder mechanism on the spine. Strive to keep it simple, consistent, and up to date.

BOOKS: PRINT ON DEMAND

The print-on-demand business, which started as a method for publishers to save money and resources, is becoming a tool for those who desire a bound document of their own work. Print on demand makes it possible to economically produce books singly or in small quantities, and new software simplifies the book design process. Websites such as Blurb.com supply user-friendly software so individuals can design their own soft or hardcover books on a variety of papers. Available for purchase by anyone, the finished product is made to order. Another source is the combination printer and order-fulfillment house Lulu.com, which offers editing, marketing, and distribution services. An additional option is MagCloud.com, which offers users a variety of printed and web-based publishing formats and distribution services. This growing industry has opened up the previously closed and conservative business of

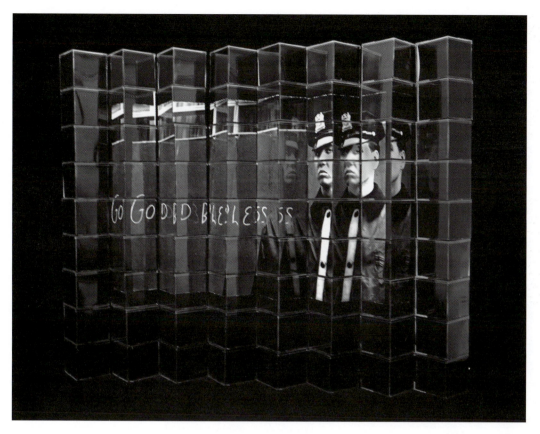

FIGURE 9.7 This installation is a stylized, three-dimensional image catalog representing the competing social landscapes that shaped the American Zeitgeist of the 1960s. The thousands of resulting pictures are presented in 4 x 4 x 4-inch transparent boxes that echo the Kodak Instamatic photo cube of that era. Taken together, these stackable cubes establish montages, sculptural structures, and individual compound portraits that can be disassembled and recast in new configurations that present numerous interpretive possibilities.

Credit: © Robert Hirsch. *God Bless*, from the series *The Sixties Cubed: A Counter Culture of Images*, 2011. 36 x 32 inches. Mixed media. Courtesy of CEPA Gallery and Indigo Art, Buffalo, NY.

publishing, turning the making of books into a means of expression that is less fixed, more interactive, and much more diversified in content. For more on this subject, see Chapter 12, "Artists' Books and Albums."

IMAGES ON A SCREEN: WEB SHARING

The display screen has generated a mind-boggling, democratic outpouring of images and is rapidly replacing the gallery wall and the book page as the major venue for looking at pictures. Moreover, projected images are becoming a more prevalent presentation method in contemporary imagemaking. Web sharing can be a first step in freeing your images from your hard drive and getting them into visual circulation. Sites such as flickr.com and smartphone applications like Instagram link billions of personal photos, graphics, slide shows, and videos to hundreds of thousands of websites, from Facebook to Craigslist. Some sites, such as www.smugmug.com, cater to amateurs posting family snapshots, although they also offer accounts with professional features that allow people to present, view, comment, and purchase watermark-protected images. The Web-sharing trend is also spinning off new ways of interacting with pictures. Websites, such as snapfish.com, allow individuals to organize their pictures, make albums and digital scrapbooks and edit and order prints and have them delivered by mail or at

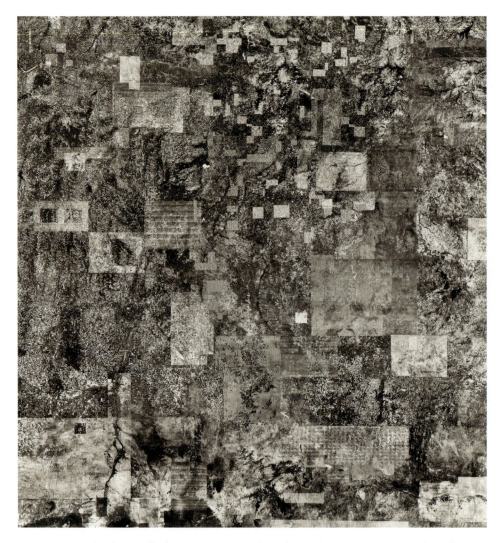

FIGURE 9.8 Richard Boutwell informs us: "I use Google Earth to gather the source imagery that will go into the final composite. The parts of the world I have used in this series illuminate the colossal impact of the last century's large-scale industrialization on the Earth in terms of energy and natural resources: atomic weapons testing; the production of nuclear energy and the long-term storage of radioactive waste; fossil fuel exploration and extraction; large-scale mining operations needed to support increased reliance on technology and renewable energy; and human intervention and manipulation of wetlands and waterways for energy generation, commerce, and recreation. By looking at the Earth from such a removed vantage point, I have attempted to put into perspective the immensity of the Earth as well as humanity's ever-increasing capacity and seeming willingness to affect global environmental change. My hope is that by seeing the Earth at this scale, without visible borders and recognizable landmarks, we can see the need for individual and collective action to mitigate future environmental disaster."

Credit: © Richard Boutwell. *Picken's Plan, Ogallala Aquifer, Northern Texas to South Dakota*, 2012. 17 1/4 × 15 3/4 inches. Platinum/palladium print.

retail locations. Web-sharing sites also make it convenient for people to link their images to blogs and social networking sites. Some people have explored *mash-ups*, which combine content from more than one source into a new integrated experience, such as using Google Earth to "geo-tag" pictures and thus create travel albums with added context and location by pairing maps with photographs. Others use Google Street View as source material for a new genre of street photography, exemplifying how makers now utilize the billions of online images to formulate new projects directly from their keyboard without even touching a camera.

BOX 9.5 WEB DESIGN RESOURCES

- **Adobe Dreamweaver**: www.adobe.com/products/dreamweaver.html

- **The Bare Bones Guide to HTML**: lists every official HTML tag in common usage. HTML tags are a text string used in HTML to identify a page element's appearance, format, and type. These HTML markup tags tell the World Wide Web browser how to display the text: werbach.com/barebones

- **Cascading Style Sheets**: examples of how they can be used to control the look of web content: www.csszengarden.com

- **FTP application for the Mac**: fetchsoftworks.com

- **InterNIC**: Internet domain name registration services: www.internic.net

- **Web Design**: en.wikipedia.org/wiki/Web_design

- **Web Style Guide**: an overview of the entire process, available in print and online: www.webstyleguide.com

- **Web training resource**: online tutorials: www.w3schools.com

- **World Wide Web Consortium (W3C)**: the international organization that develops web standards: www.w3.org

WEBSITE DESIGN/HTML

Once you have a coherent body of work, consider building your own website or hiring an expert web designer to uniquely showcase your imagemaking capabilities. There are numerous website tutorials, templates, and web designer resources available on the Internet, which can assist in building a simple website. Study websites that are easy to navigate and possess cogent organization and intriguing features. Then, incorporate these attributes into your design plan. A successful website involves a commitment, as it needs to be regularly updated or people will not return to it. Keep the focus of this website on your visual work, and leave your private life to your social networking sites like Facebook.

There are numerous online resources to learn about writing HTML, a simple, universal markup language that allows web publishers to create text and images that can be viewed by anyone on the Web, regardless of what kind of computer or browser is being used.

HTML documents, also known as *web pages*, are what your web browser retrieves from web servers linked to the Internet. No special software is required to create an HTML page—only a word processing program and a working knowledge of HTML. Many imaging software programs offer powerful automated features that permit a simple website to be made and posted in minutes. Box 9.5 offers a list of online references that artist, educator, and website designer Michael Bosworth provides to his students.

Specific HTML software programs, such as Dreamweaver and GoLive, offer informative Help menu options at the top of the screen as well as excellent pop-up manuals and tutorials. The HTML pages created in such programs can be opened and edited in any WYSIWYG (what you see is what you get) editor on any platform, allowing you to preview the result while the document is being created. These programs also include their own proprietary site management tools that are not part of HTML or the Web and are not necessary to know.

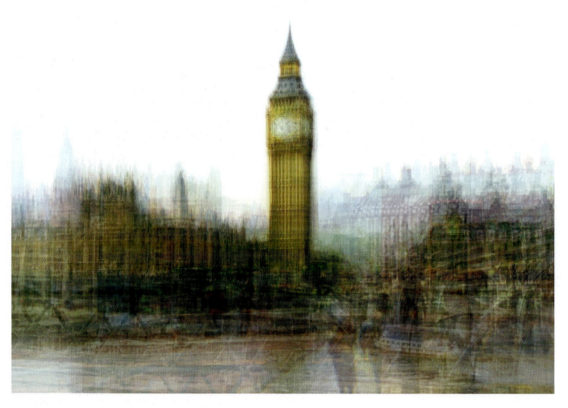

FIGURE 9.9 Today's travelogues are not likely to be slide shows or tangible albums found in our homes, but rather digital images shared online in the public realm. These travel souvenirs become anonymous products of tourism, searchable by the keywords ascribed to them by their makers. Conducting such keyword searches of famed monuments hosted on photo-sharing websites, Corinne Vionnet weaved together small sections of 100 tourist snapshots to fashion this ethereal scene in which Big Ben appears to float in a dreamlike blue haze. Each construction espouses the "tourist gaze," its distorted subject functioning to document and serve as a memory device that does not fix time. Instead, it funnels multiple experiences that occurred over time into one singular space.

Credit: © Corinne Vionnet. *London*, from the series *Photo Opportunities*, 2006. 15¾ x 11¾ inches. Inkjet print.

FACTORS AFFECTING PRINT PRESERVATION

There are supplementary methods of displaying finished prints. Whichever process or material you use, your images can achieve their maximum natural life span if you exercise a few precautions.

FACTORS AFFECTING PRINT STABILITY

All the commonly used color printing processes are fugitive, meaning they fade over time. Two main factors affect print stability. The greatest enemy is light-fading, which is caused by all types of ambient light and UV radiation. Duration, intensity, and quality of the light are all factors in the rate of change. The second adversary is dark-fading, which begins as soon as the image is made. Caused by ambient relative humidity and temperature, it occurs even if an image is sealed in a light-tight box. Both these processes affect the various color materials that make up an image—though not at the same rate—causing color changes and shifts over time. Wax, such as archival Renaissance Wax, can be applied to prints to protect against fingerprints and moisture.

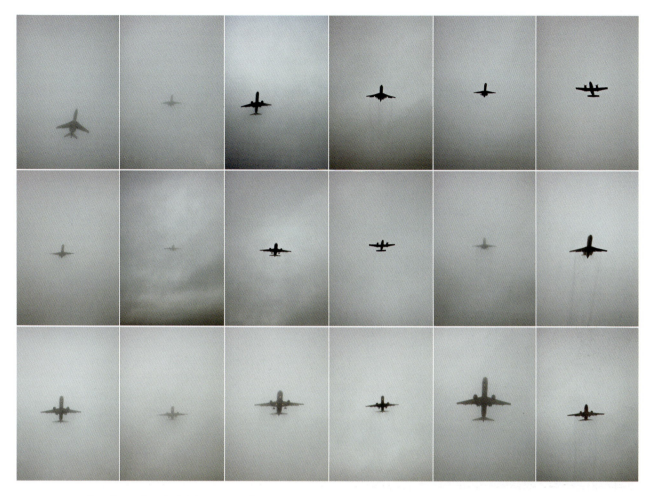

FIGURE 9.10 On a foggy day, Keith Johnson spent hours using a stationary camera to photograph planes landing. To emphasize the diffused typology, he generated a grid using Photoshop's Contact Sheet II. The resulting print is presented "bare," without glass or a mat, after four or five applications of archival Renaissance Wax. Johnson says: "the waxing process can give the color more volume, make the blacks blacker, and improve the glossy look while making the print fingerprint and spit proof."

Credit: © Keith Johnson. *Planes Flying 11:00*, 2011. 30 x 40 inches. Waxed inkjet print.

BOX 9.6 MATERIALS ADVERSELY AFFECTING PRINT LIFE SPAN

- Adhesive-coated pages and plastic covers in "magnetic" pressure-sensitive albums
- Animal glue
- Brown envelops or wrapping paper
- Cardboard
- Cellophane tape
- Glassine
- Masking tape

- Rubber cement
- Spray adhesives
- White glues
- Avoid contact with shellac, varnish, wood, and materials made with PVCs (polyvinyl coatings).
- Write on the back of a print with a soft lead pencil. Avoid ballpoint pens and Sharpies, as they can bleed through and stain the print.

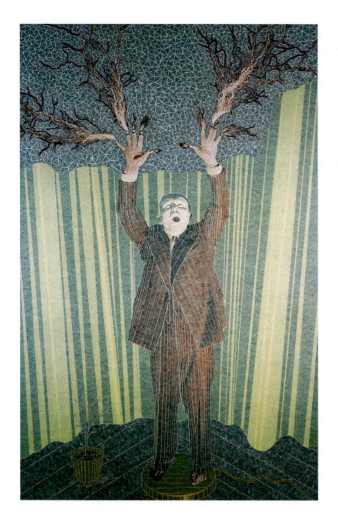

FIGURE 9.11 Referring to himself as a tapist who works with precision and ardor, Patrick Nagatani obsessively applies masking tape on the surface of images to "find a zone of no thought" in which he constructs a new form of beauty. Nagatani explains: "The subtle color of the tape creates my range of hues for my 'painting' palette. There are varying degrees of translucency, and the amount of layers dictate a value shift. The tearing and cutting of the tape parodies a variety of 'brush strokes.' The original surface images are chromogenic color prints from a variety of sources, which often have been collaged and manipulated in Photoshop. These are cold mounted with Coda (a two-sided archival adhesive) to archival museum rag board. Next, the board is contact-cemented to oak wood laminate and stretcher bars are wood-glued into place for stability. Then, the finished taped surface is multi-coated with different strengths of Golden Acrylic Matte Medium. Lastly, two brush coatings of Golden Polymer Varnish with UVLS (Ultraviolet filters and stabilizers) are applied. Although masking tape is not an archival medium, the matte medium both seals the piece from oxidation and soaks through the masking tape for added adhesion. The resulting piece, which is three-dimensional and wonderful to touch, might be seen as an evolving entity with the spirit of permanence and impermanence interwoven into the materials used in the artistic process."

Credit: © Patrick Ryoichi Nagatani. *Desire for Magic*, 2007. 48 x 29 x 1½ inches. Chromogenic color print and mixed media.

Choosing the correct material for specific situations ensures their longest useful life. For instance, since regular inkjet papers are not intended for display in the direct sunlight of a showroom or studio window, use the special display materials that are designed for these conditions. Box 9.6 lists materials that should not be allowed to make contact with your prints, as they can damage them over a period of time.

COLOR PRINT LIFE SPAN

How long will your color pictures last? The answer is, nobody knows. Information about this question remains under debate, and there is no reliable set of standards or a database that provides definitive responses. Henry Wilhelm, an independent researcher in the field of photographic preservation, provides published tests of many digital and conventional materials, but it should be noted that his findings have not been substantiated by other independent research. For his latest test information, see www.wilhelm-research.com.

What we do know is that standard inkjet prints may last for only a few months or, in any case, no longer than ordinary color chromogenic photographs (the standard RA-4 wet color print process), depending on the printer, ink, and paper. They are often more vulnerable to degradation than conventional prints, especially in terms of moisture. As for conventional photographs, Kodak claims that images on its latest chromogenic RA-4 color paper will be "acceptable" to most people after more than 100 years in a photo album, without extended exposure to light, and more than

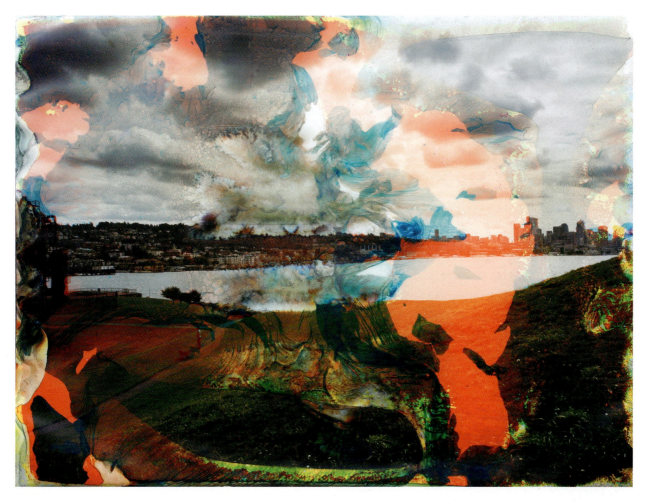

FIGURE 9.12 To convey a sense of transience in his work, Matthew Brandt does the opposite of what photographic preservationists suggest. He reports, "I collect water from the lakes and reservoirs I photograph in the western United States. Then I place prints made of each locale in water from that site for varying lengths of time—days to weeks, or even months. During this soaking period, the water breaks down the layers of colors that make up the chromogenic color prints, resulting in a degraded image. This is not only a project about the metaphor of a photographic subject that meets its image, but also a reflection on the depleting 'wetness' of chemical photography along with the depleting waterlines of our western lakes and reservoirs."

Credit: © Matthew Brandt. *Lake Union WA 4*, from the series, *Lakes and Reservoirs*, 2010. 30 x 40 inches. Chromogenic color print soaked in Lake Union water. Courtesy of M+B Gallery, Los Angeles, CA, and Yossi Milo Gallery, New York, NY.

60 years under normal ambient light conditions at home. However, Kodak does not provide any written guarantee except to say their paper provides "excellent dye stability and print longevity." Claims have been made that expensive, professionally produced pigment-based color prints will last 500 years without fading. With the ever-changing combinations of inks and papers, it is a good idea to check reliable, independent sources on the Web for the latest findings.

PRINT DISPLAY ENVIRONMENT

Avoid displaying prints for extended periods under any bright light, as ultraviolet rays, including sunlight and fluorescent lights, produce more rapid fading. Tungsten spots offer a minimum of harmful UV. Fluorescent lights can be covered with UV-absorbing sleeves. Some people have tried protecting prints with UV-filter glazing on the glass. However, Wilhelm advises that this will offer little or no additional protection for most types

of color prints. To minimize damage, try to maintain display temperatures below 80°F/27°C; protect the print surface from physical contact with moisture and from fingers, smudges, or anything that might cause a scratch or stain; and take care in how prints are stacked in storage.

BOX 9.7 LONG-TERM PRINT PROTECTION GUIDELINES

1. Make new prints of old images on the latest archival material.
2. Produce two prints of important images on stable material, one for display and the other for dark storage.
3. Make copy prints or high-resolution scans of all one-of-a-kind pictures, including Polaroids.

BOX 9.8 SOURCES OF PRESENTATION AND PRESERVATION SUPPLIES

Archival Methods
www.archivalmethods.com

Conservation Resources International
www.conservationresources.com

Freestyle Photographic Supplies
www.freestylephoto.biz

Light Impressions
www.lightimpressionsdirect.com

TALAS Division, Technical Library Services
http://talasonline.com

University Products Inc.
www.universityproducts.com

STORAGE ENVIRONMENT

Archival storage boxes, with a nonbuffered paper interior, offer excellent protection for color prints (see Box 9.7). Ideally, color prints should be stored in a clean, cool (50–60°F; 10–15°C), dark, dry, dust-free area with a relative humidity of about 25 to 40 percent. Avoid exposure to any ultraviolet light source. Use a sealed desiccant (a substance that absorbs moisture) if the prints are subject to high humidity. Keep photographs away from all types of atmospheric pollutants, adhesives, paints, and any source of ozone, including inkjet printers. Periodically check the storage area to make sure there has been no infestation of bugs or microorganisms.

DIGITAL ARCHIVES

Digital data is an excellent candidate for both on-site and off-site long-term image storage because it can be easily and precisely duplicated. It is wise to start using an image management program to preserve and organize your digital collection. There is an array of options available for sorting, cataloging, and archiving your digital images, from simple freeware to sophisticated professional programs. Check them out online to see what is appropriate for your needs. Also, public archives, such as www.nasa.gov/multimedia/imagegallery/index.html, can be mined as source material.

LONG-TERM STORAGE AND MIGRATING DIGITAL ARCHIVES

For the short term, a convenient way to save and move select amounts of digital information, such as image files, is with a pocket flash drive. For long-term storage, external hard drives with full backup programs, such as Time Machine, are recommended. Also, cloud storage, data that is stored on an off-site server, is highly recommended as a fail-safe option. Rapid change is synonymous with the digital world. What is important to bear in mind is that as technology advances, you need to migrate your digital archives to the most up-to-date system of materials and devices.

FIGURE 9.13 Evan Hawkins's series are created using a combination of found photographs, NASA scans of the original Apollo mission films, and his own photography, which are digitally stitched together to create a uniform image. Hawkins relates: "These images began with a fascination centered around the similarities and disparities between the bottom of the ocean and the surface of the moon. The similarities of extreme environment, pressure, light, sound, inaccessibility, solitude, and even the tidal forces of the moon on the oceans led me to the visual, psychological, physiological and existential exploration of the altered reality created by this juxtaposition. The basic premise is to create visually cohesive work that is disjunctive and absurd when analyzed." To reflect this empty unknowingness, Hawkins presents the work in black mats with black frames.

Credit: © Evan Hawkins. *AS17-145-22167*, 2015. 16 x 16 inches. Inkjet print. Courtesy of Robert Hirsch Collection.

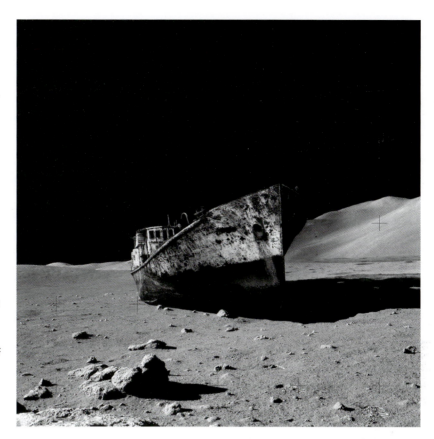

TRANSFERRING FILM-BASED IMAGES TO A DIGITAL FORMAT

To add to your digital archive, scan your film negatives and analog prints. To be useful, the scans need to accurately capture color and detail. Many consumer film scanners do not have the resolution necessary to capture all the information in a negative or print, especially highlights and shadow detail. For best results, use a top-notch scanner or get high-end scans done at a service bureau. Bring snapshots to a photoprocessor with a high-speed scanner that quickly digitizes the images for your use. Always back up the new files.

DIGITAL ASSET MANAGEMENT (DAM): POST-PRODUCTION SOFTWARE

There are several programs, such as Portfolio Server from Extensis and Picasa, a free program from Google, which allow photographers to catalog and manage their images. Lightroom also provides excellent advanced cataloging features. These photographic cataloging programs furnish the ability to tag each image with keywords to help one instantly find, edit, and output any image in a computer and/or storage device. Each time one of these programs is opened, it automatically locates pictures and folders. The cumbersome organizational tagging task is streamlined with simplified image identification and easy drag-and-drop techniques for adding keywords. Pictures can be organized using visual catalogs and embedded metadata to instantly view, sort, and manage all your images. These photographic cataloging programs recognize that digital images are just another form of digital information and can be managed by a single, multifaceted program. For more on digital asset management, consult the information on resources in Box 9.10.

DIGITAL PRINT STABILITY

Since the advent of digital imaging, the inkjet printer has been the mainstay of physical electronic output. When these printers became available to the artist market, imagemakers were impressed with the image quality but were disappointed with their image stability. In the 1990s, a cottage industry sprang up to market different inks and media for different applications, such as black-and-white printing, each one having its advantages and disadvantages.

DYE-BASED INKS

Dye-based inks were the first to be developed by printer manufacturers and are the standard inks supplied by computer and office supply stores. Generally these inks have excellent color and saturation but have a tendency to soak into paper, thus making the ink less efficient and subject to bleeding at the edges, producing poor print quality. Dye-based inks fade rapidly, as they are inherently unstable and may contain solvents or be applied on specialized paper coatings to promote rapid drying. Prints made with dye-based inks should be kept away from moisture, as they can bleed, feather, or spot upon contact with liquids or soften and bleed in conditions of high humidity.

PIGMENTED INKS

Pigmented inks contain other agents to help the pigment adhere to the surface of the paper and prevent it from being removed by mechanical abrasion. These inks are helpful when printing on paper because the pigment stays on the surface of the paper instead of soaking in, which means that less ink is needed to create the same intensity of color.

Pigmented inks have a greater resistance to light-fading than dyes, but generally have substantially lower color saturation. Since they are not absorbed into paper as readily as dye-based inks, they are more prone to fingerprints, smears, and smudges. Still, pigmented inks combine the light-fastness of pigments with the brightness of dyes, making them a good compromise.

Both dye and pigmented inks can appear mottled because of the uneven absorption of the ink. As dyes and pigments can absorb and reflect light differently (they have different spectral reflectance characteristics), they can appear to be a match in daylight but may look like different colors when viewed under tungsten or fluorescent light, a phenomenon known as *metamerism*.

Fundamentally, conventional inks are oil-based dyes, while pigmented inks are made of tiny chunks of solid pigment suspended in a liquid solution. According to their advocates, the latest pigmented inks offer improved, deeper, richer colors and have fewer tendencies to bleed, feather, or run. Some testing laboratories have rated the archival qualities of pigmented ink and acid-free paper combinations at more than 200 years. These labs performed accelerated fading tests, using high doses of light and varying humidity, to predict how long an image will last before fading becomes substantially noticeable. Their predictions have been called into question, however, because many did not take into account gas fading—a pigment's ability to withstand fading due to prolonged exposure to airborne contaminants, such as ozone. Ozone is created by a variety of sources—including cars, household cleaners, solvents, and inkjet printers—and can fade pigmented inks in a matter of months.

Be wary: Inks are constantly being updated and altered. Many companies produce inks that are compatible with name-brand printers, but they may not possess the same ingredients and archival characteristics as the original factory inks. Therefore, let the buyer beware. Make sure your printing materials are suitable for your consistency requirements and long-term expectations.

PRINTING MEDIA

Contemporary printers can print on a variety of different media, including gloss and matte paper, acid-free rag, bamboo, canvas, cloth, metal, and vinyl, among others.

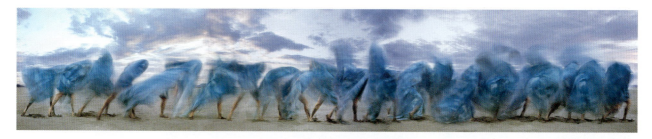

FIGURE 9.14 Karalee Kuchar explains: "My ritualistic engagement with the Great Salt Lake is a series of performances in which I made thirty separate long exposures that I composited into a single image to map endurance and movement over an elongated period of time. The twelve-foot, fabric shroud is a cyanotype photogram that I made by placing reeds collected from the Great Salt Lake onto fabric. It acted as a veil to allow me to blend my dance-like movements into the surrounding desert. The resulting panoramic image, printed on Hahnemühle photo rag, was placed on a wall with small T-shaped pins to make it immediately accessible to the viewer. The unframed print relates to the imagery describing intimacy and vulnerability. The natural look of the rag paper complements the fusion of figure and landscape, adding depth and richness to the imagery."

Credit: © Karalee Kuchar. *Ghostbird*, 2016. 36 x 172 inches. Inkjet print.

The material a digital print is made on often has a greater effect on its longevity and color reproduction than the inks. While acid-free papers are considered the best for image longevity, frequently print life-expectancy predictions are based solely on specific inks and paper combinations. Coated papers are available that can improve the color gamut of inkjet prints, make them dry faster, and make them water resistant. As well, images can be printed on transparency film. The material base of a digital print is often resistant, but these coatings can affect an ink's ability to withstand long-term fading. Also, a number of dye-based and pigmented inks are not compatible with certain gloss papers because of ink absorption difficulties. Media and ink formulations are changing rapidly. Check the latest information on specific inks and media before beginning your digital project, and consider reprinting images as new and improved materials become available.

PROTECTING PIGMENT PRINTS

With the present selection of inks and media, the best way to protect images is to keep prints made with pigments out of direct sunlight and present them under glass using only acid-free papers and matting materials. Proper framing also can reduce a print's exposure to harmful atmospheric contaminants.

CAMERA COPY WORK

Preparing work for presentation often necessitates making photographic copies. Pictures to be copied can be positioned vertically on a wall or laid on a clean, flat surface. The camera may be tripod mounted or hand-held, depending on the light source and ISO sensitivity. Camera movement must be avoided to produce sharp results. For accurate results, be sure the camera back is parallel to the print surface and the lighting is uniform. Avoid shadows falling across the picture. Use a slow ISO setting (100) to obtain the most precise color rendition and maximum detail without digital noise.

LENS SELECTION: MACRO LENS/ MODE

The selection of lens affects the outcome. With a DSLR, a normal focal-length macro lens is an ideal choice. The characteristics of a true macro lens include a flat picture field, high edge-to-edge definition, and the utmost color accuracy. This combination delivers uniform sharpness and color rendition, regardless of focus distance, from the center to the edge of the lens.

Zoom lenses with a macro mode can be used, but may produce soft (not sharp) results. Bellows attachments, extension tubes, and auxiliary lenses—often

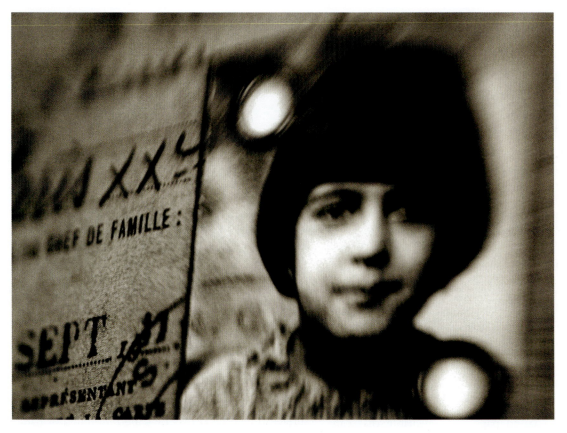

FIGURE 9.15 Copying work can be a time of creative interaction with the source material. Images can serve as models from which new scenes are envisioned using color, focus, light, and selective isolation. In this instance, a macro lens was employed to create distortion that gives the image a new interpretation and meaning within the context of thousands of close-up portraits of French children murdered by the Nazis and their "willing executioners." The series expresses a sense of transgenerational loss that surrounds the unfulfilled potential of lives unlived. As part of the installation, each phantasmal portrait was placed inside a scale-model boxcar, based on the blueprints of the same ones that transported these children to their deaths at extermination camps, as a symbol of their missing bodies.

Credit: © Robert Hirsch. *Untitled*, from the series *Ghosts: French Holocaust Children*, 2011 x 2016. Variable dimensions. Inkjet print. Courtesy of CEPA Gallery, Buffalo, NY.

referred to as *diopters*—are usually supplied in sets of varying degrees of magnification and can convert a normal focal-length lens into a very versatile copy lens.

A macro lens or macro mode can also serve as a postmodern revisualization tool. After all, who says the first version of an image is always the best one? Try rephotographing small sections of images using intrinsic photographic methods, such as angle, cropping, focus, and directional light to alter the original's context and meaning. Magnifying devices/lenses also can be used in front of a lens when traditional photographic values are not a concern.

COPY LIGHTING

Good results can be obtained by using a daylight color balance setting and shooting the pictures outside, on a clear day, in direct sunlight, between the hours of 10:00 a.m. and 2:00 p.m. This will avoid shadows, which can create an unwanted color cast.

If copying is done indoors, an ideal lighting source is photographic daylight fluorescent bulbs (5000 K), which do not get hot and thus keep both photographer and subject matter at room temperature. Conventional photographic tungsten floodlights (3200 K) can be used, but they do get hot and change color temperature

FIGURE 9.16 When copying work, one should set up two lights at equal distances on each side of the camera at 45° angles to the work being copied. Be sure to meter from a gray card, not off the surface of the work being copied, to ensure proper exposure. Make sure the color balance of your camera is set to match the color temperature of your light sources. Polarizing filters can be attached to the lights and/or to the camera to control reflections and to increase color contrast and saturation. Use daylight florescent bulbs instead of "hot" tungsten floodlights to minimize heat and control color balance.

as they age. Whatever your lighting source, be certain your camera's color balance setting or film matches the Kelvin temperature of the copy lights. For consistent results, place a light at an equal distance from each side of the camera and at a 45-degree angle to the picture being copied, which will produce even, glare-free light (see Figure 9.16).

EXPOSURE

Indoors or outdoors, take a meter reading from a standard neutral gray card for the most accurate results. Metering off the picture itself can produce inconsistent results. Let the gray card fill the frame, but do not focus on it. For close-up work, the exposure should be determined with the gray card at the correct focus distance. Try to let the image fill as much of the frame as possible, without chopping off any of it. Use a tripod or a shutter speed of at least 1/125 second to ensure sharp results. Review your exposures and make adjustments as needed.

PRESENTING YOUR WORK

Get your work out there. When preparing digital images for review, pay close attention to specific submission details. Digital files that are not properly made, correctly labeled and identified, or neatly presented will not receive a favorable welcome at a competition, gallery, school, or job interview. Prepare files that open quickly on any platform (no large files). Include a cover letter and appropriate support materials, such as your resumé, an exhibition list, and a concise statement concerning the work. Make sure each image is clearly identified so the person on the receiving end can easily distinguish which images are of interest. A separate checklist, referring to the titled or numbered images, should be included, providing each image's title, size, presentation size, and process (output method). Be selective, ruthlessly edit, decide what is important, highlight important information, do not bombard the receiver with too much data, and do not inflate your documents with inconsequential, inaccurate, or misleading material.

SHIPPING

When mailing materials, be sure to provide hardcopies of all text documents. Do not expect reviewers to print your files. Include an image checklist that gives the title, date, size, and, when appropriate, type of output (such as inkjet print) of each image so it can be easily identified. Make sure your name is on all materials and that they are sent in a clean envelope, along with your complete contact information. Enclose a self-addressed stamped envelope (SASE), with the correct amount of postage, to help ensure the return of your materials. Write "Do Not Bend" on the front and back of the shipping envelope. Do not send original materials unless they are requested. Valuable and irreplaceable materials should be sent by first-class mail with delivery confirmation or via one of the overnight package services. Note that the insurance coverage provided by most standard parcel services will reimburse only the material costs of making an image and not the value you place on it.

FIGURE 9.17 Composed of 1,440 4 x 6-inch images of sunsets, Penelope Umbrico's piece presents the most widely photographed subject on the photo-sharing website Flickr, where she gathered her image captures. The iconic image of the sun evoking warmth, life, and spirituality contrasts sharply with the equally infinite but cold, calculated electrical circuitry and Internet databases where they now reside. The title, denoting the number of hits resulting from Umbrico's initial search, becomes a comment on the increasing use of Web-based photo communities and a reflection of the collective content there. Recording this fleeting, changing number is analogous to the act of recording the brief sunset itself.

Credit: © Penelope Umbrico. *5377 Suns From Flickr (Partial) 4/28/09*, 2009. 48 x 72 feet. Chromogenic color prints. Courtesy of the Hasted Kraeutler Gallery, New York, NY.

COPYRIGHT OF YOUR OWN WORK

According to the U.S. Copyright Office in Washington, DC, it is not necessary to place the notice of copyright on works published for the first time on or after March 1, 1989, in order to secure ownership of copyright; failure to place a notice of copyright on the work will not result in the loss of copyright. However, the Copyright Office still recommends that owners of copyrights continue to place a notice of copyright on their works to secure all their rights. The copyright notice for visual works should include three components: (1) the word *copyright* or the symbol for copyright, which is the letter C enclosed by a circle (©); (2) the name of the copyright owner; and (3) the year of the first publication of the image—for example, © Merry-Jane Henderson 2018. Copyright notice is not required on unpublished work, but it is advisable to affix notices of copyright, which can be done in your metadata, to avoid inadvertent publication without notice. It is illegal for photographic labs to duplicate images with a copyright notice on them without written permission from the holder of the copyright. For additional information, see the U.S. Copyright Office, Library of Congress, www.loc.gov/copyright. Take into account that once an image is digitally available, it can easily take on a life of its own, copyrighted or not.

WHERE TO SEND WORK

There is intense competition for exhibitions, gallery representation, and commercial connections. Prepare to be persistent and steeled for rejection. Numerous publications and websites identify opportunities. (See Box 9.9). Keep your spirits up by finding a mentor and engaging with a community of like-minded artists. As your work advances and clarifies, you then might want to consider a portfolio review by a visiting artist and/or one of the major venues, such as Review Santa Fe (http://visitcenter.org/overview).

FIGURES 9.18/9.19 Christian Faur begins with Works Progress Administration (WPA) photographs of people in desolate, empty landscapes during the Great Depression of the 1930s to reference our current economic and social crisis. "Inspired by Franz Kafka's novel *The Castle* (1926), where the protagonist seeks to find work as a land surveyor but gets caught up in the system's bureaucracy, the title of the show serves as a metaphor for impenetrable political systems that enable greed and corruption, leaving the individual at the whim of those in power." After making colored crayons that resemble wax pixels, Faur uses them to reconstruct these black-and-white photographs and give them back the lost color of their time. "Although color film was available, its cost precluded widespread use. The economic crisis had removed color not only metaphorically from everyday life experiences but also from the aesthetic possibilities of its times."

Credit: (*Left*) © Christian Faur. *Winds*, 2010. 50 x 30 inches. Hand-cast encaustic crayons (assembled). Courtesy of Kim Forest Gallery, New York, NY. (*Right*) © Christian Faur. *Winds* (detail), 2010. Digital file. Courtesy of Kim Forest Gallery, New York, NY.

BOX 9.9 EXHIBITION OPPORTUNITIES

- Art in America/Annual Guide to Museums, Galleries, Artists, 575 Broadway, New York, NY 10012 (annually published).
- Art Opportunities Monthly:www.artopportunitiesmonthly.com
- Photographer's Market (annually published): www.northlightshop.com
- Professional Artist (The Calls e-newsletter): www.professionalartistmag.com
- "On Making and Marketing Art" by Mary Virginia Swanson: www.mvswanson
- Blogs that offer information about work calls and portfolio review events as well as marketing advice, including lensculture.com and lenscratch.com

FIGURE 10.0 Fred Scruton tells us he "broadens the idea of documentation to embrace capturing the 'spirit' of the work—using methods outside a more 'forensic' constraint—such as is required in photojournalism. For example, artificially lighting the subjects in ways that perhaps better capture their 'spirit' than how they might look when photographed under traditional available light conditions. Embracing the 'truth is stranger than fiction' tradition of street photography, this documentary project celebrates the expressive vitality of mostly self-taught artists working outside the mainstream of contemporary art. Freed from film-based limitations, the 'enhanced' digital-era print quality of this project is meant to more realistically document the human eye's retinal rendition of the scene, and to more satisfyingly recall the expressive exuberance of the subject."

Credit: © Fred Scruton. *Marin/Martinez Halloween Display, Cleveland, OH,* 2014. 24 x 30 inches. Chromogenic color print.

Seeing with a Camera

THE FRAMING EFFECT: VIEWPOINT

One of the fundamental tasks of any imagemaker is to define what the essential subject of the picture is going to be. Once the subject is defined, you should be attentive to the viewpoint, or vantage point, for the framing of an image is a crucial basic compositional device that determines how an image is presented and in turn received by its audience. The capacity to compose succinctly gives clarity and cohesion to a maker's experience, yet viewpoint is such an elemental ingredient that it is often so taken for granted to the point of being ignored. The angle of view lets an imagemaker control balance, content, light, perspective, and scale within the composition. It also determines the color saturation and whether or not the hues form color contrast or harmony. This chapter is designed to encourage you to eliminate some of the self-imposed limits on the "windows" by which we visualize the world, to break away from the standardized conventions of representation, and, through experimentation, to discover additional ways of presenting your visual voice.

The monitor on your digital camera offers a tool useful for the composition and review of your images. Be sure to utilize it to its fullest extent.

SEEING DYNAMICALLY

Casual snapshooters raise their camera to eye level and push the shutter release. However, the world seen through a camera should be more precisely defined than it is when seen with only your eyes. The true imagemaker explores the visual possibilities of a scene and attempts to find a way to present the subject in accordance with a desired outcome.

How you frame the world is as important as what you see in the frame. In *De pictura* (1435), Leon Battista Alberti codified the basic geometry of the linear perspective and instructed painters to consider the frame of a painting as an open window. With the exception of avant-garde work, this notion of the single frame has remained the staple of imagemaking. However, as an increasing number of digital imagemakers work with a multitude of windows that coexist and often overlap, this classic concept of perspective is inevitably being altered.

Changing the window by which a scene is presented does not require any additional expense or new equipment, just a shift in camera position. This small step can transform a subject and allow it to be seen from an innovative standpoint. It can give viewers more information, let a subject be seen in a way that was not possible before, and/or introduce an alternate point of view. Photo educator Fred Scruton of Edinboro University of Pennsylvania, tells his students that such experiments

can help them to break away from their customary sight angles and take them for a ride into unfamiliar visual territory, a ride that can increase receptiveness to a distinctly photographic visual vocabulary.

Often we go heavy-eyed through the routines of life. We walk down a street with blinders, not really seeing because we have been there countless times before. We act like somnambulists who know what to expect; everything is in place, with no chance for surprise. To actively see, you must be awake, aware, and open to wonderment and its companion: astonishment. In *Art Matters* (2001), Peter de Bolla writes:

> *Wonder requires us to acknowledge what we do not know or may never know, to acknowledge the limits of knowledge. It is, then, a different species of knowledge, a way of knowing that does not lead to certainties or truths about the world or the way things are. It is a state of mind that, like being in love, colors all that we know we know.*[1]

Wonderment can be experienced in ordinary or extraordinary situations and brings with it a sense of amazement, awe, and surprise. Being able to visually communicate these powerful feelings is a surefire way of engaging viewers.

When seeing dynamically, you are letting innovative things happen and not relying on past expectations and clichés to get you through a situation. Seeing dynamically involves being conscious of color and space and learning to organize these elements in a persuasive manner. The more deeply you look, the more you can penetrate a subject; in turn, the more you are able to see even more clearly, concisely, and intensely. Put into practice, Russian ballet impresario Sergei Diaghilev's exhortation to his sometime collaborator, artist Jean Cocteau: "Astonish me!"

WORKING METHODS

Select a subject that inspires personal wonderment and that will engage your viewers. Then, proceed to use a combination of viewpoint and light to generate your visual statement. At this stage, all sorts of questions should be running through your mind as part of the decision-making process. Answering them requires independent visual thinking and experimentation. Try not to compete with what you have seen others doing. Competition tends to lead to the copying of ideas and style. Direct copying means no longer discovering things on your own. Watch out for envy too, as it also can detour you from your own direction and inclinations. The most rewarding pictures tend to be those that are made from both your heart and your mind. Box 10.1 presents some methods to consider. Use your monitor to review and adjust your exposures as you work.

EFFECTIVELY USING ANGLES OF VIEW

When deliberating compositional possibilities, consider these five basic angles of view and some of their general qualities:

- Eye-level angle views are more neutral, dispassionate, and less directorial than high- or low-angle ones. Eye-level shots tend to encourage viewers to make their own reading of a scene. They present a normal, everyday view of how we see the world. This angle is a favorite of visual/realistic photographers (see Chapter 5) because it puts a subject on a more equal footing with the observer. A regular focal-length lens setting is commonly used when working in this manner.

- Low-angle viewpoints tend to present a certain sense of motion by increasing the apparent height of the subject and conveying a sense of verticality. The general environment is diminished in importance, as the upper portion of the composition, such as the sky, takes on a greater prominence. At the same time, the importance or visual weight of the subject is amplified. An individual figure becomes more heroic and larger than life. A subject can also appear more looming, dominating the visual space and bringing forth a sense of uncertainty. Photographing a person from

FIGURE 10.1 Dan Younger of the University of Missouri in Saint Louis thinks, "One of the best things about photography is the necessity to be there." From this perspective, he seeks out crowded public places to capture "the mysterious and idiosyncratic nature of human behavior." These odd, mysterious "unofficial" scenes ask viewers to provide their own narrative about what is taking place. Younger makes many pictures and relies on a lengthy selection process, paring down images first through his persistence of memory—identifying which images remain vivid in his mind. These preliminary images are printed and shown to colleagues and untrained friends for input. This process is repeated until a final edit is achieved.

Credit: © Dan Younger. *Untitled (Venice Beach, California)* from the series *Travel Places*, 2010. 48 x 36 inches. Inkjet print.

below can inspire respect, awe, or fear. In a landscape, a low-angle shot can generate a more intense sense of spatial depth by bringing added visual importance to the foreground. Use a wide-angle lens to maximize this effect.

- High-angle shots have the opposite effect to low ones. They can provide a general overview of the subject by giving an added importance to the surrounding environment. However, as the height of the angle increases, the importance of the subject is diminished, and care must be taken that the setting does not overwhelm a subject. High angles may indicate vulnerability, weakness, or the

harmlessness and/or openness of a subject, or deliver a condescending view of a subject by making it appear powerless, enmeshed, or out of control. A high-angle shot reduces the apparent height of objects, and the sense of movement within the frame is reduced, making it unsuitable for conveying a sensation of motion or speed. This angle can be effective for portraying a situation that is wearying or repressive.

- Wide-angle viewpoints are often employed to exaggerate the sense of space and direct the viewer's observation and attention in a specific direction. However, wide-angle compositions,

BOX 10.1 VIEWPOINT WORKING METHODS

1. Begin with a conventional horizontal shot at eye level, metering from the subject. Walk around the subject. Crouch low, lie down, stand on tiptoes, and find a point that raises the angle of view above the subject. Notice how the direction of light either hides or reveals aspects of the subject. Move in closer to the subject and then get farther back than the original position. Now, make exposures at a lower angle than the original eye-level view. Try putting the camera right on the ground. Look through the camera's viewing system; move and twist around and see what happens to the subject. When it looks good, make another exposure. Repeat making vertical exposures.

2. Change the exposure. What happens when you expose for highlights? What about depth of field? Will a small, medium, or large f-stop help to create more intense visual impact? How does altering the exposure affect the mood of the scene?

3. Decide whether to emphasize the foreground or background. How will this decision affect the viewers' relationship with the subject? Try both horizontal and vertical viewpoints.

4. Get behind the subject and make a picture from that point of view. How is this different from the front view? What is gained and what is lost by presenting this viewpoint?

5. Photograph the subject from the left and right sides. How is this different from the front and back views? What is gained and what is lost by presenting this point of view?

6. Make pictures from above the subject. How does this change the sense of space within the composition and your sense of the subject?

7. Experiment with different focal length settings. See what changes occur in the points of emphasis and spatial relationships due to depth of field as you shift from wide-angle to telephoto focal lengths.

8. Get close. Imagine walking by a pizzeria and seeing the pizzas through the window and thinking they look really good. Then, you go inside the shop and get a pizza right under your nose, experiencing it firsthand. What a difference getting close made! Look for details that reveal the essence of the entire subject and strive to capture them. This method of visceral simplification can speak directly and plainly to viewers.

9. Back away. Make images that make known the subject's relationship to its environment.

10. Introduce the unexpected into your visual thinking. Employ your instincts to make images of the subject without using the camera's viewing system. Go with what feels "right." This can be very liberating and can bring to the surface composition arrangements that your conscious mind may not have been able to contemplate.

11. Work to convey your sense of wonderment, as it is a conduit for eliciting viewer astonishment. The camera can give one a societal license to come close to the unapproachable in ways that may otherwise be regarded as unacceptable in daily social situations. Use this visual license to make the strongest possible statement without being irresponsible or infringing the rights of others.

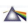

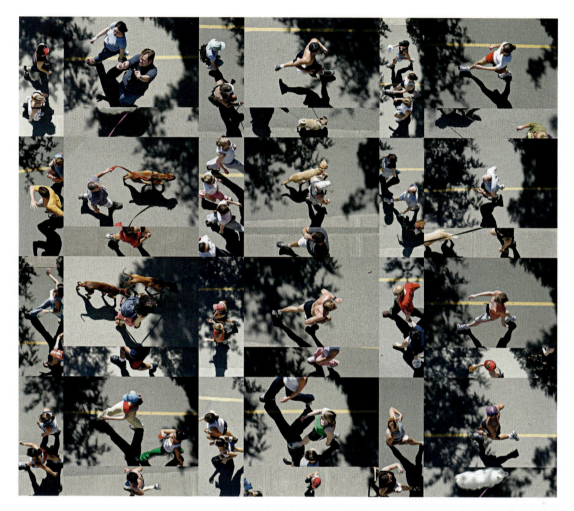

FIGURE 10.2 "My working process is one of image configuration, placing multiple images in relationships to each other to create a new spatiality. I use digital and physical methods, finding that using both gives me the most fertile ground—the huge 'vertical' stacks of imagery that are possible to store on digital media are vast, but locked into the 'window' of the computer screen. The physical tabletop, large and filled with small prints, is a vast array capable of being scanned by our built-in peripheral vision, but is limited by being composed of discrete physical objects. But by using both realms, the physical and the digital, I can make compositions that tap both. This piece was preconceived in its basic structure and content, the vast and subtle detail within a social substructure [the world of joggers]. The images resulted from shooting sessions in which I stood on an elevated stadium-style bench structure and looked straight down at a well-used jogging path at the same time of day so that individual images from different sessions could be used together seamlessly."

Credit: © Paul Berger. *WalkRun,* 2004. 35 x 47 inches. Inkjet print.

such as those pioneered by cinematographer Gregg Toland in *Citizen Kane* (1941), can also be democratic in nature, for their tremendous depth of field brings into focus all aspects of a scene, thus encouraging viewers to discover what in a scene is visually intriguing to them.

- Bird's-eye views are photographed from high above a subject and can appear perplexing and disorientating to viewers. Since we ordinarily do not see life from this perspective, a scene may initially appear abstract, obscure, or unidentifiable. The height of the shot enables viewers to hover over the subject from a Divine perspective. A subject appears inconsequential, reinforcing the idea of fate or destiny—that something beyond the subject's control is going to happen. Bauhaus

master László Moholy-Nagy favored all-encompassing overhead views to represent "new, previously unknown relationships . . . between the known and as yet unknown optical." Wide-angle focal lengths are often employed to further exaggerate the sense of space and direct the viewer's observation and attention in a specific direction. A specialty lens, such as Lensbaby, can be used to deliver shallow focus, producing a miniature perspective similar to a toy train layout.

- Oblique angles occur when the camera is tilted, making for an unstable horizon line. This throws a scene out of balance because the natural horizontal and vertical lines are converted into unstable, diagonal lines. An individual photographed at an oblique angle appears to be tilting to one side.

Oblique angles are disorientating to the viewer. They may suggest angst, imbalance, impending movement, tension, or transition, projecting precariousness or imminent change. Haptic/expressionistic imagemakers favor compositions made from extreme angles, as they confine an audience to an idiosyncratic point of view.

SELECTIVE FOCUS

Since its inception photography has acted as a surrogate witness that captured and preserved people, places, things, and events. To meet this expectation, the majority of photographers have strived to make sharp pictures so that the subject details can be studied

EXERCISE 10.1 SELECTIVE FOCUS

Make images that utilize selective focus to generate significant viewer interest by taking into account the following suggestions:

- Determine: What is the most important element of the scene? What do you want to emphasize or de-emphasize? What do you want viewers to look at first and concentrate on?
- Manually focus on the key subject to be emphasized. Later, experiment with different autofocus-area settings, such as closest or single subject.
- Set the lens to its widest aperture to minimize depth of field.
- Use a normal or telephoto focal length, as wide-angle focal lengths have more depth of field at any given aperture.
- Get in close to the principal subject. The nearer you are to the subject, the more critical focus becomes.
- Practice focusing back and forth as though tuning a string instrument. Go past the point you think works and then come back and decide the focal point.
- Try tilting the camera to see how oblique angles can affect the focus.
- Experiment with slower than normal shutter speeds while handholding the camera.
- Working in a dimly lit situation, make a series of exposures with the shutter positioned on the B (bulb) setting while using a flash. Holding the shutter down for a few seconds creates a single image with two exposures. The exposure from the flash will be sharp and still, whereas the ambient light exposure that results from holding the shutter open will be soft and fluid.
- Review images on your camera's monitor and make corrections as you work.
- Utilize imaging software to manipulate the captured images' focus.

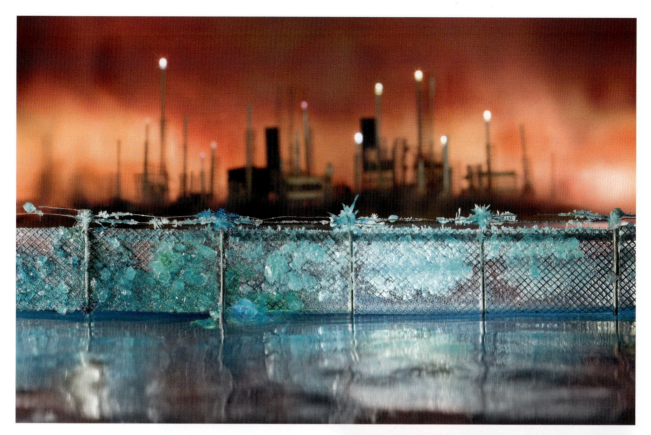

FIGURE 10.3 Crista Dix of Wall Space Gallery reflects: "Ground Waters explores the intersection of science, environment, and technology. By building extensive sets and flooding them with a liquid crystal solution and letting them decay and grow over time, Hickok chronicles their rise and demise as they overtake the structures. In creating her own geologic timeline, her images give us a deeper narrative of the chemicals we ingest, what are we dumping into our water systems, and how it is affecting our environment and ourselves." To produce this image, Hickok digitally merged seven different photographs, changing the background color and adding details such as lens flare on the lights.

Credit: © Liz Hickok. *Incident*, from the series *Ground Waters*, 2015. 60 x 120 inches. Inkjet print.

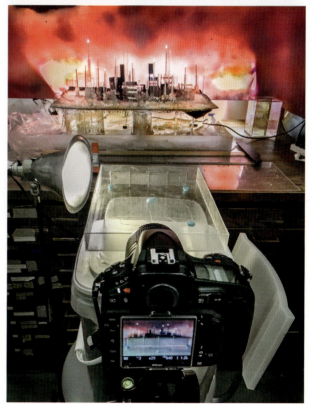

FIGURE 10.4 Studio setup for Liz Hickok's *Incident*, from the series *Ground Waters*, 2015.

Credit: © Liz Hickok. Studio setup for *Incident*, from the series *Ground Waters*, 2015. Digital file.

at leisure. The issue of focus played a critical role in defining serious nineteenth-century artistic practice. During the 1860s, Julia Margaret Cameron's wet-plate photographs helped to establish the issue of selective focus as a criterion of peerless practice. The making of "out-of-focus" images was considered an expressive remedy that shifted the artificial, machine focus of a camera toward a more natural vision. Cameron considered focusing to be a fluid process during which she would stop when something looked beautiful to her eye, "instead of screwing the lens to the more definite focus which all other photographers insist upon." Pictorialists, such as Robert Demachy and Gertrude Käsebier, placed importance on how a subject was handled rather than on the subject itself, and they utilized a soft focus to evoke mystery and de-emphasize photography's connection with reality, which helped their work fit into that era's definition of

FIGURE 10.5 Examining what constitutes fact and fiction in a photograph by blurring the limits between reality and fiction, Toni Hafkenscheid uses the innate characteristics of camera vision to make actual places look like model train layouts in which the tracks are set in an artificial landscape of cotton wool trees, plastic buildings, cardboard mountains, and tiny figurines. "When looking at this landscape at a normal distance, I almost felt like God, high above this artificial world and in total control of it as well. If you looked close enough (eyes about 2 inches above the train tracks) though, this world would start to look almost real again. I explore this illusion of real and fake through shallow depth of field to make some parts of the image soft and others in focus. The colors in the photographs are tweaked to look like old postcards and recall an idealized view of an immediate future typical of the 1950s."

Credit: © Toni Hafkenscheid. *Train Snaking Through Mountain*, from the series *HO*, 2001. 30 x 30 inches. Chromogenic color print. Courtesy of Birch Libralato Gallery, Toronto, ON.

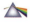

what constituted art. Recently, photographers have again been actively experimenting with how focus can be altered to control photographic meaning (see Exercise 10.1).

CONTRAST

When you are making color images, the intensity and the relationship of one color to another within the scene plays a vital role in creating contrast. If you are making black-and-white images, then contrast is created by the difference between the darkest and lightest areas of the composition.

COMPLEMENTARY COLORS

Complementary colors, opposite each other on the color wheel, generate the most contrast. The subtractive combinations of blue against yellow, green against magenta, and red against cyan form the strongest color contrasts. When looking at the reflected colors of a finished print, some people prefer to use the pigment primary combinations of red against green, blue against orange, and yellow against purple as the basis of their discussion. This allows photographic prints to be discussed with the same language as the other visual arts, such as painting.

It is thought that complementary colors produce contrast because of fatigue in the rods and cones of the human retina. The reason is that the human eye cannot accommodate each of these wavelengths of light simultaneously. Think of a zoom lens going back and forth between its maximum and minimum focal lengths while trying to maintain critical focus on a single point—this is what the eye attempts to do when it sees complementary colors.

WARM AND COOL COLORS

Warm and cool colors can be very effective in crafting and controlling contrast. Warm colors tend to advance and therefore are considered active and vigorous colors, whereas cool colors are apt to recede and generally be more passive. Dark colors against light ones also produce

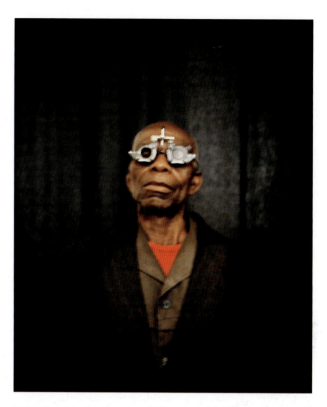

FIGURE 10.6 For five years, Stefano De Luigi utilized a 6 x 7-cm camera to photograph blind and visually impaired people in Africa, China, Eastern Europe, South America, and Southeast Asia to describe the condition of their daily life. This image is warm and engaging, while the blurriness generates a hazy softness that sharply contrasts with the cold, scientific—even science fiction–like— appearance of the optometry equipment, drawing attention to this man's condition. The overall project has been displayed in multiple forms, including book, gallery exhibitions, multimedia, and web gallery.

Credit: © Stefano De Luigi. *Virunga Hospital, Ophthalmologist Examination. Bukavu, DRC,* from the series *Blanco,* 2005. Variable dimensions. Digital file.

contrast, as does a desaturated color placed next to a saturated one. Pastel colors can provide contrast, if there is enough separation between the colors on the color wheel.

CREATING COLOR CONTRAST

Color contrast can give emphasis to a subject photographed against a complementary background. Areas of contrasting colors can create a visual restlessness that imparts a sense of movement within a composition.

EXERCISE 10.2 COLOR CONTRAST

Make photographs that incorporate one of the following color contrast effects:

1. **Complementary contrast**. Use colors that are opposite each other on the color wheel, such as a yellow building against a blue sky.

2. **Primary or active contrast**. The juxtaposition of two primary colors can produce a bright, vibrant, and upbeat ambience.

3. **Passive contrast**. A quiet, easy, restful mood can be achieved by using a neutral background as a staging area for the principal subject. A simple, dark backdrop can be employed to offset a light area and slow down the visual dynamics of the picture.

4. **Active and passive contrast**. Use a cool color against a warm one. Determining the proper proportions of each is vital to making this effective.

5. **Complex contrast**. The use of contrasting primary colors creates complex contrast. With the proper treatment, it can elicit visual excitement that provides a robust interplay of the objects within a composition and acts as a connecting device between seemingly diverse elements. Be careful to employ the contrasting colors thoughtfully, or the point of emphasis can become confused and/or lost in an array of colors.

Active and passive colors can compress and flatten the visual space and bring patterns to the forefront. Warm and cool colors can be used to produce a sense of balance within the scene. Dynamic tension can be built by introducing active colors alongside each other in the picture space (see Exercise 10.2).

DOMINANT COLOR

Dominant color occurs when the primary subject is color itself. The Post-Impressionist painter Paul Cézanne observed, "When color is at its richest, form is at its fullest." Artistic movements such as Abstract Expressionism, Color Field painting, and Op Art have explored the diversity of visual experiences that are created through the interplay of color. Relationships among colors can affect all ingredients within the picture space. Different combinations can fashion both calm and tension as well as cause objects to either step forward, look flat, or recede into the background. Dominant color may elicit intoxicating textures, drawing one's eye forcefully into an image. Works that exploit

this effect use color itself to represent personal emotions, moods, or spirituality, adding drama and psychological depth that can breathe life into an image (see Exercise 10.3). Classic examples of the luminous application of color in an expressive manner can be seen in the sixteenth-century Venetian school paintings of Titian.

BE STRAIGHTFORWARD

When putting together a composition, keep it simple and straightforward. Let one hue clearly dominate. Avoid incorporating too many colors, as this may produce visual confusion when assorted colors compete to control the image space. The proportions of the colors within the scene will determine which is the strongest. For instance, a small amount of a warm color, such as red, can visually balance and dominate a much greater area of a cool color, such as green. Similarly, a small area of a bright color can dominate a larger, adjacent flat field of color. Bear in mind that color value is relative and not absolute and therefore changes from person to person and situation to situation.

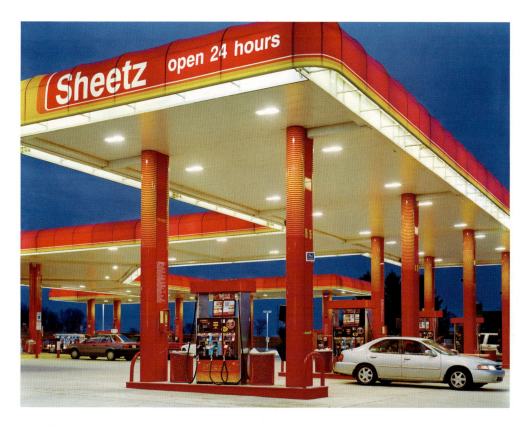

FIGURE 10.7 Joshua Lutz made two scans from the same 8 x 10-inch negative, one for the highlights and midtones and another for the shadows, and combined them to maintain as much color saturation and detail as possible. "These images explore how our priorities dictate the transformation and use of the land. Although I am interested in the ideas surrounding the interpretation of images as well as those concerning the environment, architecture, and general planning, I prefer a less literal approach that conveys a mood or a feeling."

Credit: © Joshua Lutz. *Sheetz*, 2005. 30 x 40 inches. Inkjet print. Courtesy of Gitterman Gallery, New York, NY.

EXERCISE 10.3 DOMINANT COLOR

Plan and execute images that use dominant color(s) to reveal form at its fullest and to create a sense of space. Fill your composition in a way that allows viewers to experience the perceptual and physical space of the color(s). Think of the sense of sound you get when listening to music with high-quality earbuds. It's the same as reading a good book—you give yourself over to the experience the artist has created. In this case, convey that feeling through your use of color. What new meaning is brought forth?

SUSTAIN COMPELLING COMPOSITION

Strong colors attract and transact with our attention. Take advantage of that transaction by employing a strategy that ensures that the dominant color preserves a working accord with the core point of interest. If color is not the overriding theme, then it should reinforce and enhance the subject. Don't let color and intent clash; otherwise, viewers may have difficulty determining the image's purpose. Avoid sending conflicting or confusing messages to the audience. You cannot paste a few features on a subject, call it a duck, and expect people to believe it. Maintain a clear objective and provide a well-marked visual path for the viewers' eye. Robust colors visually reinforce the importance of shape within your composition. Use tight, controlled framing to

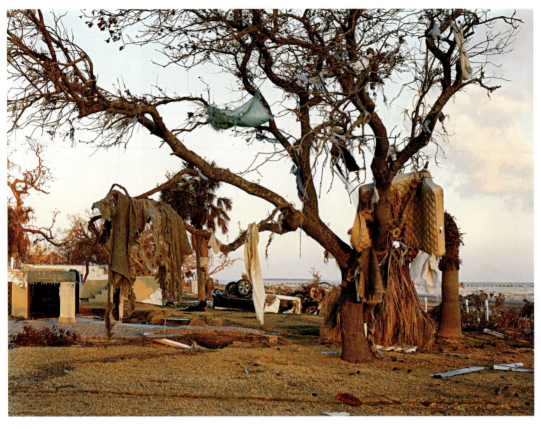

FIGURE 10.8 As part of his project *American Power*, which examines America's cultural investment in energy, Mitch Epstein made this picture about six weeks after Hurricane Katrina struck. This straight-on image is one of contradictions. The warm, soft light stands in stark juxtaposition to the detritus of tragedy flung on a bared tree like some kind of post-tempest Spanish moss.

Credit: © Mitch Epstein. *Biloxi, Mississippi*, 2005. Variable dimensions. Inkjet print. Courtesy of Black River Productions Ltd. and Sikkema Jenkins & Co., New York, NY.

obtain dynamic graphic effects. Get in close and dispense with the nonessential elements. Consider using a neutral or a black background to make the color pop out even more.

HARMONIC COLOR

Harmonic colors are closely grouped together on the color wheel. Any single quarter section of the color wheel is considered to exhibit color harmony. The most basic harmonic compositions contain only two colors, which are desaturated and flat in appearance. The lack of complementary colors makes seeing the subtle differences in these adjacent hues much more straight-

forward. Constancy and evenness in light and tone can assist in bringing forward harmonic color relationships. Deeply saturated colors that may be technically close to each other on the color wheel can still produce much contrast and interfere with the harmony. Therefore, start by setting the camera's saturation mode to normal or reduced levels and avoid using the enhanced color mode. Also, try reducing the camera's contrast mode.

EFFECTIVE HARMONY

Color harmony can easily be spotted in nature, but it is a highly subjective matter whose effectiveness depends on the colors, the situation, and the intended effect. The

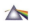

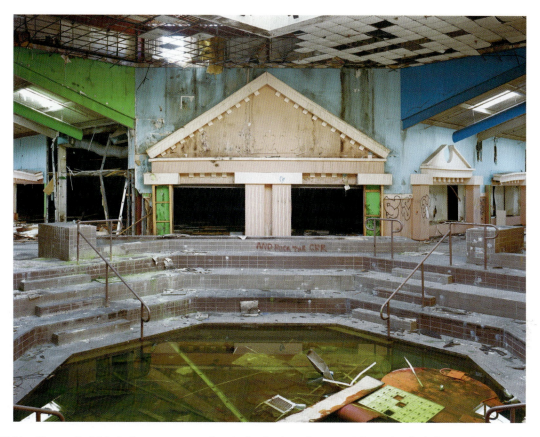

FIGURE 10.9 Brian Ulrich utilizes an 8 x 10-inch view camera to explore the implications of commercialism within the hulking architecture of abandoned big-box stores and malls, emptied and laid barren in the wake of the recent economic downturn. Ulrich takes the harsh conditions of the spaces he chooses in stride, stating, "One room in the mall was on fire when we arrived. We used the green mucky water in the photograph to put it out so I could photograph! I only fell once while precariously balancing the camera on various found wood to get the proper vantage point for the picture."

Credit: © Brian Ulrich. *Belz Factory Outlet Mall 1*, from the series *Dark Stores, Ghost Boxes and Dead Malls*, 2009. Variable dimensions. Inkjet print.

tangible, visual effect is dependent on the actual colors themselves. Passive colors tend to be peaceful and harmonize more easily than the warm, active hues. For example, blue and violet are adjacent to each other on the color wheel and are harmonious in a restrained and subdued manner. On the opposite side of the color wheel are orange and yellow. These two colors harmonize in a much more animated and vibrant fashion.

In an urban, human-made environment, discordant, jarring, and unharmonious colors are encountered everywhere, as people randomly place contrasting colors next to each other. Look for and incorporate neutral areas, which offer balance within the scene, and de-emphasize differences among diverse colors.

Exercising care in the quality of light, the angle of view, and in determining an appropriate proportional mixture of these discordant colors can bring a sense of symmetry and vitality to a flat or inactive compositional arrangement. Both contrasting and harmonic colors can be linked together by working with basic design elements, such as repeating patterns and shapes.

Pay close attention when framing the picture space, taking care to notice exactly what is in all corners of the frame. Eliminate any hue that can interfere with the fragile interplay of the closely related colors. Use your monitor to review each exposure. The utilization of soft, unsaturated color in diffused light is an established method of crafting harmonious color relationships.

Repeating and/or weaving harmonic colors throughout the picture space, which also intensifies the patterns and shapes within the composition, may bolster harmonic effects. Look for common qualities in balance, rhythm, texture, and tone to connect the colors.

An atmosphere of color unity can be orchestrated by slightly adjusting the camera's color balance setting and/or by adding a small amount of filtration in front of the lens that matches the cast of the color of the light in the scene. Another method is to desaturate the hues through the use of diffused light or a soft filter in front of the lens. These effects can also be achieved later with imaging software (see Exercise 10.4).

ISOLATED COLOR

The visual energy of a color depends more on its relationship to other colors and its placement within a scene than on the size of the area it occupies. Imagine a light-colored, in-ground swimming pool on a calm and clear afternoon reflecting harmonious blue-sky colors that are even, smooth, and unified. Now, throw in a red beach ball. Pow! The bright ball generates a visual explosion that surprises the eye and instantly becomes emphatic, with its solitariness reaching out like a visual magnet. Its atypical individuality also introduces needed variety into the composition.

EXERCISE 10.4 HARMONY

Make harmonic images from the following areas:

1. **Natural color harmony**. Pay close attention to the compositional location of the horizon line in the landscape. Organize a landscape that does not follow the traditional compositional Rule of Thirds. Photograph a scene that includes little or no sky. Make a skyscape with little or no foreground. Be on the lookout for symmetry in nature. One method to achieve balance is to look for repetition, such as reflections, to include in your composition. This can be especially effective when water is in the picture space. If the harmony produced by cool colors feels too uninviting or standoffish, try adding a small area of a muted complementary color. This can draw warmth and interest back into the picture. Look for a defining detail from the landscape that can represent what you are after in a condensed and simplified manner. Often, showing less can let viewers see more, by encouraging more active engagement with the image.

2. **Urban color harmony**. Find a place where people have consciously and deliberately made an effort to blend human-made creations into an overall environment. Flat lighting can be used to play down the differences in the various color combinations within an urban setting. Smooth, early morning light can be utilized for the same effect. Try to avoid the visual hustle and bustle of urban life that tends to yield visual chaos. Finding scenes of calmness and stillness within a busy cityscape will help to achieve harmony.

3. **Still-life harmony**. Organize a collection of objects that demonstrate your ability to control the picture space, including the background, the quality of light, and the camera position, to ensure a harmonic composition. Consider the sparing and subtle use of filters or color balance to enhance the harmonic mood.

4. **Harmonious portrait**. Make a portrait by simplifying the background, selecting clothes and props to go with the subject, and using neutral colors and similar shapes. Consider using soft directional lighting, as it can minimize complementary colors and convey an impression of unity. Tracing paper placed in front of any light source, at a safe distance to prevent fire, is a simple and inexpensive way to diffuse the light.

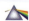

FIGURE 10.10 By digitally erasing the barriers and surroundings of the human-made environment in which animals were captive (zoo cages or pens), Allison Hunter creates a featureless landscape to show her subjects as empowered beings in a world without people. "The resulting photographs produce an unsettling landscape where the animal, lifted out of a humanizing context, can re-enter its own world."

Credit: © Allison Hunter. *Untitled #7*, from the series *Simply Stunning*, 2006. 30 x 50 inches. Chromogenic color print. Courtesy of 511 Gallery, New York, NY.

Colors tend to be at their greatest intensity when they are viewed against a flat, neutral setting. Warm colors visually step forward, adding depth and spark into a flat picture. On an overcast, hazy or dusty day, in which the landscape appears nearly dimensionless, add a small amount of a warm color, and immediately contrast, depth, drama, emphasis, and variety arise out of this evenness and uniformity. Warm colors can also be deployed as dynamic backgrounds to balance and/or offset monochromatic subject matter (see Exercise 10.5).

EXERCISE 10.5 ISOLATED COLOR

Based on the previous discussion, make photographs that utilize isolated color to achieve their meaning and visual impact.

CHANCE FAVORS THE PREPARED MIND

Delivering a powerful single color to the right spot at the right time often requires advance planning. Anticipating the moment greatly increases the chances of this happening. Being prepared also enhances the likelihood of something useful happening, as "chance favors the prepared mind." Coordinating the light, background, and proportion of a particular color means being at ease and confident with the equipment and techniques used. Practice and readiness are prerequisites that let an imagemaker take advantage of chance opportunities.

Carefully observe the situation and ask yourself questions such as What focal length may best deliver the correct proportion of that single color into the composition? But don't get bogged down with your fixed ideas. Remain ready to improvise and go with the flow. For instance, if the focal length of your lens is not long (telephoto) enough, will getting closer help you achieve the desired outcome? Remain open and

receptive, and be willing to adapt and accommodate your plans to the reality on the ground without becoming overly irritated or disenchanted. Consider combining other approaches into your thinking. For example, would incorporating movement generate additional visual interest? What might happen if you placed your camera on a tripod and used a slow shutter speed to interject a warm object in motion within a static monochrome environment?

MONOCHROME IMAGES

Some people believe a good color photograph has to represent many colors. However, that is not necessarily the case. Often, reducing the number of colors can produce a more effective composition than bombarding viewers with every color in the rainbow.

Strictly speaking, a monochromatic photograph is one that has only one color, but in a broader operational sense, the genre includes any image that achieves its overall effect through the management of a single color, even if other colors are present. A case in point can be seen in Tim Burton's animated film *Corpse Bride* (2005), which makes impressive use of the play between monochrome and color scenes for dramatic and psychological effect.

THE PERSONAL NATURE OF MONOCHROME

Monochromatic images can be directly connected to our moods. For example, when we feel down in the dumps, we say we are blue—not orange or yellow. Utilize such associations when building your image. Monochrome simplifies a composition and tends to elicit a more intuitive and subjective reaction than a full-color image with its empirical associations to outer reality. Consequently, such images are made not so much as a document to be read for information, but as a representation of an inner event that evokes a personalized sense of place and time. Monochromatic scenes can alter the customary flow of time and flatten the sense of visual space.

Exposure is critical to maintain the desired atmosphere and color. Monochromes do not have to lack contrast. Harmonious and subdued colors can be employed to give monochromatic impressions. When you are organizing a monochrome composition, it is important to rely upon the play of light and shadow to create dramatic compositions when there is an absence of strong color. When both the highlights and the shadows are extreme, consider lowering the contrast setting on your camera for better exposure (see Exercise 10.6).

COLOR CONTAMINATION

When dealing with a "delicate" monochromatic image, be aware of environmental color contamination. This occurs when a colored object within the scene reflects its color onto other items within the picture area. This is most visible when working with white or light-colored items. It is even possible for a white object to make another white object appear to be off-white. Color contamination can also be caused from outside the frame, such as when a photographer's bright red shirt or a green wall reflects back onto the principal neutral-colored subject. Careful observation of the scene, its arrangement, and the selection of objects to be photographed is the best approach for dealing with this problem at the time of image capture. Imaging software can later be used to make adjustments, but with monochromatic images, such subtle corrections can be difficult to implement.

AERIAL PERSPECTIVE

Aerial perspective occurs when the atmospheric scattering of light mutes colors in distant scenes so the tones appear progressively paler as the landscape recedes into space (see also the next section on perspective). This blending and softening of colors can assist in forming a monochromatic scene. Be aware that aerial perspective also makes faraway objects appear noticeably bluer, which can be corrected at the time of exposure with a slight warming or yellow filter or later adjusted with imaging software.

FIGURE 10.11 John Dickson's spray-paint drawings transform low-resolution Internet images from Francis Ford Coppola's *Apocalypse Now* (1979) and Werner Herzog's *Nosferatu The Vampyre* (1979). After re-sizing and adjusting brightness and contrast in Photoshop, "I print them out and use the print as a mask. I cut out the darkest areas first, place the print image down on a sheet of paper, and then apply black spray paint. Next, I cut out the next darkest tones, spray again, and so on, working my way towards the whites. Black spray paint approximates the subtleties of light and atmosphere, while adding graininess similar to that of film," creating a dark atmosphere of war, death, and disintegration.

Credit: © John Dickson. *Dresden*, 2011. 8½ x 10¾ inches. Spray paint on paper. Courtesy of Robert Hirsch Collection.

EXERCISE 10.6 MONOCHROMATIC COLOR

Make photographic images that utilize monochromatic color concepts to capitalize on their visual strength. Purposely direct a monochromatic effect to elicit a specific mood.

Consider the following environmental conditions as starting points for monochromatic compositions in which both color and the details are naturally suppressed and simplified: early morning, late afternoon, fog, dust, pollution, rain- and snowstorms, smoke or iced or steamed windows, plus scenes illuminated by diffused light that have lower-than-average contrast.

Other methods that can be employed to mute colors include deliberately "defocusing" (putting the entire image out of focus); selective focusing (putting a specific part of the image out of focus); using a slow shutter speed and moving the camera while the shutter is open; various soft-focus methods, such as a diffusion or soft-focus screen; and the use of filters. These courses of action can later be accentuated with post-capture software.

FIGURE 10.12 "The series focuses on our fascination with our own bodies. By isolating the point of focus, I invite viewers to imagine themselves in the same place behind the 'wall.' The flat monochrome color with its blue-green cast suggests the proneness toward age, whereas the cracked texture implies the fragility of the environment."

Credit: © Katya Evdokimova. *The Silhouette*, 2005. 16½ x 12 inches. Inkjet print.

FIGURE 10.13 (*Below*) Deborah Orloff's series *Holzwege*, literally translated as "wood path," refers to forest paths leading into the unknown and uncertainty. Pairing disparate scenes, Orloff blends layers of images and opacities to create ambiguous and surreal landscapes, which merge and disappear into one another. She relies on the eye-level perspective of a driver or a pedestrian in combination with leading-line and large-scale prints to draw the viewer's eye into her fabricated landscape. The fog defuses the detail, encouraging one to explore and transform these fictitious scenes.

Credit: © Deborah Orloff. *Holzwege 1*, 2006–2009. 22½ x 34 inches. Chromogenic color print.

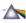

PERSPECTIVE

Perspective controls the sensation of depth, allowing imagemakers to give two-dimensional space the illusion of a third dimension. Light and shadow provide an initial starting point in creating a feeling of visual depth, but the actual illusion that one object in the composition is closer to the foreground than another is brought about through the use of perspective.

ESSENTIAL METHODS OF PERSPECTIVE CONTROL

The following are basic types of perspective control commonly exercised in photography:

- Aerial perspective is the effect in which colors and tones become blurred, faded, and indistinct over distance, due to atmospheric diffusion. Colors and details in the foreground appear brighter, sharper, and warmer and have a darker value than those that are farther away. There is a proportional decrease in luminance and warmth with distance, which can be reduced by adjusting your camera's White Balance or by using 81A and 81B warming filters.

- Diminishing scale creates the impression of depth through the assumption that the farther an object is from a viewer, the smaller it appears to be. By composing with something large in the foreground and something smaller in the middle ground or background, one can heighten the feeling of depth. It also is possible to fool the viewers' sense of depth by reversing this order.

- Depth can be limited by visually incorporating a well-developed sense of pattern into the composition, which tends to flatten the sense of picture space. Also, removing the horizon line can alter the illusion of depth. Another option is to set the camera lens at its shortest (wide-angle) focal length and place it so close to a subject that it cannot be sharply focused, thereby spurring interest by unconsciously encouraging viewers to actively hunt for something sharp in the picture space.

- Linear perspective occurs when parallel lines or planes gradually converge in the distance. As they recede, they seem to meet at a point on the horizon line, known as the *vanishing point*, and disappear. Lowering or raising your camera position will increase or decrease this effect.

- Overlapping perspective occurs when one shape in the picture frame is placed in front of another, partially obscuring what is behind it, and thereby giving the suggestion of depth.

- Perspective and focus can be modified (including viewpoints) and controlled with post-capture software, such as Tilt-Shift (see Chapters 3 and 4), that provides advanced controls for simulating shallow depth of field.

- Position makes the visual supposition that objects placed in a higher position within the composition are farther back in space than those toward the bottom of the frame. The same conventions that apply to diminishing scale apply to position.

- Selective focus is an excellent photographic method for creating the illusion of depth. To the eye, a critically focused object offset by an unsharp object appears to be on a different plane. Setting the lens aperture to its maximum (largest) opening will diminish the depth of field and facilitate the separation of the foreground from the middle ground and background. Since the depth of field is extremely limited, the object of focus is sharply defined, whereas the detail in the remainder of the picture appears nebulous and vague. Also, using a longer-than-normal (telephoto) focal length reduces the amount of depth of field at any given f-stop. The longer the focal length of the lens, the less depth of field it will have at any given aperture.

- Two-point linear perspective can be achieved by photographing a subject from an oblique angle (an angle that is not a right angle and therefore is neither parallel with nor perpendicular to a given line or plane). This effect can be seen in a subject

with vertical parallel lines, such as a tall building. When viewed from a corner, two walls of the building seem to recede toward two vanishing points rather than a single one. The closer the corner of the building is to the center of your composition, the greater the sense of depth, distance, and space. If the building is placed in one of the corners of the composition, it flattens one of the walls while making the other look steep.

CONVERGING LINES

A common problem when working with perspective is converging vertical lines. For instance, when you are making an image of the entire front of a tall building, it is possible that you may have to slightly tilt the camera to take it all in or that you may need a wide-angle focal length; both of these choices cause the building's vertical lines to converge or move together.

Convergence can be visually pleasing, as it accentuates the building's sense of height. But what if you need to maintain correct perspective and keep the vertical lines parallel and straight? It is possible to minimize this effect by moving farther away from the building and setting your zoom lens to a longer focal length. This often is not possible in a confined urban environment. If you have a DSLR, some cameras

FIGURE 10.14 "The *Test People* depicts a future time when a capacity for flight (or controlled antigravity) has been developed in humans. Its boundaries are being studied and tested in a semi-scientific manner. It is an awkward struggle for the test subjects to integrate these new possibilities for movement into the strictly gravity-based architecture of their domestic environments. Aspects of real war and gaming creep in. Stunt artists are photographed against a green screen, and alpha masks of them are created with Corel KnockOut. The backgrounds are composites of floor-to-ceiling images of the space seamed together in Photoshop. The stunt artists' images are then added in, and color balanced and stretched to match the range of color casts in the scene as well as the lens distortions."

Credit: © Sabrina Raaf. *Over and Again*, from the series *Test People*, 2004. 86 x 26 inches. Inkjet print. Courtesy of Wendy Cooper Gallery, Chicago, IL.

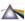

FIGURE 10.15 Christopher Jordan states, "The suburbs are unlikely places for poetic mysticism. As symbols of progress and the American dream (or nightmare), these neighborhoods often lack individuality, character, and uniqueness. Paradoxically, this banality can incubate something mysterious, wondrous, and mythological." Jordan prints and rephotographs his images of suburban neighborhoods, arching, cutting, and obscuring the physical prints with vellum overlays to obfuscate the perceived reality of the scenes. The resulting muted color palette "explores the ambiguity between photographic expectation and neo-pictorialist space, signification and abstraction, and the real versus the uncanny."

Credit: © Christopher Jordan. *Suburban Sublime 13*, 2010. 20 x 30 inches. Inkjet print.

have a built-in Perspective Control or Straighten feature that can carry out basic corrections, but the best and most expensive solution is a special perspective-control shift lens. Another option is a larger-format camera that has a rising front and/or a tilting back, which permits perspective correction. In the end, the most practical solution is likely post-exposure imaging software that allows for precise perspective adjustments (see Exercise 10.7).

EXERCISE 10.7 **PERSPECTIVE**

Create robust visual statements that make the most of the perspective control methods covered in this section.

SUBDUED COLOR

Subdued color images often possess a uniform tonality and contain unsaturated colors. Soft, flat light produces quiet colors. Color can also be subdued by adding black, gray, or white by means of lighting and/or exposure or by selecting desaturated tones. Low levels of light reduce saturation. Delicate colors can occur in failing evening light, when shadows add gray and black to the scene, generating a calm and silent atmosphere. Any form of light scattering, such as flare or reflection, introduces white, thus desaturating colors, and can produce a more serious ambience. Choosing a reserved background color scheme can make certain colors appear less saturated. Restrained colors can often be found in aged and weathered surfaces. A limited or low range of tones mutes color and can stimulate a sense of drama, mystery, sensuality, and an element of the unknown (see Exercise 10.8).

OPERATIONAL PROCEDURES

Specific subdued color techniques to consider include the following:

- Work with a limited color palette.
- Select a dark, simple, uncluttered background.
- Concentrate on an overall low-key color scheme.
- Illuminate the subject from a low angle.
- Minimize background detail by using a higher shutter speed and a larger lens opening to reduce depth of field.
- Expose for the highlights, allowing the shadows to be dark and deep. Bracket and review your exposures until you achieve the desired effect.
- Intentionally compose the principal subject to block out a portion of the key illumination source. This generates a rim lighting effect, which also reduces the overall color contrast and tonal range.
- Work with a diffused or low illumination source, which also reduces the overall tonal range. This naturally occurs in fog, mist, and/or before and after storms.
- Try a diffusion filter or improvise with a piece of transparent, light-colored cloth or stocking.
- Utilize imaging software to make post-capture adjustments to colors and/or depth of field.

As there are unlimited software adjustment options, users typically incur a greater tax on their time by altering an image after it is made in-camera. The more you can do to get the desired image at the time of capture, the less time you will need to electronically manage and edit it.

EXERCISE 10.8 SUBDUED COLOR

Make use of at least one of the working techniques mentioned to produce images that rely on quiet, subdued color for their impact.

HIGHLIGHTS AND SHADOWS

Convention dictates that photographs have ample highlight and shadow detail to convey a convincing rendition of reality. A camera's built-in exposure meter automatically carries out this function by averaging the difference between the light and the dark areas according to various programmable modes. However, in some instances you may be able to make a more visually exciting interpretation by emphasizing one or the other. This effect can be achieved by exposing for the opposite of what you want to emphasize. For example, if you want the shadows to be very dark, you would expose for the highlight area in which you want to retain detail. This can be done by physically moving closer to the subject or by optically zooming in close so that the highlight area fills the frame, taking a light meter reading from this spot, setting the exposure based on this reading, and then moving or zooming back and composing the scene. Review your exposures and make adjustments until you are satisfied. To emphasize the highlights, expose for the key shadow area in the same manner (see Exercise 10.9).

EXERCISE 10.9 CONTRAST

Find or create a scene that has a considerable difference in the highlight and shadow areas. Then, make a series of images of the scene in which one image accentuates the highlight areas; a second, the shadow areas; and a third that has detail in both. Then add a black-and-white object and photograph the scene again. Analyze how and why each image works, deciding which one best satisfies you. What is it about that image that speaks to you? How did adding a black-and-white object affect the scene? How can these findings be applied to other picture-making situations?

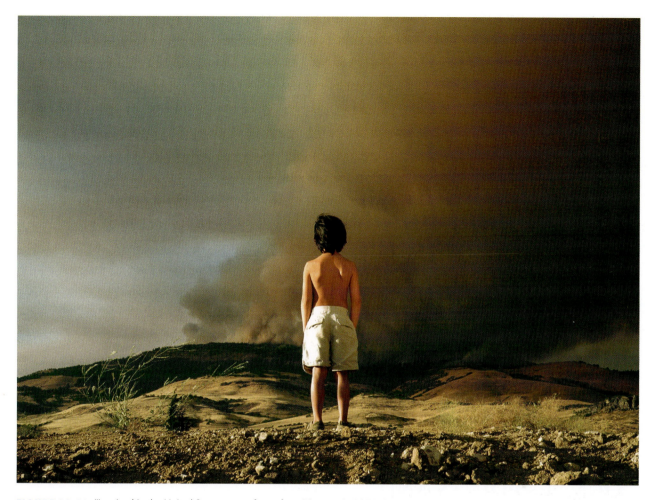

FIGURE 10.16 "I arrived in the United States as a refugee from Vietnam in 1975. As an American, my illusionary Garden of Eden was made unstable by the events of September 11. *East of Eden* is a manifestation of my need to offer, as a war survivor, my perspective on the present landscape of anxiety. The historical strategy of utilizing the landscape as a metaphor for nationalism and optimism—as in the paintings of the Hudson River School—provides the background for my thesis of reframing Eden in the context of a post-apocalyptic landscape. My intentions are not limited to the portrayal of death and despair, but also to portraying the hope and regeneration experienced by the inhabitants of the contemporary political and psychic landscape."

Credit: © Pipo Nguyen-Duy. *Mountain Fire*, from the series *East of Eden*, 2002. 30 x 40 inches. Chromogenic color print.

ATTRACTION AND REPULSION

People are attracted to certain individual and collective groups of colors yet repelled by others. What is your preferred color or colors? Think about what colors regularly appear in your life, in the clothes you wear or in the decoration of your personal space. Do these colors frequently appear in your work? Given a choice, are there colors that you will avoid being around? Do such colors ordinarily show up in your images?

SURMOUNTING PRECONCEPTIONS

After making images (see Exercise 10.10), study them and list the associations that come to mind regarding the colors. Did changing the natural color of an object affect your feeling and thinking about it? By purposely working with a color that you dislike, is it possible to change your relationship to it? Can you dissect your preferences and overcome specific dislikes of color that result from instilled prejudices, inexperience, lack of insight, or the failure to think for yourself? Do you really loathe

EXERCISE 10.10 ATTRACTION AND REPULSION

List the colors that attract you and those that you find distasteful and repellent. Then, do the following:

- Make an image that revolves around your favorite color or combination of colors. What qualities do these colors possess that you find appealing?
- Make another picture that deals with a color or colors that you dislike. What are the characteristics of these colors that you find offensive?
- Change the color of a known object through the use of light or paint at the time of exposure or through the use of imaging software. How does altering the natural color affect your response to this object?

the color ocher, or was it your mother's least favorite color? Asking and honestly answering such questions can help keep your possibilities open, giving you the personal freedom to explore your full potential.

COUNTERPOINTS AND OPPOSITES

Counterpoints are ideas or themes used to create a contrast with the main element. For instance, in music, an orchestra counterpoints the vocal parts. In the visual world, we can see color contrasts in our living environment, where black moldings can counterpoint off-white walls and wooden floors. Hence, the overall visual impact is the result of all the colors that make up the scene.

Now, consider an offshoot of counterpoints—that is, opposites. In the Western world, opposites are considered to be antithetical, or mutually exclusive positions. However, in ancient Chinese philosophy, the concept of yin and yang describes two opposing yet necessarily linked primal forces found universally in all things. Of these complementary elements, yin is symbolized by water and is feminine, passive, and dark—corresponding to the night and downward-seeking—while yang is symbolized by fire and is masculine, active, and light—corresponding to the day and upward-seeking (see Chapter 2).

More culturally familiar opposite concepts include old and new, happy and sad, young and elderly, large and small, soft and hard, high and low, bright and dull, messy and neat, sweet and sour, fast and slow, good and evil, calm and stormy, peaceful and warlike, hate and love, apathy and passion, individual and group female and male, intimacy and distance, seduction and repulsion.

Opposites can also be purely visual, such as angular and flowing, or circular and sharp. Opposites may also be conceptual, relying on the play of contradictory states of being, such as inner and outer reality or nature and the human-made (see Exercise 10.11).

EXERCISE 10.11 OPPOSITES

Make images dealing with the theme of opposites, such as those listed in the previous section, without utilizing well-worn symbols. Think abstractly and intuitively. Analyze your reactions to these pairs of contrasts. How do such juxtapositions affect your interpretation? Are they what you expected? Is viewer reaction consistent or is it individualistic? What does this tell you about the nature of apparent opposites? Is it possible that each contains the seed of its opposite and cannot exist without the other?

NOTE

1. Peter de Bolla, *Art Matters* (Cambridge: Harvard University Press, 2001), 143.

FIGURE 10.17 "This series uses digital imaging technology coupled with the analog camera to create three distinct views of the same portion of earth by utilizing microscopic, satellite, and photographic images." The three distinct views are presented as a triptych that allows Jeremiah Ariaz to "draw attention to how our relationship to nature is informed by the broadening means we have to literally see ourselves in the land we occupy."

Credit: © Jeremiah Ariaz. *Sahara*, from the series *Envisioning the Land*, 2007. Variable dimensions. Inkjet print. Courtesy of Dolphin Gallery, Kansas City, MO.

FIGURE 11.0 Thomas Demand remakes the world in paper and cardboard and then photographs the results. For this project, he used a digital program to cut each of the 900,000 layers of heavy gray cardboard, weighing 50 tons, which he used to build his grotto, layer upon layer. Wanting certain parts of the final photograph to lack definition, Demand actually built "pixels" in cardboard, tiny squares that deceive the eye into thinking the photograph is unfocused, whereas it is in fact reproducing the "reality" of the sculpted grotto. "Digital is just a technique of the imagination. It is opening possibilities that wouldn't have been there before. But I lose interest in a photograph once I see it is digitally made because it is all about betraying you in a way. I think my work has a lot in common with what digital wants, rather than being digital. Basically, it is constructing a reality for the surface of a picture."

Credit: © Thomas Demand. *Grotte*, 2006. 78 x 173 inches. Chromogenic color print. Courtesy of VG Bild-Kunst, Bonn, Germany/Artists Rights Society (ARS) and 303 Gallery, New York, NY.

Solutions: Thinking and Writing about Images

There are innumerable ways of defining the creative process, but its nucleus is the result of thinking critically about an issue or problem that leads to a defined, concrete action. Visual thinking involves an imaginative and resourceful interaction between an imagemaker and a subject. Definition and description are central components of the process, for they allow us to acknowledge and take responsibility for a problem and its meaningful solution.

Problems arise from every aspect of life. They can spring from our private world of friends, loved ones, or family. They may come from our work-world situations of bosses and coworkers. Others we willingly take on or have thrust upon us from the outside world by educational, economic, political, and even accidental circumstances. We cannot try to solve every problem we encounter. We must be selective about which problems we choose to tackle; otherwise, we will be overwhelmed and unable to accomplish anything.

A problem is a situation for consideration. It is a question for open discussion and should not be ignored or treated as a cause of anxiety. Defining the true nature of a problem paves the way for understanding, which can lead to a successful resolution of the problem. To obtain the maximum benefit from this book, you need to begin thinking about how photographic images can be used to arrive at your specific destination. This can occur when intellect and sentiment combine to find the most suitable technical means of taking an idea from the imagination and bringing it into existence. For the successful imagemaker, imaginative and technical means coexist and support each other.

Photography does not imitate nature, as it is often said to do, but it does manifest personal realities. Photography can provide us with the means to create, invent, and originate ideas from our imaginations and bring our thoughts into the physical world. A finished image depends on the properties of the specific materials involved in its creation. By gaining an understanding of the range of photographic concepts, equipment, materials, and processes, we put ourselves in a position to better control the final results of this collaboration of cerebral and material worlds.

Learning to control a process is the first step an imagemaker must master to transform an abstract idea into a physical reality. To facilitate the transformation from mind to medium, an imagemaker needs to discover how to direct energy effectively through the available technical means. This text introduces an assortment of such methods, gives examples of how others have applied them, provides basic working procedures, and encourages each reader to make future inquiries. Once a person obtains a basic understanding of a process, creative control over it can freely commence with skeptical inquiry, active dreaming, and reflective philosophy, with or without regard to authority or tradition.

FIGURE 11.1 "This work examines the problems of trauma and uncertainty carried from my upbringing as a Polish immigrant. The models are mannequins, and their faces are slide projections of images made of my father and myself. There is an undercurrent of helplessness and misdirection linked with schizophrenic parenting, excommunication, and constant movement. My elders believed that children did not have a choice. Frequently I heard a Polish equivalent of 'Children should be seen and not heard.' I am attempting to give these children voices."

Credit: © Ursula Sokolowska. *Untitled #57*, from the series *Constructed Family*, 2006. 30 x 30 inches. Chromogenic color print. Courtesy of Schneider Gallery, Chicago, IL.

THINKING STRUCTURE: A PROCESS FOR DISCOVERY AND PROBLEM SOLVING

Once you have determined that a project is feasible, it is time to devise a plan to make it happen. Most people perform better when they organize their thoughts with a point of departure and a specific destination in mind. The use of a thinking model can be helpful for instigating, clarifying, and keeping the creative process moving. Such a structure can reveal errors and inconsistencies and can assist in substantiating the suitability of a working method. Look for an open and flexible system that expands your thought process and unlocks new vistas and working premises to solve problems.

A structured approach provides the reassurance of starting out on a known road, but there are many routes to most destinations. For this reason, using the same rigid model in every situation can lead to trite results. If a thinking process is overly confining and precisely spells out everything, creativity ceases; boredom sets in; and repetitive, programmed outcomes result. Grabbing hold of known responses can be dishonest because they are someone else's answers. To avoid stale, off-the-shelf solutions, work with a model that encourages experiments that can take you outside the system, including your usual ways of thinking. Systems that

BOX 11.1 GETTING STARTED: PROJECT VIABILITY

Before embarking on any project, determine its viability by considering the following issues:

- **Interest**: What is my level of interest? Am I willing to spend my time, energy, and resources on it? Can I fulfill an internal promise to see my idea through to completion?
- **Selection**: What knowledge do I have about this subject? Narrow down your choice and be specific about what you are going to include. Once you have begun, it is all right to rethink and change, contract, or expand the project as new information is gained.
- **Audience**: Will other people or venues be interested in this subject? Can I engage and retain viewer attention without violating my personal integrity or that of the subject?
- **Visualization**: Is this a subject that lends itself to a robust visual interpretation? Subjects and themes that portray action or intense emotions are generally easier to visualize than intellectual concepts. Think of films, videos, and still images you appreciate and why they stick in your mind. In the main, you will likely discover their message and story are delivered principally through imagery, with careful use of dialog and sound.
- **Accessibility**: Is this a practical project? Is everyone involved willing to cooperate? Does it fit into your time and financial resource budgets? Can you work at times that are accessible to the subject and yourself?
- **Research**: How can I learn more about the subject? What is available online? Look at the work of other imagemakers who have covered similar subjects. Analyze what they got right. What would you do differently? Discuss the subject with those directly involved to understand what they are thinking and feeling. Read what others have uncovered. Talk with people who have expertise with the subject. Write out your thoughts to assist in expanding and clarifying your understanding. Consider different approaches and ideas and how they can be tied in together. Use these pieces of information to generate your own ideas that can be visually expressed.

function well inspire the confidence to make choices without dictating exactly what to do in every situation. A good thinking model provides a channel for the free flow of creative energies without diverting their strength by demanding absolute adherence to arbitrary procedures. Such a model can open up the possibilities of new visions and provide a means of imaging what you have discovered.

The following pages offer a six-stage thinking model for the creative interaction between imagemaker and subject (see Table 11.1). Use it as a starting point, but feel free to expand, contract, analyze, and/or criticize

this model. Improve upon it or modify it to fit your own prototype. The vital point is to reason, reflect, and determine what works for you to visually convey your concepts with images. Discovery demands the freedom to ask uninhibited questions and go in new directions because experimental work disrupts traditional modes of operation. Initial ideas about originality, subject matter, how images can look, process, and treatment should all be questioned during the creative process. An ideal thinking model encourages you to ask tough, provocative questions, not only of others, but also, and most importantly, of yourself.

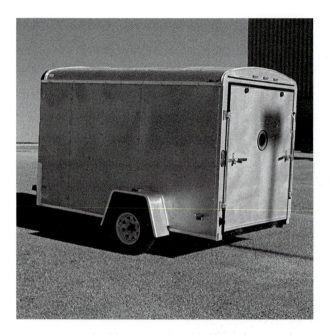

FIGURE 11.2 Al Wildey's research enabled him to bring together a combination of old and new photographic imaging systems. He modified a cargo trailer into a light-tight camera obscura that forms an image on a large sheet of acrylic hung at the focal point inside, where a digital camera was set up on a tripod to record the projected image.

Credit: © Al Wildey. *Camera Obscura Trailer*, 2006. Variable dimensions. Inkjet print.

FIGURE 11.3 Al Wildey's circular image, made using his cargo-trailer pinhole camera, represents his investigation of the landscape genre that "invokes a sense of fifteenth-century photographic prehistory that serves as the catalyst for a distinctly twenty-first-century conclusion."

Credit: © Al Wildey. *Yield*, 2006. 30 x 30 inches. Inkjet print.

A THINKING MODEL

Thinking involves a continuous processing of inter-mingling events and ideas in a way that often does not follow a precise order. Feel free to skip around or go back and forth between steps or to devise a method that is suitable to your circumstances. The steps outlined in this chapter can be approached in a circular, continuous cycle or in a linear manner, that is, one step in front of the next until the destination is reached. They may also be considered in a hopscotch fashion of skipping around from one step to another or by crisscrossing the steps. Don't hesitate to switch models if the one you are using is not working out. Don't be in a rush. Make time to deliberate about what you want to communicate and how you will make that happen. Keep in mind what Henry David Thoreau wrote in *Walden* (1854):

We are in great haste to construct a magnetic telegraph from Maine to Texas; but Maine and Texas, it may be, have nothing important to communicate. . . . We are eager to tunnel under the Atlantic and bring the old world some weeks nearer to the new; but perchance the first news that will leak through into the broad, flapping American ear will be that the Princess Adelaide has the whooping cough. After all, the man whose horse trots a mile in a minute does not carry the most important messages; . . .[1]

STAGE 1: THINKING TIME

Thinking time commences when you experience the first conscious awareness of an idea. Ask yourself, Where did this idea come from? Sometimes you can trace it back to an external stimulus, such as talking with friends, streaming a video, seeing something online, reading a book, or observing a situation. Other times,

TABLE 11.1 Thinking Model

Stage		Actions
1.	Thinking Time	This is the time for discovering and taking hold of crucial ideas. Get going. Don't procrastinate! Keep a source notebook for idea generation.
2.	Search for Form	Make a self-declaration accepting the concept and the challenge to give the abstract idea concrete form by visualizing all the possibilities.
3.	Definition and Approach	Select equipment, materials, and methods that provide the best route for the visual development of the idea.
4.	Bring It Together	Pull all your visual knowledge and resources together into a concrete visual plan.
5.	Operations Review	Take an initial examination of your images to determine strengths and weaknesses, make corrections, and decide future actions, including whether your approach is still workable or whether you need to re-evaluate and reshoot.
6.	Evaluation	Review all steps by formulating questions that reflect your concerns, expectations, needs, and wants. Determine what does and does not work, analyze why, and decide what has to be redone and how to do it better.

FIGURE 11.4 "This image was inspired by astronomical, planetary, medical, and microscopic scientific/digital imaging. I use my scanner like a camera and import anything I can, from objects and fabric to my own drawings to newspaper images, junk mail, old money, museum maps, and things from the Internet. Plus I create drawings in Illustrator and import them into Photoshop. In wanting to expand on what is possible in the digital medium, my greatest artistic challenge is to defeat my own tendencies, and open my mind to new possibilities; technically it is about maintaining patience."

Credit: © Brian Moss. *Planets and Moons*, 2006. 11 x 16 inches. Chromogenic color print.

it may be internal. It may be produced by apprehension or pleasure based on your memory of experiences and knowledge. It might be brought about through conscious thought directed toward a particular subject. It could strike without warning, seemingly out of nowhere, having either emotional or intellectual origins. It can arrive while you are commuting or in the middle of the night in the form of a dream.

What should you do when an idea first makes itself known? Don't lose it. Many ideas emerge only to get lost in the routines of daily life. Ideas can be the spark that ignites the act of creation. It does no good to have a marvelous idea if you cannot hold onto it. If you ignore it, the ember will die out. Make an effort to preserve the idea by recording it without delay. If it is a thought, write it down. If it is a visual image, capture it. If you do not have a camera, make a thumbnail sketch. Don't be concerned about making a master-work. Record what has piqued your interest and analyze it later. The essential point is to break inertia and generate fresh, unprocessed source material.

Getting Ideas

Generating first-rate ideas to solve visual problems requires increasing one's awareness and ability to think critically and independently. This conscious responsiveness demands the self-discipline of asking questions, acknowledging new facts, skeptically reasoning through your predispositions, and taking on the responsibility of gaining knowledge. Allow reason, logic, emotions, and

sensations to enter into the process. Be prepared to break with habit and take chances as the process unfolds (see Box 11.2).

Listen to yourself and others to get preliminary courses of direction and information. Problem solving necessitates coming to grips with the true nature of the situation. Do not hold onto one idea, as absolutist beliefs can be crippling to creative problem solving. The quest for an absolute tends to get in the way of good imagemaking solutions. Be skeptical of people claiming to have all the answers. Simplistic, cookie-cutter solutions extend erroneous answers for the slothful and the unthinking. Suspending beliefs opens one to new ways of exploring and understanding life. The ability to accept the uncertainty of complexity and contradiction, instead of the assurance of certainty and simplicity, is characteristic of an intrepid explorer and a good problem solver. Later, you can compare your new knowledge and beliefs against the old ones. Often, these comparisons will result in contradictions, but they, in turn, can generate innovative insights about the problem and lead to fulfilling solutions based on

BOX 11.2 GETTING IDEAS

Here are suggestions that can generate new ideas:

- **Stick to what you know.** Make images of subjects with which you are familiar.
- **Discover something new.** Make images of something with which you are unfamiliar but that you would like to explore.
- **Look at other images, including, comics, drawings, films, graphic novels, paintings, prints, posters, videos, and websites.** When an image makes an impression, figure out specifically what either appeals to you or disturbs you. Incorporate these findings as active ingredients into your way of seeing and working.
- **Study the history of photography.** H. G. Wells wrote, "History is a race between education and catastrophe." The present and the future cannot be understood without knowledge of the past. Arm yourself with knowledge. Look for concepts, ideas, and processes that appeal to your personal requirements and artistic direction as a springboard for future direction.
- **Consider the themes of literary works** that have made an impression on you.
- **Collect all sorts of materials** that might be useful in making future works.

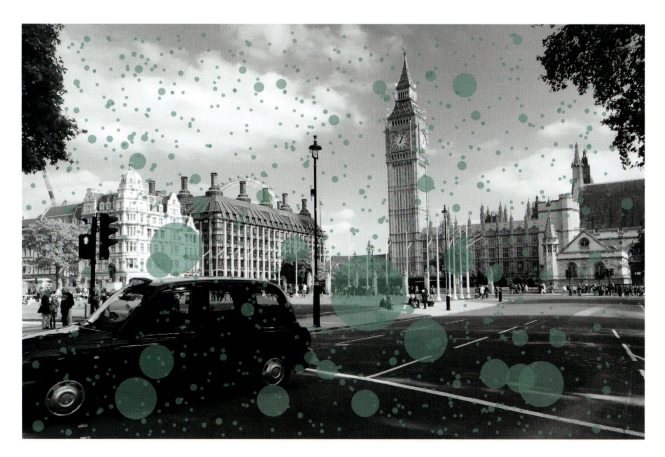

FIGURE 11.5 Adriane Little explains: "Literature is riddled with dead or otherwise missing mothers and the writing of Virginia Woolf is no exception as maternal loss reappears across her novels. For *Mapping Mrs. Dalloway*, I walked the streets of London and photographed along the path that Mrs. Dalloway walks in the 1925 novel of the same title. Using software called Processing, the text of the novel has been divided evenly across the images and transformed into visual mapping so that the green circles grow larger the more often a particular word was repeated. I perceive the interaction of the mapping within each image as moments of loss. The green that is used for the mapping was color matched from photographs I took of the wall paint while inside of Virginia Woolf's home, Monk's House, where Woolf wrote most of *Mrs. Dalloway*."

Credit © Adriane Little. *Mapping Mrs. Dalloway #7*, 2016. 16 x 24 inches. Inkjet print.

personal experiences and needs that combine the apt techniques for your vision.

Challenging Fear

Fear can be paralyzing and the major block to getting new ideas. Fear takes on endless forms: fear of the unknown, of being wrong, of being seen as foolish, or of changing the way in which something has been done in the past. Fear can be aggravated by procrastination and a lack of preparation. Apprehension brought on by trying to anticipate every possible consequence and end result deters creative development by misdirecting or restraining imaginative energy. It is okay to make mistakes; do not insist that everything be absolutely perfect. Gaffes can open conduits to new possibilities, and mishaps can be good fortune in disguise. It is better to take a chance and see what happens than to let a promising opportunity disappear. Beginners are not expected to be experts, so use this status to your advantage. Learning involves doing, so make those extra exposures and prints to see what happens. Consider what artist Sol LeWitt wrote to his fellow artist Eva Hesse:

Learn to say "Fuck You" to the world once in a while. You have every right to. Just stop thinking, worrying, looking over your shoulder wondering, doubting, fearing, hurting, hoping for some easy way out, struggling, grasping, confusing, itching, scratching, mumbling, bumbling, grumbling, humbling, stumbling, numbling, rumbling, gambling, tumbling, scumbling, scrambling, hitching, hatching, bitching, moaning, groaning, honing, boning, horse-shitting, hair-splitting, nit-picking, piss-trickling, nose sticking, ass-gouging, eyeball-poking, finger-pointing, alleyway-sneaking, long waiting, small stepping, evil-eyeing, back-scratching, searching, perching, besmirching, grinding, grinding, grinding away at yourself. Stop it and just DO! . . . Try and tickle something inside you. . . . Don't worry about cool, make your own uncool. Make your own, your own world. If you fear, make it work for you—draw & paint your fear and anxiety.[2]

Source Notebook and Journal Keeping

There are times when you cannot immediately act on your idea. In these situations, record it in an analog or digital notebook. Take the time to transfer, edit, and organize all your notes into a source notebook so your ideas will be preserved in one place. A notebook may include found material, such as articles, quotes, and images, as well as your own written and visual thoughts, and any other items that stimulate your thought processes.

Keeping a notebook can help you sort through experiences and define and develop ideas. Don't worry about following up on every idea. The notebook will help you sift through your ideas and decide which are worth pursuing. Consider your notebook a compass that can help direct your creative travel. It can also provide a personal history of ideas for future reference. As your needs and interests change, an idea that you dismissed earlier may provide the direction you are currently seeking.

Keeping a journal in which you record reflections about events experienced each day can be an invaluable way to evaluate your performance, set goals, and find new ways to solve problems. Many people resist keeping a journal because they think they are not good writers,

that someone will read their innermost thoughts, that their thoughts are petty, or that they have more important things to do. Instead of thinking of this journal as a diary in which you relate the day's events, think of it as a container for self-reflection, self-expression, and self-exploration. Rather than retelling the day's events, use it to find a way to express your thoughts, which may be applied to directing a course of your vision.

The Success Game

Seekers should avoid playing the success game that relies on statistical results to determine achievement. If a photographer were to add up the number of frames exposed and compare it with the number of satisfying images produced, a typical average might be 1 percent. What is not reflected in an empirical average is the intangible enjoyment involved in the imagemaking experience that requires the integration of abstract ideas and concrete operations. Good imagemakers find ways to overcome their doubts and make choices that lead to better pictures. Choice defines who we are, the direction of our work, how it is brought to life, and what viewers might derive from it. Find the area of the making process that gives you the most pleasure and devote your time to it. As Ansel Adams reflected, "Photography is a way of knowing."

STAGE 2: SEARCH FOR FORM

When you are searching for concrete representations of an idea, both the problem and the challenge need to be acknowledged. The core problem is how to present the idea in a visual form that communicates your thoughts and feelings to the intended audience. The challenge is to create visual impact and feel satisfied with the outcome. It is about having something to say and finding an adept way to present it. This is the growth stage of the idea. You acknowledge the problem, take responsibility to commit your time and resources toward its resolution, and make an internal declaration to uncover the possibilities and see the project through to completion.

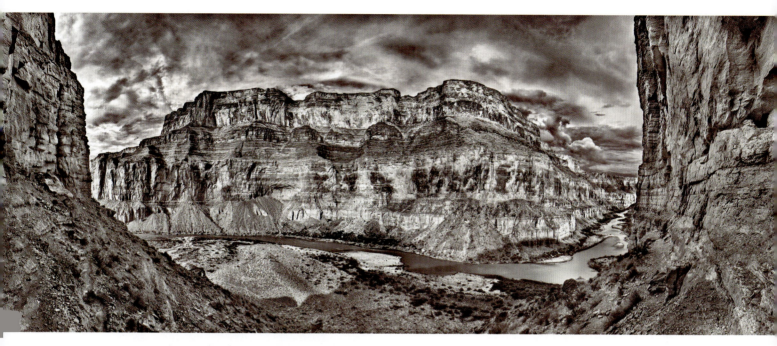

FIGURE 11.6 William Lesch clarifies: "This photograph is part of an extended series I am working on at the bottom of the Grand Canyon. I am trying to arrive at a portrait of place that goes beyond the pretty picture, the Kodachrome moments so commonly photographed in a dramatic place. Taking my inspiration from the early Western exploratory photography of Timothy O'Sullivan and William Henry Jackson, I have been working on everything from landscape photographs that include each night's camp and boats to stops along the route, texture of the water, rocks, canyon walls, plants, the entire ecosystem of place at the bottom of the Canyon and the experience of passing through it on boats. In camera exposure control allowed fast sets of HDR exposure using shutter up function to eliminate camera movement for maximum sharpness and resolution. Software used in post processing allows total image control for such things as panorama stitching from 6 overlapping vertical photos, burning in clouds, opening up shadows, and balancing light/dark tonalities as well as final image toning and printing."

Credit: © William Lesch. *Grand Canyon Panorama, 180 Degree View from Nankoweap Anasazi Granaries*, 2010. 30 x 84 inches. Inkjet print.

The Possibility Scale

Now is the time to ponder your previous experiences and knowledge. Start visualizing the idea in many different forms. Practice using the concept of the *artistic possibility scale*, which states that there are no visual impossibilities, only different levels of possibility. It suspends traditional rationalism and its doctrine of the sovereignty of formulated, step-by-step technique and gives you the freedom to say, "If I can imagine it, there could be a way to make it happen." Think of the fantastic works by Leonardo da Vinci, Mary Shelley, Jules Verne, and H. G. Wells that anticipated future technical inventions and changes in society, and take inspiration from them. The possibility scale embraces the notion that our mind is not wholly dependent on a formulated empirical technique to achieve success. Give your imagination free rein, and then analyze the strong and weak points of each of your visualizations. Specifically ask yourself, How might digital imaging methods allow me to re-see the familiar? Envision how the choice of lens focal length, horizontal or vertical image format, point of view, quality of light, and post-camera image processing procedures might affect the final outcome. Let these pictures run inside the internal projection room of your brain. Do not limit your visualizations, but look for elements that will provide continuity and unity to your vision.

Quiet Time

Consciously break your regular routine and working habits to stimulate the problem-solving process. Turn off the bombardment of external stimuli and listen in

silence to what is happening inside you. Sit down and chart out your ideas on a big piece of paper with a marking pen or soft lead pencil. Get beyond surface scanning and see more deeply before making any final decisions. This process entails getting to the "real" problem and not getting sidetracked by its symptoms. It involves deciding where difficulties in your course of action may lie and narrowing down the focus of what you plan to cover. Keep asking "what if" questions: What if I use this ISO? What if I use this exposure mode? What if I use this type of light? What if I use flash? What if I do post-capture manipulation? Take into account and weigh the possibilities and, above all, keep wondering about everything with the goal of astonishing yourself.

STAGE 3: DEFINITION AND APPROACH

The third stage defines the direction of the action to be taken to solve the problem. This process involves analyzing the problem and determining its essential features and feelings. It includes taking the problem apart, doing research to discover all its ingredients and working out their relationship to the whole. This is the time to question everything and to generate many possible courses to follow. Steer clear of falling in love with one idea or assuming you know the answer before completing this process. Go out onto a limb; defer judgment. Try techniques such as drawing and listing attributes that describe all you know about the problem, including the internal structure, patterns, and form of the problem and the breakdown of its individual parts.

After defining the problem, you can develop an engaging approach and pick the equipment, materials, and techniques that will enable you to speak in a convincing visual voice. Give thought to both previsualization (before the exposure is made) and postvisualization (after the image has been captured) methods. Mastering the methods will not guarantee persuasive results, but it will provide a means to overcome the limitations inherent in the mechanics of

FIGURE 11.7 Since the late 1980s, Vik Muniz has used the camera to record the images he makes by hand. Whether constructed in two or three dimensions, his work uses nontraditional materials, including chocolate, thread, dust, toy soldiers, and diamonds, and often references well-known images. For this series, Muniz arranged color paint samples to create pointillist renderings of images from art history, in this instance a self-portrait of the painter Chuck Close, whose work has a close relationship to photography. Muniz questions photography's truth-telling capacity and explores how our culture of images impacts visual experience. His photographs blur the line separating abstraction from representation and call into question what we see and how we see. In the process, Muniz shifts between roles as painter, sculptor, draftsman, photographer, writer, conceptualist, prankster, and critic.

Credit: © Vik Muniz. *After Chuck Close*, from the series *Pictures of Color*, 2001. 60 x 45 inches. Dye-destruction print. Courtesy of Sikkema Jenkins & Co., New York, NY.

photo-based images. Put together all the solutions that have been considered, and keep an open mind to the alternatives. Keep a backup idea in case a detour is encountered. Do not be afraid to experiment, to take chances, or to try something that has not been done previously, as new ideas and directions may present themselves during any part of the process.

FIGURE 11.8 "What is the essence of a digital image? It is pure data, which is best revealed in the histogram. By looking at the color information, one can visualize the data. Here I recomposed a reproduction of Leonardo da Vinci's *The Last Supper* (1498) without changing any of the data. By using the information found in the histogram, I count the number of pixels associated with each color value. I then redistribute that value in another graphic form. The result is an image that would read the same but not look the same. This demonstrates the possibilities of how an image and meaning can change while the data remains constant."

Credit: © Bill Davis. *The Last Supper*, 2005. 5 x 10 inches. Inkjet print.

STAGE 4: BRINGING IT TOGETHER

In the fourth stage, you muster your resources and put them into visual action. You are no longer thinking or talking about making pictures; you are actually involved in making images. Try out the visualizations you have generated and selected. Take pleasure in the process; it can be as rewarding as the final manifestation of the idea. Do not hesitate to make many exposures; use the camera as an artist uses a sketchbook. These recordings are starting places for realizing your visual ideas. The only way to know what something will look like photographed is by making photographs. Allow the act of photographing to lead you. Don't worry about making masterpieces or mistakes; that will be dealt with later. Keep photographing.

A likely working scenario first involves the pre-capture considerations of subject, quality of light, angle of view, focal length, and exposure determination.

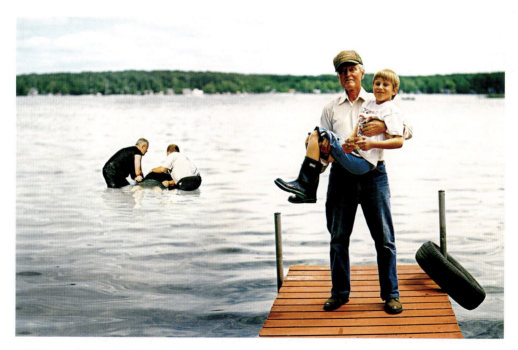

FIGURE 11.9 Marcella Hackbardt's images address issues of the family. "Familial relationships are often described as one of flesh and blood, referring to a biological bond connecting family members, a bond which is sentimentalized as intense and lasting. However, within the family unit, interactions of blood and flesh actually both shape and threaten the family's form and content. While 'flesh and blood' refers to a biological notion of who qualifies as a family, the digital nature of the images suggests a family shaped by constructions, technology, and manipulation."

Credit: © Marcella Hackbardt. *Practical Knowledge*, from the series *Story of Knowledges*, 2006. 22 x 36 inches. Chromogenic color print.

Next, consider how you plan to use the image. Do you intend it for viewing on a screen or as a print? Ask yourself, Will I get the results I want by outputting a straightforward camera capture, or should I use imaging software to make major alterations to the image? Once the final look of the captured image has been determined, decide which procedures and materials to use, such as which paper type and surface to print on.

STAGE 5: OPERATIONS REVIEW

As you work, use your monitor to examine each captured image. If possible, after each shooting session, download your images to a larger, color-corrected screen for review. During this initial in-process evaluation, what do you see? Is this what you had in mind? What worked? What didn't work? Why did or didn't it work? What could be done to make the image more effective? Pinpoint specific sources of dissatisfaction. Can post-capture software take you where you want to go? Is your approach workable, or do you need to reassess, take a different course of action, and reshoot?

STAGE 6: EVALUATION

Stage 6 is the step for reviewing everything that you have done. Formulate questions that reflect your concerns, expectations, needs, and wants. Get explicit and give thorough answers. In addition to the questions asked in Stage 5, ask yourself, Am I satisfied with the outcome? Why or why not? Did I accomplish what I set out to do? Have I deviated from my original approach? What methods did I use to accomplish my goals? If I were to reshoot this project, what would I do differently? Locate, define, and discuss sources of satisfaction and dissatisfaction. Have others look at the work and listen to what they have to say. Now, ask the big questions: Do these images meet my goals? Is the final work aesthetically, spiritually, and technically satisfying? If the answers are yes, note the things you did that were helpful and apply them to future efforts. If the answers are no, it is time to re-evaluate and reshoot. A large part of learning involves being able to deal with failure. Often, we learn more from our failures than from our successes. Pablo Picasso said, "Even the great artists have failures." Do not get scared away. Keep making images.

How do you know when you have created a "good" image? Experience will help you to form your own methods of judgment based on personal experiences and input from additional sources. Some points to consider include Were you able to define your internal thoughts? Did you find and master a technique that allows you to present the final photograph with the desired feeling and power? Have you gained insight and understanding into the true nature of the challenge? Has this experience been translated through the medium to the intended audience? Did viewers connect to the picture? Was it one that they couldn't get out of their mind? What did you learn from viewer reaction? When the image fits the problem and the problem solver, a successful resolution has been achieved.

Satisfying work carries the mark of centered individual thought that results from a well-formed interior thinking process. Becoming a skillful imagemaker necessitates incorporating these attitudes into your visual outlook. Be alert for that defining moment in the process of photography that defies words—when there is nothing else, just you and the subject. If we could express everything we wanted in other media, there would be no need for the visual arts. When used in combination with awareness and intellect, good imagemaking allows us to express things that would not otherwise be possible. When this union occurs, superior images arise.

Once you are satisfied with the image, it is time to think about presentation. Will the image be stronger individually or in a group? Will it be shown on the screen, as a print, or both? If the final destination is a print, should it be mounted, matted, floated, framed, or shown in book format? Keep asking yourself questions and maintain an open mind. Do not seek perfection because it is impossible and you will not reach your goal. If the selected idea is not working out, be flexible and attempt something else. Don't get discouraged, as this is a time of discovery, growth, and

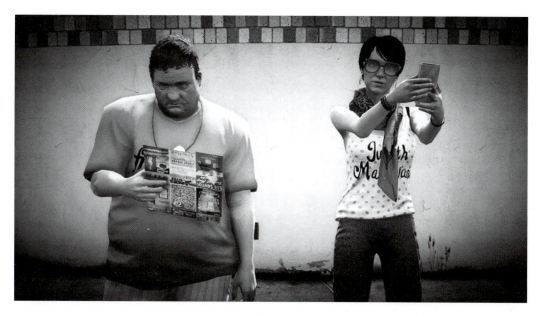

FIGURE 11.10 This series was made on the camera phone within the virtual world of *Grand Theft Auto V*, set in a faux version of the Los Angeles area where sophisticated algorithms generate and simulate everything, from the weather to investment bankers, prostitutes, and surfer dudes. Ravn tells us: "You have freedom within the game and a camera phone that was utilized to explore alienation in the digital age, as well as what can be seen as a new frontier for photographic work. Here the simulated virtual worlds open up a new dimension and modes of expression for photographers, as they will only come closer in resemblance to our physical world as the technology progresses."

Credit: © Morten Rockford Ravn. *Selfie*, from the series *Fear and Loathing in GTA V*. 2016. Dimensions vary. Digital file.

learning. Make sure you learn from your successes by keeping a record of what has been done and how it was accomplished. This is empirical knowledge: repeatable results gained from experience.

Lastly, being persistent and doing the actual work make the difference between success and failure over the long run:

Nothing in the world can take the place of persistence. Talent will not; nothing is more common than unsuccessful men with great talent. Genius will not; unrewarded genius is almost a proverb. Education will not; the world is full of educated derelicts. Persistence and determination alone are omnipotent.[3]

THE PHOTOGRAPH AS A MATRIX

Although photography is a seamless medium, capable of capturing a complete image all at once, any camera-produced image is only the matrix for the final work.

Does this make photography closer to music and theater than to drawing and painting? A drawing or a painting is what it is, a unique object, and copies of it are not the same as the original. On the other hand, music and theater exist and even gain power through their ability to be widely interpreted and modified by individual performers. In his canonical essay, "The Work of Art in the Age of Mechanical Reproduction" (1936), Walter Benjamin argues that, traditionally, a painting or sculpture intrinsically has traits he describes as *aura*, originating from our recognition of its unconditional uniqueness. That is why people continue to line up for a glimpse of Leonardo da Vinci's *Mona Lisa* (circa 1503–1519): not just to see it, but to stand in its acknowledged hallowed presence. In an age of technology, Benjamin recognized that this aura of matchless individuality is diluted by the ready availability of reproductions, which makes it possible for us to see a work of art without ever locking our eyes on the original. For instance, you can now take virtual tours of hundreds of museums on your desktop via sites

like Google Arts & Culture that features content from over 1,000 leading museums and archives. Moreover, one of the native characteristics of the most influential art form of our times, photography-based imaging, is the absence of the "original." Unlimited copies and variations can easily be made from a photograph's matrix base. Photography's power resides in its ability to reproduce, which is evident in popular video games, such as *Grand Theft Auto*. Benjamin endorsed reproducible works and their lack of aura. He deduced that aura was an ambiguous, snobbish mystery maintained as a status symbol by the upper classes and that its disappearance could pave the way for a new and more democratic art form: The social significance of film, "particularly in its most positive form, is inconceivable without its destructive, cathartic aspect, that is, the liquidation of the traditional value of cultural heritage."[4]

SIZE MATTERS

Working with a matrix-based medium like digital imaging allows one to take advantage of one of Benjamin's speculations. Because the image is never fixed, each maker is empowered to determine and alter the size of a print to suit various conditions and situations, which is significant because differences in size shift how we see and interpret images. Digitally, one has the potential to make an image the size of a button or the length and width of a roll of paper. Looking at a small print requires a sustained level of concentration. Small images encourage the mind to focus within a contained, narrow field of vision that allows the entire view to be taken in all at once, which has long been one of photography's intimate delights. We read larger pictures differently, from a distance in a piecemeal fashion, bit by bit, in a manner similar to how we view films in a movie theater, which is different from how we read images on a television or computer screen. Big images reveal more detail that affects the visual equilibrium of the entire picture—where our eyes are drawn, how they

move within the image space, and where they finally come to rest.

Ultimately, superior results render your ideas and intentions visible. A successful solution is one that fits both problem and problem solver. Making this happen requires jumping in—"chance favors the prepared mind"—and becoming part of the imagemaking process.

COMMUNICATING CULTURAL KNOWLEDGE

Good problem-solving and technical skills will not communicate much to others unless they are connected to credible ways of thinking about the issues that are being imaged. The larger, overarching concerns traffic in the variety of purposes that photography performs in our lives and culture. Photography's relationship to reality is paradoxical. Conscientious work can provoke without coercing, while providing pleasure that is mediated by the viewer's judgment. In the recent past, works by such artists as Robert Mapplethorpe and Andres Serrano have been flash points for those who oppose the gay lifestyle and support ending National Endowment for the Arts (NEA) funding to individual artists and alternative arts organizations. Some people have interpreted their images as advertisements for aberrant acts because they see the function of photography in a capitalist consumer society as selling a product, not as a vehicle for provoking controversial ideas. Artists such as Robert Heinecken have helped redefine the boundaries of photographic practice by asking, Does one have to use a camera to make significant photographic work? Critic Arthur C. Danto calls such a maker a "photographist," which he defines as "an artist who uses photographs for artistic means and whose function is partly philosophical reflection on the nature of the kind of art it exemplifies." Other makers, such as Cindy Sherman and Carrie Mae Weems, use images to challenge our assumptions about gender, identity, and race.

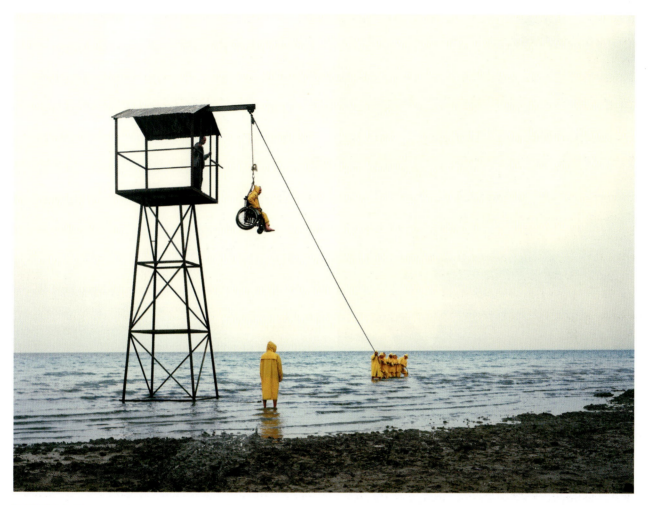

FIGURE 11.11 The perplexing vistas and fraught history of Israel provide the backdrop for Oded Hirsch's work. His large-scale scenes feature surreal mechanisms, taken from his short films made in a remote kibbutz (communal village) where he grew up. Here at the Sea of Galilee (Lake Kinneret), Hirsch had slicker-clad men hoist his paralyzed father and wheelchair to the top of an old watchtower in the rain. Hirsch tells us, "In the past 10 years the kibbutz has gone through fundamental changes and today it is scarcely different from any other capitalistic enterprise. I try to bring back the old ideals and recapture the team spirit that used to be an integral part of our lives by recruiting people to take part in staged, artistic spectacles. I am interested in making people work together and be committed to a community collaborative art endeavor."

Credit: © Oded Hirsch. *Halfman*, 2010. 40 x 50 inches. Inkjet print. Courtesy of Thierry Goldberg Projects, New York, NY.

The material covered in this text is designed to let you discover the many possibilities for photographic imagemaking. This information can help you to bring into existence that which never was. It starts to supply answers to the question, Why not? It raises the question, How can I get beyond just recording the reflections of the surface? Such thinking disrupts the conventional assumption that the purpose of photography is to mirror outer reality. Unfamiliar images can make people uncomfortable because there are no prescribed guidelines on how to respond. Be prepared to discuss challenges and to offer entryways of understanding when presenting unconventional work.

You can meet a challenge and use it to your advantage if you are prepared and have done your thinking, are making images you care about, and have learned to control the imagemaking process so that it merges in and becomes a vital part of the visual

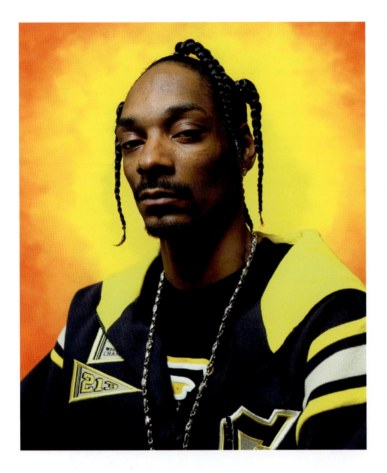

FIGURE 11.12 Dye-destruction print. In 1989, U.S. Senator Jesse Helms accused Andres Serrano of taunting the American public. Serrano's *America*, a mix of formalism and theatricality, presents over 100 archetypical portraits of Americans and is a wonderful rebuttal to Helms's finger-pointing. Presented bigger than life and backlit by a quasi-Divine aura, each subject looks highly glamorous. The photographs have an ironic component that mocks a certain type of kitsch portraiture. But as a group, the portraits project such an intense, vivid presence that it is hard not to feel moved by the democratic saga.

Credit: © Andres Serrano. *Snoop Dogg*, 2002. 40 x 32½ inches. Courtesy of Paula Copper Gallery, New York, NY.

statement. When a situation permits, take on the role of an instructor and explain the information that was required to handle the problem in your particular way. It is likely you will learn more about your subject by trying to teach someone else about it. Nobody learns more about a subject than a well-prepared and patient educator. It is also possible that the explanation will help your audience to see something new and unlock new doors of perception.

THE IMAGE EXPERIENCE: PHOTOGRAPHIC MEANING IS CHANGEABLE

One of the paradoxes of photographic imagery is that its meaning is innately unstable, for it can be deduced only upon being seen. People do not need Photo-shop to alter an image's meaning. Our minds naturally perform this task, editing information as we see fit, better and quicker than any computer program. Without captions describing journalism's traditional Five W's— who, what, where, when, and why—photographs are defined within the context of a viewer's viewpoint. In a quest for meaning, audiences do not merely consume images but, like a Rorschach test, build and rebuild them, re-seeing them within their own comprehension of the past and the present and in real time. In this manner, an imagemaker's work can flow forward and backward in time while being connected to the present.

Compelling images that continue to fascinate and inspire people, such as previously mentioned Leonardo da Vinci (1452–1519), convey the maker's ability to see similarities and forge connections when others see only differences. For instance, Leonardo observed the similarity between tresses of hair and flowing water, and drew both to show us the associations. In his notebook he wrote:

> *Observe the motion of the surface of water, which resembles the behavior of hair, which has two motions, of which one depends on the weight of the strands, the other on the line of its revolving; thus water makes revolving eddies, one part of which depends upon the impetus of the principal current, and the other depends on the incident and reflected motions.*[5]

Leonardo's curiosity and extraordinary ability to look closely at life persuade us to see things as they are,

FIGURE 11.13 Trevor Paglen's work investigates the practice of seeing with machines and, in turn, weapons systems. His images range from the systematic scanning of a drone to visualizing unsecured satellite communications. In this instance, he captures a magnetic field in which the "light" was shifted up into a spectrum visible to the human eye. The tension between these pastoral landscapes and an impersonal vision highlight the fissures and gaps of a vast, intangible network, raising the notion of the sublime. "I am interested in 'entangled photography' or 'relational photography'—thinking about photography beyond photographs. What if the 'fact' of photographing something is the essential critical point of a work? A crucial part of this work is not always what the images look like, so much as the politics of producing them."

Credit: © Trevor Paglen. *The Fence (Lake Kickapoo, Texas)*, 2010. 50 x 40 inches. Chromogenic color pint.

to examine, and to *ask why* the world is the way it is and not to unthinkingly accept what is given. (For more on this topic, see the work by Martin Kemp in the "References" section at the end of this chapter.)

Work that reverberates with viewers is often open-ended, requiring its audience to be more actively involved in shaping its meaning. When our images avoid the restrictions of being didactic, polemic, or illustrative, they can inspire thinking that leads to deeper perceptions, insights, and understanding. Such unrestrained images can transport us into another realm for intellectual and emotional exploration without leaving our home environs, permitting us to be transformed while pursuing our personal freedom and individualism yet reminding us of our collective connection and responsibility to society at large.

Other times, images may resist explanation. If an image could be explained in 25 or fewer words, we would not need the image—only the explanation. Imagemaking is not social science, and not every image should be expected to deliver an empirical meaning. Sometimes, an image can be confounding, and it may well be precisely this mysterious perplexity that remains at the heart of the image experience. For some, such uncertainty can create the "image jitters," an anxiety of not "getting it." Learning to appreciate how images can function is a multifaceted process that involves aesthetics and culture, and one should not expect insight or understanding without doing the work of analysis, investigation, and assessment. Nobody will respond to every image, but one of the rewarding aspects about taking the time to examine hard-to-get images is that it allows you to become part of the creation and discovery process. You can derive your own interpretation based on such counterpoints as attraction and angst, bafflement and order, dreams and reality, while experiencing the enjoyment of discerning meaning for yourself and then informing others about your findings. Being amenable to a variety of meanings helps make us more mentally agile and tolerant of other viewpoints. The realm of images can provide thought experiments that boost, hone, and enhance our minds and being in the world. Keep in mind Oscar Wilde's remark, "The moment you think you understand a work of art, it's dead for you." Fantastic images are living entities that repeatedly draw viewers back to them because they can reveal things you don't know or see are there until you need to know them.

BOX 11.3 ONLINE PHOTOGRAPHIC COLLECTIONS AND EXHIBITION SITES

The American Museum of Photography	www.photographymuseum.com
American Photography: A Century of Images	www.pbs.org/ktca/americanphotography
CEPA Gallery	www.cepagallery.org
George Eastman House	www.eastmanhouse.org
J. Paul Getty Museum	www.getty.edu/museum
International Center of Photography	www.icp.org/
L'Oeil de la Photographie	www.loeildelaphotographie.com/en
Lenscratch	http://lenscratch.com
The Library of Congress Print Room	www.loc.gov/rr/print
LOC: American Memory Collections	http://memory.loc.gov/ammem/index.html
Light Work	www.lightwork.org
Luminous-Lint	www.luminous-lint.com
Masters of Photography	http://masters-of-photography.com
Museum of Modern Art	www.moma.org/explore/collection/photography
New York Public Library	www.nypl.org
photo-eye Gallery	www.photoeye.com/gallery
The Photographers' Gallery	www.photonet.org.uk
Smithsonian Institution	www.si.edu/Collections
Women in Photography International	www.womeninphotography.org
Zone Zero	www.zonezero.com

WRITING ABOUT IMAGES

Solving visual problems involves learning the language of photography. One way of expanding your visual vocabulary and learning to recognize its *semiotics* (signs and symbols) is to write about pictures, for this will deepen your insight into your own working methods, predispositions, and influences and the diverse roles photography can perform. Begin by visiting top-notch, professionally managed online photographic collections or exhibition venues (see Box 11.3) and/or a brick-and-mortar library to browse through the photography and art books and periodicals. If you have access to exhibitions, plan on visiting a few different ones. Don't limit yourself only to photography; rather, select a variety of media, styles, and eras. Spend time leisurely interacting with the work and recording your thoughts. Use a digital voice recording device to capture your impressions and use as a starting place to write short, simple, and specific sentences.

When permissible, photograph works that intrigue you and/or acquire exhibition publications, such as postcards and catalogs, for reference. Next, write a structured review having an introductory premise, a body of well-thought-out observations and evidence, and a conclusion based on the data you presented. Begin by selecting work you find affirmative, engaging, and stimulating. Relate your observations and opinions and support them with specific details derived from your experience with the work. Imagine you are in a court; give direct evidence based on your firsthand account, not generalizations or unfounded information. If you have the means and know-how, include illustrations. Consider including the following topics:

- *Describe the work:* Description comprises the physical character, subject matter, and its form. Form entails how a subject is presented (refer to Chapter 2). Can you determine the color and/or composition key?

How are figure-ground relationships used? How do these qualities inform the overall nature of the work and the persona it projects?

- *Evaluate the technique:* What methods are employed? Is there anything unusual? Does the methodology work for you? Why or why not? Discuss exposure and use of light, along with printing and presentation methods used to generate the total visual effect. Would you do anything differently? Why or why not?

- *Review your personal reaction:* Pay attention to your first reactions. What initially attracted you to this work? Did the magnetism last? Did the work deliver what you expected? Would you want to keep looking at this work over a period of time, as in your living space? Does the maker have a visual or haptic outlook (see Chapter 6)? How does this inform the nature of the work? Did you find yourself thinking or dreaming about the work later? Answer each question with a why or why not response.

- *Interpret the meaning:* Ask yourself: Who made it? What is the point of view of the imagemaker? What was the maker trying to communicate? Does the imagemaker succeed? What is the larger context of the work? Who was it made for? Do the images stand on their own merits, or do they require an accompanying statement or explanation? What is your interpretation of the work? Does it present a narrative account, or is it an open-ended visualization? Does it appeal to your emotions or your intellect? If the work is in a group or series, evaluate how selected images work individually and in terms of the group. Do single images hold their own ground, or are they dependent on being seen in series? Does the imagemaker use any text? If so, which do you first gravitate toward, the image or the text? How does the text affect your perception of the image's meaning? How would your understanding of the piece be different if there were no text? Present clear, succinct, and persuasive arguments, giving evidence to back up your point of view.

- *Integrate new ideas:* Examine and define the work's attributes that appeal to and affect you. Be specific and cite examples. Then, consider how it might be possible for you to learn from and integrate these concepts into your way of thinking and working.

- *Do the opposite:* Go back to the same body of work and select work(s) that you find off-putting. Repeat the previous steps to uncover what adversely affects you. Identify specific points, such as content, color, or composition, and ask yourself what you could do to avoid incorporating such unwanted characteristics into your work.

- *Seek out knowledge:* Seek out someone who is knowledgeable and involved in similar work. Present the work to that person and conduct a friendly discussion. What are that person's views? Does that individual agree or disagree with your assessment? Do your opinions hold together and make a convincing case? Identify both your persuasive and ineffectual points. How can they be improved? Can you see another point of view? What new territory did this other person open for you? How does this affect the way you view the work now?

WRITING AN ARTIST'S STATEMENT

When sending your own work out for review or exhibition, you need to include a statement that concisely explains the conceptual aspects of your work. Essentially, an artist's statement explains why you do what you do and what your work is about. A precisely written statement can forge a connection between the artist and the audience, stimulating awareness and understanding of your work. Artists' statements vary in form, length, and substance. Take into consideration the following: your audience; your materials and medium; the subject of your work; the methodologies and theories that have influenced you; and your own background, purpose, and/or perspective. There are no simple formulas, but the subsequent steps shown in Box 11.4 have been put together with the assistance of Kathleen Campbell, imagemaker and educator, to provide a starting place for writing a concise, easy-to-read, one-page artist's statement.

BOX 11.4 GUIDELINES FOR WRITING AN ARTIST'S STATEMENT

1. The purpose of your artist's statement is to clearly and succinctly explain and give your ideas credibility. Begin by listing what your ideas are and where they come from.

2. Reflect upon your own work and find patterns of interest, and then ask yourself the following: What kind of work do you enjoy making and looking at? Do you photograph landscapes or people? Do you prefer to set up subject matter or find it directly from life? Do you gravitate toward cool or warm colors? Do you favor simple or complex compositions? Do you consider yourself to be a visual or haptic person? What ideas, themes, or common denominators can you discover?

3. Select an artist whose work strongly appeals to you and find out what that artist has to say. Review the procedures from the previous section, "Writing about Images."

4. Do research. Ideas are built upon other ideas. Your work can share an idea with someone else and still be your own work. Artists get ideas from other artists, history, literature, philosophy, and politics. Where do your ideas come from? What ideas appeal to you? When you come across an idea or concept that is a magnet to you, write it down and then rewrite it in your own words, giving it your own personal perspective.

5. Can viewers interpret your image, not knowing what you intended and not having had your experiences? Keep in mind that an image is not the same thing as an actual experience. Generally, it is a two-dimensional representation of colors and shapes on a piece of paper. It is a symbol or a metaphor, but not the event itself.

6. Take into account that all images possess meaning, even if you find requests to explain your work annoying. People will make interpretations whether you want them to or not.

7. Learn the difference between denotation and connotation. Denotation is what images appear to be on the surface, such as a picture of a lake. Connotation is all the associations you can imagine people might "get" from the picture of the lake. There are pictures of lakes and pictures of lakes. Are yours cool and intellectual or warm and romantic? Make a list of all the denotations and connotations you can see in your work. Show the work to others and see what else they come up with.

8. Use metaphors, statements that are representative or symbolic of something else, especially something abstract. Literal statements lead toward literal interpretations. You are not "illustrating" your concept or idea, step by step, but fashioning a metaphor that involves your use of form and process to convey it (even if you do not discuss these in your statement). For example, darkness can be a metaphor for atmosphere. You do not have to hammer people with your intended meaning in your statement if the image(s) creates an interpretable metaphor. Metaphors also can have layers of meaning, so viewers can bring their own insights to the work.

9. A statement should provide a toehold for understanding the ideas behind your images. Don't tell viewers "what they should get" out of your work; rather, point them in a specific direction. By and large, images have more than one interpretation, so allow others the freedom to formulate their own interpretation. On the other hand, this is not an excuse to avoid articulating your own analysis.

10. Make sure your words agree with what can be seen in your pictures. Do not write about things that are not there. If your words and images do not agree, either change the words or change the images until there is an articulate consistency between them.

11. Keep it simple and specific. Avoid making negative statements, writing too much, repeating or overexplaining, using vague generalities, making grandiose statements, or relying on jargon or incomprehensible language. Big words don't make up for weak ideas.

12. Discuss the technical process only if it is integrally related to your idea or is unusual and requires explanation.

13. Include a separate image checklist with the title (if any) of each work, its creation date, dimensions (height before width), process (such as inkjet print), and a general technical overview about the methods utilized to realize your vision. Provide detailed technical analysis upon request.

14. Ask others who are familiar with your work to evaluate your statement. Review, rewrite, and recheck the spelling, grammar, and organizational flow of your document. Writing involves rewriting, and the process of rewriting will also help you gain insight into your work. An artist's statement is a flexible document. You may have more than one for different audiences, and it should be reviewed and revised each time you use it.

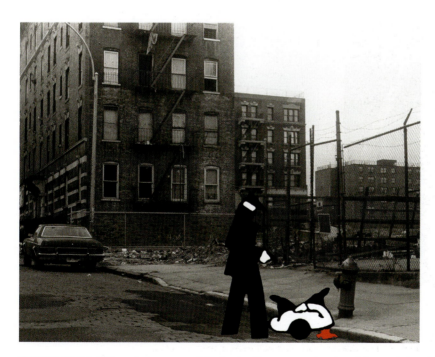

FIGURE 11.14 "This project was one of the first leading to my exploration of the semiotics of the visual language of the photographic image. While I started using icons as image in this series, my exploration later led to the use of text as image. Text as photograph raises questions about the human thought process, the categorization of data, visual language processing, and our individual cultural/social conditioning. I am interested in the way in which the viewer contributes to the context and meaning of individual images."

Credit: © Susan Evans. *Crime Scene, #4*, from *Crime Series*, 1991. 8 x 10 inches. Inkjet print.

ESSENTIALS OF IMAGE DISCUSSION

The following are suggested guidelines for participating in a group discussion about photographic images.

In terms of your own work, prepare talking points that will allow you to clearly and concisely state the intended purpose of your work for others to consider. List questions about the areas for which you would most like to get feedback. Ask yourself: What makes for constructive criticism? What constitutes negative commentary?

When offering commentary on other people's work, follow your own rules, but think *before* you speak and avoid getting personal. Make suggestions in the form of positive questions as opposed to negative statements, such as "What would it look like if you did . . . ?" or "What is the significance of . . . ?"

When evaluating work, consider the following:

- *Instant reaction:* Write down, but do not speak, your first free associations of what affects you, turns you on and/or off, and why. What is the first word or phrase that comes to mind while looking at the work?

- *Physical description:* Objectively state what you see as if for the benefit of someone who can't see the piece.

FIGURE 11.15 (*Above left*)

Credit: © Lloyd Wolf. *April Fool*, 1992. 11 x 8½ inches. Electrostatic print.

FIGURE 11.16 (*Above right*) Since 1974, Lloyd Wolf has created and mailed annual April Fool's cards to friends and family. Wolf transitioned from black-and-white prints to color Xerox and then to scanners. This series exists outside the bounds of his professional documentary work. "There is no established aesthetic, no right way of making work like this, which I find liberating and fun. It gives me a reason and forum to experiment and not worry about making art, but to just make pictures. These are my annual report. Everyone else sends Christmas or Hanukkah cards; I celebrate spring." This whimsical image is digitally assembled and manipulated.

Credit: © Lloyd Wolf. *April Fool 2011*, 2011. 11 x 8½ inches. Inkjet print.

FIGURE 11.17 The theoretical impetus for Terry Towery's work comes from the postmodern idea that there is no such thing as originality. However, in Towery's artist's statement, one learns he is "re-creating in miniature the iconic imagery of the early exploration era of photo history, which suggested the sublime power of the natural world . . . in this case, Roger Fenton's *The Valley of the Shadow of Death*, 1855. In addition, I have invented Timothy Eugene O'Tower, a fictional exploration photographer, as a way of framing the work and to push the elements of fiction and simulacra. Using the veracity of photography, I create worlds where, at first glance, everything appears as it should. It isn't until further probing that we realize that our sense of scale is unnerved and we are left to figure out what is real and what is created. The images blur the line between truth and the imagination. Questions as to photography's authenticity and its relationship to truth in the digital age have become a movement within both the photographic and art worlds."

Credit: © Terry Towery. *View of Crimean War Battle Scene*, 2006. 9¼ x 12 inches. Platinum palladium print.

- *Formal construction:* Analyze the composition, use of design elements, color, craftsmanship, and presentation.
- *Meaning:* Discuss relationships that the work evokes about your life experiences. Does the work have a narrative quality? What does the title or lack of title tell you? Use a noun or plain phrase to identify and name the work in terms of people, places, or things. Bear in mind a long-standing observation from the Talmud about how people interpret life: "We do not see the world as it is. We see the world as we are."
- *World links:* Discuss connections of the work to culture, history, and society and other artists or works you have observed.

JOHN CAGE'S RULES

John Cage (1912–1992) was an American experimental music composer, writer, visual artist, and educator who used chance operations, in which some elements are decided by chance procedures, from the *I Ching* to star charts and Zen Buddhist beliefs, to affirm life and wake us up to the very life we are living. Box 11.5 sets down some of his suggestions for getting the most out of any educational environment.

Cage's philosophy of being open to new experiences can be summed up by his remark, "I don't know why people are afraid of new ideas. I'm afraid of old ones."

BOX 11.5 SOME RULES AND HINTS FOR STUDENTS AND TEACHERS OR ANYBODY ELSE, BY JOHN CAGE

RULE 1: Find a place you trust and then try trusting it for a while.

RULE 2: **General Duties of a Student**:
> Pull everything out of your teacher.
> Pull everything out of your fellow students.

RULE 3: **General Duties of a Teacher**:
> Pull everything out of your students.

RULE 4: Consider everything as an experiment.

RULE 5: **Be self-disciplined**. This means finding someone wise or smart and choosing to follow him or her. To be disciplined is to follow in a good way. To be self-disciplined is to follow in a better way.

RULE 6: **Follow the leader**. Nothing is a mistake. There is no win and no fail. There is only *make*.

RULE 7: **The only rule is work**. If you work, it will lead to something. It is the people who do all of the work all the time who eventually catch on to things. You can fool the fans, but not the players.

RULE 8: Do not try to create and analyze at the same time. They are different processes.

RULE 9: Be happy whenever you can manage it. Enjoy yourself. It is lighter than you think.

RULE 10: We are breaking all the rules, even our own rules, and how do we do that? By leaving plenty of room for X qualities.

HELPFUL HINTS: Always be around. Come or go to everything. Always go to classes. Read everything you can get your hands on. Look at movies carefully and often. Save everything. It may come in handy later.

NOTES

1. Henry David Thoreau. *Walden or, Life in the Woods* (Boston and New York: Houghton Mifflin Company, 1893), 84–85.

2. Gary Garrels, editor. *Sol LeWitt: A Retrospective* (San Francisco and New Haven: San Francisco Museum of Modern Art and Yale University Press, 2000), 79.

3. Elizabeth M. Knowles, editor. *The Oxford Dictionary of Quotations,* 5th edition (Oxford and New York: Oxford University Press, 1999), 236. Attributed to President Calvin Coolidge in the program for his memorial service.

4. Hannah Arendt, editor. *Walter Benjamin—Illuminations: Essays and Reflections*, translated by Harry Zohn (New York: Schocken Books, 1969), 221.

5. Jay A. Levenson, editor. *Circa 1492: Art in the Age of Exploration* (Washington and New Haven: National Gallery of Art and Yale University Press, 1991), 273.

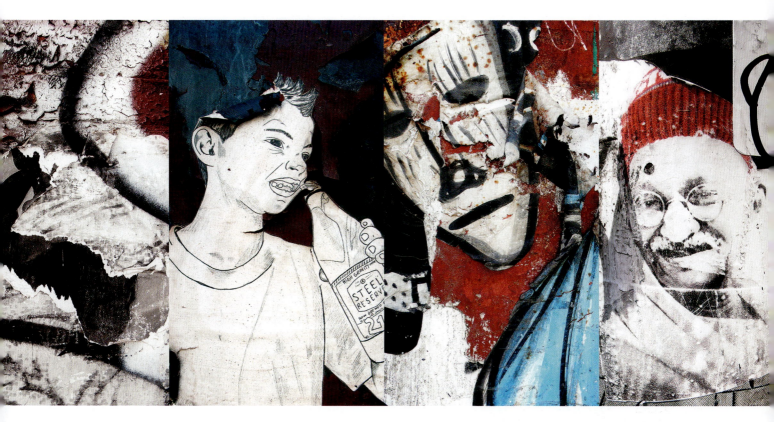

FIGURE 11.18 René West informs that "Since 2007 I have walked the streets of cities in 15 states, making thousands of photographs with a macro lens of these chance encounters between posting, tagging, painting, taping, and gluing on city walls and their eventual decay. Combining images generates a sense of movement and energy that is analogous to walking down the street. The large prints, positioned side by side, produce a dialogue among themselves. The paper's matte surface resembles posters on the street after a few good rains and helps to make textures and peeling paper appear three-dimensional.

Credit: © René West. *Steel Gandhi 4*, 2014–2017. 16 x 28½ inches (assembled side by side). Inkjet prints.

REFERENCES

Barrett, Terry. *Criticizing Photographs: An Introduction to Understanding*. Fifth Edition. New York: McGraw-Hill Humanities, 2011.

Barthes, Roland. (Translation by Richard Howard.) *Camera Lucida: Reflections on Photography*. New York: Hill and Wang, 1981.

Booth, Wayne C., Gregory G. Colomb, and Joseph M. Williams. *The Craft of Research*. Fourth Edition. Chicago: University of Chicago Press, 2016.

Buster, Kendall, and Paula Crawford. *The Critique Handbook: The Art Student's Sourcebook and Survival Guide*. Second Edition. Upper Saddle River, NJ: Pearson/Prentice Hall, 2009.

Kleon, Austin. "How to Steal Like an Artist (And 9 Other Things Nobody Told Me)." New York: Workman Publishing Company, 2012.

Sontag, Susan. *On Photography*. New York: Farrar, Straus and Giroux, 1977.

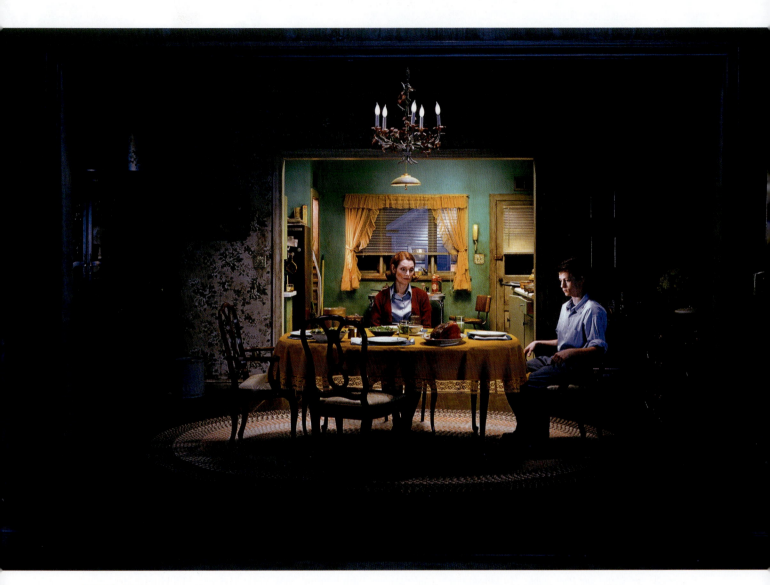

FIGURE 12.0 Working with a film crew and combining multiple exposures, Gregory Crewdson builds pristine cinematic images that depict the psychological pathos of a suburban America where people anxiously stare into space seemingly searching for something they have lost or have yet to find. Crewdson, whose father was a psychoanalyst, remarks, "On some unconscious level, all my photographs project my own fears and desires."

Credit: © Gregory Crewdson. *Untitled, Winter,* from the series *Beneath the Roses,* 2005. 64½ x 95¼ inches. Chromogenic color print. Courtesy of Luhring Augustine, New York, NY.

Imagemaker on Assignment

MAKING PORTRAITS: WHO AM I AND WHO ARE YOU?

Since 1493, when Albrecht Dürer began a series of painted self-portraits that provided insight into the changing nature of his character and beliefs over a lifetime, artists have expressed numerous inner concerns through self-portraiture. Self-portraits allow artists to show awareness of their own appearance and traits, producing evidence of the intricacies of their lives. Self-portraits continue gazing back at viewers in another place and time, perhaps long after their makers are dead. Self-portraits can be projections of the self that represent you as you are, or they can present hidden, even secret, aspects of the self. Traditionally, self-portraits were used to demonstrate social status, talent, wealth, and/or religious beliefs.

More recently, Andy Warhol constantly relied on self-portraiture to reflect on his position as a famous artist, performing a variety of roles that examine celebrity, disaster, and death. Cindy Sherman has made self-portraits cloaked in historical guises that confront and challenge archetypes and stereotypes about the roles men and women play within society. Robert Mapplethorpe photographed himself to explore his sexual identity. Chuck Close has made more than 100 self-portraits in a variety of media that merge manual and mechanical processes to explore the boundary lines between the abstract and the representational, the methodical and the subjective, and the personal and the public self. On the other hand, Nan Golden uses her camera to become part of her intimate relationships, recording her subjective internal feelings rather than objective external experiences. The camera joins and clarifies what is going on between Goldin and the subjects of her group of friends.

SELF-PORTRAIT RESEARCH

Before you begin a self-portrait, it can be instructive to delve into the works of earlier artists who have explored the genre and to note their research methodology, their lighting and compositional choices, and what ideas their works express. It is their ideas that continue to make their images worth studying.

Some marvelous artists whose self-portraits can be instructive include the following:

- Leonardo da Vinci is said to have used himself as the model for Jesus in his painting of the *Last Supper*, 1498.
- Rembrandt's self-portraits were an outlet for feelings and ideas concerning the nature of human existence that he could not express in the portraits of wealthy clients.
- Gustave Courbet embellished his self-portraits, transforming them into fantasies.

- Vincent van Gogh's self-portraits reveal an intensity of expression concentrated in the eyes as he seemingly "looked" for answers to questions that plagued him.
- Pablo Picasso's later self-portraits reveal the anguish of old age.
- Marc Chagall's self-portraits are memoirs of his Jewish childhood in Russia.
- Frida Kahlo's work served as a cathartic emotional release to the troubling events of her life.
- Jackson Pollock's drip-and-splatter paintings do not directly represent human figures, but the impulsiveness and spontaneity of his methods can be seen as a more realistic outpouring of his pent-up feelings than if he had used meticulous brushstrokes.
- Mark Rothko's abstract paintings may also be considered self-portraits, for they express his

deepest passions. Rothko noted, "The people who weep before my pictures are having the same religious experience I had when I painted them."

SELF-PORTRAITS

Portraying oneself before the camera has been a staple of photography since its invention. Hippolyte Bayard, who invented a photographic process at the same time as Daguerre and was the first artist known to hold a photography exhibition, photographed himself as a corpse in 1840. Countess de Castiglione, a nineteenth-century forerunner of Cindy Sherman, commissioned 400 to 500 photographs of herself in numerous guises.

To begin a self-portrait, develop a concept or idea that will lead you through the process. A tried-and-true method of reacquainting you with yourself is to sit down in front of a mirror, alone, without any outside distractions and, with pencil and paper, make a series of contour drawings. Anyone can do a contour drawing: look into a mirror and draw what you see and feel, without looking at the paper until you are finished. Based on what you learn from your contour drawings, formulate the direction of your self-portrait. Your images should express a sense of self-awareness and reveal something that is important for others to know about you and your attitude about life. While it is true that well-learned techniques help us to clarify our voice, it is our ideas that create powerful images.

FIGURE 12.1 "Photography is my identity—it is how I examine my self-image as an overweight female in her mid-20s dealing with the ever-present pressures from the outside world as it relates to this issue of self-identity. I have built a relationship between the camera and myself. Through this I invite viewers into my private day-to-day life, exploring vulnerabilities that I carry associated with a life-long struggle with my body image. I aim to raise questions regarding beauty, body image, and identity through a focused observation of my personal story, which translate to many cultural universals in our contemporary society."

Credit: © Jen Davis. 4 A.M., 2003. 20 x 24 inches. Chromogenic color print. Courtesy of Lee Marks Fine Art, Shelbyville, IN.

PORTRAIT OF ANOTHER PERSON

Next, list the qualities in portraits that have stood the test of time, such as the enigmatic smile in Leonardo da Vinci's *Mona Lisa,* circa 1503–1519, which continue to fascinate people and draw them into the picture. Lasting portraits avoid the obvious and, in doing so, require the viewer's involvement to extract meaning. Take a look at others, such as Richard Avedon, Harry Callahan, Dave Hill, or David LaChapelle, who have explored this area. Now, make a photographic portrait of someone you know who not only shows

FIGURE 12.2 Suzanne Opton photographed more than 90 soldiers at Fort Drum, New York, shortly after their return from active duty in Iraq or Afghanistan. "My intention was to focus on the individual soldier's vulnerability and to look into the face of someone who'd seen something unforgettable. By the simple displacement of lying their heads down, we are reminded of each soldier's humanity. Working with a large-format camera, I was invisible under the dark cloth as my subject held still in this uncomfortable position. It is a quiet way of working. Each soldier was alone—captured with only his or her thoughts and the moment. With these portraits, the head becomes a straightforward object, a piece of fallen statuary. The implication of being shot down was not lost on these men and women, but the pose is also intimate—like seeing someone opposite you with his head on the pillow."

Credit: © Suzanne Opton. *Soldier: Claxton—120 Days in Afghanistan*, 2004. 41 x 52 inches. Chromogenic color print.

the appearance of the person, but gives artistic insight into the nature of this person's character.

ENVIRONMENTAL PORTRAIT

Make a portrait that shows your audience how an individual interacts with the surrounding environment. What does the background environment add to the portrait that a close-up does not? Concentrate on showing only one part of your subject's surroundings so that the importance of the individual is not diminished. In a traditional environmental portrait, the person being portrayed is placed in a setting that shares information about his or her life and/or interests. Typically, an individual may hold an object related to his or her profession or personal interest. Look at the work of Arnold Newman for formal environmental portraits or the Farm Security Administration (FSA) photographers, such as Dorothea Lange and Russell Lee, for more natural models. For contemporary portraits, check out Mary-Ellen Mark, who started her career as a movie set photographer.

When setting up such a portrait, ask yourself: How and what does the setting and inclusion of any object add to what viewers can learn about the subject's life and interests? Also, consider creating your own backdrop, either physically or digitally, which places a sitter in a unique location, perhaps one that the person would like to visit, be it Monument Valley, New York City, or the moon.

Another option is to incorporate personal objects into the environment that represent an absent presence.

FAUXTOGRAPHY: PHOTOGRAPHY'S SUBJECTIVE NATURE

In terms of how we know and respond to the world, photography plays a major role. Photography's inherent ability to transcribe external reality enables it to present what appears to be an accurate and unbiased validation of a scene or a moment. While photography is expert at depicting events, it also actively and/or subtly interprets happenings, as current societal values are continually integrated and interjected into them. In actuality, the purported impartial lens allows every conceivable distortion of reality to take place. Surprisingly, even in this digital age, people are "shocked" when news photos turn out to be manipulated. The phenomenon of tampering with news photographs for propaganda purposes, especially by Middle East terrorist groups, has become so prevalent that a new slang term, *fauxtography*, has been coined to describe it.

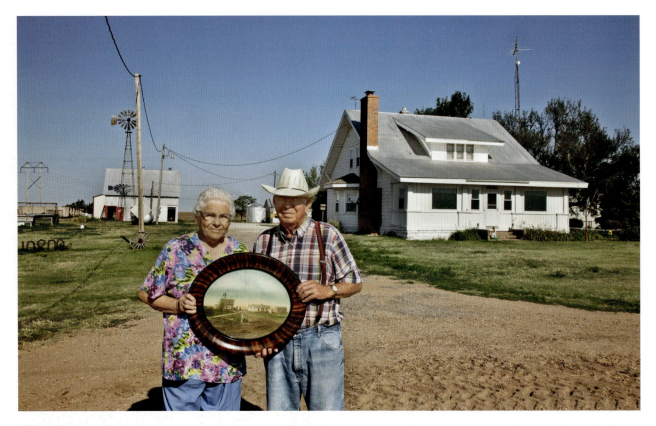

FIGURE 12.3 Larry Schwarm apprises us: "This photograph is part of an ongoing series about Kansas farmers, their connection to the land, and how they make decisions on land usage. An overwhelming number of farmers, when asked why they do what they do, say it is because it is what their parents did before them. This image typifies that idea and also happens to be of my parents. My father's father was given the farm from his father as a wedding present in 1912. My parents are holding a photograph of the farmstead when my grandfather first got it. A new house was built in 1917–1921. The original barn is still standing and the windmill is in the same location. Laurence was born in this house 93 years ago and has lived in it his entire life. They have been married for 74 years."

Credit: © Larry Schwarm. *Laurence and Pauline Schwarm with a Photograph of His Father's Original Farmstead Taken about 1912*, 2012. 20 x 30 inches. Inkjet print.

Previously, people assumed that artists depicted scenes using their imagination, freely adding or subtracting items, but photographers were not supposed to do that. Now, digital imaging has collapsed this profound psychological boundary. Still, we persist in bestowing the power and burden of veracity on photographs. We insist on carrying forward the belief that photography can re-create an original scene with absolute fidelity because that belief adds a sense of certainty, which makes us feel more secure in an uncertain world. This die-hard faith seems to rescue and save the past—often lending it dignity and romance, making us feel a little less mortal—but, like Swiss cheese, it is full of holes (see Exercise 12.1).

TRUTHINESS AND WIKIALITY

In the context of our times, we are conscious that a camera can capture infinitesimal detail, but we also recognize how it can be used to craft distortions or lies about a subject; that is, we know that camera images represent a highly "subjective truth" that can never be taken at face value and always requires analysis. This topic of authenticity has received much cultural attention on television, particularly by political satirist Stephen Colbert, who has popularized such buzzwords as *truthiness*, meaning "truth unencumbered by the facts," and *Wikiality*, derived from the open-source website Wikipedia—a.k.a. the "people's encyclopedia"

—and meaning "reality as determined by majority vote." Citing how astronomers voted Pluto off the list of planets, Colbert points out that in user-created realities, such as Wiki websites, anything can become "true" if enough people say it is. These phenomena can also be seen in the dramatic rise of *fake news* websites that intentionally publish conspiracy theories, disinformation, hoaxes, and propaganda to fuel Web traffic via social media. Unlike news satire, such as the *Daily Show*, these sites purposely deceive and profit from viewers' ignorance, gullibility, and prejudices.

FIGURE 12.4 "These works are all inspired by summers spent in my studio located in an old funeral parlor on an island off the coast of Maine. For this image I created a small carte de visite with a logo for the fictitious *Deschamps Old Funeral Parlor Photography*. Gérard de Nerval was a nineteenth-century Romantic French poet who wrote a famous poem, which is the inspiration for this image. To realize my vision of a romantic, decaying tower choked by vines, I combined photographs of a tree, a landscape, a sky, and various architectural details lifted from old stone buildings."

Credit: © Francois Deschamps. *La Tour Abolie*, from the series *Circa 1900*, 2005. 10 x 6½ inches. Inkjet print.

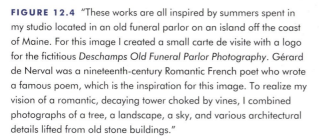

EXERCISE 12.1 DIGITAL TRUTH: HUMAN USER FUSION

Artist and educator Bill Davis has designed a collaborative pedagogical project for his students at Western Michigan University. Its purpose is to visually demonstrate that digital truth is always in flux by having students "manufacture" an artificial face, in the manner of artist Nancy Burson (see Chapter 1), which is averaged from the digital images that all the members of the group take of one another. By having individuals modify their own image and fuse it with images of every user, they create a collective group face that equitably redistributes their own appropriated facial features. In a studio setting, a simple headshot is made of each student, who is encouraged to wear his or her favorite T-shirt, hat, gloves, scarf, jacket, and/or jewelry. Students also sample and switch tattoos or product logos. Imaging software is then used to fuse these images into a single, pan-cultural, and diverse "Common Face." At the end of the project, each student finds traces of his or her own face, but must ultimately concede to the artificial life and image he or she has rendered. Davis says: "It's sophisticated for beginning students and is appropriate for studies of identity, culture, and datagraphic imaging. These images shock and do what all photographs do . . . remind us to remember. But how do we remember something that never existed?"

FIGURE 12.5 Morgan Sandacz relates: "These portraits are tightly structured outcomes of the *Human User Fusion* project. The act of fusing various features of multiple human faces can be daunting, as can the results. I approached the task by emphasizing the unique qualities of my subjects; but the difficult part is putting the distinctive structures together in a convincingly manner. Here I used Photoshop to mold two sisters and their brother together. Knowing the curves and symmetries of a human face is something I have learned through practice. Also, I call upon my fashion rooted training that deals with accenting and highlighting a subject to their perfection."

Credit: © Morgan Sandacz. *Human 003*, 2015. 8 x 9 inches. Inkjet print.

PICTURING SOCIAL IDENTITY

Prior to popular recognition that an imagemaker could control and manipulate a subject before the lens, photography had been used to impose a visual identity upon groups of people outside the dominant culture, thus shaping how that particular group of people was perceived. Nineteenth-century ethnological studies, such as John Thomson's *The Antiquities of Cambodia* (1867) and *Illustrations of China and Its People* (1873–1874), brought back to Europe exotic images that confirmed preexisting attitudes, prejudices, and stereotypes held by the Western power elite. Thomson made pictures for people who considered "the other" as mentally inferior and technologically and socially primitive. His work reflected the values of the British colonial system, which believed in the "White Man's Burden," the right and the duty to govern other lands and enlighten the natives in the ways of Christianity and

the Queen. Such practices helped to objectify and exploit the native populations, who had no control over how they were pictured or the context in which their pictures were distributed within the society at large. In the twentieth century, government agencies, such as the U.S. Farm Security Administration (FSA), utilized a wide-ranging group of outside photographers to inform the public about the plight of the rural poor and to showcase and gain support for the agencies' work. Now, online social networking, multiplayer role-playing games, and virtual worlds, such as *Second Life*, allow the transformation of identity through the creation of avatars, graphic representations of a user's character. One Internet effort, www.insideoutproject.net, which was a participatory project between the artist JR and the TED Prize, took images of personal identity and provided a way of making them public. To participate, you uploaded a portrait, added your story, received a poster of your submission in the mail, posted it in a public place, and then shared the results online.

DEPICTING SOCIAL CUSTOMS

Concentrate on specific practices that give your group a shared, cohesive experience. Social customs and rituals involve the act of bonding and provide the collective glue that forms a common allegiance transcending individuality. They are a unifying force that allows us to blend into a community of shared ambitions, beliefs, despairs, dreams, passions, and values. Self-controlled images of such inner rituals can give a group the power of ownership over how its communal visual image is characterized, identified, and defined by the society at large. Examine traditions that may have been intentionally concealed, and question why this was the case. Keep asking this key question: What does it mean to be a member of this specific "circle"? Make photographs that examine historical depictions and update your group's own stories.

Consider a strategy of depicting individual stories that possess the capacity to move outward and engage

a larger narrative tradition by looking for collective human traits. This method recognizes that a sense of community is an ongoing process requiring the participation of each new generation to keep a story alive and relevant. The picturing and preserving of social customs extends the time that participants can spend celebrating and contemplating their own values. By picturing core experiences and myths as well as sacred objects and places, you can provide an infrastructure of social interactions that become part of the group's consciousness. Your images indirectly announce that what is of significance is of our own choosing and creation. This alteration in self-perception can help provide the confidence to deconstruct old legends and reformulate a community's social identity to meet its current needs.

WHO CAN REPRESENT US?

Imaging social identity raises some thought-provoking questions. Who has the right to represent a particular group? Must one be African American to make work about slavery; a homosexual, lesbian, or transgender, to comment about sexual preference; or non-Caucasian, to discuss racial discrimination? Does having a direct link with a specific group automatically confer legitimacy to make images about that group? What about people who strongly identify with a group but do not possess their recognizable characteristics? Can a white person document the blues? Can being a member of an inner circle cloud one's vision or purposely lead one to make propaganda images that falsely depict a group? Can you have a memory or claim something you did not directly experience? Can Jews born after World War II produce compelling commentary about the Holocaust? Is it possible for outsiders to reveal things that insiders can't see or don't want shown, and do they have the right to do so? Who determines the validity of such experiences and bestows the credentials to make legitimate images? And finally, can the values of one culture be superior to the values of another? Why or why not? (See Exercise 12.2.)

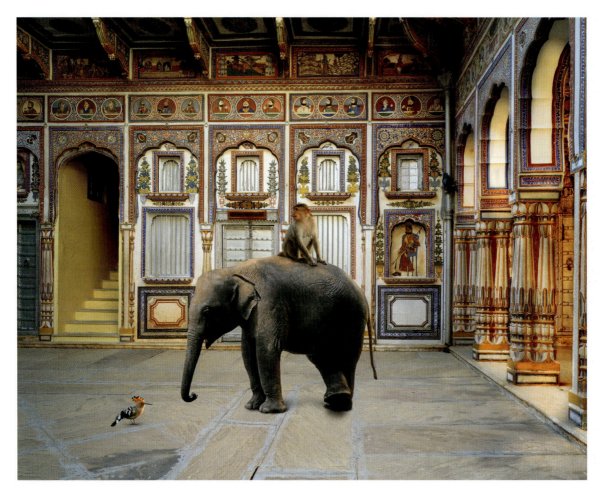

FIGURE 12.6 In her *India Song* series, Karen Knorr celebrates the visual intensity and mystery of the myths and tales of northern India by utilizing sacred and secular settings to emphasize caste, femininity, and the stories' relationship to the animal world. She separately photographed the interiors and live animals and then digitally combined them. The results echo and renew the *Panchatantra* (an ancient Indian collection of animal fables) and blur the boundaries between reality and illusion. Knorr says this work "pays homage to the extraordinary beauty and power of Rajput and Mughal architecture and the hybrid cultures represented in stories that are written and represented in miniature paintings, sculptures found in temples, palaces, havelis [mansions], and mausoleums, and also folk and tribal art."

Credit: © Karen Knorr. *The Conqueror of the World*, from the series *India Song*, 2010. 48 x 60 inches. Ink jet print. Courtesy of James Danziger Gallery, New York, NY.

EXERCISE 12.2 PORTRAITS FROM WITHIN

Your mission is to make images of members of your specific cultural subgroup(s) or of those with whom you have shared similar circumstances. The purpose is to provide a contextualized reading based on your experience as a member of a particular subculture that offers a new portrait that more closely reveals how your group currently sees itself. Your pictures should be centered on your bond with the group, which provides an innate sense of trust with the subjects. This view from within, rather than a gaze from without, should convey a sense of intimacy and openness between your subjects and yourself, visually communicating firsthand accounts of your group's social rituals and values.

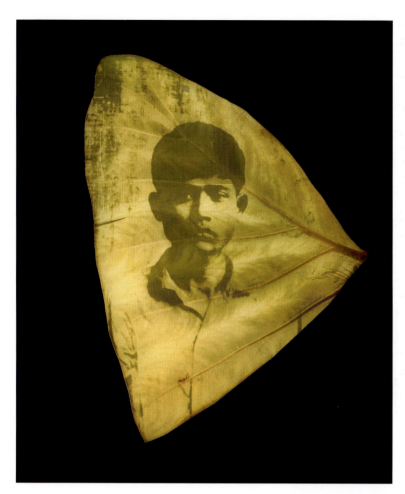

FIGURE 12.7 Binh Danh makes images dealing with the long-term aftereffects of the Vietnam War. Using a process he invented, he prints digitized versions of found photographs, rendering them onto the surface of leaves by exploiting the natural process of photosynthesis. The leaves, still living, are pressed between glass plates with the negative and exposed to sunlight for a week to several months. "The image formation is due to chlorophyll, light, carbon dioxide, and water: the life source of plants and, consequently, the Earth. The fragile works are then cast in resin, like biological samples for scientific studies."

Credit: © Binh Danh. *The Botany of Tuol Sleng #11*, 2006. 11¾ x 10¾ x 1⅛ inches. Chlorophyll print and resin. Courtesy of Haines Gallery, San Francisco, CA.

INTERIOR EXPERIENCE: THE SIGNIFICANCE OF DAILY LIFE

Photography shows and tells people about their world. It is a prime communicator of knowledge and feelings, providing a sense of "you were there." Photography reaches out in all directions, through television, magazines, newspapers, movies, videos, and, of course, the Web, encompassing everyone, even those who do not want to be touched. Although some people still think of photography in terms of its documentary abilities, capturing the exterior world, it also offers opportunities to explore our interior affairs and to depict how we see, interpret, and know our inner world (see Exercise 12.3).

PHILOSOPHICAL BELIEF: OPTIMISM, PESSIMISM, AND EXISTENTIALISM

Use your camera vision to image an abstract philosophical belief. Determine whether your current outlook is basically optimistic or pessimistic. Western philosophy is built on the notions of reason and progress, not to mention the American ideal of the "pursuit of happiness." But pessimists are skeptical about the concept of progress and see no point in seeking happiness, believing that, when it comes, it is usually by surprise. Being a pessimist is not about being depressed or misanthropic, nor does it hold that we have a one-way ticket toward annihilation. Fundamentally, pessimism doubts that applying human reasoning to the world's problems will have a positive or long-lasting effect.

EXERCISE 12.3 INTERIOR EXPERIENCES

For this project, use your powers of camera vision to probe the inner realities of your mind rather than the outer reality of the street to make images dealing with the following themes:

- **Inner Fantasy**: Construct an image of an inner fantasy. Create a space where you are free to act out multiple and often conflicting and paradoxical identifications of the self. Consider both narcissistic and selfless fantasies and where to draw the line of acceptable cultural/social limits. Involve viewers in the psychic tensions between the inner and outer self, allowing them to experience the inherent fluidity of psychic life and its potential for change. Allow your creative energy to spring from yourself. Your own experiences and ideas communicated directly to another will be more meaningful and powerful than imitating someone else's approach.

- **Memorable Dream or Memory**: Construct an image or a series of images recalling a visually noteworthy aspect of a memorable dream or memory. Purposely set things up to be lit and photographed. Be your own producer and director. Utilize this control to achieve your desired results.

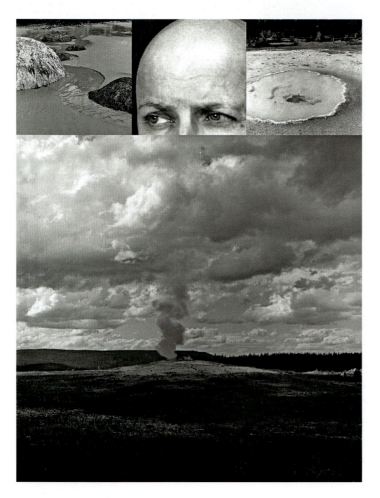

FIGURE 12.8 "These photographic composites deal with the poetic impact of certain landscapes and aspects of classical architecture and art history on my life, and how these influences continue to remain in memory, resurfacing at unexpected moments. My photographs are autobiographical and represent my effort to clarify, to find meaning and significance in daily existence. Here, I was undergoing chemotherapy. Often epiphanies occur while traveling, as I try to locate related images that express my feelings about particular landscapes. Sometimes these photographs are taken on separate visits, thus the name of the series, *Return Trips*. I am fascinated by the way photographs that are placed in proximity can become a whole that is greater than the sum of the parts."

Credit: © Bea Nettles. *Hole*, from the series *Return Trips*, 2005. 23 x 17 inches. Inkjet print.

Another difference between optimists and pessimists is their outlook regarding time. Optimists see the passing of time as an opportunity to better the world. Pessimists consider it a burden and a tragedy. Passing time marks the physical decline of our body toward death and acts as a barrier that separates us from those we care about. Optimists see history as the ongoing rise of civilization. Pessimists believe that any seeming progress has unseen costs and unintended consequences. Even when the world seems to be progressing, it is not really getting better. Polio may be cured, but only to be replaced by a new disease, such as AIDS or Zika. Jet airplanes speed travel, but make noise, have large carbon emissions, and can drop bombs or be crashed into skyscrapers.

Existentialism rejects the belief that life has an inherent meaning and embraces the freedom of personal responsibility and choice, holding that accountability enhances rather than encumbers our existence. Far from being nihilistic, it says most people take on responsibilities because doing so puts them in charge of their situation, defines who they are, and gives meaning to their life. It embraces core American beliefs of individualism, self-reliance, and cooperation—in brief: we are what we do. For instance, most people who enter public service do so because they want to change things for the better, make a contribution. Even corrupt politicians maintain they did not start out hungering for power and wealth and hope they might be remembered for whatever good they did.

Use these theoretical counterpoints as visual toeholds to conceive of how to image something—an idea—which does not physically exist for one to photograph.

PSYCHOLOGICAL DRAMA

Imagine a psychological drama. Ask: What is it you want to conjure up? Do you need a literal, explicit narrative, or can your concepts be more figurative and obliquely implied? Are you raising questions or seeking answers? What conclusion would you like your audience to reach? Use your concerns, fears, or neuroses as opportunities for examination and growth toward resolution. Consider these possibilities: How can your pictures be

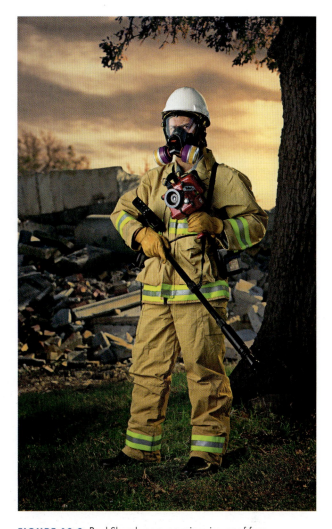

FIGURE 12.9 Paul Shambroom examines issues of fear, safety, and liberty in post-9/11 America by photographing official training facilities, equipment, and personnel involved in efforts to prepare for and respond to terrorist attacks. Portraits of emergency workers standing in the landscape dressed in their full gear hint at elegant full-length portraits of nobility. "The location of lighting and digital work create a sense of disconnection between the subject and the landscape. The light is contradictory (does not match in quality or direction), much as we see in the practice of eighteenth- and nineteenth-century Western portrait paintings."

Credit: © Paul Shambroom. *Urban Search and Rescue* ("Disaster City" National Emergency Response and Rescue Training Center, Texas Engineering and Extension Service [TEEX], College Station, TX), from the series *Security*, 2004. 63 x 38 inches. Inkjet print.

FIGURE 12.10 Bill Davis informs us: "I made this leadoff image for my *History Revision Project*. It is meant to spark critical thinking and creative scholarship. As released by an Iranian Military News Agency, the original image was appropriated from newspapers published in various cities across the United States. Using Photoshop, I duplicated parts of the launched missiles to create a total of five warheads. Masking, content aware, the rubber stamp tool, feathered selections, and the brush tool were used to modify the smoke, the sky, and the missiles. The canvass option was created to extend the borders of the original photo. As my students and I often work from web-resolution images, this file was modestly interpolated to prepare it for printing as I often find the best ideas are not always matched with the best image quality. While we are able to modestly achieve suitable exhibition-quality prints, I teach students to prioritize the quality of their ideas over the quality of their technology."

Credit: © Bill Davis. *Strike*, from the *History Revision Project*, 2015. 8 x 12 inches. Inkjet print.

FIGURE 12.11 Newspaper front pages reproducing Iranian fake news photograph.

Credit: Mike Nizza and Patrick J. Lyons, "In an Iranian Image, a Missile too Many, *New York Times*, July 10, 2008. https://thelede.blogs.nytimes.com/2008/07/10/in-an-iranian-image-a-missile-too-many/?xr=1

used to confront something that you find perplexing and/or unsettling? Is it possible for the process of photography to lead you toward a new understanding of this situation? Can an image increase your knowledge about yourself? Can the act of picturemaking produce a change in your attitudes about something or make you more sympathetic to a particular point of view? How can you expand a private moment into a shared, collective experience? Avoid chasing yourself, by making the effort to break free of your habitual practices and see the situation with fresh eyes.

SOCIAL ISSUES

The duality of photography to politicize any social issue currently under debate while at the same time reflecting the values you so dearly hold to can create a dilemma.

Such topics can deal with war, race, religion, gender, health, environment, or sexual orientation. Address an issue of which you have direct personal experience. Ask yourself whether these images are being made solely to express your own feeling. Or do you want others to consider adopting your position or do you want to simply educate? Approaches can be varied to meet the needs of specific viewing groups. Think about the type of response and reaction you want the viewers to have. If you want viewers to be sympathetic, avoid ranting, and self-righteous finger-pointing and find a more subtle approach that does not alienate people. Understatement and humor often can be more convincing tactics, as they allow viewers to let down their guard and actually look at what you have produced, which may result in unanticipated affirmative viewer reactions. If this is of no consequence, then blaze away (see Exercise 12.4).

EXERCISE 12.4 FAKE NEWS: HISTORY REVISION

History is not a fixed entity but is always in flux, being written and rewritten through one's personal filter of culture and identity. Taking familiar pictures and purposely setting them in a new context forces us to see things in new ways. Digital images are simple to review and revise, allowing us to express what we know and to create new territory to contemplate.

Imagemaker and educator Bill Davis brings this ability to the attention of his students by asking them to construct a layered image of an event that never happened or rewrites history. Davis encourages one to rethink by posing "what if" questions. What if the South had won the American Civil War? What if Hitler had been a successful painter? What if Donald Trump had lost the 2016 election? In the context of global warming, what might your home state look like in 50 years? What could a world map look like if the oceans and the land were reversed, and what would produce such a horrendous change?

The first step is to create a History Revision Project Sheet and clearly write out your responses to the following:

1. List a moment in history that had a significant impact on you or on one or more future generations.
2. What is the most significant remaining image or series of images that illustrates this moment?
3. Envision history with a different outcome and describe the outcome. Be visually descriptive.
4. List the images you are using from your chosen historical moment to redefine that moment. Will you need more than one image?
5. Illustrate your reconstructed history using your imaging software and your History Revision Project Sheet.

FABRICATION FOR THE CAMERA: DIRECTORIAL MODE

Traditionally, most photographers went out and found things in the natural world to photograph. Today, many imagemakers rebuff this approach and embrace post-documentary practices by manufacturing images that do not exist in the real world. These image-makers create and orchestrate productions in which events and lighting are controlled and which may involve live models, arranged objects, and painted sets. Once the photographs are made, the self-created stage is struck, leaving no evidence except the images. In some cases, the final work may include images and a three-dimensional installation that might have an audio and/or a video component (see Exercises 12.5 and 12.6).

EXERCISE 12.5
FABRICATE AN ENVIRONMENT

Fabricate your own environment. Arrange real people and objects in an environment for the purpose of photographing an event that you have orchestrated, where you have directorial and technical control. Give special thought to lighting and depth of field. Imaging software may be used to enhance your camera-based image, but not as the primary source of creation.

EXERCISE 12.6 FABRICATION

Another option is offered by Professor Kathleen Robbins at the University of South Carolina's McMaster College of Art. Her assignment is as follows:

1. Write a brief story, a few pages in length, describing a personally significant event or moment: "One day back in Yoknapatawpha, . . ." You can write about a particular event from your childhood or one from yesterday afternoon. Be descriptive and let it flow.
2. Watch your favorite movie. Notice individual scenes in the film that stick with you. How did the director film the scene? How does it begin and end? Are there breaks or interruptions in the timeline? Imagine the relationship between this scene and the screenplay from which it was derived.
3. Review your own story. How would a director film your scene? Sketch out a simple visual storyboard.
4. Condense your storyboard into a single image. This image typically should depict the pivotal or climactic moment of your story. How are you going to execute this photograph? Plan the setting, the color scheme, the props, the actors, the lighting, and the camera angle. Sketch that image.
5. Photograph the image you have sketched.

For ideas and inspiration, look at the work of Janine Antoni, Boyd Webb, James Casebere, Gregory Crewdson, Anna Gaskell, David Haxton, Teun Hocks, Jan Kaila, David Levinthal, Tracey Moffatt, Sarah Moon, Patrick Nagatani, and Jeff Wall.

For more information, see Hoy, Anne H. *Fabrications: Staged, Altered, and Appropriated Photographs.* New York: Abbeville Press, 1987.

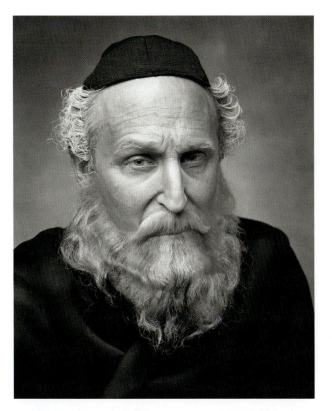

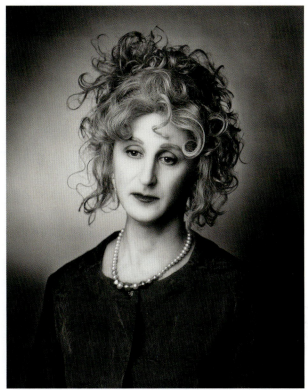

FIGURE 12.12 After genealogical research, Rafael Goldchain uses theatrical makeup, costuming, lighting, and digital manipulation to photographically transform himself into his pre-Holocaust, Eastern European, Jewish family, documenting a history that previously survived only in memories and stories. His reenactments encourage us to look at family photographs "to know ourselves through the photographic trace left by the lost ancestral other. As a group, the family portraits form an inter-subjective connection between us and those we mourn." Drum scanning 4 x 5-inch negatives allows Goldchain to capture very fine detail, enhance realism, and make large prints.

Credit: © Rafael Goldchain. *Self-Portrait as Leizer Goldszajn, b. Poland, 1880s, d. Poland, early 1940*, from the series *Familial Ground*, 2001. 40 x 30 inches. Chromogenic color print.

FIGURE 12.13

Credit: © Rafael Goldchain. *Self-Portrait as Reizl Goldszajn, b. Poland, 1905, d. Buenos Aires, Argentina, 1975*, from the series *Familial Ground*, 2000. 40 x 30 inches. Chromogenic color print.

THE SOCIAL LANDSCAPE

The term *landscape* originates from the Dutch word *landschap*, meaning "landship." It represented a segment of nature that could be taken in at a glance, from a single point of view, and encompassed the land as well as animals, buildings, and people. Broadly, the landscape can be defined as an artificial collection of human-made spaces on the earth's surface purposely constructed to organize space and time. However, beginning in the nineteenth century, there was an aesthetic movement to segregate nature from humanity and its institutions. The results of this can be seen in the public belief in a pristine, unpopulated, transcendental environment, such as those depicted by the Sierra Club. This glorification of what it was like to be alone in an untouched world can be beautifully romantic, but it does not take into account how most people now experience the landscape.

Present-day landscape images include broader parameters than in the past, often conveying a sense of

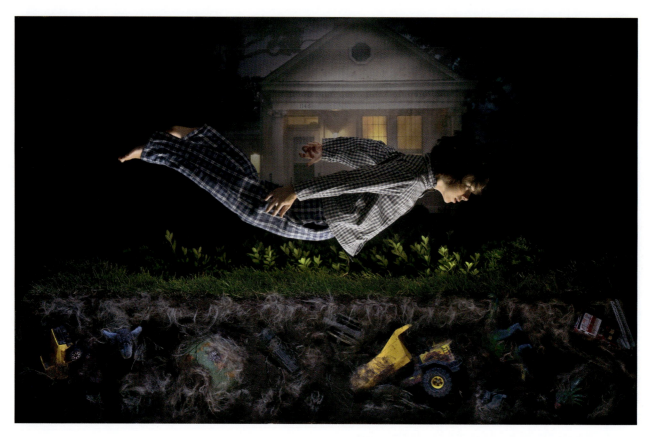

FIGURE 12.14 Laura Hartford's *Like a Weed* is "an on-going series of my son Jake, which began in 2002 when he was 6 years old. The work is a personal reflection on the hopes and fears of parenting as well as pervasive metaphors linking the female form with nature." Hartford's elaborate imaginary places are not the product of digital compositing; rather, she uses sketches to plan these scenes, and then employs simple tools and materials to fabricate them. "To include a house in the background of this scene, I photographed a friend's home and had an 8 x 10-foot banner printed, which I then used in the background of the set." She exposed with the widest possible lens aperture to limit the depth of field, making the foreground sharp and the background soft.

Credit: © Laura Hartford. *Hovering Between Us II*, from the series *Like a Weed*, 2009. 26 x 40 inches. Inkjet print.

place and time in relationship to human experience. Some imagemakers continue to impart the beauty and grandeur of nature by making images that give viewers a sense of looking at the scene without any political or social message. However, some of the most thought-provoking work presents the "social landscape" fashioned by human aesthetics, desires, ethics, and necessities. The *social landscape* can be defined as a personalized response, expressing life through the ideas, personality, and social/economic/political concerns of the imagemaker, incorporating the informal artistic qualities of the snapshot to comment on "people and people things." The beginnings of this approach can be seen in William Klein's *Life Is Good & Good for You in New York* (1956), Robert Frank's *The Americans* (1959), Garry Winogrand's *The Animals* (1969), and Lee Friedlander's *Self Portrait* (1970).

Within this context, the landscape becomes a symbolic convergence of physical, geological processes and intellectual, cultural meanings. More than a slice of nature, the landscape develops into a portrait of the social forces that shape our world, and imagemakers respond to this process of societal change that imprints itself on the land (see Exercise 12.7). In this framework, the social landscape can be divided into three areas that shape our collective identities:

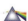

FIGURE 12.15 In 1985, some Americans were aware of Alaska's Inside Passage, but few knew it was the domain of the Tongass rainforest, the largest and rarest temperate rainforest in the world. Clear-cut logging had been eroding the wildness of the ancient forest, but the grassroots campaign against the logging gained momentum with the publication of Robert Glenn Ketchum's *The Tongass: Alaska's Vanishing Rain Forest* in 1986. The book proved to be a formidable tool and became a key part of a three-year media campaign during which it was distributed to all members of the U.S. Congress. In 1990, the Tongass Timber Reform Bill was signed into law, the largest such reform regulation in American history, protecting one million acres of old-growth forest and creating five new wilderness areas. Nonetheless, the battle over millions of additional acres of Tongass forest continues to this day.

Credit: © Robert Glenn Ketchum. *Louisiana Pacific–Ketchikan*, from *The Tongass Rainforest Campaign*, 1986. Variable dimensions. Dye-destruction print. Courtesy of Fahey/Klein Gallery, Los Angeles, CA.

- The *cultural landscape* speaks to the ongoing issues of identity faced by all groups and subgroups, including indigenous and immigrant peoples, and their relationship to the landscape.
- The *environmental landscape* examines the relationships between humans and their physical landscapes.
- The *social landscape* looks at political conflict and social transformations as reflected in people's everyday lives.

STILL LIFE

The pictorial representation of a collection of inanimate objects, the still life was especially popular in seventeenth-century Dutch painting. Still-life subject matter was readily available and did not move, tire, or complain as a model would. Traditionally, painters selected natural items, such as flowers or wild game, and combined them with man-made domestic items, such as books, tableware, and foodstuffs. The tradition of still life is found in the roots of photography. Daguerre and

FIGURE 12.16 The ParkeHarrisons utilize an austere and open-ended narrative to represent their concerns about the complex environmental crisis and the peculiar relationship between nature and technology. Their bleak palette and blood-fueled marking contraption imply a tale of loss, human struggle, and exploration within a harsh and indifferent landscape.

Credit: © Robert and Shana ParkeHarrison. *Scribe*, 2005. 40 x 85 inches. Chromogenic color print.

EXERCISE 12.7 SOCIAL LANDSCAPE

Decide what subdivision of the social landscape you have the greatest affinity for. Then, launch a cognitive investigation for appropriate subjects. Concentrate on the interrelationship between humans and nature and determine the essential visual qualities you want to convey. For instance:

- Explore the influences of landforms on human occupancy and vice versa.
- Find and study contemporary examples, such as Robert Adams, Edward Burtynsky, Catherine Chalmers, David Hanson, Robert Glenn Ketchum, and others who have visualized the social landscape.
- Examine how different attitudes and ways of life leave their imprint on the landscape.
- Look at how class, ethnicity, and gender affect one's relationship to the land.
- Scrutinize both the problems and the opportunities each issue presents.
- Determine how to represent the negative and positive effects of human activities.
- Study how allegorical symbols and other visual methods can transmit cultural values and perspectives.
- Assess how your aesthetic decisions, such as the use of depth of field and scale, will affect the visual outcome and viewer response.

For additional information, see Jussim, Estelle, with Elizabeth Lindquist-Cock. *Landscape as Photograph*. New Haven, CT: Yale University Press, 1985.

FIGURE 12.17 Doug DuBois started photographing his family in 1984 around the time his father had a near-fatal accident and his mother suffered a nervous breakdown. Through the years, DuBois has continued to make commonplace yet anxious portraits of his family members that balance on the edge of exploitation. Yet they continue to willingly follow a direction that results in his composed family narratives. This still life evokes the naive imagination of childhood. DuBois fills us in: "At the beginning of the twentieth century, 10-year-old Jacques-Henri Lartigue (see *Lartigue: Album of a Century*, 2003) made a photograph of the toys on his bedroom floor. What's useful about this reference is it invites the three of us—my 4-year-old nephew, who artfully arranged the dinosaurs; me, the photographer of his display; and a long deceased Frenchman—to dwell on the carpet and share the arcane secrets of childhood. The rest of you must remain outside—waiting, I hope, to join in."

Credit: © Doug DuBois. *My Sister's Bedroom*, from the series *All the Days and Nights*, 2004. 30 x 40 inches. Chromogenic color print.

Talbot made still-life photographs, taking advantage of the inanimate arrangements during the long exposures necessary in early photography.

Still-life images allow imagemakers control over their composition's design elements and lighting effects. Today, still life is pursued by both artistic and commercial photographers and has laid the groundwork for advertising and product illustration photography. The challenge is to build an image, from the camera's point of view, which delivers a well-defined composition. For a modernist approach, look at the work of Edward Weston or Irving Penn. For a contemporary line of attack, check out Martin Klimas's shattering still lifes.

STILL-LIFE DELIBERATIONS

Look at work created for artistic and commercial purposes by photographers and artists using other media, especially painting, including Cubism and Photorealism. Ask yourself: What is working visually in the images or artwork you found? What feels misplaced or is off-balance? Once you have examined the professionals' work, formulate your own still-life vision. Pick a theme that intrigues you, for it can provide a solid structure for completing the process.

Photographing still lifes affords you the opportunity to work alone and to set your own pace, managing all the pictorial elements without the distractions and problems of working with live models. This extra time

and privacy allows you to concentrate on composition and lighting.

Collect and organize your objects and props. Choose a location, such as the corner of a room or a larger studio space, where there is enough space to arrange your lights. It can be beneficial to pick a space where the setup can be left undisturbed, which allows you sufficient time to study, linger, and interact with your construct before you begin photographing. This approach also lets you go back and make adjustments after reviewing your first round of images. Select the background setting. It may be a seamless paper or a personal construct.

Pay close attention to the type of lighting, which sets the emotional and psychological stage for your image while revealing the natural properties of the objects of your still life. Consider which lighting scheme is best to use: natural, artificial, or a combination of both (see Chapter 5). Start with only one main light. What direction should the key light come from: front, side, top, or bottom? Play with different placements and distances from your setup. Do you need diffusers to reduce contrast or reflectors to bounce light into the shadows? Use a second light only to bring out the background or reduce shadows. When working with two lights, watch out for double shadows, as overlapping areas of illumination tend to produce visual confusion. Would colored gels or filters help produce the atmosphere you want? Where and how will you determine your exposure reading?

Stay loose, play with the objects, and try out different compositional arrangements. Look for combinations of colors, shapes, and textures that promote your theme. Continue reassessing your lighting arrangements. Once the composition is set, concentrate on the prime characteristics you want your image to reveal and emphasize. Test various lens f-stops and focus points to manage depth of field and detail. Review exposures as you go and adjust accordingly. Could post-exposure imaging procedures enhance and strengthen your intended viewpoint? Also, give thought to how the final piece will be presented and viewed.

Finally, when the opportunity presents itself, use a view camera to make a still life. This will provide hands-

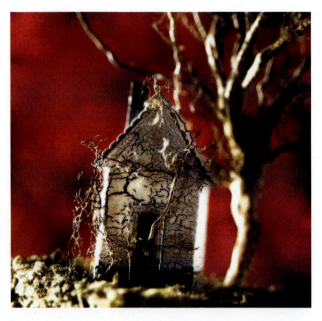

FIGURE 12.18 Coming from a large dysfunctional family, Thomas Siegmund uses his *The Good House* series to examine "the fluid nature of relationships and their complexities; our obsessions with the search for companionship; and issues of love and intimacy, passages and journeys." The houses, which Siegmund constructs from scratch, "are mysterious, haunting, dreamlike, anxious, dangerous, comical, but not inviting. The advantage of working with still life is that you can stay engaged—studying, thinking, shooting, resting, and coming back with a fresh approach." Siegmund sees his "art as a vehicle for healing and storytelling. As I complete each image, I sense a cleansing. I'm taken to a place that is both peaceful and uncomplicated."

Credit: © Thomas Siegmund. *Untitled #15*, from the series *The Good House*, 2008. 12 x 12 inches. Chromogenic color print.

on experience with its adjustments (swings, tilts, and rising front), increasing your control over the final image, especially with depth of field and perspective.

THE HUMAN FORM

The human body has been a stimulating and controversial subject since photography's beginnings. Of course, some interest in the human body has always been solely prurient, as in the making of pornography, but the nude has a long history as a venerable subject for artists. The nude has been a stage to depict beauty, culpability, gentleness, horror, innocence, magnificence, and repulsiveness. The liveliness of this genre can be seen in the

FIGURE 12.19 This series portrays a taboo subject—children in pain—and demonstrates the continued widespread acceptance of a photograph as a bearer of truth. We see a crying child and want to comfort him or her. Controversy followed this series. Jill Greenberg says, "The children I photographed were not harmed in any way. Toddlers cry easily. I would give them a lollipop and then take it away. Children's emotions are close to the surface. They haven't learned how to hide their moment-to-moment feelings. This makes them compelling models to convey my message: I cannot fully protect my children from a world of human and natural disasters."

Credit: © Jill Greenberg. *Grand Old Party*, from the series *End Times*, 2005. 50 x 42 inches. Inkjet print. Courtesy of Paul Kopeikin Gallery, Los Angeles, CA.

FIGURE 12.20 "I choose to portray these male types on a woman's skin to show the strength, beauty, and dignity of women. I use my body to make humorous and political statements, to break through doors that seem to limit women's ambitions, and to inspire women to stand up and be seen as equal to men in society. My body is fully painted in a studio setting with liquid latex to create each character. Once the body has been painted and dried (usually a 5-hour process), a gloss protectant is then sprayed as a sealant. Only a few props are real objects. The body is presented nude to leave visible the focus of a female gender. After the photo shoot and impromptu performance, the images are imported into Photoshop and transformed into fast, stop-action video projections for the wall."

Credit: © Kelly Flynn. *Cowboy 2*, from the series *iLatex*, 2006. 30 x 20 inches. Inkjet print. Courtesy of Chelsea Galleria, Miami, FL.

multitude of ways in which the human figure has been represented, both thematically—as a cherub, a goddess, a warrior, or a vegetable—and stylistically, as both complete, whole forms and fractured deconstructions.

In the early nineteenth century, the traditional male nude became a taboo subject (fig leaves had to be added to cover up the objectionable genitalia), causing artists to concentrate on the female form. During this era, it also became unacceptable to show pubic hair, a convention still enforced in many locales. Only recently has the male form been reintroduced into the public arena, often with a chorus of disapproval, as with the work of Robert Mapplethorpe, whose graphic gay images provoked government censorship and funding cuts to the arts. Cable television, streaming, and the Web have opened the floodgates for mundane, provocative, and sometimes offensive images of the body (see Exercise 12.8).

EXERCISE 12.8 HUMAN FORM

Make a determination about the following topics before getting started:

- Identify your underlying theme, how you can visualize it, and how you can go about creating it.
- Select a human form that personifies your ideas.
- What type of background will be most effective?
- Are you going to provide context for your subject, or are you going to objectify it?
- How does your approach mirror our cultural ideas and ideals?
- Do you want a naturalistic, real-world setting or one that is abstract and artificial?
- Do you want to present the entire figure or a portion of it?
- What is the effect when you manipulate or deconstruct the human form?
- How can you use sections of the body to signify and objectify the whole?
- Will the figure be clothed, nude, or partially dressed?
- Will you require props? If so, how will you acquire them?
- What mood do you want to induce through your selection of colors and lights: dramatic, erotic, innocent, loving, provocative, romantic, secretive, sensual, or vulnerable?
- Would a cool or warm color scheme be more effective?
- Will overall high-key or low-key lighting produce your results?
- What about the angle of the lights? Do you want to reveal texture?
- Will soft, indirect light, good for revealing subtleties of form through tonal graduations, deliver what you are after? Or would directional light, creating more contrast, darker shadows, and a bolder, more graphic mood meet your intentions?
- How can camera positioning and lens focal length be utilized to produce the psychological effects you desire?
- Should focus be sharp or diffused?
- Do you plan any post-exposure work?
- How will the work be presented?

Establish a good working rapport with the legal age model(s). Get a signed release form (available online) if you intend to circulate any of the resulting images so everyone is clear about their usage. Explain what you want to visually convey. Offer direction, but be willing to take suggestions. Leave any hidden agendas or expectations somewhere else. Do not intimidate models into doing anything that they find objectionable. Concentrate on making photographs.

For more information and examples about the human form, see the following:

Ewing, William A., editor. *The Body: Photographs of the Human Form.* San Francisco: Chronicle Books, 1994.

Gill, Michael. *Image of the Body: Aspects of the Nude.* New York: Doubleday, 1989.

Pultz, John. *The Body and the Lens: Photography 1839 to the Present.* New York: Harry N. Abrams, 1995.

THE SCREEN: ANOTHER PICTURE REALITY

Digital images live electronically and often are viewed only on a screen, eliminating the physical attributes of an ordinary photographic print. Photographing images shown on a screen provides an opportunity for the imagemaker to extend the meaning of the images. Your camera can capture these images as a single image or can modify their original meaning by permitting these images to blend and interact with other images or environments. Below are some guidelines for making images from a screen:

1. Use a clean, flat display to minimize distortion.
2. Place the camera on a tripod. Adjust the focal length of the lens, filling the entire frame with an image, or work with the Macro mode to concentrate on a small area of the display.
3. Turn off the room lights and cover the windows to avoid reflections on the screen.
4. When available, use a display hood or place a black piece of cardboard in front of the camera, with a hole cut in it for the lens. This will help eliminate camera and other reflections from being recorded.
5. Adjust the picture contrast on the display/monitor to a slightly darker (flatter) than normal setting; this will produce a more accurate rendition.
6. Adjust the color to meet your requirements.
7. Most displays generate a new frame about every 1/30 second. If the shutter speed is higher than 1/30 second, the leading edge of the scanning beam will appear on the picture as a dark, slightly curved line. If you do not want this line in your images, select a shutter speed of 1/30 second or slower. Experiment with shutter speeds of 1/15 and 1/8 second and review for effect.
8. Experiment with different white balance settings.
9. A DVD/Blue-ray disc player, computer, or other digital device or a software application allows an imagemaker to control the screen images and provides the ability to repeat an image until it can be captured as desired.

If the image being photographed is static or can be frozen on the screen, try using the slower speeds to ensure the frame line is not visible. Once the correct shutter speed is selected, make all exposure adjustments by using the lens aperture. If screen lines are unacceptable, images can be captured with a film recorder that makes its image based on electronic signals rather than from a direct screen shot.

ALTERNATIVE APPROACHES

Nontraditional screen representations can be made using the following methods:

- Vary shutter speed slower/faster than 1/30 second.
- Handgrip the camera at oblique angles to the display.
- Get close to the screen to exaggerate the image and limit the depth of field.
- Move camera during exposure.
- Make paper negatives instead of digital capture.
- Adjust the color balance of the display from its normal position.
- Vary the horizontal and vertical hold positions from their standard adjustments.
- Put transparent material having a color, image, or texture in front of the display.
- Fabricate a situation to be photographed that includes a screen image.
- Incorporate into your composition an image that appears on a monitor or screen.
- Project an image onto the display.
- Incorporate an image that appears on a monitor or screen into your composition.
- Use a magnet to distort the display image on cathode ray tube (CRT) units. Beware that this may put the unit out of adjustment and require professional repair afterward.

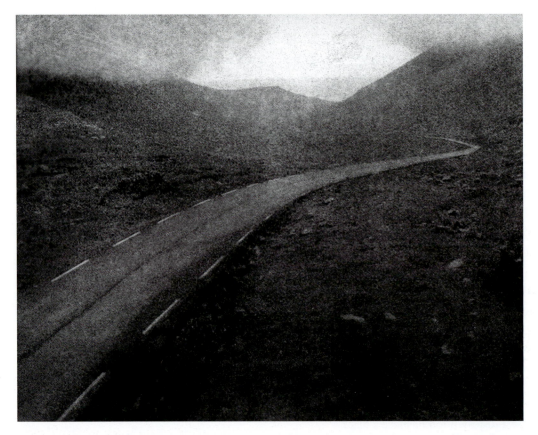

FIGURE 12.21 Marcus DeSieno lets us know: "In our increasingly intrusive electronic culture, how do we delineate the boundaries between public and private? *Surveillance Landscapes* is a body of work that interrogates how surveillance technology has changed our relationship to—and understanding of—landscape and place. To produce this work, I hack into surveillance cameras, public webcams, and CCTV feeds in pursuit of the 'classical' picturesque landscape and the concept of the sublime. The resulting visual product becomes dislocated from its automated origins and leads to an investigation of land, of borders, and power. Ultimately, I hope to undermine these schemes of social control through photographs—found and curated while exploiting the technological mechanisms of power in our surveillance society. In this series I obscured the pixelization of the Internet imagery by making waxed paper negatives with my 4 x 5-inch view. The soft focus, paper fibers, and brush strokes paralleled the aesthetic values of Pre-Raphaelite and early Pictorialist photography. These aesthetic effects also created a melancholic emotional feeling that I felt created a dialog for the audience about the image's origins being from surveillance technology."

Credit: © Marcus DeSieno. 62.009730-6.771640, from the series *Surveillance Landscapes*, 2015. 32 x 40 inches. Inkjet print.

TEXT AND IMAGES

In Western culture, we equate learning and knowledge with words. Popular media feed us endless combinations of pictures and text (screen crawls), screens within screens of images, and flashy headlines simultaneously competing and playing off one another. With separate and discrete sets of symbols, the brain has to deal with contending sets of messages. This juxtaposition can be used to convey additional straightforward information, humor, irony, and surreal spatial arrangements or to create conditions of fantasy and meaning that would be impossible with only one set of symbols. These types of image/text combinations provide a rich opportunity to delve into psychological and other kinds of relationships between images and words. Notice how the meaning of an image can shift, depending on the text that accompanies it. Wright Morris, who spent a lifetime investigating the synergy between photographs and words, concluded that "The mind is its own place, the visible world is another, and visual and verbal images sustain the dialogue between them."

In terms of contemporary graphic design, examine Stefan Sagmeister's *Things I Have Learned in My Life So Far, Updated Edition* (2013).

Photographs are very good at conveying actions or generating commercial, inspirational, and patriotic visual myths, but not so good at explaining complex ideas. Combining images and text can help us bridge this communications gulf between images and spoken language. We tend to think pictorially, but when we need to communicate, we generally transform these images into thoughts and the thoughts into language. During this process, the nimbleness, plasticity, and texture of the image are often sacrificed. This process is further complicated as viewers interpret this translation in their own minds. Much like in the parlor game of *Telephone*, the transmission of errors and personal predilections makes it unlikely that the received message will match the one that was sent. The reason is that we build a physical outline of what we see from our own experiences and ideas, which in essence leads us to either recognize or not recognize ourselves in all that we perceive.

Digital image messaging expands our communications capabilities by encouraging the seamless combination of images into the flow of our text messaging, emails, and cell phone use. Visual "chain letters" of still and moving images are now a daily part of our online experience. Image messaging can generate new interactions and meanings as viewers respond by adding their own images and/or text to the mix.

Imagemaker and educator Liz Lee assigns her students to investigate photographic images as an ambiguous and therefore vague framework of associations, stressing how they are capable of affecting emotions, expressing or

EXERCISE 12.9 **TEXT AND IMAGES**

Think of situations where text can be used with a photograph to create an amalgamated meaning. A good way to practice and gain experience with this is by making collages, both manually and digitally, and appropriating (using) found images and text. After completing this exercise, contemplate making your own image and text combinations. Reflect on the methods suggested in Box 12.1 for combining pictures and text, and experiment with those that you think will work best for your idea. Additionally, take into account how text itself can be the principal subject of an image. For reference, visit websites such as www.thevisualdictionary.net, which features a photographic catalog of words from advertising, graffiti, signage, and even tattoos.

Evaluate your completed images and discuss: What do you notice happening when you combine pictures and text? Does one overpower the other? Do you want to strike a balance between the two? Is there a blending or a duality of the two symbols? Should you give more weight to one than the other? How does the addition of text affect the way in which you read the work? Which do you examine first? In a literate culture, which has more importance? How can you effectively play one off the other?

If you want to ensure the supremacy of the photograph, use your words as a support and not as a crutch to hold up a weak photograph. Let your words supply information that enhances your imagery. If this is not a concern, create arrangements that challenge the traditional relationships between pictures and words.

How does the meaning of an image change when text is added or the original text is altered? What differences in effect do you see between manual and digital ways of working? Finally, how important is it for you, as an imagemaker, to be led by the internal visual impulse of images, as opposed to words?

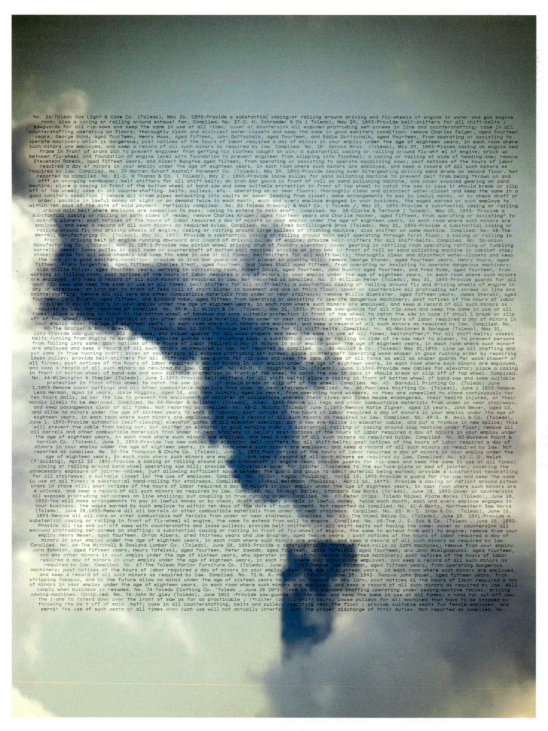

FIGURE 12.22 Christopher Burnett uses hypermedia and literature in conjunction with visual media to question how we actively use language and text in the landscape and space. His images are taken from telescopic samplings of the atmospheric effects of the nuclear energy plant in Shippingport, PA. Burnett then overlays these images with text composites from literary and vernacular sources, such as M. G. J. Minneart's *Light and Color in the Outdoors,* the *Ohio Department of Inspections 1893 Annual Report,* and his own science fiction writings. "At a precise tangent of the horizon at a specified date, this series attempts to evoke in a similar way the many strands of industrial experience as an efflorescence of light, land, and the written voice."

Credit: © Christopher Burnett. *No. 3, River Valley Horizon 2010.11.13,* 2010. 22 x 17 inches. Inkjet print.

FIGURE 12.23

Credit: © Christopher Burnett. No. 3, *River Valley Horizon 2010.11.13 (detail)*, 2011. Variable Dimensions. Digital File.

activating memories, desires, and/or fears. The image defines an object in its visual form without ambiguity but cannot make reliable statements about the possible meanings or implications of that object. It is impossible for any art form to portray objective reality. A photograph, more than any other art form, depends significantly on reality since the object must have existed in time and space in order to be photographed. Consequently, the photograph carries a reality-based message, but its meaning is often confused through the interpretation of the object represented. By interacting with text, a photograph can precisely specify emotional or intellectual content and provoke questions (see Exercise 12.9).

Working from this premise, Lee's students are asked to do the following:

- Research works by artists, such as Robert Cumming and Hinda Schuman, who incorporate text into their imagery. Observe how others like Betty Lee and Carrie Mae Weems use text as a running narrative that accompanies an image or how Robert Heinecken, Barbara Kruger, and Mary Kelly utilize words to disrupt the initial meaning of the image and cause viewers to question the nature of interpretation. Also pay attention to how font style delivers meaning.

- Locate three images that convey this idea and make copies of them. Be sure to include the name of the photographer, the title of the image (if there is one), and the type of photograph (gelatin silver, tintype, chromogenic color print).

- Provide a concise explanation of why you think each image you have selected is a good example of text and image. In particular, analyze how the words and images interact, and write a brief interpretive paragraph on what you believe the photographer is trying to convey, visually and conceptually.

- Previsualize an image–text relationship about a topic that has been on your mind, and then make new images that you will use to create a final statement.

FIGURE 12.24 Jody Zellen is concerned with the design, patterns, and structure of the urban environment. "Rather than document a city, I employ media-generated representations of contemporary and historic cities as raw material for aesthetic and social explorations to mirror the experience of navigating a charged metropolitan area. The drawings were tracings from newspapers where images from both sides of the page were simultaneously seen. The drawings were then scanned and collaged in Photoshop to explore the relationships between news images and the texts used to describe the events."

Credit: © Jody Zellen. *Hands Terror*, 2006. 30 x 40 inches. Inkjet print.

- Create a project that best represents your ideas and what you have learned about text and image (see Figure 12.25). This image may be a single 8 × 10-inch print; it may involve serial images or a more elaborate presentation format. Consider the many aspects of how text can be incorporated into your piece: Style, handwritten or typed? Font, serif or sans serif? Should the words be presented within the image, around the image, or as a separate unit?

Photographer and educator Collette Fournier takes another approach, by having her students create a series of personal storyboard images based on prose (including personal prose), song, or poetry. The class researches the work of photographers who make strong black-and-white portrait narratives, such as Harry Callahan, Bruce Davidson, Mary Ellen Mark, Duane Michals, Gordon Parks, and Jerry Uelsmann. After studying these examples, students prepare a storyboard based on their selected text. This is done to give students an appreciation of professional photography business practices, where storyboards are often the norm, and to teach them to previsualize imagery. From the storyboard, they produce five or six strong photographs that demonstrate their photographic knowledge of composition, design elements, Rule of Thirds, selective focus, and depth of field. Students are encouraged to superimpose text onto the imagery. The results can make an excellent portfolio piece that demonstrates a combination of vision and technical skills.

FIGURE 12.25 Jessie Lampack's haptic solution to professor Liz Lee's text and image assignment involved combining prints from scratched negatives with typewriter paper, acrylic paint, masking and duct tape, and staples on a mat board. The predominant text is a riff on the word perfection.

Credit: © Jessie Lampack. *Untitled* (detail from triptych), 2005. 10 x 11 inches. Mixed media.

FIGURE 12.26 Collette Fournier returned to a photograph she had previously made of a significant family member and decided to reinterpret it by thinking of it as a billboard and incorporating text that included important background information about this family member. Fournier carried out her plan by scanning the image and then reworking it, experimenting with both text and pixelation, to create "a photographic memorial of Uncle Ray, who shared a special light in my life."

Credit: © Collette V. Fournier. *Uncle Ray Was a Drummer*, from the series *Digital Family*, 2001. 14 x 11 inches. Inkjet print.

BOX 12.1 METHODS FOR WORKING WITH TEXT AND IMAGES

- Include words within the original camera image.
- Cut and apply text from printed publications.
- Generate text on a computer, print it, and glue it on the image.
- Vary color and font size.
- Add wording with press-on letters or a stencil.
- Use a rubber stamp set. Experiment with different colored inks.

- Write directly on the image. Try a variety of media.
- Insert text with imaging software.
- Set the copy separately from the image in the form of a caption or box.
- Employ text to expand the original meaning of the image.
- Utilize language to alter the original intent of the image.

ARTISTS' BOOKS AND ALBUMS

The incorporation of photographs into books began shortly after the invention of photography in 1839. Anna Atkins's *Photographs of British Algae: Cyanotype Impressions* (1843–1853) and Henry Fox Talbot's *The Pencil of Nature* (1844–1846) are the earliest examples of how paper photographs were integrated into books. The images in these books were "tipped in," added by hand,

as there was no satisfactory method for direct reproduction of photographs and text until the halftone process was perfected in the 1880s.

The *carte de visite*, French for "visiting card," was a 3½ × 2¼-inch photograph, usually a full-length portrait, mounted on a 4 × 2½-inch card. Introduced in the early 1850s, the carte became a fad during the 1860s in America and Europe, with millions being made of individuals, celebrities, and tourist attractions. People exchanged and collected cartes, keeping them in albums

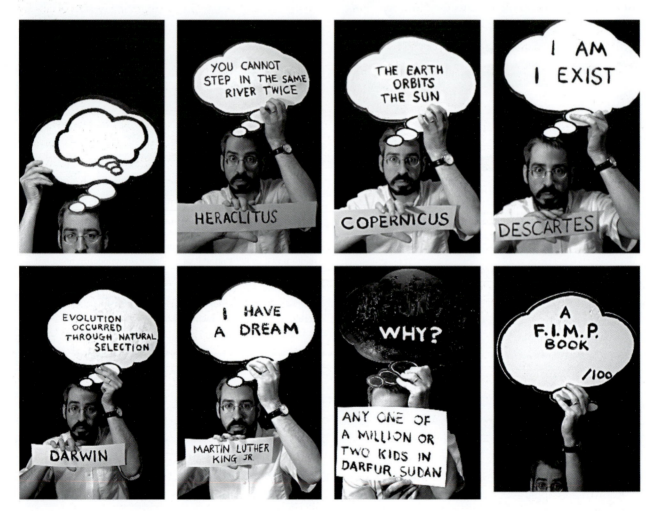

FIGURE 12.27 "*Thinking about Thinking* is one of over 60 artist's books that I have made for my Fiji Island Mermaid Press 'artists' book of the month club.' Much of my work indirectly addresses questions about how we know what we know, and the stories we tell ourselves to make sense of the world. I wanted to make images in which a 'thought balloon' was a physical object occupying the same space as the depicted thinker, and everything was composed in the camera at the time of capture. A thought balloon was constructed from foam core, with the text painted and repainted for each page. The images were printed out, glued to a 'master sheet' to make an eight-page spread that is slightly smaller than a standard sized piece of paper, and Xeroxed onto 32-pound resume paper. The pages were trimmed to size, folded, and sliced to make a tiny 2.5 x 4-inch book, and signed."

Credit: © Marc Snyder. *Thinking about Thinking*, 2006. 2½ x 4 inches. Electrostatic prints. Courtesy of Fiji Mermaid Press, Pittsburgh, PA.

with special cutout pages for convenient viewing, which gave rise to the custom of keeping a photo album. People also personalized them. An outstanding example of this practice can be seen in the mixed-media cartes of Lady Filmer (circa 1864), who cut and pasted cards into designs that were interlaced with watercolor and text, creating what can be considered an early prototype of an artist-made book.

In the late 1960s, experimental imagemakers began to cut and paste and make use of quick-copy centers, rubber stamps, and obsolete, unwanted printing equipment as they rediscovered the artist-made book as a vehicle to express diaristic and narrative themes as well as those of dreams, friendship, love, sequential time, and sociopolitical issues.

The book format offers an intimate viewing experience in which one can control the time spent with each image and provides an affordable alternative method, controlled by the maker, of getting work out to a larger audience. Now, there are workshops, classes, conferences, printers, distributors, and booksellers that specialize in artists' books (see Box 12.2). Programs like iWork's Pages offer journal templates. Scrapbooking stores offer printable album pages and companion digital album cover sets, translucent interleaves, and binding hardware that simplify the production of making your own artists' book. Making one's own artists' book with both analog and digital components allows one to become familiar with the process of bookmaking (see Exercise 12.10). Also, see Chapter 9, "Books: Print on Demand."

Digitization has made it easier for artist-made books to combine photographs, drawings, marks, appropriated materials, and text within a single image. If you prefer going all digital, investigate online printing services, such as Blurb.com, that provide templates for making books, which are then printed on demand. Lulu.com offers a range of professional services. Software such as iPhoto and Lightroom provide book options.

Digital bookmaking can include elements of performance through moving images and sound, which may be viewed on a cell phone or other digital device. Interactive programs may require the viewer to make choices that determine the content, flow, or outcome of a work, which may be modified with each viewing.

EXERCISE 12.10 BOOK OF YOUR OWN

Create your own book that can be outputted using digital means. Start by selecting a theme. Keep it simple, work with the familiar, and give yourself a condensed time frame. For instance, decide to make a record of a weekend trip. Photograph the people you are traveling with and those whom you meet. Photograph signs as well as exterior and interior views of all the places you visit. Break out of the single image concept. Consider photographing the foreground, middle ground, and background of a scene and later digitally stitching the images together, or try making sequential images that record the passing of time. Include a map of your route, a written account of a conversation, or anything that intrigues you. Collect articles, business cards, menus, postcards, and tourist pamphlets. Use a small memo book to record your thoughts. Upon your return, digitize these materials by scanning or photographing. Be spontaneous. Make lots of pictures. Review the previous section "Text and Images" to get ideas for integrating words and pictures.

Select your own paper size and color, and bind them to make your own book. A simple binding method is to take a handheld hole punch and measure three equally spaced holes (on the left side or top) and punch. Using the first as a guide, punch the remaining pages in the same manner. Small metal key rings or heavy thread can be used as binders. As experience is gained, consider tackling other themes and altering the presentation format.

BOX 12.2 SOURCES OF PHOTOGRAPHIC AND ARTISTS' BOOKS

- **Aperture Gallery and Bookstore**
 547 West 27th Street, 4th Floor
 New York, NY 10001
 www.aperture.org

- **Center for Book Arts**
 28 West 27th Street, 3rd Floor
 New York, NY 10001
 www.centerforbookarts.org

- **D.A.P./Distributed Art Publishers, Inc.**
 155 Sixth Avenue, 2nd Floor
 New York, NY 10013
 www.artbook.com

- **Light Work**
 316 Waverly Avenue
 Syracuse, NY 13244
 www.lightwork.org

- **photo-eye**
 376 Garcia Street
 Santa Fe, NM 87501
 www.photoeye.com

- **Printed Matter**
 195 Tenth Avenue
 New York, NY 10011
 www.printedmatter.org

- **Western New York Book Arts Collaborative**
 468 Washington Street
 Buffalo, NY 14203
 http://wnybookarts.org

SELF-ASSIGNMENT: CREATION AND EVALUATION

Some of the best photographs are made when image-makers pursue their own inclinations. Seize the opportunity to make those pictures you have been dreaming about, and then measure your plan against what you accomplished. Bear in mind what hipster Neal Cassady said, "Art is good when it springs from necessity. This kind of origin is the guarantee of its value; there is no other."[1]

EVALUATION GUIDE—BEFORE MAKING IMAGES

Before you make any images, think about and respond to the following:

1. Write a clear, concise statement of the specific goals you intend to accomplish. Speak to your target audience using their language.
2. Describe and list your purposes, both objective and subjective, and how you plan to reach them.
3. What problems do you anticipate encountering? How do you propose to deal with them?

BOX 12.3 ARTISTS' AND PHOTOGRAPHIC BOOKS: REFERENCES

Bright, Betty. *No Longer Innocent: Book Art in America, 1960–1980.* New York: Granary Books, 2005.

Drucker, Johanna. *The Century of Artists' Books.* Second Edition. New York: Granary Books, 2004. (Available from D.A.P., www.artbook.com)

Holleley, Douglas. *Digital Book Design and Publishing.* Elmira Heights, NY, and Rochester, NY: Clarellen and Cary Graphic Arts Press, 2001.

Lyons, Joan, editor. *Artists' Books: A Critical Anthology and Sourcebook.* Rochester, NY: Visual Studies Workshop Press, 1985.

Lyons, Joan, editor. *Artists' Books: Visual Studies Workshop Press, 1971–2008.* Rochester, NY: Visual Studies Workshop Press, 2009.

Parr, Martin and Gerry Badger. *The Photobook: A History Volume I.* London and New York: Phaidon Press, 2004.

Parr, Martin and Gerry Badger. *The Photobook: A History Volume II.* London and New York: Phaidon Press, 2006.

Roth, Andrew, Vince Aletti, Richard Benson, et al. *The Book of 101 Books: The Seminal Photographic Books of the Twentieth Century.* New York: Roth Horowitz, 2001.

Smith, Keith. *200 Books: An Annotated Bibliography.* www.keithsmithbooks.com

Smith, Keith. *Bookbinding for Book Artists.* www.keithsmithbooks.com

Smith, Keith. *The New Structure of the Visual Book.* Fourth Edition. www.keithsmithbooks.com

Smith, Keith. *The New Text in the Book Format.* www.keithsmithbooks.com

GUIDE TO EVALUATION—AFTER PHOTOGRAPHING

After making your images, answer these questions:

1. *Achievement:* How many of the stated objectives were obtained? How well was it done? Are you satisfied? What benefits have you gained? What new knowledge have you acquired? What new skills have you developed? Have any of your previous attitudes been either changed or reinforced? Has the way that you see things been altered?

2. *The unexpected:* What unforeseen benefits or problems did you encounter? Did anything happen to alter or change your original plan? How did you do with the unplanned events? Was there anything that you should have done to make better images that you did not do? How will this help you to be a better imagemaker in the future?

3. *Goals compared with achievement:* Compare your final results with the original list of goals. What did you do right? What did you do wrong? What are the reasons? What would you do differently next time? Were the problems encountered aesthetic, technical, or logistical in nature? Which were the most difficult to deal with? What have you learned? How has it affected your working methods? Measure how well the objectives of the assignment were met. What grade would you give a student on this project if you were the teacher? Why? Be specific.

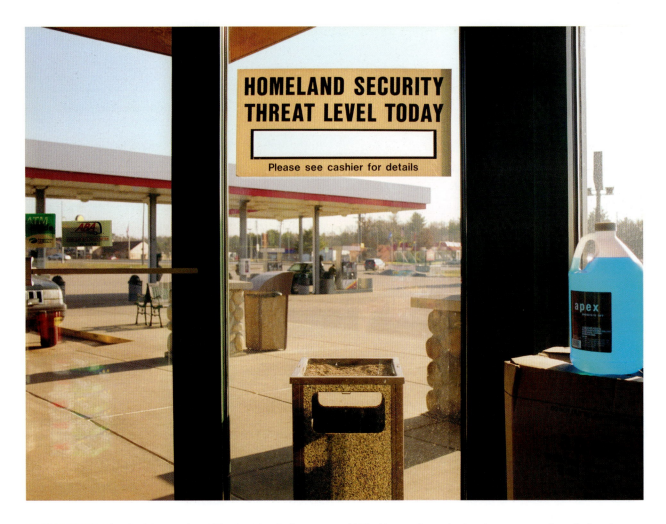

FIGURE 12.28 After the 9/11 attack in 2001, President Bush encouraged U.S. citizens to boost the American economy through shopping, thereby equating consumerism with patriotism. Brian Ulrich's self-assignment, the *Copia Project*, was a direct response to that advice, "a long-term photographic examination of the peculiarities and complexities of the consumer-dominated culture in which we live. Through large-scale photographs taken within both the big-box retail stores and the thrift shops that house our recycled goods, *Copia* explores not only the everyday activities of shopping, but the economic, cultural, social, and political implications of commercialism and the roles we play in self-destruction, over-consumption, and as targets of advertising."

Credit: © Brian Ulrich. *Black River Falls, WI*, 2006. 30 x 40 inches. Chromogenic color print. Courtesy of Rhona Hoffman Gallery, Chicago, IL; Julie Saul Gallery, New York, NY; and Robert Koch Gallery, San Francisco, CA.

NOTE

1. David Sandison and Graham Vickers, *Neal Cassady: The Fast Life of a Beat Hero* (Chicago: Chicago Review Press, 2006), 134.

FIGURE 12.29 Jeffrey Milstein apprises us: "When I was young I had a love of planes and flying. My earliest aerial photographs were taken while flying a rented Cessna 150 around Los Angeles as a teenager. I was fascinated by how everything looked from above. Fifty years later I took to the air again to photograph the man-made landscape, this time with high resolution stabilized cameras and a vision informed by my years spent as an architect and photographer. I am interested in documenting the patterns, layering, and complexity of cities, highlighting airports, container ports, recreational facilities, and residential and commercial developments, all of which grow organically over time. At an altitude of one to two thousand feet, a view unavailable from the ground opens up. From here you have grand vistas, yet you are close enough to see intimate details."

Credit: © Jeffrey Milstein. *NYC 10 Empire State Building*, 2015. 40½ x 54 inches. Inkjet print.

FIGURE A1.0 Laurie Tümer states that this work "provides visualizations of ubiquitous synthetic pesticides. I borrow a technique developed by the environmental scientist Richard Fenske that uses fluorescent tracer dyes, UV light, and a camera to give farm workers simulated pictures of their pesticide exposure after applications. I apply the tracer technique to explore what it implies for those of us who are not farm workers, but are exposed daily to the same pesticides in our homes and neighborhoods through applications and drift. As theatrical simulations, often involving over 50 separate images, they function in the realm of the imagination, illuminating what often appears as constellations charting the chemical's movement and settling. In his book *Beauty in Photography* (1981), Robert Adams addresses the paradoxes of beautiful images about unattractive subjects by discussing how Lewis Hine struck a perfect balance between this tension by showing what was bad, so we could oppose it, and showing what was good, so we would value it."

Credit: © Laurie Tümer. *Glowing Evidence: In My Study A&B*, 2006. 23 x 39 inches. Lenticular print.

Safety: Protecting Yourself and Your Digital Imaging Equipment

Although working digitally does not expose an image-maker to hazardous chemicals or fumes, one should be aware of the possible health effects connected to working regularly with a computer.

ERGONOMIC WORKSTATIONS

Many desks and computer-related equipment have hard, angled leading edges that can come in contact with your arm or wrist. These hard edges can create contact stress, affecting blood vessels and nerves, possibly causing tingling and sore fingers. One can minimize contact stress by:

- Padding table edges with inexpensive materials, such as pipe insulation.
- Using a wrist rest.
- Purchasing computer furniture with rounded desktop edges.

MONITOR EMISSIONS: ELF/VLF

Extremely low frequency (ELF) and very low frequency (VLF) emissions are types of electromagnetic radiation created by monitors. Some research studies have linked these emissions to an increased risk of cancer or miscarriage. Keep your eyes at least 18 inches away from the screen and avoid prolonged exposure. Use a low-emission monitor or install a screen filter.

EYESTRAIN

Eyestrain can be reduced by working in a properly lit room and by keeping the screen free of dust and clear of reflections. Periodically shift your focus from the screen to an object at infinity to rest your eyes. When possible, close your eyes for a few minutes and allow them to relax.

PROPER POSTURE/ LOWER BACK PROBLEMS

Sit in a fully adjustable ergonomic chair with your feet flat on the floor or on a footrest. The top of your monitor should be at about eye level. Another option is to use a sit-to-stand desk that has adjustable heights so it is possible to work standing upright, which can greatly help those with back problems.

CARPAL TUNNEL SYNDROME

Carpal tunnel syndrome, caused by repetitive movements and improper keyboard and mouse use, is characterized by numbness and tingling in the wrists and hands. In advanced stages, the syndrome can cause permanent nerve damage. Keep your wrists flat, straight, and at a height equal to your elbows to help prevent injury. Learning how to operate the mouse with your non-dominant hand can also help reduce repetitive movement stress.

FIGURE A1.1 Alan Sailer literally shot the subject of this image with a high-speed pellet rifle, capturing the action in slow motion using a homemade, microsecond flash unit set to a 1-second delay and a laser trigger. Sailer's photographs evoke a sense of excitement, whimsy, and even danger frozen in time, creating new landscapes from seemingly mundane objects. Safety goggles are recommended when photographing such subjects.

Credit: © Alan Sailer. *Oh Those Chocolate Eyeballs Itch,* 2009. Variable dimensions. Digital file.

TAKING BREAKS

Taking a 5-minute break and getting out of your chair every hour will help keep you sane and prevent fatigue. Try mixing non-computer–related activities into your digital routine. At your desk, stretching and yoga exercises, which can be found on the Internet, are suggested. Also, stay hydrated, which will also force you to take bathroom breaks from your tasks.

NEUTRAL BODY POSITIONING

When you add up the number of hours you spend every year working with computer equipment, it becomes apparent that it is to your benefit to properly set up a computer workstation. To accomplish this, you will find it useful to understand the concept of neutral body positioning, a comfortable working posture in which your joints are naturally aligned. Working with your body in a neutral position reduces stress and strain on the muscles, tendons, and skeletal system and decreases your risk of developing a musculoskeletal disorder (MSD). The following are the U.S. Department of Labor's Occupational Safety & Health Administration (OSHA) guidelines for maintaining neutral body postures while working at your computer workstation:

- *Hands, wrists,* and *forearms* are straight, in line, and approximately parallel to the floor.
- *Head* is forward facing, level or bent slightly downward, and center balanced. Normally, your head is in line with your *torso.*
- Shoulders *are relaxed, and* upper arms *hang normally at the side of your body.*

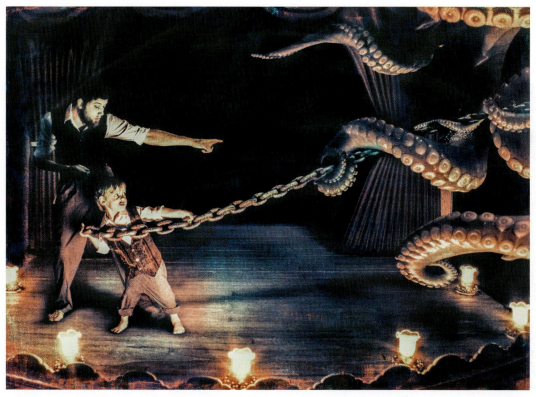

FIGURE A1.2 Dan Herrera began this piece with a sketch and short story he wrote. Herrera continues: "I constructed and photographed a miniature set that was composited in Photoshop and sent back through time using cyanotype and gum bichromate printing. Slowly, my digital image re-materializes as an imperfect one-of-a-kind object. I use the gum bichromate process because of its historical connection to the narrative, and the beautifully complex and imperfect surface detail that it yields. The resulting prints look like true artifacts that were transmitted from another reality—blurring the lines between photographic realism and painterly illusion. This aesthetic absorbs the viewer in a narrative that is both futuristic and nostalgic."

Credit: © Dan Herrera. *Continuity*, 2010. 40 x 30 inches. Cyanotype and four-color gum bichromate print on watercolor paper.

- *Elbows* are kept close to your body and are bent between 90 and 120°.
- *Feet* are firmly supported by the floor or a footrest.
- *Back* is fully supported with appropriate lumbar support when sitting vertical or leaning back slightly.
- *Thighs* and *hips* are supported by a well-padded, ergonomic seat that is usually parallel to the floor.
- *Knees* are about the same height as the hips, with the *feet* slightly forward.

CHANGE YOUR WORKING POSITION

Regardless of how good your working posture is, it is not healthy to work in the same posture or sit still for prolonged periods of time. Change your working position frequently throughout the day by carrying out the following activities:

- Stretch your fingers, hands, arms, and torso regularly.
- Make small adjustments to your chair, backrest, and footrest.
- Stand up and walk around for a few minutes periodically.

For additional information, visit the OSHA site at www.osha.gov. Then, go to www.osha.gov/SLTC/etools/computerworkstations/index.html.

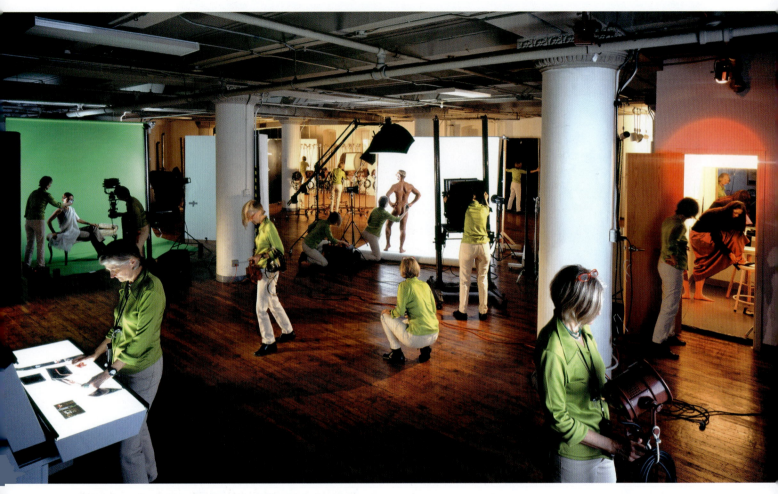

FIGURE A2.0 "The subject of *People at Work* is the double nature of labor at all levels of the social hierarchy—a round of tasks, often with no satisfying meaning, and a field for the exercise of aptitudes. By compositing digital photographs that compact the varied tasks of individual workers into a single frame, I seek to communicate simultaneously the frenzied tedium of a wide variety of occupations and the intensity of effort that people put into them. The color images come about through a practice of taking photographs with a 4 x 5-inch camera of individuals whom I direct to perform the tasks associated with their jobs, at their workplaces. I scan the photographs into the computer and then digitally composite them into images that show at once all of the significant tasks associated with each job. The result in each case is a concentrated look at a person at work that conveys both a sense of frantic alienation and an amazement at the feats performed by workers in what are often considered the most ordinary, routine, and undemanding occupations. For most people, work has elements of both depravity and dignity. I seek to make that tension come alive, so that we can appreciate one another's endeavors at the same time that we question their intrinsic worth."

Credit: © Nathan Baker. *Photography Studio,* from the series *People at Work*, 2004. 40 x 50 inches. Inkjet print. Courtesy of Schneider Gallery, Chicago, IL, and Robert Koch Gallery, San Francisco, CA.

Careers

Photography offers a wide variety of challenging career opportunities, especially for independent and motivated individuals. According to the Bureau of Labor Statistics, there are about 125,000 working photographers in the United States today with a median pay of about $32,000 per year. Employment of photographers is projected to grow 3 percent through 2024. Salaried jobs may be more difficult to find as more companies contract with freelancers rather than hire their own photographers. People interested in pursuing a photographic career are typically imaginative, visually curious, possess a good sense of design, and enjoy making their own photographs and acquiring technical knowledge to improve their craft. High school students should have a general academic background and pursue courses and creative activities in the arts, computer science, and journalism, including working on the school newspaper and yearbook. They can also take workshops and after-school or summer classes in photography and art. Students can demonstrate their ability by preparing a portfolio of their work to show to prospective colleges and universities.

Many colleges and universities offer photography courses, and some have programs that lead to bachelor's and master's degrees in the subject. A number of art schools and technical schools also offer instruction and practical training in photography. Information about photography careers and accredited programs can be found online at www.photographyschools.com.

THE WORKING PHOTOGRAPHER

Photographers work in many different industries. A large number of them are *freelance* photographers; that is, they are self-employed. They may own their own businesses, be employed for limited periods of time by different companies, work part-time, or utilize photography as a second income. In his 2012 commencement address at the University of the Arts, writer Neil Gaiman offered these observations about freelancers:

> . . . people keep working in a freelance world, and more and more of today's world is freelance, because their work is good, and because they're easy to get along with, and because they deliver the work on time. And you don't even need all three — two out of three is fine. People will tolerate how unpleasant you are if your work is good and you deliver it on time. People will forgive the lateness of your work if it's good and they like you. And you don't have to be as good as everyone else if you're on time and it's always a pleasure to hear from you.[1]

Others make their livelihood by working for companies in support of communication, marketing, the development and/or sales of equipment, products, and technologies.

• *Animators* work with industry-grade digital animation tools, such as 3DS Max, After Effects,

Blender, and Maya along with Photoshop, to bring realistic models and environments into virtual reality for the game, film, and video industries. Employment opportunities include 3-D modeler, animator, art director, film and video editor, graphic designer, stop-motion animator, and video game designer. Stop-motion animators are often accomplished photographers who work with physical rigs, cameras, and lighting equipment.

- *Commercial photographers* take pictures for advertisements or for illustrations that appear in books, magazines, websites, or other publications. These photographers work with subjects as varied as architecture, food, equipment, and fashion.

- *Corporate communications* is a field where photographers with a range of skills, especially writing, can find employment. Because many photographers often have excellent computer expertise, they work on corporate events, such as national sales presentations and trade shows.

- *Freelance photographers* are independent-minded people who succeed by combining their photographic knowledge with expertise or interest in another arena. For example, a photographer who loves nature can profit by making animal and landscape photographs. Within this field, one might further specialize in a single area, such as underwater photography. Others make photographs and/or write for photography magazines and educational publishers. Photographers who find their own specialty or niche often start their own business. These self-employed individuals, known as *freelancers* or *independents*, take a career path that can be demanding but also very fulfilling. They must be excellent problem solvers and possess the skills of a businessperson as well as the artistic attributes of a photographer. Currently, more than half of working photographers are self-employed.

- *Fine art photographers* produce photographs that are sold as fine art. These photographers exhibit their work in museums and sell their pictures through commercial art galleries and at art festivals. Fine arts photographers rarely can support themselves solely through their art, so they often take other jobs.

- *Industrial photographers* take pictures for industrial purposes, of such subjects as company officials or machinery, which are used in project analysis, technical documentation, or annual reports.

- *Portrait photographers* take pictures of people and of special events in people's lives. Some photographers in this field specialize in one type of portraiture, such as children, families, or weddings. Portrait photographers must like working with people and know how to pose their subjects to create pleasing effects.

- *Photojournalists* take pictures of events, people, and locations for newspapers and other news outlets. They must be skilled at seeking out and recording dramatic action in such fields as politics and sports. A photojournalist must be prepared to travel and work quickly under the pressure of a deadline. Due to time constraints, photojournalists need to have strong previsualization skills and be able to edit as they work and are prohibited from using post-processing to make corrections.

- *Scientific photographers* work in a number of specialized areas. Major fields of scientific photography include *medical, forensic,* and *engineering photography*. Medical photographers may work with medical equipment, such as microscopes, X-ray machines, and various scanning systems as part of research, education, or to help diagnose and treat disease. Forensic photographers work for law enforcement as part of a team that investigates and documents crime scenes to gather evidence for legal purposes. Engineering photographers help improve the design of equipment and structural materials. These photographers sometimes use high-speed cameras to "stop" the action of machines and to make visible the flaws in metal, plastic, and other materials. Others use photography to make new discoveries about our solar system.

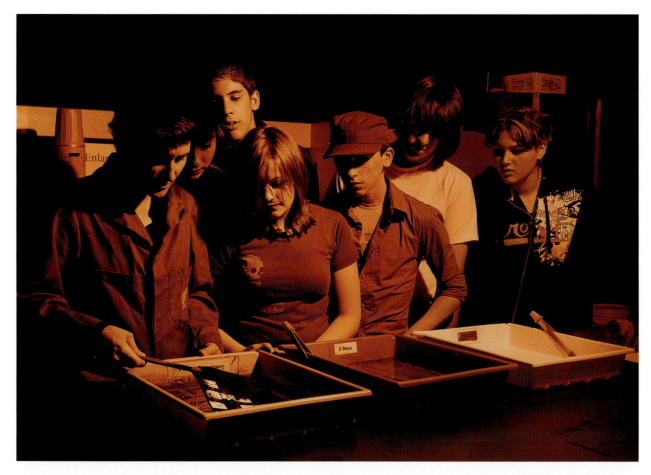

FIGURE A2.1 In this image showing the creation of an image, the professional artist is replaced by a group of high school students being shown the rudiments of traditional darkroom photography. "The moment where a latent image becomes visible on the paper is a magical moment familiar to anyone who has witnessed its occurrence. It is also a moment that will become increasingly rare as chemical photography is replaced by digital imagemaking. This element is underlined by the fact that this is a technically 'impossible' photograph in terms of traditional photography. An exposure under the safelight of a darkroom would take too long for motion to be stopped and, as such, additional lighting and digital techniques were required for the creation of the final image. As such it acts as both an homage and lament for a dying aspect of photography to which the medium has been inextricably linked since its inception."

Credit: © Adam Harrison. *Darkroom Lesson*, 2005. 31½ x 43½ inches. Inkjet print. Courtesy of Dyan Marie Projects, Toronto, ON.

GETTING STARTED

Many young people start their careers by working as interns or photographic studio assistants. They may help collect props, prepare sets, arrange products to be photographed, process images, and manage databases. Working under a successful professional is a time-honored way of learning the business and provides real-life training for opening one's own business in the future. A growing number of galleries and museums employ people knowledgeable about fine art photography and photographic history to manage their photography collections, document artwork and its installation, and assist in organizing exhibitions. Other photographically minded people work in website design and desktop publishing. Careers also are open to people who can teach or write about photography. Other areas include photo processing and printing, photo editing, image library maintenance, equipment manufacturing, sales of equipment and supplies, and equipment maintenance and repair. Technically minded people can follow pathways in research and development of new

photographic equipment and products. The important thing is to find a path going in your direction and take it. Your persistence, passion, and mastery of practice are what make the difference between those who become professionals and those who remain amateurs. As in most arts-related fields, people who work the hardest are generally the ones who find success.

NOTE

1. Neil Gaiman Addresses the University of the Arts Class of 2012, https://vimeo.com/42372767

REFERENCES

Carr, Susan. *The Art and Business of Photography*. New York: Allworth Press, 2011.

Congdon, Lisa, et al. *Art, Inc.: The Essential Guide for Building Your Career as an Artist*. San Francisco: Chronicle Books, 2014.

Kleon, Austin. *Show Your Work!: 10 Ways to Share Your Creativity and Get Discovered*. New York: Workman Publishing Company, 2014.

Madoff, Steven Henry, editor. *Art School (Propositions for the 21st Century)*. Cambridge: MIT Press, 2009.

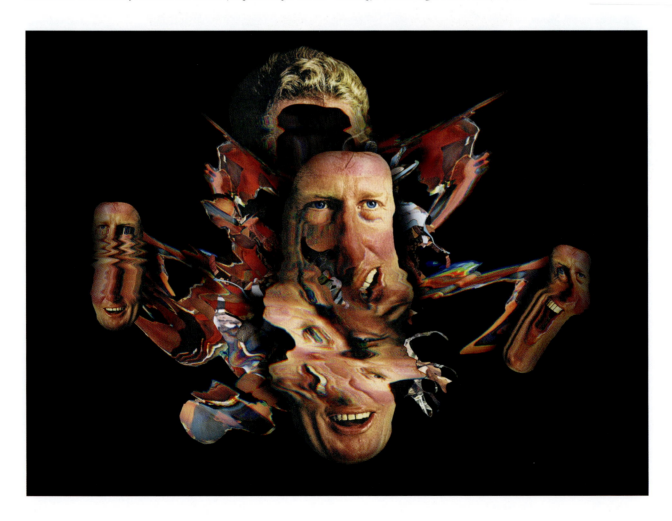

FIGURE A2.3 W. H. Runcie, M.D., Health Officer. Town of Hempstead, NY. *John is Not Really Dull – He May Only Need His Eyes Examined*, circa 1937. Color silkscreen.

Credit: Work Projects Administration Art Project. Library of Congress (LC-USZC2-5332).

FIGURE A2.2 Kevin Kline conveys: "Utilizing a scanner as a camera, this image was manipulated by varying scan resolution settings that increase or decrease scan time. This allows for movement of paper elements, appropriated from vintage magazines, placed on the scanner bed to produce different effects. The results were composited in Photoshop with shadow layers and lighting treatments added to produce depth. The visual language of marketing and mass media is utilized to create a nightmarish homunculus, in the manner of Hieronymus Bosch, to evoke anxiety and amplify the consumptive culture they represent."

Credit: © Kevin Kline. *Boschplode*, 2013. 30 x 40 inches. Inkjet print.

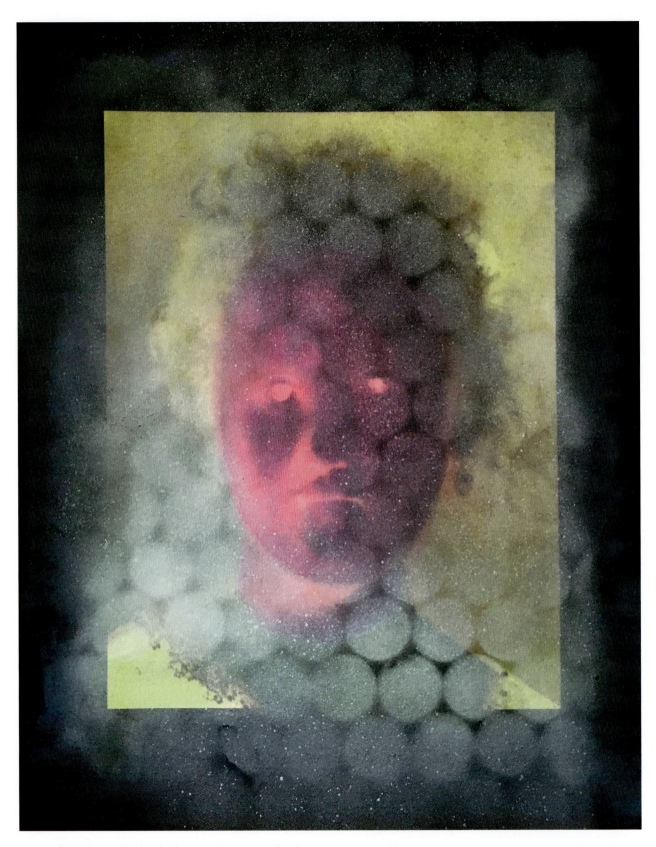

Molly McCall says: "The idea of exploring the use of paintings as photography came out of the question 'What is a photograph?' I began by using early European masters' paintings in a photographic context to create a dialogue between the two mediums and investigate the sense of time and the historical gap between them. The photograph of the painting was scanned and printed as a digital negative, then printed as an analog photograph in the darkroom. After processing, the photograph was then abstractly painted with oil and acrylic paints and finished with a matte varnish. Color and mark-making are also used to emphasize or diminish certain elements of the photographic image, similar to the deterioration and fading of physical and material things over time."

Credit: © Molly McCall. *Scarlet Girl*, from the series *In the In-Between*, 2016. 20 x 16 inches. Gelatin silver print with hand applied color.

Index

Page numbers in *italics* refer to figures.

3-D (stereo) cameras 73

A

Abbott, Berenice: *Blossom Restaurant, Manhattan* 220; *Changing New York* 220
Abeles, Kim, *Thunder of Waters* 50
Abstract Expressionism 9, 193, 318
accents 38
actual space 47
Adams, Ansel 9, 23, 32, 151, 342
Adams, Bill, *Billboard 2006* 39
Adamson, Robert 5
aerial perspective 324, 327
AF Assist Lamp 86
afternoon light 161
Airey, Theresa, *The Wishing Well* 146
albedo 165
Alberti, Leon Battista 309
albums 390–91
Allen, Thomas, *Chemistry* 169
Andersen, Barry, *Sheep and Standing Stone, Avebury, England* 278
Anderson, Chris, *The Long Tail: Why the Future of Business Is Selling Less of More* 117
angle of view 83; equivalency table 84
animation *see* cell animation programs; digital animation; timeline animation
animators 402
anti-shake system 206
Aperture Priority mode 79–80
appropriation 10, 12, 79, 222
Arbus, Diane 10
archival presentation 283; cold-mounting 291; dry-mounting process 287, 289–291; floating a print 291; frames 291; mat board criteria 286; mat board selection 284–86; mat cutting steps 288–89; minimum image and board sizes 289; portfolio 292; presentation materials 283; print-on-demand books 292–93; spray mounting 291; unusual frames and presentations 291; wet-mounting process 287; window mat 284–85

Ariaz, Jeremiah, *Sahara*, from the series *Envisioning the Land* 333
Armstrong, Bill, *Mandala*, from the series *Infinity* 210
artificial light 169–171; compact fluorescent (CFL) spiral bulb 170; continuous lighting 170; emulating the sun 170; LED lighting panels 170; modeling light 170; photoflood light 170; placement of the light 172; size of the main/key light 172; strobe 170
artistic possibility scale 343
artists' books 390–91; exercise 391; references 393; sources of 392
artist's statement 353–56
Aspect Modes 98
Atkins, Anna, *Photographs of British Algae: Cyanotype Impressions* 390
Atmospheric Aerosol 166
attraction and repulsion 331–32
audience. *See* viewers
Augustine of Hippo (saint) 201
Austin, Ashley 176–77
autofocus lock 207
autofocus modes 85–86
Automatic mode 80
Avedon, Richard 362
AVFoundation 278
Ayres, Shannon, *Reenactor 03* 226

B

Barnett, Susan A., *Spike: The Cronies*, from the series *Not In Your Face* 162
backdrops: black velvet 181; seamless paper 181
backlighting 139, 140, 175
Bacon, Francis 26
Bacon, Pat 23
Bahat, Tami, *The Painter* 282
Baker, Nathan, *Photography Studio*, from the series *People at Work* 400
balance 41; alternating rhythm 42–43; asymmetrical 42, 43; exercise 43; progressive rhythm 43; radial 42; symmetrical 41, 43; with texture 42; through color and value 42; through contrasts in value 42
banding 95

barn doors 176

Barth, Uta 209

Bateman, Edward 92, 266; *CDV Utah 1869* 55; *Dog Printer* 242–43; *Still image from Untitled Cinématographe* 268

batteries: choices of 104–5; cold condition care 105, 107; in digital cameras 104; general tips 106; guidelines for care 105

Bauhaus style 313–14

Bayard, Hippolyte 362

Bayer filter mosaic 65

beach lighting 169

Becker, Craig, *Scratch 31*, from the series *Scratch*, xxix

Becker, Olaf Otto, *Haifossnebel, Iceland* 157

beginner's mind 31–32

Belkin, Katerina, *The Road*, ii

Benjamin, Walter 347–48

Berger, Paul, *WalkRun* 313

Berkman, Stephen, *Conjoined Twins* 3

Beuys, Joseph 16

bicubic interpolation 248

bicubic smoother 248

bird's-eye-views 313–14

bit color 263–64; comparing 8-bit and 16-bit modes 264

bitmapped images 269

Blacklow, Laura, *Confessions of a Jew, Double Page* 28

Blakely, Colin, *Rain Turning to Freezing Rain Overnight*, from the series *Domestic Weather Patterns* 128

blogs (weblogs) 64, 117, 279

Bloom, Suzanne, *Solstice 12.21.05* 91

blooming 95

blur, filters for 210–11

blurred images 209–10

BMP 76

bokeh 210–11

books, print-on-demand 292–93

Bosworth, Michael 174, 295; *Floodtown* video installation view, from the series *Not Me and Probably Not You* 60; *Lighting Glass* 178; *Lighting Metal* 178; *Lighting Water* 179; *Portrait Lighting* 176–77; *Upstate* 217

Boughton, Alice 6

Boughton, Nadine, *Cape Canaveral*, from the series *Fortune and the Feminine* 230

Bourke-White, Margaret 8

Boutwell, Richard, *Picken's Plan, Ogallala Aquifer, Northern Texas to South Dakota* 294

Bowen, Susan, *Citizen's Thermal Energy Plant* 212–13

Brackenbury, Deborah, *Wannabes (Brother and Sister)* 261

bracketing 126–27, 141, 167, 168, 219

Bram, Richard: *Century 21, Church and Dey Streets, New York City* 191; *Isabel Trio 3rd* 203

Brandt, Matthew, *Lake Union WA 4*, from the series *Lakes and Reservoirs* 299

Brandt, Nick, *Wasteland with Elephant*, from the series *Inherit the Dust* 259

Breisach, Kristi, *All Things American* 53

Briggs, Priscilla, *MAC* 141

brightness range 93, 128–29; with artificial light 173

Bringing It Together (Thinking Model Stage 4) 345–46

Burkholder, Dan: *Big Fish along Highway, Minnesota* 130; *Tree in April Snow, Catskills* 150

Burkholder, Jill Skupin, *Running Deer, Catskills* 69

Burnett, Christopher: *No 3, River Valley Horizon 2010 11.13* 386; *No 3, River Valley Horizon 2010 11.13 (detail)* 387

Burson, Nancy 15, 365

Burtynsky, Edward, *China Recycling #7, Wire Yard, Wenxi, Zhejiang Province* 184

Butski, Tricia, *Visage*, from the series *Semblance* 193

Callahan, Harry 223, 362, 388

calotypes 4–5

camera care 107; protection against the elements 107, 109; top 10 maintenance suggestions 108

camera obscura 59–60

cameras: components of 61; digital camera backs 72; digital single-lens reflex (DSLR) 60; disposable film cameras 72; drones 72; free-form movement of 213–14; homemade film cameras 72; imaging system of 62–63; instant cameras 72; kit cameras 72; lens test chart, 29; light field (plenoptic) cameras 72; Lytro 65, 72; mirrorless 85; motion picture 237; multimedia 72; panoramic 72; photomicrograph cameras 72; pinhole 72–73, 131, 271; point-and-shoot 68; rangefinder 85; remote (trail) 73; role of 59; selection of 75; smartphone 60, 71–72; spy (hidden) 73; stereo (3-D) 73; superzoom 126; telescope 73; time-lapse 73; toy film 73; underwater 73; viewers 73; wearable 73; web cameras (webcams) 73; *see also* camera care; digital cameras

camera time: and blur 209–11; and compound images 228; contact sheet sequence 224, 227; controlling 204; drawing with light 216–17; and equipment movement 212–13; extended time exposures 215–16; extending the action 204–5; flash and slow shutter speed 214–15; and free-form camera movement 213–14; image-based installations 231–32; joiners 227; many make one 224; motion blur filters 210; with multiple images 218; pan shot 211–12; photographic collage 229; photomontage 228; post-camera visualization 222; Post Documentary approach 221–22; projection 217–18; public art 232–34; recomposing reality 236–37; rephotography 220–21; sandwiching/overlapping

transparencies 219; sequences 223; shutter speed 204; slices of time 227–28; and social media 235; stopping the action 205–8; stopping the action with electronic flash 209; three-dimensionality 229–230; using a grid 224

Cameron, Julia Margaret 5, 209, 316

Campbell, Kathleen, *Relics from the Garden: Disappearing Airplane* 113

Camus, Albert 17

Capa, Robert 8, 32

Caponigro, John Paul, *Path, I* 45

Capture NX 269

card readers 115

career opportunities 16, 27; animators 401–2; commercial photographers 402; corporate communications 402; fine art photographers 402; freelance photographers 402; getting started 403–4; industrial photographers 402; internships 403; photojournalists 402; portrait photographers 402; scientific photographers 402

Carey, Ellen, *Blinks* 280

carpal tunnel syndrome 398

Carpenter, *Ghost* 231

Carr, Christine, *221.05.72, 2008* 127

carte de visite 390

Cartier-Bresson, Henri 23; *The Decisive Moment* 204

Cassady, Neal 392

Cassinelli, Alvaro, *The Khronos Projector* 231–32

Cassini Imaging Team, *Approaching Northern Summer* 13

Castiglione, Countess de 362

cataloging programs 114

CCD (charge-coupled device) 64

CDs (compact discs) 114, 115

cell animation programs 278

center spot filter 149

Chagall, Marc 362

Chambers, Tom, *Dirt Road Dogs* xxv

chance favors 323–24

changeable color filter 149

charge-coupled device (CCD) 64

Charlesworth, Bruce, *Drip*, from the series *Serum* 123

Chaskielberg, Alejandro, *The Paraguayans*, from the series *The High Tide* 171

chiaroscuro 38

Christenberry, William 10; *Pure Oil Sign in Landscape, near Marion, Alabama* 11

Christo, *The Gates* 231

circle of confusion 80

Cirio, Paolo, *Face to Facebook* 235

citizen journalism 60–61, 63–64, 203

clips 278

Close, Chuck 361

cloud storage 114, 116, 300

CMYK (cyan, magenta, yellow, black) 255, 262, 266, 267, 273

Cocteau, Jean 26

cold-mounting 291

collage 229

Collette, Ulric, *Genetic Portrait, Sister/Brother: Karine, 29, and Dany, 25* 118

Collignon, Bob, *RedSWAY*, from the series *Dance With The Devil* 292

collodion (wet-plate) process 5

color: and balance 42; color modes 145; color saturation control 145; compelling composition using 319; complementary 317; creating contrast in 317–18; dominant 318, 319; harmonic 320–22; hue adjustment 145–46; incorrect reproduction 146; isolated 322–23; monochromatic 324–26; passive 321; RGB mixing 145–46; subdued 329–330; surrounding 266; symbolism of 54; what you see is what you get 265–66; *see also* digital colors

colored filters, homemade 150

Color Field painting 318

color filter array (CFA) 65, 92

color harmony 320–22

color key 195, 197

color management 265

Color Modes 98, 145

color monitors 262–63

Color saturation control 145

color separation 132

color space, controlling 265

color spot filter 149

color temperature 143–44; of CFL bulbs 170; warm and cool 317

color tints 219

color vignette filter 149

color wheel 146

commercial photographers 402

communication: of cultural knowledge 348–350; with design 31

compact discs (CD) 114, 115

Compact System Cameras (CSC) 71

complementary metal-oxide semiconductor (CMOS) technology 64

composition 388; subtractive 32–33; *see also* design principles; visual elements

composition key 195, 197

compound images 228

computer: as multimedia stage 276, 278; valuable data habits 277

Connell, Kelli, *Kitchen Tension* 13

contact sheet sequence 224, 227

Continuous-servo focus setting 86
continuous shutter mode 90, 238
contrast 38, 168, 317, 330; with artificial light 173; and
 balance 42; in colors 317–18
Cornell, Joseph 291
corporate communications 402
counterpoints and opposites 332
Courbet, Gustave 361
Craigslist 293
creation and evaluation 392
creative looking 185
Crewdson, Gregory, *Untitled, Winter* from the series *Beneath
 the Roses* 360
Crippens, Kirk, *3-Car Garage*, from the series *Foreclosure,
 USA* 133
critics, role of 26–27
crop factor 83
cross screen filter 149
cubomania 229
cultural knowledge 348–350
cultural landscape 377
Cumming, Robert 387
Cunningham, Imogen 9
cyanotypes 10

D

Dadaism 39, 228
Daguerre, Louis-Jacques-Mandé 3
daguerreotypes 3
DAM (digital asset management) 113–14, 301
Danh, Binh, *The Botany of Tuol Sleng #11* 369
Dante, Arthur C. 348
Davenport, Meredith, *Untitled* 135
Davidson, Bruce 388
Davis, Bill 365, 373; *The Last Supper* 345; *Site 03140*, from the
 series *No Dark in Sight* 164; *Strike*, from the History
 Revision Project 372
Davis, Debra A. 48; *Repetition Increases Outcome*, from the
 series *Incidental Specimens* 114
Davis, Jen, *4 A.M.* 362
Davis, Tim, *Searchlights*, from the series *Illuminations* 106
Definition and Approach ("Thinking Model Stage 3") 344
De Luigi, Stefano, *Virunga Hospital, Ophthalmologist
 Examination, Bukavu, DRC* 317
Demachy, Robert 316; *Photo-Aquatint or the Gum-Bichromate
 Process* 6
Demand, Thomas, *Grotto* 334
depth, illusion of 327
depth of field 38, 48, 80–82, 206, 388; controlling 81;
 extended 82; limited 82

Deschamps, François, *La Tour Abolie*, from the series *Circa
 1900* 365
desert lighting 169
DeSiena, Marcus, *62.009730-6.771640*, from the series
 Surveillance Landscapes 384
design: communicating with 31; considering attention span
 and staying power 33–34; departure point 33; elements of
 32; and the need for focus 32; process of 32; visual 51
 388
design principles 35; balance 41–43; emphasis 38; Golden
 Mean: the rule of thirds 40; scale and proportion 39–40;
 unity and variety 37–38
Dickson, John, *Dresden* 325
diffraction filter 149
diffusion filters 149, 176–77; homemade 150–51
digital animation 4
digital archives: cloud storage 300; digital asset management
 (DAM) 113–14, 301; external hard drives 300; long-term
 storage 300; migrating 300; transferring film-based images
 to digital format 301
digital asset management (DAM) 113–14, 301
digital bookmaking 391
digital camera backs 72
digital camera features 63; aspect modes 98; battery
 104–7; color filter array 65; color modes 98; digital
 aberrations: noise, banding, blooming, and spots 95–96;
 digital ISO/sensitivity 95; firmware 103; flash 101;
 format in MP resolution 92; guide or help mode 100;
 image enhancement and scene modes 98; image
 resolution 65–66; image sensors: CCD and CMOS
 64–65; image stabilization 101; memory buffer 103;
 metadata/EXIF 94–95; metering modes 96; monitor
 93; monitor playback mode and histogram 93–94;
 noise reduction 100; optical and digital zoom 95;
 removable memory storage 103; resolution and print size
 92–93; sharpening mode 99–100; software 103; special
 effect modes 98; video mode 96–99; white balance
 96–97
digital camera types 68; all-in-one 68; compact 68–69;
 medium-format 71–72; mirrorless 70–71; scanning backs
 68; single-lens reflex cameras 69–70; single-lens
 translucent 70; smartphone cameras 68, 71–72; wearable
 73; see also digital camera features; digital cameras
digital cameras: and citizen journalism 63–64; ground rules
 109; see also digital camera features; digital camera types
digital colors: CMYK 255, 262, 266, 267, 273; RGB 65, 96,
 98, 109, 111, 124, 145–46, 247, 248, 255, 262–67, 267,
 273
digital files see digital images; image display
digital filters 151–52, 271
digital galleries 279
digital image messaging 385

digital images: adjusting size 249–250; bit color 263–64; color management 265; on color monitors 262–63; controlling color space 265; corruption of 261–62; evaluating 357; future of 279–280; image viewers 252–53; image window 253; information displayed 254–55; on the Internet 278–79; monochrome 324–26; post-capture software programs 253; preserving original capture 250; and printer resolution 246; prints 253; raster (bitmapped) 269; resampling (interpolation) 248–49; retouching 283; scaling 250; scanning backs 109–13; screen images 252–53; size of 348; sizing 246, 248; storing 113–16; from a television or monitor display 383; and text 384–89; thinking and writing about 335; web sharing 293–94; website design 295; working with raw file formats 250–52; and WYSIWYG (what you see is what you get) 265–66. *See also* dots per square inch (DPI); pixels per square inch (PPI); *see also* print images; screen images

digital imaging 3–4, 12 cut/copy and paste functions 270; digital filter function 151–52, 271; scale and distort functions 270; toolbar icons for additional photo editing 271–75; top main menu options 269

digital imaging transformation 12, 15; advantages of 20; disadvantages of 20

digital memory: hard disks 267; RAM 267; ROM 267

Digital Negative (DNG) format 78, 251

digital noise 95–96

digital photography 193, 194–95; effect on the arts 193–94

digital prints *see* digital images; digital print stability; print images

digital print stability: dye-based inks 302; pigmented inks 302; printing media 302–3; projecting pigment prints 303; *see also* print preservation

digital scanners 12

digital single-lens reflex (DSLR) cameras 69–70

digital truth 365

digital versatile discs (DVD) 114, 115

digital zoom 95

diminutive effect 39

disposable film cameras 72

DNG (Digital Negative) format 78, 251

documentary approach 7–8

Donato, Frank, *Starbucks* 148

dot pitch (DP) 244, 245

dots per square inch (DPI) 66–67, 244, 245–46, 247, 249; and visual acuity 67–68

double exposure filter 149

Dow, Beth: *Bags*, from the *Fieldwork* series 6

DP (dot pitch) 244, 245

DPI (dots per square inch) 66–67, 244, 245–46, 247, 249; and visual acuity 67–68

Dreamweaver software 295

drones 72

droplet size 255–56

drum scanners 109–10

dry-mounting process 287, 289–291

DSLR (digital single-lens reflex) cameras 69–70

dual color filter 149

DuBois, Doug, *My Sister's Bedroom*, from the series *All the Days and Nights* 379

Dürer, Albrecht 361

dust 166, 168

DVDs (digital versatile discs) 114, 115

dye-based inks 257, 302

Dynamic Range Chart 129

Eastman, George 237

Eastman Kodak Office Building at Night, Rochester, N. Y. 281

Edgerton, Harold "Doc" 209–10

Edison, Thomas 237

Edwards, Beth Yarnell, *Niki, Age 24* 180

Eggleston, William 10

Einstein, Albert 27–28, 201

electronic flash 134–35; flash basics 137; use to stop action 209

electronic imaging *see* digital imaging

electronic viewfinder (EVF) 68–69, 70, 85, 126

Emerson, Peter Henry: *The Death of Naturalistic Photography* 6; *Naturalistic Photography for Students of the Art* 6

emphasis 38

Enrique, Klaus, *Head of a Woman #3* 36

environmental landscape 377

environmental portraits 363

EPS (Encapsulated PostScript) 76

Epstein, Mitch, *Biloxi, Mississippi* 320

equipment movement 212–13

Erb, Carol, *The Veldt* xx

Erf, Greg 284

ergonomic workstations 397; changing your working position 399; neutral body positioning 398–99; proper posture 397; taking breaks 398

Ernst, Max 229

Ernst Leitz GmbH 83

ethical behavior 34

evaluation: after photographing 393; before making images 392

Evaluation (Thinking Model Stage 6) 346–47

Evans, Susan, *Crime Scene #4*, from *Crime Series* 355

Evans, Walker 8

Evdokimova, Katya, *The Silhouette* 326

EVF (electronic viewfinder) 68–69, 70, 85, 126

exhibition sites, online 352

EXIF (Exchangeable Image File) 94–95, 250

existentialism 371

exposing to the right 129

exposure 243; averaging incident and reflect exposures 141; basic light reading methods 130–32; by bracketing 127; brightness range 128–29; camera metering programs 125; compensation 127; contrast/control compensation 133–34; deceiving a meter 126; determining 90–91; electronic flash and basic fill flash 134–37; electronic viewfinder (EVF) 126; exposing to the right 129; flash techniques 137–38; handheld meters 128; high dynamic range (HDR) imaging 129; how a light meter works 123–24; light metering techniques 134; light meters are 18 percent gray contrast 121; long exposures and digital noise 142–43; manual override 127–28; metering guidelines 122; multiple 218; reciprocity law 141–42; red eye 137, 139; reflective and incident light 121, 123; Scene Mode exposures 141; subject in bright light 140; subject in shadow 140; theoretical equivalents 142; unusual lighting conditions 139–140; using a camera monitor 125–26; using a gray card 124–25; zoom exposure 141

extended depth of field 82; *see also* depth of field

extended time exposures 215–16

external hard disc drives 115, 300

extremely low frequency (ELF) emissions 397

ex voto painting xxv

eye-level angle views 310

eyestrain 397

fabrication 374; and the social landscape 375–77

Facebook 193, 235, 293, 295

face detection (FD) 86

fake news 372–73

fall light 166

Farm Security Administration (FSA) 8, 363, 367

Faur, Christian, *Winds* 307

fauxtography 363–64

FD (face detection) 86

figure-ground relationships 47, 197–98

file formats 75–76; image compression algorithms: lossless and lossy 76

file headers 78

fill flash 135–37, 141

film scanners 109; *see also* scanners and scanning

filters 82; controlling reflections 147–49; digital 151–52; for emotional impact 151; filter factor 146–47; for fluorescent and other gas-filled lights 152–53; for high-intensity discharge lamps/mercury and sodium vapor sources 153;

homemade colored and diffusion 150–51; how filters work 146; lens filters 146; motion blur 206, 210; natural density 147; plugins 151–52; radial blur 210; red, green, or blue (RGB) 65; smartphone applications 152; special effects 149, 150; ultraviolet, skylight, and haze 149

fine art photographers 402

Finkelstein, Richard, Home Movie, from the series *Sitting in the Dark with Strangers* 156

fire 168–69

firmware 103

fisheye lenses 89

flash: auxiliary unit 215; in digital cameras 101; and slow shutter speed 214–15

flash memory media 115

flatbed scanners 109; *see also* scanners and scanning

Flick, Robbert, *Along Whittier Boulevard* (detail), from *L.A. Document* series 225

Flickr 117, 235, 293

floating a print 291

floppy disks 114

fluorescent light 152

Flynn Kelly, *Cowboy 2*, from the series *iLatex* 381

focal length 82–83, 212–13; 35mm film camera equivalencies 83; and angle of view 83; calculating equivalency for digital sensors 83–84; conversion table 84; focal length rule 83; telephoto 206, 207

focal point 38

focus, selective 314

fog 166

fog filter 149

Folberg, Neil, *Passing Shadow at Summer Solstice*, from the series *Taking Measure* 154

Fontcuberta, Joan: *Cercopithecus Icarocornu*, from the series *Fauna* 19; *Landscapes Without Memory* 230

Foran, Patrick, *Live Coverage* 104

Formiguera, Pere, *Cercopithecus Icarocornu*, from the series *Fauna* 19

found objects 112

Fournier, Collette 388; *Uncle Ray Was a Drummer*, from the series *Digital Family* 389

frame grabber 112, 112–13

frames 291

framing 319–320, 321

framing effect 309; *see also* viewpoint

framing filter 149

Frank, Robert 9; *The Americans* 376

Frederick, Ivan, *Prisoner Being Tortured, Abu Ghraib Prison* (a.k.a. *The Hooded Man*) 64

free-form camera movement 213–14

freelance photographers 402

Freund, Giselle, *Photography and Society* 36

Friedlander, Lee, *Self Portrait* 376

Friend, Amy, *Stargazers*, 119

front light 175

Frydlender, Barry, *Last Peace Demonstration* 14

FSA (Farm Security Administration) 8, 363, 367

f-stops 79, 126, 143

Fuji Frontier Print system 261

Fuss, Adam, *Untitled* 36

G

Galloway, Stephen, *Scatter*, from the series *NextNature* 37

gels (gelatin filter sheets) 177, 217

geo-tags 294

Giclée printing 258

GIF (Graphics Interchange Format) 76; use for animation 237

Gindlesberger, Hans, *Untitled (Nighthawks)*, from the series *I'm in the Wrong Film*, 198

Gitelson, Jonathan, *What Does It All Mean?* 22

glare 168

Glaser, Karen, *Leon's Dome*, from the series *Florida Springs and Swamps* 74

global shutter 90

globular blur 210

Goldchain, Rafael: *Self-Portrait as Leizer Goldszajn, b. Poland, 1880s, d. Poland, early 1940*, from the series *Familial Ground* 375; *Self-Portrait as Reizl Goldszajn, b. Poland, 1905, d. Buenos Aires, Argentina, 1975*, from the series *Familial Ground* 375

Golden, Nan 361

Golden Hour 160, 161, 163

Golden Mean 40; exercise 40–41; in the Renaissance 42

GoLive software 295

Google Earth 12, 221, 294

GoPro 73

Gordon, Daniel, *Red Eyed Woman* 9

Gowin, Emmet, *The Photographer's Wife: Emmet Gowin's Photographs of Edith* 223

graduated filter 149

Graphics Interchange Format (GIF) 76; use for animation 237

Gray, Richard, *98.6 TH* 75

gray card 124–25

Greenberg, Jill, *Grand Old Party*, from the series *End Times* 381

grid 224

Groney, Ryan, *Flaming Buster Sword* 183; *Got a Light* 139

Groom, Red, *Ruckus Manhattan* 231

Group f/64 9

Guide Mode 100

gum printing 6, 10

Gursky, Andreas, *Nha Trang, Vietnam* 30–31

H

Hackbardt, Marcella, *Practical Knowledge*, from the series *Story of Knowledge* 345

Hafkenscheid, Toni, *Train Snaking Through Mountain*, from the series *HO* 316

Halpern, Greg, *Untitled*, from the series *Landscapes without Violence* 116

handheld meters 128

haptic-expressionists 190–91, 193

hard disc drives, 114, 115, 267; external vs. internal 115

Harper, Jessica Todd, *Chloe and Sybil and Becky* 158

Harrison, Adam, *Darkroom Lesson* 403

Hartford, Laura, *Hovering Between Us II*, from the series *Like a Weed* 376

Hawkins, Evan, *AS17-145-22167* 300

haze 166, 168

haze filters 149

Heartfield, John 228

heat 168–69

HEIC (High Efficiency Image Format) 77

Heinecken, Robert 10, 348, 387

heliochromy 4

Help Mode 100

Henderson, Adele, *Globes of Our Time* 54

Henrich, Biff: No title 211; *Untitled* 165

Herman, Rachel, *Neal and Chris*, from the series *The Imp of Love* 167

Hernandez, Richard Koci 113

Herrera, Dan, *Continuity*, 399

Hickok, Liz: *Incident*, from the series *Ground Waters* 315; studio setup for *Incident* 315

hidden cameras 73

high-angle viewpoints 311

high dynamic range (HDR) imaging 4, 129

High Efficiency Image Format (HEIC) 77

highlights 139, 141, 161, 172, 330

high side light 175

Hill, David Octavius 5, 362

Hill, Ed, *Solstice 12.21.05* 91

Hines, Jessica, *My Brother's War: Chapter 7, Untitled 11. I Pray for Your Spirit* 199

Hines, Lewis W. 7

Hirsch, Oded, *Halfman* 349

Hirsch, Robert: *Atomic Couple*, from the installation *Pluto's Cave—Unseen Terror: The Bomb and Other Bogeymen* 219; *Globes of Our Time* 54; *God Bless*, from the series *The Sixties Cubed: A Counter Culture of Images* 293; *Mug Shot #39*, from the series *Buffalo Rogues Gallery of 1934* 222; *World in a Jar: War and Trauma* (installation detail) 25

histograms 93–94, 124, 252

Höch, Hannah 229

Hockney, David 227; *Cameraworks* 224

Hod, Nir, *Mother* 196

Holzer, Jenny, *For the City* 233

homemade film cameras 72

homemade filters 150–51

HTML 295

Hue adjustment 145–46

human form 380–81; exercise 382

Hunter, Allison, *Untitled #7,* from the series *Simply Stunning* 323

Huston, Robert, *Universal Class Face* 14

hypermedia 386

ICC profiles 265

Illustrator 76

image-based installations 231–32

image compression 76

image corruption 261–62

image display 244; dots per square inch (DPI) 245–46; pixels per square inch (PPI) 244–45; for print images 247; for screen images 247; *see also* digital files

Image Enhancement Modes 98

Image Factors Sensor Equivalency 85

imagemakers *see* photographers

imagemaking, photo-based 16–17, 19–28; visual vs. haptic 189–191, 193; *see also* photography

image quality, factors affecting 243

image resolution 65–66, 252; dots per square inch (DPI) 66–68, 67–68; pixels per square inch (PPI) 65–66, 67

images *see* digital images; print images

image stabilization 101, 211–12

image transfer 116

image viewers 252–53

image window 253

imaging applications 267

imaging system: digital sensor array 62; lens 62; mirror 62; mirrorless 63; pentaprism 62–63

incident light 121; *see also* light

industrial photographers 402

information sharing 279

infrared (IR) light 143

infrared camera conversion 69

inimage 229

inkAID 259

inkjet printers 253, 255, 258; droplet size 255–56

inks 257

Instagram 117, 293

installations 12; image-based 231–32

instant cameras 72

Interchangeable Lens Cameras (ILC) 71

interior experiences: inner fantasy 370; memorable dream or memory 370; philosophical beliefs 369–370; psychological drama 371, 373; social issues 373

internal hard disc drives 115

International Color Consortium (ICC) 265

International Standards Organization (ISO) 95, 243

Internet and the World Wide Web 278–79; manufacturers' websites 281; online photographic collections and exhibition sites 352

internships 403

interpolation 65, 248–49

Iris print 258

iron-on inkjet transfer 259–260

ISO (International Standards Organization) 95, 243

Jantzen, Ellen, *Pueblo Ascending,* from the series *Coming Into Focus* 277

Jarrell, Randall 23, 26

Jeanne-Claude, *The Gates* 231

Johan, Simen, *Untitled #133,* from the series *Until the Kingdom Comes* 122

John Cage's Rules 358

Johnson, Keith: *Do Not Open* 132; *Planes Flying 11:00* 297

joiners 227

Joint Photographic Experts Group (JPEG) 76, 77, 239, 250, 251

Jordan, Christopher, *Suburban Sublime* 329

journal keeping 342

JPEG (Joint Photographic Experts Group) 76, 77, 250, 251; for timeline animation 239

jump drives 115

Kahlo, Frida 362

Kahn, Nicholas, *Lunar Landing* (detail), from *The Apollo Prophecies* 228

Kaprow, Allan 231

Käsebier, Gertrude 6, 316

Kazanjian, Jim, *Untitled,* xxvi

Kellner, Thomas, *La Sagrada Familia, Barcelona* 226

Kelly, Mary 387

Kelvin scale 143

Kenny, Kay, *Dreamland Speaks When Shadows Walk, #7* 7

Ketchum, Robert Glenn, *Louisiana Pacific-Ketchikan,* from *The Tongass Rainforest Campaign* 377

key light 172

Kim, Atta, *3 Buddhas*, from *ON-AIR* Project 240

Kirsch, Russell A. 12

kit cameras 72

Klein, William 9; *Life Is Good & Good For You in New York* 376

Klimas, Martin 379

Kline, Kevin, *Boschplode*, 404

Klink, Oliver, *Ancient Farming*, from the series *Consequences* 161

Knorr, Karen, *The Conqueror of the World*, from the series *India Song* 368

Kodachrome 219

Kruck, Martin: *Canopy*, from the series *Habitorium* 260; *Xscape #6* 102

Kruger, Barbara 387

Kucharm Karalee, *Ghostbird* 303

Labate, Joseph 41

LaChapelle, David 362

Lagate, Joseph, *Landscape #1152* 152

LaMarca, *Untitled*, from the series *Forest Defenders* 131

Lampack, Jessie, *Untitled* (detail from triptych) 389

Lange, Dorothea 8, 363

Larson, Nate, *A Portrait of Rudy Giuliani* 94

Lazertran 259, 261

LCD (liquid crystal display) monitors 125–26

Lee, Betty 387

Lee, Evan, *Every Part from a Contaflex Camera, Disassembled by the Artist During Winter, 1998* 58–59

Lee, Liz 385, 387; *Observational Drawings: Eye* 2

Lee, Russell 363

Le Gray, Gustave 5

Leica cameras 72

Lemm, Sebastian, *Subtraction #1* 18

Lensbaby 210–11

lenses, zoom 126

lens filters *see* filters

lens system 78; aperture 78–79; aperture/f-stop control/shutter control/exposure modes 79–80; autofocus modes 85–86; depth of field 80–82; determining exposure 90–91; focusing the image 84–85; lens focal length 82–84; normal lenses 86–87; shutter lag 90; shutter modes 90; shutter speed control 90; shutters: rolling and global 89–90; special-use lenses 88–89; telephoto lenses 87–88; types of lenses 86–89; wide-angle lenses 87; zoom lenses 86

Leonardo da Vinci 350; *Mona Lisa* 42, 362

Lesch, William: *Grand Canyon Panorama, 180 Degree View from Nankoweap Anasazi Granaries* 343; *Lightstorm over Tucson, 4 Hour Time-lapse Montage* 200

Levere, Douglas: *Everywhere, CO. INC, Manhattan*, from the project *New York Changing* 221; *New York Changing* 220

Levine, Sherrie 12

Levinthal, David, *Dallas 1963* 81

light: and the camera 157; color of 144; color temperature and the Kelvin scale 143–44; drawing with 216–17; polarized and unpolarized 147–49; reflected 167; thingness of 155–56; white balance 144–45; *see also* artificial light; natural light

Light, Michael, *045 Stokes, 19 Kilotons, Nevada, 1957* from *100 Suns* 280

light field (plenoptic) cameras 72

lighting: averaging incident and reflect exposures 141; backlight 139, 140; Dynamic Range Chart 129; fluorescent light 152–53; gas-filled lights 152–53; glare 139; high-intensity discharge lamps 153; highlights 141; indoors 208; large highlights 139; long exposures 142; mercury and sodium vapor sources 153; from an odd angle 139; reflections 139; strobe light 176; stroboscopic effect 155; subject in bright light 140; subject in shadow 140; from television or computer screens 139; in the work space 266–67; zoom exposure 141

lighting accessories: barn doors 176; diffuser 176–77; gels 177; reflector card 177; reflectors 181; seamless paper backdrops 181; snoot 181; softbox 181; studio strobes 181; umbrellas 181

lighting methods 174; back light 175; front light 175; high side light 175; under light 175; low side light 175; side light 175; top light 175

light metering techniques: exposing for tonal variations 134; metering for the subject 134

light meters 123

lightning 166

light reading: average daylight 130; brilliant sunlight 130, 132; contrast control/tone compensation 133–34; diffused light 132; dim light 133

Lightroom (cataloging program) 114, 253

light sources: color temperature of 144; exercise 182

limited depth of field 82; *see also* depth of field

line 45

linear blur 210

linear perspective 327; two-point 327–28

liquid crystal display (LCD) monitors 125–26

lithophanes 230, 231

Little, Adriane, *Mapping Mrs. Dalloway #7* 341

lossless image compression 76

lossy image compression 76

low-angle viewpoints 310–11

Lowenfeld, Victor 189–190

lower back problems 397

low side light 175

Ludovico, Alessandro, *Face to Facebook* 235

Lutz, Joshua, *Sheetz* 319

Lux, Loretta, *Sasha and Ruby* 180

Lyons, Patrick J., "In an Iranian Image, a Missile too Many" 372

Lytro cameras 65, 72

 M

Maas, Rita, *Pirates vs. Cardinals 5-2, May 13 2009*, from the series *Reality TV* 97

macro lenses 88

Madigan, Martha, *Graciela: Growth III* 192

Magic Hour 160, 161, 163

Magyar, Adam, *Squares #517* 44

Maio, Mark, *20/20* 153

Mann, John, *Untitled (To France)*, from the series *Folded in Place* 82

manufacturers' websites 281

many make one 224

Mapplethorpe, Robert 348, 361, 381

Marc, Stephen, *Untitled*, from the *Passage on the Underground Railroad* Project 229

Mark, Mary-Ellen 363, 388

Marsh, Fredrik, Homage to Frederick Sommer 46

mashups 117, 294

Maskell, Alfred, *Photo-Aquatint or the Gum-Bichromate Process* 6

Massard, Didier, *Rhinoceros* 172

mat board: criteria for 286; cutting steps 288–89; image and board sizes 289; selection of 284–85

mat cutters 285

McCall, Molly, *Scarlet Girl*, from the series *In-Between* 406

McCormack, Dan, *Sara* 271

McGovern, Thomas, *The New City #18* 162

Means, Amanda: *Flower #61, inversion* 5; *Flower #61, positive* 5

mechanical storage 115

medium-format cameras 71–72

megapixel myth 243

megapixels 65, 92, 244

memory, removable 103

memory buffer 103

metadata/EXIF 94–95

metamerism 257, 302

metering: center-weighted 125; guidelines for 122; highlight-biased 125; shadow-biased 125; spot method 125; thru-the-lens (TTL) 121

Metering Modes 96

Metzker, Ray K. 10, 32

Meyer, Diane, *Me and Tom*, from the series *Quiet Moments Spent with Friends* 187

Michals, Duane 223, 388

Michals, Robin, *Jupiter*, from the series *Daily Bread* 236

microprisms 85

midday light 160

MILC (mirrorless cameras with interchangeable lenses) 70–71

Miller, Roland: *Abandoned in Place* series 47; *Apollo Saturn V F1 Engine Cluster* 47

Mills, Joe, *House* 96

Milstein, Jeffrey, *NYC 10 Empire State Building*, 395

Minter, Marilyn, *Shit Kicker* 136

mirage 78

mirrorless cameras 85; with interchangeable lenses (MILC) 70–71

mist 166

mixed media 259–260; preparing digital prints for 260–61

modeling light 170

Moholy-Nagy, László 314

monitor playback mode 93–94

monitors 93, 125–26; emissions from 397

monochromatic color 324–26; and aerial perspective 324; color contamination in 324; exercise 325

monopod 90, 211

Moon, Beth, *Lyra*, from the series *Diamond Nights* 142

moonlight 164–65

Moore, Andrew, *National Time, Former Cass Technical High School, Detroit*, from the series *Detroit Disassembled* 202

Moore, Gordon 129

Moore's Law 129

Morell, Abelardo, *Square Light on Landscape, Big Bend National Park, Texas* 163

morning light 160

Morris, Wright 384

Mortensen, William 9

Mosch, Steven P., *Tabby Ruins #3, Spring Island, SC* 71

Moskovitz, Morry, *Sean* 44

Moss, Brian, *Planets and Moons* 339

motion blur filters 206, 210

motion picture cameras 237

multi-image filter 149

multi-image prism 213

multimedia cameras 72

multiple exposure 218

Muniz, Vik, *After Chuck Close*, from the series *Pictures of Color* 344

Murai, Richard, *Altar, Interior, The Bayon, Angkor Thom, Cambodia* 89

mural-size prints 258

Muybridge, Eadweard 205–6; *Animal Locomotion* 206; *Galloping Horse, Motion Study—Sallie Gardner* 238; timeline setup 237

Mylar 46

Nagatani, Patrick Ryoichi: *Desire for Magic* 298; *Model A Woody, National Radio Astronomy Observatory (VLA), Plains of St. Augustin, New Mexico, U.S.A.* 21

National Endowment for the Arts (NEA) 348

National Geographic 12, 15

natural light 155; afternoon 161; beach and desert 169; bright sunlight 208; contrast/brightness range 173; cycle of 158; daylight 208; dust 168; fog and mist 166; Golden or Magic Hour 160; "good light" 156–57; heat and fire 168–69; late evening 208; midday 160; moonlight 164–65; morning 160; night 163; overcast 208; rain 166; and the seasons 165–66; snow 167; snow effects 167–68; before sunrise 160; sunset 161; time of day/type of light 159–160; twilight/evening 163; weather and atmospheric conditions 166–69

ND (neutral density) filters 147

NEA (National Endowment for the Arts) 348

nearest neighbor 248

negative space 47

Nègre, Charles 5

Netflix 118

Nettles, Bea 10; *Hole*, from the series *Return Trips* 370

neutral body positioning 398–99

neutral density (ND) filters 147

Newman, Arnold 363

new media 15

news magazines 8

Nguyen-Duy, Pipo, *Mountain Fire*, from the series *East of Eden* 331

Nix, Lori, *California Fire* 38

Nizza, Mike, "In an Iranian Image, a Missile too Many" 372

noise 95–96

noise reduction 100

normal lenses 86–87

nudes 380–81

observation: artistic vs. scientific 187; creative looking 185; stimulating looking 185; and visual literacy 188

O'Donnell, Sue, *Dragonflies* 262

O'Keeffe, Georgia 221

Op Art 318

open websites 117–18

Opera, John, *Forms I*, 57

Operations Review (Thinking Model Stage 5) 346

opposites 332

optical stabilization 206

optical zoom 95

optimism 369, 371

option/shift/command tools 276

Opton, Suzanne, *Soldier: Claxton—120 Days in Afghanistan* 363

Orland, Ted, *Dancing Girl*, from the series *Seabright at Midnight* 99

Orloff, Deborah, *Holzwege 1* 326

Oropallo, Deborah, *George* xxi

out-of-focus images 209–10

overlapping perspective 327

Owens, Bill, *Model Home, Plano, TX,* from the series *The New Suburbia* 102

Ozbilici, Burhan, *Assassination of Russia's Ambassador to Turkey* 8

Paglen, Trevor, *The Fence (Lake Kickapoo, Texas)* 351

panoramic cameras 72

pan shot 211–12

pan zooming 213

paper selection, coated vs. uncoated 256–57

parallax error 68

ParkeHarrison, Robert, *Scribe* 378

ParkeHarrison, Shana, *Scribe* 378

Parks, Gordon 388

Parr, Martin, *Singapore*, from the series *Road Trip* 61

patterns 37–38, 48–49; of line 45

Pearce, Jeannie, *Female Blackbird* 75

Penn, Irving 379

perspective: aerial 324, 327; converging lines 328–29; linear 327; overlapping 327; two-point linear 327–28

perspective control lenses 89

pessimism 369, 371

Pfahl, John, *Isle of the Dead* 270

photoflood light 170

photograms 280

photographers: approach to time and space 24; bias of 4; and the communication of meaning 23, 31; creative work of 23; and creativity in other fields 27–28; defining beauty and truth 19–20; difficulties encountered by 22–23; explaining photographs 26; finding subjects 20–21; as flâneurs 188; haptic-expressionists as 190–91, 193; means of becoming a photographer 16; motivations of 22; prior knowledge of 26; proficiency of 23; quality of output 23; role of 12, 31, 187; traits of 16–17; value of studying others' images 25–26; visual-realists as 190; *see also* career opportunities

photographic books 393

photographic collage 229

photographic collections, online 352

photographic copies 303; copy lighting 304–5; exposure 305; lens selection 303–4

photographic equipment 27

photographic history 3–4, 25, 36–37; alternative scene 10; collodion (wet-plate) process 5; combination printing 5–6, 10; digital imaging transformation 12, 15; documentary/photojournalistic approach 7–8; electronic imaging 12; Group f/64 9; gum printing 6, 10; new media 15; Photo-Secessionists 7; before Photoshop 4–5; the Pictorialists 6–7; postmodernism 10, 12; postvisualization 9, 10; previsualization 8–9; rise of color photography 10; social landscape and the snapshot aesthetic 9–10; straight photography 6, 7, 8–9; *tableau vivant* 5; Zone System 9

photographs: calotypes 5; cyanotypes 10; daguerreotypes 5; definition of 16; empathy in 17; experiencing 350–51; explanations for 26; with hand-applied color 4; as matrix 347–48; meaning of 19; retouched 5; unique function of 15, 17; wet-plate (collodion) process 316; *see also* digital images; print images

photography: cinematic 223; effect on the arts 193–95; and fauxtography 363–64; finding new inspirations for 21–22; function of 2, 7; as global conversation 117–18; importance of 17; and interior experience 369–373; language and grammar of 3, 34; native characteristics of 35–37; privilege of 34; role of theory in 27; as subtractive composition 32–33; and truthiness 364–65; use by NASA 12; and Wikiality 364–65

photojournalism 7–8, 113, 402

photomicrographs 72

photomontage 228

Photoshop 76; stop-motion interface 239; Timeline Animation 237–39

Photoshop tools: changing mouse pointer 276; layers 276; *see also* toolbar icons for photo editing

photosites 65

Photo-synth 230

Picasso, Pablo 362

Pichler, Klaus, *Dust #8: Tailor* 186

picoliters 255–56

PICT 76

Pictorialists 316

pictorial space 47

picturemakers *see* photographers

picturemaking: history of 1; *see also* photographic history

picture review 252

Piezography 161

pigment-based inks 257, 302

pinhole cameras 72–73, 131, 271

Pinney, Melissa Ann, *Marilyn*, from the series *Girl Ascending* 35

pixels 65; dead 95; importance of 243–44; *see also* pixels per square inch (PPI)

pixels per square inch (PPI) 65–66, 67, 244–45, 246, 247, 249

Plexiglass 291

plugins 151–52

Plumb, Colleen, *Meat Packer* 79

PNG (Portable Network Graphics) 76, 250, 251

podcasts 15

polarizers 148–49, 168; linear and circular 149

Polidori, Robert, *2732 Orleans Avenue, New Orleans, LA*, from the series *After the Flood* 120

Pollock, Jackson 193, 362

poly silk cloth 259

Pompe, Kathleen, *Jellyfish at Monterey* 227

Porco, Caroline 13

portfolio 292

portrait photographers 402

portraits 361, 362–63; from within 368; environmental 363; and social identity 366–68

positive space 47

Post Documentary approach 221–22

postvisualization 9, 10, 220, 222

PPI (pixels per square inch) 65–66, 67, 244–45, 246, 247, 249

presentation 305; copyright of your work 306; exhibition opportunities 307; shipping 305; sources for preservation and presentation supplies 307; where to send work 306

preservation, sources for preservation and presentation supplies 307

previsualization 8–9

Prince, Douglas, *Extrusion Map 89* 66

Prince, Richard 12, 222

print images 253; attributes of 252; best practices 247; digital files for 252; evaluating 357; function of 15; permanence of 258; preparing for mixed media 260–61; sizing 248. *See also* digital print stability

printing: desktop inkjet printers 258; droplet size: picoliters 255–56; Giclée printing 258; inkjet printers 253, 255–56; inks 257; Iris print 258; mural-size prints 258; paper selection 256–57; and printer resolution 246; print permanence 258; service bureaus 261; unusual printing materials 259–261; *see also* dots per square inch (DPI)

print-on-demand books 292–93

print preservation 296; archival wax 296–97; color print life span 298–99; display environment 299–300; factors affecting print stability 296; long-term guidelines 300; materials adversely affecting print lifespan 297; sources of supplies 300; storage environment 300; *see also* archival presentation; digital archives; digital print stability

print size 92–93

print surfaces, Kodak RA-4 color paper 298–99

prism filter 149

ProCamera 208
Program mode 80
projection 217–18, 233
project viability 337
proper posture 397
proportion 39–40
Proust, Marcel 25
psychological drama 371, 373
public art 232–34
public commons 118
purple light 163

Q

QuickTime 278

R

Raaf, Sabrina, *Over and Again*, from the series *Test People* 328
radial blur filter 210
rain 166
RAM (random access memory) 267
rangefinder cameras 85
raster images 269
Ravn, Morten Rockford, *Selfie*, from the series *Fear and Loathing in GTA V* 347
RAW files 76, 77–78, 250–52
Ray, Man 2
reality, recomposing 236–37
Reciprocity Law 141–42
recomposing reality 236–37
red eye 137, 139
reflections 139, 141, 168
reflective light 121; *see also* light
reflector card 177
reflectors 181
Rejlander, Oscar Gustav 5; *Two Ways of Life* 5
Rembrandt 361
remote cameras 73
repair 283
rephotography 220–21
Resample Image 246, 248, 249
resampling 248–49
resolution and print size 92–93
retouching 283
Revell, Graham 40
RGB (red, green, blue) color mixing 65, 96, 98, 109, 111, 124, 145–46, 247, 248, 255, 262–67, 267, 273
rhythm: alternating 42–43; progressive 43
Riis, Jacob A. 7

Robbins, Kathleen 374
Robinson, Henry Peach 5–6; *Pictorial Effect in Photography* 6
Roetter, Joyce, *Self-Portrait, SPECT Scan #10* 53
rolling shutter 89
ROM (read-only memory) 267
Rothko, Mark 362
Rothstein, Arthur 8
Rudensky, Sasha, *Mannequin, Moscow, Russia* 33
Rule of Thirds 40, 388

S

safety issues 397–99
Sagmeister, Stefan, *Things I Have Learned In My Life So Far, Updated Edition* 385
Sailer, Alan: *Last Crayon Standing* 209; *Oh Those Chocolate Eyeballs Itch* 398
Sandacz, Morgan, *Human 003* 366
Sander, August 162
Sandford, David, *Orange Dawn* 206
Sasson, Steve 63
Sauer, Damon, *Death Rubbing: Unidentified Iraqi Civilian* 192
scale 39–40; diminishing 327; on scanners 112
scaling 243, 250
scanners and scanning 109, 213, 301; drum 109–10; flatbed and film 109; scale and spatial effects 112; scanning guidelines 110; scanning steps 110–11
scanning backs 68, 213
Scene Modes 98, 141
Scheer, Joseph, *Grammia virgo* 49
Schneider, Betsy 40
School of the Art Institute of Chicago (SAIC), Generative Systems Department 12
Schroeder, Sarah, *Fries with That* 207
Schuman, Hinda 387
Schwarm, Larry 223; *Burning Sugar Cane, Bayou Tesch, Louisiana* 140; *Columns of Smoke for CRP Fire near Bedford, Kansas* 168; *Laurence and Pauline Schwarm with a Photograph of his Father's Original Farmstead taken about 1912* 364
scientific photographers 402
screen images 253; attributes of 252; best practices 247; sizing 248; *see also* digital images
Scruton, Frederick 173, 309; *Marin/Martinez Halloween Display, Cleveland, OH* 308; *Ronald Mann, Clio, MI* 214
seamless paper backdrops 181
search engines 279
Search for Form (Thinking Model Stage 2) 342; possibility scale 343; quiet time 343–44
Second View: The Rephotographic Survey Project 220
selective focus 314, 316–17, 388

Selesnick, Richard, *Lunar Landing* (detail), from *The Apollo Prophecies* 228

self-portraits 361–62

self-timer shutter mode 90

sensors: in a digital camera 64; in a traditional camera 62

sequences 223

Serrano, Andres 348; *Snoop Dogg* 350

Seven Deadly Sins exercise 223

shadows 330

Shambroom, Paul, *Urban Search and Rescue*, from the series *Security* 371

shape 46; abstract 46; geometric 46; natural 46; nonobjective 46; symbolism of 54

Sharpening Modes 99–100

Sheridan, Sonia Landy 12

Sherman, Cindy 12, 348, 362; *Untitled Film Stills* 12

Shindelman, Marni, *A Portrait of Rudy Giuliani* 94

Shore, Stephen 10

Shutter Priority mode 80

shutters: determining exposure 90–91; rolling and global 89–90; shutter lag 90; shutter modes 90

shutter speed 79, 207; and blur 210; controlling 90, 205; on digital cameras 208–9; and motion 208; shutter speed rule 90; slow 214–15

Siber, Matt, *Burger King*, from the series *Floating Logos* 53

Sickert, Walter 26

side light 175

Siegmund, Thomas, *Untitled #15*, from the series *The Good House* 380

silicon photodiodes (SPDs) 65

Silvia, Lesley 171

single frame shutter mode 90

single-lens translucent (SLT) cameras 70

Single-servo focus setting 86

Siskind, Aaron 9

sizing 246, 248

Skarbakka, Kerry, *Office*, from the series *Life Goes On* 24

skylight filters 149

Slankard, Mark, *Bathroom with Twin Pop*, from the series *Minor Invasions* 88

slave unit 135, 176

slices of time 227–28

slide film 219

Slow Sync mode 214–15

SLT (single-lens translucent) cameras 70

smartphone applications 152

smartphone cameras 72; components of 71; controlling shutter speed 208–9; lenses in 244; making superior captures with 71

Smith, Henry Holmes 46

Smith, W. Eugene 8

Smithson, Robert, *Spiral Jetty* 234

Snapfish 293

snapshot aesthetic 10

snoot 181

snow 167

snow effects 167–68

Snyder, Marc, *Thinking About Thinking* 390

social customs 367

social identity 366–68

social landscape 9–10, 375–77, 377; exercise 378

social media 61, 235, 293, 295

social networking 15, 64, 295, 367

softbox 181

software: Bokeh 211; in-camera 103; for color display 265; digital asset management (DAM) 301; for digital imaging 267; digital post-capture 253; HTML 295; imaging 235; landscape-rendering 230; print drivers 246; raster/bitmapped 269; special imaging 230; Tilt-Shift 210; vector graphics 269

Sokolowska, Ursula, *Untitled #57*, from the series *Constructed Family* 336

solid-state storage 114, 115

Solomon, Dan, *Witness #7* 34

Sommer, Frederick 46

source notebook 342

space 47; actual 47; pictorial 47; positive and negative 47; virtual 47

Spagnoli, Jerry, *Marathon* 131

spatial effects, on scanners 112

Special Effect Modes 98–99

special-use lenses 88–89

Spencer, Nancy, *White Horse, Black Horse* 74

Sperber, Devorah, *After the Mona Lisa 8* 186

split field filter 149

spots 96

spray mounting 291

SPDs (silicon photodiodes) 65

spring light 165

spy cameras 73

Staller, Jan, Dawn 167

Starn, Doug: *Big Bambú: 5,000 Arms to Hold You* 232; *The Strange Loop You Are* 232

Starn, Mike: *Big Bambú: 5,000 Arms to Hold You* 232; *The Strange Loop You Are* 232

star tracker 215

star trails exposures 216

Steichen, Edward 170

stereo cameras 73

stereo images 230

Stieglitz, Alfred 7, 221; *Camera Work* 7

still life 377, 379; deliberations 379–380

stimulating looking 185

stop-action images 205–8

stopping action 143

storage: cloud storage 114, 116; compact discs (CD) 114, 115; digital 113; digital access management (DAM) 113–14; digital versatile discs (DVD) 114, 115; external hard disc drives 115; flash memory media 115; hard drives 115; image transfer 116; internal hard disc drives 115; jump drives 115; mechanical storage 115; media for 114; solid-state storage 115; USB drives 115

storms 166

Strand, Paul 7

street photography 294

Strembicki, Stan, *Ruined Flag, Lawless High School, Lower 9th Ward* 17

strobe light 176, 181

stroboscopic effect 155

Strom, Stephen, *Hillsides, looking east from Ubehebe Crater, Death Valley National Park* 49

Strosnider, Luke, *Dune, White Sands National Monument, New Mexico, circa 1942*, from the series *Ansel Adams/New Landscapes* 94

studio strobes 181

subdued color images 329–330

Sugimoto, Hiroshi 209

summer light 165–66

sunset 161

Surrealism 39, 155, 229

surveillance images 12

Suzuki, Shunryu, *Zen Mind, Beginner's Mind* 31

symbolism 49, 51; of colors 54; commercial 51; of common elements 54, 56; cosmic 51; cultural 51–52; magical 52; patriotic and political 52; personal 52, 56; psychological 52; religious 52; of shapes 54; status 52; traditional 52

sync cord 135

T

Tagged Image File Format (TIFF) 76, 77, 250, 251

taking breaks 398

Talbitzer, Sheila, *Untitled #5* 18

Talbot, Henry Fox 4, 118; *The Open Door* 21; *The Pencil of Nature* 20, 390

Taylor, Maggie, *Strange Days IV* 110

Taylor, Michael: *Flight*, from the series *Luminescence* 216; *Helios* 123

telephoto lenses 87–88, 206, 207

telescopes 73

text: exercise 385; and images 384–89; methods for working with 389

texture 42, 48; background 48; tactile 48; visual 48

thermal imaging camera 75

thinking: about digital images 335; process of 336–37

Thinking Model: Stage 1: Thinking Time 338–342; Stage 2: Search for Form 339, 342–44; Stage 3: Definition and Approach 339, 344; Stage 4: Bring It Together 339, 345–46; Stage 5: Operations Review 339, 346; Stage 6: Evaluation 339, 346–47

Thinking Time (Thinking Model Stage 1) 338–340; challenging fear 341–42; getting ideas 340–41; source notebook and journal keeping 342; the success game 342

Thompson, Calla, *Untitled* 263

Thompson, John 366

Thoreau, Henry David 338

three-dimensional images 229–230

three-dimensionality 38

three-dimensional modeling programs 278

thru-the-lens (TTL) metering 121

TIFF (Tagged Image File Format) 76, 77, 250, 251

Tilt-Shift software 210

tilt zooming 213

time: nature of 201; perception of 202–3; *see also* camera time

time-lapse cameras 73

timeline animation 237; getting started 238–39; preparing still image files 239, 241

Todd, David Evan, *Nikon SLR*, from the series *Still Photography* 108

Tone Mapping 129

toolbar icons for photo editing: black arrow 272; blur tools 274; brush and pencil tools 273; clone 273; color picker 275; crop tool 272–73; dodge and burn tools 274; eraser 274; eye dropper 273; gradient tools 274; hand tools 275; healing brush tools 273; history brush 274; lasso tool 272; magic wand 272; marquee tools 272; move tool 272; path selection tools 275; pen tools 274; quick mask 275; rectangle shape tools 275; screen modes 275; text 275; zoom 275

top light 175

Towery, Terry, *View of Crimean War Battle Scene* 357

toy film cameras 73

trail cameras 73

translucence 173

transparencies, sandwiching/overlapping 219

tripods 47, 71, 73, 90, 95, 101, 129, 133, 138, 147, 159, 163, 164, 167, 173, 182, 208, 211–16, 218, 238, 239, 303, 305, 324, 338, 383

TTL (thru-the-lens) metering 121

Tumblr 117

Tümer, Laurie: *Cloud #8584*, from the series *Clouds* 285; *Glowing Evidence: In My Study A&B* 396

twilight 163

Twitter 235

Uelsmann, Jerry 10, 388

Ulrich, Brian: *Belz Factory Outlet Mall 1*, from the series *Dark Stores, Ghost boxes and Dead Malls* 321; *Black River Falls, WI* 394

ultraviolet (UV) filters 149

ultraviolet (UV) light 143, 149

umbrellas 181

under light 175

underwater cameras 73

unity 37–38

unknown photographer, *Boy from Warsaw Ghetto Uprising* 196

USB drives 115

Valentino, John 51

value, and balance 42

van Gogh, Vincent 362

variety 37–38

vector graphics software 269

Ventura, Paolo, *Automaton #15* 194

very low frequency (VLF) emissions 397

video blogs (vlogs) 15, 64

video clips 278

Video grab, *The Boy in the Ambulance* 234

video memory (VRAM) 263

Video Mode 98–99

view cameras 73

viewers: bias of 4; function of 17; role of 2

viewpoint: angles of view 310–11; bird's-eye-views 313–14; eye-level angle views 310; high-angle viewpoints 311; low-angle viewpoints 310–11; seeing dynamically 309–10; wide-angle lenses 313; wide-angle viewpoints 311; working methods 310, 312

Vionnet, Corinne, *London*, from the series *Photo Opportunities* 296

virtual space 47, 118

visual acuity, and DPI 67–68

visual design 51

visual elements: line 45; pattern 48–49; shape 46; space 47; symbolism 49, 51–52, 54, 56; texture 48

visualization 8; post-camera 222

visual language 185, 187

visual literacy 188

visual-realists 190

VLF (very low frequency) emissions 397

von Stuck, Franz, *Internationale Hygiene, Dresden* (exhibition poster) xxviii

VRAM (video memory) 263

Wade, Cara Lee, *The Lie That Leads to Truth* 11

Walker, Chris, *Ash Grove, Missouri, 2:15 A.M.* 215

Walker, Kara E., *8 Possible Beginnings or: The Creation of African-America, Parts 1-8, A Moving Picture* (video still) 15

Wall, Jeff, *After "Invisible Man" by Ralph Ellison, the Prologue* xxx

Waltzer, Garie, *Eifel Tower, Paris* 189

Warhol, Andy 361

wax, archival 296–97

wearable digital cameras 73

weather and atmospheric conditions: beach lighting 169; desert lighting 169; dust 166, 168; fire 168–69; fog 166; glare 168; haze 166, 168; heat 168–69; lightning 166; mist 166; rain 166; snow 167; snow effects 167–68; storms 166

web cameras (webcams) 73

web logs (blogs) 64, 117, 279

web pages 295

website design 295

Weems, Carrie Mae 12, 348, 387

West, René, *Steel Gandhi 4*, 359

Weston, Edward 8, 379

wet mounting 287

wet-plate (collodion) process 5

what you see is what you get (WYSIWYG) 265–66, 295

White, Clarence H. 51

White, Minor 9

white balance 96, 144–45; and artificial light 170

wide-angle lenses 87, 311, 313

Wi-Fi memory cards 116

Wildey, Al: *Camera Obscura Trailer* 338; *Yield* 338

Wilkins, Kristen S., *Us Girls*, from the series *Autoportraits* 257

Winogrand, Garry 10, 40, 59; *The Animals* 376

winter light 165

Wolf, Lloyd, *April Fool* 356

Wood, John 10

workstations, ergonomic 397

World Wide Web *see* Internet and the World Wide Web

writing: about images 352–53; artist's statement 353–56; essentials of image discussion 356–57

WYSIWYG (what you see is what you get) 265–66, 295

Younger, Dan, *Untitled (Venice Beach, California)* 311

YouTube 118, 203, 235

Zellen, Jody, *Hands Terror* 388

Zigmund, Tricia: *Collapse of the Swaying Steady* 205; *My Every Midnight* 174

zone of focus 80

Zone System 9

zoom, optical and digital 95

zoom exposure 141

zooming 212–13

zoom lenses 86, 126

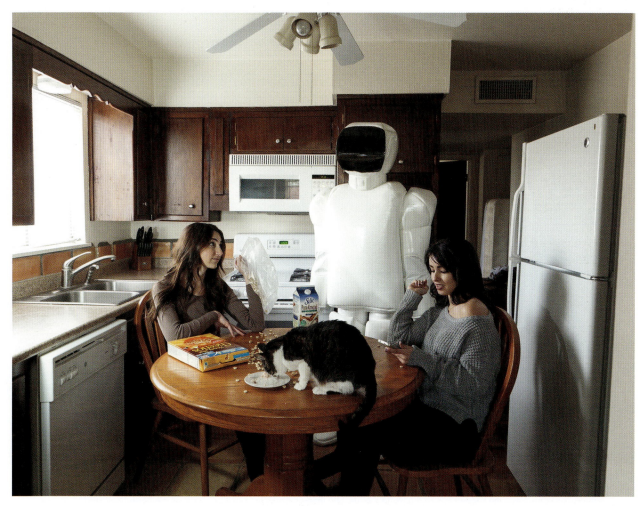

Abbey Hepner informs us: "While living in Japan I became interested in caretaker robots that were being developed to tend for their ballooning aging population. Each scene was staged and nothing was composited. I made a costume to mimic the robots being built. The face of the robot is a screen, reflecting the pervasiveness of devices like smartphones and computers. This evocative technology mediates many of our real-world relationships. I am not sure how this series ends; it is meant to be ambiguous. Its fate will depend on the way we use it and who we are attempting to replace with it."

Credit: © Abbey Hepner. *Untitled 2*, from the series *Robot Caretakers*, 2014. Dimensions variable. Inkjet print.

Emma Powell and Kirsten Hoving share that "*Svala's Saga* is a photographic fairy tale that is told through multiple interrelated photographs in which Svala is confronted with the sudden loss of the world's birds. She then embarks on a mythic quest: as the Earth heats and cools, she journeys through the wilderness searching for the last remaining eggs. *Svala's Saga* harnesses the power of fiction to explore topics such as climate change and species extinction. The prints are produced utilizing a combination of digital editing, compositing, a digital color under-print, and a digital negative with the palladium chemical process."

Credit: © Emma Powell and Kirsten Hoving. *Sighting*, from the series *Svala's Saga*, 2015. 16 x 20 inches. Inkjet over palladium print.